D1493744

CHINA

The Three Emperors

1662–1795

Edited by

EVELYN S. RAWSKI and JESSICA RAWSON

ROYAL ACADEMY OF ARTS

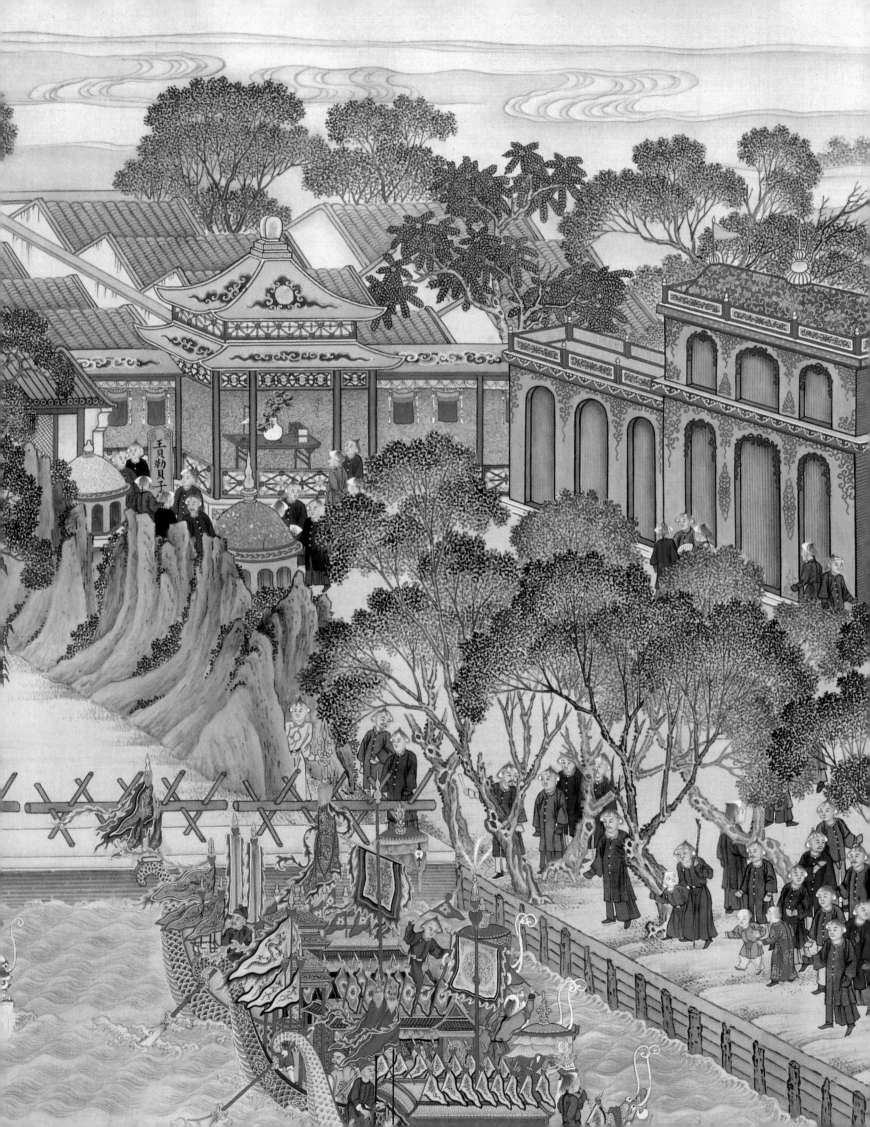

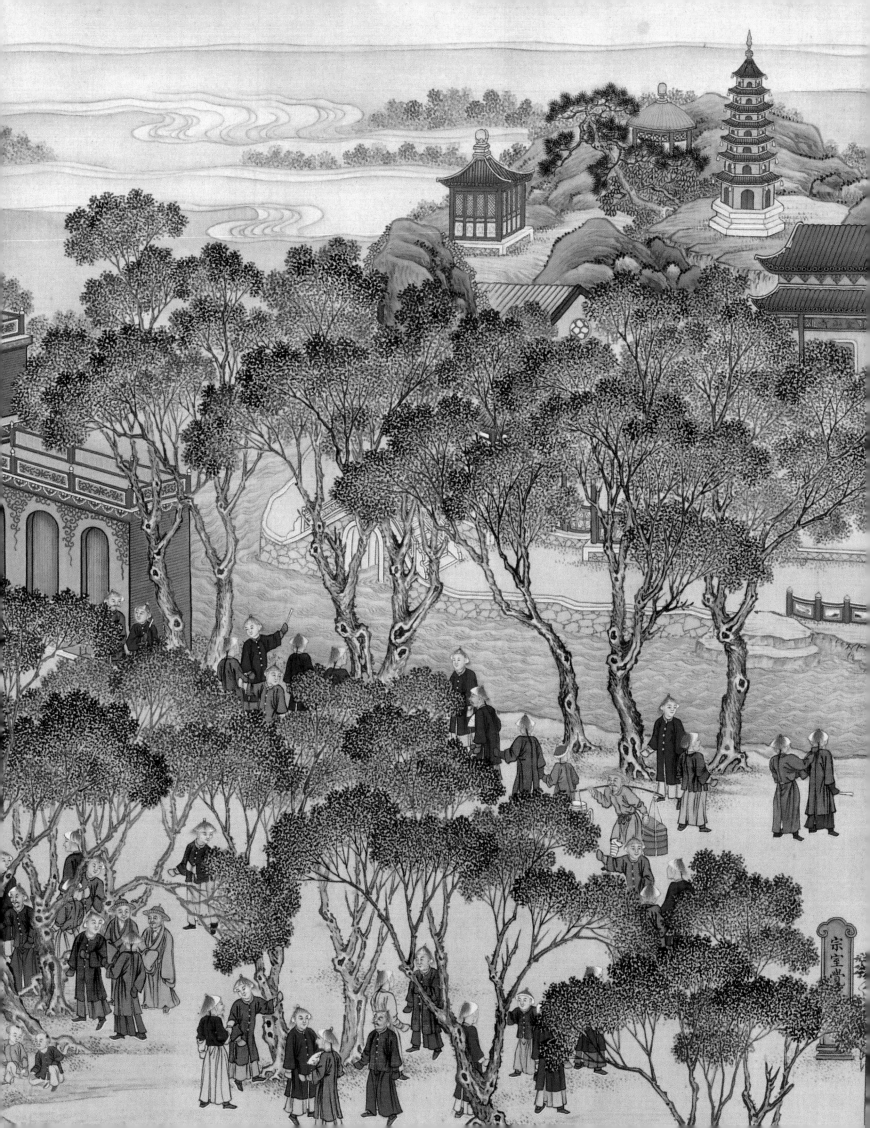

First published on the occasion of the exhibition
'China: The Three Emperors, 1662–1795'

Royal Academy of Arts, London
12 November 2005 – 17 April 2006

Sponsored by

The Royal Academy of Arts is grateful to Her Majesty's
Government for agreeing to indemnify this exhibition
under the National Heritage Act 1980, and to Resource,
The Council for Museums, Archives and Libraries, for its
help in arranging the indemnity.

EXHIBITION CURATORS
Hiromi Kinoshita
Regina Krahl
Alfreda Murck
Jessica Rawson
Cecilia Treves

EXHIBITION ORGANISATION
Anna Conlan
Lucy Hunt
Susan Thompson
Emeline Winston

PHOTOGRAPHIC AND COPYRIGHT CO-ORDINATION
Roberta Stansfield

CATALOGUE
Royal Academy Publications
David Breuer
Harry Burden
Claire Callow
Carola Krueger
Peter Sawbridge
Nick Tite

Translation from the German (Gerald Holzwarth),
French (Michèle Pirazzoli-t'Serstevens) and Chinese
(Fu Hongzhan, Hua Ning, Li Yanxia, Nie Chongzheng,
Wen Jinxiang, Yuan Hongqi): Translate-A-Book, Oxford

Copy-editor: Valerie C. Doran

Picture research: Sara Ayad

Colour origination: DawkinsColour

Design and cartography: Isambard Thomas, London

Printed in Italy by Graphicom

British Library Cataloguing-in-Publication Data
A catalogue record for this book is available from the
British Library

ISBN 1-903973-70-8 (paperback)
ISBN 1-903973-69-4 (hardback)

Distributed outside the United States and Canada
by Thames & Hudson Ltd, London

Distributed in the United States and Canada
by Harry N. Abrams, Inc., New York

EDITORS' NOTE
Unless otherwise stated, measurements are given in centimetres,
height before width before depth.

A number of catalogue plates are intended to be read from
right to left; a small red arrow above the image has been used
to indicate this. Sets of album leaves, however, have been
arranged so that their sequence can be read across both pages,
from left to right, from the top row down.

Romanised terms from Chinese, Manchu, Mongolian, Tibetan
and Sanskrit are to be found throughout the text. For Chinese,
the *Hanyu pinyin* romanisation system has been applied, except in
occasional bibliographic references where the title was published
using a different system, such as Wade-Giles. For all other
languages, in the interests of a general audience, phonetic systems
rather than formal transliteration systems have been employed,
without the use of diacritics. Exceptions include reference notes
regarding Tibetan texts or terms, where the Wiley transliteration
system has been applied at the request of the author; and certain
bibliographic references in which the published title employs
the Wiley system. Any inconsistencies are the responsibility
of the copy-editor and not of the authors.

The illustrations in these preliminaries and those at the opening
of each section of the catalogue are details of the following plates:
pages 2–3, cat. 25; page 5, cat. 79; pages 8–9, cat. 297; page 13,
cat. 42; page 14, cat. 269; page 65, cat. 3; page 77, cat. 25; page
117, cat. 38; page 129, cat. 47; page 155, cat. 65; page 179, cat. 84;
page 209, cat. 123; page 241, cat. 167; page 271, cat. 194; page
307, cat. 243; page 357, cat. 272; and page 382, cat. 303.

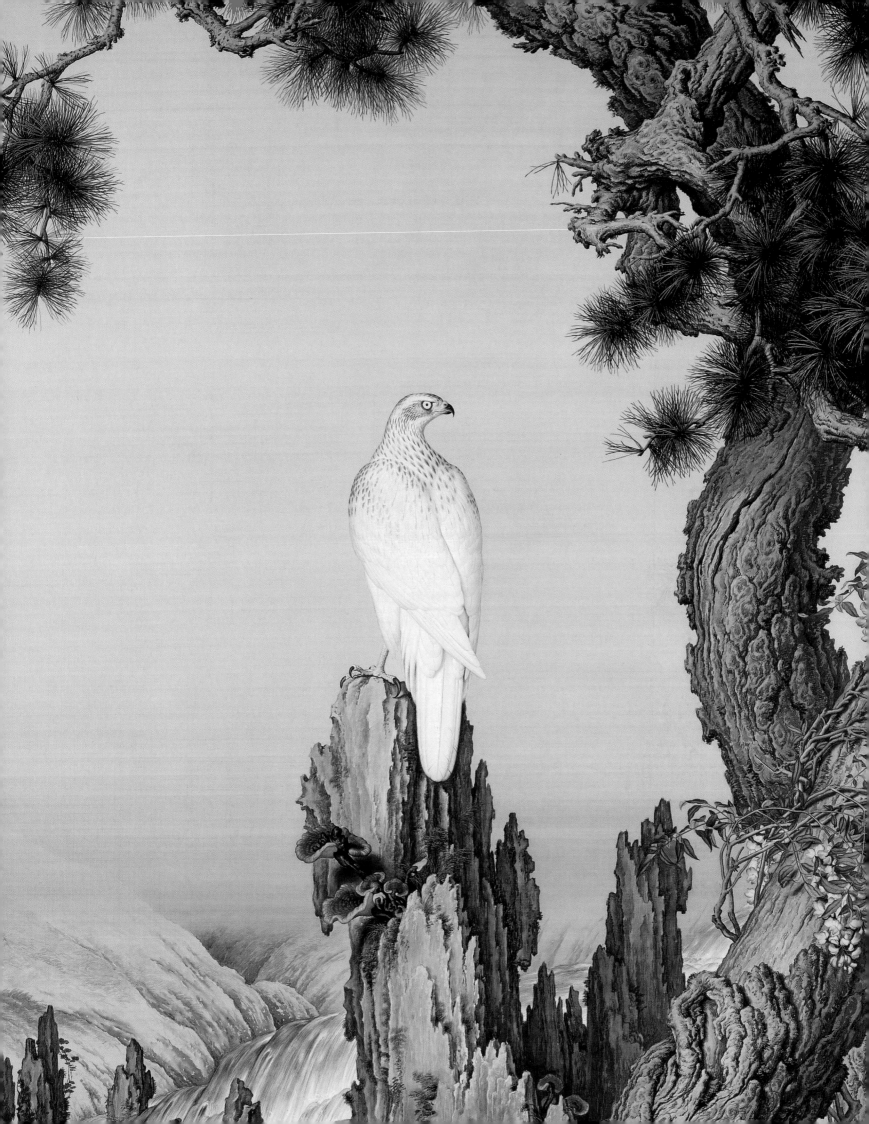

President's Foreword

The cultural treasures of China present to the West the extraordinary achievements of a great country with a long history. The Royal Academy is extremely proud to host 'China: The Three Emperors, 1662–1795', the third major display in our galleries of China's artistic wealth. We remember above all the spectacular 'International Exhibition of Chinese Art' of 1935–36 to which the Chinese government made unprecedented loans seventy years ago. Covering the whole of Chinese history from the Neolithic period to the eighteenth century, that legendary show gave London its first taste of the glories and range of Chinese art. More recently, in 1973–74, 'The Genius of China' presented important archaeological discoveries made since the founding of the People's Republic of China and left a lasting impression on the many people who saw it.

The present exhibition is devoted to the artistic riches of the Qing at a time when the dynasty was in its ascendancy. On display at the Royal Academy are some of the finest works of art created during the reigns of its three most powerful rulers. The Kangxi, Yongzheng and Qianlong Emperors had at their command highly skilled and imaginative artists working in all media: painting, calligraphy, books and manuscripts, porcelain, lacquerware, furniture, textiles, weaponry and ceremonial armour, scientific and astronomical instruments, and clocks. Together with the palaces they inhabited, both in Beijing and in the surrounding countryside, these three emperors created a whole universe to the glory of their state. A number of artists and craftsmen found their way to China from Western Europe, most notably the Jesuit court painter Giuseppe Castiglione, some of whose finest work is represented here.

'China: The Three Emperors, 1662–1795' has come about through a successful collaboration with the Palace Museum, Beijing. One of the world's largest museums, and the one-time residence of the emperors, the Palace Museum preserves not only what remains of the ancient art collection accumulated over many centuries, but also the many diverse items once used in the palace. Never before has the Palace Museum made loans of such generosity; nor has it ever sent abroad so many national treasures. The Royal Academy wishes to thank Minister Zheng Xinmiao, the Director of the Palace Museum, for his support throughout the preparation and installation of the exhibition. The staff of the Palace Museum have played a vital role, sharing scholarly understanding and selecting exhibits of the highest quality. We would like to express our particular appreciation to Director Li Ji and to all his colleagues in the several departments with which the Royal Academy has worked closely.

In Beijing the Ministry of Culture and the State Administration for Cultural Heritage (SACH) have offered their advice and friendship. The exhibition would not have been possible without the full support of SACH. We thank Shan Jixiang, Director General, and Zhang Jianxin, Head of External Affairs, who has guided the project to secure the final approval of the State Council of the Chinese Government. In London, the Royal

Academy has enjoyed a close relationship with the Embassy of the People's Republic of China. It is especially grateful to His Excellency Zha Peixin, Ambassador of the People's Republic of China, as well as his predecessor, Ambassador Ma Zhengang, for their kind encouragement. Together with Minister Li Ruiyu and Counsellor Ke Yasha, they have given us invaluable advice throughout.

'China: The Three Emperors, 1662–1795' owes its inception to the vision of Jane Portal, curator of Chinese art at the British Museum. The display has grown from the initial proposal into its present form thanks to the work of a team of curators led by Jessica Rawson. We owe her our most sincere thanks for her unstinting commitment to all aspects of the project and the experience she has brought to bear on it. Special thanks go to Alfreda Murck, whose scholarship and counsel has benefited the exhibition in so many ways; to Regina Krahl for her contribution to the selection of artefacts and to the shaping of the exhibition; and to Hiromi Kinoshita, who from the outset has dedicated the utmost energy and enthusiasm to the project. At the Royal Academy, the exhibition could not have been so successfully advanced without the major contribution of Cecilia Treves in the Exhibitions Department, headed by Norman Rosenthal. We also wish to acknowledge Ivor Heal for the beautiful installation.

Many have helped with the project's realisation, among them Susan Thompson, who conducted negotiations on the agreement with the Palace Museum, and Lucy Hunt, who has overseen the organisation of the exhibition. This substantial catalogue, published to coincide with the opening, brings together the work of scholars from China, Britain, Europe and the United States of America. Once again, Royal Academy Publications have dedicated a great deal of time and energy to its preparation, which has been expertly handled by Peter Sawbridge and David Breuer. We are deeply appreciative of their hard work.

The Royal Academy is much indebted to its sponsor Goldman Sachs, with whom we have so successfully co-operated in the past. Their generosity has enabled us to present this remarkable exhibition.

Finally we wish to express our gratitude to the lenders, first and foremost the Palace Museum, whose commitment during this, its eightieth anniversary year, is especially appreciated. We thank also our other lenders, both public and private, whose willingness to part with their works has made this display all the more sumptuous and significant: a complex portrait of the flourishing of seventeenth- and eighteenth-century Qing culture emerges. We thank them all for their important loans.

The Royal Academy is honoured to be able to open the exhibition to coincide with the State Visit of President Hu Jintao. We are confident that 'China: The Three Emperors, 1662–1795' will once again testify to the huge interest in the cultural heritage of the People's Republic of China that exists at a moment when Britain and China are increasingly working together. It is our hope that the Royal Academy's exhibition will make a major contribution to mutual understanding and serve to strengthen the increasingly strong links that are now developing in so many ways between our two countries.

Sir Nicholas Grimshaw
President, Royal Academy of Arts

Sponsor's Preface

Goldman Sachs is proud to sponsor this unique and historic exhibition showcasing the artistic and cultural treasures of the Qing dynasty. 'China: The Three Emperors, 1662–1795' reveals the scope and splendour of China's past, its rich cultural traditions and the personalities and artistry that brought them to life.

Many of the works presented here – drawn largely from the great collections of the Palace Museum, Beijing – have never been shown outside China. From breathtaking paintings and ancient scrolls to fine armour and scientific instruments, the exhibition grants us an unprecedented look at life during the reigns of three of the most powerful emperors of China's last dynasty.

We are privileged to continue our longstanding relationship with the Royal Academy of Arts. Goldman Sachs supported the Royal Academy's exhibitions 'Alberto Giacometti, 1901–1966' in 1996 and 'Picasso: Painter and Sculptor in Clay' in 1998, and we are delighted now to participate in this truly exceptional exhibition of so many great works of art from imperial China.

Henry M. Paulson Jr
Chairman and Chief Executive, The Goldman Sachs Group, Inc.

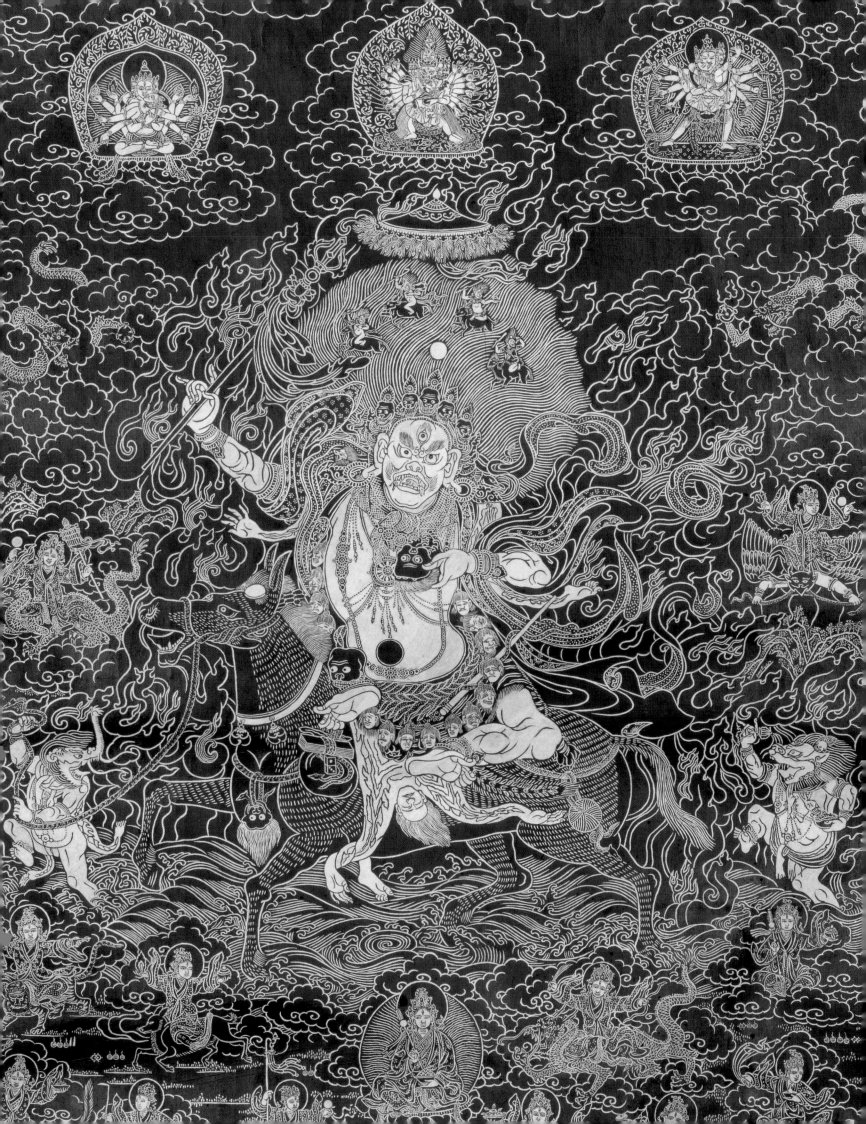

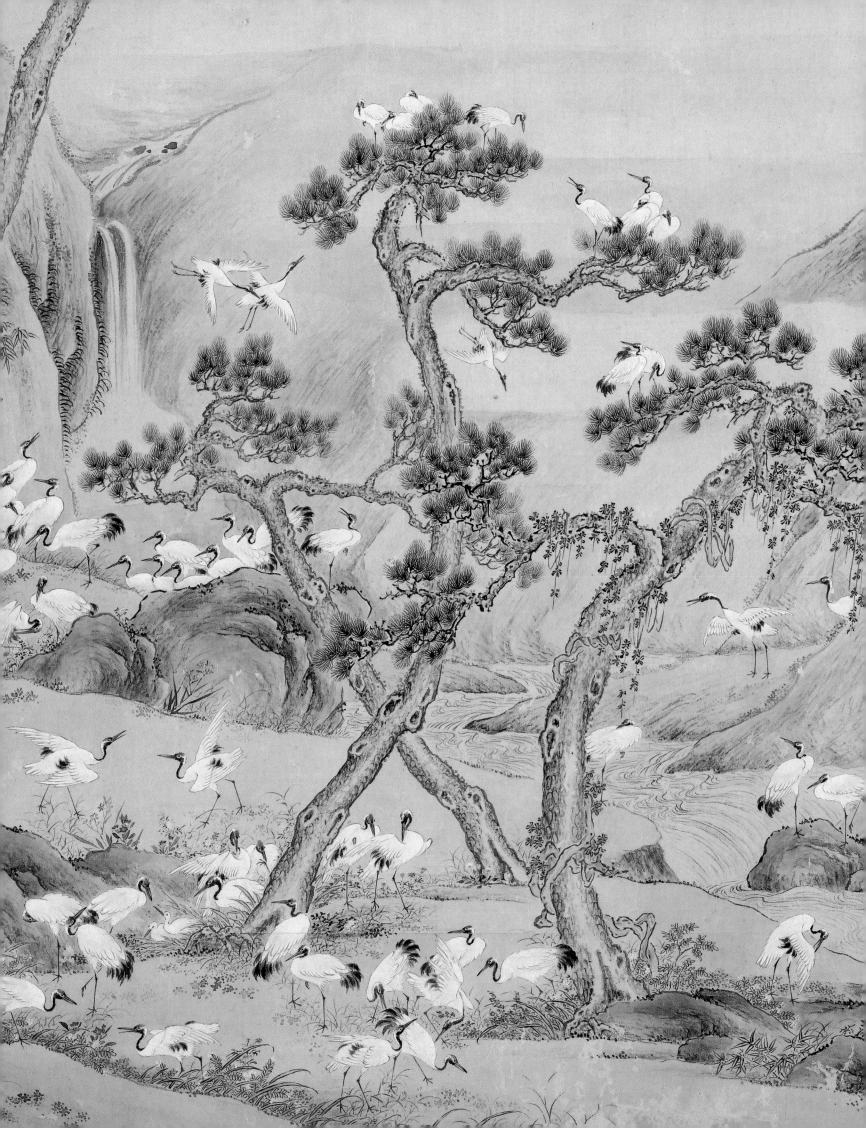

Acknowledgements

The curators of the exhibition would like to express their gratitude to the following individuals for their invaluable assistance during the realisation of this exhibition:

Betsy Geiser Allaire, Eoin Billings, Vanessa Brand, Bennet Bronson, Elaine Buck, Herbert Butz, Priscilla Chak, William Chak, Colin Chinnery, Nicholas Chow, Craig Clunas, Anna Conlan, Abbie Coppard, Dan Cowap, Keith Davies, Duan Yong, Gregory Eades, Hajni Elias, Giuseppe Eskenazi, Fang Bin, Rebecca Feng, Lawton W. Fitt, Neil Fitzgerald, Roy Fox, Anna Fu, Pam Gaible, Robert Graham, Nicholas Grindley, Guan Xueling, Guo Meixia, Guo Yaling, Jessica Harrison-Hall, Happy Harun, Maxwell K. Hearn, Chuimei Ho, John Holmes, Sunnifa Hope, Tessa Hore, Hu Chui, Sir Christopher Hum CMG, Graham Hutt, Ji Tianbin, Ke Yasha, Denis Keefe, Robert Knox, Lisa Lawrence, Li Ji, Li Shaoyi, Liang Jinsheng, Liu Zhigang, Linda Lloyd Jones, Albert Lutz, Ma Haixuan, Ma Xiarou, Anna Maris, Irene Martin, Matt Matcuk, Shane McCausland, Carol Michaelson, Timothy M. Mikulski, Nancy Mitchell, Angie Morrow, Nancy Murphy, Matthew Nation, Barbara O'Connor, Stacey Pierson, Michèle Pirazzoli-t'Serstevens, Francesca Pons, Jane Portal, Julian Raby, John Rawson, Susannah Rayner, Catherine Rickman, Lydia Seager, Roger Smith, Jules Speelman, Keith Spriggs, Louise Squire, Roberta Stansfield, Kate Storey, Jan Stuart, Sunny Sun, Tanya Szrajber, David Tang, Keith Taylor, Isambard Thomas, David Thompson, Julian Thompson, Susan Thompson, Gabriela Truly, Shelagh Vainker, Edmund von der Burg, Daisy Wang, James C. Y. Watt, Pauline Webber, Robert F. Weiglein, Sarah-Louise Wilkinson, Ming Wilson, Diane T. Woo, Jonathan Woolf, Yang Fan, Yoshiko Yasamura, Yin Yimei, Yu Hui, Yuan Hongqi, Zhang Hongxing, Zhang Jianxin, Zhang Ruihua, Zhang Yan.

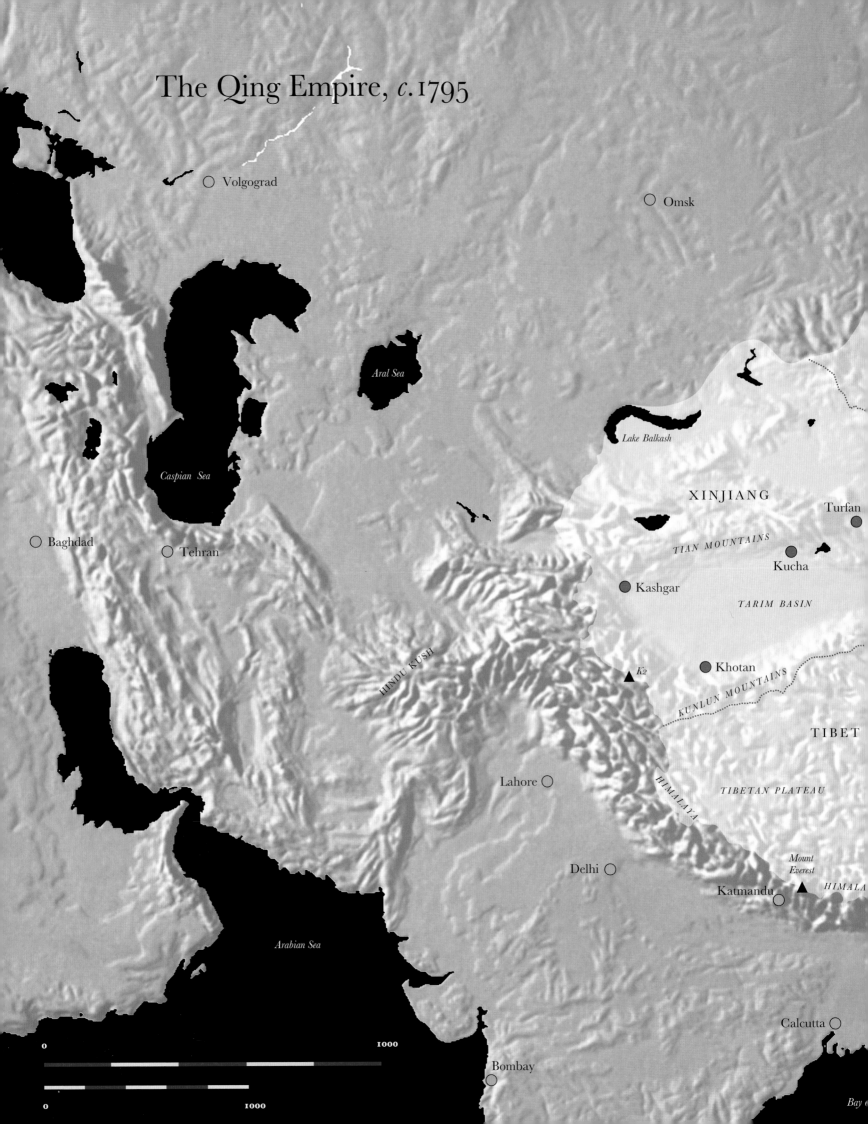

The Qing Empire, *c.*1795

○ Volgograd

○ Omsk

Aral Sea

Lake Balkash

XINJIANG

○ Turfan

● Kucha

TIAN MOUNTAINS

Caspian Sea

TARIM BASIN

○ Baghdad

○ Tehran

● Kashgar

▲ K2 ● Khotan

HINDU KUSH

KUNLUN MOUNTAINS

TIBET

Lahore ○

HIMALAYA

TIBETAN PLATEAU

Delhi ○

Mount Everest

Katmandu ○ ▲ *HIMALA*

Arabian Sea

Calcutta ○

0 1000

Bombay ○

0 1000

Bay o

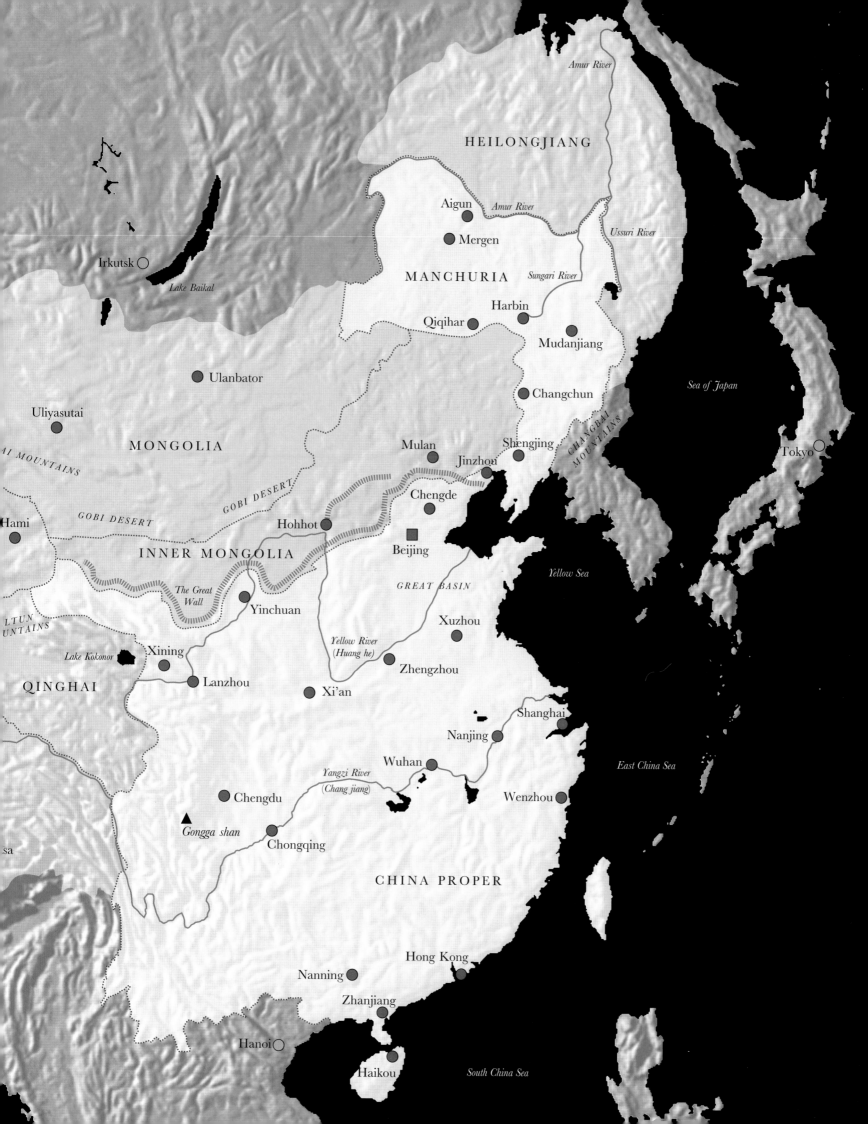

Major Altars and Districts in Qing Period Beijing

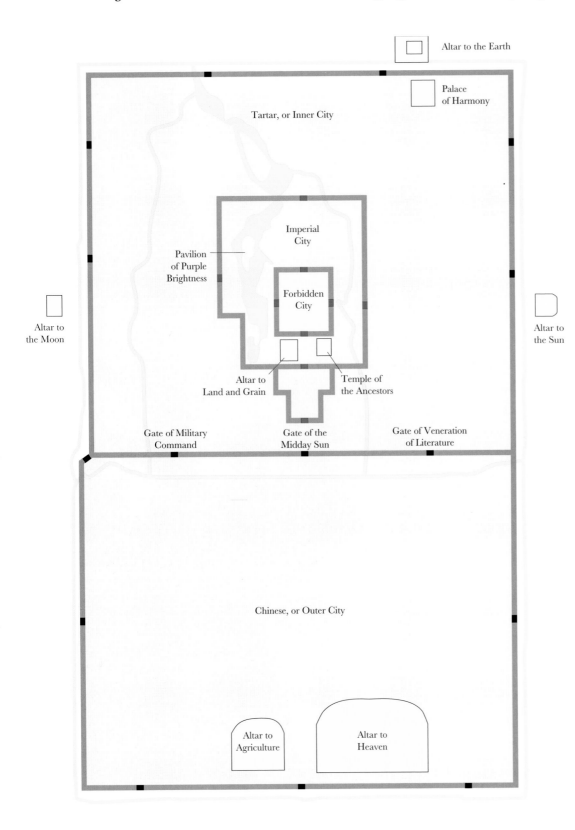

Altar to the Earth

Palace of Harmony

Tartar, or Inner City

Imperial City

Pavilion of Purple Brightness

Forbidden City

Altar to the Moon

Altar to the Sun

Altar to Land and Grain

Temple of the Ancestors

Gate of Military Command

Gate of the Midday Sun

Gate of Veneration of Literature

Chinese, or Outer City

Altar to Agriculture

Altar to Heaven

The Forbidden City

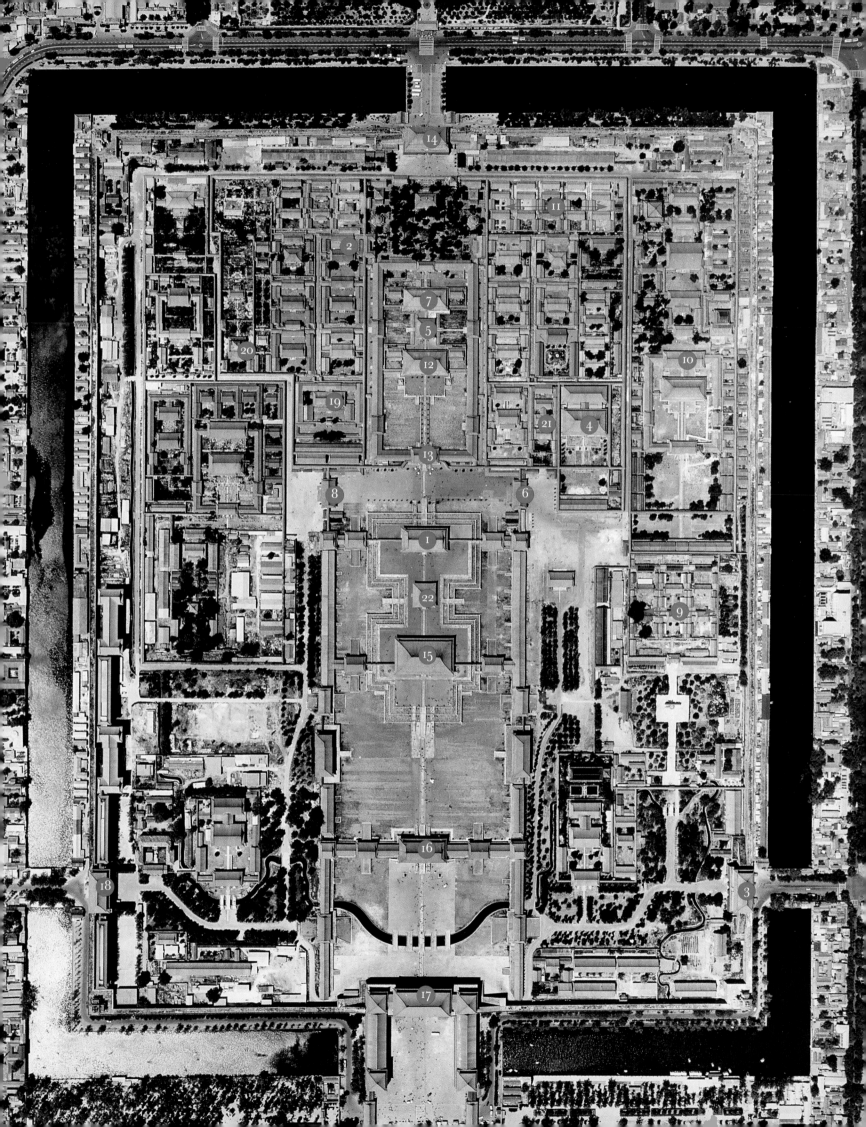

Chronology

EVELYN S. RAWSKI

1661

CHINA 2 February: Fulin, the first Qing Emperor, dies of smallpox; Xuanye (1654–1722), succeeds him and reigns as the Kangxi Emperor (r.1662–1722).

ENGLAND Following the death of Oliver Cromwell in 1658, the monarchy (Charles II), the Church of England and Parliament are restored in 1660.

FRANCE With the death of Cardinal Mazarin, Louis XIV (r.1643–1715) takes personal charge of government.

1662

CHINA Dutch traders are expelled from the island of Taiwan by Ming loyalist forces. Although their leader, Zheng Chenggong (Koxinga), had died in June 1662, his heirs are able to defy the Manchus and hold Taiwan for two more decades. The Kangxi Emperor orders evacuation of the south China coast in an effort to suppress piracy.

1682

RUSSIA Peter the Great's reign begins (1682–1725). He embarks on a programme of 'westernisation', expands the empire in the Baltic region, and moves against the Turks and against nomadic tribes in Central Asia.

1683

CHINA The successful pacification of the Rebellion of the Three Feudatories and the capture of Taiwan from Ming loyalist forces marks the end of the Manchu conquest. The ban on maritime trade, enforced in 1655, is lifted.

EUROPE At Vienna, the Ottomans are turned back by Habsburg forces and their allies, marking the high point of the Ottoman advance into Central Europe.

1688–89

ENGLAND A Dutch invasion attracting substantial English support forces James II (r.1685–88) off the throne. The Dutch Stadtholder, William of Orange, and his wife, Mary, James's daughter, are crowned in his place.

CHINA Treaty of Nerchinsk settles the Sino-Russian border in north Asia.

1690

ENGLAND John Locke's *Two Treatises of Government* are published, positing individual rights, apart from the state: these ideas are later adopted by the American colonies in their independence movement.

1691

CHINA The Kalkha Mongols submit to the Qing at Dolon Nor, adding what is now Mongolia to the Qing empire.

1696

CHINA At Jao Modo, Qing forces led by the Kangxi Emperor defeat the Zunghar Mongols under Galdan.

1707

BRITAIN Act of Union joins England and Scotland to form Great Britain.

1715

FRANCE Louis XV (r.1715–74) ascends the throne; his ministers attempted, with slight success, to rationalise the taxation system and the traditional systems of privilege on which it rested.

1720

CHINA A Zunghar invasion of Lhasa prompts Qing forces to intervene and establish a military garrison in the Tibetan capital; this marks the beginning of a Qing protectorate over Tibet.

1722

CHINA Yinzhen (1678–1735) succeeds upon his father's death and reigns as the Yongzheng Emperor (r.1723–35); he carves out Amdo and Kham (eastern Tibet) and attaches them administratively to Sichuan Province.

1728

CHINA The Treaty of Kiakhta supplements the Treaty of Nerchinsk and resolves boundary disputes with Russia; regulated Sino-Russian trade commences.

1735

CHINA Death of the Yongzheng Emperor. Hongli (1711–1799) succeeds upon his father's death and reigns as the Qianlong Emperor (r.1736–95).

1748

FRANCE Montesquieu's *Spirit of the Laws* is published, advocating the separation and balance of powers as a defence against absolutism.

1751–72

FRANCE *Encyclopédie*, edited by Denis Diderot, appears in seventeen volumes; this was a compendium of scientific, technical and historical knowledge expressing Enlightenment thought.

1759

CHINA Qing forces successfully subjugate the Zunghar Mongols and complete the Qing penetration of present-day Xinjiang. The territory of the Qing empire reaches its greatest extent.

1760

CHINA The court restricts European trade to one port, Canton (Guangzhou); foreigners are permitted to reside in Canton during the trading season but must deal exclusively with designated Chinese Hong merchants, in what came to be called the 'Canton system' of trade.

1762

FRANCE Rousseau's *Social Contract* is published; although its ideas about the General Will were not immediately popular, this work was later to influence political theorists.

RUSSIA Catherine II (the Great) (r.1762–96) becomes ruler of Russia; she continued the process begun by Peter to absorb neighbouring domains to the west and south that were nominally Polish or Turkish, with marked success. Internally, as one of the most conspicuous of the 'enlightened despots', she continued cultural exchanges with western Europe.

1768

BRITAIN Captain James Cook (1728–1779) begins his first voyage; before he returns (1771) he will have explored the coastline of New Zealand and parts of 'New Holland' (Australia).

1769

BRITAIN Watt's steam engine and Arkwright's water-frame mark important advances in the harnessing of non-human sources of energy that are a precursor of the Industrial Revolution.

1771

CHINA The Torghut Mongols (known as Kalmyks to the Russians), who had migrated in the late sixteenth and early seventeenth centuries to pastures along the Volga and other rivers, return to their old lands and accept Qing overlordship.

1774

FRANCE Louis XVI (r. 1774–93) becomes king; he and his ministers attempt to resolve long-standing structural encumbrances to the tax system, stimulating noble resistance and the summoning of the Estates-General (1789).

1776

CHINA In the process of compiling the *Complete Library of the Four Treasuries* (*Siku quanshu*), a massive project to collect, edit and reproduce the finest writings in classics, history, philosophy and *belles lettres*, some politically suspect writings are discovered. The Qianlong Emperor orders a massive purge that has been called a 'literary inquisition' (1776–82).

BRITAIN The Declaration of Independence escalates British attacks against the American colonies in the War of American Independence. Adam Smith's *Wealth of Nations* is published.

1780

CHINA The Third Panchen Lama visits the Qianlong Emperor at his summer villa in Rehe (present-day Chengde).

1788

CHINA The Qianlong Emperor responds to a plea from the Vietnamese Le dynasty ruler and sends an army to restore him to the throne; after military reverses the Qing recognise the Nguyen as the legitimate rulers of Vietnam.

1789

FRANCE The French Revolution begins with a meeting of the Estates-General in Paris. In August the National Assembly issues the Declaration of the Rights of Man and the Citizen, which lists fundamental human rights and duties of citizens, including freedom of speech, press and assembly, and religion.

1790

CHINA Qing troops are mobilised to defend Tibet from assault by the Gurkhas of Nepal; the successful campaign leads to Nepal becoming a tributary state (1792).

1792

FRANCE The First French Republic is proclaimed.

1793

CHINA Lord Macartney heads a British embassy to the Qing court in what turns out to be a failed mission.

1795

CHINA The White Lotus Uprising breaks out in the Han River highlands, a frontier region that was being incorporated into the administrative framework. The rebellion was not to be successfully suppressed until 1804.

1795–96

CHINA The Qianlong Emperor abdicates, in an unprecedented step. (The 1795 ending date of his reign given throughout this catalogue is the traditional date based on the Chinese lunar calendar. According to the Western calendar, however, the Qianlong Emperor actually abdicated on 9 February 1796.) His son, Yongyan, mounts the throne as the Jiaqing Emperor (r.1796–1820).

I

The 'Prosperous Age': China in the Kangxi, Yongzheng and Qianlong Reigns

EVELYN S. RAWSKI

The Kangxi, Yongzheng and Qianlong reigns, which cover the period from 1662 until 1795, can be approached from a number of different perspectives. In the eyes of many historians in the People's Republic of China, these reigns represent not only the peak of the Qing dynasty which ruled China from 1644 until 1911, but also the historical peak of the dynastic form of rule. While praising the economic, political and cultural achievements of the age, these historical appraisals compare the Qing unfavourably to Western Europe, where advances towards modernity were occurring at the same time (see my Chronology on pp. 20–21).

The perspective of Chinese historians writing outside China is somewhat different. Some scholars place the extraordinary cultural and political achievements of what might be called the Qing 'long eighteenth century' within a larger global context, highlighting the connections which linked the Qing empire to Europe, Southeast Asia and even the Americas and suggesting parallels between historical developments in China and parts of Europe. These somewhat contradictory grand summations of the period will be discussed in the concluding section of this essay.

A Conquest Dynasty

In recent years scholars outside China have re-emphasised the ethnic origins of the Qing rulers, the Manchu Aisin Gioro clan, in order to deconstruct the nationalist bias in the writing of Chinese history during the twentieth century.[1] Rather than casting Qing history as a chapter in the history of the modern Chinese nation, this view focuses on how its origins as a conquest dynasty affected Qing rule. The rulers of the Qing were a northeast Asian people, the Jurchen, who had ruled north China from 1115 to 1234 as the Jin dynasty. They were very conscious of their historical, cultural and linguistic separation from the Chinese speakers to the south. Like earlier non-Han conquest regimes ruling parts of the Chinese-speaking world from the tenth to fourteenth centuries, the Manchus (a name they adopted for themselves in 1636) were careful to maintain their separate

Fig. 1
Anonymous, 'Imperial Patent of Nobility in Manchu and Chinese Scripts', Qing dynasty, Jiaqing period, 1799. Handscroll, ink, colour and white pigment on five sections of silk brocade, 30.4–30.7 × 181.5 cm. National Library of China. Such patents were often posthumously conferred on a meritorious official's parents. Because Chinese is written from right to left and Manchu from left to right, the two inscriptions begin at opposite ends and conclude in the middle of the scroll.

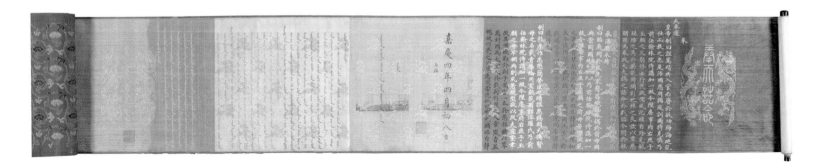

PERSONAL NAME	LIFE DATES	REIGN NAME	REIGN DATES	TEMPLE NAME	POSTHUMOUS NAME
Taksi	—	Xiezu	—	Xuan	—
Nurgaci	1559–1626	Tianming	1616–1626	Taizu	Gao
[Hongtaiji][1]	1592–1643	Tianzong, Chongde[2]	1627–1643	Taizong	Wen
Fulin	1638–1661	Shunzhi	1644–1661	Shizu	Zhang
Xuanye	1654–1722	Kangxi	1662–1722	Shengzu	Ren
Yinzhen	1678–1735	Yongzheng	1722–1735	Shizong	Xian
Hongli	1711–1799	Qianlong	1736–1795[3]	Gaozong	Chun
Yongyan	1760–1820	Jiaqing	1796–1820	Renzong	Rui
Minning	1782–1850	Daoguang	1821–1850	Xuanzong	Cheng
Yizhu	1831–1861	Xianfeng	1851–1861	Wenzong	Xian
Zaichun	1856–1875	Tongzhi	1862–1874	Muzong	Yi
Zaitian	1871–1908	Guangxu	1875–1908	Dezong	Jing
Puyi	1906–1967	Xuantong	1909–1911	—	—

Fig. 2
Emperors of the Qing Dynasty
and the Imperial Ancestors

NOTES TO THE TABLE

1 'Hongtaiji' was probably a title and not a personal
name. See Crossley 1997, p. 208.

2 Reign name from 1636 to 1643.

3 The 1795 ending date of the Qianlong Emperor's reign
given throughout this book is the traditional date based
on the Chinese lunar calendar. According to the
Western calendar, however, the Qianlong Emperor
actually abdicated on 9 February 1796.

SOURCES
Norman 1978, p. 319; Chen 1982; Bo Yang 1986, 1,
pp.246–48.

identity. Early in the seventeenth century, they created a writing system for their language, and then made Manchu one of the two state languages of the dynasty (fig.1).[2]

The new scholarship also challenges the perspective of Chinese-language records which portray a sinicised Qing government dominated by Han Chinese literati. After 1648 the conquest élite, composed of banner nobles and imperial kinsmen, was separated from the subjugated population, and administratively superimposed upon the Han Chinese bureaucracy.[3] The core of the Qing conquest élite was comprised of households registered in the Eight Banners. Banners were military units that also became administrative units for the registration, conscription, taxation and mobilisation of the tribes and peoples who enlisted in the Manchu cause before 1644. The banners that entered Beijing[4] in 1644 were a multi-ethnic force, composed of 'transfrontiersmen' of Korean, Han, Mongol and Manchu origins residing in northeast Asia. By 1644 the original Eight Banners had tripled into Manchu, Mongol and Martial Han (*Hanjun*) units which, despite their designations, were frequently ethnically mixed.

The primary division in Qing society, separating bannermen from the civilian population, was not ethnically based, since there were also bannermen of Han Chinese origin, who were sharply distinguished from Han Chinese belonging to the subjugated Ming population. After 1648, the two groups lived apart: in the primary capital, Beijing, bannermen resided in the Inner City, while Han civilians lived in the southern Outer City (see Map 2). Bannermen posted to strategic garrisons located throughout the empire also lived in separate walled quarters. They were governed by separate laws from those that applied to the subjugated Han population. In theory and with relatively few exceptions, intermarriage between bannermen and the civilian Han was forbidden.[5]

Banner nobles, whether of Manchu, Mongol or Han descent (Han who submitted in the early conquest period were incorporated into the banners), formed a privileged hereditary élite whose titles and favoured access to office stemmed from the achievements of the ancestors during the conquest. While expanding the throne's control of the Eight Banners, the Kangxi Emperor also created a bifurcated system of governance. Retaining the bureaucratic model of the Ming dynasty for the administration of China Proper, he appointed bannermen to important supervisory posts in the northeast homeland and the Inner Asian frontier.

The system of checks and balances was also applied to the councils of state. Power in the Qing dynasty was divided between the 'outer court', where the Emperor held public audiences with Han Chinese bureaucrats, and the 'inner court', inside the 'Great Interior' (see Map 3), where the personal living quarters of the Emperor and members of the imperial family were located. In 1662 the highest decision-making body in the outer court was the Grand Secretariat, but the major decision-making body during the seventeenth and early eighteenth centuries was another agency, the Deliberative Council of Princes

and High Officials (hereafter, Deliberative Council) which was staffed by banner nobles and bannermen.

The Kangxi Emperor used the Grand Secretariat to process the bureaucratic paperwork for routine administration matters. At the same time, he created an 'inner court' circle of advisors, drawn predominantly though not entirely from the conquest élite. In sharp contrast to the Ming, who barred imperial princes from participation in government, the Manchus tapped their sons and other kinsmen as well as men from notable banner families for important administrative, military and diplomatic duties. Because the Kangxi, Yongzheng and Qianlong Emperors conducted routine government business in halls located within the 'Great Interior', which became the centre for a Manchu-dominated coterie of imperial advisors, the physical separation of 'inner' and 'outer' courts also reflected a significant political dichotomy (fig.3).[6]

The dominance of the conquest élite in decision-making continued from the Kangxi reign into the Yongzheng era, as the Emperor used a small group of personal favourites to guide policy in times of crisis.[7] During the Qianlong reign, the Han Chinese bureaucracy which dominated the 'outer court' gradually diluted the power of imperial princes and banner nobles, but the existence of an inner group of advisors who belonged to the conquest élite persisted until the very end of the dynasty.

Traditional historical records were primarily compiled by Chinese officials and scholars, and they tend to concentrate on institutions and policies. Less considered by most scholars are the individual personalities and characters of the three emperors under discussion. As will be examined below, each of the three rulers confronted rather different problems in rulership and different historical conditions which helped to shape their reigns. But there were also some important commonalities. One of the imponderable factors in appraising the quality of a reign is the physical strength and personality of the individual on the throne. Monarchies founder when the ruler dies at a young age, leaving

Fig. 3
This throne hall within the 'Great Interior' was used for state business by the Kangxi, Yongzheng and Qianlong Emperors.

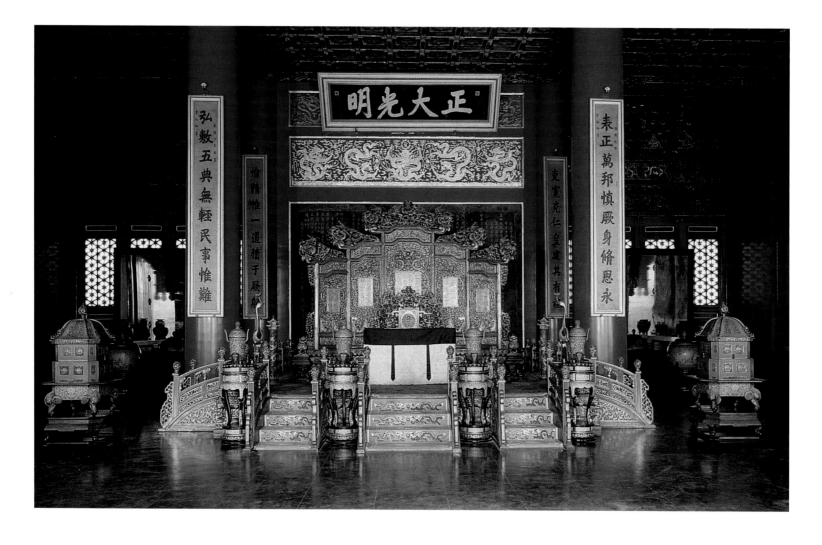

an infant to succeed him or no clear heir to the throne. Longevity is itself an enormous stabilising force, and was certainly a factor in the achievements of these three Qing emperors. Xuanye,[8] the Kangxi Emperor, lived to the age of sixty-eight by Western reckoning;[9] Yinzhen, the Yongzheng Emperor, to the age of fifty-six; and Hongli, the Qianlong Emperor, was eighty-seven when he died. At a time when the average life expectancy at birth was in the mid-thirties for males, these figures are impressive.[10]

Historical records, which include the 'Diaries of Rest and Repose' (qiju zhu) for each reign, also depict three men who were extremely conscientious and diligent in their application to affairs of state. A study of the daily routines of the Kangxi and Yongzheng Emperors shows that the Emperor regularly awoke before dawn and adhered to a rigorous daily work schedule of meeting officials, performing state rituals, and reading the voluminous official documents, stopping for only two meals.[11] The achievements of the early Qing were at least partially due to the ability of the Kangxi and Qianlong Emperors to apply themselves consistently to the tasks of rulership for sixty years.

The Kangxi, Yongzheng and Qianlong Emperors spent a great deal of time away from the Forbidden City. The Qianlong Emperor was the most travelled: in 1762 he spent only one third of the year in the Forbidden City. Between late September and July he alternated between the Forbidden City and the imperial villas northwest of Beijing. Like his grandfather, he spent his summers in Rehe (later renamed Chengde) which was situated on the boundary between the North China Plain and the Mongolian steppe outside the Great Wall (fig.4). Rehe was the site for important meetings with Mongol nobles, Uighur *begs* (Muslim notables) and Tibetan Buddhist prelates, who came to pay homage to the Emperor.[12] Rehe was also where the Panchen Lama, the second-highest ranking Tibetan Buddhist cleric, came on the occasion of the Emperor's seventieth birthday (1780); and the site for the meeting in 1793 between Hongli and Lord Macartney, heading a British embassy to the Qing.[13]

The business of government moved along with the Emperor, whose entourage sometimes numbered 3,000 people, including his wives, kinsmen, eunuch servants, palace maids and guardsmen. Selected officials heading the primary agencies of government had offices in the imperial villas, and accompanied the Kangxi and Qianlong Emperors in their annual travels to Rehe. From Rehe, the Emperor and his companions would ride to the imperial hunting reserve of Mulan, about 60 miles to the north, for the autumn hunt. There the Emperor participated in large-scale hunts for bear and deer. In addition to providing recreation and food, these hunts tested the horsemanship and archery skills of the soldiers. On his way home, the Emperor sometimes paused at the tombs of his ancestors, which lay about 60 miles east of Beijing.

The Kangxi, Yongzheng and Qianlong Emperors creatively synthesised elements taken from several political traditions to grasp personal control over a complex administrative system. Reversing the late sixteenth- and early seventeenth-century trend towards weak emperorship, they introduced a series of institutional innovations that gathered the reins of decision-making firmly into imperial hands. Bureaucratic paperwork was streamlined and functionally classified to separate important matters from routine ones. Imperial scrutiny of the civil service bureaucracy was intensified by the Kangxi Emperor, who created a confidential system of palace memorials that bypassed the bureaucracy and went directly to the Emperor. Supplementing routine reports that made their way upwards through regular channels, the palace memorial system advanced the Emperor's ability to acquire sensitive intelligence about officials and maintain the throne's dominance over its civil service.[14]

An Overview of the Kangxi, Yongzheng and Qianlong Reigns

The Kangxi Emperor (r.1662–1722) came to the throne in the midst of the Manchu conquest; his major task was to complete the military subjugation of the Ming populace, then to consolidate power and legitimate Qing rule, not only among Han Chinese but also among his Manchu and Mongol subjects. His successor, the Yongzheng Emperor (r.1723–35) advanced Manchu authority into Tibet and adjoining regions, implemented administrative and fiscal reforms, and completed the ascendancy of the throne over the banner princes. In the process of completing Qing expansion into Inner Asia, the Qianlong Emperor (r.1736–95)[15] created an ideology of universal monarchy that provided the foundation for a multi-ethnic empire. At the same time, he created policies to halt the loss of Manchu identity among bannermen, and continued to revise earlier histories of the Manchus to reinforce the dynasty's legitimacy.

The Kangxi Reign (1662–1722)

CONQUEST AND CONSOLIDATION

When Xuanye, the Kangxi Emperor, ascended the throne in 1662, the political situation in China was not at all clear. His father, the Shunzhi Emperor, was not yet twenty-three when he died of smallpox, and Xuanye came to the throne before he was seven years old. Until 1669, four regents ruled in his stead: Ebilun and Oboi (d.1669) were high-ranking officials in the Bordered Yellow Banner; Suksaha (d.1667) was a member of the Plain White Banner; and the senior regent, Soni (d.1667), belonged to the Plain Yellow Banner. In reaction to what many banner officials regarded as the father's excessively pro-Han (Chinese) orientation, the regents, who were led by Oboi, adopted a pro-Manchu policy while pursuing the successful completion of the conquest of the Ming territories (China Proper) that began in 1644 (fig.5).

The military and political situation in China Proper was extremely fluid in the 1640s and 1650s. In 1644, when troops led by the rebel Li Zicheng occupied the capital city of Beijing, the flight of high officials and the suicide of the last Ming emperor created a power vacuum. Factionalism atomised effective resistance against either domestic rebels or the external threat posed by the Manchus, who had been attacking Ming garrisons in the northeast for decades. Although a number of loyalist movements emerged, each organised around an imperial kinsman who could claim the Ming throne, leadership passed by default into the hands of local notables throughout the country. Officials and scholars who had won prestigious degrees in the civil service examinations and were accustomed to taking leadership found that they had to negotiate with local military leaders in order to restore law and order and defend their communities. Military commanders for their part demanded more rewards and recognition as their power increased. The Ming dynasty fell apart while political and military leaders quarrelled among themselves.[16]

The 1644 entry of Manchu banner forces into China Proper and their takeover of Beijing marked the beginning of the Manchu conquest. Victory was only partially

Fig. 5
Anonymous court artists, *Portrait of Oboi*, Qing dynasty, mid-eighteenth to early twentieth century. Hanging scroll, ink and colour on silk, 193.7 × 125 cm. Arthur M. Sackler Gallery, Smithsonian Institution, Washington DC. Purchase – Smithsonian Collections Acquisition Programme and partial gift of Richard G. Pritzlaff (s1991.93). Oboi was the most powerful of the regents who governed in the early years of the Kangxi period. He was purged in 1669, when the Kangxi Emperor took personal control of state affairs, and died in prison.

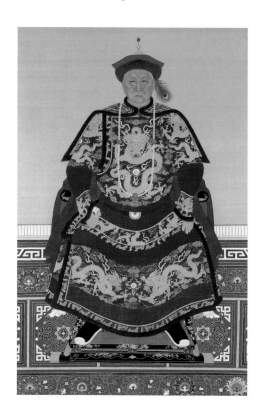

Fig. 6
Map of Taiwan, Qianlong period, 1787 or
earlier. Handscroll, ink and colour on paper,
*c.*40.5–40.6 × 437.9 cm. National Library
of China (232/1784-2/3638). After the Qing
eradicated the Zheng empire, Taiwan was
populated by Chinese peasants from the southeast,
who transformed its river valleys into rice paddies.
Taiwan was administratively designated a Chinese
province in 1885.

achieved on the battlefield. Equally important to the outcome was the willingness of
many Ming military and civilian leaders to change sides. When confronted by the
Manchu banner forces, disgruntled Ming commanders and officials often surrendered,
accepted rewards and honours, and served the Manchus. There were cases of heroic
resistance – the siege of Yangzhou (1645) is an oft-cited example – but Yangzhou was
an exception, not the rule.

Because of the speed with which many Ming localities surrendered, the Manchu
banner troops found themselves unable to translate initial victories into firm local control.
The vastness of the Ming territories, the relatively small size of the conquering forces,
and the complexity of local and regional politics during the conquest caused the entire
Shunzhi reign (1644–61) to be dominated by fluctuating military fortunes. In north
China, virtually the entire Ming military command surrendered without battle and swore
allegiance to the Qing. Protracted resistance to the conquest occurred in the rich Yangzi
delta, the region known as Jiangnan (literally, 'south of the river'), but by the spring of
1646 most of the area was under Manchu control. Claimants to the Ming throne kept
moving south before the Qing advance. Despite successful penetration of south and
southwest China in 1647, the banner troops were spread too thinly to retain and
consolidate their control over surrendered districts, and were forced to retreat in the face
of a new round of military campaigns led by local notables and military leaders in 1648
and 1649. The banner forces launched a new offensive in 1650, and in 1662, the first year
of the Kangxi reign, the last Ming claimant, the Prince of Gui, held by the King of
Burma, was turned over to Qing authorities and executed by strangulation.

Qing efforts to suppress the loyalist resistance led by Zheng Chenggong began in 1644
and continued several decades into the Kangxi reign.[17] Zheng Chenggong, the man

known to the West as Koxinga, was born into a family of maritime traders. His father, Zheng Zhilong, built a vast trading empire with branches in Nagasaki, the Philippines and Taiwan (fig.6). Zheng Zhilong managed overseas trade in the coastal port of Xiamen (Amoy), in Fujian Province, and collected taxes and commissions on goods traded from Taiwan and Xiamen. His son, Chenggong, was an educated scholar who obtained a licentiate (*shengyuan*) degree from the Ming dynasty and studied at the imperial academy in Nanjing, the Ming southern capital.

Zheng Zhilong sided with the Ming loyalists in 1644, but switched sides in 1646; the Qing then reneged on their promises and held him hostage in Beijing. There was a struggle over control of his empire, which Zheng Chenggong won. Chenggong's commitment to the cause of the Yongli Emperor (one of the claimants to the Ming throne) allowed him maximum freedom – the Yongli court was stationed far away in Guangzhou – while retaining the legitimation that fealty to the lost dynasty provided.

Zheng Chenggong's anti-Qing resistance movement was unified in command and funded by the semi-piratical and semi-legitimate maritime activities of the Zheng organisation which was based in the villages of the Fujian coast. Armed with excellent military intelligence, Zheng Chenggong was also lucky to be grappling with a Qing force which lacked a navy to begin with and also put highest priority on the land campaigns. The Qing alternated between attempts to coerce and to entice him to surrender. From 1651 to 1659, when Zheng Chenggong invaded the Yangzi delta, his side prevailed in the successive campaigns mounted against him. Forced to retreat to his home base after failing to capture Nanjing, he defeated the Qing fleet at Xiamen (1660). In 1661 Zheng moved his headquarters to Taiwan and forced the Dutch East India Company out of the trading post they had erected on the southwest coast.

Zheng Chenggong died in June 1662, but his son and heir, Zheng Jing, was able to retake Xiamen in 1674, and reincorporated southeast Asia into the family's maritime trading network. In 1670, Zheng Jing allowed the English East India Company to open an office in Taiwan. Zheng Jing died in 1681; two years later Admiral Shi Lang captured the last of the Zheng leaders and concluded the conquest.

Consolidation of control over the newly acquired lands of the Ming was the major motive stimulating the 'War of the Three Feudatories' (Sanfan, 1673–81), which was a major hurdle for the young Emperor to overcome. South and southwest China were under the effective control of three Han Chinese generals: Shang Kexi (fig. 7) and Geng Jimao had joined the Manchu cause in 1633; Wu Sangui was the famous Ming commander who had opened the gates at Shanhaiguan and invited the Qing banner troops inside China Proper in 1644. All three men were rewarded with princely titles and led major portions of the Qing military campaigns in the south and west. By the 1660s, Wu Sangui controlled the provinces of Yunnan and Guizhou as well as parts of Hunan and Sichuan; Shang Kexi was in charge of Guangdong and parts of Guangxi; and Geng Jimao ruled Fujian.

In sharp contrast to Ming administrative practice, these three princes controlled regional tax revenues and had supervisory powers over all aspects of military and civil government. Moreover, in 1671 both Shang and Geng were succeeded in these posts by their sons. It appeared that a hereditary system of decentralised local rule was being created, and attempts by the Kangxi court to take back the authority that had been ceded sparked the rebellion of Wu Sangui (December 1673), who was followed by Geng Jingzhong (1674) and Shang Zhixin (1676). These rebellions posed a serious challenge to the Qing. Geng and Shang surrendered in 1676 but the Qing were unable to put down Wu Sangui, who died in 1678. Sangui's successor, Wu Shifan, finally committed suicide in 1681 as Qing forces besieged his capital. The south and southwest were then incorporated into the regular system of provincial administration that the Qing had inherited from their predecessors.

WOOING HAN CHINESE LITERATI

A second major policy goal in the Kangxi reign was to win over the educated Han Chinese élite. The court supported Confucianism as the foundation of the state, at least

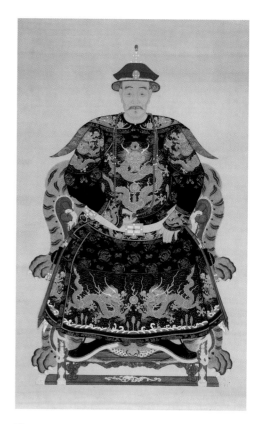

Fig. 7
Anonymous court artists, *Portrait of Shang Kexi*, Qing dynasty, nineteenth to early twentieth century. Hanging scroll, ink and colour on silk, 188.9 × 117 cm. Arthur M. Sackler Gallery, Smithsonian Institution, Washington DC. Purchase – Smithsonian Collections Acquisition Programme and partial gift of Richard G. Pritzlaff (s1991.81). Shang Kexi was heaped with honours, and given the title of 'Prince Who Pacifies the South' for his military contribution to the Qing conquest. The War of the Three Feudatories began when the Qing approved Shang's retirement and initiated plans to strengthen their control over his domain.

as far as its administration of Chinese-speaking subjects was concerned. Whereas the Shunzhi Emperor's literacy in Chinese appears to have been weak (the conquest generation of Manchus spoke Mongolian and Manchu), the Kangxi Emperor was able to converse easily in Chinese. He invited Confucian scholars to educate him and his sons, appointed leading Confucian scholars to court as personal secretaries and installed them in the Southern Study inside the Forbidden City. The Emperor presided over Confucian state rituals. He also participated in the traditional 'court lectures', events at court in which learned scholars instructed the Emperor in Confucian morality and thought by lecturing on the Confucian Canon. In 1670, the Emperor issued the 'Sacred Edicts' (*Shengyu*), which promoted Confucian moral values among commoners.

Neo-Confucianism had emphasised the personal loyalty that an official owed to the dynasty he served; for this reason, Han Chinese men born before 1644 were reluctant to sit for the civil service examinations held by the Qing government. In addition to the regularly scheduled exams, the Kangxi Emperor ordered a special examination (*boxue hongci*) in 1679 to recruit men of special talent. Fifty degrees were awarded to the winners, who were appointed to compile the official history of the previous Ming dynasty. Imperial commissions for dictionaries and other scholarly compilations and massive publication projects provided employment for educated men and eased anti-Manchu sentiment among Han Chinese literati residing in Nanjing and other cultural centres in the Yangzi delta.

In keeping with longstanding Chinese imperial tradition, the Kangxi Emperor and his successors patronised the arts. The imperial factories were founded in 1661 to produce clothing, *objets d'art* and religious objects for court use and the gift exchanges that reinforced the Emperor's relationships with his officials, subjects and vassal states. The workshops were expanded in 1693 into fourteen units, specialising in the manufacture of textiles, metal, glass, enamels, leather, icons, paintings and printed books. At their peak in the Qianlong reign, there were thirty-eight of these Palace Workshops (collectively called the Zaoban chu) scattered throughout the Forbidden City and the imperial villas northwest of Beijing, as well as imperial silk factories in Suzhou, Hangzhou and Jiangning.

The Kangxi Emperor also presented himself to Han Chinese subjects through the famous Southern Tours (fig. 8). Beginning in 1684, and on five other occasions (1689, 1699, 1703, 1705 and 1707), these stately imperial progressions took the Emperor, along with a massive entourage, southwards to Jiangnan, the economic and cultural heartland of the Han Chinese literati. The Emperor personally inspected the dykes which prevented the Yellow River from flooding large portions of the North China Plain and the Grand Canal which links the capital to the Yangzi delta. During these tours, the Emperor summoned local officials to report on weather conditions and the harvest, and he received and was entertained by prominent local notables. His visit to Qufu in 1684 rendered homage to the birthplace of Confucius. On that same trip the Emperor climbed to the peak of the sacred Mount Tai, replicating a pilgrimage made by earlier rulers.[18] The Kangxi Southern Tours were followed by the Qianlong Emperor in 1751, 1757, 1762, 1765, 1780 and 1784.

DOMESTICATING THE BANNER PRINCES

Winning over his Han Chinese subjects was only part of the agenda of the Kangxi Emperor, albeit the one that has been most often described in Chinese histories of the period. He also significantly strengthened the power of the throne over the banner lords. During the early seventeenth century, leadership in the emerging banner organisation was determined by military merit and monopolised by the kinsmen and descendants of the Qing dynastic founder, Nurgaci (1559–1626), and his brothers. No one could become a banner lord (Manchu: *beile*) without successful generalship. *Beile* enjoyed almost absolute power over their own banners during the first half of the seventeenth century; they were co-sharers in the division of war booty; and they deliberated on all state matters.

The domestication of the banner lords was begun during the Kangxi reign and completed in the Yongzheng reign. The Kangxi Emperor personally controlled three

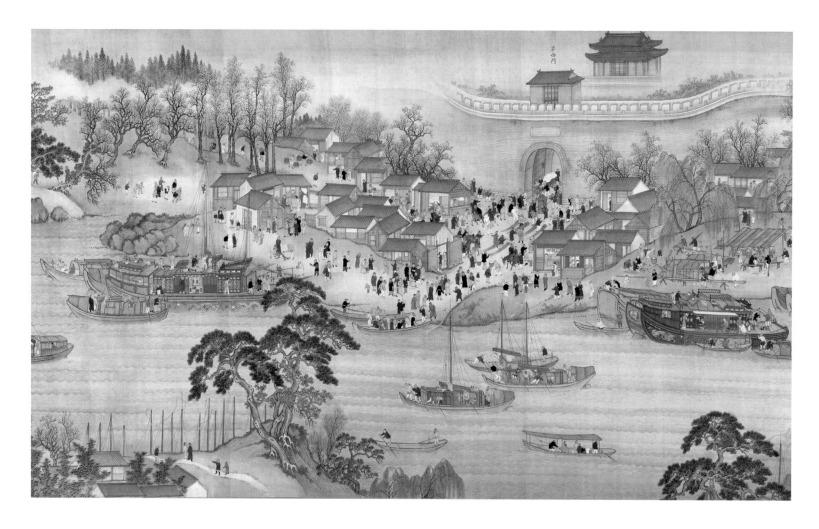

Fig. 8
Detail of cat. 13, Wang Hui (1632–1717) and assistants,
*The Kangxi Emperor's Southern Inspection Tour, Scroll
Eleven: Nanjing to Jinshan*, 1691–98. Handscroll, colour
on silk, 67.8 × 2612 cm. The Palace Museum, Beijing,
Gu9208

of the eight banners – the Bordered Yellow, Plain Yellow and Plain White – whereas the
banner lords each controlled only one banner. After dismal performances by banner lords
who led the armies during the War of the Three Feudatories, the banner lord's right to
command his own troops in battle was taken away, and the Emperor himself appointed
commanders, frequently his own sons, to lead the army on subsequent campaigns. Banner
administration was gradually bureaucratised and the banner lord's power to control the
lives of the men under him was given to banner officials from notable clans. The sharing
of war booty, which resulted in the fabulous wealth of the early princedoms, ended; the
Emperor now provided estates for his sons from the resources under his personal control.
As a consequence, imperial sons received more modest estates of much smaller size. With
the exception of a few princely lines descended from conquest heroes, a prince's rank
(and thus his stipend and the size of his estate) was reduced with each generation. They
were re-assigned to the lower five banners when they were invested with princely titles,
gradually diluting the cohesion of those units and their loyalty to the banner lord.

All imperial princes lived in Beijing and required the Emperor's consent to travel from
the capital. The Emperor controlled virtually every aspect of their lives. Princes could not
marry or give their daughters in marriage without the Emperor's approval. When they
died, the heirs to their princely titles had to be confirmed by the Emperor, who turned
back successors who did not demonstrate proper conduct and values. By these measures,
the Kangxi, Yongzheng and Qianlong Emperors turned a hereditary nobility into a
service nobility.

The three emperors also devised measures to educate and help support the growing
number of imperial kinsmen who were impoverished. The Yongzheng Emperor
established special schools, and the Qianlong Emperor permitted some clansmen to
sit for the metropolitan examination without qualifying in the lower level exams. Other
kinsmen obtained examination degrees through the orthodox route and held
bureaucratic posts in the capital and the provinces.

Eunuchs have often been identified as the cause of a dynasty's downfall: by virtue of their position in the imperial palace, they were well-placed to subvert the ruling house from the inside. In the Kangxi reign bondservants belonging to the three banners in the Emperor's personal control were appointed to posts in the Imperial Household Department (Neiwu fu) to supervise eunuchs. This agency was probably created in the 1620s as the personal household administration of Nurgaci; it lapsed between 1653 and 1661 and was reorganised in 1667.[19] Under the Kangxi Emperor and his successors, the size of the Imperial Household Department grew steadily: from 402 officials in 1662 to 939 in 1722 and 1,623 by 1796. It not only managed the Emperor's household affairs but frequently performed diplomatic and fiscal tasks that went beyond this primary responsibility, providing another tool for imperial action that was not constrained by bureaucratic precedent.

Bondservants (Manchu: *booi*, belonging to the household) were a hereditarily servile group, descended from Chinese and other residents of northeast Asia who were taken captive during the conquest period and divided as booty among the banner nobles. Bondservants in the Emperor's upper three banners became his household servants, and as such, were eligible for appointment to palace posts. Occupying the lower rungs of the banner hierarchy, bondservants were legally prohibited from marrying into the families of other bannermen; they were ideal imperial servants because they were completely dependent upon the throne for their status. Bondservants could hold offices in the Imperial Household Department.

SUCCESSION STRUGGLES

The Kangxi Emperor's achievements lay in expanding imperial authority against the banner lords and within the Han Chinese bureaucratic system inherited from the Ming. His conspicuous failure lay in institutionalising the succession practices of the Qing ruling house. Elsewhere, I have described the fratricide resulting from the Jurchen custom of permitting brothers as well as sons to succeed tribal leaders.[20] By the Kangxi reign, father–son succession had prevailed, but which son should be selected?

Most Han Chinese dynasties, including the Ming, designated the eldest son of the empress as the heir apparent or crown prince. The Manchus did not have this tradition. Ming rules provided predictable and stable succession by fixing the procedure for naming an heir, designating this heir when he was very young, and removing all other sons from the capital to the provinces, where each was provided with an estate. The Manchus inherited the Inner Asian tradition which selected leaders on the basis of merit rather than birth order or the status of the birth mother: in theory and in practice, all sons were eligible to succeed as emperor. Moreover, in keeping with the collegial tradition of leadership within the ruling Aisin Gioro lineage, all of the Emperor's sons resided in the capital, where they were under their father's eye. Unlike the Ming, which banned imperial princes from participating in governance, the Qing imperial princes were assigned to various military, administrative and diplomatic tasks.

Xuanye himself was not the Shunzhi Emperor's eldest son; historians say he was selected because he had survived smallpox, the disease that killed his father.[21] Xuanye was not yet twenty when his empress (Empress Xiaocheng) died giving birth to his second son, Yinreng. When he was two, Yinreng was declared crown prince (fig.9). It seemed that the Kangxi Emperor would establish the Ming practice as precedent for the Manchu ruling house, but in 1708, the Emperor disinherited Yinreng after accusing him of an attempt on his father's life. Reconciliation (1709) and restoration to the heirship proved to be temporary; in 1712, Yinreng was again disinherited and placed under confinement. Despite passionate appeals by several officials, Xuanye refused to name another heir until his deathbed.[22]

Beyond Yinreng's own behaviour – the records say that he 'indulged in immoral practices' and associated with men of 'evil character' – lie more fundamental reasons that were inherent in the institutional mechanisms that the Kangxi Emperor had created. The empress was always selected from the powerful families at court, and her male kinsmen could use their relationship to the heir apparent to pursue their own aggrandisement. The Emperor was very watchful lest a faction of officials coalesce

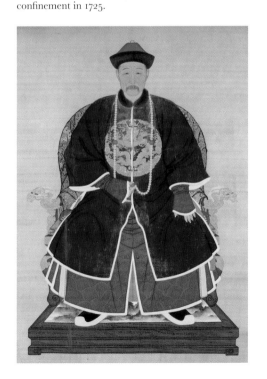

Fig. 9
Anonymous court artists, *Yinreng as Heir Apparent*, eighteenth to nineteenth century. Hanging scroll, ink and colour on silk, 164.2 × 115.6 cm. Arthur M. Sackler Gallery, Smithsonian Institution, Washington DC. Purchase – Smithsonian Collections Acquisition Programme and partial gift of Richard G. Pritzlaff (s1991.109). In 1708 the Kangxi Emperor accused his son Yinreng of attempted patricide and removed him from his position as his heir. Yinreng was pardoned in 1709 and restored as heir apparent, only to fall from favour again in 1712. He died in confinement in 1725.

around the heir, creating a clique at court that would weaken his own personal control. He purged Yinreng's great-uncle, Songgotu, for this reason in 1703. The Emperor seems to have concluded that naming an heir endangered his own authority.

Removing Yinreng as heir apparent, however, stimulated the outbreak of open discord among Xuanye's other sons. Factions formed around several who were especially ambitious, and eventually eight more of the Emperor's twenty sons were punished for their actions. The eldest, Yinti, was stripped of his princedom in 1708 for using sorcery against Yinreng. He died in confinement, as did his full brother Yinzhi.

The repudiation of the Ming system of succession was to be permanent. Yinzhen, whose ascent to the throne upon the Kangxi Emperor's death in 1722 was tainted by rumours that his father's will had been fabricated,[23] continued on the course set by Xuanye. To satisfy those pressing him to stabilise the realm by naming an heir, Yinzhen devised the system of 'secret succession' which was followed by his successors throughout the Qing dynasty. He wrote the name of his heir and sealed the edict in a casket that he placed in the rafters in the Qianqing palace, to be opened only after his death.

The Yongzheng Reign (1722–1735)

The Yongzheng Emperor tightened fiscal administration and reformed corrupt practices that had developed in the latter part of his father's reign. During the first decades of its rule, the Qing government had consolidated taxes on land and corvée taxes (these constituted the bulk of central government revenues) under the Ministry of Revenue, and reversed the Ming custom of providing different central government ministries with earmarked revenue sources. The quotas stipulated in his father's edict of 1712 which had merged land and corvée taxes into a single tax had been frozen, with the result that officials at various levels of government increased revenues by adding surcharges. Meanwhile, wealthy landowners bribed local clerks in order to evade paying what they owed. The Yongzheng Emperor failed to conduct new land surveys that would create a new basis for taxation, but he rationalised the elaborate system of surcharges and increased the delivery of tax funds to the capital.[24]

Yinzhen was equally successful in completing the subjugation of the banner lords to the throne. He limited the number of bannermen who were under the control of a banner prince, bureaucratised recruitment of company captains, standardised the administration of the banners and expanded the imperial surveillance system. The power to adjudicate disputes and punish bannermen was taken from the princes and transferred to central government agencies. The Emperor could now intervene in the hereditary succession of the banner princedoms.

As more and more Han Chinese settlers migrated to the southwest and west, the Qing government moved to incorporate non-Han minority groups living in these regions. The Yongzheng Emperor tightened administrative control over the minority peoples by abolishing the tribal chieftain (*tusi*) system that had been inherited from the Ming dynasty.[25] Prominent provincial officials like Chen Hongmou (1696–1771) established charitable schools in these localities as a means of acculturating the minorities.[26] Along a different though parallel track, the Emperor tried to release a number of groups from their outcaste status by permitting them to change their hereditary occupations and to register as ordinary commoners.

It was during the prosecution of the unsuccessful campaigns against the Zunghars (from 1729 onwards) that the Yongzheng Emperor created a new decision-making body which evolved after his death into the Grand Council.[27] In the beginning this was an informal 'inner council' of a few men, who could be called for consultations at any hour when messages from the battle front arrived. From the Emperor's perspective, ad hoc committees such as this allowed him to evade the constraints imposed by the bureaucratic regulations of the outer court. Deliberative groups could be formed at need, dissolved after they had served their purposes, and staffed without regard to seniority and other bureaucratic rules. Inner-court rule, of course, also heavily favoured the conquest élite.

The Qianlong Reign (1736–1795)

Traditional Chinese history divides the long Qianlong reign into three periods. The first, lasting until 1749, was the era of 'good rule', thanks to the able advice of senior ministers like Ortai (1680–1745) and Zhang Tingyu (1672–1755). From 1750 to 1780, the Emperor's chief advisors were his brother-in-law, Fuheng (d.1770), and Yu Minzhong (1714–1780), neither of whom was able to oppose him. Finally, the 1780s and 1790s are usually linked with the Emperor's predilection for his favourite, Heshen (1750–1799), who is blamed for the corruption and decadence of this period. The 'foundations of government were permanently undermined' by the deterioration of rule, and could not be repaired by Hongli's successors.[28]

The Qianlong Emperor is also known for several political campaigns to censor implied or explicit references to his non-Han origin, fearing that these would stimulate anti-Manchu sentiments among his subjects. The most notorious example of imperial censorship was the literary inquisition of 1776–82, which has been described as 'a principal instrument for taming the previous vitality of Chinese political and social thought'.[29] The inquisition eventually blacklisted 2,400 books and prosecuted their authors and the individuals who owned them. Rather than emphasising imperial power, however, recent studies of this and earlier political purges stress its inherent limitations: purges could not succeed without the willing co-operation of the Han Chinese literati.[30]

The Qianlong Emperor would have characterised his own reign in a somewhat different manner. He was very proud of his military achievements, summarising the 'ten great victories' from the 1750s to 1792 that annihilated the Zunghars, pacified the Turkic-speaking Muslims to incorporate the territory of present-day Xinjiang into the empire, suppressed Gurkha invasions into Tibet, and suppressed the Jinchuan rebels in Sichuan Province. The Qing empire created during the Qianlong reign was bigger than the current People's Republic of China, most notably by the addition of Mongolia.

The Qianlong Emperor identified himself as the ruler of five peoples: the Manchus, Mongols, Tibetans, Uighurs (Turkic-speaking Muslims) and Chinese. Each was separate, linked only by their relationship with the Emperor himself. The throne tried to preserve the cultures of these peoples even as it approved of policies to sinicise other minorities in south and southwest China. The Emperor commissioned translations, dictionary compilations and other projects to promote the languages and cultures of his Inner Asian subjects. As Pamela Crossley has observed,

> The emperor himself may have regarded it as an unprecedented achievement, in which a single person, in a single era, embodied magisterial bureaucratic government, universal dominion inherited from the Mongolian great khans, and the sagely kingship of the Chinese community.[31]

The Qianlong reign also represented the high point in a long-term process of administrative consolidation that began in the Kangxi reign. Through bondservants, bannermen and others outside the Han Chinese bureaucracy, the Emperor could bypass bureaucratic channels and also obtain additional information on bureaucratic performance. To escape from the dangers of eunuch influence in the court, these rulers used banner nobles and imperial kinsmen in the administration of the Imperial Household Department, whose own powers were expanded. In provincial administration, a bannerman was appointed governor-general to oversee the work of Han Chinese governors. And the number of bannermen appointed to the supreme decision-making body of the Qianlong period, the Grand Council, exceeded Han Chinese in over forty of the sixty years of the reign.[32]

The system of checks and balances was also applied to the administration of the Inner Asian regions, which was further regularised and bureaucratised.[33] Bureaucratisation involved reorganising tribes and Mongol confederations into a banner-league system, inserting appointed officials as administrators and reducing the power of the hereditary tribal leaders who held noble titles from the Qing court. The northeast, Mongolia, Tibet and Turkestan fell under the jurisdiction of the Court of Colonial Affairs (Lifan yuan), an agency outside the regular civil service which was headed by a Manchu or Mongol

Fig. 10
Anonymous court artists, *Portrait of Tsereng*, late nineteenth to early twentieth century. Hanging scroll, ink and colour on silk, 144 × 83 cm. Arthur M. Sackler Gallery, Smithsonian Institution, Washington DC. Purchase – Smithsonian Collections Acquisition Programme and partial gift of Richard G. Pritzlaff (s1991.62). Tsereng was a Khalkha noble who married the Kangxi Emperor's tenth daughter and rose to a position of great honour in Qing service. He was one of only two Mongols who were commemorated in the imperial Temple of the Ancestors after his death.

official. Mongol banners and leagues were governed by *jasak* (Manchu: banner chiefs) appointed by the Court. Eastern Mongols were completely incorporated into the Qing system and distinguished from the 'outer' (*wai*) banners of the Khalkha (fig.10).

A number of *amban* (Manchu: great or high officials) were appointed to oversee the affairs of the Khalkha Mongols and western Mongols. All of the Khalkha khans were now under the leadership of the Qing emperor who was the *khaghan* or 'khan of khans'. Free seasonal migration from summer to winter pastures was no longer allowed: now the territorial boundaries of each tribe's pasturelands were drawn by the Qing court.

Bannermen were also appointed to oversee governmental affairs in Lhasa and the procedure for appointing Tibetan élites to government positions was gradually burcaucratised. While local Muslim notables (*begs*) continued to govern the oasis towns of the Tarim Basin, their powers were gradually curtailed by regulations sent from Beijing.

DEMOGRAPHIC AND ECONOMIC TRENDS

Qing governance rested on a prosperous eighteenth century. After 1684, when bans on maritime trade and coastal residence were lifted, there was an expansion of the overseas Chinese trade between the southeast ports of Xiamen and Nagasaki, Manila and Batavia. Chinese merchants participated alongside Europeans in an intra-Asian trade that stretched from Japan in the east to Persia in the west: silk, porcelain, sugar and tea were exported from China in exchange for southeast Asian spices, raw cotton from western India and rice from Thailand and the Philippines. In the early nineteenth century, the volume of the intra-Asian trade was roughly equivalent to the whole of the English East India Company trade.[34] The Fujian merchants who traded out of Xiamen also exported rice and sugar to the mainland from Taiwan, which was being settled by fellow provincials.

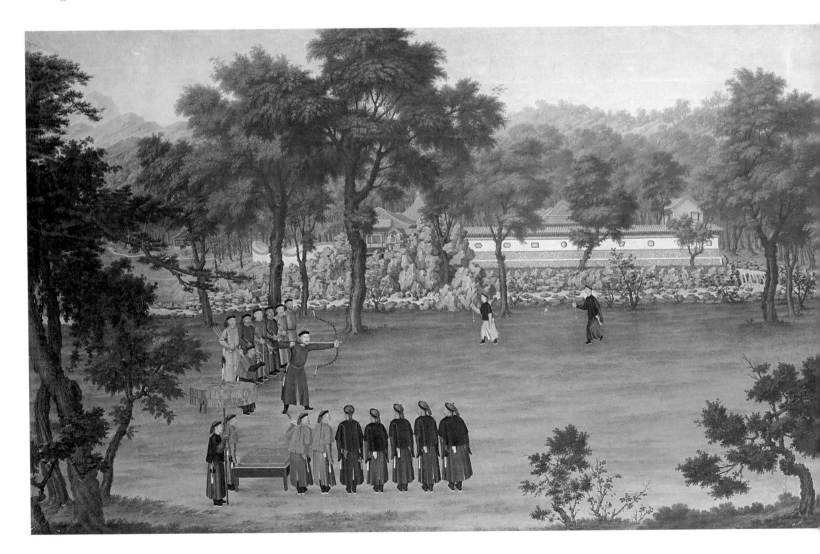

Emigration followed trade: the foreign entrepots of Amoy (Xiamen) and Canton (Guangzhou) became embarkation points for Chinese moving to Indochina, Singapore and Batavia where they became important commercial intermediaries.

From the Kangxi to the Qianlong reigns trade with Europe expanded greatly, as Chinese products became part of a 'revolution in the history of consumption'.[35] A steady increase in Chinese exports tilted the net balance of trade in China's favour. Economic growth was also apparent in the domestic economy: population rose by an estimated two-thirds between 1650 and 1750 while cultivated acreage increased by about fifty percent.[36] Significant internal migrations also marked the eighteenth century. Farmers moved from the more densely settled southeast and interior provinces of south China to the southwest and far west; others moved from the southeast Fujian coast to Taiwan; and some moved westward from north and central China into the uncultivated Han River highlands. The expansion of empire and the Pax Manjurica stimulated trade that spanned the non-Han and Chinese-speaking worlds; northeastern farmers were linked to the consumers of the Yangzi delta cities via a bustling coastal trade.

Government treasuries were overflowing during the Qianlong reign. In contrast to the late sixteenth and early seventeenth centuries, when government revenues dwindled despite expanding foreign trade and commercialisation, a consolidation of tax revenues, centralisation of tax collection, and a tightening of the implementation of regulations during the Kangxi and Yongzheng reigns produced the treasury surpluses of 1766, when the total government revenues were almost double the figures for 1652 and 56 percent greater than the figures for 1682.[37]

The Emperor also tapped his personal wealth in pursuit of his military and political goals. The documents indicate that funds sometimes flowed from the Privy Purse to the Ministry of Revenue and at other times reversed course. While we have no figures on the total size of the Emperor's Privy Purse, archival research suggests a steady expansion of economic activities from the Kangxi to the Qianlong reigns.

The Imperial Household Department 'was the biggest landlord, the biggest single employer of workers and artisans, and the ultimate recipient of much of the varied wealth of the empire'.[38] Imperial landholdings continued to increase during the eighteenth century, as did the income from rents collected annually from the imperial estates in the countryside as well as urban property in Beijing's Inner City, where bannermen resided. In addition, the Emperor received 'surplus quotas' from customs posts in Canton and elsewhere. Trade in ginseng, a precious product of the northeast, was an imperial monopoly and profits from ginseng sales went into the Privy Purse. Additional profits came from the imperial monopolies on unworked jade and furs as well as some revenues from sales of salt certificates (a state monopoly). There were occasional windfalls from the 'self-imposed' fines on officials seeking imperial pardons.

The Imperial Household Department also lent out money to merchants and collected interest on these funds. The Kangxi Emperor opened imperial pawnshops to support imports of copper, a monetary metal; his successor expanded the capital of the pawnshops and used the return (approximately 10 percent a month) to subsidise the weddings and funeral expenses of bannermen and, later, other welfare expenditures. During the Qianlong reign, pawnshops provided a steady and reliable income for regular administrative expenses incurred by the imperial house.

Society and Culture in the Qianlong Reign

COSMOPOLITAN INFLUENCES

Qing society was both 'extremely diverse and highly integrated'.[39] From the sixteenth century onward, Jesuits brought knowledge of scientific and technological advances in Europe to the Ming and then the Qing courts. The Kangxi Emperor studied Western mathematics, and resolved disputes (1668–69) between Chinese and European calendrical models in favour of the Jesuits, placing them in charge of the Imperial Board of Astronomy. He was intrigued by European musical pitch, and commissioned a major work on Chinese pitch as a result of this exposure. The Emperor invited Jesuits to

Fig. 11
Jean-Denis Attiret (Wang Zhicheng; 1702–1768), *The Qianlong Emperor Shooting an Arrow*, 1754. Screen, oil on paper, 95 × 213.7 cm. The Palace Museum, Beijing, Gu8760. The Qianlong Emperor prided himself on his ability as an archer, a martial skill highly prized in Manchu culture.

introduce European cartography to his court and commissioned them to create new maps of his expanding empire (1707–17). The Jesuits were employed in Qing negotiations with the Russians that culminated in the Treaty of Nerchinsk (1689), which was written in five languages (Latin, Manchu, Chinese, Mongolian and Russian), and in the Treaty of Kiakhta, which fixed the boundary between Mongolia and Russia.

Jesuits like Giuseppe Castiglione, who worked at the court from 1715 to his death in 1766, joined Chinese, Tibetan, Uighur and Mongol artists in the production of objects, buildings and entertainments for court consumption. The sharing of borders with an expansionist Russian empire provided another channel for commercial and cultural exchange. With a hostel and language school of their own in Beijing during the eighteenth century, Russians resided in the capital.

Within the Chinese-speaking part of the Qing empire, the rise of market towns and the expansion of a regional and in some cases national marketing network facilitated the exchange of goods and information between urban and rural residents. Well-to-do landlords in the Yangzi delta moved to the towns and cities, where they formed a consuming public that stimulated an efflorescence of urban culture. Although hereditary slavery did persist in some regions, it was very much an exception to the general trend towards contractual relations between landlord and tenant and employer and employee. Indeed, the criminal cases housed in the First Historical Archives provide cases of contracts to sell wives and children as slaves or to share the sexual services of a wife in exchange for labour, testifying to the penetration of a contract culture even among persons who did not adhere to Confucian values.[40]

Commercialisation and enhanced social mobility were not without their psychic toll. Literati anxiety about *nouveaux-riches* upstarts is evident from the sixteenth century onward. At about the same time, illustrated editions of popular fiction and drama appear as conspicuous new products of commercial publishing houses. Although many extant editions are high-quality productions intended for wealthy bibliophiles, cheaper editions also flourished, and were probably the channel through which illustrations, many of them derived from popular drama, became visual tropes, replicated on Jingdezhen porcelains of the mid-seventeenth century for the upwardly mobile household, or as motifs in embroidery for wardrobe accessories.[41]

The expansion of printing continued into the eighteenth century. Recent studies document the continued penetration of book culture through the emergence of regional publishing enterprises, book peddlers' market routes and book lists.[42] The discovery by Cynthia Brokaw of the replication of the élite Confucian curriculum in these lists of inferior imprints provides further evidence of the success of élite efforts to inculcate the rest of the population in the normative values that we call Confucian. But this Confucianised normative culture was specific to China Proper, the region within the Great Wall that defined the Ming domain.

MANCHU AND INNER ASIAN CULTURE

In Tibet, Mongolia, the northeast and the western regions, the Qing emperors promoted policies that enhanced separate cultural traditions. At home, the three emperors worried about preserving Manchu identity. Adoption of Chinese as the spoken language of bannermen was first observed during the Kangxi reign, and the Qianlong Emperor responded by vigorously attempting to assert and perpetuate a Manchu identity, defined in terms of language, traditional martial skills and history.[43] To preserve traditional Manchu religious practices, he commissioned and published a major compilation on Manchu shamanism (fig. 12). He also tried to purify Manchu and purge it of Chinese-derived vocabulary.

Qing conquest altered the structure of the Manchu language but also extended education in Manchu to Mongols incorporated into the Eight Banners. Schools were established for bannermen, and there were special examinations in Manchu and Mongolian that qualified individuals for civil service posts. As Manchu speakers from different regions were brought into close contact through their allocated assignments, dialectal variations were reduced, with the speech of Beijing becoming the standard.

Written Manchu, which was developed in the early seventeenth century, was adopted along with Chinese as the official language of government, and attained a standardised form that persisted throughout the dynasty.

The spoken Chinese language of Beijing was shaped by the non-Han rulers who occupied the city from the tenth to fourteenth centuries. The Manchu occupation of Beijing introduced their southern Tungusic dialect into the evolution of the twentieth-century Beijing dialect. A precursor of this dialect is said to have already existed in the Yongzheng reign, while a Qianlong era version of the spoken language may be glimpsed in snatches of conversation recorded in Cao Xueqin's contemporaneous novel, *Honglou meng* (*Dream of the Red Chamber*, also known as *Story of the Stone*). Cao's ancestors were bannermen, and the novel depicts a thinly disguised élite banner official household. Elements of Manchu grammatical style, Manchu-Chinese combinations of place names, Manchu words and Manchu-style Chinese words are scattered through the work. Even clearer evidence of the evolving spoken language can be found in some narrative ballads called 'drum rhymes' (*zidi shu*) which originated in Beijing during the Yongzheng reign. Although most surviving texts, published in the early nineteenth century, are only in Chinese, a few employ a combination of Manchu and Chinese writing.[44]

The Qing peace and imperial patronage opened linguistic doors that connected Manchus, Mongols and Tibetan speakers. Manchu princes learned Mongolian as well as Manchu and Chinese in the Palace School. A Tibetan school was established under the Court of Colonial Affairs to recruit Mongols and send them to Tibet for advanced study in writing, speaking and translating Tibetan. In Mongolia, the most important schooling was provided by the numerous monasteries and temples (approximately 2,000 existed). There, Tibetan was the most prestigious language. Mongol monks translated Tibetan texts and wrote important biographies of church notables, church histories and philosophical dissertations in that language (fig. 13).

Qing Beijing was a major centre for publishing in the Manchu, Mongolian and Tibetan languages. The government was itself a major publisher of texts, with imperially commissioned translations of Confucian classics, multi-lingual dictionaries and histories. Commercial publishing firms existed, as did monastic publishers.[45]

Fig. 12
William Henry Jackson (1843–1942), *Nanai Shaman and Assistant*, 1895. Hand-coloured lantern slide, 8.25 × 10.16 cm. Library of Congress, Prints and Photographic Division, World's Transportation Commission Photograph Collection (LC-USZ62-78838). Like the shaman in this photograph, many Manchu shamans were male, although those employed at the daily shamanic sacrifices within the Forbidden City were female.

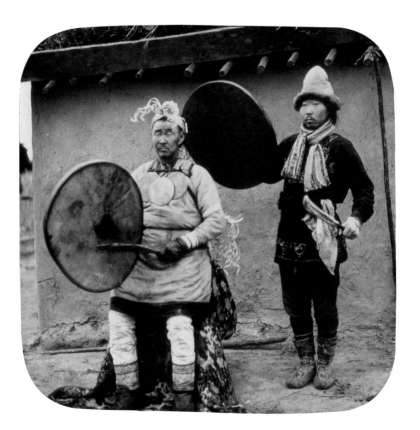

Historical Evaluations of the Period

DYNASTIC DECLINE

Traditional histories identify the last decades of the Qianlong reign as the beginning of dynastic decline. The military triumphs of the 'Ten Great Victories' were offset against the long and costly campaigns undertaken to suppress the sectarian 'White Lotus' uprising which erupted on the Han River highlands frontier in 1796 and persisted until 1804. By that date, the surpluses in the treasury had vanished, to be replaced by deficits. Disregarding the hapless Jiaqing Emperor (r.1796–1820), historians have tended to identify the corruption and decadence of the last decades of the Qianlong reign as evidence of the moral rot that signalled dynastic decline. But there is an inherent contradiction between the economic factors frequently cited – overpopulation and landlordism – and the actual events on the ground.

The White Lotus uprising occurred in the frontier settlements, not in the densely populated alluvial plains. A sectarian religion which worshipped a female deity called the Eternal Mother, the White Lotus was carried from north China into the highlands by settlers, and spread despite government bans. The sect not only answered spiritual needs but also provided a safety net for individuals leaving the security of their natal communities to venture into unknown territory.

Rebellion on the frontier could be stimulated not by the collapse of state authority, but by precisely its opposite. The magistrate of a frontier region had few local allies. Unlike the regions of older settlement, the frontier also lacked a local élite that was committed to Confucian normative values. Moreover, frontier societies that had developed in relative freedom reacted against efforts to expand the local government presence and to suppress the heterodox sectarian networks.

In the period between the abdication of the Qianlong Emperor (1795 in the Chinese traditional dating, 1796 in Western calendrical dating) and the Opium War (1840–42), there were other disturbances of the peace in ethnically diverse frontier regions of China. With the exception of the North China Plain, there was no major unrest in the populous urbanised (and highly commercialised) regions of China where the elements that are traditionally linked with dynastic decline were most concentrated: corrupt government, population pressure and the oppression of tenants by profit-seeking landlords. Those seeking explanations for the disruption of the long Pax Manjurica should perhaps think instead of the problems of frontiers: a weak state, weak local élites and ethnic/religious tensions engendered by the eighteenth century's massive population movements. From this perspective, the disorders of the turn of the nineteenth century were the unanticipated consequence of eighteenth-century successes.

CHINESE JUDGEMENTS OF THE THREE EMPERORS

Beginning in the 1980s, twelve Qing historians in the People's Republic of China wrote articles that simultaneously praised the Kangxi, Yongzheng and Qianlong reigns as representing the peak of political, economic and cultural development in China's traditional history, while emphasising its stagnation in comparison with developments taking place in Western Europe at the same time.[46]

During the 'Kang-Qian shengshi' ('prosperous age of the Kangxi until the Qianlong reigns'), rulers built the most successful multi-ethnic empire in Chinese history under a powerfully centralised state. Political order facilitated large-scale population movements from the densely populated regions into the frontiers of the southwest, northwest and far west; and domestic and foreign trade expanded. Settlers and traders moved into Inner Asian regions such as Mongolia and the northeast, with adverse effects on traditional pastoral and hunting-fishing economies that were to be felt in the nineteenth century. Yet, despite its significant historical achievements, these historians concluded that the period must be judged as having failed, since the eighteenth century was precisely the period when dynamic new historical forces were emerging in the West.

In the French Enlightenment, Montesquieu and others introduced new concepts that attacked both feudalism and the religious establishment. Europe experienced a scientific

Fig. 13
Dharani sutra quilt, made by the Suzhou Imperial
Silk Workshop (under the supervision of Yu Xing),
1909. Silk with gold thread, 223 × 152 cm. The Palace
Museum, Beijing, Qing Gong 407. Wrapped around
the bodies of deceased emperors, empresses and
higher-ranking consorts before they were placed in
their coffins, such shrouds bearing *dharani* (religious
incantations believed to have magical powers) had
a protective function.

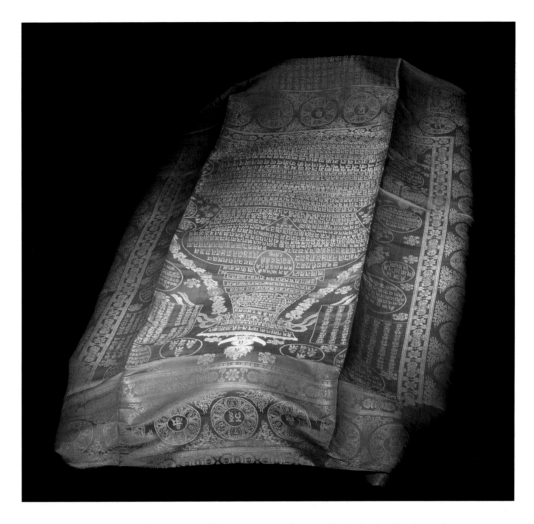

revolution, and Watt's invention of the steam engine marked the beginning of a
production revolution. The American War of Independence and the American
Constitution created a new kind of polity based on human rights; and the French
Revolution swept away the old feudal order, marking the beginning of a new epoch in
Europe.[47] In contrast, China was unable to break out of the political, economic and social
constraints of the past. The Kangxi, Yongzheng and Qianlong eras can be seen as
a maximisation of the potential inherent within a traditional structure but, especially when
seen in a global context, the historical developments of these three reigns were insufficient
to allow China to keep pace with Europe. As Gao Xiang writes:

If we place the Kang-Qian period against the world stage, then we discover: while the Qing dynasty was
at its peak, while people were drunk with the cultural and military achievements of the prosperous age,
a production revolution broke out in Europe, technological discoveries and social transformation were
continually produced…Here, the differences between China and the West split them apart, China's fate
in modern history was determined…the formation of this kind of historical backwardness can be said to
be the tragic significance of eighteenth-century China or the Kang-Qian period.[48]

This appraisal of early Qing history echoes earlier themes in Western scholarship on
China in the 1950s and 1960s, which focused on the historical obstacles to China's
modernisation in the nineteenth and early twentieth centuries. As the Chronology in this
volume indicates, the eighteenth-century development of ideas concerning the rights of
individuals and their proper relationship to the state were the direct precursors to the
development of the concept of popular sovereignty which underlies the representative
democratic forms of government that exist in our contemporary world. No such
developments occurred in Qing society under the Kangxi, Yongzheng and Qianlong
Emperors.

Lately, scholarship outside China has evaluated the historical significance of the three
reigns somewhat differently. First, there are the recent attempts to place China within a
global history. André Gunder Frank insists that 'there was a single global world economy

with a worldwide division of labour and multilateral trade from 1500 onward', and China along with India (not Europe) constituted the 'core' of this world economy until 1800.[49] Frank's analysis rests on the observation that from the sixteenth to the eighteenth centuries, monetary metals flowed from Europe to Asia and not the other way around: the European desire for Asian products spurred an expanding trade whose net balance was in Asia's favour.

Frank's analysis, which challenges widely accepted generalisations about European hegemony and the origins of capitalism, creates a new perspective from which to evaluate the early Qing. If Asia operated alongside Europe in a single world economy, then the major distinction between Asia and Europe must be sought not in ultimate historical roots but in the culturally conditioned responses of regions to a specific situation. Kenneth Pomeranz rejects the attempt to locate the sources of the British Industrial Revolution in European developments from the Middle Ages onwards.[50] If parts of Asia and Europe were as highly developed on the eve of industrialisation as Britain, yet did not industrialise first, we should seek the sources of the British Industrial Revolution by pursuing explanations that focus specifically on the circumstances in Britain at the time.

Frank reminds us that the Kangxi, Yongzheng and Qianlong courts did not exist in a vacuum, ignorant of events and technologies emerging in Europe. Indeed, the early Qing rulers welcomed European advances, particularly but not solely in technologies that strengthened the state, and the profits from the expanding foreign trade with Europe were important in producing the 'prosperous age' itself.

The empire that was created in the early Qing should be examined alongside parallel developments in Russia.[51] Jesuit mapping and Jesuit participation in diplomatic negotiations between these two powers were instrumental in introducing new conceptions of the state. The Manchus, Russians and Zunghar Mongols acted on new concepts of territoriality that resembled those emerging in Britain, France and the Netherlands. Like European empire-builders, the Qing systematically collected information about new territories and new subject peoples. Many of the projects sponsored by the throne were aimed at strategic targets: these included detailed geographies of western regions that might be useful for future military campaigns, multi-lingual dictionaries and ethnographic information on minority peoples.[52]

The legacy of the Kangxi, Yongzheng and Qianlong Emperors stems from their creation of a multi-ethnic empire that was the direct ancestor of the modern Chinese nation. These three rulers were able to incorporate Inner Asian and Chinese ideological themes into a new kind of rulership. The new ideological synthesis was paralleled by an administrative transformation of Inner Asian polities, creating a stable empire that lasted until the early twentieth century. The Chinese state which exists today reminds us of their historical legacy.

II

The Qianlong Emperor as Art Patron and the Formation of the Collections of the Palace Museum, Beijing

GERALD HOLZWARTH

The Palace Museum in Beijing is one of the world's largest museums. As the one-time residence of the emperors and hence the centre of the Chinese empire, it preserves not only what remains of the ancient art collection of the 'sons of heaven', accumulated over thousands of years, but also the many diverse items pertaining to the palace interiors, the performance of religious rites, and daily life at court. In over 9,000 rooms it houses over a million items, of which about 800,000 were taken over from the holdings of the Qing court. Although the major part of the original imperial art collection was evacuated during the civil war and finally moved to Taiwan in 1949, where it today constitutes the National Palace Museum in Taipei, most Qing dynasty court paintings and all the palace furnishings remained in Beijing.

Since 1949 the holdings of the Palace Museum in Beijing have gradually recovered, with the acquisition of about 220,000 items, including some 500 paintings and pieces of calligraphy, many of which had been lost from the collection in the early days of the People's Republic. More than 10,000 bronzes and ceramics from new excavations have also been added. Leaving aside these new acquisitions, the holdings taken over from the palace of the Qing dynasty may be divided according to their original function into four main groups, which indicate their differing significance for art historians.

The first group comprises the items which were collected as works of art and which constitute the actual palace collection in a narrow sense. They were listed in collection catalogues, and evaluated and classified in accordance with traditional theories of art. There was a market for such works, and forgeries did of course occur. In order to understand such items adequately, the Emperor needed to be an art expert with an educated taste. This group comprises primarily the paintings and calligraphy that, as a rule, were included in the imperial catalogue. No essential distinction was made between the works of old masters and works newly created by court artists, or even the paintings and calligraphy created by the Emperor himself.

The central core of this first group consists of items surviving from the ancient palace collection dating back to the Tang period (618–907) – especially ancient bronzes, jade objects and porcelain, along with calligraphy and paintings, but also items collected typically by scholars, such as inkstones and seals, or rare natural objects, such as bizarrely shaped stones or wood fungi (cat. 199) that were given artistic status by being mounted. These objects were admired and eulogised by the imperial collector. However, they were not in general intended to be exhibited and displayed, but were wrapped in silk cloths and kept in boxes. Their owner would only take them out to look at them and enjoy them alone or in the company of like-minded friends.[1] This approach to the treatment and collecting of art differs greatly from European traditions, and can also be seen in the common Chinese term for a collection of paintings and calligraphy: 'secret book-box' (*biji*).[2] The Chinese conception of collecting is highlighted most impressively in the small

curio cabinets (*duobaoge*), boxes with a complicated construction, including many subdivisions and drawers, which the Qianlong Emperor had made to house the small valuables of his collection;[3] many were made as elaborate birthday gifts for him (fig. 14).

In contrast to the 'hidden' artworks of the first group, works in the second group were intended for display, whether to adorn palace halls or to convey a political message. This group includes paintings originally pasted onto the wall (*tieluo*) (cat. 76) and large hanging scrolls (cat. 65). Large handscrolls containing documentary paintings (cats 13, 14, 78) were, however, treated as works of art and included in the imperial catalogue. This leads to a certain discrepancy between their two functions: as documents with a political statement, which ought really to be on view; and as works of art. This group also includes the various panels bearing imperial calligraphy hung in the palace interiors; paintings and calligraphy on screens; and hanging scrolls for decoration or with symbols of promised happiness (cats 269, 270), such as New Year's pictures.

Along with pictures and ritual objects in the interiors of Buddhist and Daoist temples, the third group includes ritual objects for the Confucian state cult, such as ritual portraits of the emperors (cats 1, 2, 6), state seals, throne ensembles (cats 17–22), and musical instruments for the imperial ritual music (cats 31, 32). The portraits of imperial ancestors were kept in a special hall, where they were worshipped with regular sacrifices. They were thus not part of the art collection and as such did not bear any collectors' seals. Nor were the other hanging scrolls showing imperial portraits given the usual collectors' seals, but only the personal seals of the Qianlong Emperor, such as his large jubilee seals (see cats 16, 186).

The fourth group includes clothing and accessories (cats 3, 305, 306), armour (fig. 51), items for daily use made of porcelain, lacquer, jade or metal, as well as furniture and all manner of decorative objects from the palace interiors, but also the utensils for the Emperor's desk which were used daily for writing, along with books, seals and official documents.

The following account is concerned exclusively with the actual imperial art collection – one of the greatest collections in history – and the part played by the Qing emperors in its restoration and development.

The Collections of the Qing Dynasty and the Patronage of the Qianlong Emperor

When they succeeded to political power in China, the Qing rulers inherited the ancient palace collection of the Ming emperors, the oldest art collection in the world with a continuous collecting tradition of about 1,600 years. Its forerunners can even be traced back to the Bronze Age Shang dynasty (*c*.1500–1050 BC).[4] By the time of the early Qing dynasty, large private collections were dominant in China. The first Qing rulers, in particular the Shunzhi Emperor (r.1644–61), gave away valuable old paintings to their meritorious allies who had supported the Manchu takeover, such as Song Quan (1598–1652), the governor of Beijing at the time. His son Song Luo (1634–1713) became one of the greatest collectors of this period. Geng Zhaozhong (d.1686), the son of the conqueror of Guangdong and Fujian, who was richly rewarded, was likewise able to build up a large, high-quality collection. The Qianlong Emperor later even copied one of his numerous collector's seals.[5] The Manchu Songgotu (d.1703), the uncle of the Kangxi Emperor's wife, was given pictures for his services and owned a large art collection. All these private collectors used a fixed set of three to eight different seals for works in their collections. The most important collector and greatest connoisseur of art of this period was Liang Qingbiao (1620–1691), whose two collector's seals adorn many of the best works of the later imperial collection.

The Kangxi Emperor was a passionate calligrapher and numerous examples of his work have survived (cats 121–22, 125–28). In the last twenty years of his life at every full moon and every new moon he copied out extracts from the Heart Sutra, filling a total of 420 albums. His stylistic models were Mi Fu (1052–1107) and Dong Qichang (1555–1636). He also wrote poetic inscriptions on pictures from the imperial collection, but mainly on

Fig. 14
Curio cabinet with carved dragon and phoenix design containing 47 items, Qianlong period (1736–95). Sandalwood, 30.5 × 30.3 × 16.5 cm. Collection of the National Palace Museum, Taiwan, Republic of China. The compartment for the jade collection is decorated with painting and calligraphy by, among others, Yu Minzhong (1714–1780), then the mightiest minister of the empire. Also enclosed is an English clock and a Japanese gold-lacquered box.

paintings by contemporary court painters, such as Jiang Tingxi (1669–1732). He was less well versed as an art expert and generally relied on the judgement of the Hanlin scholar Gao Shiqi (1645–1703), who served him as both private secretary and art advisor. The latter was, however, himself a great collector and his catalogue notes reveal that he supplied the Emperor mainly with inferior forgeries, keeping the originals for himself. In 1708 the Kangxi Emperor ordered a large encyclopaedia of texts on calligraphy and painting, the *Compendium of Calligraphy and Painting from the Peiwen Studio* (*Peiwenzhai shuhua pu*). However, his most important contribution to the imperial collection was to set up numerous workshops and painting studios at the court, which supplied the collection with fresh works of art. The silk factories in Suzhou were also reorganised and produced new kinds of mounting-silks of outstanding quality following ancient designs, with which the scrolls of the palace collection were remounted. The classic mounting of the Qing era and the traditional patterns that were redesigned at that time remain the yardstick to this day.

The Yongzheng Emperor is considered the best calligrapher among the Qing rulers. He took a lively interest in the development of the arts and encouraged court painting (cats 38, 167). He was particularly interested in the imperial porcelain factory at Jingdezhen, to which he appointed Tang Ying (1682–1756) as director in 1728. The most delicate porcelain with a new kind of enamel painting now enhanced the palace collection (cat. 183).

But the real renewal of the imperial collection came under the personal direction of the Qianlong Emperor. He was the last of the great imperial art collectors and patrons in Chinese history. Not only did he reassemble many of the treasures that had been dispersed to private collections, but he also gave them a new face through magnificent new mountings and the addition of his inscriptions and seals. Furthermore, he expanded the collection many times over with the work of his numerous palace workshops and court painters. Every work of art had first to be inspected by him at the draft stage. He assessed the ancient paintings and works of calligraphy in person and gave them his seal of approval. He thus determined the artistic taste of his age and the overall form of the imperial collection. With it he created a canon of Chinese art that to this day wields an authoritative influence. His genuine passion for the pursuit of art and for collecting art was apparently stimulated by his grandfather, the Kangxi Emperor, and his uncle Yinxi (1711–1758), a talented landscape painter. He learned to paint himself and began to collect paintings at the age of eighteen. His first collector's seals on pictures, the 'Collection of Hongli' (*Hongli tushu*) and the 'Seal of the Fourth Imperial Son' (*Huang sizi zhang*), date from 1729. From 1730 he provided the works in his collection with a seal bearing his new studio name, framed by two dragons: the 'Seal of the Collection of the Hall of Delight in the Good' (*Leshan tang tushu ji*).

After his accession to the throne in 1735 the Qianlong Emperor combined his personal passion for collecting with a concern for self-presentation and efforts to further his political goals as Emperor. As a Manchu he strove incessantly to demonstrate his complete mastery of Chinese scholarship to ensure that he would be accepted as a model ruler in the spirit of the Confucian state ideology. Art collecting and proven expertise in the fields of calligraphy and painting were part of this ambition. By emulating the great imperial collectors and patrons, such as Emperor Huizong (r.1101–25) of the Song period (960–1279) or Emperor Wenzong (r.1328–32) of the Yuan period (1271–1368), he placed himself and Manchu rule in the legitimate tradition of Chinese dynastic history. Moreover the Qianlong Emperor saw himself in the role of preserver and restorer of the Chinese cultural heritage. In the imperial collection, artistic masterpieces were to be collected as a form of mandatory canon and handed down to posterity, as is indicated in one of his seals: 'Suitable for Sons and Grandsons (Posterity)' (*Yi zisun*). This enterprise also entailed the Emperor's personal assessment of the works and his correction of possible mistakes, such as false attributions or iconographic errors. The Emperor bought up the great private collections of the seventeenth century and reintegrated their treasures into the imperial collection. One of his largest purchases took place in 1746, when a bundle containing 1,000 pieces of painting and calligraphy from the collections of the Hanlin scholar

Gao Shiqi and the wealthy salt-merchant An Qi (1683–1732) was bought for two thousand pieces of silver. The bundle contained many of the best works of the later imperial collection.

At the same time in the various studios of the Imperial Painting Academy (consisting of two co-operating workshops named Huayuan chu and Ruyi guan, respectively) more than 160 artists were at work. The Emperor commissioned paintings in the classical literati style as well as large documentary painting projects in a Sino-Western hybrid style (cats 11, 16). The Emperor's own works in calligraphy and painting alone run into the thousands. In addition he had a particular liking for jade (cats 223, 225, 227). This is reflected in the enormous output of new pieces from the Palace Workshops (Zaoban chu) and the imperial workshops in Suzhou and Yangzhou. Most of the several thousand jade items in the imperial collection date from his reign. The Emperor was also particularly interested in collecting ancient bronzes (cats 204, 205), bronze mirrors (cat. 198) and seals, which he caused to be documented in comprehensive and lavishly presented catalogues. The impressive assemblage of European clocks (cats 92–95) which he likewise had copied in his court workshops also bears witness to his passion for collecting. This passion is, however, most clearly revealed in the innumerable small curio cabinets in which he kept thousands of smaller items.

Nevertheless the Qianlong Emperor repeatedly stressed that he only devoted himself to his collection in the free time left to him by affairs of state, and that it was inappropriate for an emperor to spend much time on collecting. However, the high status which he accorded to the imperial art collection can be seen in the fact that he named his small private studio after the three most precious masterpieces in his collection: the Studio of the Three Rarities (Sanxi tang; fig.15). These were three items of calligraphy by Wang Xizhi (303–361), his son Wang Xianzhi (344–386) and his nephew Wang Xun (350–401). In the first month of 1746 the Emperor completed this group by acquiring the calligraphy by Wang Xun (fig.16) and a month later named his studio after it. The Emperor loved names with different levels of meaning. In his 'Report on the Studio of the Three Rarities'[6] he explains that there are three possible interpretations of the name. The first lies in the juxtaposition of the three famous masterpieces by the Three Wangs, which at the same time represent the origins of the classical tradition of Chinese calligraphy. Proudly he remarks that he was chosen to reunite these three precious items after more than a thousand years of separation. The second interpretation of the name,

Fig. 15
The Studio of the Three Rarities (Sanxi tang) in the Hall of Mental Cultivation (Yangxin dian). The pieces of calligraphy – the name of the studio and a poetic couplet – are in the Qianlong Emperor's hand.

Fig. 16
Wang Xun (350–401), *Letter to Bo Yuan* (*Boyuan tie*),
fourth century. Handscroll, ink on paper,
25.1 × 17.2 cm. Palace Museum, Beijing, Xin145155.
One of the 'Three Rarities' of the Qianlong
Emperor, this letter by Wang Xun consists of five
lines of bold running script in the centre, with a
commentary by Dong Qichang (1555–1636) to
the left and a standard set of six seals, four jubilee
seals, three inscriptions and a painting by the
Qianlong Emperor.

as 'Studio of Threefold Striving', reveals a guiding moral principle then very fitting for him
as Emperor: 'The educated man strives after wisdom, the wise man strives after holiness,
and the saint strives after heavenliness.'[7] The third level of meaning constitutes an act of
homage to his teacher Cai Shiyuan (1682–1733). The latter's studio name was 'Studio of
Twofold Striving' (Erxi tang). Cai Shiyuan explained that it was inappropriate for him
to strive for heavenliness himself and that he, therefore, had named his studio thus.

But Cai also added a further interpretation of his studio's name, which can also be
read as 'Studio of the Two Xi'. This points to his two preferred models of scholarship,
two men with the character *xi* in their style names: Zhen Xiyuan (Zhen Dexiu, 1178–1235)
and Fan Xiwen (Fan Zhongyan, 989–1052). In this respect, he communicated to the
young prince that one should not strive to emulate the eminent Zhu Xi (1130–1200), the
founder of neo-Confucianism, or the famous national hero Zhuge Liang (181–234), but
instead be content with the former's pupil Zhen Xiyuan and the dedicated official Fan
Xiwen. Thus, by adding a single brush stroke – the character *er*, for two, has two strokes,
while the character *san*, for three, has one more – the Qianlong Emperor created his
own studio name out of his teacher's studio name, and at the same time gave it a
new interpretation.

The Inscriptions of the Qianlong Emperor

The Qianlong Emperor was a passionate poet and essayist. In his collected writings, which
were published in a tenfold series between 1749 and 1800, over 40,000 poems and 1,300
prose texts are listed, making him one of the most prolific writers of all time.[8] At the same
time his literary work also helped him to formulate his own image as Emperor. In the
porcelain factory at Jingdezhen, pieces were adorned with his poems (cat. 213), as were
inksticks and brush pots. Moreover the Emperor made innumerable items from his
collection the subject of poetic eulogies: jades, paintings and calligraphy, along with
ceramics of the Song period, inkstones, carvings and even jade archer's rings. Jades in the
palace collection alone elicited 840 poems, which in most cases the Emperor had engraved
on the items in question. There is a long tradition of poems of this sort in praise of
particular objects (*yongwu shi*), and the Qianlong Emperor used it in order to link his name
both physically and intellectually with ancient artistic tradition. He also regularly added
poetic inscriptions to the paintings of the imperial collection, following the example of the
emperors of the Song dynasty and the literati painters of the Ming. They were a mark of
distinction for the work, and a visible sign of his rightful role as Emperor.

Most particular to the Qianlong Emperor is another type of inscription, revealing a
unique practice of dealing with works of art that he seems to have developed for himself.
On certain fixed occasions over a long period he contemplated a number of paintings or
works of calligraphy which possessed special meaning for him, inscribing each regularly

with mostly private notes on the circumstances of enjoying them, using them almost as a diary. They became part of his life and he took them with him on his travels in order to compare paintings with the actual landscape, or to hang them in special rooms in palaces where he lodged, to inscribe them on every visit there.

The most famous of these are the Ziming copy of the long handscroll *Dwelling in the Fuchun Mountains (Fuchun shanju tu)* by Huang Gongwang (1269–1354) (fig. 17) and the album with the calligraphy *Clearing after Snowfall (Kuai xue shi jing tie)* by Wang Xizhi.[9] The former he used to compare with the Fuchun mountains on his trips to the south, adding 55 inscriptions to it; for the latter he made it a custom to make inscriptions on occasions of heavy snowfall in wintertime, in all more than seventy poems and notes. The famous *Wanluan Thatched Hall (Wanluan caotang tu)* by Dong Qichang (fig. 18), dated 1597, is another example of this practice.[10] In 1754 the Qianlong Emperor changed the name of his study at the travel palace at Mount Pan to 'Wanluan' ('Pleasant and Delicate') after this painting and had it hung on its wall.[11] Every time he visited this palace from then on he would enjoy the painting in its hall and add an inscription to it, praising the harmony of the painted *Thatched Hall* and the real Thatched Hall with its beautiful environment of rocks and waterfalls. In all he made nineteen visits from 1754 until 1797 and left nineteen meticulously dated inscriptions, commemorating them for posterity.[12] The large hanging scroll *Mount Pan (Pan shan)* (cat. 191), painted by the Qianlong Emperor himself, is a further example of this practice. From 1745 to 1793 on every visit to his palace on Mount Pan he added one or several poems to the picture, making a total of thirty-four inscribed poems which filled up all the free space on the scroll. This makes the painting a unique document of the Emperor's thoughts and feelings.

Of a quite different kind and with a quite different function are the Qianlong Emperor's art-historical inscriptions, in which he discusses authenticity, attribution or iconography. These may be brief one-line comments, or lengthy colophons in which problems are discussed in great detail. The Emperor was a convinced rationalist, always concerned to correct possible errors or mistakes. He owed this critical attitude in large part to his most important teacher, Cai Shiyuan, originally director of the Aofeng academy in Fuzhou, who at court generally stood for a rationalistic line of tradition in neo-Confucianism. From him the Qianlong Emperor learned how to write critical essays and to work in a scholarly fashion as a historian. He combined the traditional method of careful textual research (*kaojuxue*) with the empirical method of precise material investigation. He thereby developed the literary genre of the art-critical colophon, which Mi Fu had established during the Song dynasty, into a kind of art-historical essay. With art-historical methods that were almost modern, he and his advisers wrote the first systematic investigations into works of art based on actual research. The Qianlong Emperor's colophon of 1786 on the frontispiece of the handscroll *The Goddess of the Luo River*, traditionally attributed to Gu Kaizhi (*c.*344–*c.*406), is an example from a later period when his expertise was fully developed. At that time he used to furnish his essays with poetic headlines and had a second, more detailed essay on the subject composed by his scholars and written at the end of the scroll.[13] The painting (fig. 19) illustrates the famous

prose poem of the same name by Cao Zhi (192–232), describing the poet's encounter with a river goddess. The original composition, which may have been created in the fifth or sixth centuries, has not survived; only later copies exist. The example discussed here by the Emperor, which found its way into the palace collection in 1786, was probably produced in the mid-twelfth century and copied from an older version.[14] The Emperor compares it with two further versions in the palace collection and concludes that it cannot be the work of Gu Kaizhi as it was labelled. He was thereby correcting even the famous art expert Liang Qingbiao:

> In the old palace collection there is a handscroll *The Goddess of the Luo River* by Gu Kaizhi. At the end of it there is the prose poem written by Zhao Mengfu. We have now acquired another handscroll representing the goddess of the Luo River. On the title label it is described as a painting by Gu Kaizhi. The text of the prose poem is located within the picture in individual sections. Whether the calligraphy is the work of Wang Xianzhi or of Gu Kaizhi himself is as yet undecided. In the *xinyou* year (1741) we added an inscription to the first scroll, in which we originally took it for an original by Changkang (Gu Kaizhi). Subsequently, in the *jisi* year (1749), we set about reassessing it, and we compared it with the picture *Admonitions of the Instructress to the Court Ladies (Nüshi zhentu)*, by Gu Kaizhi, held in the palace collection [fig.20]. But the spiritual flavour of the latter is absolutely wonderful, the style of the brushwork is completely different. Therefore although it (the Luoshenfu scroll acquired earlier) cannot have been painted by Gu Kaizhi, there can on the other hand be no doubt that it must be the work of a famous master from the Song period or earlier. The calligraphy of the prose poem 'The Goddess of the Luo River' by Wuxing (Zhao Mengfu) at the end of the scroll is likewise a copy from a later period. We therefore added a further inscription, along with the thirteen lines by Daling (Wang Xianzhi) copied in our own hand, as a reminder of the pleasure of looking at the scroll.

The Emperor goes on to compare the newly acquired painting with a third version in his collection, before examining the damaged and lost parts of the scroll, and discussing the authenticity of the signatures of former art experts. He concludes that the painting must be a copy from the Song period after an original composition now lost. His observations and chronological attributions in this colophon are shared by present-day experts and demonstrate that as a connoisseur of art he was perfectly capable of obtaining correct results, even if he did not always do so. What was new was his systematic, pragmatic procedure which can be seen as evidence of the emergence of scientific thinking in eighteenth-century China.

Catalogues of the Collections

The Qianlong Emperor was an encyclopaedist and a reviver of tradition. In numerous projects – as, for example, the edition of a collection of all the written works of the empire, the *Complete Library of the Four Treasuries (Siku quanshu)* (fig.67) – he aspired not only to take account of and to canonise the inherited cultural tradition, but also to subject it to critical scrutiny and to correct errors where required. These projects also include the comprehensive catalogues of the imperial collections, in which he gave scholarly assessment and systematic documentation of the treasures of the palace collection that hitherto had lacked order.

Fig. 19
Traditionally attributed to Gu Kaizhi (*c.*344–*c.*406), *The Goddess of the Luo River* (*Fang Gu Kaizhi Luoshen tu*) (detail), twelfth-century copy of a sixth-century or earlier work. Handscroll, ink and colour on silk, 26 × 646 cm. Liaoning Provincial Museum

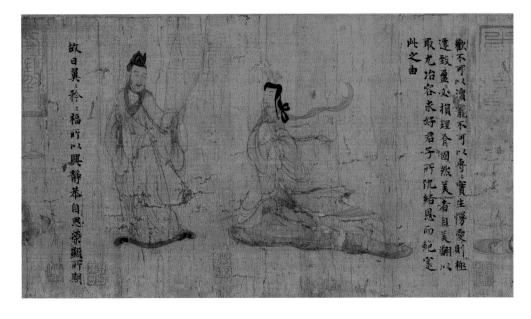

Fig. 20
Traditionally attributed to Gu Kaizhi (*c.*344–*c.*406), *Admonitions of the Instructress to the Court Ladies* (detail), late fifth or sixth century. Handscroll, ink and colour on silk, 24.8 × 348.2 cm. British Museum, London (OA 1903.4-8.1)

The most important of these catalogues is that of the imperial collection of calligraphy and paintings which was compiled in 1744–45. It consists of two parts: the catalogue of calligraphy and paintings with religious subject-matter, with the title *Pearl Forest of the Secret Hall* (*Bidian zhulin*), and the catalogue of secular works with the title *Precious Collection of the Stone Moat [Pavilion]* (*Shiqu baoji*) (fig. 21). In both titles the Emperor indicated that antiquity was his model, by referring to the designation of the buildings of the imperial library in the palace of the Han era (206 BC–AD 220). Emperor Wudi (r. 140–87 BC) had a Secret Hall (Bi ge) built to house the imperial archive and the palace collection. The Stone Moat Pavilion (Shiqu ge) was built by the founder of the Han dynasty, the Emperor Gaozu (r. 206–195 BC), to accommodate the palace library of the preceding Qin dynasty (221–206 BC).[15] Its name was derived from its surrounding moat which was lined with large stones and filled with water.[16] The Qianlong Emperor used the term 'Stone Moat' (*shiqu*) to denote the palace collection in general.

When the imperial catalogue was compiled, its immediate models were the catalogues of the great seventeenth-century private collectors Sun Chengze (1592–1676), Gao Shiqi and Bian Yongyu (1645–1712). From the group of high-ranking scholars in the imperial secretariat, the Emperor put together a staff of four responsible compilers – there were five for the second part – who included his former teachers Zhang Zhao (1691–1745) and Liang Shizheng (1697–1763), whose task was to inspect the calligraphy and paintings, select them for the catalogue and compose the entries. The two parts, listing religious and secular works, comprised a total of about 2,000 paintings and an approximately equal number of calligraphic items. The works were divided into first and second class. The first

class (*shangdeng*) included only originals and works of high quality, while copies and dubious works of lesser quality were allocated to the second class (*cideng*). The works in the first class were documented thoroughly, with precise details of mount, dimensions, medium and subject-matter. Following this, all inscriptions, colophons and seals on the painting or its mount were listed. With works in the second class, only the material, the medium and the artist's signature were noted after the title. In the first part, the *Bidian zhulin*, works were thematically divided into works from imperial hands, Buddhist works and Daoist works. In the second part, the *Shiqu baoji*, they were arranged according to the four palace halls in which they were kept. Within these categories, they were first arranged according to format (album, handscroll or hanging scroll), and only then organised chronologically by artist. This arrangement makes it somewhat difficult to locate specific works, but the catalogue was conceived primarily as an inventory for the individual palace halls.

During the reign of the Qianlong Emperor the imperial collection of calligraphy and paintings increased considerably, making it necessary to compile a supplement to the catalogue, the *Bidian zhulin/ Shiqu baoji xubian*, which was completed in 1793. The staff of ten compilers included such prominent scholars as Wang Jie (1725–1805), Shen Chu (d. 1799) and Ruan Yuan (1764–1849). Some 1,800 paintings and an equivalent number of calligraphic items were included in this supplement. The first part, listing works with religious subject-matter, was very small, comprising only ten percent of the scope of the second part, which contained the secular works. About half the items were works by Qing court artists or works by the Emperor himself, and half were of pre-Qing date. The listed works were no longer divided into first and second class, but were all documented with the same degree of thoroughness. In addition to mount, measurements, medium and subject-matter, all inscriptions, colophons and seals to be seen on a work were listed and fully reproduced. Five manuscript copies of the catalogue were produced and distributed between the palaces: two copies to the imperial palace in Beijing, and one each to the summer palace of the Yuanming yuan (Garden of Perfect Brightness) outside Beijing, the Bishu shanzhuang (Mountain Villa to Escape the Heat) in Rehe (present-day Chengde), and the old palace in Shenyang.

The third series of the catalogue, *Bidian zhulin/ Shiqu baoji sanbian*, was compiled in 1815–16 by order of the Jiaqing Emperor (r. 1796–1820) following the principles adopted in the second series. The three series of the catalogue together list a total of more than 5,600 paintings and several thousand calligraphic works on 22,495 double pages. This marks the culmination of the long tradition of Chinese catalogues of calligraphy and

Fig. 21
The catalogue of calligraphy and painting in the palace collection, *Precious Collection of the Stone Moat [Pavilion]* (*Shiqu baoji*), 1745. First double page of the entry to the handscroll *Admonitions of the Instructress to the Court Ladies*, attributed to Gu Kaizhi. Reprint, Taipei, 1971. Collection of the National Palace Museum, Taiwan, Republic of China

painting. The most comprehensive and complete catalogue of paintings in the history of Chinese art, it remains to this day the principal point of reference for the works included. Special catalogues were compiled for portraits of the emperors and empresses of earlier dynasties along with portraits of distinguished officials. These were later added to the third series of the imperial catalogue.

Other artefacts were also documented in comprehensive catalogues compiled in accordance with scholarly principles. The most impressive is the catalogue of bronzes which has a total of four parts. In 1749, shortly after the completion of the first series of the painting and calligraphy catalogue, the Emperor issued an edict for the creation of a catalogue of the bronzes to be modelled on the bronze catalogues of the Emperor Huizong (r.1101–25) of the Song dynasty. The first catalogue, the *Mirror of the Antiquities of the Western Apartments* (*Xiqing gujian*), was printed in 1755 (cat. 204).[17] It listed 1,529 bronze items, which were all illustrated and provided with explanatory notes. The inscriptions on the pieces were also carefully copied. However, the draughtsmen were prone to error, and many forgeries were not recognised as such. The second catalogue, *Assessed Antiquities of the Ningshou Palace* (*Ningshou jiangu*), followed between 1776 and 1781. It listed 600 ritual bronzes and 101 bronze mirrors. Between 1781 and 1793 two more continuation volumes were compiled, documenting a total of 1,885 bronze items in the imperial depository and in the Shenyang palace. The four catalogues together covered 4,115 bronze items. A collection of 567 coins from the oldest period to the Ming era was also documented there.

Another lavish catalogue was devoted to the inkstones in the palace collection (fig. 22). As essential items of scholarly culture (cat. 136), these gave great value to the educated class from which officials were drawn, and had been collected with passionate enthusiasm and described in dozens of catalogues since as early as the Song era.[18] The Emperor commissioned such a work in 1778: 'The inkstones in the inner palace are too numerous by far…There is no catalogue bringing them together, which means that their tradition could be lost. That would be deplorable!'[19] He instructed the Grand Secretary Yu Minzhong (1714–1780) and several other high-ranking civil servants from the imperial secretariat to select the 200 inkstones of the highest quality from the palace collection and produce a catalogue with illustrations and explanatory notes.[20] In it, all the surfaces of the inkstones which bear inscriptions are documented in a total of 464 detailed and accurate drawings. The Emperor even commissioned a second set of illustrations in the Western manner from Men Yingzhao (fl.1778–1782). The stones are arranged chronologically and by material, and an appendix lists the imitations of ancient inkstones commissioned by the Qianlong Emperor. The catalogue is the most comprehensive in history, and its illustrations and explanatory notes are of the highest quality.

In addition, catalogues or illustrated albums were compiled of valuable books, porcelain, paintings on fans and other items from the palace collection.

The Seals of the Qianlong Emperor

The custom of impressing seals on paintings or calligraphy grew in the seventh century out of working with written documents in the palace archive. Individual written items were pasted together to form handscrolls and by adding seals over the seams they were, so to speak, authenticated. Down to the twelfth century, the seals of the imperial collection were also added to paintings and calligraphy almost exclusively over the seams; that is to say, they were impressed at the beginning and end of the painting, half on the painting and half on its mount. The famous inventory seal with which the holdings of the palace collection were impressed at the beginning of the Ming dynasty, the so-called Siyin half-seal, was also used in this way.[21] The Mongol rulers of the Yuan dynasty were among the first to impress large seals of the imperial collection in a prominent place on the painting proper. In the Ming and Qing periods private collectors also stamped numerous special collection seals on the paintings and calligraphy in their collections. The Qianlong Emperor adopted this custom, and from the sets of seals of the Song emperors, such as the seven seals of the Emperor Huizong, and the grand seals of the Yuan rulers, he developed his own standard set for works in the imperial collection, comprising three, six or eight

Fig. 23 (*opposite*)
Zhao Mengfu (1254–1322), *Sheep and Goat*, c.1290. Handscroll, ink on paper, 25.2 × 48.4 cm. Artist's inscription to the left, and a poem by the Qianlong Emperor dated 1784 between the two animals. Freer Gallery of Art, Smithsonian Institution, Washington DC – Purchase (F1931.4). The work contains impressions of the Emperor's standard set of eight seals: in the first column to the right of the artist's inscription, the second impression down, 'Seal of Subtle Assessment in the Studio of the Three Rarities'; the third, square impression, 'Suitable for Sons and Grandsons (Posterity)'; at the head of the next column, 'Assessed in the Qianlong [Era]'; immediately below the Qianlong Emperor's poem, the circular impression, 'Assessment of the Stone Moat [Pavilion]'; below it, the square impression, 'New Compilation of the Precious Collection'; below that, the rectangular impression, 'Seal of Storage of the Palace of Renewed Splendour'; to the right of the Qianlong Emperor's poem, the oval impression, 'Seal of Imperial Inspection in the Qianlong [Reign]'; and in the next column, the third impression down, 'Precious Collection of the Stone Moat [Pavilion]'. Three impressions of the Qianlong Emperor's jubilee seals appear on the mount to the right.

Fig. 22
Catalogue of Inkstones of the Western Apartments (*Xiqing yanpu*), 1778. A page of the catalogue depicting an inkstone made of Songhua stone with a cover furnished with a poem by the Qianlong Emperor. Ink on paper. Collection of the National Palace Museum, Taiwan, Republic of China

Fig. 24
Impressions of the Qianlong Emperor's seventieth and eightieth birthday seals: 'Seal of the Son of Heaven, Rare Since Antiquity' and 'Seal of the Eighty-Year-Old Who Concerns Himself with the Eight Tasks of Government'

seals (fig. 23). It is no coincidence that he modelled his large seals on those of the imperial collectors of the Jin (1115–1234) and Yuan dynasties, who were regarded as ancestors by the Manchus. Located in a prominent position on the upper part of the picture, they show that he has inspected and evaluated it, and included it in the imperial catalogue. All works which the Emperor had scrutinised and approved were initially given the imperial seal of inspection, the 'Seal of Imperial Inspection in the Qianlong [Reign]' (*Qianlong yulan zhi bao*), which was used in both a square and a more elegant oval version (see also cat. 195).[22]

Works which were included in the imperial catalogue were also impressed with two further seals: the small rectangular catalogue seal 'Precious Collection of the Stone Moat [Pavilion]' (*Shiqu baoji*), or 'Pearl Forest of the Secret Hall' (*Bidian zhulin*) for works with religious subject-matter, and the seal of the hall in which the work was kept.[23] Works in the first class were additionally given three more seals indicating their special quality: the round seal 'Assessed in the Qianlong Era' (*Qianlong jianshang*); the seal of the imperial Studio 'Seal of Subtle Assessment in the Studio of the Three Rarities' (*Sanxi tang jingjian xi*); and the seal 'Suitable for Sons and Grandsons (Posterity)' (*Yi zisun*). These six imperial seals are located in the upper area of pictures and at the margin in such a way that they do not detract from the composition. Only if these spaces were already occupied by former collectors' seals would they be impressed in unfortunate places, but always preserving an overall aesthetic balance. When the second series of the catalogue was compiled between 1791 and 1793, all the works included were given a set of eight seals, comprising the six seals listed above and two additional seals indicating the supplements to the catalogue: 'Assessment of the Stone Moat [Pavilion]' (*Shiqu dingjian*) and 'New Compilation of the Precious Collection' (*Baoji chongbian*) for secular works, or 'New Compilation of the Secret Hall' (*Bidian xinbian*) and 'New Assessment of the Pearl Forest' (*Zhulin chongding*) for works with religious subject-matter.[24] In each case the first of these two seals was round, the second was square, which shows that the aesthetic effect of the seals was considered. All the seals were cut to a high standard by reputable artists,[25] and produced a balanced overall effect by the sequence of the diverse forms and the alternation of high- and low-relief work.

From 1780 great jubilee seals commemorating the Emperor's birthdays or similar occasions were additionally impressed on the works in the imperial collection (fig. 24). They constituted a form of visual glorification of the Emperor, and bestowed on him grandiloquent honorary titles, a practice which he had previously rejected. To mark his seventieth birthday, a large square seal was designed which extolled the great age, rarely

reached, of the ruler: the 'Seal of the Son of Heaven, Rare Since Antiquity' (*Guxi tianzi zhi bao*) (see fig. 24).[26] Two years later the Emperor had a further version of the seal with a round shape made from an old jade knob of a scroll: 'The Son of Heaven, Rare Since Antiquity' (*Guxi tianzi*). It became one of his favourite seals and can be seen on many paintings and calligraphic items (see fig. 23, at the top of the mount). In most cases (as in fig. 23) it is accompanied by a rectangular congratulatory seal 'Long Life' (*shou*). Impressions from these jubilee seals were often located prominently in the middle of the picture. One of his largest jubilee seals with a very wide margin commemorates the birthday of his first great-great-grandson in 1784, the 'Seal of the Son of Heaven, Rare Since Antiquity, of the Hall of the Five Happinesses and Five Generations' (*Wufu wudai tang guxi tianzi bao*) (see cat. 191, the large seal in the middle of the top of the painting, and fig. 16, at the top of the mount on the right hand side).[27] Five generations living together under one roof has always been a Chinese ideal. On his eightieth birthday in 1790 the Emperor had another large square seal cut, the 'Seal of the Eighty-Year-Old Who Concerns Himself with the Eight Tasks of Government' (*Bazheng maonian zhi bao*) (fig. 24).[28] In 1792, to mark the victory over the Ghurkas in Nepal, another great seal followed, celebrating the ten great military successes of his reign: 'Seal of the Old Man of the Tenfold Perfection' (*Shiquan laoren zhi bao*).[29]

This series of proud commemorative seals came to an end with the seal documenting the Emperor's long-announced voluntary abdication on Lunar New Year's Day (9 February) 1796.[30] It gives the new title to which he had a right from that time on: 'Seal of the All-Highest Emperor' (*Taishang huangdi zhi bao*) (see fig. 23, the large square seal on the mount, cat. 194 and cat. 191, the seal on the left).[31] On his accession to the throne, the Qianlong Emperor had vowed to heaven that he did not intend to reign for longer than his grandfather, the Kangxi Emperor, who had occupied the throne for 61 years. Moreover, with a reign of 60 years he had completed a full calendrical cycle. On paintings in the imperial collection, these great jubilee seals often form impressive groups of three or even five seals (fig. 25).[32]

Housing the Collections

Although many items in the imperial collection were stored in special rooms in the palace, the most important artistic treasures were kept in the Emperor's personal residences. In the case of the paintings and calligraphy included in the imperial catalogue, we have very precise knowledge of the halls in which they were kept, since the catalogue is organised on these terms. In the first series of the catalogue, completed in 1746, there were four main halls. Each had its own storage seal, which was part of the fixed order of seals.

The most important paintings and calligraphy were kept in the Palace of Heavenly Purity (Qianqing gong), positioned on the central axis. This was the Kangxi Emperor's personal residence. Although after his father's death the Yongzheng Emperor transferred his personal residence to the much smaller hall situated to the west, the Hall of Mental Cultivation (Yangxin dian), the Palace of Heavenly Purity retained its pre-eminent position. In 1745, for example, all the paintings and calligraphy with religious subject-matter were kept there, as were works from the Emperor's hand and important masterpieces.

The second storage hall was the residence of the Yongzheng and Qianlong Emperors, the Hall of Mental Cultivation mentioned above. This was where the Qianlong Emperor had set up his private studio, the Studio of the Three Rarities, where he inspected the paintings and calligraphy of his collection; accordingly, important works from the palace collection were also kept there.

The third storage hall, the Palace of Double Glory (Chonghua gong), had been the Qianlong Emperor's residence when he was a prince (1727–35), before he acceded to the throne. It is the northernmost palace to the west of the central axis. In his youth the prince had kept his collection of paintings and calligraphy in the building and he left them there after he came to the throne.

Fig. 25
Anonymous court painter, *The Qianlong Emperor as a Chinese Literatus and Art Lover, Playing the Zither in Front of a Painting in His Own Hand (Hongli xunfeng qinyun tu)*, probably 1766. Ink and colour on paper, 149.5 × 77 cm. With five of his jubilee seals. Palace Museum, Beijing, Gu6515. After the painting *Amusement with Zither and Calligraphy (Qin shu lezhi)*, attributed to Liu Songnian (1174–1224), now in the National Palace Museum, Taiwan

The fourth main storage hall was the Imperial Study (Yushu fang), situated to the east of the central axis. Here also important works were housed. In the second series of the catalogue (*Shiqu baoji xubian*), completed in 1793, two further main stores were added to these four halls: the Palace of Tranquil Longevity (Ningshou gong), built in 1771–76 as the future place of retirement of the Emperor after his planned abdication, and the Hall of Pure Development (Chunhua xuan) in the summer palace, Yuanming yuan, in the northwest outer area of Beijing. This hall, completed in 1770, was planned as a counterpart to the Hall of Tranquil Longevity, as a summer palace for the Emperor after his abdication. Here many items from the palace collection were likewise housed.

In addition there were numerous smaller halls, in each of which there were only a few works. In 1745 there were fifteen such subsidiary halls in all. In 1793 there were six in the palace and three further subsidiary halls in the Western Garden. In the Yuanming yuan at that time there were a further twenty-six storage places named in the catalogue. To these there must be added three more gardens in the region of the western mountains (Xiang shan) where works were also kept.

As we have seen, the Qianlong Emperor was in the habit of keeping works from his collection that had a particular significance for him in special buildings, which he renamed after these works or after significant collectors from history. His studio, the Studio of the Three Rarities (fig. 15), is the best-known example. He also named a hall after the studio name of the famous art theoretician and collector Dong Qichang, the Studio of Meditation in Painting (Huachan shi), in which he kept his two favourite pieces from Dong Qichang's collection. When in 1746 he discovered that he was the owner of four handscrolls from the former collection of Gu Congyi (1523–1588), one of them being the *Admonitions of the Instructress to the Court Ladies* by Gu Kaizhi (fig.20), he kept them in a room to which he gave the name 'All Four Beauties Complete' (Simei ju). To the hall in which he assembled the thirteen handscrolls with illustrations by Ma Hezhi (*c.*1150–1190) to the *Book of Poetry (Shijing)*, he gave the name Hall of Learning from the Odes (Xueshi tang). He kept pictures from the collection of the famous Ming period collector Xiang Yuangbian (1525–1590) in a studio in the summer palace at Rehe, which he named the Studio of the Heavenly Flute (Tianlai shuwu) after the collector's studio of the same name (Tianlai ge). He even named a small room in the Hall of Mental Cultivation (Yangxin dian) the Room of the Ink Clouds (Moyun shi) after an antique ink cake of the tenth century stored there. Whenever he bestowed a name in this way the Emperor wrote a detailed essay explaining the relevant circumstances and associations. This perhaps shows more than anything else his genuine love of art collecting and his aspiration to emulate his historical models.

In contrast to his grandfather, the Kangxi Emperor, who showed great interest in European sciences like mathematics or geography, and regularly discussed these with the Jesuit missionaries, the Qianlong Emperor, said to have been a child prodigy, concentrated his ambition on the renewal of the classical Chinese cultural heritage. His models were the legendary rulers of Chinese antiquity as well as the highly educated Chinese scholars whom he aimed to emulate. His engagement with poetry, essay-writing and art-collecting, as well as his lasting desire to be depicted in a classical way in numerous paintings of his collection, all show his vision of creating a new golden age for the enlarged empire modelled on the ideals of the past. He was convinced that under his reign Chinese civilisation had reached an unprecedented height of development.

III

Imperial Architecture of the Qing: Palaces and Retreats

FRANCES WOOD

On 5 June 1644, Dorgon, fourteenth son of Nurgaci, Commander of the Army and Regent during the Shunzhi Emperor's infancy, made his way to the Forbidden City (Zijin cheng), palace of the defeated Ming emperors and the seat of their government.[1] He stood on the steps of the Wuying dian (Hall of Military Eminence), which was still smouldering, and made his first pronouncements. On 8 and 9 June, Fan Wencheng (1597–1666), a Chinese appointed as one of the first four Grand Secretaries of the Qing dynasty, gave audiences to the Jesuit father Adam Schall von Bell, who was concerned about the fate of his Church, on the same spot.[2]

It is difficult to estimate how much the Forbidden City had been damaged in the brief occupation by Li Zicheng's rebel troops (April–June 1644) and their expulsion by the Manchu army, but it is clear from Dorgon and Fan Wenchang's activities that it was suitable for immediate occupation by the new rulers of China. Probably for reasons both pragmatic and symbolic, it remained the centre of government and the main home of the Qing emperors until the departure of the disenthroned Xuantong Emperor, Puyi (r.1909–11), in 1924.

The Forbidden City inherited by the new Qing rulers was built on the order of the Yongle Emperor (r.1402–24), third emperor of the Ming dynasty (1368–1644), when he planned to move the capital from Nanjing to Beijing.[3] For the original construction and for all subsequent renovations, materials were collected from all over China. Timbers of oak, elm, catalpa, fir and camphor were collected from Hunan, Hubei, Zhejiang and Jiangxi Provinces and, for the solid main columns of the major halls, massive trunks of *Phoebe nanmu*, a coarse-grained hardwood that grew to an impressive size in the mountainous areas of Sichuan Province, were shipped along the Yangzi River and hauled up the Grand Canal.[4] Timber was the main construction material in Chinese buildings and while lesser constructions often had columns made of a timber patchwork, concealed beneath protective paint, the massive columns of the Forbidden City's halls were made from single trunks of *Phoebe nanmu*.

The halls of the Forbidden City were raised high off the ground on platforms made from marble quarried at Fangshan, some 50 kilometres west of Beijing. 'Mugwort marble', a hard white marble with a slight green tinge, was used for the huge dragon-carved slabs over which the Emperor was carried in his sedan chair, and 'white jade' marble was used for the carved balustrades which surrounded all the terraces and bridges of the Forbidden City. Slabs at least seven metres long were required to fill the space between the timber columns, and the carved slabs over which the Emperor was carried could weigh as much as 5,000 kilogrammes.

Many of the other building materials were found or made in distant parts of the country. Lime was quarried near Zhoukoudian and in the counties surrounding Beijing, with other sources of high quality lime in Shanxi and Jiangxi Provinces. Red clay to wash

the walls and fix roof tiles was extracted and processed in Shandong Province; yellow clay from Hebei was used to colour the walls of the great halls; and fine gold leaf, used in much architectural decoration, on red dragon pillars, gable decorations and elsewhere, came from Suzhou.[5]

The great open courtyards between the halls were paved with fine-grained, hard-wearing 'settled clay bricks' from Linqing in Shandong, shipped up the Grand Canal. The interiors of the buildings were paved with dark grey 'metal bricks', the name derived from the ringing sound they made when struck. These were produced in the Suzhou and Songjiang areas and also shipped up the Grand Canal.

The various types of roof tiles, yellow-glazed for the halls, unglazed grey for the smaller domestic buildings, were produced in Beijing. The extraction of clay to the southeast of the city created lakes which now form part of Taoranting park. The first sets of glazed tiles were made in Liulichang ('glazed tile works'), later the centre of the antique and antiquarian book trade in Beijing.[6]

The construction of Yongle's palace between 1417 and 1420 was supervised by an Annamese, Nguyen An (d.1453), with a million convict and conscript labourers carrying out the heavy work on site while a hundred thousand specialised craftsmen worked on timber construction, decorative lattice-work and stone-carving. At the end of 1420, the Forbidden City was finished. Its red-washed walls encircled an area 961 metres long and 753 metres wide. Outside was the imperial city, protected by a 52-metre-wide moat and a 10-metre-high wall.

The complex was divided into two parts. The southern area was known as the 'outer city', and consisted of three axes with the three main yellow-tiled halls and gates raised on white marble platforms standing in vast courtyards on the central axis. The buildings of the western axis included the Wuying dian, or Hall of Military Eminence, where the Qianlong Emperor had a printing and editorial office for the production of 'palace books'. On the east was the Wenhua dian (Hall of Literary Glory) and the imperial library. To the rear of the enclosure was the 'inner palace' with its many lower yellow- or grey-roofed halls where the imperial family and its retinue of maids and servants lived among studies, temples and gardens (fig.27). This division followed the stipulation of the *Liji* (*Book of Rites*), traditionally ascribed to Confucius, that 'court affairs should be to the front, sleeping quarters to the rear'.[7]

Fig. 26
The Taihe dian (Hall of Supreme Harmony) seen from across the courtyard, Forbidden City, Beijing. The Taihe dian was the formal audience hall within the Forbidden City. This vast courtyard would be filled with officials, arrayed in formal rows, to perform the congratulatory ritual at the New Year.

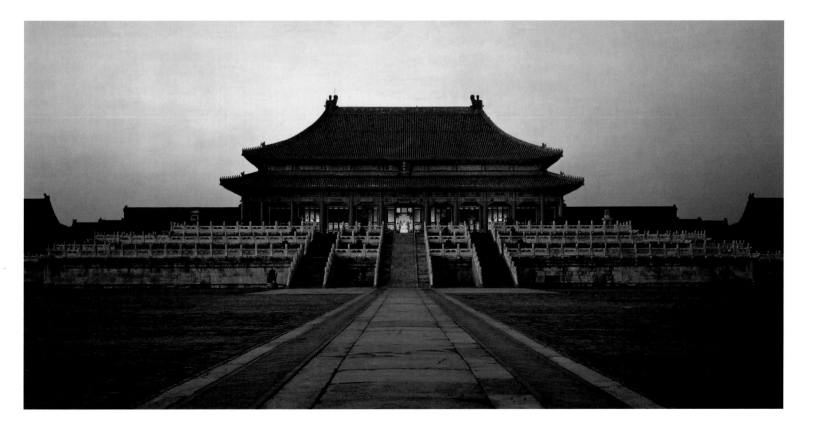

Inheriting a palace meant inheriting much Chinese imperial symbolism, such as the proliferation of 'imperial' dragons on roofs and floors, rows of nine bosses on doors – the number nine was also symbolic of the Emperor – and the 'imperial' yellow of the roof tiles and phoenix decorations (representing the empress) on ceilings in the inner palace. The Qing emperors established their occupation by renaming the main halls in 1645, giving them the names by which they are still known: Taihe dian (Hall of Supreme Harmony; fig. 26), Zhonghe dian (Hall of Complete Harmony) and Baohe dian (Hall of Preserving Harmony). Renovations began in the same year, starting with the Qianqing gong (Palace of Heavenly Purity), followed by the refurbishment of the Wu men (Meridian Gate) (1647), the rebuilding of the Cining gong (Palace of Compassion and Tranquillity) for the Empress Dowager (1653), a large-scale renovation of the inner palace apartments (1655), and the construction of the Fengxian dian (Hall for Worshipping Ancestors) (1657).[8]

Over the next 200 years, repair, rebuilding and new construction continued within the red walls of the palace, using the same materials, the same external colours and respecting the same architectural principles, although several emperors ordered the construction of whole new complexes and tastes in interior design changed. In 1955, it was calculated that of the 9,000 *jian* or 'rooms' of the original Ming palace, 8,662 were still intact, suggesting that the Qing did not make substantial alterations in plan, although the uses of some buildings changed.[9] However, almost continuous repairs were needed, owing to frequent and destructive fires, particularly those recorded in 1679, 1740, 1758, 1783, 1797, 1869, 1870 and 1888.[10]

Although building work in the Forbidden City in the early days of the Qing was largely confined to repair and restoration, the uses of several significant buildings were transformed. In 1656, the Kunning gong (Palace of Earthly Tranquillity), the residence of the Ming empresses on the main axis of the inner palace, was altered, its windows and doors changed, and stoves for cooking meat installed so that it could be used instead for the daily Manchu shamanistic rituals, carried out by women shamans and eunuchs. Here, and in other parts of the Forbidden City, were the tall pine poles onto which cooked meat offerings were hoisted.

Fig. 27
A bird's eye view from Coal Hill of the packed buildings of the inner palace, Forbidden City, Beijing

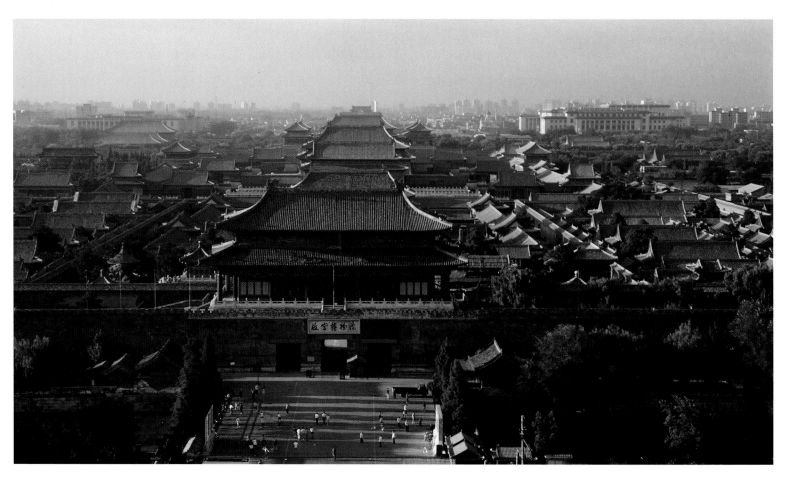

Whereas the Ming emperors generally inhabited specified halls, during the Qing
there was some movement around the palace. The Shunzhi Emperor lived in the Baohe
dian, the Kangxi Emperor used both the Qianqing gong and the Yangxin dian as his
living quarters, and while the Ming heir always lived on the eastern side of the palace,
a new Chonghua gong (Palace of Double Glory) was built by the Yongzheng Emperor
for his heir-designate, Hongli (the future Qianlong Emperor), on the western side of the
inner palace in 1727. The Yongzheng Emperor himself chose, on his accession, not to
occupy the Qianqing gong (Palace of Heavenly Purity), the main hall on the central
axis of the inner palace and the traditional residence of the Ming emperors. Instead
he, and the Qianlong Emperor on his accession, occupied the smaller Yangxin dian
(Hall of Mental Cultivation) to the west, using the Qianqing gong for ceremonies
and audiences.

The three main halls, symbols of imperial power, were restored and renovated as
required but otherwise left as they had always been for use during the annual round
of ceremonies and audiences. The daily work of government was also controlled from
the Forbidden City. During the Ming, the separation between the private areas and
the public, governmental area was rigidly observed, but the Qing emperors were more
relaxed, bringing the reception of foreign ambassadors into the Qianqing gong and
into the Yangxin dian. The Kangxi Emperor also summoned the French Jesuit Father
Gerbillon to give him instruction in mathematics in the Yangxin dian, deep in the inner
palace.[11] Much of the daily work of imperial government took place in the gate building
at the entrance to the Qianqing gong. A throne was set up behind a table covered in
yellow silk, with carpets unrolled in front of it, so that officials offering memorials for
imperial consideration could prostrate themselves on the carpet as they awaited the
imperial decision.[12]

The Forbidden City also housed many religious buildings, and some of these were
altered to fit Manchu beliefs and practices. The Fengxian dian (Hall for Worshipping
Ancestors) was constructed on the orders of the Shunzhi Emperor in 1657. Although it
occupied the same site as the ancestral temple of the Ming imperial house, the new
construction, built to house the ancestral tablets of the Qing from Nurgaci onwards, was a
massive nine-bay structure with the double-eaved, hipped roof found only on the highest-
ranking buildings of the Forbidden City. The interior of the main hall is also magnificent,
with embossed gold-leaf decoration covering the interior ceiling beams (fig.28).[13]

Two shrines to Confucius were maintained within the Forbidden City, and the Yongzheng Emperor ordered the construction of a temple to the City God in the northwestern corner of the Forbidden City in 1726. Annual rites were held in the main Daoist shrine within the palace, the Qin'an dian (Hall of Imperial Peace), the main building in the imperial garden at the northern end of the central axis of the inner palace. The Qianlong Emperor commissioned most of the new religious buildings in the Forbidden City, favouring the Tibetan Buddhism of the Gelugpa sect. It has been estimated that at the time of his death there were thirty-five Tibetan Buddhist halls with ten smaller shrines.[14] The Qianlong Emperor's patronage of Tibetan Buddhism involved personal belief and taste as well as the political necessity of closer relations with Mongolia and Tibet. Within the Forbidden City, the Yuhua ge (Pavilion of the Rain of Flowers), on the eastern side of the inner palace, is the most impressive of his Tibetan Buddhist constructions (fig.29). It is a three-storey pavilion with a green- and yellow-tiled roof, unusual animal mask carvings on the tops of the columns and long, sinuous gilt-bronze dragons on the four corners of the uppermost roof, similar to those seen close to the roof boss on the Xumifushou miao (Temple of Happiness and Longevity on Sumeru), which was also built for the Qianlong Emperor but at his summer retreat at Rehe (present-day Chengde).[15] The interior walls of the Yuhua ge are covered with tiny Buddha images, and the coffered ceilings decorated with Sanskrit characters and lotus petals. The pavilion houses a large circular altar topped by the paired deer and the wheel of the law seen on many Tibetan temple roofs.

The Kangxi, Yongzheng and Qianlong Emperors chose the Yangxin dian as their residence within the Forbidden City. A relatively small H-shaped hall approached from a wide courtyard with a spirit screen,[16] it was laid out with the Emperor's bedroom at the rear and a more formal room, resembling a study, in front. During the Kangxi Emperor's occupation, the hall was very simply decorated with plain white walls and white rugs on the *kang* platforms[17] built beneath the windows. Father Gerbillon described how craftsmen worked in the side apartments of the Yangxin dian, mounting pictures, gilding, carving wood and painting with lacquer.[18] The workshops were later moved, and when the Qianlong Emperor inhabited the Yangxin dian, the main room on the west side was known as the Sanxi tang (Studio of the Three Rarities; fig. 15) and used for storing the Emperor's most precious pieces of calligraphy by Wang Xizhi (303–361), Wang Xianzhi (344–386) and Wang Xun (350–401).[19] Despite its massive *caisson* ceiling with gilded dragon, the main hall remained scholarly in style, although dark bookcases were installed, flanking the simple throne, with more bookcases in the western chamber. The rear chambers were provided with heated brick *kang* platforms and built-in display cabinets for parts of the imperial collections. The *kang*, set against the rear wall of the hall, probably reflect a rare Manchu innovation within the palace, for in their homeland, *kang* were built all around rooms to provide heat in the intensely cold winters: in Chinese buildings, they were invariably built against the façade wall.

Although the Qianlong Emperor spent only three months of the year in the Forbidden City, he nevertheless embarked upon one major building project there. This was the construction of the Ningshou gong (Palace of Tranquil Longevity), built in 1689 and enlarged by the Qianlong Emperor in 1771 as his retreat upon retirement. Covering almost a sixth of the total area of the Forbidden City, this series of halls and courts in the northeastern corner of the complex is fronted by the massive double-eaved hipped-roofed Huangji dian (Hall of Imperial Supremacy) which is approached by a raised white marble walkway. Behind, in the lower, more intimate courtyards, are gardens with a cup-floating pavilion built in honour of the famous waterside drinking party held by the calligrapher Wang Xizhi (of the 'Three Rarities') in the fourth century, when his friends floated wine cups and had to recite a poem or drink wine as they bobbed past. The pavilion in the Forbidden City has a meandering channel cut in the stone floor and water was poured along the channel for drinking parties.[20]

The complex of buildings includes the Palace of Tranquil Longevity, mentioned above, and the Hall of Pleasurable Old Age (Leshou tang), titles which express the Qianlong Emperor's intention to enjoy his retirement here, although some of the smaller halls were

Fig. 29
The Pavilion of the Rain of Flowers (Yuhua ge), Forbidden City, Beijing

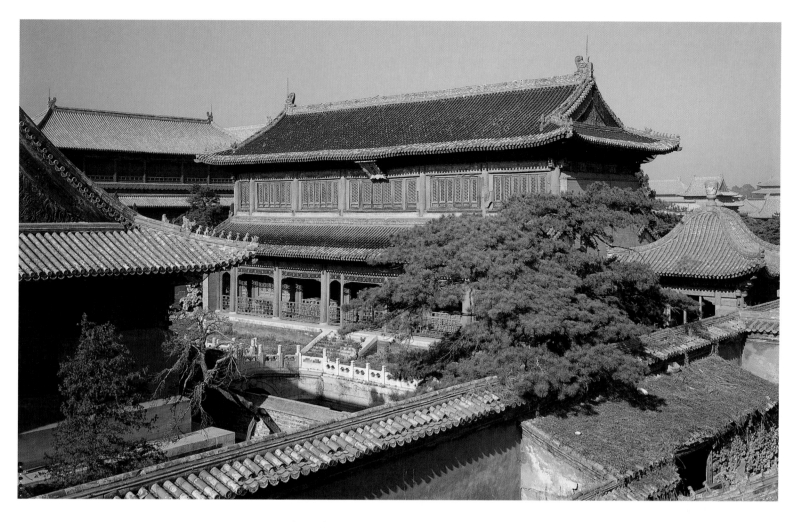

Fig. 30
The Pavilion of Literary Profundity
(Wenyuan ge), Forbidden City, Beijing

given the same names as halls in the Palace of Double Glory where he had lived as a young man.[21] In the end, the Qianlong Emperor did not occupy the complex, remaining in the Yangxin dian when he was in the Forbidden City, but various aspects of the design reflect his personal interests. He installed glass windows, a recent, foreign innovation,[22] and the interior of the Leshou tang, in particular, reflected his pleasure in collecting. It includes architectural features such as an openwork dividing screen made to display porcelains and other small treasures, and the decoration of the interior reflects the types and colours of imperial treasures. The walls are of fine dark-brown wood, with the rails of the gallery painted a grey-green colour recalling jade, celadon wares and patinated bronzes. Cloisonné enamel panels set in the walls are inlaid with jade and bronze, echoing the colours of the gallery and of the precious objects displayed.

Another new building constructed in 1774–76 in the Forbidden City on the Qianlong Emperor's orders also reflects his interest in Chinese culture. This was the Wenyuan ge (Pavilion of Literary Profundity; fig. 30), which was to house the 36,000 volumes of the massive manuscript *Siku quanshu* (*Complete Library of the Four Treasuries*), compiled between 1773 and 1784 on the Qianlong Emperor's orders (fig.67).[23] The new building was, appropriately, situated behind the Wenhua dian (Hall of Literary Glory) on the southeastern side of the outer palace, where the Qing emperors attended an annual reading of the Confucian classics.[24] The Wenyuan ge was described as having been modelled on the famous library building in Ningbo, the Tianyi ge (Pavilion of Heaven's First Creation, heaven's first creation being water), which was founded by Fan Qin (1506–1585) to house his family's extensive collection of books. Although both have an unusual six bays,[25] there are considerable differences between the two buildings. The Tianyi ge is a two-storeyed construction with a roof covered in dark, unglazed tiles with the upturned eaves characteristic of southern China. In the Wenyuan ge, the colour of the Tianyi ge's roof is reproduced in black glazed tiles (with green edging tiles) but it is broader in plan and the eaves show very little upturn, in common with the other halls

in the Forbidden City and most northern Chinese buildings. There are similarities in the plan of both buildings, for they were designed to prevent fire affecting their precious contents. Both have a pool in front, and a rockery of ornamental stones, acting as a fire barrier. Under the eaves of the Wenyuan ge are boards painted with books and manuscripts, interspersed with fire-fighting sea-horses.

The first copy of the *Siku quanshu* was housed in the Wenyuan ge and the three subsequent copies were housed in specially constructed buildings of similar design in sites of significance to the Qing. The second copy was placed in the Wensu ge (Pavilion of the Source of Literature), built in the old palace in Shenyang; the third in the Wenyuan ge (Pavilion of the Origins of Literature) in the imperial summer palace, the Yuanming yuan (Garden of Perfect Brightness), outside Beijing; and the fourth in the Wenjin ge (Pavilion of Literary Delights) in the imperial summer resort Bishu shanzhuang (Mountain Villa to Escape the Heat) at Rehe (present-day Chengde), northeast of Beijing. The Wenyuan ge was destroyed with the Yuanming yuan in 1860 but the Wenjin ge still has its eaves boards painted, like those of the Wenyuan ge in the Forbidden City, with depictions of books wrapped in blue cloth covers. A pool and rockery stand in front of it.

While paying due respect to the official primacy of the Forbidden City as the seat of government and imperial palace, the installation of the imperial collections in specially designed pavilions in the imperial summer palaces reflected the significance of these other palaces in the life of the Qianlong Emperor and his predecessors. The Kangxi Emperor spent 'several months of the year' in his summer palace, Changchun yuan (Garden of

Fig. 31
'Gaomin Temple' from an album of paintings entitled *The Stations of the Qianlong Emperor's Fifth Journey*, 1780. Ink and colour on silk, 26 × 33.5 cm. The British Library, London (Or. 12895, fol. 15). A travelling palace in the Gaomin Temple near Hangzhou, with a swastika-shaped pavilion seen by the Qianlong Emperor on his fifth Southern Tour, 1780.

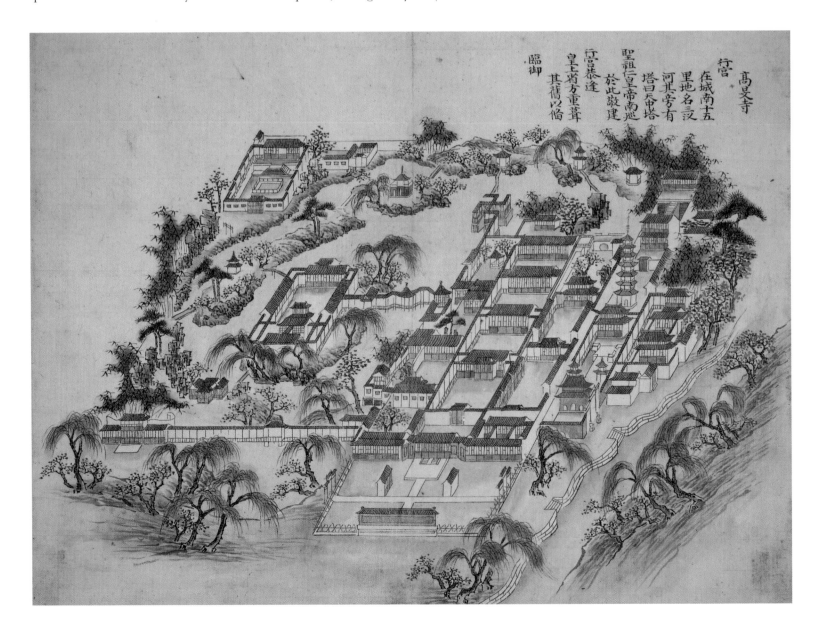

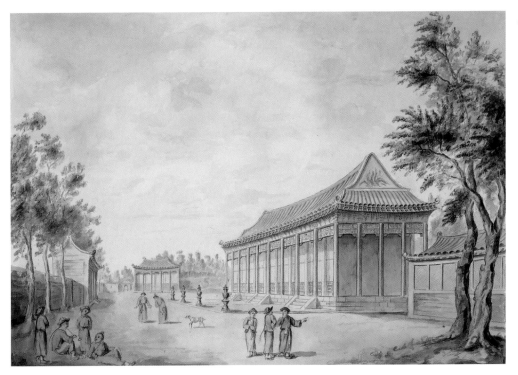

Fig. 32
William Alexander (1767–1816), 'The Hall of
Audience, Yuanming yuan (Garden of Perfect
Brightness)', from *Views and Maps Drawn by
William Alexander, John Barrow and H. W. Parish
on the Earl of Macartney's Embassy to China*, 1793–94.
Pen and ink drawing, 34.5 × 48 cm. The British
Library, London (BL Maps 8.tab.c.8)

Joyful Spring), northwest of the village of
Haidian just outside Beijing, and both the
Yongzheng and Qianlong Emperors spent
eight months of the year in their summer
retreats, away from the Forbidden City.[26]
The Forbidden City had symbolic
significance, but to these three emperors,
who still valued Manchu customs such as
hunting and archery, the restrictions of the
imperial city were a confinement. They did
establish the Jian ting (Arrow Pavilion) in
a vast empty space on the east side of the
palace, where they could ride and practise
archery and test the military skills of
examination candidates,[27] but this was a poor
substitute for the real countryside. There
were many gardens within the Forbidden
City, but they were, without exception, small
courtyard gardens in the Chinese style, again,
no substitute for real views of mountains and
expanses of water. And for the Qianlong
Emperor, the most enthusiastic builder of the
Qing dynasty, the restricting layout and crammed buildings of the Forbidden City
prevented him from constructing the buildings he wanted.

The Kangxi Emperor's first summer palace was the Changchun yuan, built on the site
of a ruined garden that was said to have belonged to the father-in-law of the Wanli
Emperor of the Ming. According to the Kangxi Emperor's own account, it was to be built
according to the principle of frugality, making use of the existing layout of lakes and
streams, yet it must have been sizeable because it provided his grandson, the future
Qianlong Emperor, with the chance to practise archery on horseback when he was eleven
years old.[28] It was here that the Kangxi Emperor died in 1722. The Kangxi Emperor also
began the construction of the two major summer palaces mentioned above, the Yuanming
yuan outside Beijing and the Bishu shanzhuang at Rehe, which were to be greatly
expanded by the Qianlong Emperor.

The Yuanming yuan, begun in 1709 by the Kangxi Emperor as a summer palace
for his son, the future Yongzheng Emperor, was just north of the Changchun yuan.
The Yongzheng Emperor died in the Yuanming yuan in 1735, and the summer palace
there was extended in size by about two-thirds and enormously embellished by the
Qianlong Emperor. A similar expansion was seen during his reign at the Bishu
shanzhuang, where the Kangxi Emperor, who frequently hunted in the area, had built
his first palace in 1703.[29]

The Yuanming yuan, only a day's journey from the Forbidden City, was expanded
by the Qianlong Emperor to contain parallel establishments to those found in the
Forbidden City. There was an imperial audience hall (fig.32) where in 1793, Lord
Macartney, the first British Ambassador, laid out his presents for the Emperor. 'It is one
hundred and fifty feet long and sixty feet wide; there are windows on one side only, and
opposite to them is the Imperial Throne of carved mahogany…On each side of the
Chair of State is a beautiful argus pheasant's tail spread out into a magnificent fan of
great extent. The floor is of checkered marble, grey and white, with neat mats laid upon
it in different places to walk. At one end I observed a musical clock that played twelve
old English tunes, the "Black Joke", "Lillibulero" and other airs of the "Beggar's Opera"
…On the dial appeared in large characters, "George Clarke, Clock and Watch Maker
of Leadenhall Street, London."'[30]

There were halls where the Emperor met with his officials; many gardens of
considerable extent, including the Swastika Island, in the form of the Buddhist swastika,
an emblem of good fortune (fig.31); a garden built as a copy of the Shizi lin (Grove of

Stone Lions), a famous garden in Suzhou that was seen by the Emperor on his trips to the south of China; a drill field for archery contests and firework displays which the Emperor watched from a tent; the largest building in the garden, the Ancestral Shrine, containing the ancestral tablets of the Kangxi and Yongzheng Emperors, which were regularly worshipped; Buddhist temples; the Wenyuan ge built to house the *Siku quanshu*; and school buildings for the young princes. There was a road, with a theatre and shops where the women of the palace could 'participate in the bustle of business from which they were normally excluded', and a workshop, the Ruyi guan (As-You-Wish Studio), where Jesuits worked on snuff bottles, painting portraits and landscapes and designing garden buildings and fountains.[31] Although the stone buildings and fountains constructed in the Yuanming yuan by Jesuit priests are particularly well known (cat.91), they only occupied a tiny strip of land at the northeastern corner. They demonstrate, however, an aspect of the Qianlong Emperor's taste, which was followed by a senior member of the court, Heshen (1750–1799), who had his own 'Jesuit-style' gateway constructed at the entrance to the garden of his residence in Beijing, the Gongwang fu.

Fig. 33
Matteo Ripa (1682–1746), *The Imperial Summer Resort at Rehe* (detail) from *The Kangxi Emperor's Poems Describing the Summer Resort at Rehe*, 1711. Copper engraving, 27.5 × 39 cm. The British Library, London (19957 c.4)

It was at Rehe that the Qianlong Emperor carried out his most ambitious architectural plans. There were two major areas of construction: the summer palace and its grounds, and the outer temples. The palace buildings occupy a small area in the extreme south of the enormous wooded park area of seven square kilometres, north of the present-day city of Chengde (fig. 57). Encircled by a high wall, the park is surrounded by wooden hills, in which Père David deer were kept for hunting, and includes a large lake to the south. Apart from the palace buildings, which are low and grey-tiled, almost ostentatious in their simplicity and lack of decoration, many more elaborate pavilions, including the Wenyuan ge library, were spread throughout the park (fig. 33). There was no attempt to provide buildings that replicated the function of those in the Forbidden City, as in the Yuanming yuan, despite the fact that the Kangxi and Qianlong Emperors often spent up to six months of the year here. The Qianlong Emperor received Lord Macartney and other diplomats at Rehe, holding his audience in a splendid tent: 'In the middle of the garden was a spacious and magnificent tent, supported by gilded or painted and varnished pillars …Within the tent was placed a throne…with windows in the sides of the tent, to throw light particularly upon that part of it…The furniture of the tent was elegant, without glitter or affected embellishments…Several small round tents were pitched in front, and one of oblong form immediately behind it. The latter was intended for the Emperor, in case he should choose to retire to it from his throne. It had a sopha, or bed, at one extremity.'[32]

If the palace at Rehe had a rural simplicity, the thread of religion and politics ran through the design and construction of many of the 'outer temples'. The first two temples, constructed for the Kangxi Emperor, were Chinese in design, but later temples incorporated aspects of Tibetan architecture, most notably the Putuozongcheng miao (Temple of the School of Putuo; fig. 49), built between 1767 and 1771, which was constructed as an (approximate) copy of the great red-washed Potala Palace in Lhasa and intended to celebrate both the eightieth birthday of the Qianlong Emperor's mother and the 'return' or submission to China of the Torghuts of Astrakhan, followers of the Dalai Lama.[33] The Xumifushou miao, built for the Third Panchen Lama when he came to congratulate the Qianlong Emperor on his seventieth birthday in 1781, comprises a mixture of Chinese-style and Tibetan-style buildings.[34] It also demonstrates a link with the Qianlong Emperor's efforts to build within the confines of the Forbidden City: the giant gilded dragons on its roof can also be seen on the Yuhua ge which was built for the Qianlong Emperor in 1750 in the Forbidden City. In both cases, the inspiration for the architectural dragons may perhaps derive from the Emperor's passion for painting and antiquarianism, since they closely resemble dragons on the rooftops in one of the many paintings 're-creating' the long-lost Han palace that the Qianlong Emperor commissioned.[35] Although the Qianlong Emperor, like his predecessors, felt constrained to leave much of the Forbidden City as it had been under the Ming, spending more lavishly on palaces outside Beijing, the few buildings that he constructed within its confines are a spectacular combination of his various artistic interests: Tibetan architecture, antiquarianism, book-collecting and painting.

Catalogue

Images of Imperial Grandeur

JAN STUART

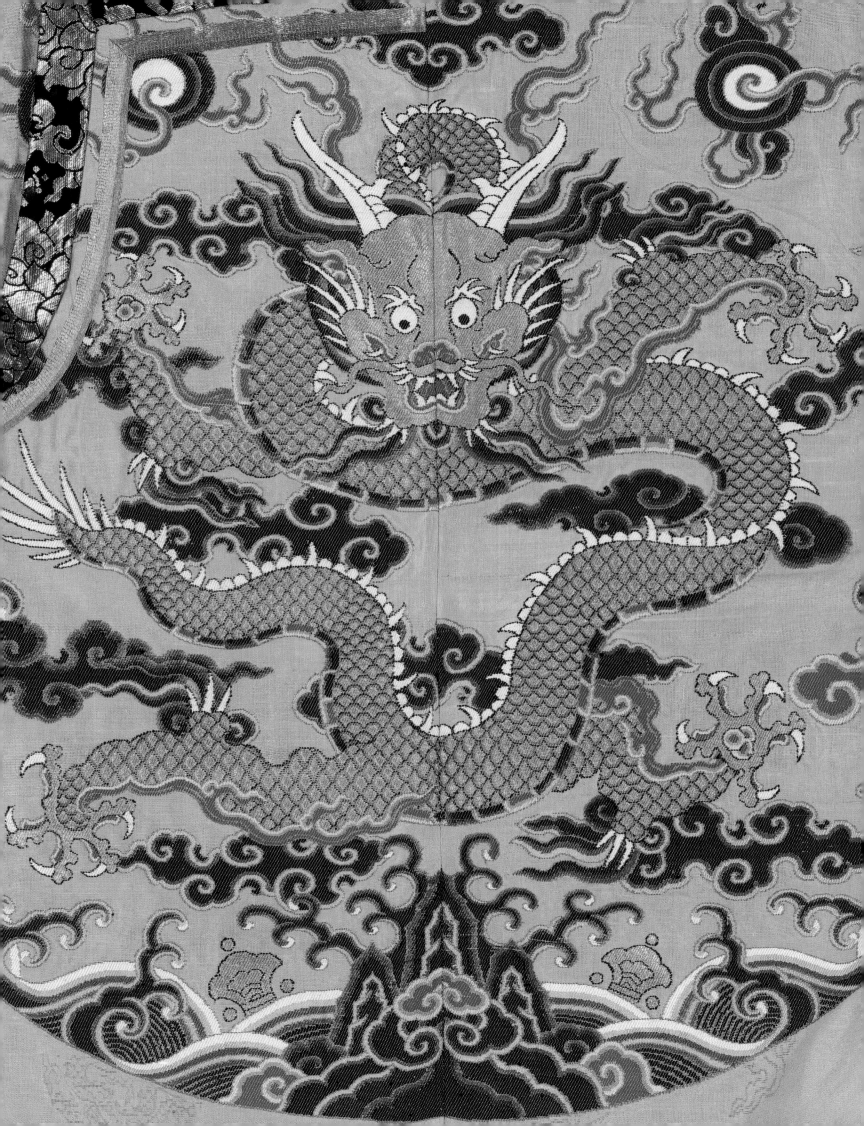

The Kangxi, Yongzheng and Qianlong Emperors brilliantly employed all the arts as 'tools for the glorification of the state'[1] and in this vein devoted unprecedented attention to having their likenesses produced by court painters. Foremost, these Manchu rulers appropriated the long-standing Chinese imperial tradition of formal, hieratic images as an agent of statecraft, but they also greatly expanded upon the uses and variety of self-representations commissioned at the palace. The portraits of greatest political significance to the court were the near life-size formal or iconic paintings presented in this section (cats 1, 2, 6, 10), which are called 'sacred likenesses' (*shengrong, yurong* and *shenyu*), a set of terms reserved for the imperial countenance.[2]

Less formal portraits of the emperors engaged in animated activities, such as following scholarly pursuits (cats 96, 165) or poised for military action (cat. 61), also enjoyed wide popularity at the court. Some of the most intriguing images announce in pictorial terms the all-encompassing nature of the Emperor. His exalted status permitted him to assume alternative identities, such as when the Yongzheng Emperor had himself depicted wearing a Westerner's wig or a Tibetan monk's garments (cat. 167), or the Qianlong Emperor was presented as a Buddha (cat. 47). The Qianlong Emperor's ardent passion for portraiture has prompted critical remarks from twentieth-century scholars that he was 'egocentric' and interested in the 'collecting of himself', but it is more observant to view the acute sense of self-awareness of the Qianlong Emperor, his father and grandfather and their promotion of self-images as astute political strategy.[3] After the Qianlong Emperor, imperial portraiture was never practised with the same level of intensity or artistic command as in the early Qing, but even in the last gasp of the empire, the rulers continued to invest portraits, including those in the new medium of photography, with power as a vehicle to record imperial authority and grandeur (fig. 34).

All imperial likenesses, formal and informal, were executed in the Palace Workshops by a team of artists. Every image had to be approved by the Emperor in draft form to obtain his authorisation before completion.[4] The emperors recruited the finest talents at the court for portraits, often selecting resident Western Jesuit painters to render the imperial visage, but formal portraits never bore a signature and never revealed any nuance of personal artistic expression. Official in nature and ritual in function, in their own time, these majestic portraits were never considered to be 'art'.

In formal portraiture the Manchus closely followed an inherited pictorial code that dictated presentation of a royal figure in a seated posture, turned fully frontal, and rendered in total stasis at the centre of the composition. Any sense of facial expression or presentation of personality beyond a sense of solemn dignity and unflappable self-composure is eschewed. The sitter is divorced from a physical setting beyond the prop of a throne chair and carpet, in order to focus attention more fully on the figure, which is typically rendered with greater illusionism for the face than the body. Facial physiognomy was understood in Chinese culture as the outward manifestation of a person's Heaven-endowed nature and his or her countenance was considered synonymous with personal identity.

Large, sumptuously mounted court portraits were displayed in contexts of life and death, including domestic family venerations and major celebrations such as inaugurations and imperial birthdays. Grand images of the emperors at an advanced age were used after their deaths in state ancestor rituals. Sitters in a formal likeness always wear elaborate ceremonial dress (cats 3–5, 7, 8), which held special meaning as a key to signify Manchu ethnicity in paintings that were otherwise closely modelled on pre-Qing visual conventions. The subjects' magnificent costumes – whose conspicuous side openings, horseshoe cuffs and wide, detachable collars were features of Qing invention – as well as their elaborate headgear, belts, necklaces and, for the women, the custom of wearing three pierced earrings per lobe (again new fashions in the Qing) all attested to Manchu heritage, a source of extreme imperial pride. The political connotations of the distinctly ethnic clothing portrayed in formal portraits ensured that artists paid meticulous attention to all details of the costumes.

Before reflecting on the historical context of the formal portraits, it is worthwhile to point out that when seen in the confinement of a museum gallery, something of their original impact may be diminished. Only

when they are imagined at the centre of a multi-sensory spectacle, with heady, perfumed incense smoke veiling the sitters' visages, with the sounds of rustling silk garments and tinkling jade girdle ornaments overheard as viewers kowtow and prostrate themselves before the paintings, and with their jewelled colours and accents of gold dancing in flickering candlelight do the portraits assume their intended magnificence. In the museum spotlight they exude a cool, academic polish and a superior technical perfection, but this is only one dimension of their power. At the centre of ritual performance these likenesses seemed even more spectacular and held even greater emotive force than they do in isolation.

Like formal portraits of earlier emperors, images of the Qing rulers were intended to be seen by only a small group of society's élite. Before the twentieth century it was both anathema and criminally punishable for commoners to own images of current or former rulers.[5] Although as early as the Han dynasty (206 BC–AD 220), Chinese emperors recognised that kings far to the west had their images stamped on widely circulated coins, Chinese tradition demanded that solo portraits of rulers, both statues and paintings, be used only for ceremonies with specially chosen audiences. The Song dynasty (960–1279) was the crucial, formative period when important portraits were developed in their roles in state sacrifices and in ancestor rites; Song imperial portraits became a prototype for all subsequent dynasties.[6] Certainly artistic differences evolved between the time of the Song and Qing, notably a change towards ever more rigid frontality that occurred in the Ming (1368–1644) and greater illusionism in the faces in the Qing, but the Song practices established a continuous context for the use of imperial portraiture in expressions of filial piety and the conduct of state ancestor worship, which was invested with great political significance.

In China, legitimate imperial descendants were expected to conduct the full range of rites associated with ancestor worship, an ancient set of values and rituals which presumed that death did not totally sever the relationship between the living and the deceased. Well-cared-for ancestors bring good fortune to their descendants, while ignored spirits wreak havoc as ghosts. In the Song dynasty, a rightfully chosen imperial

descendant was charged with presiding over the performance of Confucian rituals conducted in the presence of ancestor tablets and also over ceremonies conducted by Buddhist and Daoist clergy, which generally took place in front of portraits. Gradually, over the course of the Song, portraiture also came into use in Confucian sacrifices to the dead, despite initial resistance based on fear that a portrait could never be completely realistic. If even one hair of a person were misrepresented in a painting, it was dreaded that the ritual might be tragically misdirected to someone else.[7] Ultimately this worry was overruled, probably because the emotional power of an image proved greater than that of the written word that was the lone adornment of an ancestor tablet.[8]

From the Yuan dynasty (1271–1368) on, with only brief interruptions, portraits were ensconced in state rites, and the possession of imperial portraits from the preceding dynasty was considered an important claim to legitimacy. The Qing rulers continued the earlier practices of venerating portraits, including them in the ancestral rites for their own family. Some formal Qing portraits, also as in previous dynastic practice, had functions in life, but their paramount purpose was to hang either near state altars, or to be displayed on specific occasions in imperial halls that functioned as the equivalent of ancestral altars for domestic worship. For example, after the Yongzheng Emperor died, daily rituals were performed in front of a portrait of him before he was

Fig. 34
The Dowager Empress Cixi (1834–1908) on an occasion to mark her seventieth birthday, late 1903–early 1904. Modern gelatin silver print made from a glass negative, photographer Xuling. Archives, Freer Gallery of Art and Arthur M. Sackler Gallery, Smithsonian Institution, Washington DC. Purchase, Neg. no. SC-GR-262

Fig. 35
Interior of the Hall of the Sovereign of
Longevity (Shouhuang dian), Forbidden
City, c.1930

Fig. 36
Anonymous court artists, *Portrait of Nurgaci*,
Qing period. Hanging scroll,
ink and colours on silk, 276 × 166 cm.
The Palace Museum, Beijing, Gu6366

buried, but these were domestic, not state, rites.[9] Portraits could also serve more official roles in death ceremonies, as was seen after the demise of the Qianlong Emperor. According to custom his spirit tablet was installed in the Temple to the Ancestors and at the same time, imperial portraits of him were taken to the pre-1644 Qing capital, Mukden (present-day Shenyang), and placed in a Temple to the Ancestors there.

About eight months after the Qianlong Emperor's death, his portrait and those of two of his empresses were hung in the Shouhuang dian, a major hall erected by the Yongzheng Emperor and renovated by the Qianlong Emperor, which stood in Jingshan, the imperial park opposite the Shenwu (north) gate of the Forbidden City. This was the equivalent of a family ancestor hall for the Qing rulers and the Qianlong Emperor introduced the custom of sacrificing in front of the imperial portraits in the Shouhuang dian at the New Year. These portraits could also be unrolled and hung for ceremonies, as when an emperor needed to introduce his bride-to-be to his forebears. Rituals performed by both men and women were conducted in this hall, where portraits of imperial ancestors, beginning with Nurgaci (the dynastic founder, 1559–1626) and including empresses, were hung on large standing screens placed in the hall, and altars

furnished with ritual vessels were set up in front of the paintings (fig. 35). Qing court artists were charged with producing likenesses of all the imperial family, including those from before the 1644 conquest who may not have had images painted in their own lifetime (fig. 36).

The ways in which the Qing emperors had themselves and their women presented rely heavily on earlier traditions but also involved a new synthetic Sino-Western painting style that hints at the cultural pluralism of the Qing empire and also reveals these emperors' particular fascination with optical realism as a seemingly objective lens to document their place in history. The faces are modelled with subtle degrees of shading and Western perspective, although never enough to imbue the sitter with a sense of temporality as if he or she had been depicted at a certain time of day or under lighting specific to a particular place. The greatness of these formal portraits lies in their ability to invest the monarch with an appearance of permanence and monumentality befitting a Supreme Sovereign, the rightful recipient of Heaven's Mandate.

I

Anonymous court artists
*Portrait of the Kangxi Emperor
in Court Dress*

Late Kangxi period

Hanging scroll, colour on silk,
278.5 × 143 cm

The Palace Museum, Beijing, Gu6396

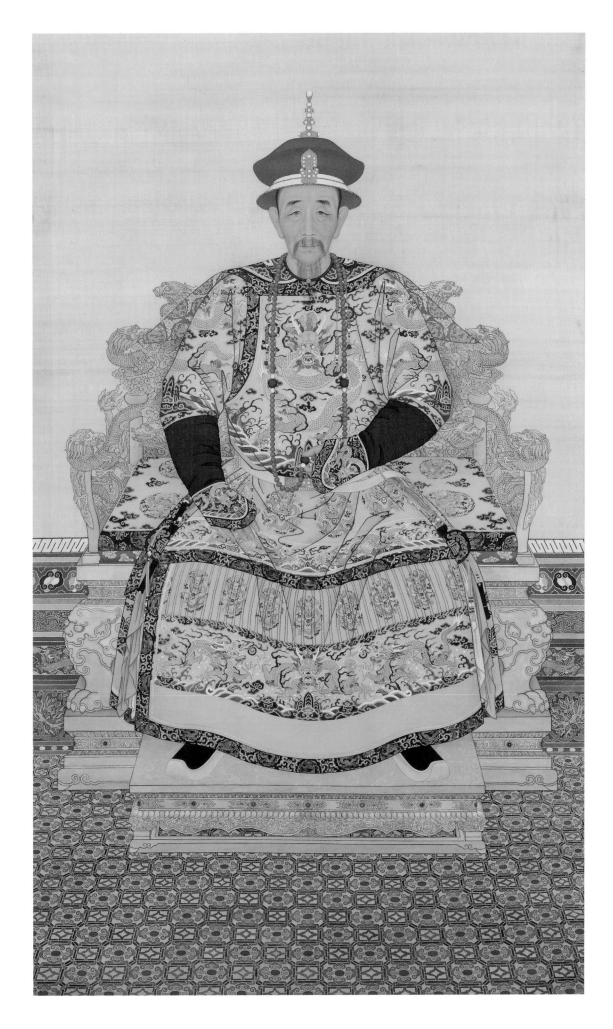

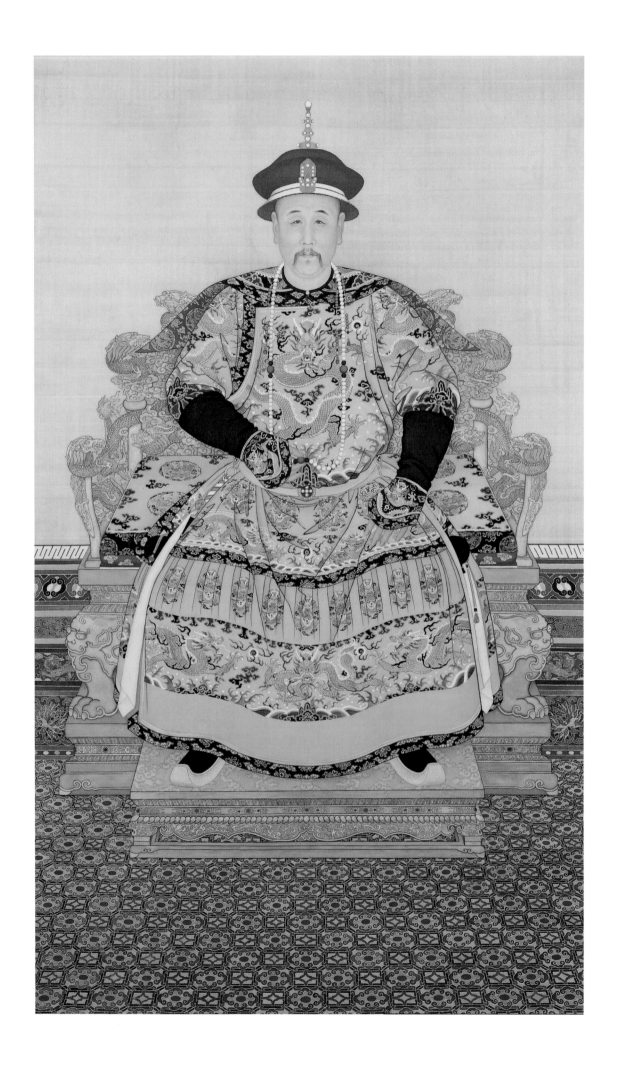

2 ←

Anonymous court artists
*Portrait of the Yongzheng Emperor
in Court Dress*

Yongzheng period

Hanging scroll, colour on silk,
277 × 143.4 cm

The Palace Museum, Beijing, Gu6431

3 ↓

Emperor's yellow court robe
(*chaofu*)

Kangxi period

Patterned silk gauze with areas of
brocaded metal thread, length 145 cm;
collar embroidered with silk and metal
thread and trimmed with silk and metal
brocade

The Palace Museum, Beijing, Gu41898

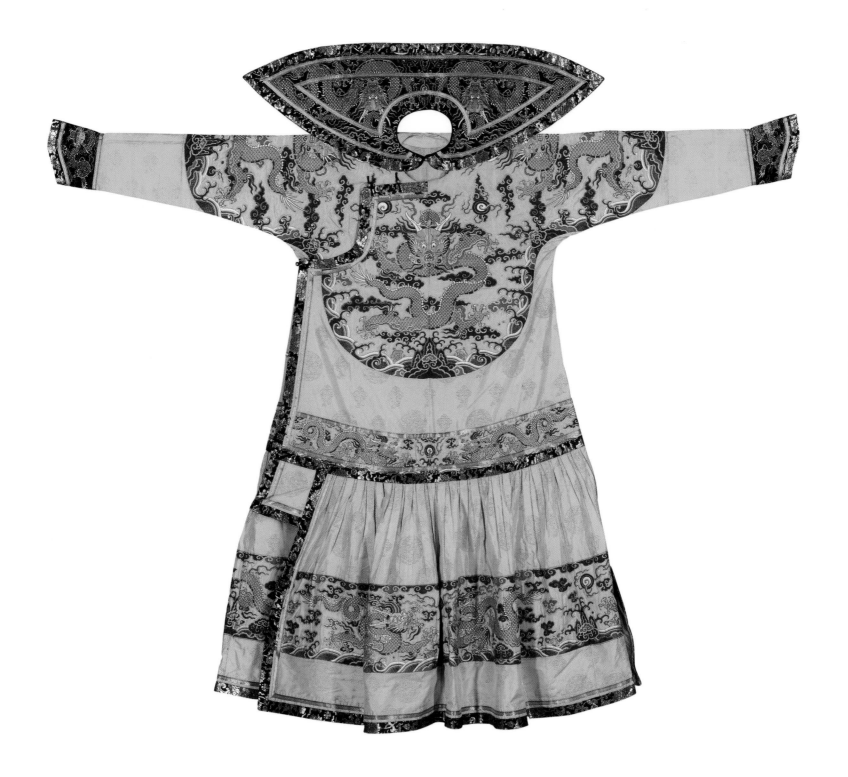

4 →

Emperor's winter court hat

Qianlong period

Sable, freshwater pearls mounted
on gilt bronze, gold, red silk floss,
height 39 cm

The Palace Museum, Beijing, Gu59739

6 →

Anonymous court artists
*Portrait of the Qianlong Emperor
in Court Dress*

Qianlong period

Hanging scroll, colour on silk,
205.5 × 133.5 cm

The Palace Museum, Beijing, Gu6465

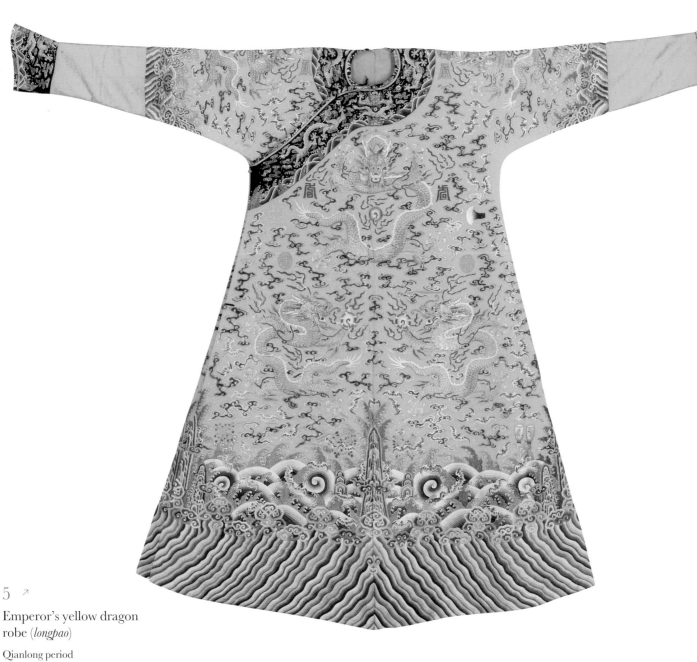

5 ↗

Emperor's yellow dragon
robe (*longpao*)

Qianlong period

Silk with polychrome floss silk
embroidery, trimmed with silk
and metal thread brocade,
length 143 cm

The Palace Museum, Beijing, Gu41993

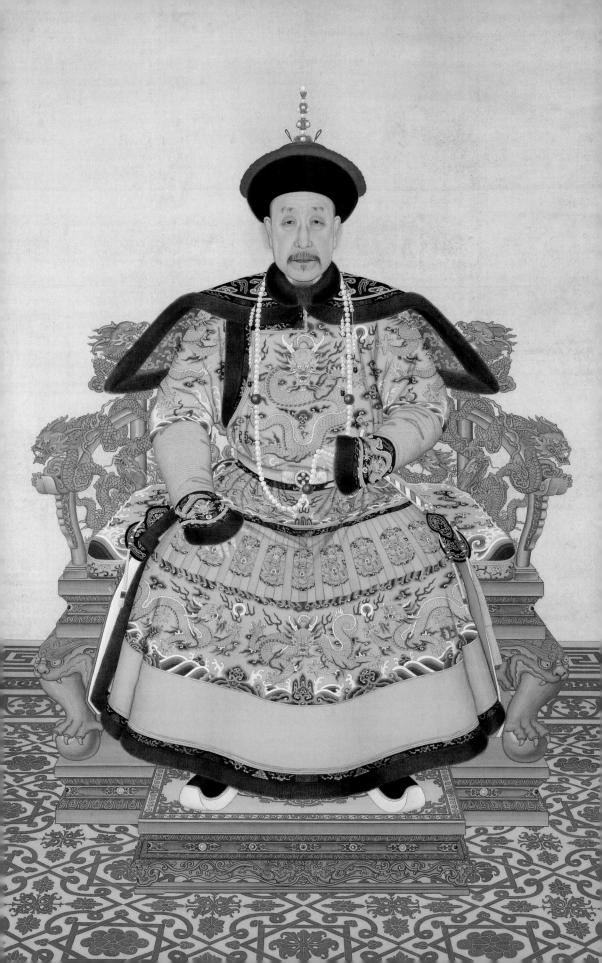

7 ←

**Blue court coat (*chaogua*)
for an empress**

Yongzheng period

Silk with metal thread and polychrome
floss silk embroidery, trimmed with silk
and metal thread brocade, red silk lining,
length 140 cm

The Palace Museum, Beijing, Gu43484

9 ↑

**Pair of free-standing dragons
emerging from waves among
clouds, with flaming pearls
rising from rocks**

Qianlong period

Gilt bronze and cloisonné enamel,
height 94 cm

Xing Shuan Lin Collection

8 ←

**Yellow court robe (*chaofu*)
for an empress**

Yongzheng period

Ribbed silk with floss silk and metal
thread, brocade trimming around the
edges; patterned blue silk gauze lining;
cuffs lined with silk satin; shoulder wings
lined with metal thread brocade, length
140 cm. Collar: embroidered with silk
and metal thread and trimmed with silk
and metal brocade

The Palace Museum, Beijing, Gu41902

Anonymous court artists
Portrait of the Xiaosheng
Empress Dowager

Qianlong period, 1751

Hanging scroll, colour on silk,
230.5 × 141.3 cm

The Palace Museum, Beijing, Gu6452

2

Qing Dynasty Court Painting

NIE CHONGZHENG

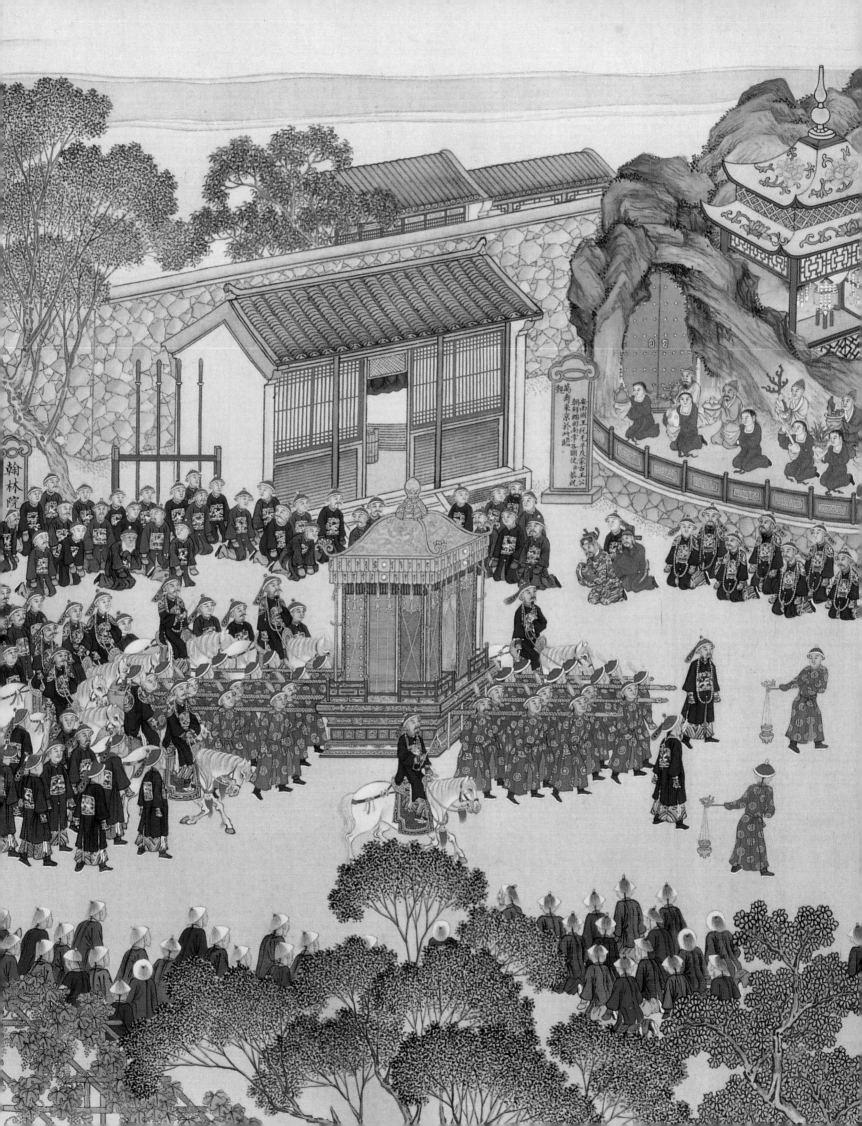

Within the wide range of Chinese painting, two groups stand out: the paintings by the scholar officials or literati, which are discussed on pp. 306–11, and court paintings, which are considered here. From the period after the fall of the Han dynasty in the early third century, and possibly earlier, rulers had employed artists to embellish their palaces and temples. In later periods, to support this activity, groups of professional artists – organised into an academy[1] – were employed by the court to record events and to decorate palaces and the temples patronised by the emperors.

A comparison of Qing court painting with that of the preceding Ming dynasty (1368–1644) reveals little difference in subject-matter. The principal categories in both periods were flower, bird and animal paintings for palace decoration (cats 80, 268–70); historical figures and stories; paintings which recorded important contemporary events (cats 76, 78, 83) and figures (cats 61, 65); and religious subjects (cat. 38), particularly Lamaism (cat. 47), which, although it had occasionally featured in the Ming dynasty, was a comparatively new theme. Paintings of historical figures made up only a small proportion of the Qing output; in contrast, contemporary events and figures were particularly popular and became common subjects for Qing court paintings. Because the Han people had dominated China for so long, Chinese history is, for the most part, their history. When Qing forces defeated the Chinese with their military prowess and seized power from the Ming dynasty, and because the founder of the Qing dynasty was a Manchu, whose homeland was the northeast region near Mount Changbai and the Heilong River (Heilong jiang), the Qing tried to establish their own subject-matter in order to play a major role on the stage of Chinese history. Thus, they placed greater emphasis on recording important contemporary events and individuals, preferring to ignore historical figures and stories.

By comparison with similar subjects from the Song (960–1279), Yuan (1271–1368) and Ming dynasties, Qing paintings of important events and figures are more elaborate. In addition, they were produced in larger quantities than in previous dynasties. Before the invention of the camera and television, the only way to present important historical events was through painting, and the Kangxi, Yongzheng and Qianlong Emperors made the best use of the medium. These portraits of emperors, empresses and meritorious officials show us China as it was hundreds of years ago, and as such have great historical value (cats 24, 25). Among the most concrete and vivid are those that depict the relationship between the Qing government and the minority tribes living on the border of northwestern and southwestern China (cat. 77) during the Qianlong Emperor's reign.[2] Because the painters who created these works lived inside the palace and personally encountered important people and witnessed significant events, their paintings have verisimilitude. They used fine, delicate and skilful craftsmanship to achieve very subtle effects. The features of each individual, their costumes and those of soldiers and honour guards, weapons and outfits, the arrangement of soldiers and horses, cities and buildings, chariots, boats and bridges – all were realistically depicted in great detail (cats 12, 14, 30). Such works are, therefore, very different from the flower-and-bird and landscape paintings used to decorate the palace halls.

Although Qing court flower-and-bird paintings are similar to flower-and-bird paintings from other dynasties, most such paintings from the Qing period feature inscriptions which not only identify the individual birds, animals and plants, but also record that they were offered as tributes, and by whom, when and from where. The paintings of the dogs presented to the Qianlong Emperor are a case in point (cat. 84). Each illustration is accompanied by the dog's name and a poem about it. Such works enable us to gain an understanding of the relationship between the Qing central government and other nations and vassal states. Just like the paintings of events and important individuals, these paintings also functioned as historical records.

During the reigns of the Shunzhi Emperor (1644–61) and the Kangxi Emperor, when the Qing command of China Proper was still comparatively recent, the Qing court painting organisation was in its infancy; the artists, who were organised by the Imperial Household Department (Neiwu fu), had not yet achieved a high standard, either in terms of quality or quantity. It was not until the reigns of the Yongzheng and Qianlong

Emperors, when Qing power was at its zenith and the economy was flourishing, that the quality of Qing court painting reached its peak. Many paintings were produced at this time. The Imperial Painting Academy (Huayuan chu, also called Huazuo), had become more effective, and remained under the jurisdiction of the Imperial Household Department.

Under the terms of an imperial edict issued by the Qianlong Emperor in 1736, the Ruyi guan (As-You-Wish Studio) was formally established under the Imperial Household Department. Located to the south of the Qixiang palace, the Ruyi guan housed painters, jade-carvers, mount-makers and other artisans.[3] The Imperial Household Department's Palace Workshops (Zaoban chu) maintained a file entitled 'Ruyi guan' under the section 'files of various kinds of exquisite objects', which recorded details of painters and paintings. At the same time as his establishment of the Ruyi guan, the Qianlong Emperor abolished the title

nanjiang (southern artisan) for court painters, which had been in use since the reigns of the Kangxi and Yongzheng Emperors. They were now called the *huahuaren* (painters),[4] which reflected a higher position within the court. Some painters who were also skilled at composing poems and verse were given official titles by the Qianlong Emperor.

The high point of Qing court painting, during the reigns of the Yongzheng and Qianlong Emperors, was reflected in a number of developments. Firstly, the number of painters increased. Most of the famous and influential exponents were active in the period. Secondly, the characteristic features of Qing court painting started to take shape, among them a well-composed, neat, delicate, elegant style, which soon came to define the Qing court painting style (cat. 15). The papers, silks and colours used for paintings, as well as the mounting techniques, were of the highest quality. Most surviving Qing court paintings date from this period. Those painters who were active in the Qianlong

Fig. 37
The Lodge of Retiring from Hard Work (Juanqin zhai) in the Palace Museum, Beijing. The *trompe l'oeil* paintings on the ceiling and walls are attributed to Giuseppe Castiglione.

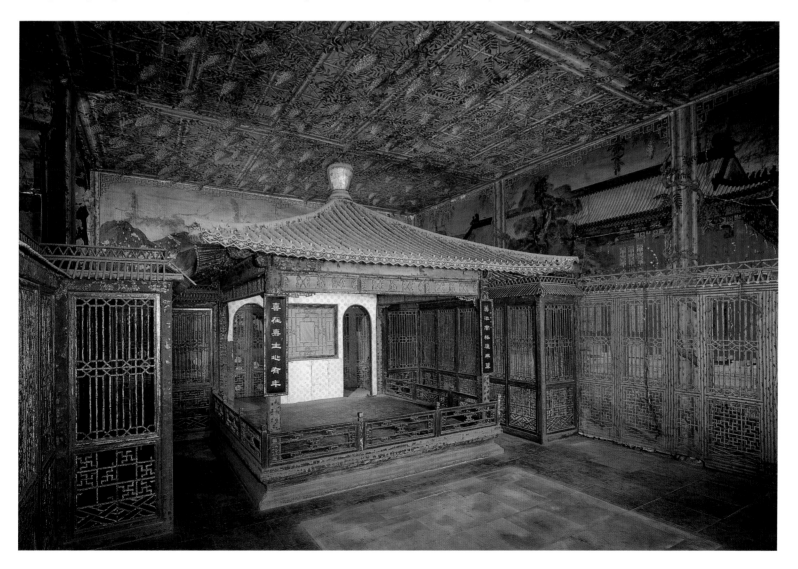

Fig. 38
Detail of a painting in the Lodge of
Retiring from Hard Work (Juanqin zhai),
showing a crane at a circular
opening in a bamboo fence.

Emperor's reign had also been employed
during the Yongzheng Emperor's time,
even though he only ruled for thirteen
years. They included artists such as Jin Kun
(cat. 30), Zhang Weibang, Ding Guanpeng
(cat. 195) and his brother Ding Guanhe.

The most innovative aspect of Qing
court painting is set out in the phrase:
zhong xi he bi (a combination of Chinese
and Western techniques). During the reigns
of the Kangxi, Yongzheng and Qianlong
Emperors, European painters at the Qing
court mastered Chinese brush-and-ink
techniques and produced a large quantity
of paintings. In return, they passed on some
of their own painting techniques to Chinese
court artists. For in addition to the Chinese
painters with official positions in the
academy, a number of European artists also
worked at the Qing court. These included
Jesuits of the Roman Catholic Church.
Well-educated, talented painters, they were
appreciated by the emperors and became
court painters. The best known were
Giuseppe Castiglione (1688–1766), Giovanni
Damasceno Salutti (1727–1781) and Giuseppe
Panzi (1734–1812) from Italy; Jean-Denis
Attiret (1702–1768) and Louis de Poirot
(1735–1814) from France; and Ignaz
Sichelbarth (1708–1780) from Bohemia.

These European artists enjoyed good
standing at court. Many of their paintings,
often on a very large scale, were intended
to decorate the walls of major rooms in the
palace. A few rooms so decorated survive,
including the the Lodge of Retiring from
Hard Work (Juanqin zhai). This room is
decorated by *trompe l'oeil* paintings attributed
to Giuseppe Castiglione (figs 37, 38).
When the Qianlong Emperor ordered
refurbishment of the European-style
buildings inside the Garden of Perfect
Brightness (Yuanming yuan) (cat. 91), he
appointed Castiglione to the position of
Chief Minister at the Imperial Parks
Administration (Feng chenyuan) under
the Imperial Household Department.
On their seventieth birthdays, Castiglione
and Sichelbarth were both presented with
precious gifts by the Emperor. Such artists
not only painted at the Qing court, but also
taught European painting techniques to the
Chinese. The resulting fusion of Chinese and
European painting styles was a key factor in
defining the Qing court painting style.

In addition, the European priest-artists
who served in the Qing court brought a new,
more realistic painting style that was to have
an enormous effect on portrait painting at
the Qing court. For instance the ritual
portraits of the Qing emperors combined
the formal postures and dress of the
Chinese tradition with subtle and realistic
presentation of the faces and characters
of the rulers (cats 1–3, 6). A portrait of the
Qianlong Emperor, datable to 1735, shows
in such a formal setting an unusually realistic
portrait of the young Emperor (fig. 39). It
depicts him as he appeared soon after he
ascended the throne at the age of 25. The
techniques are subtle and the Emperor's
features have been rendered using European
painting techniques. Indeed, the face is
expressive and there is a successful three-
dimensional effect. In addition, the rendering
of his costume is beautifully detailed.
Although no signature or seals of the artist
appear on the painting, the Palace Museum
attributes it to Giuseppe Castiglione.

The vanishing-point perspective
techniques used in Qing court painting are
closely connected with the European priest-
painters who worked at the Qing court.[5]
This form of representation had evolved
as the result of the stimulus of scientific
developments in Europe from the
Renaissance period. Techniques which
allowed very effective representation of three
dimensions, as for example in the illustration

of buildings (cat. 11), proved very attractive to the emperors. During the reign of the Yongzheng Emperor, the famous book *Shixue* (*The Study of Visual Art*), edited by Nian Xiyao (fl. early eighteenth century), a well-known painter and porcelain designer, was published. The first edition appeared in 1729, followed by a second in 1735. In the preface the author states: 'I, Nian Xiyao, conversed with Giuseppe Castiglione several times and was then able to paint Chinese paintings using European skills. I started with the method of determining the vanishing point and drawing the line and afterwards I could paint various subjects without difficulty.' The volume contains delicate and beautiful engraved illustrations to demonstrate the techniques.[6] Some Qing court artists used the techniques of perspective to draw Chinese landscapes and buildings. Although not technically accomplished, these works are clearly different from traditional Chinese paintings. Understandably, initial attempts to use new techniques were less successful than later examples.

Oil paintings, which were popular in Europe,[7] were also popular at the Qing court. At that time, oil painting was the second largest painting category after traditional Chinese painting. Not only did the Yongzheng and Qianlong Emperors allow European artists to paint in oils, but they also ordered Chinese court painters to learn oil-painting techniques from them, as is recorded in the official files of government offices. Unfortunately, few of the oil paintings dating from this period have survived. This is due in part to the materials employed at the time and in part to due to the difficulties of preserving such works in later periods, especially when the court was faced by damage caused to buildings in which works were stored, among other factors. A portrait of the Imperial Consort, Huixian, has been included to represent this genre (cat. 96).

Another type of European image-making, the copper-plate print, was also employed at the Qing court.[8] Its aim was to create a sense of different layers, as in an oil painting, but by simply using black-and-white lines. European priests brought this art form to China in the Kangxi period. Copper-plate prints were initially used to make maps. An innovation of the Qianlong period was the use of prints to depict a series of battle scenes (cat. 75). The first examples were engraved

and printed in France. Because the drafts of this series of battle scenes were drawn by European artists and the copper plates were engraved by artisans in France, they are Western in style and taste. The prints are of very high quality with a strong contrast of light and shade and an excellent presentation of the depth of field.[9] Subsequent series of battle prints were produced in China, and the technique proved to be very successful.

Many of the major Qing court paintings were collaborative works, to which, often, European artists contributed. Among the most impressive court paintings is the handscroll *The Kangxi Emperor's Southern Inspection Tour* (cat. 13). This work originally comprised twelve sections but parts have been lost. The whole painting depicts the tour of the south made by the Kangxi Emperor in 1689, showing details of the journey, with the Emperor and his entourage starting out from the capital and travelling to other cities and famous mountains, rivers and

Fig. 39
Attributed to Giuseppe Castiglione (1688–1766), *The Qianlong Emperor in Formal Court Robes*, 1735. Hanging scroll, ink and colour on silk, 242 × 179 cm. The Palace Museum, Beijing, Gu6464

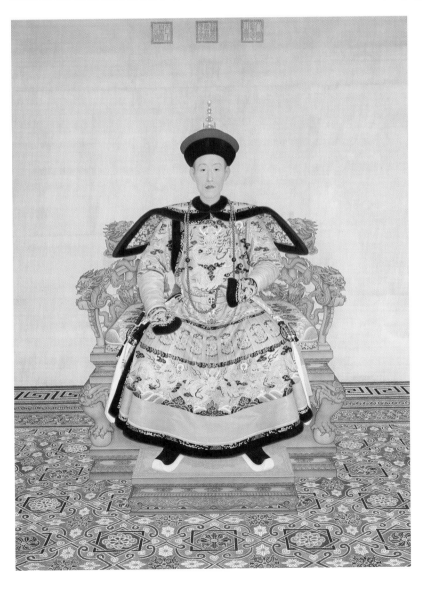

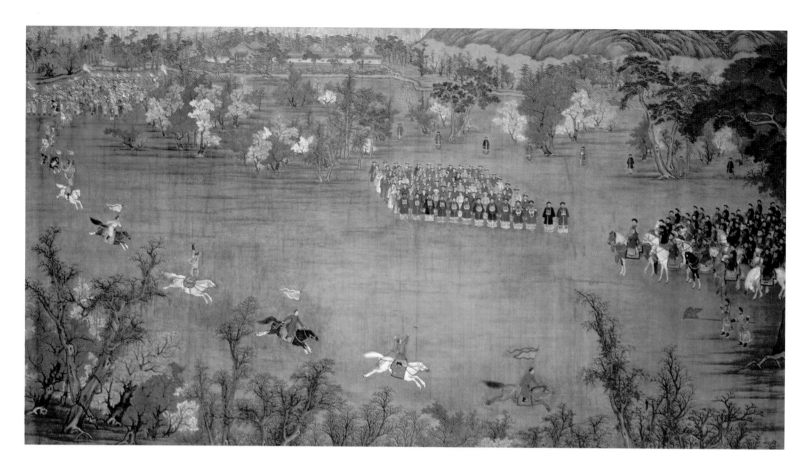

Fig. 40
Attributed to Giuseppe Castiglione
(1688–1766) and others, *Horsemanship*, 1754.
Ink and colour on silk, 225 × 425.5 cm.
The Palace Museum, Beijing, Gu5367

scenic spots. The Kangxi Emperor appears
only once in each section. This painting was
supervised by Cao Quan from the Imperial
Household Department and was organised
by Song Junye, deputy director of a
department in the Ministry of Justice.
The major artist was Wang Hui (1632–1717),
but a number of others, including Yang Jin,
Leng Mei, Wang Yun and Xu Mei, also
worked on the painting, which took six years
to finish.[10] This scroll, the first large-scale
painting to depict major events, was followed
later by *The Qianlong Emperor's Southern
Inspection Tour* (cat.14).

During the Qianlong Emperor's reign
the number of court-painting commissions
increased, including portraits of him in
formal court attire (cat. 6), in military
clothing, in ancient-style garments (cat. 187),
in casual dress (cat. 196), in Buddhist costume
(cat. 47), and in ceremonial regalia; pictures
of the Emperor on his inspection tours
(cat. 14) and out hunting (cats 26, 29);
and informal portraits of him (cat. 16).

Among these, the portrait *The Qianlong
Emperor in Ceremonial Armour on Horseback* (cat.
65) is particularly impressive. The painting
makes use of European techniques and shows
a European interest in rulers on horseback.
Inevitably, the Emperor had a strong interest

in military matters. In this portrait he wears
a robe covered with armour, a helmet and
sword, and a bow and arrow which hang
from the waist; the Manchu emperors never
forgot that their ancestors had succeeded in
establishing a new dynasty in China through
their skilful horsemanship and archery. This
painting was completed, it is thought, in the
23rd year of the Qianlong Emperor's reign
(1758), after his second inspection tour of
the horsemanship and archery of the Eight
Banners troops at Nanyuan (South Park).
It hung for a long time in an imperial
residence south of the capital.

Hunting was an important pastime
of the Qing dynasty, both as a form of
entertainment and as a way of learning
military skills. It served to maintain and
develop the Manchu martial tradition.
Three major paintings showing the
Qianlong Emperor on hunting expeditions
are included here. Each year, both the
Kangxi Emperor and the Qianlong Emperor
would go north to the Mulan hunting area,
beyond the Great Wall, and even north of
their summer residence at Rehe (present-day
Chengde) (cat. 27). The emperors would
summon members of their court and
peoples from their Mongolian and
Manchu territories to join these expeditions.

The paintings are as much a record of these important diplomatic occasions (cat. 28) as of the prowess of the emperors whether hunting on horseback (cat. 26) or on foot (cat. 29). These paintings were intended to capture the moment when the arrow is released, the return journey after killing the prey, or the feasting after a successful hunt. Full of life and portraying historical events, they encompass different aspects of the Manchu love of the chase.

Other major court paintings, including the two large horizontal scrolls *Horsemanship* (*Mashu tu*)[11] and *Imperial Banquet in the Garden of Ten Thousand Trees* (*Wanshuyuan ciyan tu*)[12] depict the exchanges between the Qing court and ethnic groups from Central Asia. These are documentary records of important events of that period. *Horsemanship* (fig. 40) depicts a display of horsemanship before the Qianlong Emperor at the summer resort at Rehe in the year 1754. This occasion took place at a banquet held to greet Amursana and other Mongols who had submitted to Qing rule. *Imperial Banquet in the Garden of Ten Thousand Trees* (cat. 76) depicts another important event in the same year: the Qianlong Emperor greets the leaders of the Khalkha Mongols, Tsereng, and others, a group that had returned to China and submitted to Chinese authority, at the imperial summer retreat at Rehe. During the reception the Qianlong Emperor was to confer the titles *qinwang* (equivalent to a first-rank prince), *junwang* (second-rank prince), *beile* (third-rank prince) and *beise* (fourth-rank prince), and bestow gifts of gold and silver, jade, porcelain and silk. The Qianlong Emperor and the leaders of the Torghut Mongols watched performances of horsemanship and fireworks together. *Horsemanship* and *Imperial Banquet in the Garden of Ten Thousand Trees* were completed by both Chinese and European court artists. Giuseppe Castiglione, Jean-Denis Attiret and Ignaz Sichelbarth were ordered to travel to Rehe to make sketches of the actual scene and to collect related material. One year in the making, the finished paintings were hung on opposite walls in a hall inside the summer palace; they can be considered as sister pieces. Although they depict very different scenes, both feature new compositional devices. The Qianlong Emperor is not placed at the centre of either painting. Instead, the submitting Mongolian leaders are arranged in the middle, with the Emperor to one side. From this arrangement, we can deduce how much importance the Qianlong Emperor attached to the leaders' submission.

But in addition to these many formal paintings there are others that show the Qianlong Emperor in more private roles. *Prince Honghi Practising Calligraphy on a Banana Leaf* (cat. 187) shows the future emperor as a scholar about to write on a leaf as if composing a religious text. Such images depicted a side of his life that was not normally seen. Many informal portraits portray scenes of the Emperor spending time with his children, enjoying family life (cat. 16). The atmosphere is very different from the pictures of the Emperor in formal dress or in ceremonial costume.

The death of the Qianlong Emperor marked the end of the prosperity of the Qing. Thereafter imperial power decreased. Later emperors were less interested in art, and the resources to support the production of court paintings were in shorter supply. Before the collapse of the Qing dynasty, the many paintings produced at court were distributed around the palace and numerous other imperial residences and gardens. Some were stolen, destroyed or lost and reappeared abroad after a combined force of British and French troops invaded Beijing in the tenth year of the Xianfeng Emperor's reign (1860) and again, when the joint forces of the eight powers occupied Beijing in the 26th year of the Guangxu Emperor's reign (1900). The surviving paintings became part of the Palace Museum's collection, which was based on the Ming and Qing collections. Apart from a small collection kept in other museums in China, most Qing dynasty court paintings are now preserved there and at the National Palace Museum in Taipei.

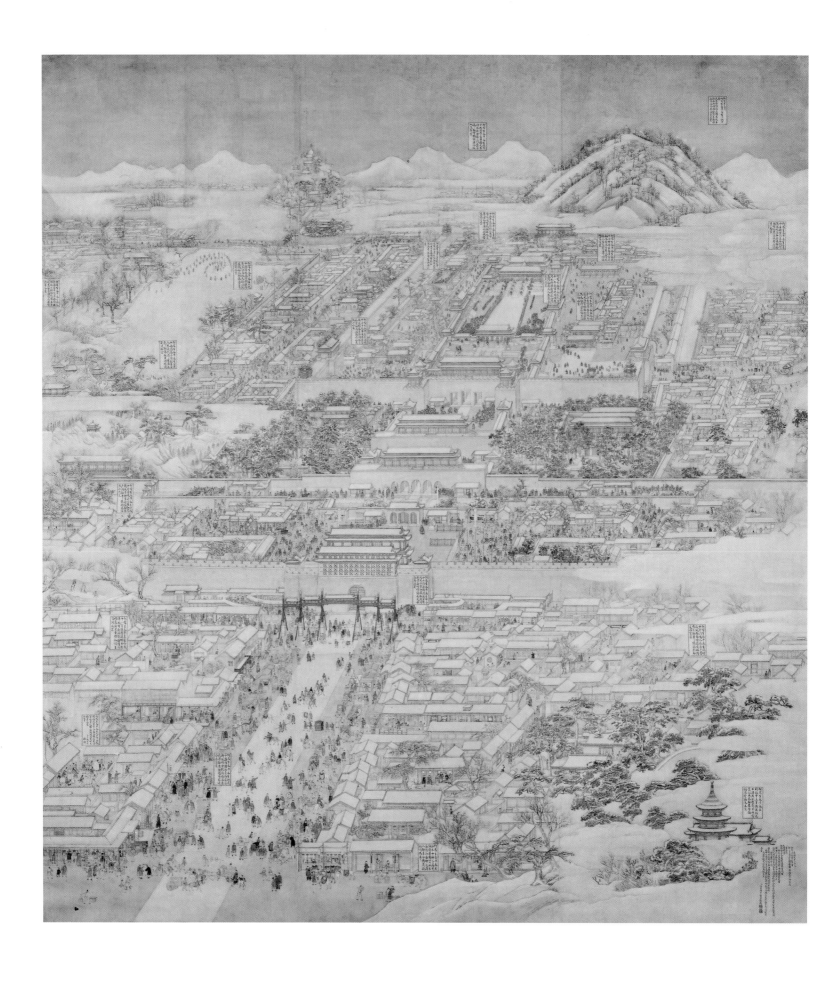

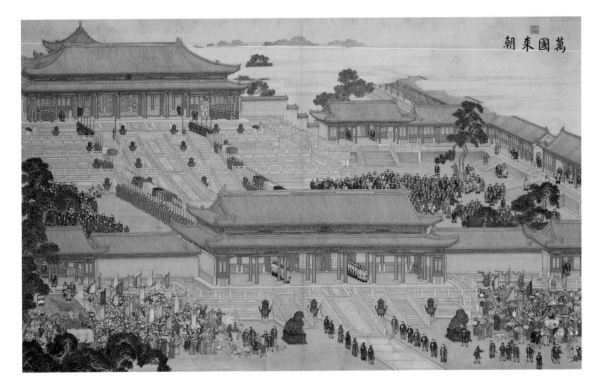

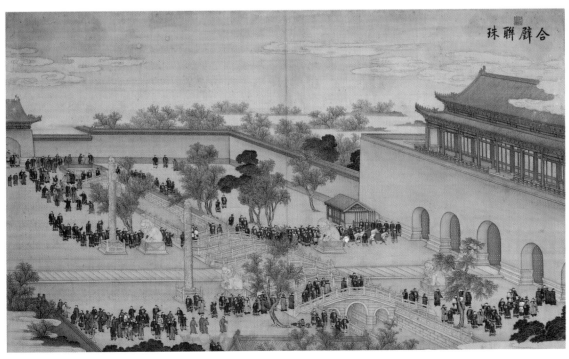

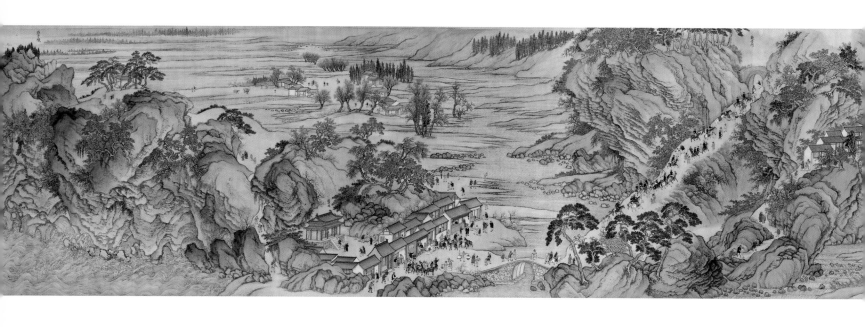

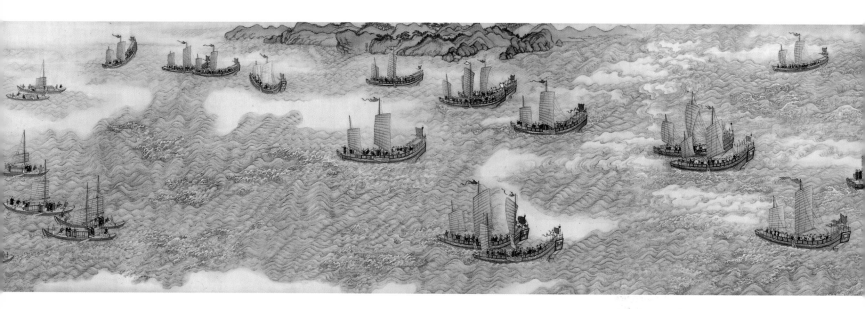

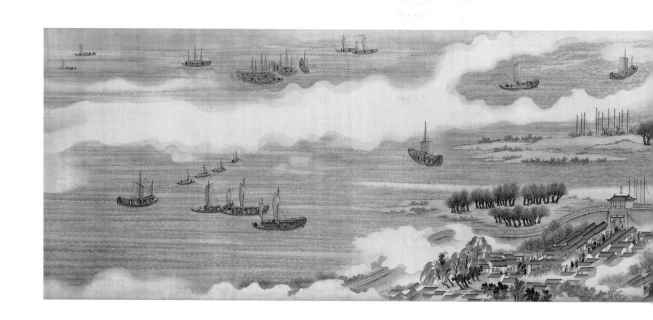

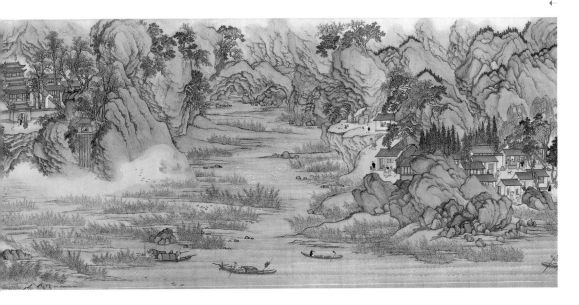

13

Wang Hui (1632–1717)
and assistants
*The Kangxi Emperor's Southern
Inspection Tour, Scroll Eleven:
Nanjing to Jinshan* (detail, showing
second half of scroll)

1691–98

Handscroll, colour on silk,
67.8 × 2612 cm

The Palace Museum, Beijing, Gu9208

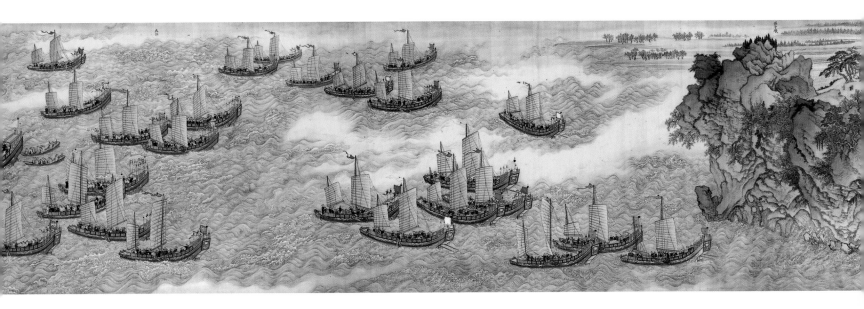

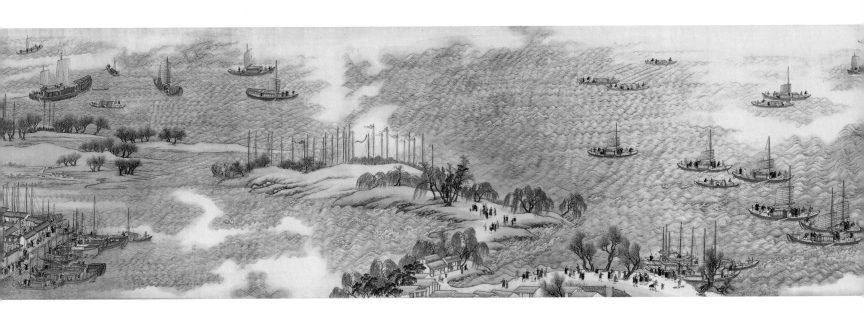

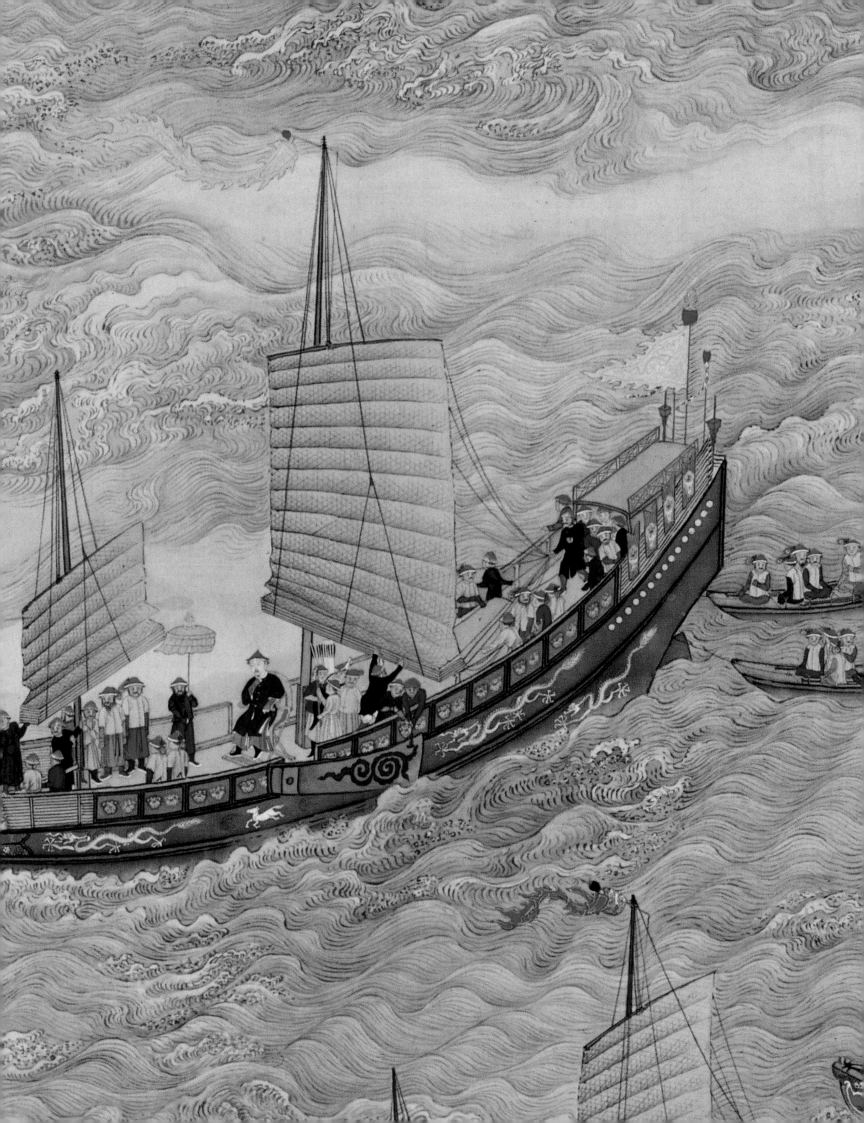

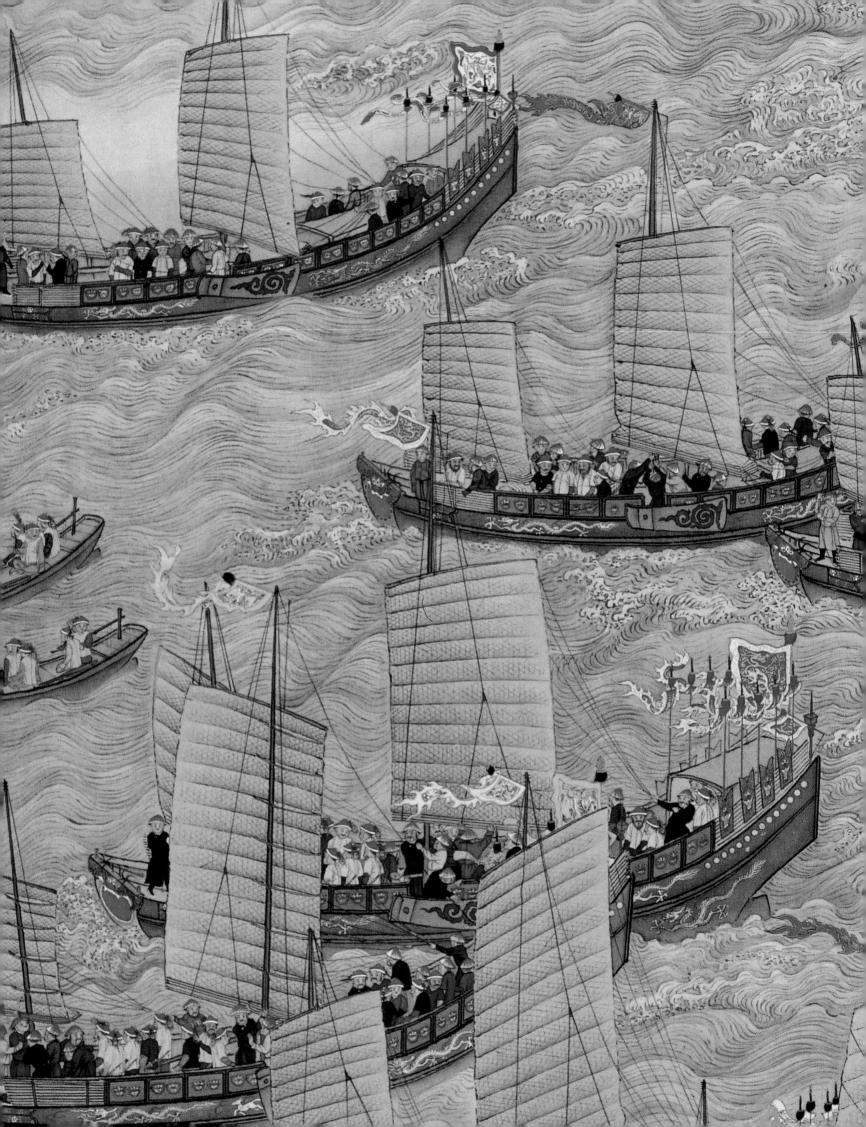

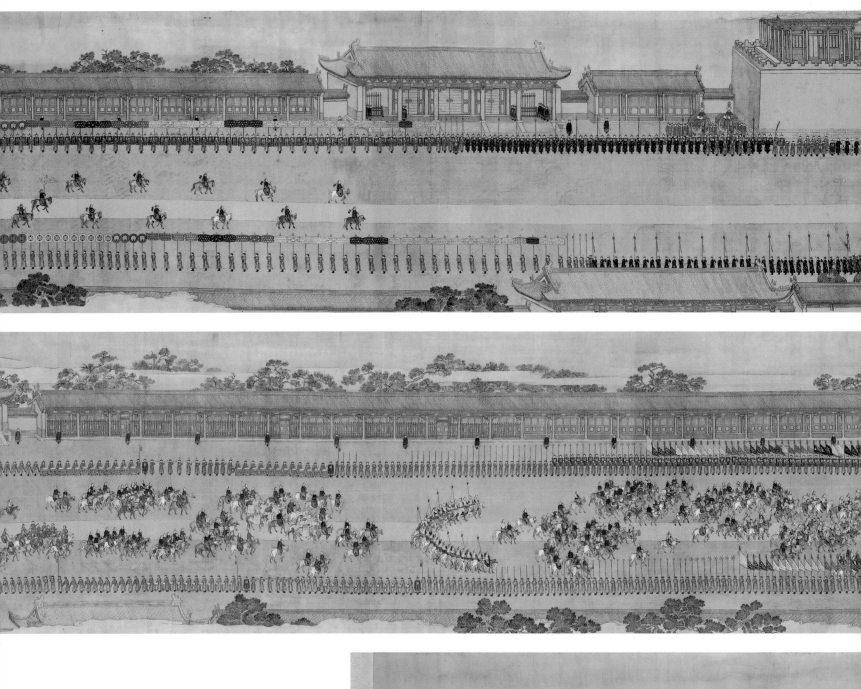
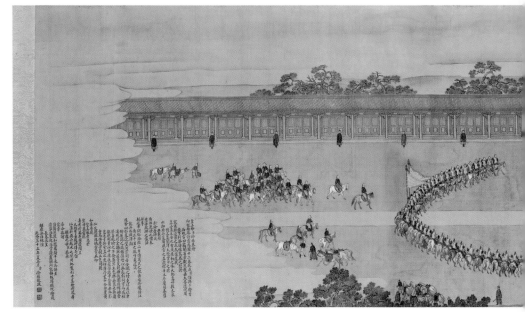

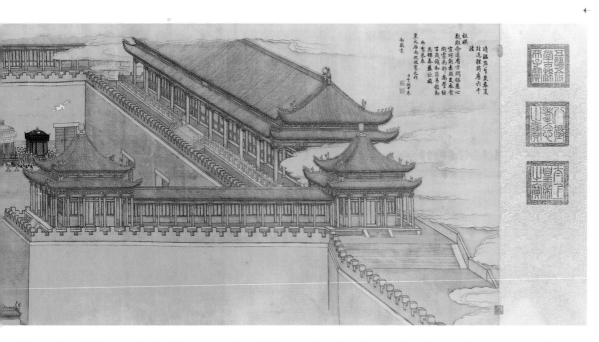

14

Xu Yang (fl. *c.* 1750–after 1776)
and assistants
*The Qianlong Emperor's Southern
Inspection Tour, Scroll Twelve:
Return to the Palace*

1764–70

Handscroll, colour on silk,
68.8 × 1029.4 cm

The Palace Museum, Beijing, Xin146673

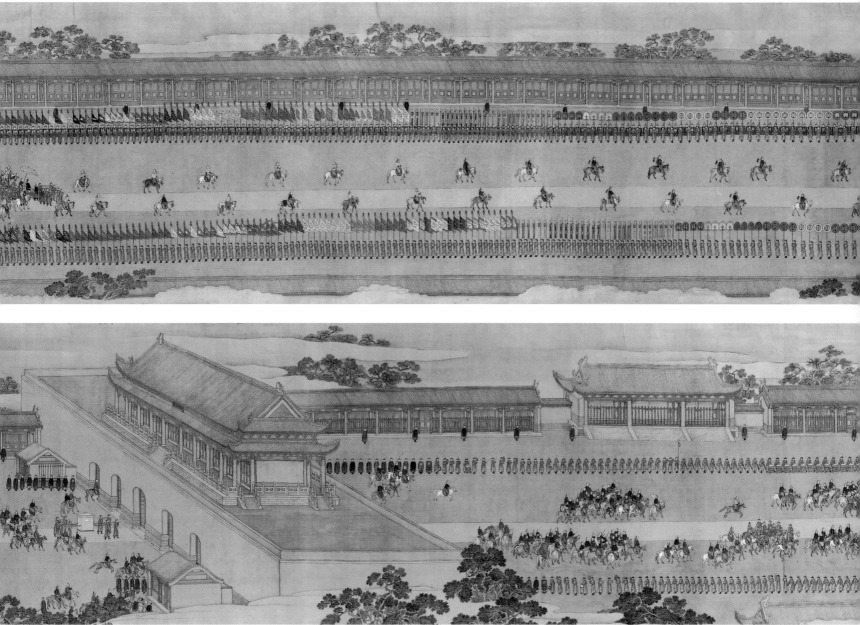

15

Anonymous court artists
*Portraits of the Yongzheng Emperor
Enjoying Himself throughout the
Twelve Months*: 1st, 4th, 5th, 8th,
9th and 12th lunar months

Yongzheng period

Six from a set of twelve hanging scrolls,
colour on silk, each 187.5 × 102 cm

The Palace Museum, Beijing, Gu6441, 1, 4, 5, 8, 9, 12

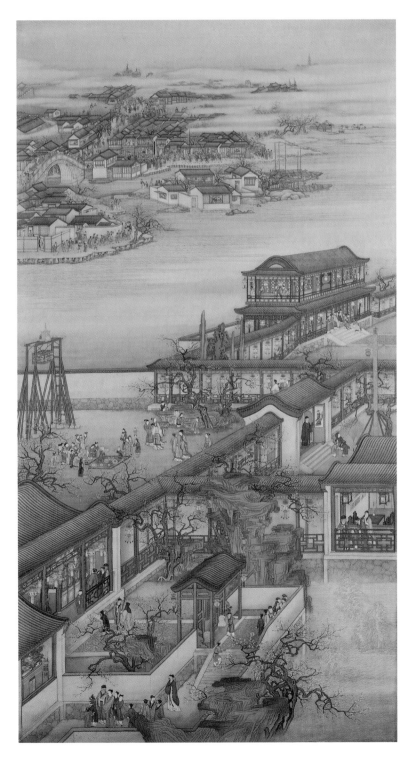

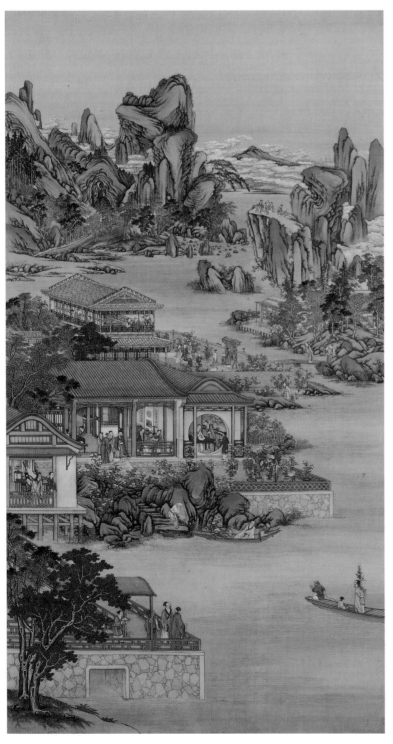
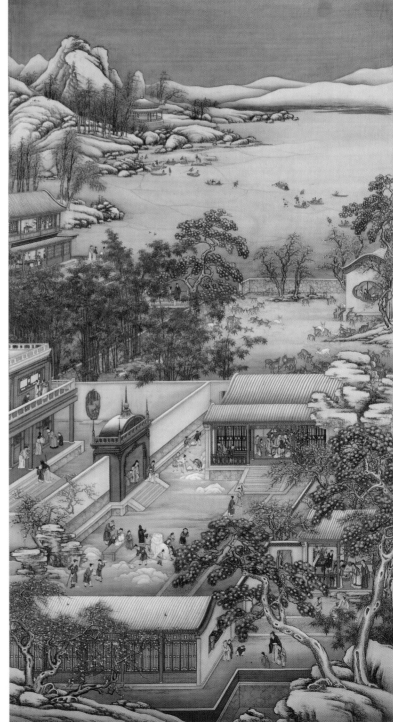

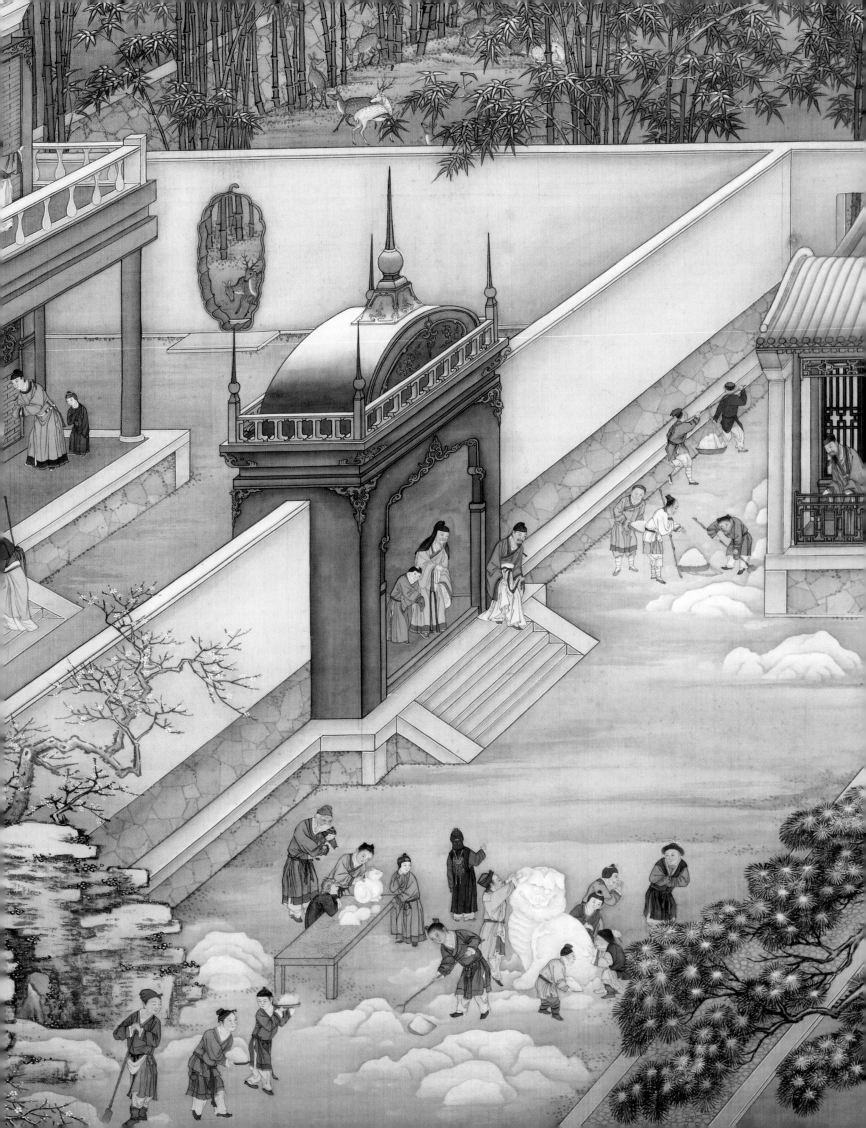

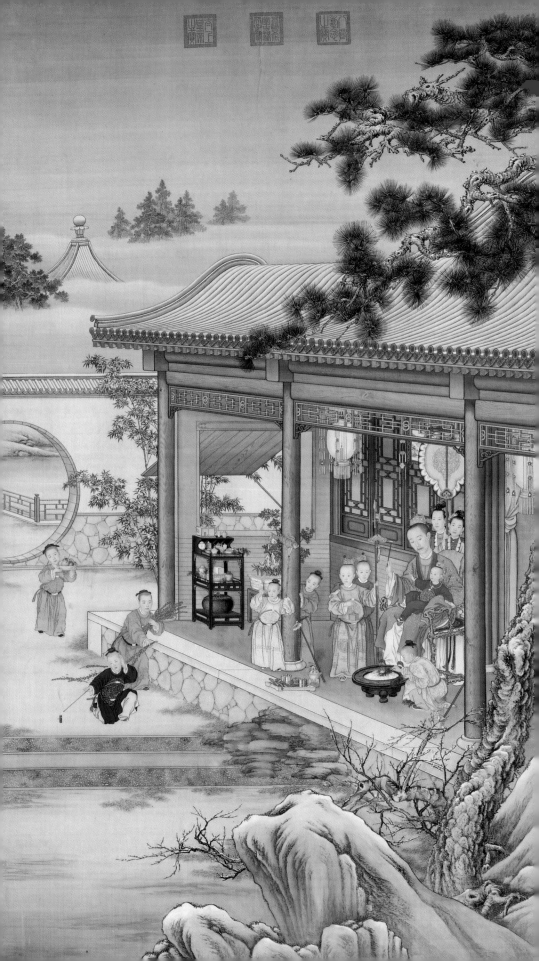

16 ←

Attributed to Giuseppe
Castiglione (Chinese name
Lang Shining, 1688–1766)
*The Qianlong Emperor and the
Royal Children on New Year's Eve*

1736–37

Hanging scroll, ink and colour on silk,
275 × 160.2 cm

Seals: three seals of the Qianlong
Emperor (1784, 1790 and 1796)

The Palace Museum, Beijing, Gu6506

17 ↓

Screen

Qianlong period

Zitan wood and red lacquer,
259 × 322 × 70 cm

The Palace Museum, Beijing, Xin178206

18 ←

Throne

Qianlong period

Zitan wood and red lacquer,
105 × 139 × 99 cm

The Palace Museum, Beijing, Gu208789

19 ←

Footstool

Qianlong period

Zitan wood and red lacquer,
14 × 77.5 × 30 cm

The Palace Museum, Beijing, Gu208955

23 →

One of a pair of charcoal stoves

Qianlong period

Cloisonné enamel,
height 83 cm

The Palace Museum, Beijing, Gu117282

20 ↑

Pair of cranes

Qianlong period

Cloisonné enamel,
height 136.5 cm

The Palace Museum, Beijing,
Gu117096, Gu117097

21 ↓

Pair of censers

Qianlong period

Dark green jade on gilt-metal base,
height 35.9 cm

The Palace Museum, Beijing, Gu103379, Gu103380

22 ↑

Pair of incense burners
with gilt pagoda finials

Qianlong period

Green jade with gilt-bronze finials,
height 96 cm

The Palace Museum, Beijing, Gu93307, Gu93308

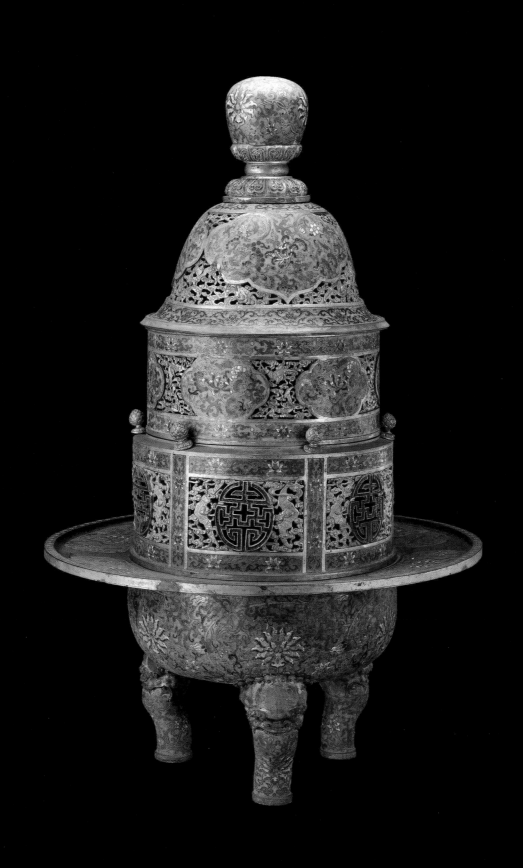

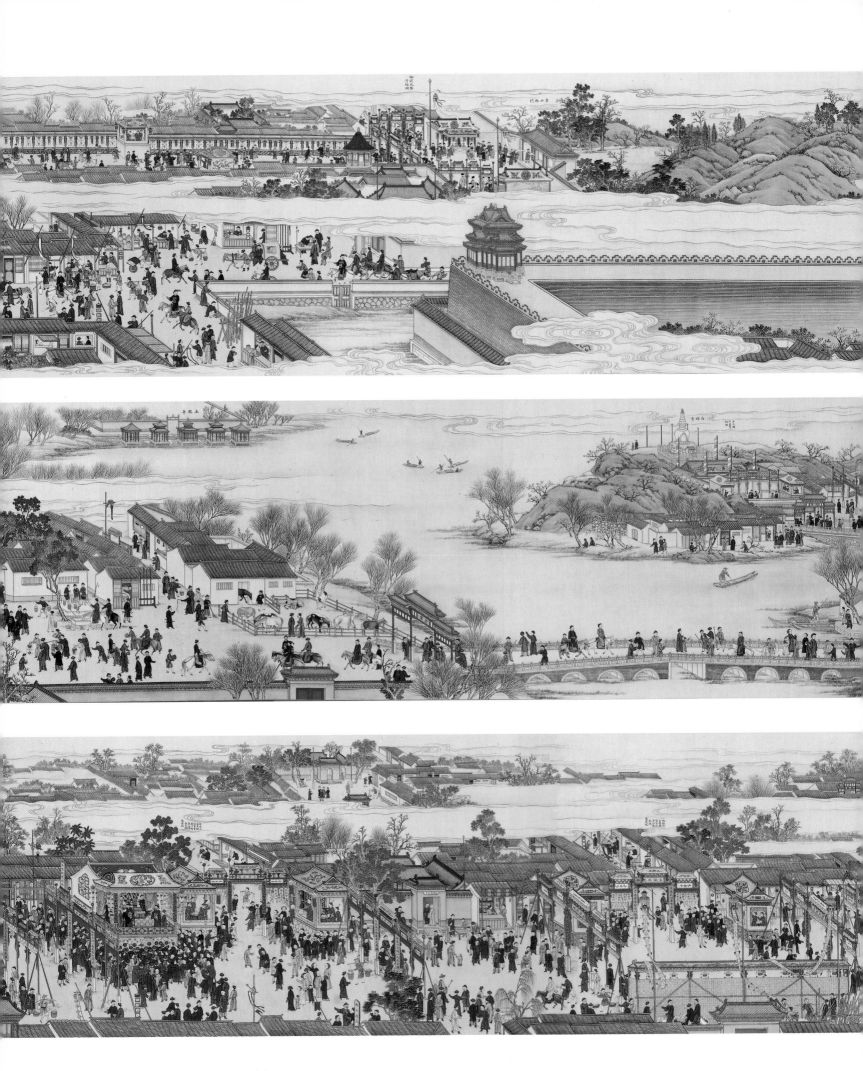

24

Anonymous court artists
*Copy of the Kangxi Emperor's
Sixtieth Birthday Celebration,
Scroll One* (detail, showing
first half of scroll)

Late eighteenth century

Handscroll, colour on silk,
45 × 3715 cm

The Palace Museum, Beijing, Gu8616/1

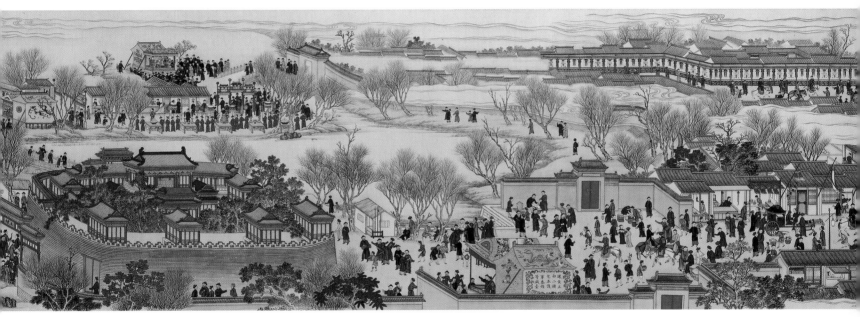

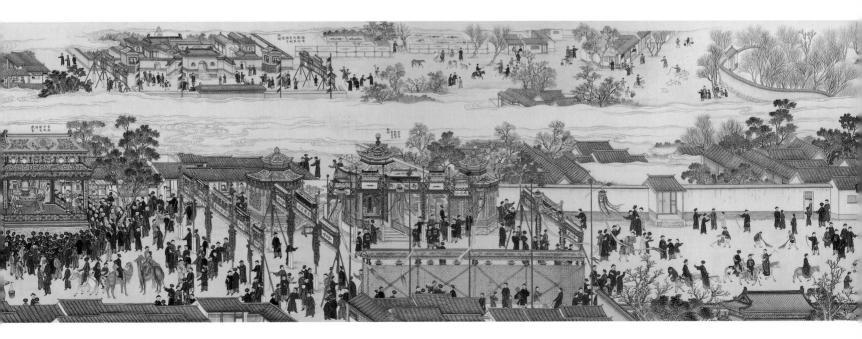

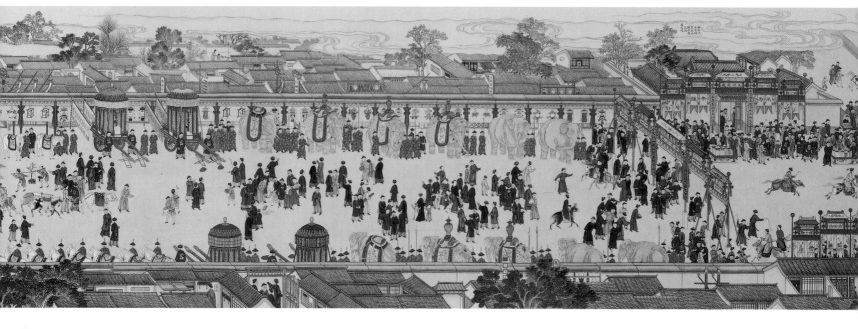

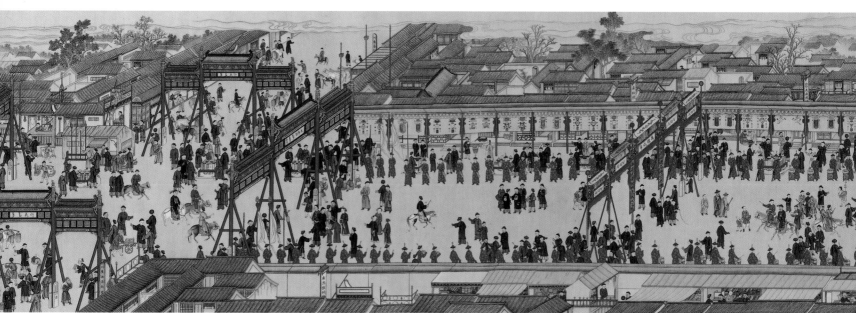

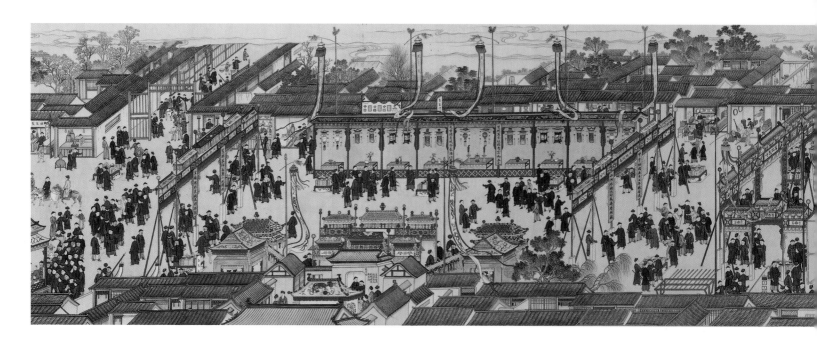

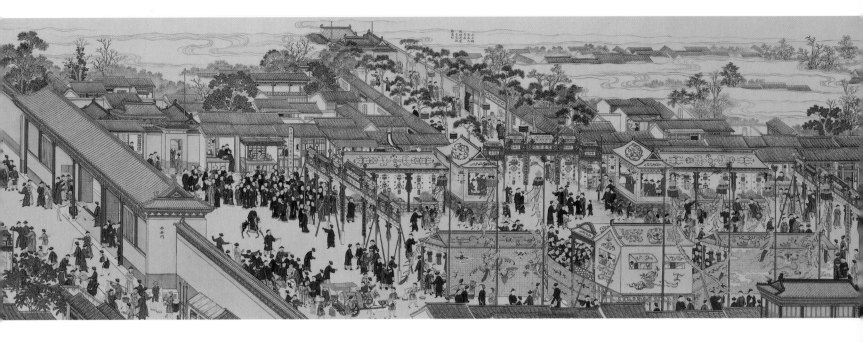

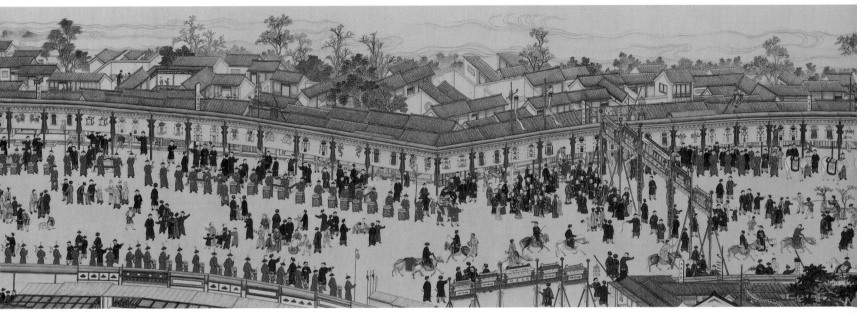

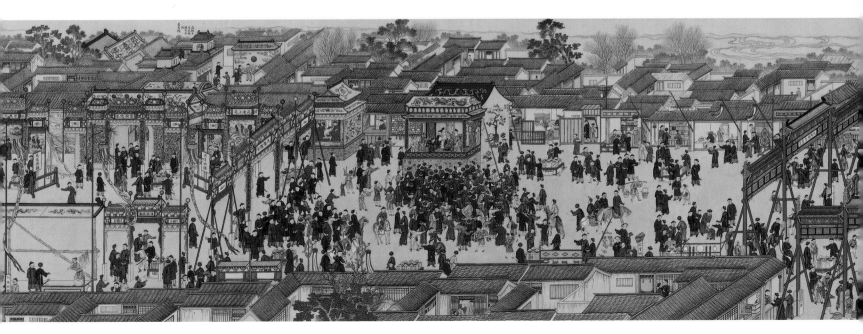

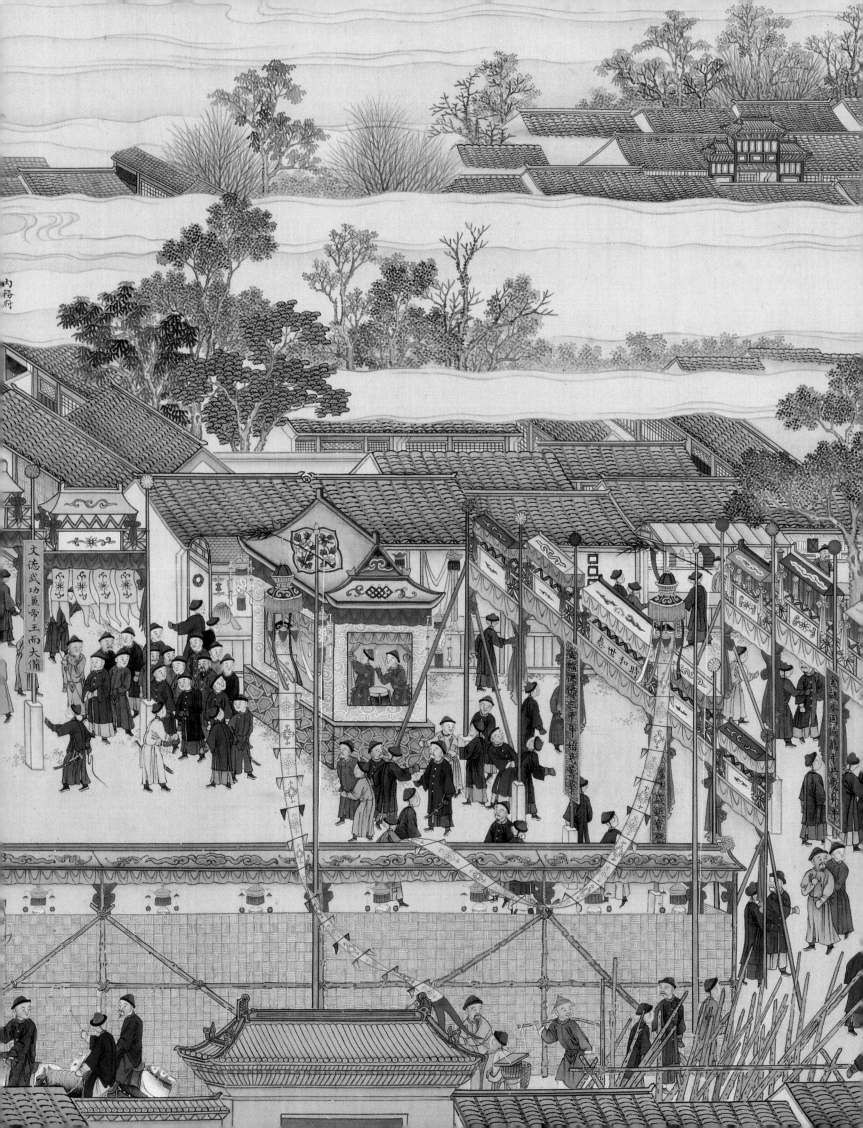

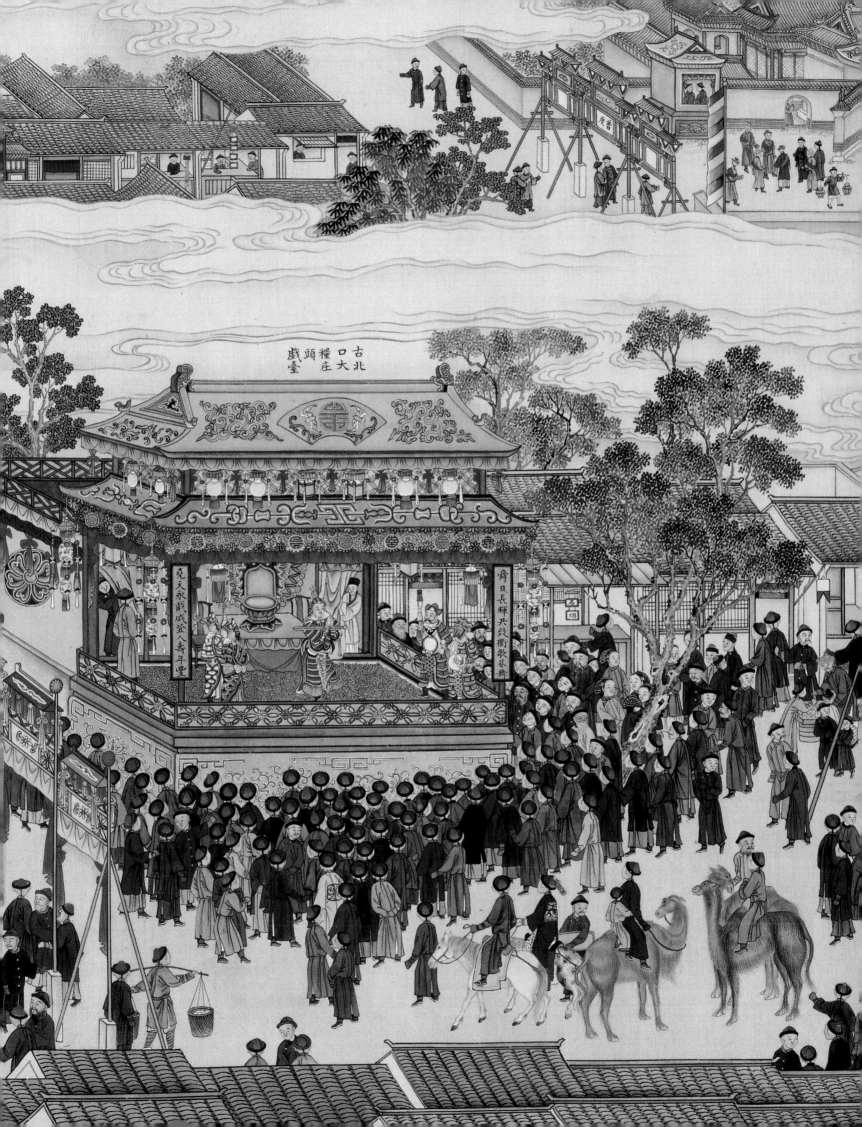

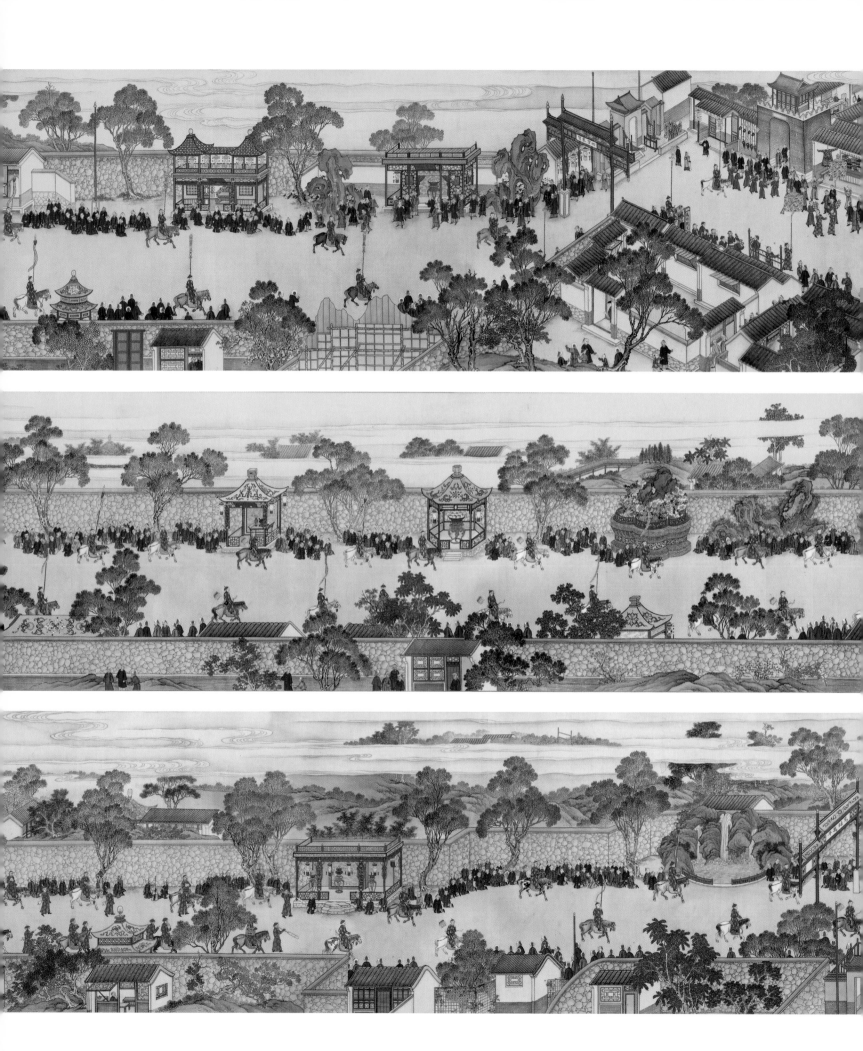

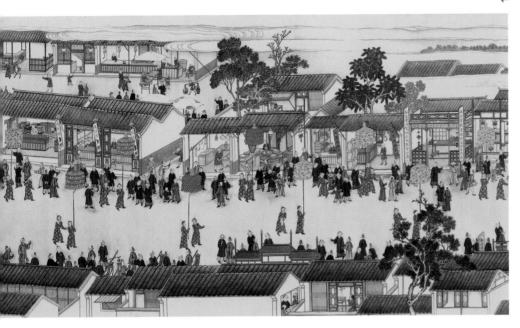

25

Anonymous court artists
The Qianlong Emperor's Eightieth Birthday Celebration, Scroll Two
(detail, showing second half of scroll)

1797
Handscroll, colour on silk,
45 × 6347.5 cm

The Palace Museum, Beijing, Gu8617/2

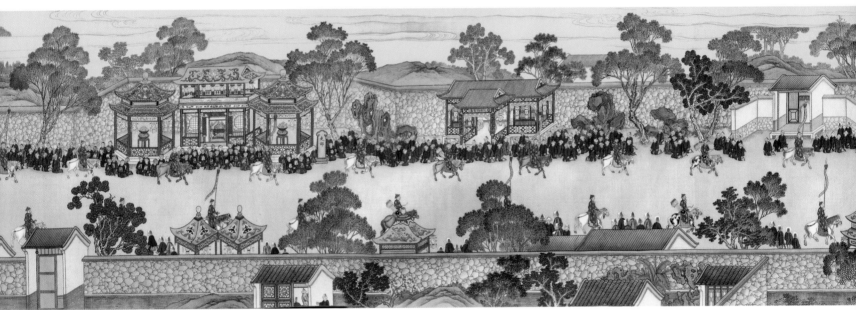

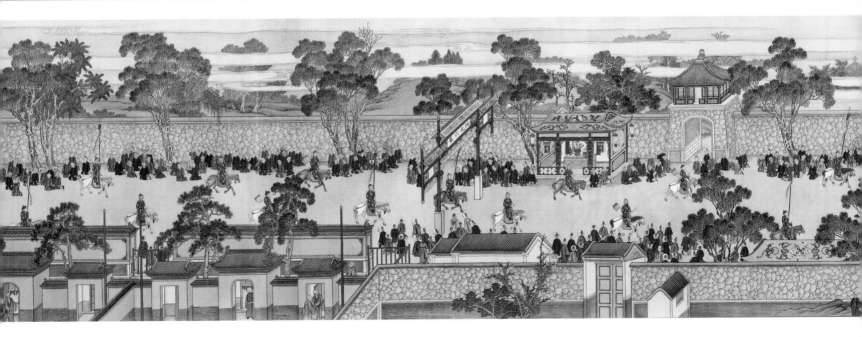

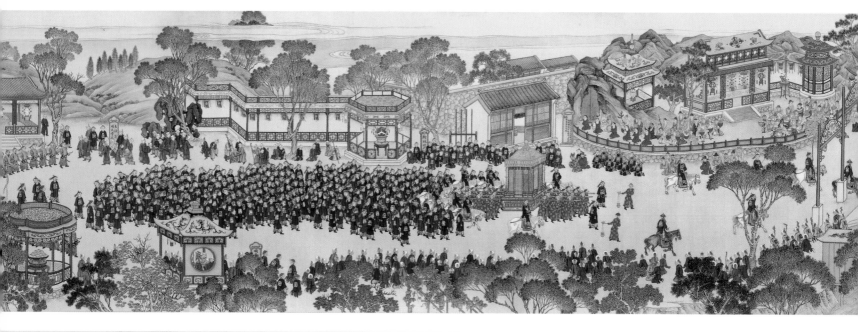

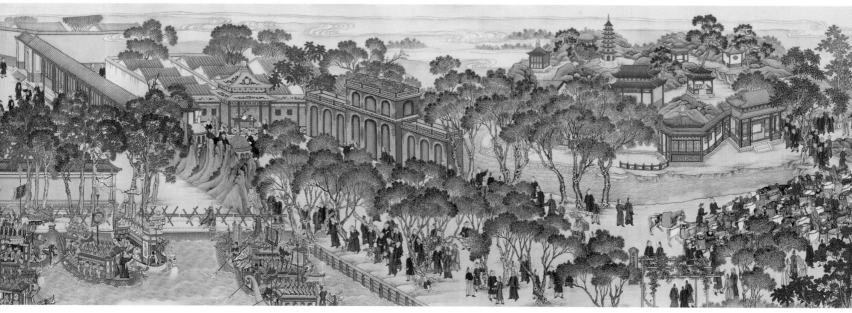

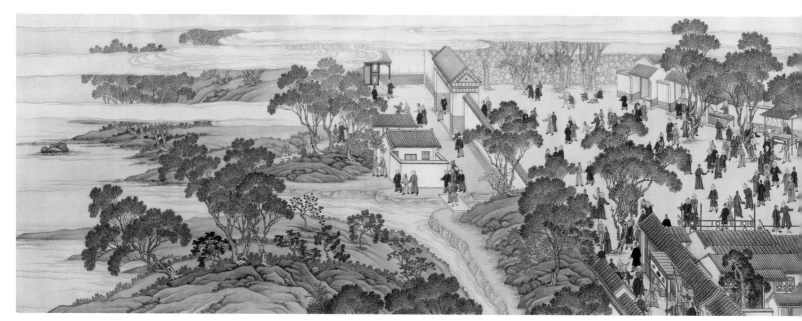

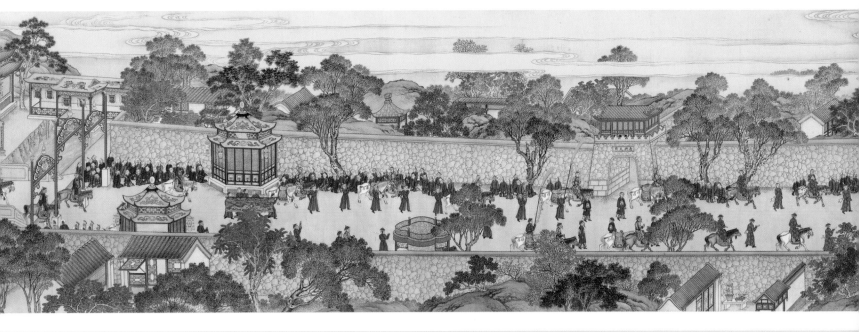

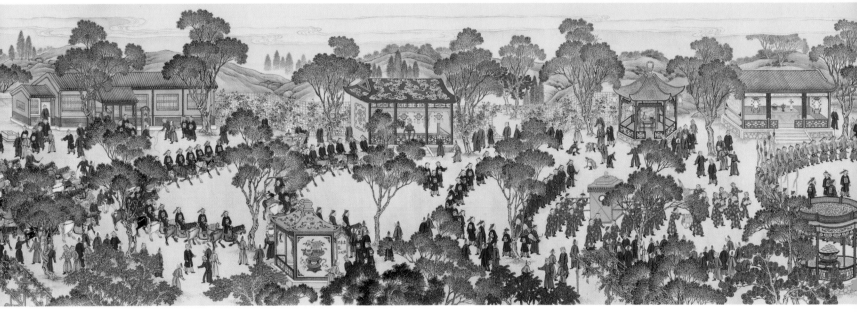

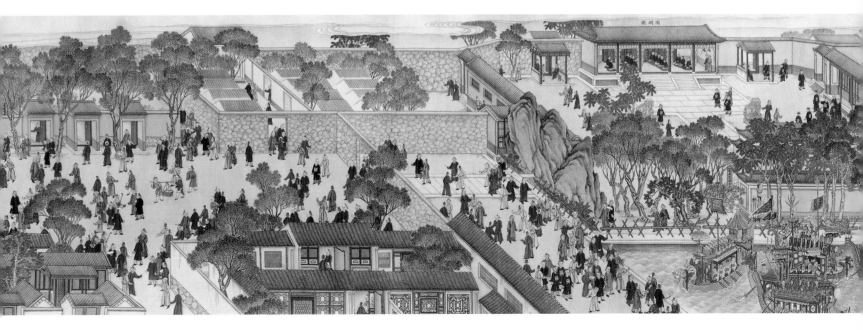

Giuseppe Castiglione
(Chinese name Lang Shining,
1688–1766) and others
The Qianlong Emperor Hunting Hare

1755

Hanging scroll, colour on silk,
115.5 × 181.4 cm

Inscriptions: signed 'Respectfully painted by
your servant Lang Shining'; on the upper
part of the painting, a poem composed by the
Qianlong Emperor and calligraphied by him

Seals: two artist's seals, two imperial seals

The Palace Museum, Beijing, Gu5362

Leng Mei (*c.*1670–1748)
Mountain Villa to Escape the Heat

1713

Hanging scroll, colour on silk,
254.8 × 172 cm

Inscription: signed 'Respectfully painted
by your servant Leng Mei' in the lower
right part of the painting

Seals: two artist's seals lower right; in the
upper part, at the centre, the seal of the
Qianlong Emperor; on the left, four
imperial seals

The Palace Museum, Beijing, Gu8210

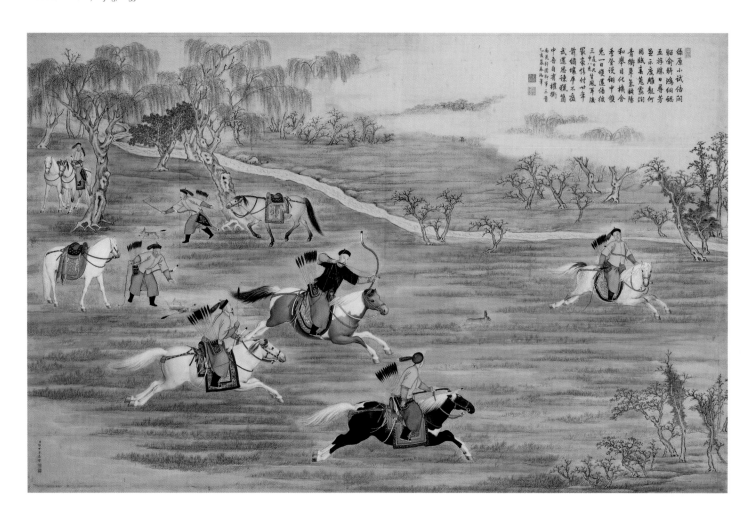

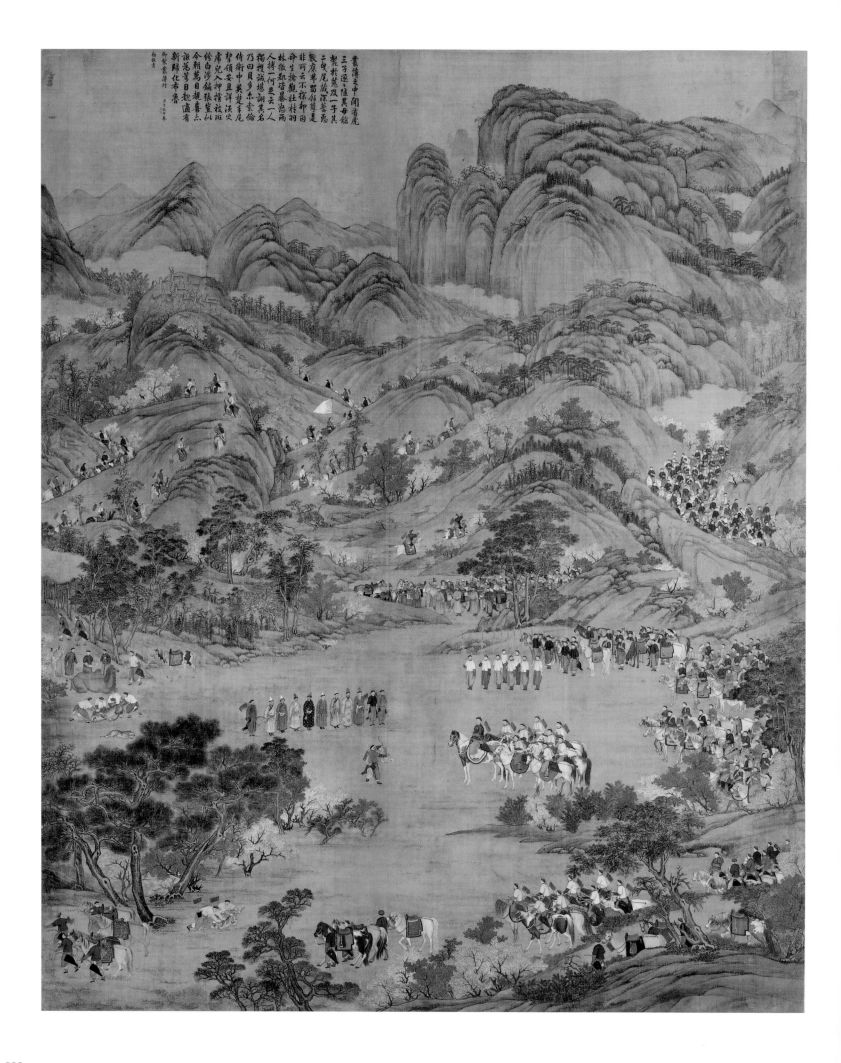

Giuseppe Castiglione
(Chinese name Lang Shining,
1688–1766) and Fang Cong
(fl.1758–1795)
*Illustration in the Spirit of the
Qianlong Emperor's Poem
'Congboxing'*

1758

Hanging scroll, colour on silk,
424×348.5 cm

Inscription: Yu Minzhong (1714–1780)

The Palace Museum, Beijing, Gu6514

Giuseppe Castiglione
(Chinese name Lang Shining,
1688–1766) and others
*The Qianlong Emperor Shooting
a Deer*

1742 (?)

Hanging scroll, colour on silk,
259×172 cm

Seals: three seals of the Qianlong
Emperor in the upper part of the
painting

Palace Museum, Beijing, Gu9204

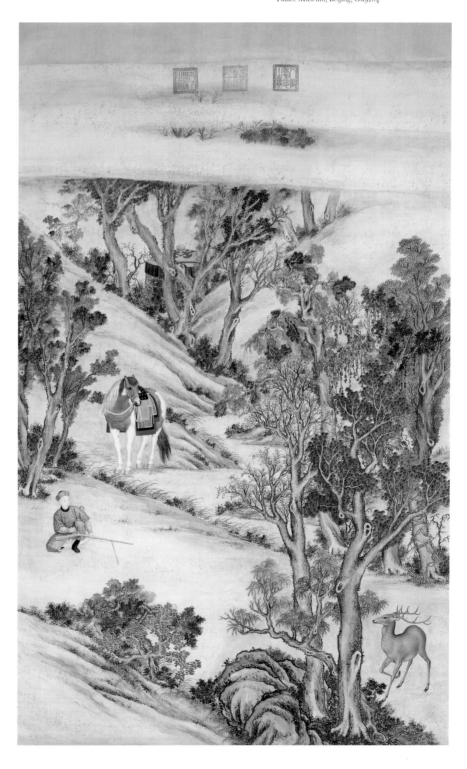

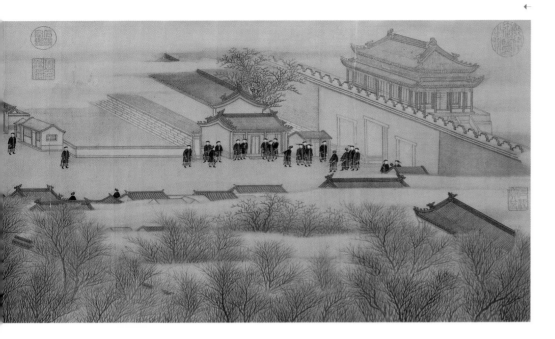

Jin Kun, Cheng Zhidao and
Fu Long'an (all active at the
imperial court during the
eighteenth century)
Ice Game on the Palace Lake

c. 1760s

Handscroll, colour on silk,
35 × 578.8 cm

Inscription: poetic essay by the
Qianlong Emperor, inscribed by Ji
Huang (1711–1794)

Seals: two by Jin Kun, two by Ji Huang,
eight seals of the Qianlong imperial
collection

The Palace Museum, Beijing, Gu6119

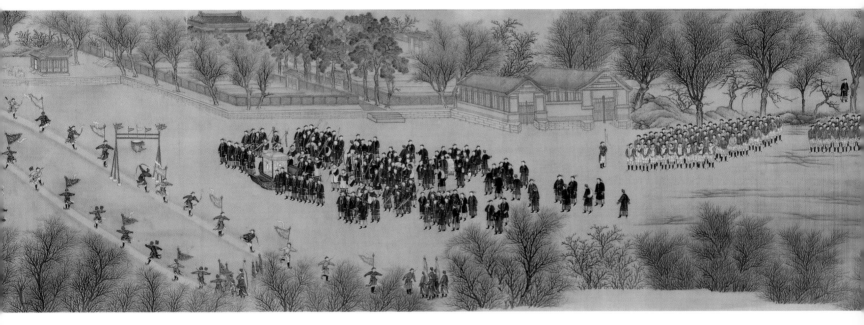

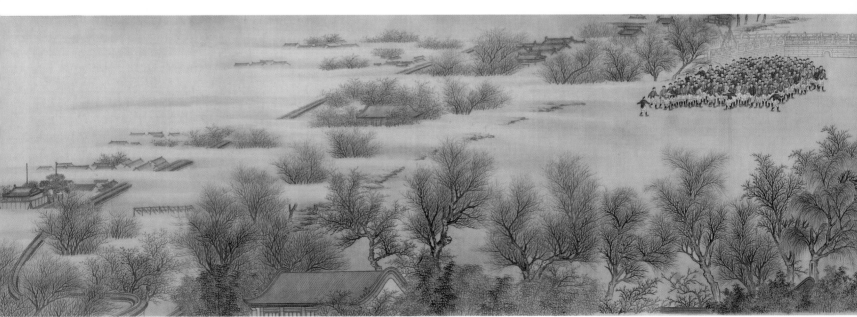

3

Ritual

PATRICIA BERGER and YUAN HONGQI

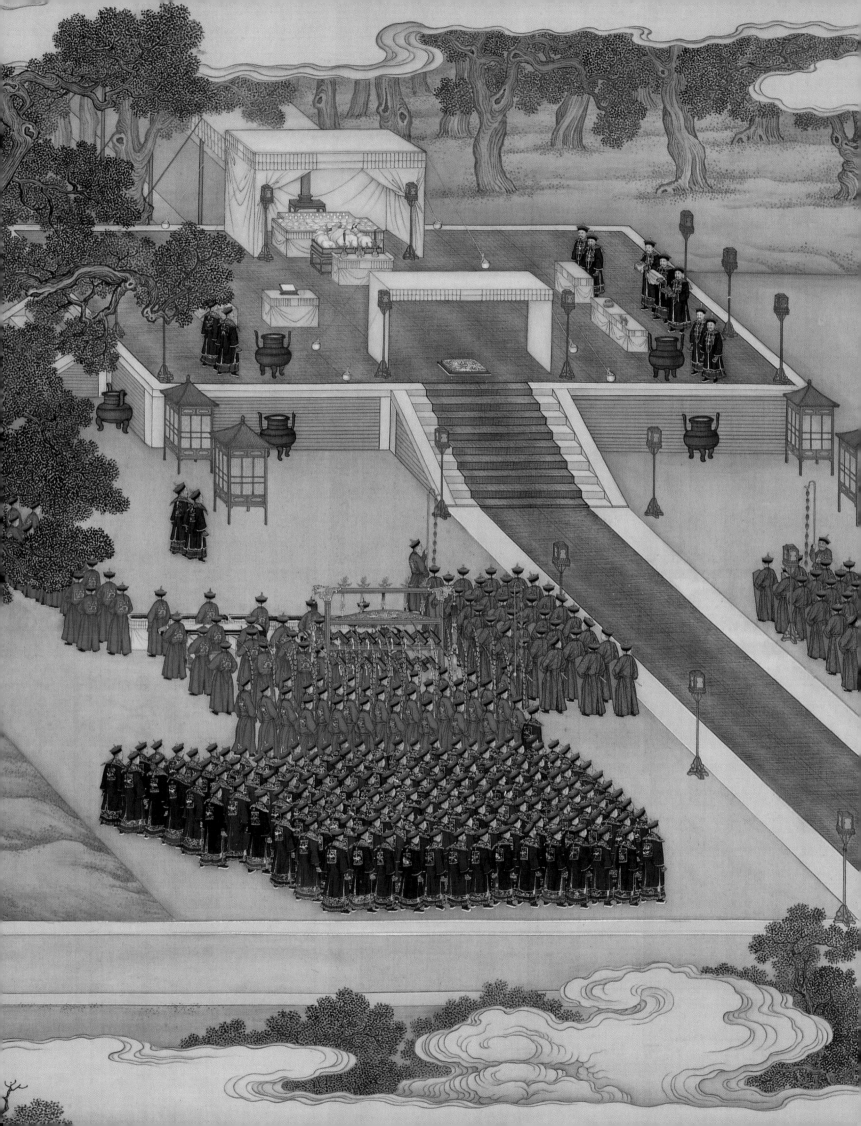

Fig. 41
Aerial view of the Temple
of Heaven, Beijing

O n 29 October 1644 the seven-year-old Manchu Shunzhi Emperor (r.1644–61) of the Qing dynasty entered Beijing under the protection of his regent, Dorgon (1612–1650), his armies and the allied troops of the Chinese general, Wu Sangui (1612–1678). The next day he proclaimed his assumption of the Mandate of Heaven – the divine right to rule China – by performing the ancient Chinese sacrifice to the Supreme Ruler of the Universe (Huangtian Shangdi) at the Ming altar, south of the Forbidden City (Zijin cheng).[1] The vast terrain of northwestern and southern China was still largely in the hands of bandits, warlords and fragmented factions of the fallen Ming dynasty (1368–1644); Qing control over China was to take decades to consolidate. Nonetheless, following ancient Chinese practices that established the Emperor as the single intermediary between Heaven and Earth, the Shunzhi Emperor's sacrifice to Heaven marked the official beginning of a new Chinese dynasty. Shortly after this momentous event, the Qing, bowing to a precedent set when the Zhou conquered the Shang in the eleventh century BC, appointed a prince of the Ming imperial lineage to preside over regular sacrifices at the tombs of the Ming emperors.

Sacrifices to Heaven, Agriculture and Silk

By far the costliest ritual burden that the Qing faced was the round of ancient Chinese sacrifices to Heaven, Earth, the Sun and Moon (cats 33–37), sacred mountains, imperial ancestors, agriculture and sericulture, which were all designed to underscore the primary values of Confucian society: humility in the face of Heaven, filial piety, productive labour and appropriate gender roles. The Qing annals show that often the emperors themselves could not fulfil their ritual obligations, either because of periods of illness or mourning or because they were on tour or at war; their clansmen often served as surrogates. Later in life, the Qianlong Emperor delegated his most solemn ritual responsibilities to his sons, on the grounds that 'there must be no error in the rite', complaining that 'he was no longer up to the strenuous "ascendings and descendings, obeisances and bowings requisite for the expected reverence" at the grand sacrifices'.[2]

The grand sacrifices were physically rigorous, as the Qianlong Emperor implied. They were also materially exacting, requiring ritual equipment that met ancient standards

of form, even if made in new materials, such as porcelain or lacquer. None was more critical than the annual sacrifice to Heaven, which marked the beginning of the dynasty's reign in China and was performed annually until its end. The sacrifice began the day before the Winter Solstice, when the Emperor went from the Forbidden City along a route blocked from public view to the inner enclosure of the Temple of Heaven (fig. 41). Crossing the 360-metre-long Bridge of Cinnabar Steps (Danbi qiao), he spent the night fasting in the moat-ringed Hall of Abstinence (Zhai gong). Two hours before daybreak, alerted that the proper sacrificial vessels and utensils were in place and the sacrifice of the victims complete, he dressed in plum-coloured robes embroidered with the twelve auspicious imperial symbols, proceeded to the altar enclosure, and waited in a yellow silk tent until the sacred tablets were brought from the Temple of Heaven. He ascended the altar's three terraces, symbols of Earth, Man and Heaven, where, to the solemn music of a carillon (see cat. 32) and flanked by ancestral tablets, he faced the tablet of the Supreme Ruler of the Universe and watched as the offering was placed on the sacrificial furnace. He then prostrated himself nine times before the tablet and

made offerings of silk and jade. After repeating this performance two more times, he waited in his tent until the tablets were safely enshrined, then returned to the palace along the same blocked route.[3]

The winter solstice began a busy season leading up to the lunar New Year, which could fall in January or February. The day before the New Year, the emperors greeted foreign emissaries in the Hall of Preserving Harmony (Baohe dian), visited their mothers, paid homage to Heaven and Earth at an altar within their own chambers, sacrificed to the shamanic Heaven, and lit incense at the shamanic altars in the Palace of Earthly Tranquillity and the Tangse, at a shrine to the domestic Kitchen God, and in the many Tibetan Buddhist and Daoist temples scattered throughout the Forbidden City. On New Year's Day the entire population of the palace moved to an elaborate ritualised choreography, designed to harmonise scores of obligations to different spirits, gods and constituencies. Beginning just after midnight, the emperors kowtowed before a portrait of Confucius in the Palace of Heavenly Purity (Qianqing gong) and before the Medicine God in the Imperial Pharmacy (Shouyao fang, literally the 'Office of Longevity Medicine'), lit incense at Daoist altars,

Fig. 42
Detail from *The Yongzheng Emperor Engaged in Ritual Ploughing*, Yongzheng period. Handscroll, colour on silk, 62 × 459 cm. Musée Guimet, Paris (MG 21449)

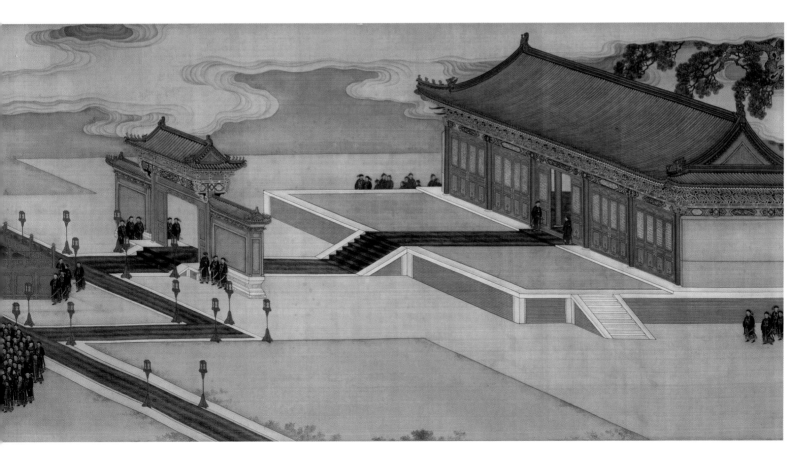

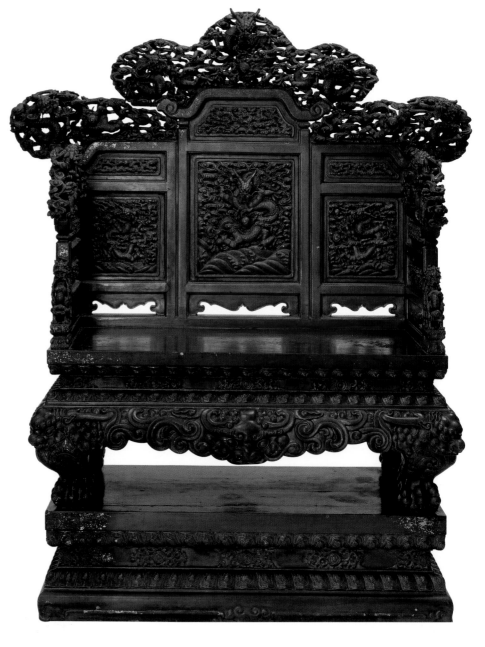

Fig. 43
Gold-lacquered throne decorated with dragons, seventeenth century. 165 × 120 × 70 cm. The Palace Museum, Beijing, Gu184334. This throne was placed inside the Emperors' ancestral temple, the Fengxian dian, and was used when making offerings to the deceased Emperor. During these his spirit tablet (fig.44) would have been placed on the seat.

Fig. 44
The Spirit Tablet of the Kangxi Emperor, Yongzheng period. Fir wood, 63.5 × 14 cm. The Palace Museum, Beijing, Gu184257. Inscribed: 'Shengzu had an immense fortune from Heaven, a master of both pen and sword, respectful, frugal, lenient, a devoted child, sincere, trustworthy, and kind. This is the spirit tablet commemorating the great achievements and benevolence of the Emperor.'

and presented offerings to portraits of imperial ancestors hung for the occasion in the Hall of the Sovereign of Longevity (Shouhuang dian; fig. 35). At the same time, the Empress Dowager, imperial wives and concubines and other palace ladies venerated the smallpox god and performed numbers of domestic rituals, all before breakfast.[4]

The Kangxi, Yongzheng and Qianlong Emperors all commissioned valuable records of their ritual activities, among them paintings and woodblock prints of their grand tours, birthday celebrations and solemn sacrifices, some of which honoured the life-sustaining work of agriculture and sericulture. In spring, the Emperor officially began the agricultural year by the ritual ploughing of furrows at an enclosure at the Altar of Agriculture (Xiannong tan; see fig. 42), one of the only times in the year when he appeared in full public view. He also sacrificed to the God of Agriculture, the culture-hero Xiannong, an event memorialised in a painting of the Yongzheng reign (cat. 38). The empress, meanwhile, modelled appropriate womanly behaviour by feeding mulberry leaves to silkworms raised at the Altar of Silkworms (Can tan). These practical and definitively Chinese tasks were also celebrated in painted and printed albums commissioned by the Kangxi Emperor.[5]

Sacrifices to the Ancestors of the Qing Emperors

In addition to the great sacrifices of State, the Qing took over Chinese practices in the offerings to their ancestors. The ancient Zhou dynasty had established the tradition

of making sacrifices to ancestors in a royal ancestral temple. Such temples were intended not only to act as memorials, but also to encourage those honoured to offer protection to their descendants. Later sacrificial ceremonies retained some of these early characteristics. Over time, the ceremonies became ever more ritualised. All such offerings included food and wine as sustenance for the ancestors.

The Manchu invaders stabilised society and ordered human relations by traditional Chinese means. These included the practice of making sacrifices to ancestors. Seven days after the Shunzhi Emperor entered Beijing (27 September 1644), he offered sacrifices to the spirit tablets of his Manchu forebears at the Temple to the Ancestors (Tai miao) which is located to the south of the Forbidden City. On 1 October, having announced the sacrifices to Heaven and Earth, described above, as well as to the Temple to the Ancestors and the Altar of Land and Grain, the Emperor also confirmed Beijing's status as the capital.

The Qing dynasty followed the Ming ritual system, regarding sacrifices at the Temple to the Ancestors as a state sacrifice, as opposed to private or family sacrifices at altars in the Hall for Worshipping Ancestors (Fengxian dian) inside the Forbidden City. The spirit tablets of deceased Qing emperors and empresses were set up in both places, as well as at the Hall of the Sovereign of Longevity located in Jingshan (Coal Hill), north of the Shenwu gate of the Forbidden City, at the imperial tombs, and in private imperial residences. Imperial tablets were also objects of ancillary sacrifice at the Altar of Heaven, Altar of Earth, and the Altar of Land and Grain. After making sacrifices at the Temple to the Ancestors, the Emperor paid his respects at the Hall for Worshipping Ancestors.

The Qing dynastic rulers practised three types of sacrifice to their ancestors: *shi xiang* (seasonal offerings), *gao ji* (declaration offerings) and *jian xin* (offerings of fresh seasonal produce).

In the first month of each season the Emperor himself performed the *shi xiang* sacrifices to his ancestors, offering fruits, vegetables and cakes. A table was positioned in front of the spirit tablets for each pair of emperors and empresses. On it were placed prescribed groups of ritual vessels,

comprising vessels for food: two *deng* and two *xing*, 20 *bian* and 20 *dou*, two *fu* and two *gui* (see figs 45–46); and drinking vessels: nine *zun*, 17 golden *jue* and 34 porcelain *jue*.

The Emperor made the *gaoji* declaration offerings in the Hall for Worshipping Ancestors for important dynastic events, such as his accession to the throne, when titular honours were conferred on princes, consorts or other members of the imperial family; his birthday; his wedding; on the crowning of the empress; when personally leading the army in battle; commanding a general; or returning in triumph. Sacrifices were made at the tombs on the death day of the Emperor or empress; the first and fifteenth of each lunar month; at Qingming (the spring festival when graves are swept); Zhongyuan (the fifteenth day of the seventh month); the winter solstice; and at the end of the year.

On the first day of each month, the *jian xin* ritual offerings of fresh seasonal produce were made to the ancestors. At each temple (for a pair of deceased emperors and empresses), offerings were made comprising one sheep, one pig and goose meat broth with rice. These were served on a table together with ritual vessels: eight *bian* and eight *dou*, two *fu*, two *gui*, two *deng* and two *xing* and three *zun*. Particular foods were prescribed for specific months. For the first lunar month, for example, carp, leeks and duck eggs were required; for the second, lettuce, spinach, spring onions, celery and mandarin perch, and so on.

The front chambers of the Temple to the Ancestors and the Hall for Worshipping Ancestors were used for making the *shi xiang* seasonal offerings and the *gao ji* declaration offerings. Eating and drinking vessels were placed on a sacrificial table set up in front of the spirit tablet of each pair of emperors and empresses. The rear chamber was for resting and contained a tent, a throne (fig. 43), a screen and a spirit tablet (fig. 44). Normally the spirit tablet was placed in the resting chamber, but during the sacrifice the tablet and throne were placed behind the sacrificial altar in the front chamber. Ritual vessels such as *deng*, *xing*, *fu*, *gui*, *bian*, *dou*, *zun* and *jue* were arranged on the sacrificial altar, along with fresh seasonal vegetables and other produce.

Fig. 45
Yellow-lacquered bamboo *bian* (altar food vessel) with cloud and dragon design, Qianlong period. Bamboo, height 28.8 cm, diameter 15.2 cm. The Palace Museum, Beijing, 19-8/19

Fig. 46
Gold-lacquered *dou* (altar food vessel) inlaid with jade, Qianlong period. Wood, height 27 cm, diameter 16 cm. Reign mark: *Daqing nianzhi*. The Palace Museum, Beijing, 19-6/7

Set of sixteen sonorous
stones (*bianqing*) with dragon
and cloud motif

Qianlong 29th year (1764)

Nephrite with stand of gold-lacquered
wood, height 350 cm

The Palace Museum, Beijing, Gu169354, 1–15/16

Set of sixteen bells (*bianzhong*)
with dragon and cloud motif

Kangxi 52nd year (1713)

Gilt bronze with stand of gold-lacquered
wood, height 350 cm

The Palace Museum, Beijing, Gu169500, 1–16

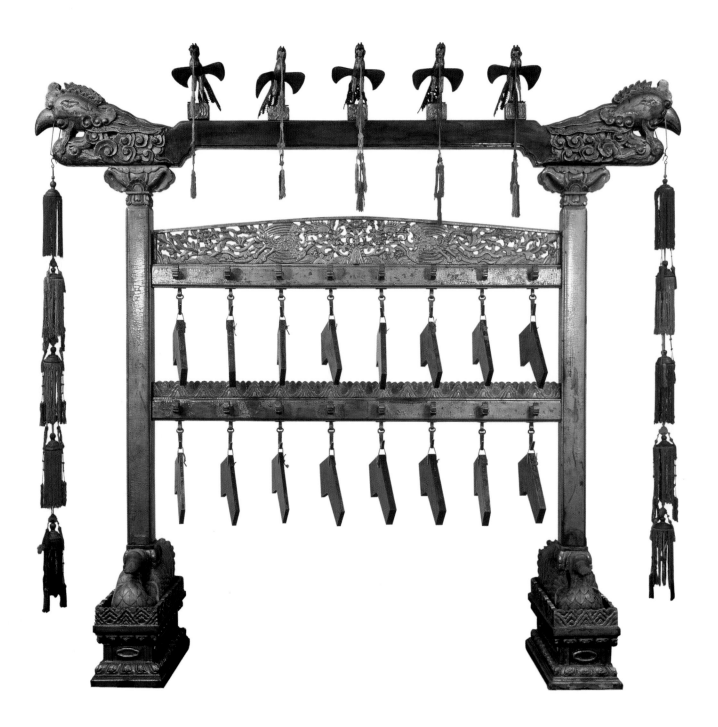

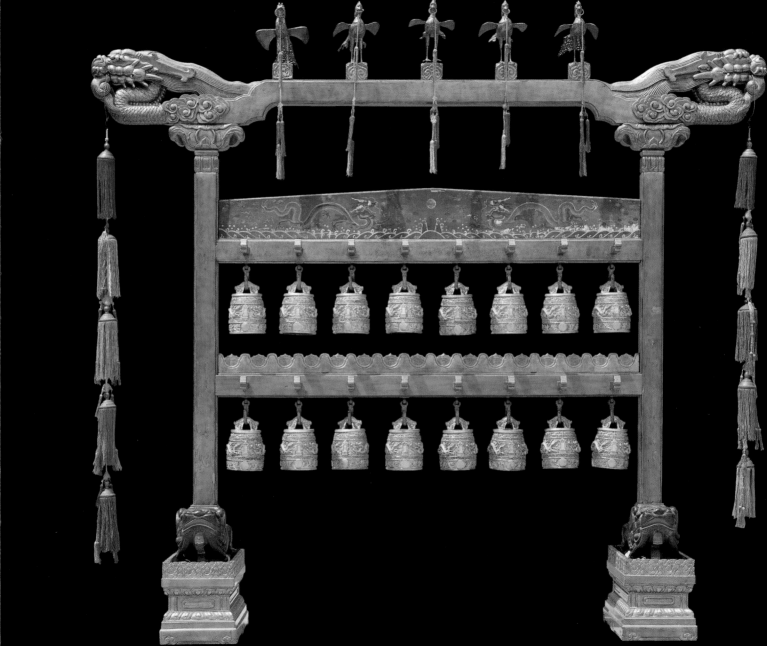

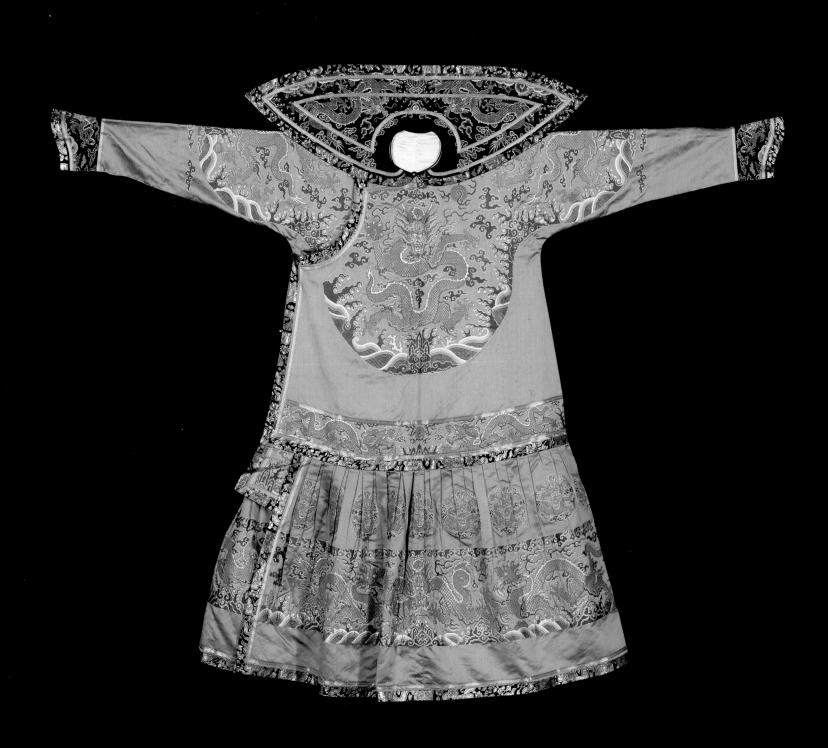

33

Emperor's 'moon white'
court robe (*chaofu*)

Yongzheng period

Silk satin with brocaded areas of
polychrome silk and metal threads,
length 143 cm. Collar embroidered
with silk and metal thread and trimmed
with silk and metal thread brocade

The Palace Museum, Beijing, Gu41893

34 →

One of a pair of *dou* (altar food
vessels) with patterns in light
relief

Qianlong period

'Moon white' porcelain, height 28 cm

The Palace Museum, Beijing, Gu186402

35 ↘

One of a pair of *fu* (altar food
vessels) with patterns in light
relief

Qianlong period

'Moon white' porcelain, height 23.5 cm

The Palace Museum, Beijing, Gu186476

36 ↗

One of a pair of *xing* (altar soup
containers) with patterns in light
relief

Qianlong period

'Moon white' porcelain, height 27 cm

The Palace Museum, Beijing, Gu186519

37 ⇒

One of a pair of *gui* (altar food
vessels) with patterns in light
relief

Qianlong period

'Moon white' porcelain, height 24 cm

The Palace Museum, Beijing, Xin7549

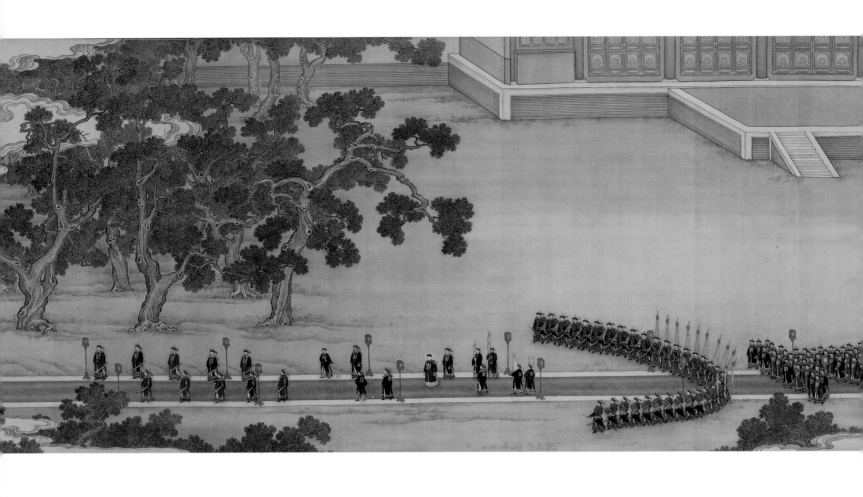

Anonymous court artists
*The Yongzheng Emperor
Offering Sacrifices at the Altar
of the God of Agriculture*

1723–35
Handscroll, colour on silk,
61.8 × 467.8 cm

The Palace Museum, Beijing, Xin121320

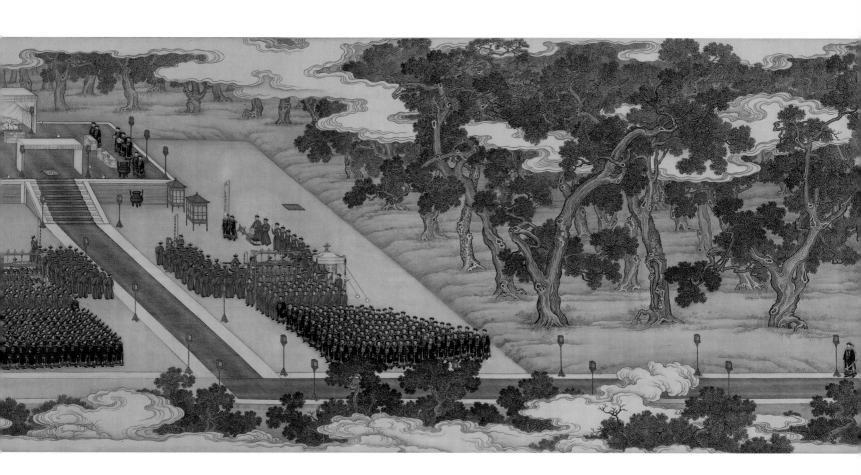

Religion

PATRICIA BERGER

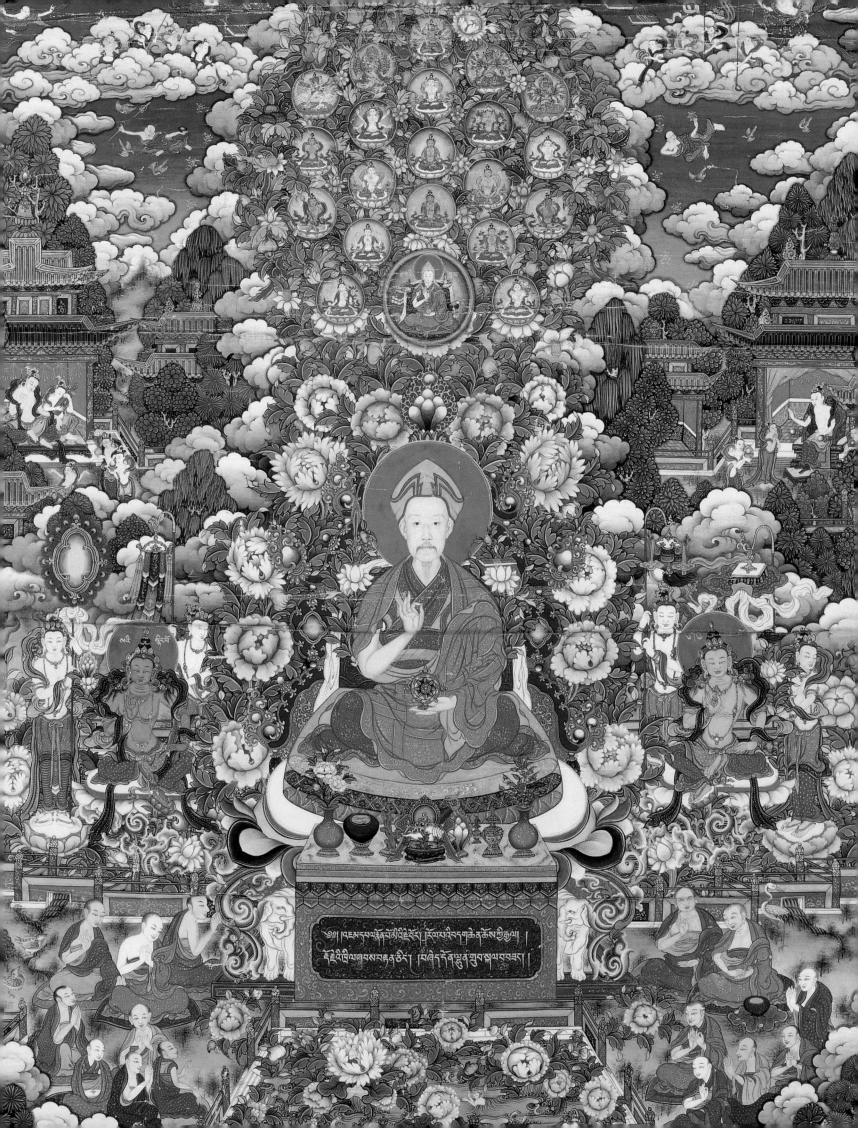

The Manchus were not a united people before they came together in the 1630s to challenge Mongol ambitions to topple the Ming dynasty (1368–1644) and recapture China. The fiction of pre-dynastic unity was crafted in the early years of the Qing, when an origin myth was conceived that included a sacred magpie who, by dropping a red fruit, miraculously impregnated a maiden with the first ancestor of the Aisin Gioro clan.[1] They also created the name 'Manchu' for themselves and slowly began to define its meaning. Central to the notion of what it meant to be Manchu was shamanism, a religious practice of the peoples of northeast Asia that views the world as set beneath the overarching dome of heaven, animated by spirits whom male or female shamans can contact in a state of trance. In its original form Manchu shamanism was not an institutionalised religion with a priestly hierarchy or written canon; in no small measure, its practices depended on the extemporaneous and unpredictable ability of spiritually gifted individuals.

Shamanic rituals were established at the Qing court immediately after the Manchus' entry into Beijing in 1644. They were rapidly integrated into the ritual calendar and, in 1747, rigorously normalised in the *Imperially Commissioned Code of Rituals and Sacrifices of the Manchus*, established by the Qianlong Emperor to maintain – or to invent – a unified sense of Manchu cultural identity.[2] The *Code* is an eclectic document in which shamans appear as an organised corps of ritualists and not as uncontrollable individuals able to communicate with spirits through trance (fig. 47). As well as rules for daily, monthly and annual ceremonies, sacrifices to specific gods, rituals of propitiation, prayers for the health of children and horses, the Great Sacrifice of Lifting the Sacrificial Pole to connect Earth and Heaven, illustrations showing the proper forms of ritual implements, and even instructions for the Bathing of the Buddha, it includes prescriptions for the New Year's Day rituals at the Palace of Earthly Tranquillity (Kunning gong), the imperial marriage chamber located at the northern end of the Forbidden City (Zijin cheng), and the Tangse, a Manchu shrine southeast of the imperial compound.

At the time of their conquest of Han China the Manchus were in the middle of

a major military campaign in Mongolia, and were confronted by Tibetan Buddhist lamas intent on conversion. The Manchus actively courted the politically astute Gelugpa (Yellow Hat order), whose leader, the Great Fifth Dalai Lama (1617–1682), sent emissaries to the Manchu capital at Mukden (modern Shenyang) in 1643, just a year before their Chinese campaign began in earnest. In 1652, the Great Fifth himself travelled to Beijing, where he recognised the Shunzhi Emperor as a *cakravartin* world-ruler who would unify Tibet, Mongolia and China into a single Buddhist empire.[3]

The Qing emperors' grand plan to reign as universal rulers over an empire that extended far beyond China was fulfilled during the Qianlong reign, when Qing territories stretched from their Manchurian homeland through China, Mongolia, Central Asian Xinjiang and, by means of diplomatic détente, into Tibet. Throughout this lengthy campaign, the Qing incorporated the diverse ritual practices they encountered into the unique and ecumenical amalgam that defined their court. This is not to say that they were intent on creating an egalitarian multiculturalism; but rather that they saw the value of controlling newly conquered territories by speaking to subjects in their own native languages and through the medium of their own cultural practices.

The Qing funnelled immense resources into their religious projects through the Imperial Household Department (Neiwu fu) and the Ministry of Rites. The Kangxi, Yongzheng and Qianlong Emperors alone established dozens of temples in Beijing, most of them dedicated to Tibetan Buddhism and the Confucian rituals of the state. But daily records of the court also show that they promoted many other religious activities, especially shrines for their own Manchu spirits, for the Chinese war god Guandi (who rapidly merged with the Tibetan hero, Gesar), and for the beloved bodhisattva of compassion, Guanyin (Sanskrit: Avalokitesvara), as well as Islamic mosques and Christian churches. They personally performed Daoist-inspired acts of abject penitence before local dragon-gods during years of drought, and patronised such popular Daoist figures as Zhenwu, god of the north, Dongyue, the Eastern Peak, and Bixia Yuanjun, the Lady of the Azure Clouds, all of whom were honoured with imperial

Fig. 47
Pair of shamanic deities, possibly called Kedun Nuoyun, eighteenth century or earlier. Cloth with stuffing, height 120 cm. The Palace Museum, Beijing, Gu199754-1/2

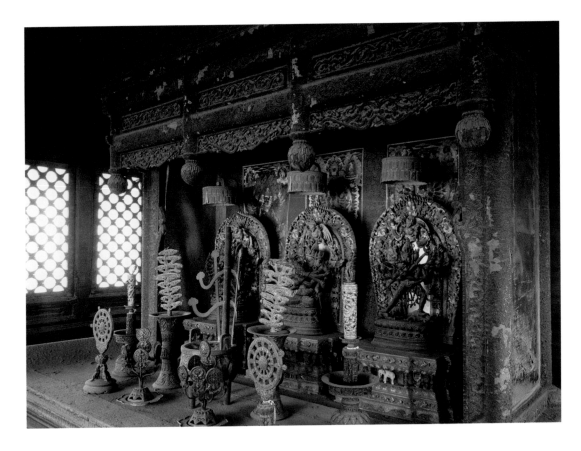

Fig. 48
The interior of the fourth floor of
the Pavilion of the Rain of Flowers
(Yuhua ge) in the Forbidden City

support at the main temple of the Quanzhen
(Complete Truth) sect of Daoism, the White
Cloud Monastery (Baiyun guan) in Beijing.

Tibetan Buddhism and the Qing Court

The Qing emperors' support of Tibetan
Buddhism had both political and personal
benefits, since it guaranteed solidarity
with the dynasty's Mongol and Tibetan
allies, assured health, long life and
abundance, and promised rapid progress
to enlightenment. Chinese, Tibetan and
Mongolian documents make it clear that
while all the Qing emperors understood
the political advantages of supporting the
Tibetan Buddhist establishment, some,
particularly the Qianlong Emperor and, to
a lesser extent, his grandfather the Kangxi
Emperor, were more personally involved
in Tibetan Buddhist practices.

On the political side, the chain of events
is well established. The Kangxi Emperor's
father, the Shunzhi Emperor, invited the
Great Fifth Dalai Lama to Beijing in 1652,
in part to thank him for recognising the
Manchus' destined role in uniting China,
Mongolia and Tibet into a single Buddhist
empire. However, vigorous Manchu
preference for the Tibetan Buddhist
Gelugpa, the order of the Dalai Lamas,

had been spurred in 1640 by the Dalai and
Panchen Lamas' joint recognition of the
Manchu rulers as emanations of Manjusri,
the bodhisattva of wisdom who was
believed to dwell in China at Wutai shan
(Mount Wutai), near the Mongolian border
(see cat. 40).[4] The Kangxi Emperor may
have been the first to take the title
'Manjughosa Emperor', referring explicitly
to his own bodhisattvahood in his preface
to a Mongolian translation of the *Kanjur*, the
Tibetan Buddhist canon, completed in 1720.[5]
His son, the Yongzheng Emperor, was much
more interested in Chan Buddhism (he wrote
his own *Discourse Record* of the conversational
exchanges of famous Chan monks) but
even he appears in an album of playful
guise portraits (cat. 167) dressed in the
robes of a Gelugpa lama, resisting the
temptations of a red snake (see p. 251).[6]

Tibetan Buddhism reached its greatest
popularity at court under the Yongzheng
Emperor's heir, the Qianlong Emperor.
He appears in a number of portraits
as a consecrated Gelugpa lama who
simultaneously holds the *dharmacakra* (wheel
of the law) of a *cakravartin* world-ruler and
carries the attributes of Manjusri on his
shoulders (cat. 47). His guru, Rolpay Dorje,
who held the religious title of Zhangjia
Hutuktu[7] ('the Zhangjia Incarnate') and

Fig. 49
The Putuozongcheng miao (Potala),
Chengde (formerly Rehe). The Qianlong
Emperor built this replica of the Potala
Palace, the Dalai Lama's palace-temple
at Lhasa, in 1771 to commemorate the
eightieth birthday of his mother, the
Dowager Empress Xiaosheng.

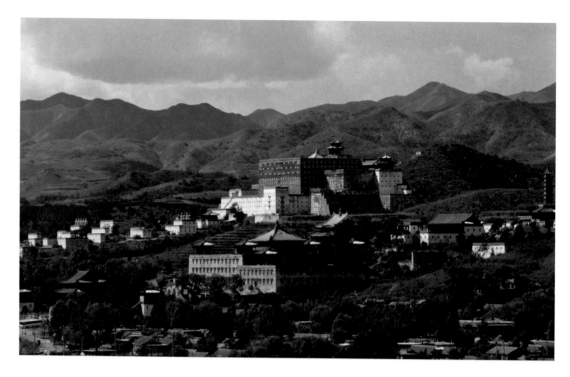

was further designated by the Emperor as Zhangjia Guoshi ('Zhangjia National Preceptor'), sits above him. Rolpay Dorje's biography reveals that he initiated the Qianlong Emperor into Tibetan Buddhism in 1745 and that the Emperor continued to study Buddhist texts and receive teachings from him until his death in 1786. Internal court documents confirm that the Emperor behaved towards his guru as any proper disciple would, even kneeling before him to touch his head to Rolpay Dorje's foot.[8]

Both the Kangxi and Qianlong Emperors left extensive material evidence of their regular engagement with Buddhism. Between them, they personally wrote out thousands of copies of the *Heart Sutra* and supported extravagant prayers for imperial birthdays that featured thousands of lamas simultaneously chanting the *Sutra of the Buddha of Boundless Life* for days on end. They also poured immense resources into the construction of Buddhist monasteries and shrines in Beijing (fig. 48), Rehe (present-day Chengde, also known as Jehol), Mongolia and Tibet, which they filled with paintings, textiles, sculpture and ritual implements. These objects, like the whole of Qing visual culture, often represent an eclectic collage of styles that joins Tibetan iconography with Chinese landscape and even European-style portraiture. The court's appetite for this kind of material was so great that it required a separate centre of production, which was established at the Hall of Central

Righteousness (Zhongzheng dian), the headquarters of Tibetan Buddhism within the Forbidden City.[9] Directed by Rolpay Dorje and other learned iconographers, artists there produced gifts of all sorts for Tibetan and Mongolian lamas and endless images of Amitayus, the Buddha of Boundless Life, for birthday celebrations. They also designed and furnished the many multi-chambered or multi-storeyed meditation chapels that were built in the Forbidden City to map out a gradual path to enlightenment for the Emperor and his family to follow.[10]

The Kangxi Emperor and his grandson spent many months of the year away from Beijing, either on tour or in their summer residences in the suburbs or at Rehe to the northeast, a memory that the Qianlong Emperor nostalgically recalled in his later years (the Yongzheng Emperor, it seems, had less gusto for the outdoors and conspicuously avoided Rehe). The imperial estate at Rehe was originally intended as a hunting lodge, where Manchus could celebrate their roots together with their Mongol allies and kin.[11] Eventually elegant pavilions in the southern Chinese style were built there, together with artificial lakes and a miniature grassland that reproduced the Mongolian steppe. Under the Kangxi and Qianlong Emperors, Rehe also became a site for temple building, Buddhist study and diplomatic exchange with Tibet. The series of Eight Outer Temples, all of them ostensibly modelled on Tibetan

prototypes such as Samye, Tibet's oldest monastery, and the Potala Palace of the Dalai Lama (fig. 49), were dedicated not just to the deities of the Buddhist pantheon but also to the celebration of great political and military events (fig. 50).[12] One of them, the Xumifushou miao (the Sumeru Temple, also known by its Tibetan name, Tashilunpo, was modelled in concept, if not in form, on the home monastery, also called Tashilunpo, of the Sixth Panchen Lama, who came to Rehe with great ceremony in 1780 (and tragically died of smallpox shortly afterwards at the Yellow Monastery, or Huang si, in Beijing). Rehe thus functioned as a place that replicated in microcosm some of the greatest sights of China, Mongolia and Tibet (a place no Qing emperor ever visited) and also embodied in material form the series of triumphs that added territory and power to the Qing empire.

The similarity of some of the goals of Tibetan Buddhist and native Chinese Daoist practices – self-cultivation, long life, good fortune and other worldly boons – may help to explain why Daoism received less support from the Qing. The Yongzheng Emperor was a great exception to this; he was very attracted to Daoist longevity practices, which may in the end have killed him because of his over-indulgence in lead-based elixirs of life.[13] But, beyond its patronage of the White Cloud Monastery in Beijing, the court in general may also have avoided overt support of Daoism because, unlike Buddhism, it was understood as a purely Chinese and essentially uncontrollable system of belief that, in contrast to Confucianism, involved a set of occult practices designed primarily for individual cultivation, not statecraft. Even so, elaborate Daoist celebrations were regularly staged around the Qianlong Emperor's birthday during his reign, along with festivities and rituals of all sorts, and the grandest and lengthiest of Daoist rituals, the *jiao* rite of communal renewal, also received regular imperial support.[14]

From the practical perspective of governance, the Qing emperors' appropriation of the rites and traditions of their diverse subjects and their support of an all-encompassing ritual calendar have to be seen as brilliant manoeuvres that enabled them successfully to rule a vast empire in ways each of their constituencies could understand, if not necessarily welcome.

Each group was simultaneously included and kept carefully separate and all ceremonial interchange was controlled by protocol. The court's theatricality and pomp so thoroughly circumscribed imperial life that the emperors' every action was constrained by rule or precedent. However, the real brilliance of the high Qing, truly one of China's most splendid periods, is in its transformation of traditional restrictions into an arena for creative invention. In this grand enterprise, religion and ritual played a major role.

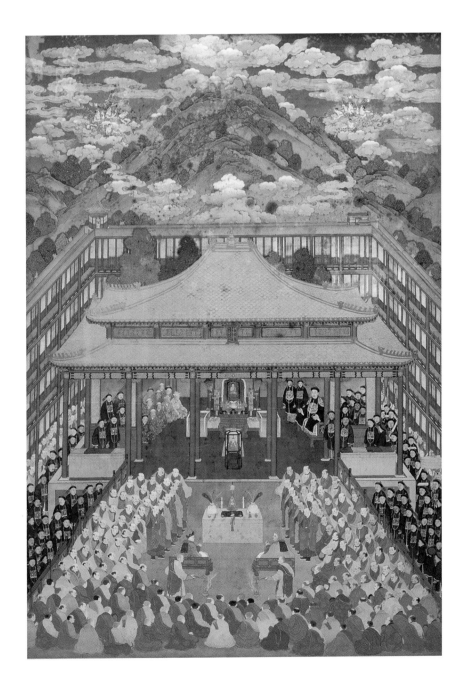

Fig. 50
Ignaz Sichelbarth (1708–1780) and others, *Ten Thousand Dharmas Return as One* (*Wanfa guiyi tu*), Qing period. Screen painting, colour on silk, 164.5 × 114.5 cm. The Palace Museum, Beijing, Gu6540. In the summer of 1771, the Qianlong Emperor held a reception for the Torghut Mongols at the Wanfa guiyi (Ten Thousand Dharmas Return as One) Pavilion in the Putuozongcheng miao (fig. 49) to celebrate their 'return' or submission to the Qing state. This collaborative painting by the Bohemian Jesuit painter Ignaz Sichelbarth and a group of Chinese, Tibetan and Mongolian artists led by the court painter Yao Wenhan commemorates this important event. It was designed to be placed in the imperial yurt at Chengde (see cat. 76) as a backdrop for the Qianlong Emperor's reception of his Mongol allies.

39

Buddhas of the Five Directions and the 35 Buddhas of Confession

*c.*1772

Five hanging scrolls mounted together, colours and gold pigment on cloth, 137 × 51.5 cm

The Palace Museum, Beijing, Gu200538

Manjusri Namasamgiti

Eighteenth century

Partial-gilt copper,
height 77.5 cm

The Palace Museum, Beijing, Gu203380

*Palden Lhamo with Images of
All the Buddhas of Great Benefit
for Everything*

1777

Thangka, gold pigment on
black layered paper, 120 × 70 cm

Inscriptions: poem by the Qianlong
Emperor, date and inventory tag,
all in Chinese, Manchu, Mongolian
and Tibetan

The Palace Museum, Beijing, Gu200645

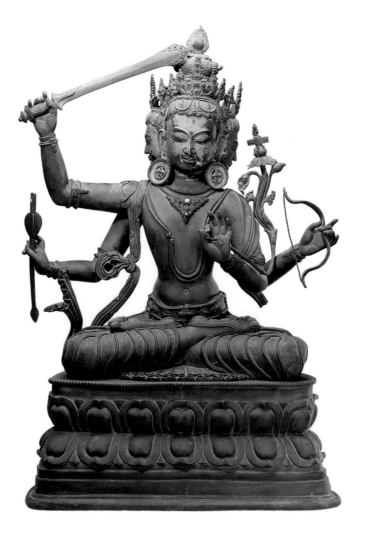

41 ↓

The Buddhas of the Five
Directions: Amitabha,
Amoghasiddhi, Vairocana,
Ratnasambhava and Aksobhya

Thirteenth century, Western Tibet

Bronze, height 47 cm

The Palace Museum, Beijing, Gu200606, 1–5

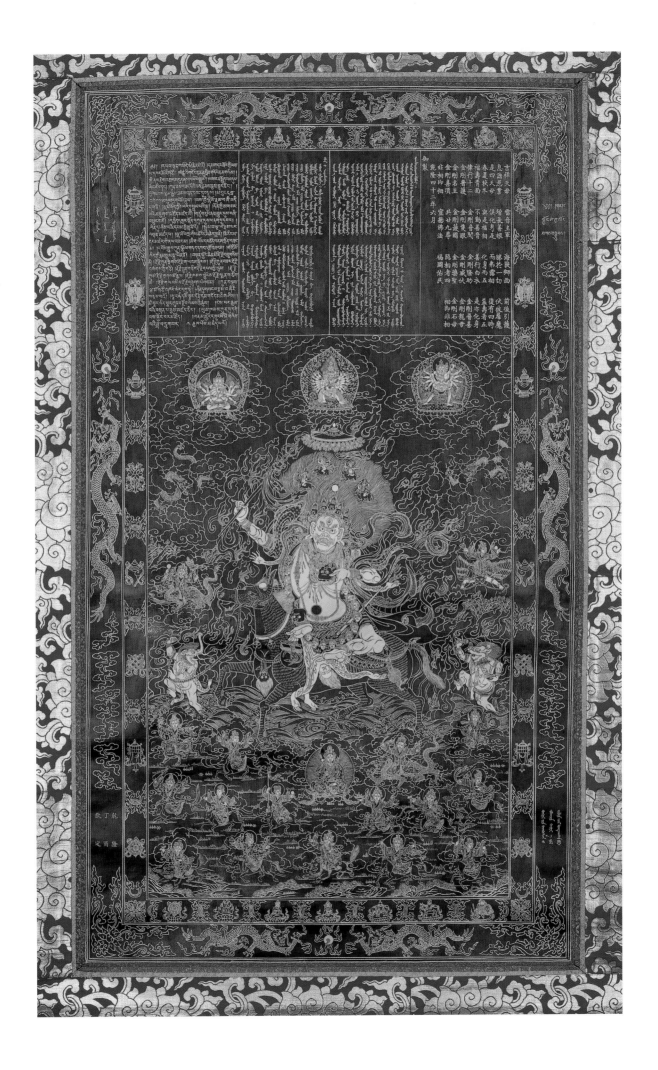

137

44 →

Altar set: a pair of flower vases, a pair of candlesticks and a censer

Qianlong mark and period

Flower vases: cloisonné enamel, silver, stained ivory and semi-precious stones, height 58 cm; candlesticks: cloisonné enamel and lacquered wood, height 43 cm; censer: cloisonné enamel on copper alloy, height 22.7 cm

Qianlong four-character reign mark

The Palace Museum, Beijing, Gu200662, 1–5

43 ↓

Embroidered table skirt with the Eight Auspicious Symbols and the Seven Royal Treasures

Eighteenth century

Embroidered silk, 80 × 224 cm

The Palace Museum, Beijing, Gu76642

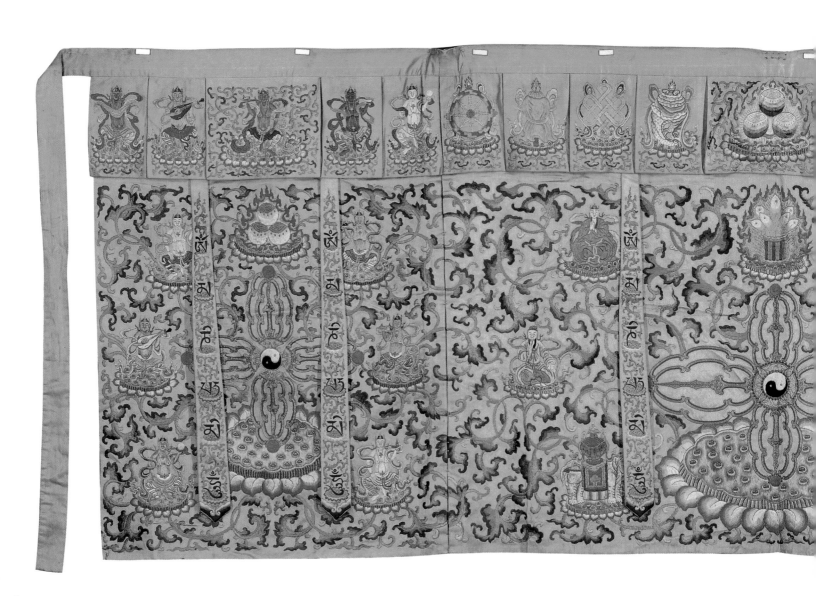

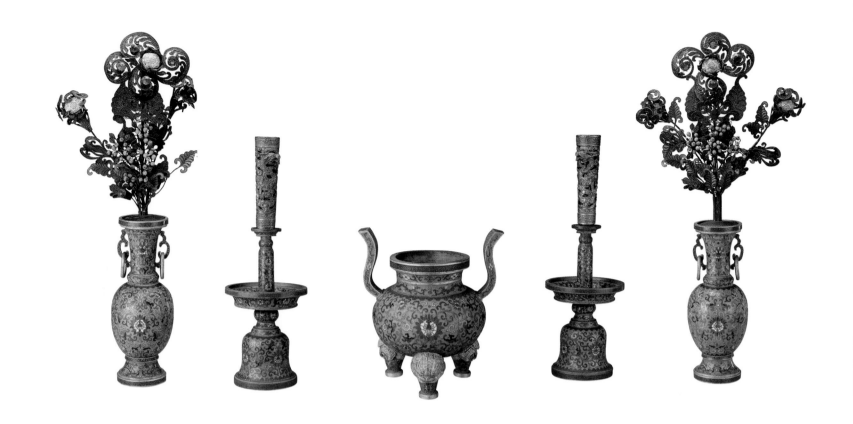

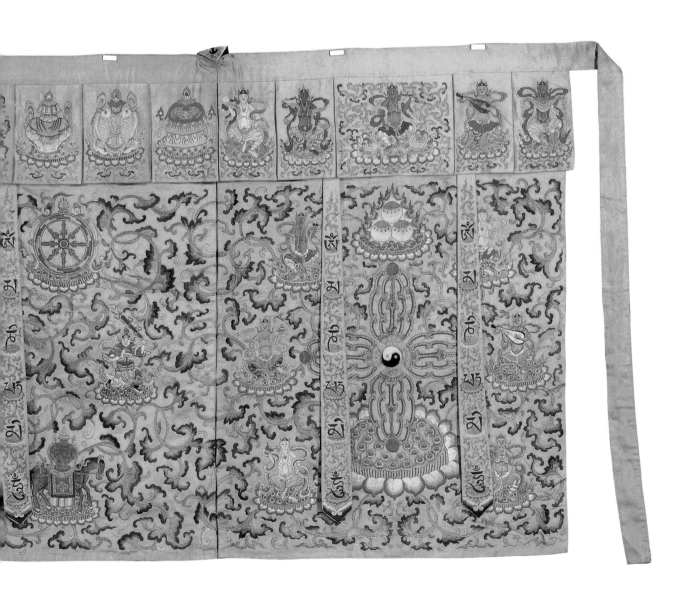

Set of Seven Royal Treasures:
Golden Wheel, Horse,
Elephant, Loyal General, Able
Minister, Woman, Divine Pearls

Eighteenth century

Dark green jade, gold and semi-precious
stones on sandalwood, jade and silver-
inlaid stands, height 32 cm

The Palace Museum, Beijing, Gu93237, 1–7

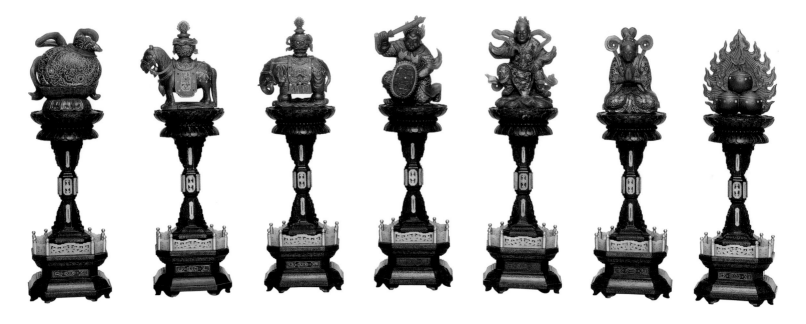

46 ↓

Set of Eight Auspicious Symbols:
Wheel of the Law, Conch Shell,
Victory Banner, Parasol, Lotus,
Vase, Paired Fish, Endless Knot

Eighteenth century

Dark green jade, gold and semi-precious
stones on sandalwood, jade and silver-
inlaid stands, height 32.5 cm

The Palace Museum, Beijing, Gu100739, 1–8

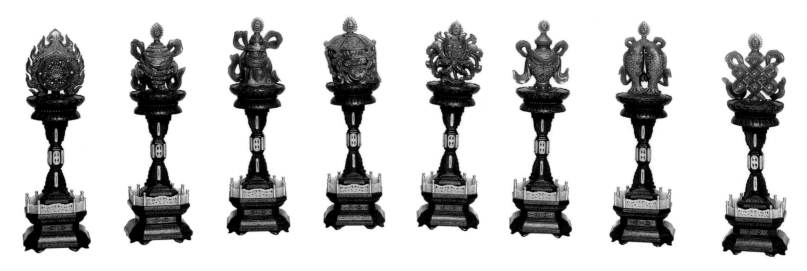

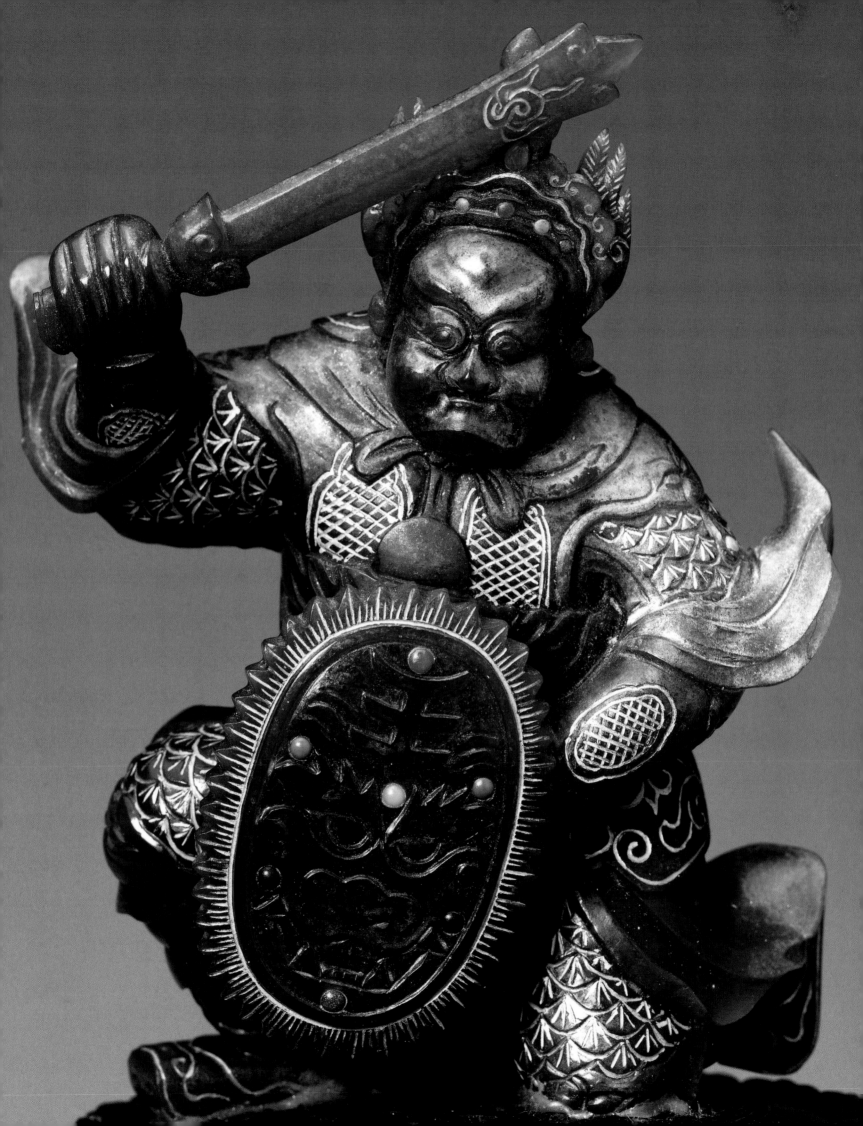

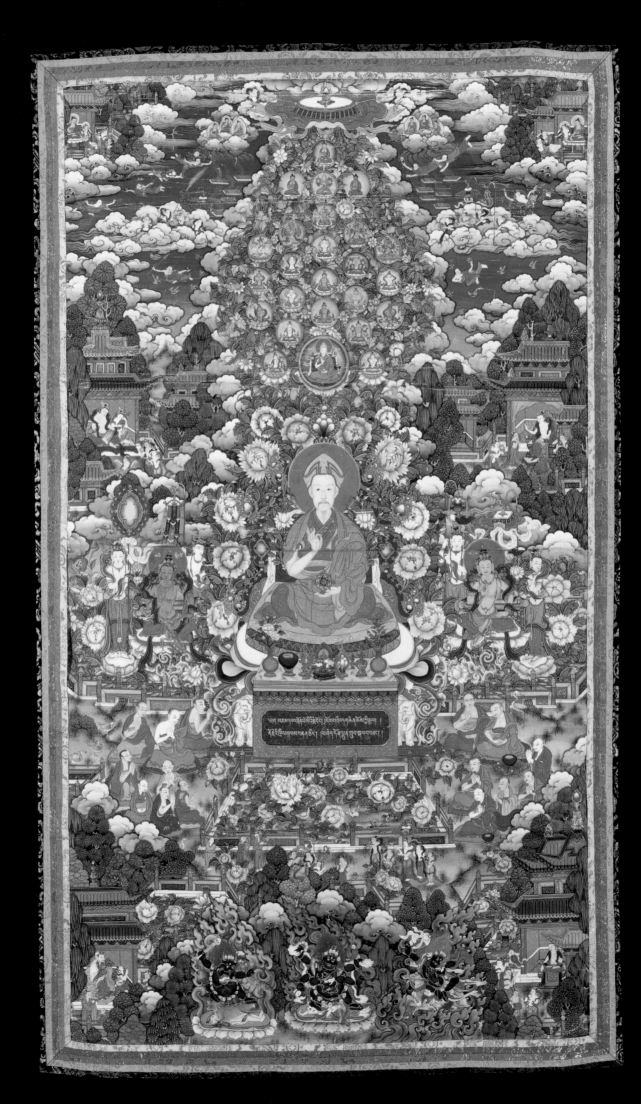

Anonymous
The Qianlong Emperor in
Buddhist Dress, Puning si

*c.*1758

Thangka, colours on cloth,
108 × 63 cm

Inscription in Tibetan

The Palace Museum, Beijing, Gu6485

48 →

Ceremonial costume for an
imperial lama: collar, sleeves,
skirt and beaded apron

Eighteenth century

Polychrome floss silk and metal thread
embroidery on silk satin ground, silk
and metal thread brocaded binding
around the edge, and stained ivory,
length of skirt 96 cm, collar 122 × 95 cm

The Palace Museum, Beijing, Gu59529

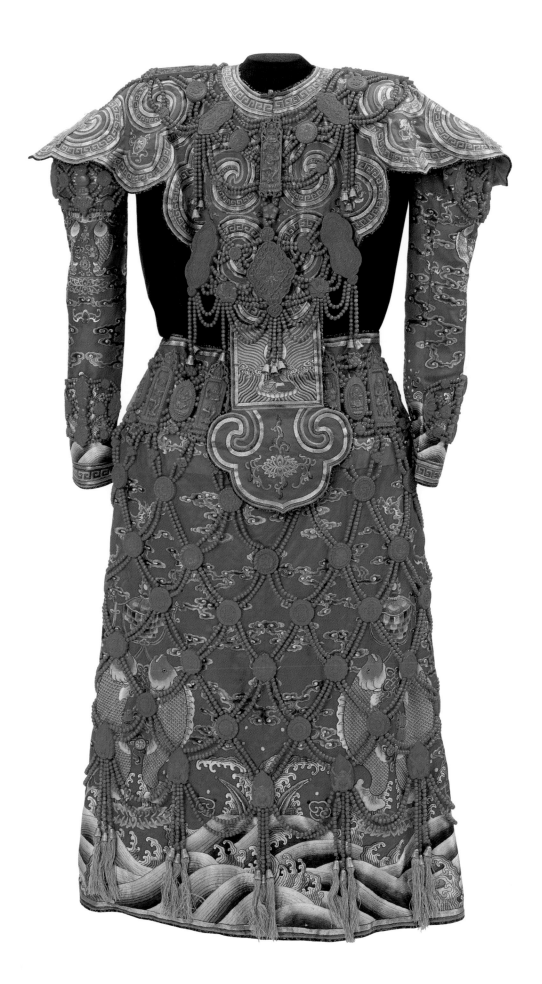

喇嘛說

佛法始自天竺　即厄納特珂克部
流而至西番　其地曰痕都斯坦部
又相傳稱為喇嘛　其地曰三藏部即番僧
書不載元明史中或訛作西番喇嘛之字謂
上即漢語稱僧為上人之意謂番
喇嘛又稱黃教蓋自西番為高僧
帕克巴思巴輩作一章嘉國師相襲
明封帝師國師者皆有之初封帕
至今者我朝惟康熙年間祇封一章嘉國師
元明之舊撰其謚勅耳

予既為喇嘛說以清漢蒙古西番四體字勒石西藏
大昭及雍和宮達賴喇嘛班禪額爾德尼咸知遵奉
乾隆壬子孟冬御筆

49

The Qianlong Emperor
(1711–1799)
On Tibetan Buddhism
(*Lama shuo*) (detail)

1792

Handscroll, ink and colour
on paper, 35 × 230 cm

Chinese, Manchu and Mongolian
(?) inscription

The Palace Museum, Beijing, Gu238658

Scripture of Great Perfections
(Dadujing)

1743

Unbound leaves, gold on paper,
each 21.6 × 62.7 cm; boards:
painted lacquer on wood,
each 12.9 × 49.5 cm

The Palace Museum, Beijing, Zong23678

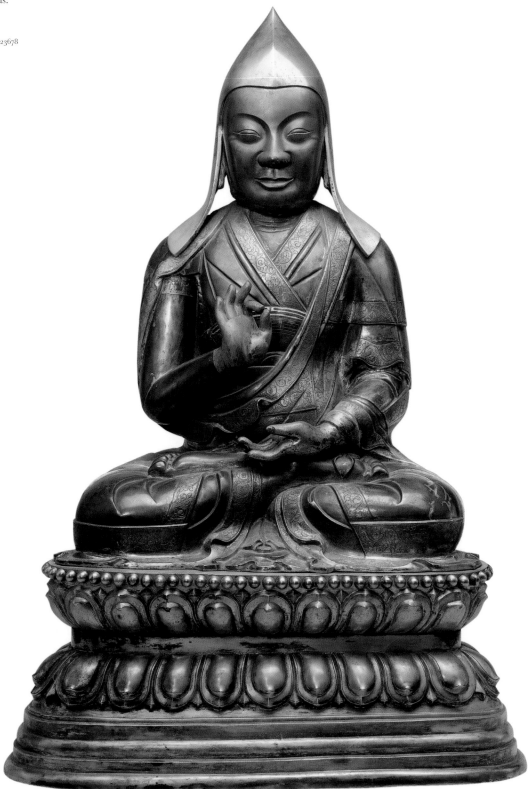

51 ←

The Zhangjia
National Preceptor

1786

Partial-gilt silver,
height 75 cm

The Palace Museum, Beijing, Gu203431

52 →

Stupa

Qianlong mark and period

Gilded metal and silver inlaid with ruby, turquoise and lapis lazuli, height 167 cm

Qianlong seven-character reign mark

The Palace Museum, Beijing, Gu178149, Gu185491

53 →

Mandala

Eighteenth century

Gilt bronze and cloisonné enamels, height 56 cm

The Palace Museum, Beijing, Gu185348

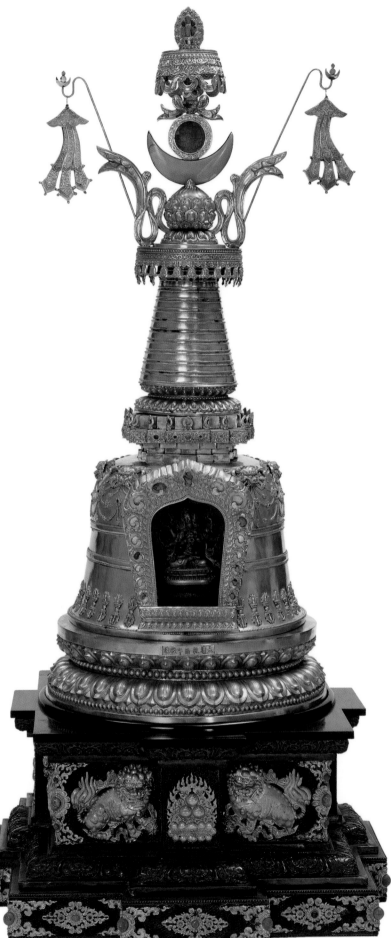

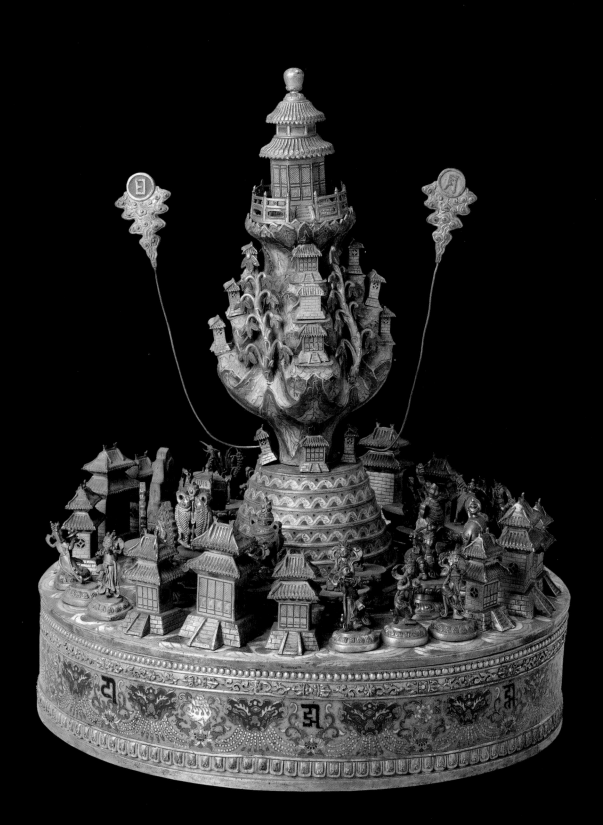

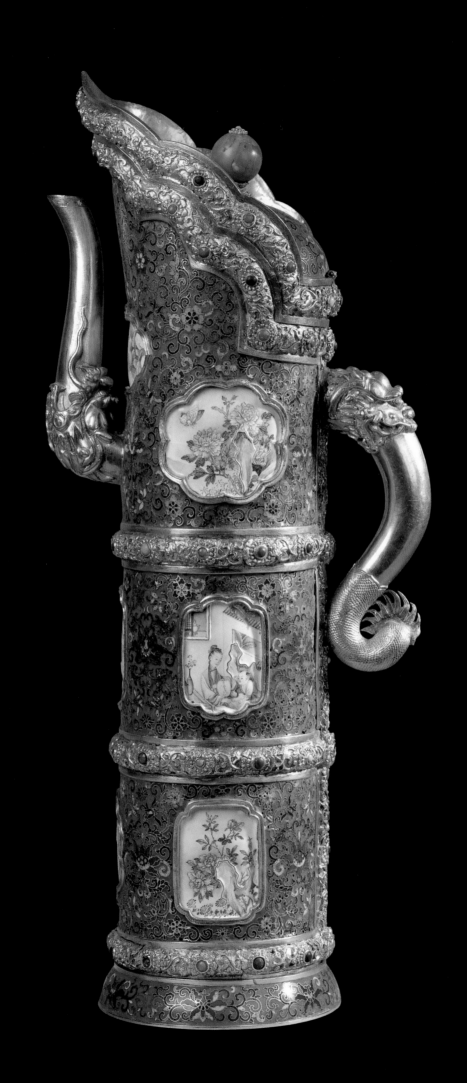

54 ←

Buddhist tea ewer and cover (*duomuhu*)

Qianlong period, Palace Workshops, Beijing

Gold body inlaid with stones and cloisonné, inset with framed raised panels showing scenes of flowers, figures and landscapes in painted enamel, 50.4 × 14 cm

Qianlong four-character mark engraved on a cartouche at the foot

Private collection

56 →

Buddhist longevity vase (*bumpa*) simulating pewter with gilding and jewels

Qianlong period, Jingdezhen, Jiangxi Province

Porcelain with enamels and gilding, height 26.4 cm

Qianlong six-character seal mark inscribed in gold on the base

Victoria and Albert Museum, London, Salting Bequest, c.499-1910

55 ↑

Duomuhu ewer simulating wood with gilt-bronze hoops

Yongzheng or Qianlong period, Jingdezhen, Jiangxi Province

Porcelain with enamels and gilding, height 45 cm

The Palace Museum, Beijing, Gu152677

57 →

Buddhist longevity vase (*bumpa*) for dried Tibetan herbs

Eighteenth century

Silver gilded in parts, inlaid with turquoise and another semi-precious stone, height 32 cm

The Palace Museum, Beijing, Gu141464

58 ←

Kapala skullcup

Eighteenth century

Human skull with silver-gilt pedestal and cover inlaid with semi-precious stones, height 26.5 cm

The Palace Museum, Beijing, Gu185717

60 →

Scripture of the Yellow Court
(*Huangtingjing*)

Qianlong mark and period

Ink on paper, box: carved red lacquer on wood, 34.4 × 15.5 × 8.6 cm

Seven-character Qianlong reign mark

Seals: *Qianlong chen han*, *Wei jing wei yi*

The Palace Museum, Beijing, Yu2298, Yu2299

59 ←

Alms bowl incised with the *Heart Sutra*

Eighteenth century

Green jade, height 8.6 cm

The Palace Museum, Beijing, Gu103516

Territories of the Qing

EVELYN S. RAWSKI

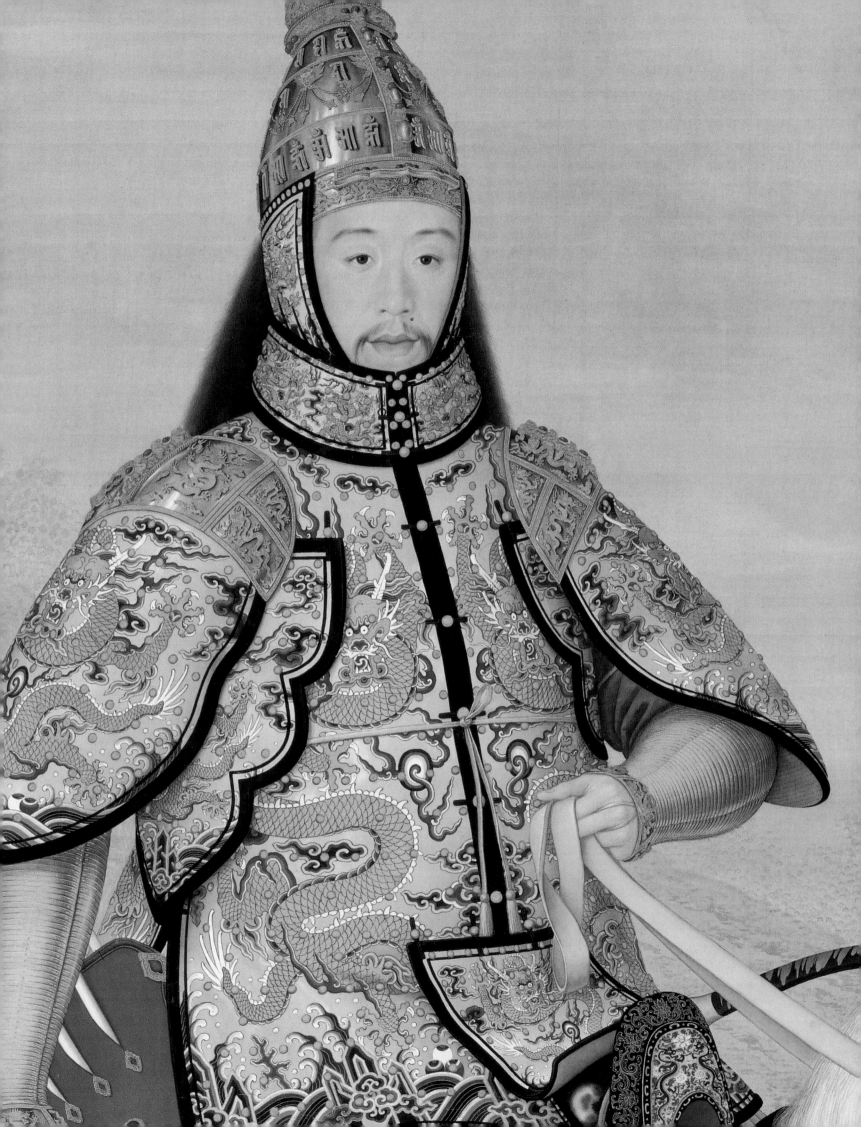

The Qing dynasty was the most successful dynasty of conquest in Chinese history, and the empire over which it ruled laid the territorial foundations of the modern Chinese nation-state. The singular achievement of the Qing was to incorporate Inner Asian and East Asian subjects into a stable multi-ethnic empire. The People's Republic of China, established in 1949, is smaller than the Qing empire at its peak by the subtraction of the independent Republic of Mongolia.

The Qing rulers came from outside the Great Wall, in northeast Asia, and claimed to be descended from the Jurchen, who had ruled part of North China during the Jin dynasty (1115–1234). Qing territorial expansion occurred within a larger context of multi-state rivalry, first between the Manchus and Mongols, then between the Russians and the Qing, for control of Inner Asia.[1] Qing conquest occurred in several phases. In the late sixteenth and early seventeenth centuries, Nurgaci (1559–1626) competed for regional primacy in northeast Asia with the Chahar Mongol ruler, Lighdan Khan (r.1604–34). With the help of the Khorchin Mongols, who submitted in 1624, Nurgaci's successor, Hongtaiji (1592–1643), drove Lighdan Khan out of his territory, married the Khan's widows, and inherited the legitimacy of the Chinggisid line.

In the same period, Mongol leaders tried to bolster their political authority by patronising Tibetan Buddhism. Virtually every ambitious Mongol chieftain emulated the lama-patron relationship established by the Mongol Yuan dynasty (1271–1368). In 1578, the eastern Mongol leader Altan Khan met with Sonam Gyatso (1543–1588), the head of the Tibetan Gelugpa (Yellow Hat order), and accepted the prelate as his 'spiritual guide and refuge', conferring the title 'Dalai Lama' on him. In exchange the lama (known in history as the Third Dalai Lama) recognised the khan as 'Protector of the Faith'.

Mongol chieftains across the steppe established lama-patron relationships with different Tibetan Buddhist prelates. When the individual recognised as the fourth Dalai Lama turned out to be a descendant of Altan Khan, Mongol rulers found they could combine religious and secular authority

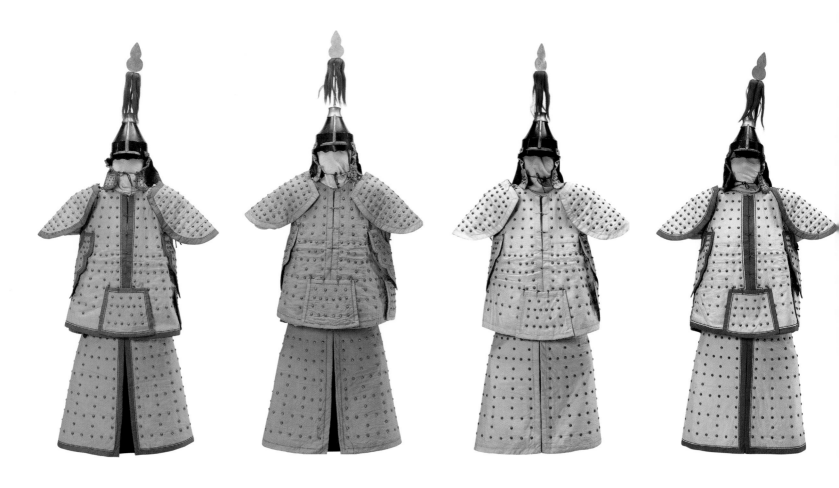

in a new conception of the foundations of rulership, based upon the notion of a reincarnate lineage of hierarchs, which had emerged in Tibet in the late thirteenth or early fourteenth century, and the Confucian Chinese notion of *zhengtong* which posited one legitimate line of rulers that transcended individual dynasties.[2]

This was the political context of the early seventeenth century in which the founders of the Qing ruling house operated. Nurgaci appointed a lama as the state preceptor of the Manchu *gurun* (tribe, state) in 1621; his successor Hongtaiji lavishly entertained the Dalai Lama's emissaries in his capital, Mukden (present-day Shenyang), in 1642–43 and received consecration in Tantric rituals that gave him the powers of the warlike deity Mahakala, who was a Protector of the Buddhist Law. Patronage of Tibetan Buddhism continued after 1644 and during the Kangxi, Yongzheng and Qianlong reigns (fig. 52).

Having unified the northeast Asian tribes under their command, the Qing conquest of Ming China began in 1644, when a Han Chinese rebel named Li Zicheng

(1606–1645) successfully occupied the Ming capital, Beijing,[3] and the last Ming emperor committed suicide. Responding to a call for help, the Manchus led a multi-ethnic banner force south of the Great Wall and drove Li's troops out of Beijing. What began as a campaign to 'defend the Ming' did not end until 1683, when all forces loyal to the Ming were subjugated and Ming claimants to the throne had been eliminated.

The completion of the Ming conquest freed the Manchu rulers to turn their attention to the consolidation of their northern and Inner Asian borders. To counter the increased Russian presence along the Amur River in Siberia, the court launched a series of military campaigns in that region that resulted in the Treaties of Nerchinsk (1689) and Kiakhta (1727), fixing the physical boundary between the two empires and establishing a framework for Sino-Russian regulated trade.[4]

The incorporation of present-day Mongolia into the empire stemmed from strife between its occupants, the Khalkha Mongols, and their neighbours to the west,

Fig. 51
Ceremonial armour of the Eight Banners, Qianlong period. Jackets and skirts: satin with cotton padding and gilt copper studs, jacket length 73 cm, skirt length 78 cm; helmets: black-lacquered ox-hide, height 38.5 cm, diameter 23 cm. Palace Museum, Beijing, Gu171198, Gu171988–92, Gu171994, Gu171999. These colourful ceremonial suits of armour belonged to the Eight Banners, who were organised by colour to guard the imperial city. The two Yellow Banners were located in the north, the two White in the east, the Red in the west and the Blue in the south; this arrangement followed the same positioning used to defend the imperial yurt on hunting expeditions.

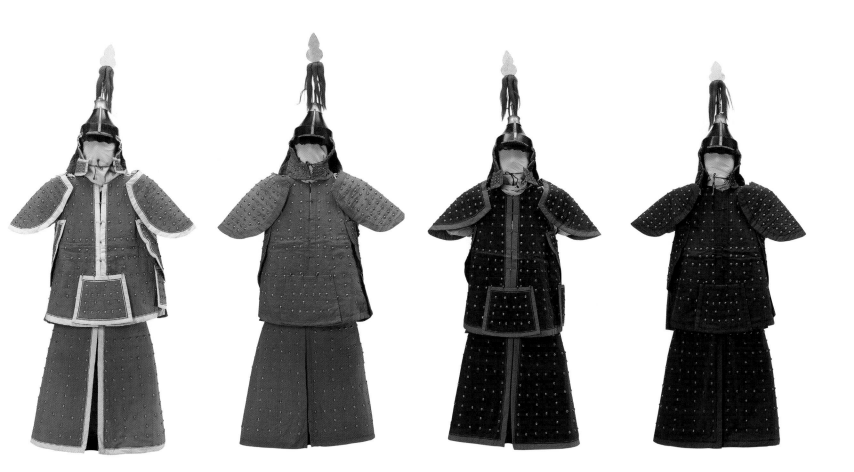

the Zunghar Mongols, who emerged as a major power on the steppe under their leader Galdan (r.1671–97). In 1688, Galdan invaded the territory of the Khalkha; the Khalkha, finding themselves at a military disadvantage, responded by submitting to the Qing in 1691 and asking for military assistance against their enemies.

The Zunghar threat was to dominate Qing policy towards Inner Asia and was a direct cause of imperial expansion. As James Millward has noted, the Zunghar could potentially have unified the peoples of Tibet, Kokonor, eastern Turkestan, and northern Mongolia into a 'pan-Buddhist, pan-Mongol front against a Manchu dynasty in China'.[5] Through a series of campaigns, which culminated in the battle of Jao Modo (1697), the Kangxi Emperor (cat. 61) defeated Galdan's forces, though the Zunghar strategic challenge persisted until the extermination of the Zunghar leader Amursana (1757) (see cat. 75).

Qing expansion into Tibet was also prompted by the multi-state politics of Inner Asia. As Nurgaci and Hongtaiji were unifying northeast Asia under their command, a similar process of territorial consolidation occurred further west, under the leadership of the Khoshuut Mongol Gushri Khan. The Khoshuut were one of the Western or Oirat Mongol tribes. Gushri Khan led an Oirat army and occupied the eastern Tibetan regions of Amdo and Kham. In 1642, having been proclaimed the *dharmaraja* (the king who upholds the Buddhist Law), Gushri Khan made the fifth Dalai Lama the secular as well as the religious ruler of Tibet. Mongol patronage enabled the Gelugpa order to win out over the other great monastic orders in Tibet. Although he initially shared power with the regent and Gushri Khan, the fifth Dalai Lama enlarged the authority of his position by presenting himself as Avalokitesvara, the Bodhisattva of Compassion.

In their conflict with the Zunghar Mongols, the Qing allied with the enemies of the Zunghar, the Khoshuut. In the 1690s, when the Kangxi Emperor moved his armies to the far west to fight Galdan, he seized the opportunity to strengthen his military presence in the region (fig. 53). Controversy over the authenticity of the sixth Dalai Lama, Tsangyang Gyatso (1683–1706), sparked a Khoshuut Mongol takeover of Tibet (1703), the removal of the sixth Dalai, and the installation of another candidate (1707) by Lajang Khan, but this candidate was repudiated by Mongol chieftains in Kokonor, who stood behind another youth who had been authenticated as the genuine rebirth by the state oracle of Tibet.

The succession dispute provided a pretext for the Zunghar invasion of Lhasa and provoked a Qing counter-response. Although the first Qing military attempt failed, a second force reached Lhasa in 1720 and expelled the Zunghars. The Qing took advantage of this opportunity to further their own interests. They supported the installation of the Kokonor Mongol candidate as seventh Dalai Lama, but ensured that actual administration was handed over to a council of ministers. Kham and Amdo, the eastern regions of Tibet, were detached and placed under the administrative control of the governor of Sichuan Province. The 1723 rebellion of Lobsang Danjin, the Khoshuut Mongol chieftain, was stimulated by Lobsang's perception that the Qing had reneged on a promise to return control over Tibet to the Khoshuut. After Lobsang was defeated, the Qing gave his territory to his rival and asserted suzerainty over Kokonor, which they renamed Qinghai.

The extension of the Qing protectorate over Tibet dates from the 1720 invasion of Lhasa. Qing control over Tibetan affairs was initially slight and indirect. A governing council of Tibetan nobles was to administer the country, but enmity among the councillors led to civil war (1727–28);

the victor of the war ruled with Qing support until his death in 1747. In 1750, when his successor was killed by the two Qing *amban* ('high officials' in Manchu, the imperial representatives in Tibet) and they themselves were attacked and killed by a Tibetan mob, the Qing significantly reinforced the power of the *amban*. A small military garrison, first established in 1721 but withdrawn from 1723 until 1728 and again from 1748 until 1750, was restored with 1,500 bannermen and soldiers from the Green Standard armies stationed in the west.

The final major conquest was the acquisition of the far western region that later became known as Xinjiang ('new territories'). This, too, was driven by the Qing desire to eliminate the Zunghar threat to the security of their empire. Internal strife over succession divided the Zunghars after the death of their khan, Galden Tseren, in 1745; some leaders, including a chieftain named Amursana, joined the Qing side in a new anti-Zunghar campaign in 1754. Initial success and the capture of the new khan, Dawachi (1755), led the Qianlong Emperor[6] to withdraw most of his forces from the region, prompting Amursana to lead a new uprising against the Qing. Amursana's followers were crushed in a new campaign in 1757, but as the Zunghar khanate collapsed, a new uprising of Muslims led by the Khoja brothers rose to challenge the Qing authorities. This, too, was eventually suppressed in 1759 (see cat. 78).

Qing administration of Inner Asia, consisting of four regions – northeast Asia (the present-day provinces of Liaoning, Jilin and Heilongjiang), Mongolia (see cat. 76), Tibet and Turkestan (later renamed Xinjiang) – was differentiated from the administration of the provinces in China Proper, the Chinese-speaking regions within the Great Wall. Whereas the latter were administered according to a framework inherited from the preceding Ming dynasty, using Chinese bureaucratic principles and personnel, the Inner Asian and Central

Fig. 53
An Cheng, *Map of the Routes from Dajianlu to Anterior and Posterior Tsang*, Qing dynasty, Guangxu period, 1901. Handscroll, ink and colour on silk, 41.4 × 316.3 cm. National Library of China (057.63/[227.003]/1901/0146)

Asian regions were referred to as the 'outer' (*wai*) domains, administered by the Court of Colonial Affairs (Lifan yuan) and staffed by banner officials. Not until 1884 did Xinjiang become a province, and the northeastern provinces of Fengtian, Jilin and Heilongjiang were created only in 1907. Mongolia, Qinghai and Tibet were never converted into provinces in the Qing period.

The Qing also applied different policies towards the Mongol tribes who submitted to them (see cat. 77). Their earliest allies, the eastern Mongols, were completely incorporated into the Qing system: this entailed removing the hereditary nobility from power and enrolling tribes into banners, administered by *jasak* (Manchu, 'banner chief'). Banners were then organised into leagues. The three khanates of the Khalkha were in 1728 reorganised into four leagues, with each league subdivided into banners. Like the eastern or 'inner' (*nei*) Mongols, these 'outer' Mongol banners were governed by *jasak* appointed by the Court of Colonial Affairs. There were twenty-four tribes and forty-nine banners in the 'inner' Mongol banners, and about two hundred banners, organised in eighteen leagues, in the 'outer' Mongol banners.[7] In addition, a governor-general of Mongolia oversaw Khalkha banner affairs from Uliasutai during the middle of the eighteenth century, and *amban* were appointed to other areas for administrative surveillance.

61 →

Anonymous court artists
Portrait of the Kangxi Emperor in Military Attire

Kangxi period

Hanging scroll, ink and colour on silk, 112.2 × 71.5 cm

The Palace Museum, Beijing, Gu6415

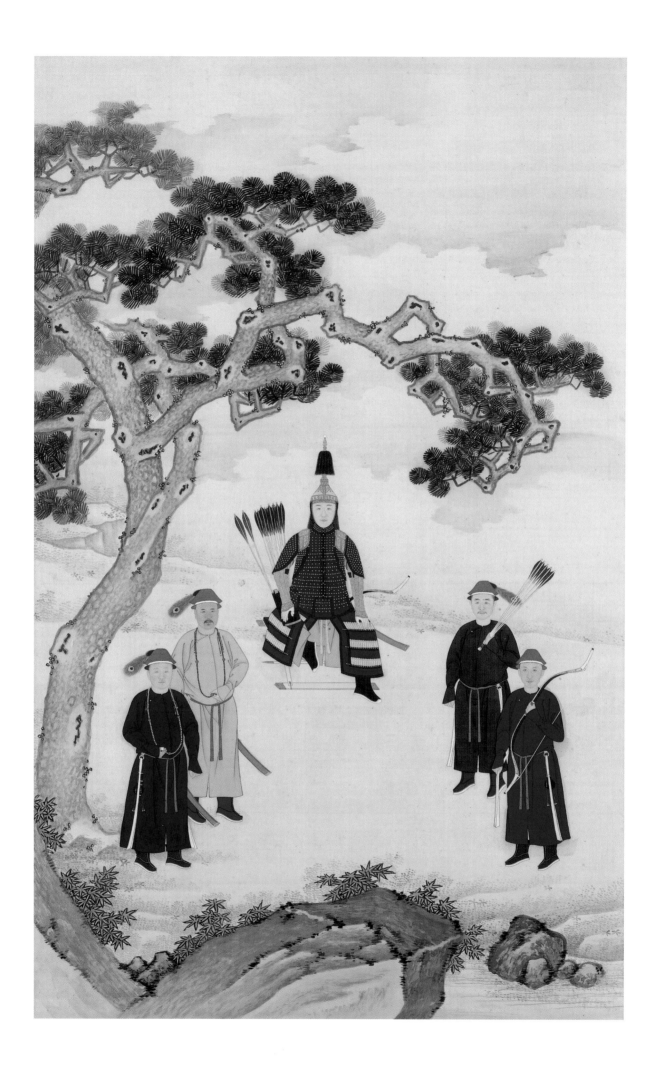

62 ←

Mineral-blue armour with silk
lining decorated with a pattern
of clouds and dragons

Kangxi period, seventeenth century

Silk satin with floss silk embroidery,
lined in silk and padded, gilt bronze
bosses and epaulettes bordered with
gilt dragon motifs inlaid with coral,
agate and malachite, tunic length
78 cm, apron length 92 cm

The Palace Museum, Beijing, Gu44498

63 ↓

Sedan chair

Qianlong period

Lacquered wood, partially gilded,
400 × 110 × 110 cm

The Palace Museum, Beijing, Gu169033, 1

64

Imperial patent of nobility
(*Fengtian gaoming*) in Manchu
and Chinese scripts awarded to
Qiu Lianhui and his wife, He

1722

Roll, ink on coloured woven silk
panels backed with paper, retained by
a polychrome silk braid and bronze (?)
toggle, 31.2 × 365.1 cm

The British Library, London, Or.5427

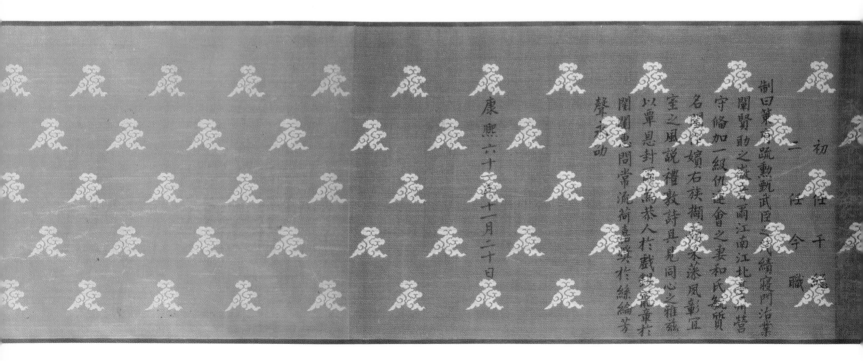

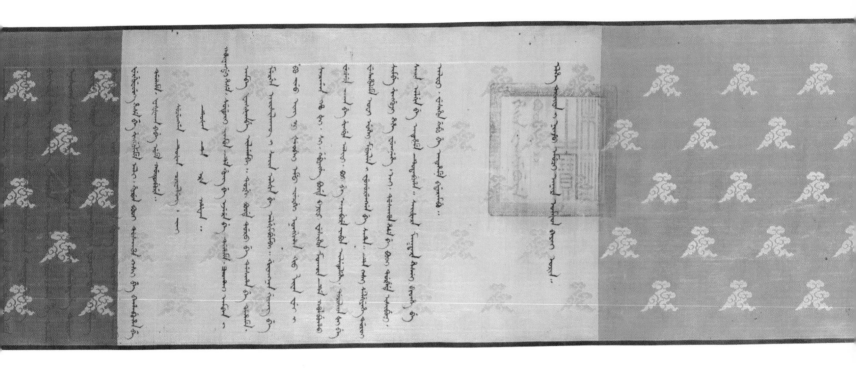

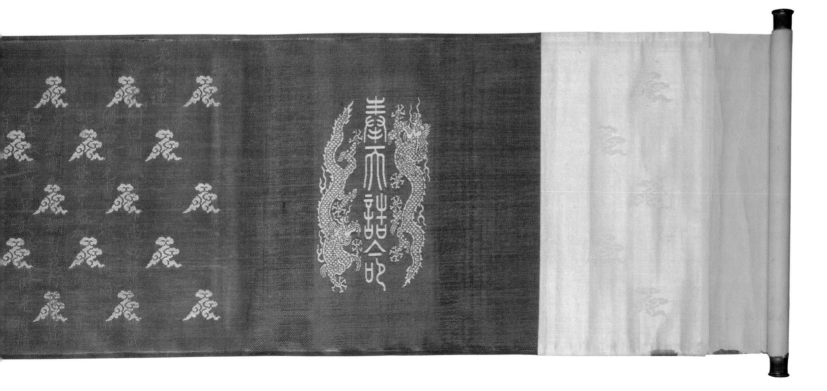

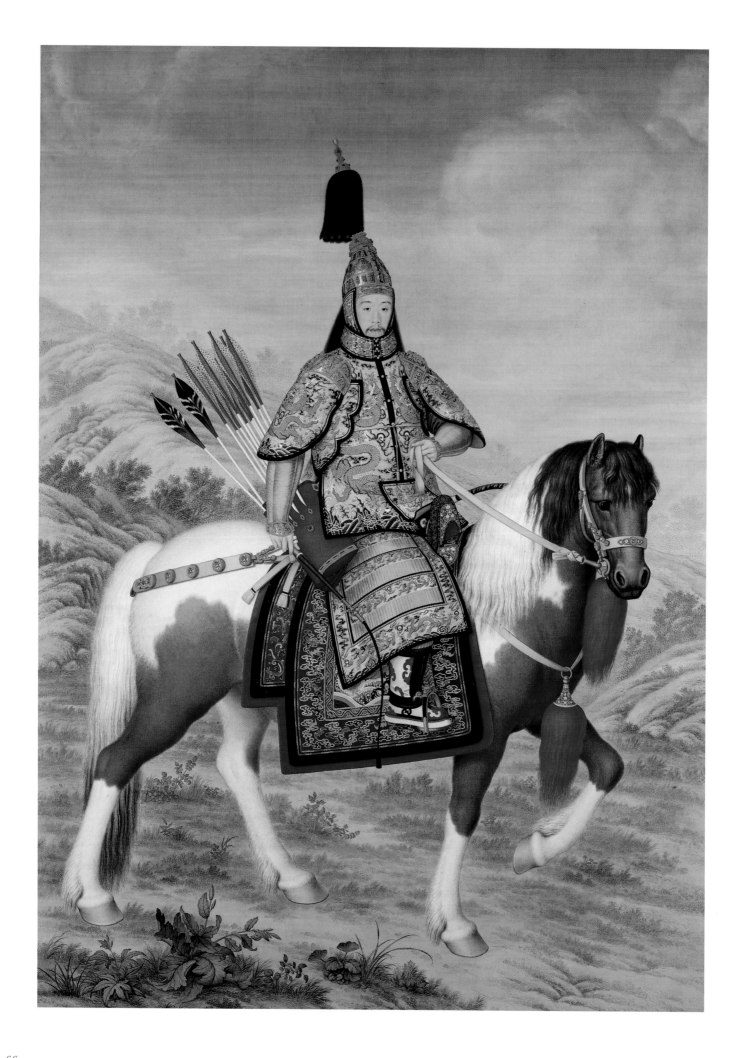

65 ←

Giuseppe Castiglione
(Chinese name Lang Shining,
1688–1766)
*The Qianlong Emperor in
Ceremonial Armour on Horseback*

1739 or 1758

Hanging scroll (originally a *tieluo*
painting), ink and colour on silk,
322.5 × 232 cm

The Palace Museum, Beijing, Gu8761

66 →

Quiver and bow case

Qianlong period

Leather covered with embroidered satin
brocade, gilded brass fittings, quiver
length 36 cm, bow case length 76 cm

The Palace Museum, Beijing, Gu222011

67

Bow ↗

Qing dynasty

White birch wood, sinew, horn,
shagreen, length 161 cm

The Palace Museum, Beijing, Xin48694

68 ↗

Pi (iron-tipped) arrows

Qing dynasty

Wooden shafts, iron and feathers,
length 90 cm

The Palace Museum, Beijing, Gu171010/1–5

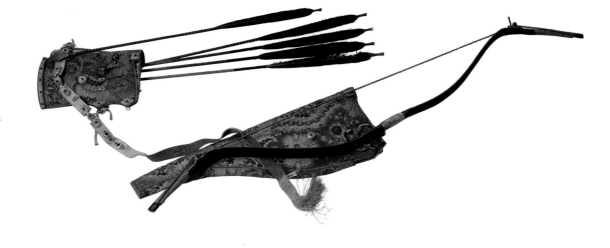

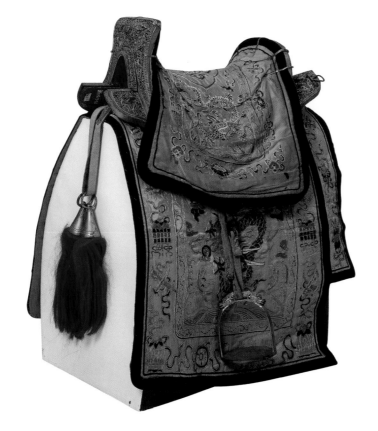

69 ←

Saddle with ornaments
and saddle cloth

Qianlong period

Saddle: brass and silk satin embroidered
with floss silk with velvet trimming,
damask-weave silk lining and wool
wadding, 32.5 × 30 × 67 cm; saddle cloth:
damask-weave embroidered silk with
velvet trimming, wool wadding and
brown cotton lining, 150 × 73.5 cm;
tackle: brass, iron, red-dyed horsehair
and silk backed with twill-weave cotton

The Palace Museum, Beijing, Gu171546, Gu212430

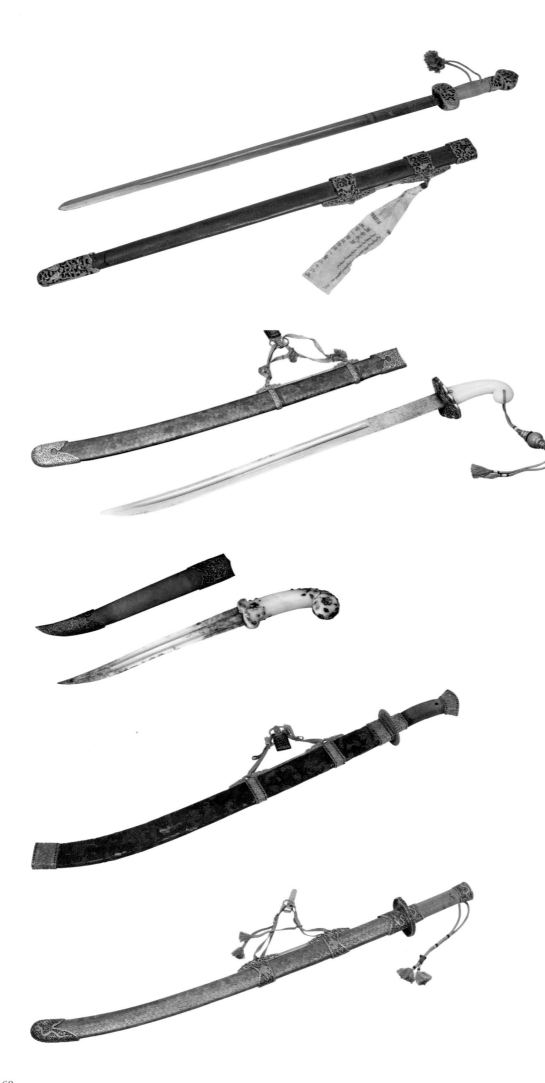

70 ←

Straight sword

Qianlong period

Steel blade, gilt-iron fittings, scabbard covered in red-stained shagreen, length 100 cm

Blade inlaid with Qianlong four-character reign mark in silver, the reverse with *di zi yihao* (no. 1 of the Earth category) and *chu yun* (emerge from cloud)

Palace inventory label in Manchu and Chinese: *di zi yihao*, *chu yun*, weight 26 *liang* (ounces), made in the Qianlong period

The Palace Museum, Beijing, Gu170428

71 ←

Sabre

Qianlong period

Jade handle with Songhua stone- and coral-beaded tassel, steel blade decorated near the hilt with inlaid gold, silver and copper wire, scabbard covered in trefoil-patterned lacquered peach-tree bark, length 95 cm

Blade inlaid with Qianlong four-character reign mark in silver, the reverse with *han feng* (Cold Edge)

The Palace Museum, Beijing, Gu170406

72 ←

Dagger

Qianlong period

Steel blade, Mughal-style jade hilt inlaid with precious stones, leather scabbard, gilt-iron fittings, length 44.5 cm

The Palace Museum, Beijing, Gu170627

73 ←

Sabre

Qianlong period

Steel blade, scabbard covered in green-stained shagreen, inlaid with dragon design in gilt and silver beads and metal fittings, length 104 cm

The Palace Museum, Beijing, Gu171086

74 ←

Sabre

Qianlong period

Steel blade inlaid with silver, copper and gold, gilt-iron fittings inlaid with turquoise, scabbard covered in trefoil-patterned lacquered peach-tree bark, length 98 cm

Blade inlaid with Qianlong four-character reign mark in silver, the reverse with *tian zi liuhao* (the 6th of the Heaven category) and *yue ren* (Moon Blade)

The Palace Museum, Beijing, Gu170451

*The Relief of the Black River
Camp (Heishui ying jiewei)*
and *Victory at Khorgos
(Heluohuosi jie)* from *Quelling
the Rebellion in the Western
Regions*

1771, 1774

Two leaves from a set of sixteen
copperplate engravings on paper,
each 55.4 × 90.8 cm, the first
engraved by J. P. Le Bas in 1771
after a drawing by Giuseppe
Castiglione (1688–1766), the
second engraved by the same
hand in 1774 after a drawing by
Jean-Denis Attiret (1702–1768)

Musée national des arts asiatiques Guimet,
Paris, MG17005, MG17008

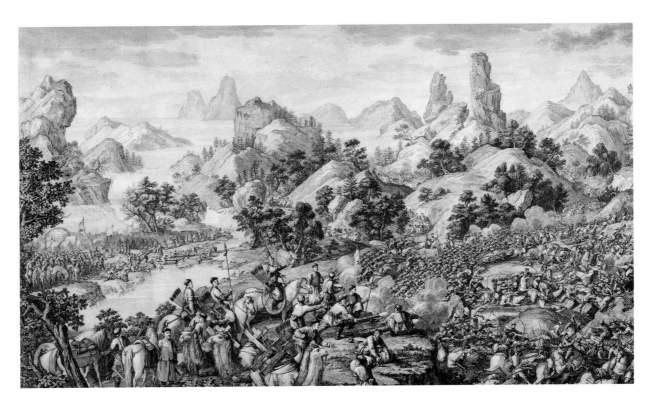

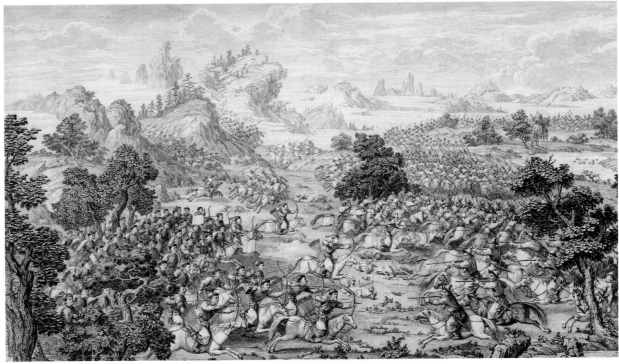

76 OVERLEAF

Attributed to Giuseppe
Castiglione (Chinese name Lang
Shining, 1688–1766), Jean-Denis
Attiret (Chinese name Wang
Zhicheng, 1702–1768), Ignaz
Sichelbarth (Chinese name Ai
Qimeng, 1708–1780) and
Chinese court painters

*Imperial Banquet in the Garden
of Ten Thousand Trees*

Completed in 1755

Horizontal wall-scroll, ink and colour
on silk, 221.5 × 419 cm

The Palace Museum, Beijing, Gu6275

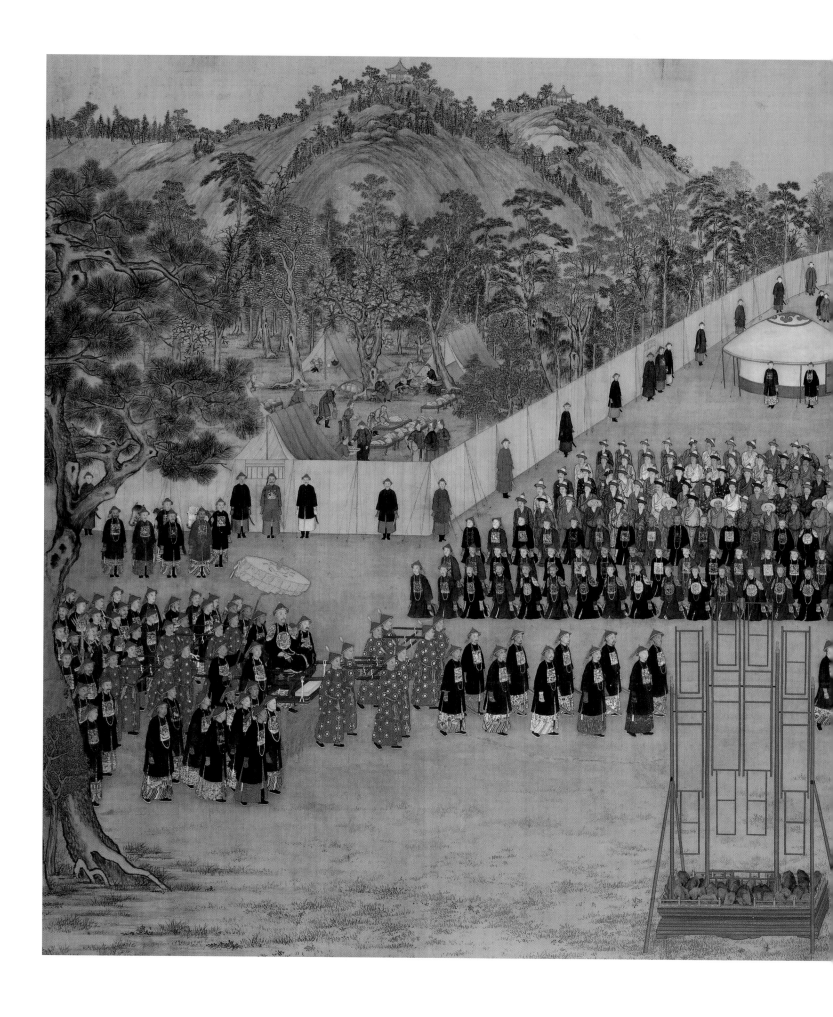

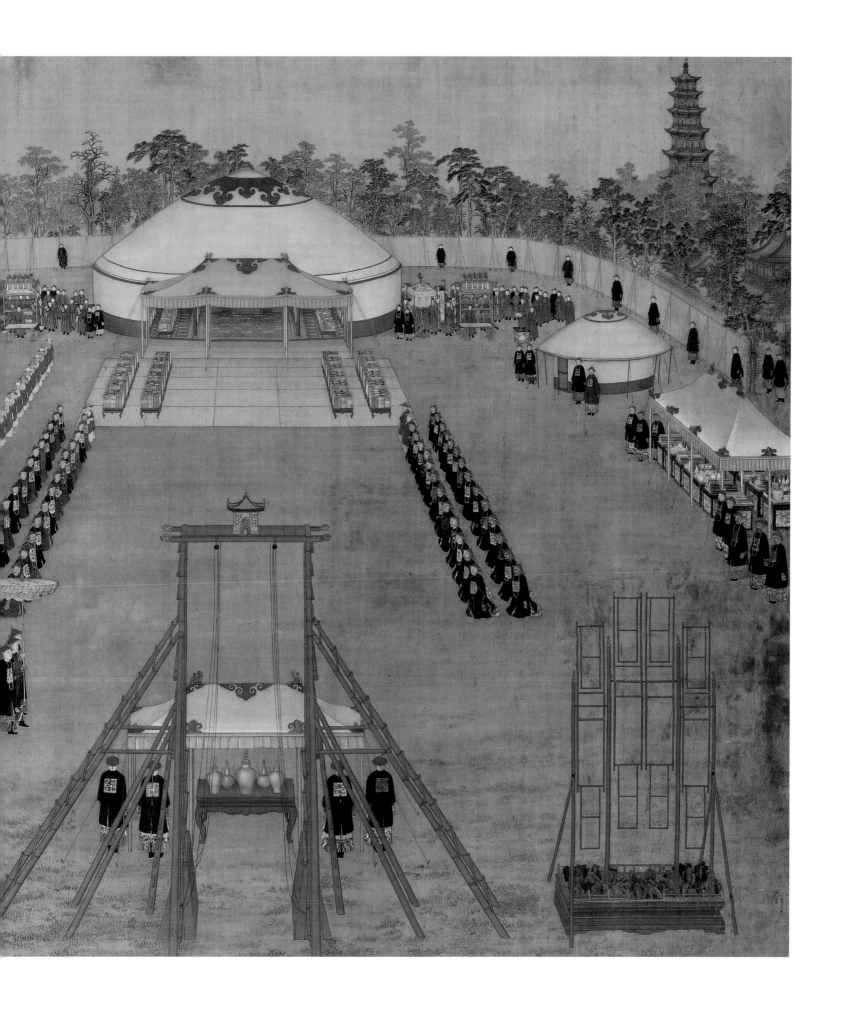

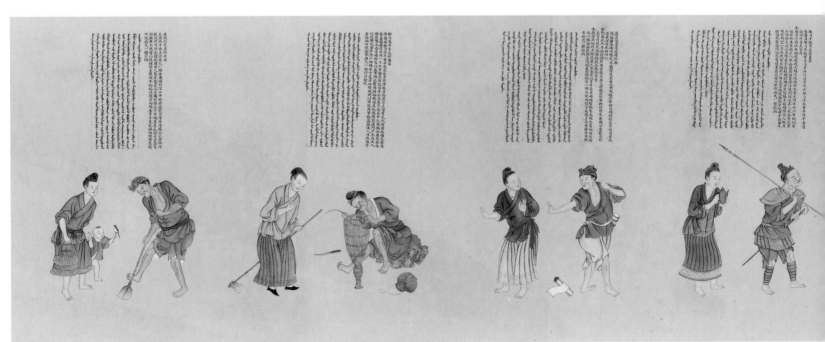

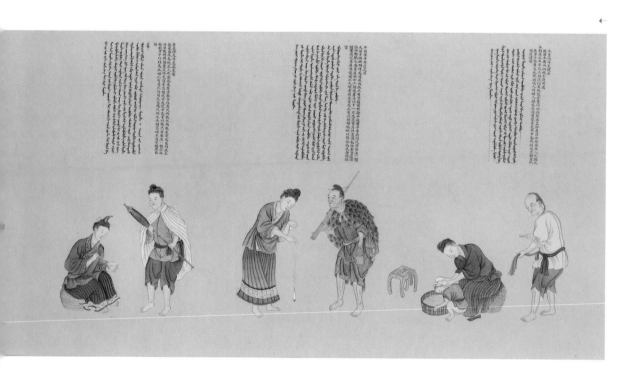

77

Anonymous court artists
Qing Imperial Illustrations of Tributaries, Scroll Four: Minorities from Yunnan, Guizhou, Guangxi (detail)

Qianlong period, *c*.1748–80

Handscroll, ink and colour on paper, 33.5 × 1603 cm

Inscriptions: title sheet by the Qianlong Emperor with *Qianlong yu bi* seal; inscriptions by Qian Weicheng and Qian Rucheng; colophon by Yu Minzhong and others

The Palace Museum, Beijing, Gu6306/4

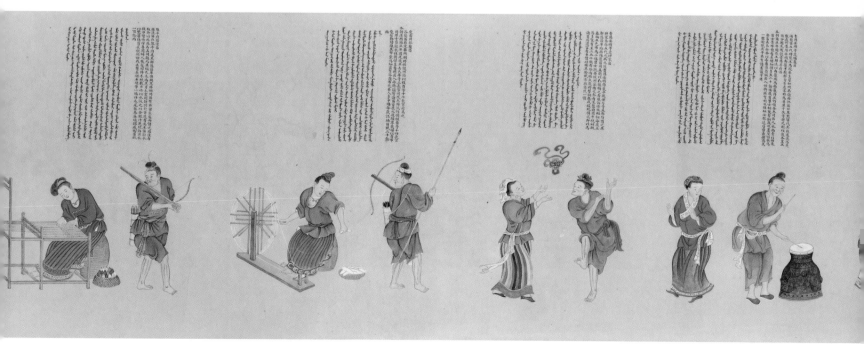

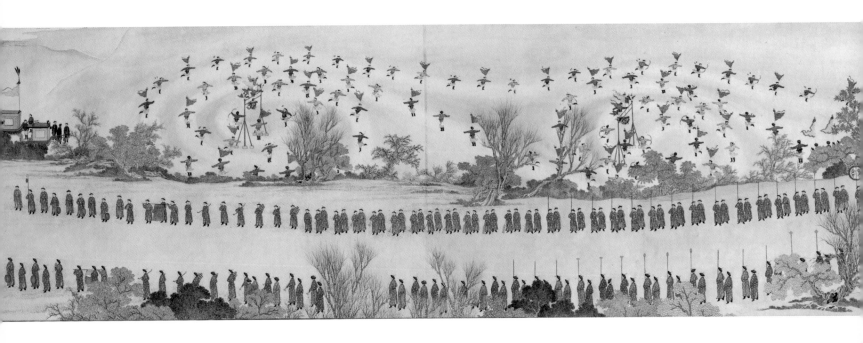

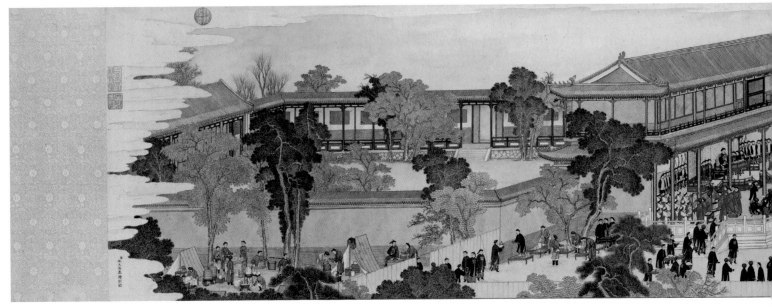

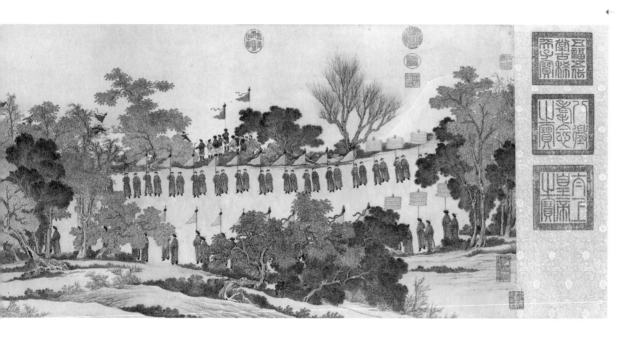

78

Yao Wenhan (fl. from 1743)
New Year's Banquet at the Pavilion of Purple Brightness

1761 or later

Handscroll, ink and colour on paper,
45.8 × 486.5 cm

Artist's signature

Seals: two seals of the artist, eleven
seals of the Qianlong imperial collection,
one seal of the Jiaqing Emperor and
one collector's seal

The Palace Museum, Beijing, Gu8242

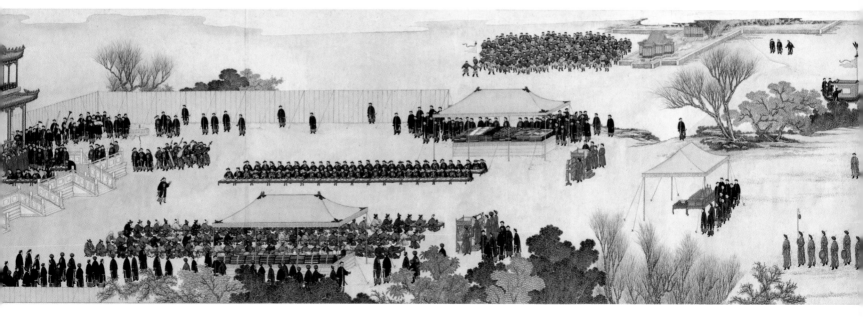

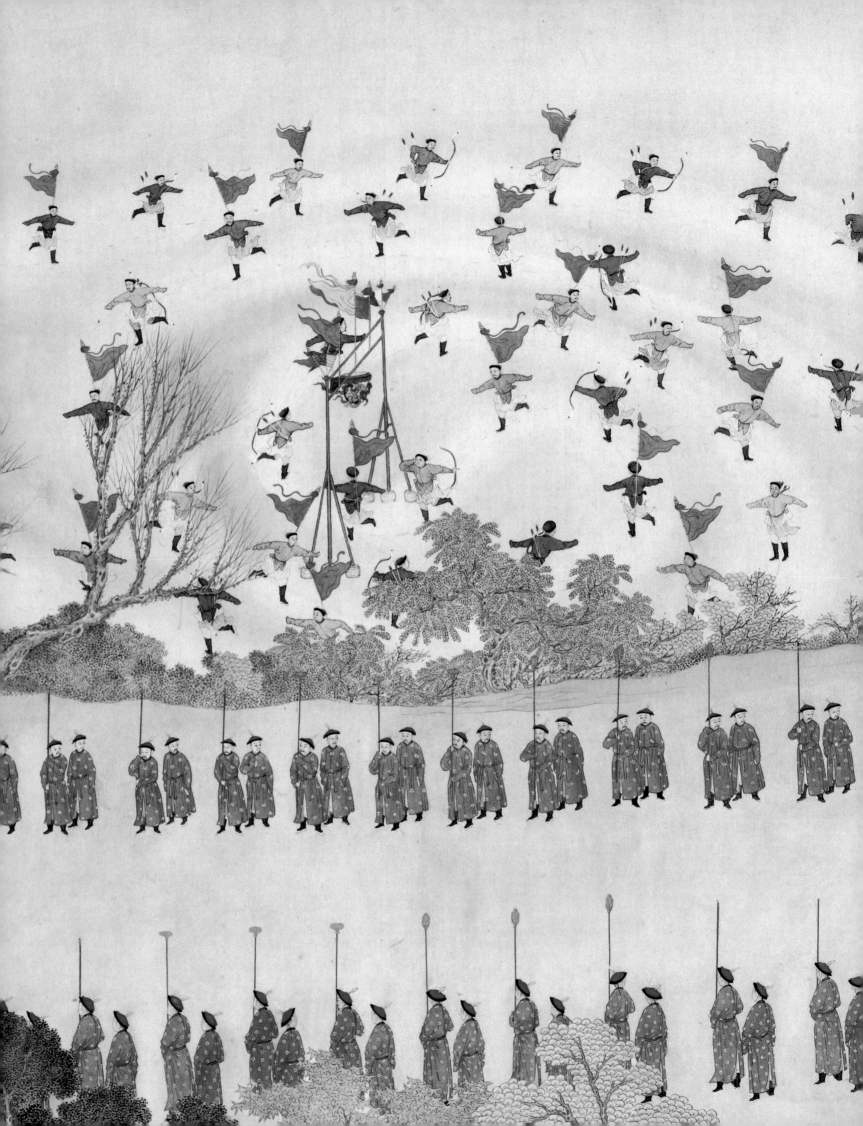

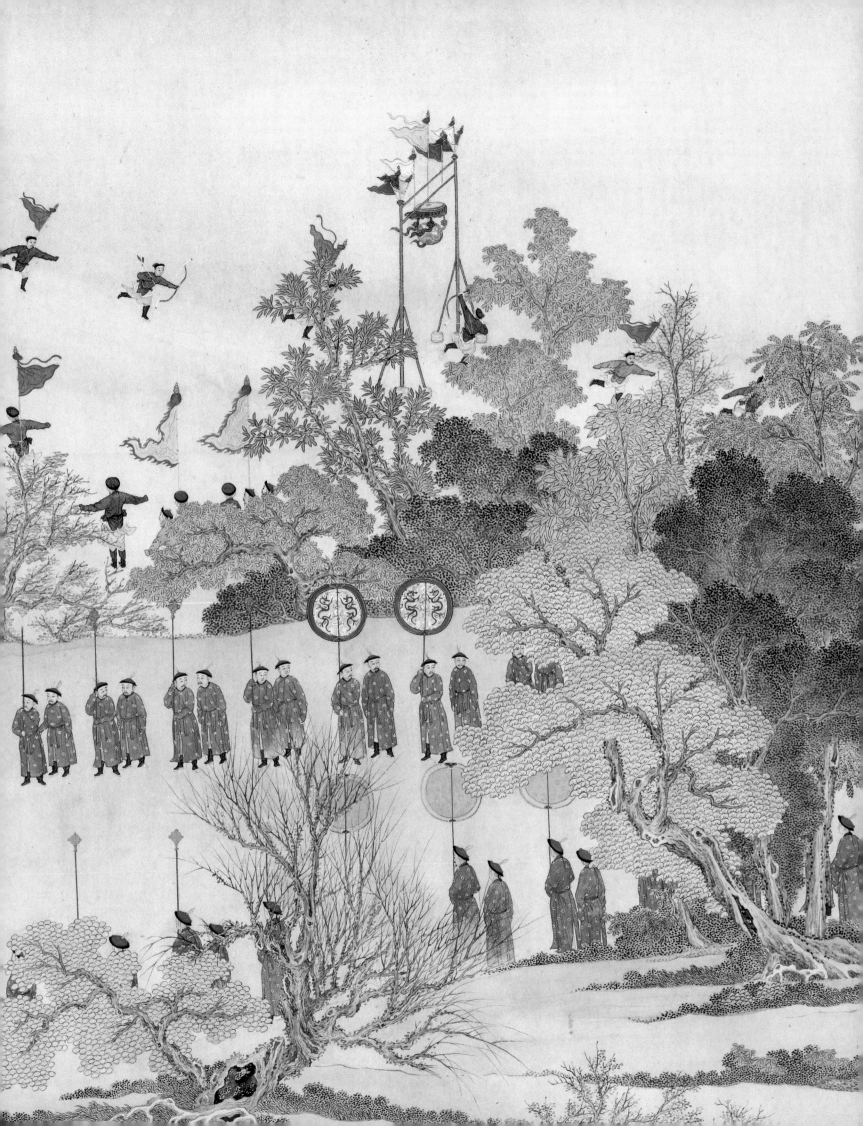

6

Diplomats, Jesuits
and Foreign Curiosities

JOANNA WALEY-COHEN

The high Qing emperors' claim to universality permeated every sphere of life – intellectual, cultural, material and spiritual – and bound them together within the overarching context of political legitimacy. In the intellectual sphere, for instance, the three Manchu emperors whose reigns spanned the years from 1662 to the end of the eighteenth century sought comprehensive knowledge of the world and its peoples. This led them, in the interests of reinforcing their authority, to sponsor a broad range of astronomic, cartographic and ethnographic projects, and to display an intense interest in new information introduced by Europeans and other foreigners. In the realm of material culture, as the Qianlong Emperor declared so famously and with such far-reaching consequences to the British envoy Lord Macartney in 1793, they claimed to 'possess all things'. This assertion was manifested in, for instance, the emperors' passion both for collecting works of art and for co-opting the

best artists and artisans to work under imperial patronage in the Imperial Painting Academy and Palace Workshops (see cats 79, 81, 97, 98, 99). It also surfaced in the imperial practice of reproducing landmarks from around the empire, such as the Potala Palace (fig. 49), Jinshan Temple and other structures erected in subtly altered forms at the resort palace in Rehe (present-day Chengde, also known as Jehol). The construction under Jesuit direction of the summer palace of the Yuanming yuan (Garden of Pefect Brightness), designed in broad conformity with European design principles to resemble the Trianon at Versailles, also came into this general category (see cat. 91).[1] In the realm of politics, emperors departed from Chinese hierarchical practices by treating more or less equally the diverse subjects of their vast empire – Mongols, Tibetans and Uighurs as well as Manchus (among whom the imperial family took precedence) and Chinese. Thus inscriptions on major public monuments

Fig. 54
Detail of cat. 83, Anonymous court artists, *Envoys from Vassal States and Foreign Countries Presenting Tribute to the Emperor*, 1761. Hanging scroll, colour on silk, 322 × 216 cm. The Palace Museum, Beijing, Gu6274

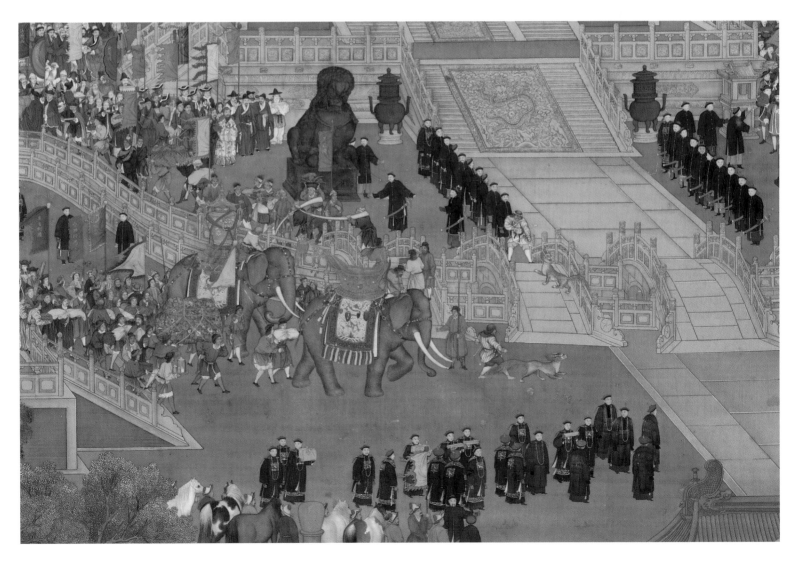

routinely appeared in all four main languages of state (normally Manchu, Chinese, Mongolian and Tibetan). The same general principles also informed imperial attempts simultaneously to satisfy their various constituencies by representing themselves as both model Confucian literati, for the benefit of their Chinese subjects, and devout Tibetan Buddhists, in an appeal to their Tibetan and Mongol subjects.[2]

Emperors were wary of the loyalty of Tibetan Buddhists because of the threat posed to their own authority by the religious leadership of the Dalai Lama. Any alternative locus of allegiance was simply unacceptable. Their caution about Christianity derived from similar reasoning, and led them to frustrate European missionaries' hopes of large-scale conversion. First, the initial toleration of the Kangxi Emperor was eroded by papal envoys' insistence on overall papal authority over Chinese Catholics; then the Yongzheng Emperor, perspicaciously expressing apprehensions about the inevitability that warships would follow missionaries, banned Christianity altogether. Finally, the Qianlong Emperor followed his grandfather's rejection of any possible competitor for the loyalty of his subjects. Although missionaries converted a few hundred thousand Chinese, for the most part they failed to persuade members of the Chinese élite that Christianity should supersede the accustomed combination of Confucianism, Buddhism and native religions (fig. 55). Yet European missionaries aroused too much imperial interest to be driven away altogether.

Among the various denominations operating in China from the late sixteenth century, the Society of Jesus succeeded in installing its members at court, in pursuit of their strategy of religious conversion from the top down. Equally important was the use of secular knowledge to attract interest before any question of religious conversion arose. This led Jesuits to present the emperors with such elaborate gifts as clocks and maps, to display European ingenuity, and to offer their services at court (see cats 80, 84, 86, 90). When the Qing displaced the Ming in 1644, the missionaries transferred their allegiance to the new regime. Among many other activities, European Jesuits directed the Qing Bureau of Astronomy after bettering Muslim astronomers' predictions of an

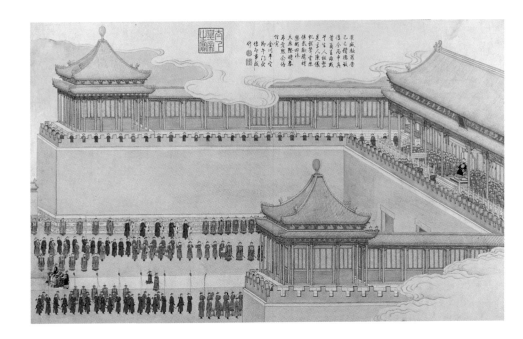

eclipse (cat. 89); they supervised foundries that produced astronomical instruments (some still visible at the Observatory in Beijing) and heavy artillery (some now displayed at the Tower of London and other European museums); instructed the Kangxi Emperor in the use of a telescope; spearheaded his project to survey the whole empire; built clocks and other devices with elaborate mechanisms; built a harpsichord; monumentalised Qing imperial successes in paintings and other media; and acted as interpreters, for example in the negotiations with Russia that led to the 1689 Treaty of Nerchinsk. They also were enormously influential as conduits of information in both directions between China and Europe.[3]

Other important sources of information about the wider world available in China included overseas populations, travelling merchants and troops returning from frontier wars. The Qing were therefore well aware of the European colonial presence in Asia – the Dutch in Batavia; the Spanish in Manila; the Portuguese, with tacit Chinese consent, in Macau; and later the British in India – and it made them very vigilant about these outsiders. It was not that they were xenophobic or antagonistic to trade, but they considered that unrestricted foreign contact was a potential threat to national security in a variety of ways. They therefore devised assorted means of keeping foreigners under control.

Formal foreign relations took various forms. A Court of Colonial Affairs (Lifan yuan) handled Qing relations with Asian

Fig. 55
Xu Yang (fl. c.1750–after 1766), *The Xianfu Ceremony*, 1760. Ink and colour on paper, 55.5 × 91.1 cm. The Palace Museum, Beijing, Gu5446. The twin ceremonies of *xianfu* and *shoufu* were reserved for important victories. They took place in front of the Meridian Gate (Wu men) of the Forbidden City. During the Qing period, these ceremonies were performed less than a dozen times, mostly in connection with the protracted wars in Central Asia that took place during the reigns of the three emperors, and for the last time in 1828. On the appointed day, designated officials led in the prisoners by a white silken cord tied around the neck. They formally announced the victory and capture of the prisoners, who were then handed over to the Ministry of Justice for execution in accordance with the law.

neighbours to the north and northwest, including Russia, mainly with a view to incorporating them into the Qing polity through ritual arrangements, and deflecting any threat to Qing supremacy in the region. The Board of Rites (Libu), one of the six main agencies of state, handled relations with other non-Chinese neighbours whose cultures somewhat resembled those of China, such as Japan, Vietnam, Burma, Thailand and Korea. From these, the Qing expected formal acknowledgement of their predominance in return for limited trading rights, in practice often supplemented by unofficial contacts. Europeans – except for missionaries, who were managed separately because, misleadingly, they seemed unconnected to international relations – were incorporated into these tributary arrangements mainly because no other category applied and because, despite budding European colonialism, they did not initially appear territorially threatening in comparison with more nearby groupings on the Inner Asian frontier (cat. 83).

Seventeenth-century Dutch and Portuguese embassies were successful in their quest for expanded trading rights only in proportion to Qing perceptions of their potential utility as allies against remnant Ming loyalists. The Qing consolidation of power ended any prospects for further concessions just as Europeans sought increased contact. Consistently cautious, the Qing began to impose restrictions regarding the times and locations of trade.

After some abortive forays, Britain eventually dispatched an embassy to request the opening of additional ports to Western trade, and diplomatic rights of residence in Beijing. This embassy, led by Lord Macartney in 1792–93, failed because of mutual misunderstanding. Each side wrongly assumed that the other would comply with their own long-standing diplomatic practices; each side thought the gifts exchanged were inadequate; and each side suspected the other of concealing their true intentions. Later embassies were scarcely more successful. This impasse was resolved only after China's defeat by Britain in the First Opium War in 1842, and then only incompletely.

British opium imports into China had originated in the late eighteenth century as a substitute for silver to pay for Chinese tea and ceramics, when no other mass commodity attracted a sufficient Chinese market. The Chinese market for foreign luxuries, however, was another matter.

Already with the urbanisation and commercial expansion of the late sixteenth century, a consumer culture had burgeoned in China, endowing the possession of material goods and the display of good taste with a new social significance. As collecting became an obsession among the wealthy, with newly rich merchants seeking to emulate the old élite, luxury goods, including exotic imports, were in huge demand. Early Jesuit gifts of clocks and mechanical toys had fitted particularly well into this context.[4]

Although the mid-seventeenth-century dynastic transition caused enormous disruption to this way of life, Qing emperors soon began collecting on a vast scale and expanding their artistic patronage, in part to show how civilised they were. Among Chinese, post-war recovery led, equally, to a resurgence of consumerism, including a renewed vogue for imported luxuries, such as snuff, that expanding European trade only encouraged (see cats 100–18). Indeed, objects imported from Europe and produced by court Jesuits piqued the curiosity of Emperor and élite alike, in a trend that uncannily mirrored the contemporaneous European fashion for chinoiserie, or objects and designs in a supposed Chinese style (cats 92, 93).[5]

The passion for foreign curiosities displayed by Manchu emperor and Chinese élite alike brings to mind a question once posed by the Qianlong Emperor to a Jesuit interlocutor: which came first – the chicken or the egg? Did the Qing emperors collect on a huge scale purely for pleasure, or to impress their Chinese subjects with their aesthetic sensibilities, or, in the spirit of universality, to co-opt an autonomous trend originating among the Chinese élite, or for a combination of these reasons? Or, when members of that élite sought to collect ever more rarefied objects, did they ultimately take their lead from their Emperor, however much they may have disdained the idea that a Manchu could be arbiter of their own tastes? We can be certain only that the increasingly international context of China's 'long eighteenth century' altered the entire framework in which such relationships were negotiated.

79

Giuseppe Castiglione (Chinese name Lang Shining, 1688–1766)
Pine, Hawk and Glossy Ganoderma

1724

Hanging scroll, colour on silk, 242.3 × 157.1 cm

Inscription: '*Song xian ying zhi tu (Picture of a Pine, Hawk and Glossy Ganoderma*), respectfully painted by your servant Lang Shining, the tenth month of the second year Yongzheng'

Seal: the Qianlong Emperor

The Palace Museum, Beijing, Gu5357

Giuseppe Castiglione
(Chinese name Lang Shining,
1688–1766)
Birds and Flowers

c. 1724–30

Hanging scroll, colour on silk,
63.7 × 32.3 cm

Inscription: signed 'respectfully painted
by your servant Lang Shining'

Seals: two seals of the artist ('Shining'
and '*gonghua*'), five seals of the Qianlong
Emperor and two seals of the Jiaqing
Emperor

The Palace Museum, Beijing, Xin146607

Louis de Poirot
(Chinese name He Qingtai,
1735–1813)
Beautiful Deer

1790

Hanging scroll, colour on paper,
195.5 × 93 cm

Inscription: signed 'Respectfully
painted on imperial order by your
servant He Qingtai in the ninth
month of the fifty-fifth year of
[the reign of] Qianlong'

Seals: two seals '*gong*' and '*hua*'
'respectfully' 'painted', six seals
of the Qianlong Emperor and
a seal of the Jiaqing Emperor

The Palace Museum, Beijing, Gu5604

82 →

Zhang Weibang
(active as a court painter,
c.1726–61)
The Spring Festival

Yongzheng or Qianlong period

Hanging scroll, colour on silk,
137.3 × 62.1 cm

Inscription: signed 'Respectfully painted
by your servant Zhang Weibang'

Seals: two seals of the artist (?), five seals
of the Qianlong Emperor and two seals
of the Jiaqing Emperor

The Palace Museum, Beijing, Gu5541

83 →

Anonymous court artists
*Envoys from Vassal States and
Foreign Countries Presenting
Tribute to the Emperor*

1761

Hanging scroll, colour on silk,
322 × 216 cm

Inscription: imperial poem

Seals: the Qianlong Emperor

The Palace Museum, Beijing, Gu6274

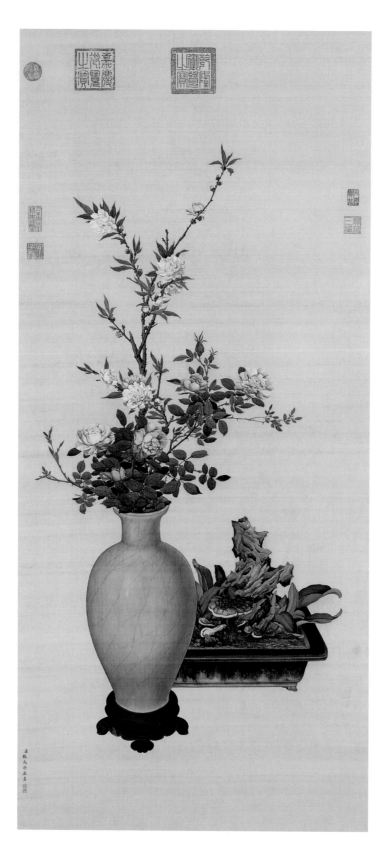

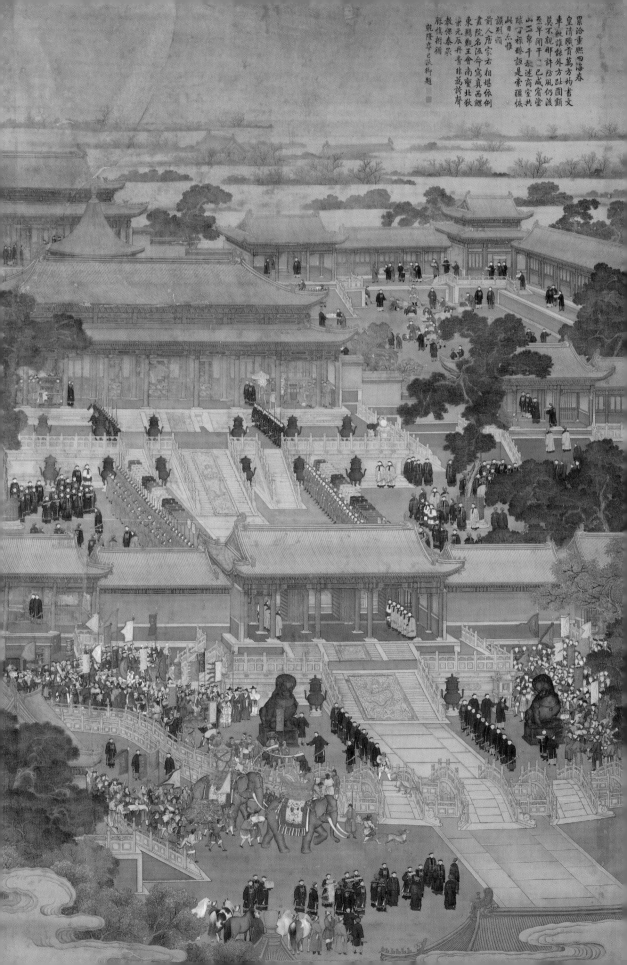

84

Ignaz Sichelbarth
(Chinese name Ai Qimeng,
1708–1780)
Ten Fine Dogs

c. 1745–58

Album of ten leaves, colour on paper,
each 24.5 × 29.3 cm

Inscription: signed 'Respectfully painted
by your servant Ai Qimeng'

Seals: two seals of the artist, with eleven
imperial seals from the Qianlong
Emperor to the Xuantong Emperor

The Palace Museum, Beijing, Xin146201, 1–10

睒星狼賛

臣梁詩正恭撰

禀靈乎斗精猖狋之
英原平艸淺疾馳若
驚訝杰曜之西流儀
㸌電之東騰洶殊姿
之莫耦孰猛相之堪
衡永無憲乎尾壹瞁
奎光而共明

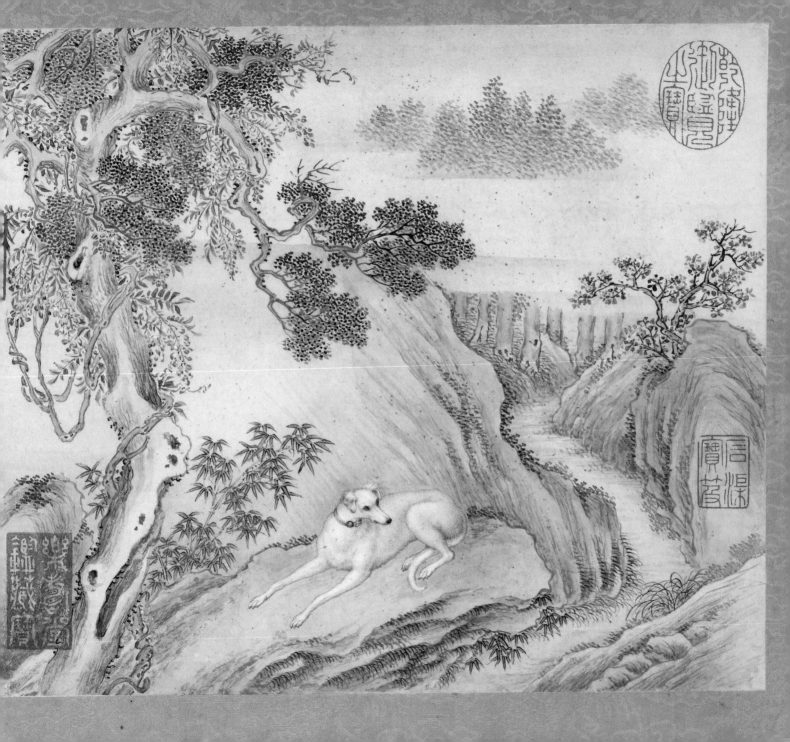

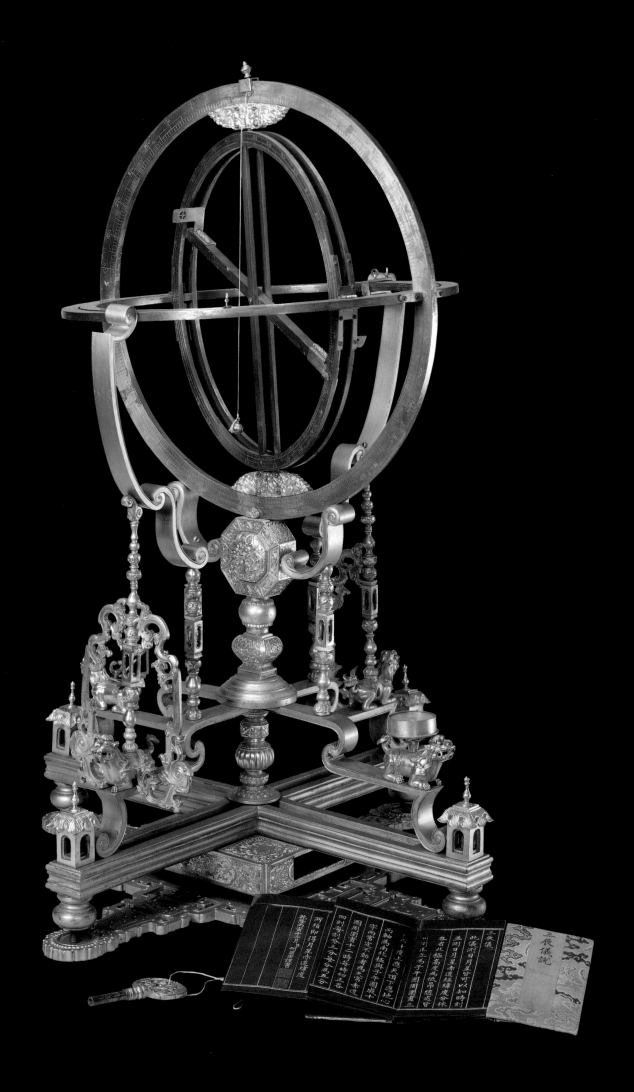

85 ←

Instrument for
celestial observation

1746

Made in the Palace Workshops,
Beijing

Gilt bronze, height 72 cm

Inscription: 'Made in the *bingyin*
year of the Qianlong reign' (1746)

The Palace Museum, Beijing, Gu141709

86 ↓

Armillary sphere inscribed
with name of Ferdinand
Verbiest (Chinese name
Nan Huairen, 1623–1688)

1669

Made by the Imperial Directorate
of Astronomy, Beijing

Silver-gilt and sandalwood,
height 37.5 cm

Inscription: carved in Manchu
and Chinese on one of the rings,
'Made in the second summer
month of the year Kangxi 8 (1669)
by Nan Huairen and others'

The Palace Museum, Beijing, Gu141931

87 →

Arc quadrant for
calculating zenith distance

Kangxi period

Made in the Palace Workshops,
Beijing

Copper, height 66 cm,
arc disc radius 35 cm

The Palace Museum, Beijing, Gu141971

88 →

Peacock-tail-shaped
travelling sundial
and compass

Qianlong period

Made in the Palace
Workshops, Beijing

Champlevé enamel,
2.2 × 3.8 × 4.8 cm

The Palace Museum, Beijing, Gu141763

Ferdinand Verbiest
(Chinese name Nan
Huairen, 1623–1688)
*Astronomical Instruments in the
Observatory* (*Lingtai yixiang zhi*),
page depicting instruments at
the Beijing Observatory

1674
Woodblock print on paper,
38 × 38.5 cm

The British Library, London, 15268.b.3

Ferdinand Verbiest
(Chinese name Nan
Huairen, 1623–1688)
Map of the Eastern Hemisphere
from *Complete Map of the
World* (*Kunyu quantu*)

1674
One map (of two), nine separate
sheets, woodcut on white paper,
each sheet average approximate
dimensions 57.5 × 51 cm

The British Library, London, Maps 183.p.41(1)

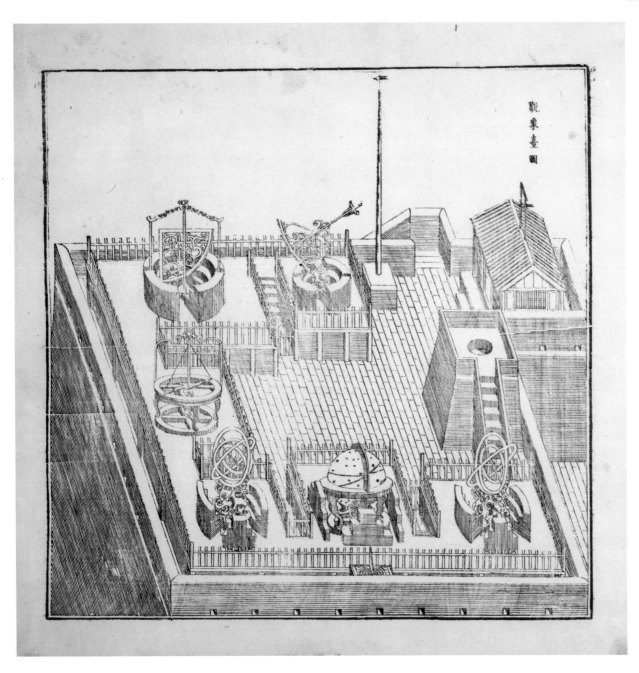

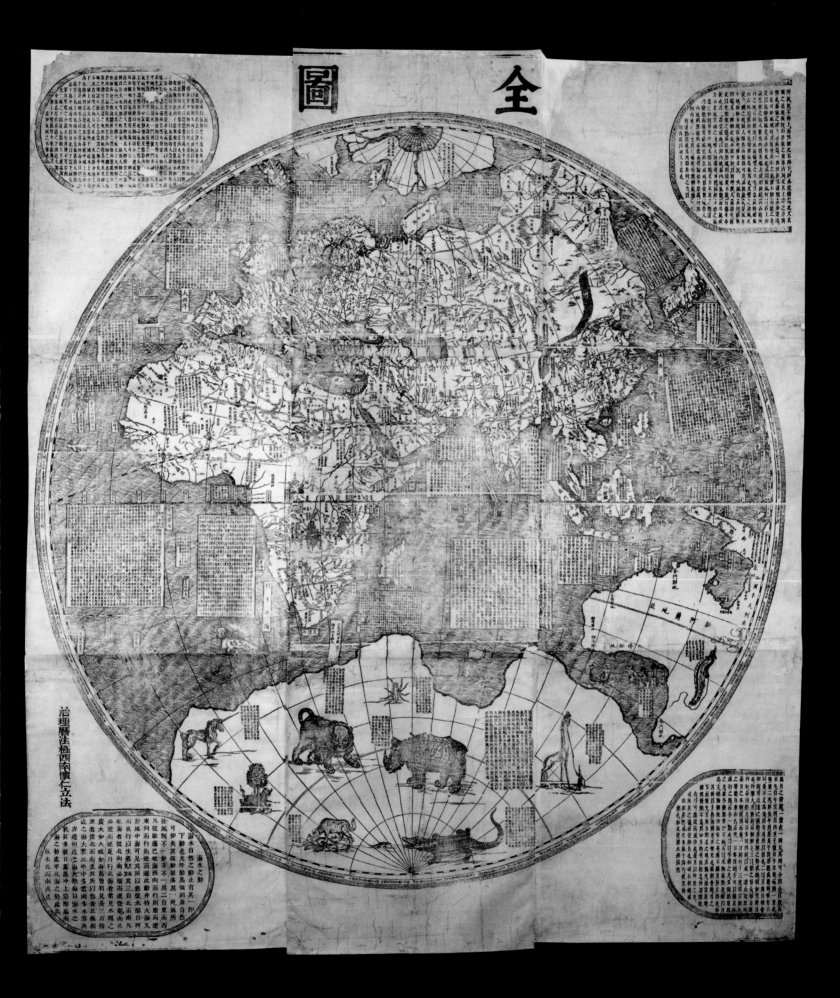

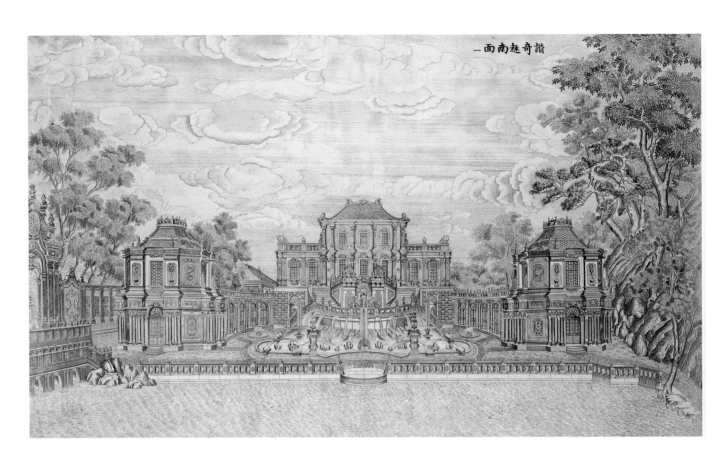

一面南趣奇諧

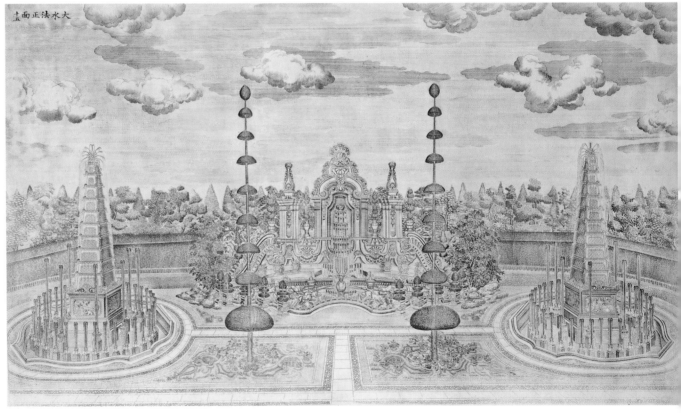

大水法正面十五

91

The Southern Façade of the Palace of the Delights of Harmony (Xieqiqu), The Western Façade of the Palace of the Calm Sea (Haiyan tang), Fountains (Dashuifa) and Ornamental Lake (Hudong xianfu) from The Yuanming yuan European Palaces

1781–86

Four copperplate engravings on paper (plates 1, 10, 15 and 20) from a set of twenty leaves, after drawings by Yi Lantai (fl. *c*. 1738–1786), each 50 × 88 cm

Inscriptions: inscribed with the name of the palace or of the landscape unit and the number of the leaf in the set

Staatliche Museen zu Berlin, Kunstbibliothek, OS 2783

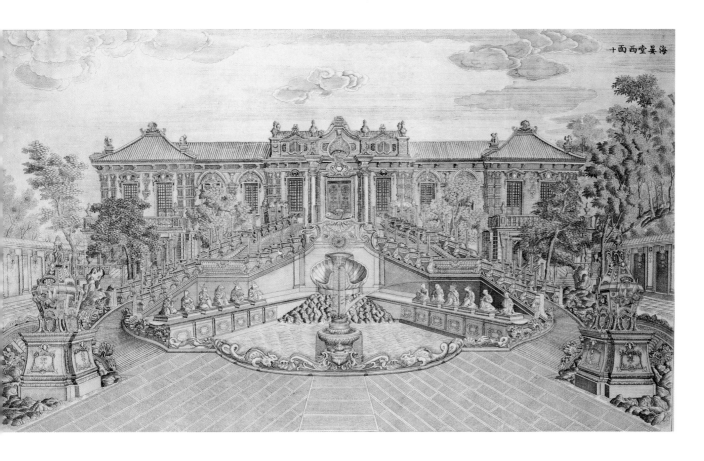

海晏堂西面 十

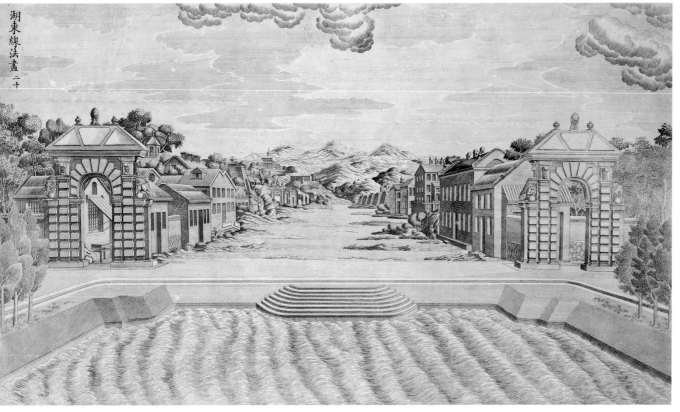

湖東線法畫 二十

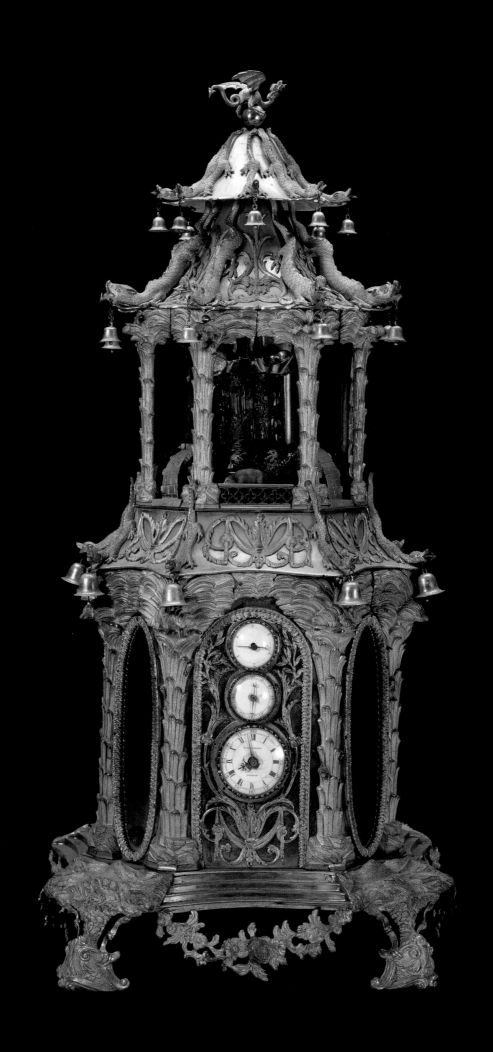

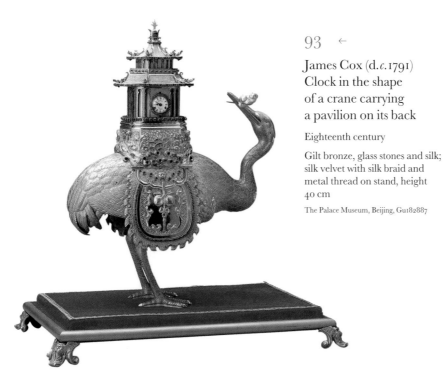

93 ←

James Cox (d. *c*.1791)
Clock in the shape
of a crane carrying
a pavilion on its back

Eighteenth century

Gilt bronze, glass stones and silk;
silk velvet with silk braid and
metal thread on stand, height
40 cm

The Palace Museum, Beijing, Gu182887

94 ↓

Four-sided gilt bronze
and yellow enamel clock

Qianlong period,
made in Guangzhou

Gilt bronze and enamel,
111 × 47 × 47 cm

The Palace Museum, Beijing, Gu183086

92 ←

Timothy Williamson
(fl. 1769–1788)
Clock in the shape
of a pavilion

Eighteenth century

Gilt bronze and coloured stones,
height 77 cm

The Palace Museum, Beijing, Gu182774

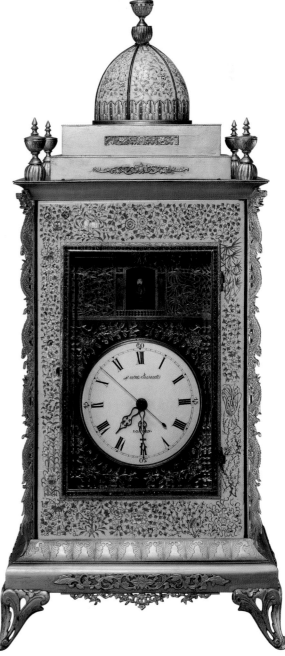

95 ↓

Clock in the form of a double-eaved pavilion with revolving figures of the Eight Immortals

Qianlong period, made in the Palace Workshops, Beijing

Zitan wood and enamel, 88 × 51 × 40 cm

Qianlong reign mark

The Palace Museum, Beijing, Gu183184

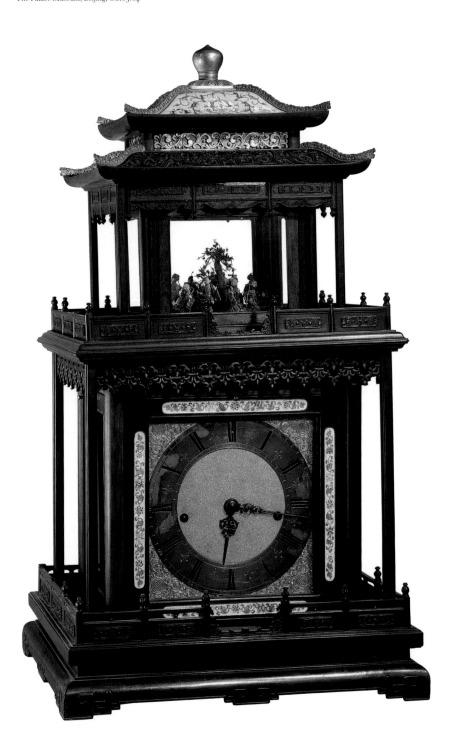

96 →

Anonymous court artist or Giuseppe Castiglione (Chinese name Lang Shining, 1688–1766)
Portrait of Huixian, Imperial Honoured Consort (huangguifei)

Qianlong period

Wall screen, oil on paper, 53.5 × 40.4 cm

The Palace Museum, Beijing, Gu9206

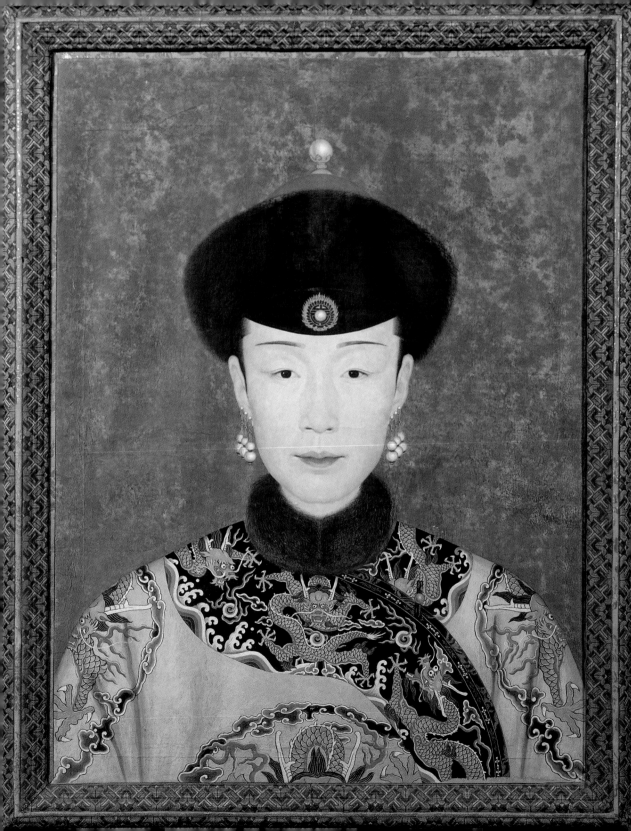

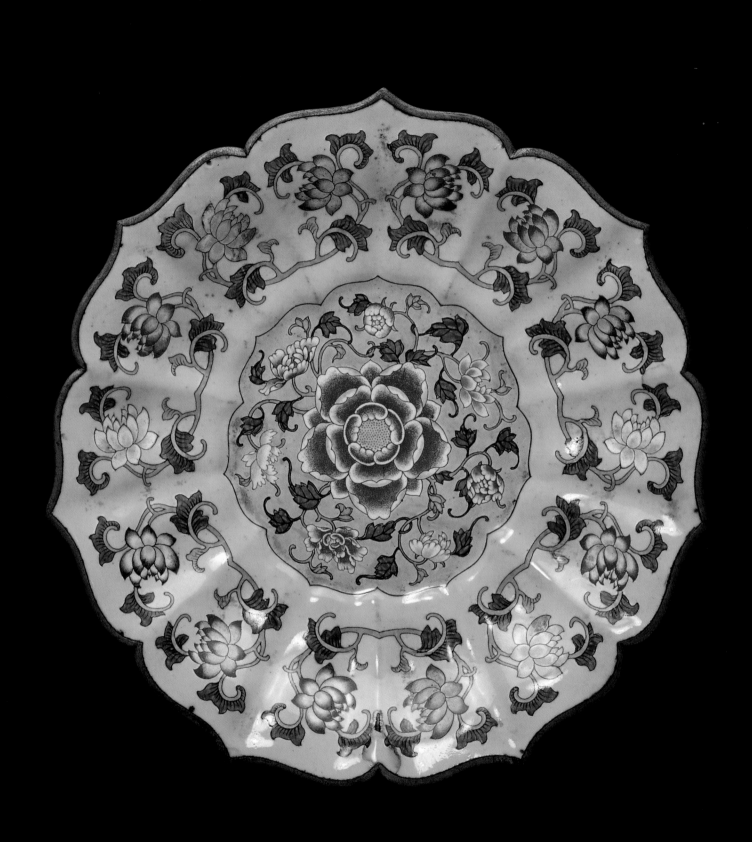

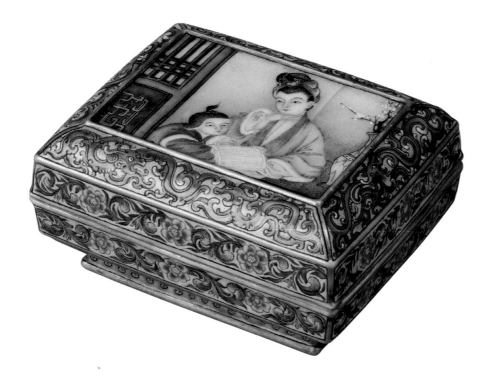

Box and cover painted with
a Western lady and child
holding a Chinese book,
archaistic dragons and
flower scrolls

Qianlong period, Palace Workshops,
Beijing, and Jingdezhen, Jiangxi
Province

Enamels and gilding on porcelain,
3.7 × 5.7 × 6.8 cm

Qianlong four-character mark in a
double square in blue enamel on the base

The Palace Museum, Beijing, Gu152669

Heptafoil dish painted in
twelve colours with peony
and lotus, and sprigs of
ginkgo on the reverse

Kangxi period, Palace Workshops,
Beijing

Enamels and gilding on copper,
diameter 17.2 cm

Kangxi yu zhi mark (made by imperial
order of Kangxi) in a double ring in blue
enamel on the white-enamelled base

The Palace Museum, Beijing, Gu116843, 5

Vase in the form of a silk pouch
tied with a ribbon, painted with
dragons among scrolling flowers

Qianlong period, Palace Workshops,
Beijing

Enamels on glass, height 18.8 cm

Qianlong four-character mark in blue
enamel inscribed on one of the flowers

Collection of the Hong Kong Museum of Art, *c.* 1995.002

100

Snuff bottle with painted enamel design of plum blossoms

Kangxi period

Copper and painted enamel, 6 × 4.5 cm

Kangxi yu zhi mark (made by imperial order of Kangxi)

The Palace Museum, Beijing, Gu 120097

101

Snuff bottle with painted enamel design of plum blossoms

Yongzheng period

Copper and painted enamel, 6 × 4 cm

Yongzheng four-character reign mark

The Palace Museum, Beijing, Gu120098

102

Pouch-shaped snuff bottle with painted enamel design of lotus scrolls

Yongzheng period

Copper and painted enamel, 3.5 × 3.2 cm

The Palace Museum, Beijing, Gu116478

103

Peacock-tail-shaped snuff bottle in painted enamel

Qianlong period

Copper and painted enamel, 4.6 × 3.7 cm

Qianlong four-character reign mark

The Palace Museum, Beijing, Gu116467

104

Snuff bottle with enamel painting of a landscape

Qianlong period

Copper and painted enamel, 6.5 × 4.4 cm

Qianlong four-character reign mark

The Palace Museum, Beijing, Gu116439

105

Snuff bottle with painted enamel design of flowers and birds

Qianlong period

Copper and painted enamel, 5.6 × 4 cm

Qianlong four-character reign mark

The Palace Museum, Beijing, Xin77299

106

Snuff bottle with painted enamel design of graceful women

Qianlong period

Copper and painted enamel, 5 × 3.5 cm

Qianlong four-character reign mark

The Palace Museum, Beijing, Gu116846

107

Fish-shaped snuff bottle with overlay design

Qianlong period

Glass, 7.5 × 3 cm

Qianlong four-character reign mark

The Palace Museum, Beijing, Gu107616

108

Snuff bottle with painted enamel design of lotus pond

Qianlong period

Glass and painted enamel, 5.5 × 4 cm

Qianlong four-character reign mark

The Palace Museum, Beijing, Gu107621

109

Gourd-shaped snuff bottle with painted enamel design of flowers, gourds and bats

Qianlong period

Glass and painted enamel, 6.4 × 3.2 cm

Qianlong four-character reign mark

The Palace Museum, Beijing, Gu107622

110

Snuff bottle with painted enamel design of Western figures

Qianlong period

Glass and painted enamel, 4.6 × 3.5 cm

Qianlong four-character reign mark

The Palace Museum, Beijing, Xin98788

111

Gourd-shaped snuff bottle

Qianlong period

Mutton-fat jade, 5.1 × 3 cm

Qianlong four-character reign mark on lower bulb

The Palace Museum, Beijing, Gu103693

112

Snuff bottle carved
with rope design

Qianlong period

Jasper, 6.7 × 4.5 cm

Qianlong four-character reign
mark in seal script

The Palace Museum, Beijing, Gu93252

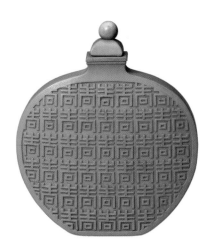

115

Snuff bottle with 'long life'
(*shou*) characters in
asparagus fern

Mid-Qing dynasty

Bamboo skin, 6.5 × 5.5 cm

The Palace Museum, Beijing, Gu121242

113

Jujube-shaped snuff bottle

Mid-Qing dynasty

Green agate, 4 × 2 cm

The Palace Museum, Beijing, Gu106115

116

Walnut-shaped snuff bottle
with design of Westerners,
inscribed with a poem
about snuff bottles and
followed by the two
characters *zhen shang*
(to keep and appreciate)

Qianlong period

Wood, 5 × 3.5 cm, with bamboo
stopper

The Palace Museum, Beijing, Gu135261, 23

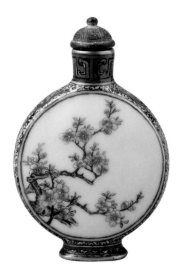

114

Snuff bottle with *famille-rose*
design of plum and
imperial poem

Qianlong period

Porcelain, 5.8 × 4 cm

Qianlong yu zhi mark (made by
imperial order of Qianlong)

The Palace Museum, Beijing, Gu152768

117

Snuff bottle shaped like
a 'Buddha's hand' fruit
(finger citron)

Possibly the example recorded in
the Yongzheng records of bottles
produced in the imperial ivory
workshops: Yongzheng period,
*c.*1725

Ivory, 5.9 × 2.1 cm

Private collection

118 ↑

Snuff dish in the shape of a
lotus leaf with a crab clasping
a chrysanthemum spray

Qianlong period

Painted enamel on copper,
7.6 × 4.5 cm

Qianlong four-character reign mark
in a square in blue enamel on the
underside

The Palace Museum, Beijing, Gu116619

119 ↘

Rococo-style vase with animal-
mask ring handles, painted
with European landscapes

Qianlong period, Guangzhou,
Guangdong Province

Enamels and gilding on copper,
height 50.5 cm

Qianlong six-character seal mark in
blue enamel in a square on the base

The Palace Museum, Beijing, Gu116624

The Kangxi Emperor:
Horseman, Man of Letters, Man of Science

REGINA KRAHL

The Kangxi Emperor was one of the most remarkable figures among China's long line of rulers, and this is a distinction he resolutely pursued (cat. 1). As a Manchu on the throne of China, he lacked a natural role model. His father, the first Qing emperor, who ruled under the title Shunzhi (1644–61), was not the conqueror of China. Having been installed on the throne as a child, he remained throughout his short life under the influence of various factions and offered little guidance for his son to follow.[1] Previous 'conquest dynasties' of China, such as the Khitan Liao (907–1125), the Jurchen Jin (1115–1234) and the Mongol Yuan (1271–1368), provided certain points of reference;[2] but basically the Kangxi Emperor had to find his own way.

The young Emperor – on the throne since the age of seven and effectively in control from the age of fifteen – went about the task of shaping the future of his immense territory by acquiring a clear understanding of every subject that mattered. He found teachers wherever he discovered a high standard of expertise. His multi-ethnic empire confronted him with a wide spectrum of cultures and brought him in touch with many different philosophies and beliefs. Confucianism, Shamanism, Buddhism and Daoism were patronised to accommodate Han Chinese, Manchus, Mongols and Tibetans;[3] Islam was tolerated as Central Asian Turkic peoples were incorporated into the empire;[4] and the propagation of Catholicism was permitted as long as the Church did not challenge the Emperor's status and his subjects' Confucian traditions.[5]

The broad vision that the Kangxi Emperor acquired was thus derived from a combination of formative influences, but in particular from his own Manchu heritage, from China's cultural traditions, and from Western science and technology. The interplay of these different spheres is reflected in many works of art from his reign; for example, in a portrait painted according to Western laws of representation, depicting the Emperor in Manchu dress and consulting Chinese books (fig. 56).

As a visible sign of adherence to his Manchu heritage and as a deliberate symbol of restraint, in contrast to the opulent fashions of the late Ming period, the Kangxi Emperor continued to wear Manchu garments. The Manchu language was kept alive, and Manchu writing, devised only decades before the foundation of the Qing dynasty, was used on many official documents next to Chinese, as joint official language (cat. 64). As one of many measures to keep in touch with the traditional Manchu homeland, the Emperor built a summer palace, the Mountain Villa to Escape the Heat (see cat. 27), high up at Rehe, present-day Chengde in Hebei Province, beyond the Great Wall and thus far from any established seats of Chinese power (fig. 57).

These were the visible, but perhaps not the most important, concessions to Manchu culture. Seen from a Manchu angle, the Chinese bureaucracy, dominated by scholars – much though it was admired – must have had the air of a bookish, ivory-tower élite, to which the Manchu 'outdoor' way of life provided a healthy counterbalance. The Emperor put great emphasis on practical skills such as riding, archery, shooting, hunting and travelling with tents, and participated in these activities, both as purely physical exercises and in actual battle (cats 61, 62). Physical strength and energy were considered assets that aided mental vigour and endurance. The Kangxi Emperor's six inspection tours to southern China sent impressive signals throughout the empire of his vitality, personal commitment and imperial splendour, and at the same time made him familiar with regions with a different geology, climate, culture and history (cat. 13).

Fig. 56
Anonymous, *The Kangxi Emperor Reading*, Qing period. Hanging scroll, colour on silk, 138 × 106.5 cm. The Palace Museum, Beijing, Gu6411

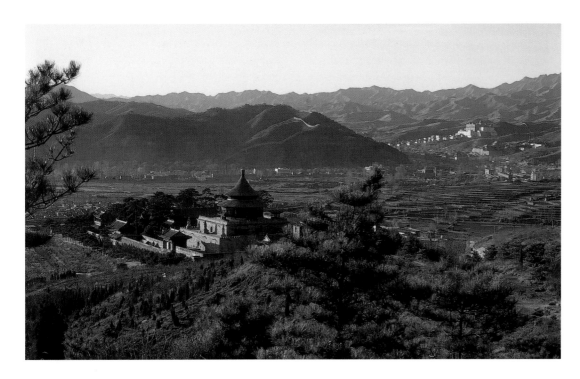

Fig. 57
View of Chengde (formerly Rehe),
Hebei Province

The educated Han Chinese literati who staffed the civil service had been the pillar of the Chinese state since antiquity and represented a power which guaranteed continuity. They were selected through a system of state examinations based on classical Confucian texts. Confucian morals and rituals, which had provided good guidance for centuries, therefore continued to supply the framework for public and private behaviour. A serious training in history, philosophy, literature and calligraphy was a prerequisite for this élite, and thus for the Emperor.

To fulfil his mandate, which was considered as given by Heaven, the Manchu Emperor had to learn his role.[6] This had been formulated by exemplary figures from three thousand years of documented history, written and interpreted by classically trained scholars. Aware of the weight of Chinese history and the quality of scholarship which he was expected to perpetuate, the Kangxi Emperor surrounded himself with educated Han Chinese. He had regular sessions with leading scholars in a small studio, the Nanshu fang (Southern Studio), in the Forbidden City, to discuss the subjects of classical learning, which he studied under instruction and on his own, and to practise his writing skills.

All policy decisions needed the Emperor's written approval, and a mountain of daily paperwork – sometimes hundreds of documents – required his personal scrutiny and comments. For the subject at hand, a knowledge of philosophical concepts and historical precedents was needed; for phrasing, a familiarity with Chinese literature; and for calligraphy, a study of ancient manuscripts and the copying of famous exemplars. Han officials might not have considered the Kangxi Emperor the most gifted calligrapher, but the importance he placed on this art is reflected in the portrait for which he posed at a young age, again in Manchu dress, pointedly wielding his writing brush (cat. 120).

The handle of that imperial brush is of blue-and-white porcelain, and his desk is equipped with a sheet of paper, a book, a small water pot with a spoon, both probably of bronze, and an inkstone, of stone, on which black ink has been prepared. This carefully chosen, minimalist display may be deceptive. As the Emperor put much weight on literary skills, desk utensils became an important branch of Chinese crafts. Since he was less enamoured with expensive materials than with quality craftsmanship, the classic materials used in the late Ming for deliberately understated scholar's items, such as stone, bamboo, wood, gourd, horn and tusk, now appeared at court among more prestigious materials such as jade, porcelain and bronze. Elaborately decorated sticks of ink (cat. 137) would be ground on ink stones (cat. 136), with water ladled from small water pots (cat. 143); the wet inkstick would then be placed on an ink stand (cat. 139). Brushes

Fig. 58
Profound Mirror of Ancient Style Texts
(*Guwen yuanjian*), an anthology selected
by the Kangxi Emperor, 1685/86.
Polychrome woodblock printed edition,
28 × 18 × 6 cm. Bibliothèque nationale
de France, Paris (MS Chinois 3595,
folios 15v–16v)

(cat. 138) of different thickness and with different types of hair for different styles of calligraphy and painting would be held in brushpots (cats 130, 132, 135), set down on brushrests while in use, and cleaned in brush washers (cats 141, 145); wrist rests (cats 131, 133, 140) helped to support the hand while writing. Seals (cat. 123) often fulfilled the role of signatures, and the vermillion seal paste was kept in small boxes (cat. 144). Incense burners and flower vases would equally form part of a scholar's study alongside the prerequisite books and scrolls.

To document his legitimacy on the throne of China, the Manchu Emperor had to display his learning. Numerous writings were published under the Kangxi Emperor's name, ranging from general treatises on morals to practical guidelines for agriculture, and poetic works (fig. 58). As a reflection of his own thinking, he emphasised in particular the teachings of Zhu Xi (1130–1200), a Neo-Confucian philosopher who argued for an adherence to logic and ethical principles.

The consolidation of Manchu power required not only instruction from the upholders of Chinese culture, but also their integration into the state structure, which in principle was upheld by bannermen (cat. 64).[7] The imperial examination system, the main method of official recruitment since the Song dynasty, was also adopted by the Manchu rulers. The Emperor tried to engage those not directly involved in administration in other ways. A grand symbolic gesture towards the Chinese élite was his call for examinations to select scholars for the compilation of the official history of the previous dynasty, the Han-ruled Ming. He also initiated or sponsored a large number of literary compilations, linguistic and lexicographic studies and other projects. This not only raised the standard of scholarship, but also occupied unemployed officials, and won the Manchu dynasty confidence and support among the Han élite.

The *Synthesis of Illustrations and Books Past and Present* (*Qinding Gujin tushu jicheng*) (cat. 129), one of the world's largest book projects, originated as a private undertaking, but was adopted as a state enterprise at the Kangxi court. Completed just before the Emperor died, this vast encyclopaedia was published in the next reign in 5,020 volumes comprising some 800,000 pages.[8] The *Complete Tang Poetry* (*Quan Tang shi*), an anthology of nearly 50,000 poems by over 2,200 writers, commissioned by the Kangxi Emperor, was completed in just two years and published in 1707, with a preface by the Emperor.

Among the lexicographic works, the *Collection of Rhymes from the Imperial Study* (*Peiwen yunfu*), a dictionary of phrases from ancient texts useful for composing poetry, is remarkable mainly for its size. The *Kangxi Dictionary* (*Kangxi zidian*), on the other hand, represents a milestone in the development of lexicography. Comprehensive, reliable and practically organised, it replaced virtually all its predecessors and remains a valid reference work today. Although its thirty compilers followed a somewhat earlier model, they considerably enlarged and systematised it, and the Emperor's patronage ensured wide distribution. Because its nearly 50,000 characters were arranged not phonetically, as had been conventional, but pictographically, the dictionary became accessible also to non-Chinese speakers, and this arrangement has remained customary to this day.[9]

These publishing projects required fine printing. Although an imperial printing-office existed in the Forbidden City, which was able to carry out outstanding projects and could do five-colour printing, several of these important imperially sponsored works were entrusted to the private printing-house of Cao Yin (1658–1712), located in Yangzhou, Jiangsu Province. Cao, a bondservant of the Plain White Banner, whom the Emperor held in high esteem, was himself a great man of letters and his printing became famous for its high standard.

Printing was not the only important charge that Cao Yin undertook for the Emperor. For several generations the Caos had been settled in southeastern China, where the family was entrusted with the lucrative offices of salt commissioners and supervisors of textile works. Cao Yin repeatedly entertained the Emperor during his southern tours, an expensive undertaking that few families in the empire could afford. The three imperial textile manufactories in Nanjing, Suzhou and Hangzhou, each employing thousands of men, were all managed by the Cao family. They produced court robes and other official textiles, ritual silk furnishings for imperial temples, imperial patent scrolls for presentation to officials and, besides fine silks, satins and velvets, also made more prosaic fabrics such as plain blue cotton cloth.[10]

Like the textile manufactories, the imperial porcelain workshops were situated in the south, far from the capital, in Jingdezhen, Jiangxi Province. They had been working for the court since the Yuan dynasty, but had ceased to receive imperial commissions during the turbulent decades at the end of the Ming. Under the Kangxi Emperor, supervised by Lang Tingji (1663–1715), of the Bordered Yellow Banner, they revived rare styles of the past, such as the notoriously difficult copper-red glazes (cats 143–48) associated with the Xuande reign (1426–35), the only time before the Kangxi period that they had been mastered.

The Kangxi Emperor assumed personal patronage of the arts and crafts as an inherited imperial obligation. Although aesthetic delights seem to have touched him less, he was keenly interested in intellectual and technical challenges. His inquisitive mind might have derived more pleasure from witnessing the creative process than from possessing the finished masterpiece. While he could rely on trusted officials to guarantee a high standard of quality, his personal input on work carried out far from the capital was limited. One of the Kangxi Emperor's greatest contributions to the arts was the establishment of additional imperial workshops in the Forbidden City itself.

His choice of location for these Palace Workshops (Zaoban chu), which formed part of the Imperial Household Department (Neiwu fu), reflects his determination to be directly involved in their activities: they were accommodated in the Inner Palace in the Hall of Mental Cultivation (Yangxin dian), the very place the Emperor had chosen as his living quarters.[11] Work done in these workshops comprised not only glamorous imperial commissions, but also official furnishings and mundane tasks such as repairs. However, this exceptional proximity, which continued under the Yongzheng and Qianlong Emperors whose interests in the arts differed from Kangxi's, brought craftsmen into closer contact with their imperial patrons than ever before. The period covered in this exhibition saw the finest works ever produced in China, and directly reflects the three Emperors' different personalities and personal tastes, with styles changing from one sovereign to the next.

The Palace Workshops were occupied with a vast range of materials: metals, particularly gold, silver and bronze; stones – precious, semi-precious and ordinary – including jade, crystal and agate; glass;

vegetal matter such as bamboo, wood, gourd and lacquer; animal matter like coral, ivory, horn and leather; and they experimented with new substances discovered inland (cat. 136) or imported from the West (cat. 163). Production processes that required a large amount of space and resources, or caused inconvenience to the Forbidden City's residents, were carried out in provincial workshops. Thus porcelain production, which created noise, heat and dirt, always remained in south China (cats 293, 302), although smaller pieces were sent to Beijing for decoration (cat. 163). Resident court artisans were instructed by the best craftsmen from all over the country, who were sent to Beijing on temporary missions. Artisans worked side by side with court painters, and Jesuits from Europe collaborated with both.

From the Jesuits the Kangxi Emperor learned about physics, chemistry, medicine and other branches of the sciences. Ferdinand Verbiest (1623–1688) produced a map of the world which was printed in 1674 (cat. 90). A cartographic survey of the whole empire commissioned from the Jesuits resulted in an atlas engraved in copper, more accurate than any maps at the time.[12] The so-called Calendar Controversy in 1668–69 convinced the Emperor that Western calendar calculations were more accurate than Chinese, and he appointed Verbiest as head of the imperial board of astronomy. Verbiest built new instruments (cats 86, 87, 89), also for the observatory, and instructed the Emperor in mathematics and astronomy. Scientific instruments were produced in the Palace Workshops and inscribed with the

imperial reign mark, which until then had been reserved for art objects; and the instruments are indeed works of art (fig. 59).

Besides their more abstract contributions to rational thinking, mathematics and geometry provided a new understanding of the laws of representation and thereby transformed court painting. The Italian Jesuit Giuseppe Castiglione (1688–1766), who came to the court in 1715 and served under all three emperors, instructed court painters in subjects such as perspective, anatomy, colour theory and *chiaroscuro* to depict depth, volume and shading (cats 79, 80, 91). The new realism introduced a kind of painting unrelated to Chinese literati painting, but suitable for official documentation (cats 65, 75, 76). The Kangxi Emperor arranged for all important state ceremonies to be recorded in minute detail by court artists (cats 13, 24) and his successors continued this practice.

A strong personality, the Kangxi Emperor has been described as determined, principled, frugal, tolerant, conciliatory, practical, open-minded and eager to learn. While tradition-bound Confucianism remained the ideological foundation of the state, its confrontation with other cultural concepts overcame the stagnation of the previous Ming dynasty. Building on tradition, but breaking with conventions that hampered progress, the Kangxi Emperor was able to rule successfully and release his empire's immense creative potential. Without losing touch with his Manchu heritage, the Kangxi Emperor became a model emperor of China, even while opening it up to Western ideas.

Fig. 59
Quadrant made in the Palace Workshops, marked 'Kangxi yu zhi' (made by imperial order of Kangxi) and of the period.
Gilt copper, arc radius 41.5 cm.
The Palace Museum, Beijing, Gu141694

Anonymous court artists
*Portrait of the Kangxi Emperor
in Informal Dress Holding
a Brush*

Kangxi period

Hanging scroll, ink and colour
on silk, 50.5 × 31.9 cm

The Palace Museum, Beijing, Gu6402

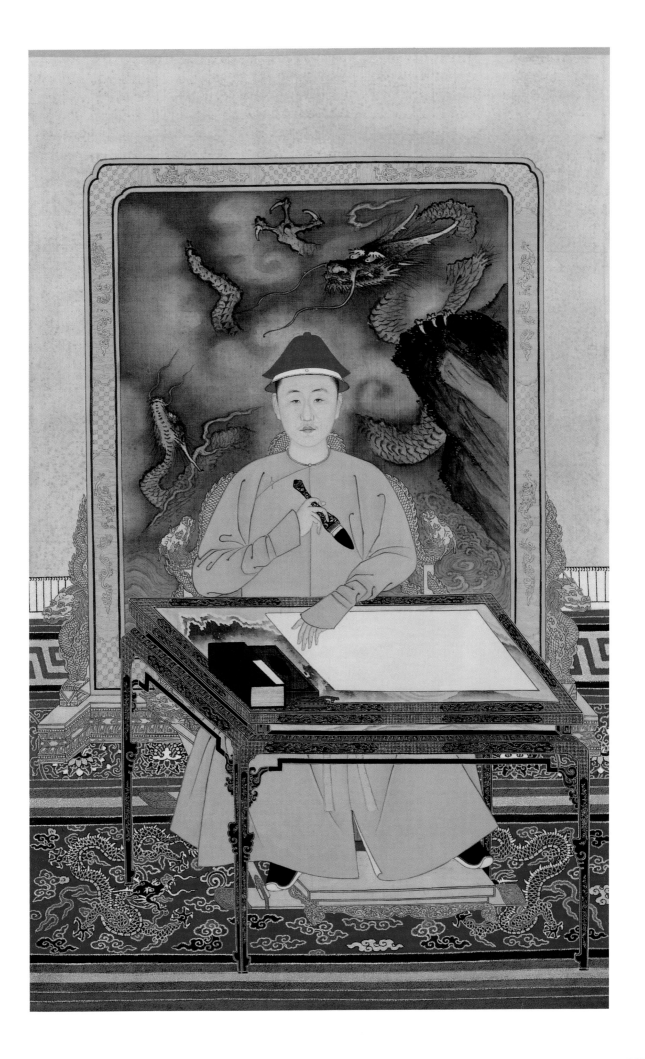

藍苕匝扶吐拕捲暎水濱劍芒開

寶匣峰彩寫蒲津下照參差行高

縠蒲弱穎自當巢翠甲凡止戲賴

鱗美以昉先後而言色故秋芳香

匹堪玩誰報涉江人

唐陳至詠芙蕖　倣董其昌

陶令籬邊菊秋來色轉佳翠攢千

片葉金剪一枝花蕊逐蜂鬚濱捲英

隨嵾翅斜帶香飄綠綺和影上窗

紗散漫搖霜彩鮮妍漏日華芳菲

彭澤見稱更在誰家

唐公乘億詠菊　倣米芾

121 ←

The Kangxi Emperor
(1654–1722)
A Tang poem about the lotus in
bloom, written in running script
in the style of Dong Qichang

c. 1703

Hanging scroll, ink on silk,
186.7 × 85.3 cm

Imperial seals: *Guiwei zai he* (*Guiwei* year
[1703] in harmony); *Yuanjian hui hao*
(Wielding the brush in the Studio of
Profound Discernment); *Sanwu jiuyou*
(Three lacks, nine haves)

Collectors' seals: *Baoji sanbian* (Volume
three of the *Precious Collection of the Stone
Moat [Pavilion]*); *Shiqu baoji suo cang*
(Collected in the *Precious Collection of the
Stone Moat [Pavilion]*); *Xuantong zunqin zhi
bao* (Treasure of the esteemed parents
of the Xuantong Emperor); *Jiaoyubu
dianyan zhi zhang* (Inspection seal of
the Department of Education)

The Palace Museum, Beijing, Gu237978

123 ↑

Seal of the Kangxi
Emperor

1662–1722

Sandalwood, 11 × 11 × 11 cm,
with cord of yellow silk

The Palace Museum, Beijing, Gu166445

122 ←

The Kangxi Emperor
(1654–1722)
A Tang poem in praise of
chrysanthemums, written in
the standard running script
in the style of Mi Fu

1703

Hanging scroll, ink on silk,
186.5 × 83.5 cm

Imperial seals: *Guiwei zai he* (*Guiwei* year
[1703] in harmony); *Yuanjian hui hao*
(Wielding the brush in the Studio of
Profound Discernment); *Sanwu jiuyou*
(Three lacks, nine haves)

Collectors' seals: *Baoji sanbian* (Volume
three of the *Precious Collection of the Stone
Moat [Pavilion]*); *Shiqu baoji suo cang*
(Collected in the *Precious Collection of
the Stone Moat [Pavilion]*); *Xuantong zunqin
zhi bao* (Treasure of the esteemed parents
of the Xuantong Emperor); *Jiaoyubu
dianyan zhi zhang* (Inspection seal of
the Department of Education)

The Palace Museum, Beijing, Gu237980

124 ↓

*Imperial Prose and Poetry of
the Kangxi Emperor* (*Yuzhi
wenji/ Shengzu wenji*), 140 *juan*

1711

Woodcut edition printed on fine
white paper in 78 fascicules,
28 × 17.5 cm

The British Library, London, 15316.e.193

125

The Kangxi Emperor (1654–1722)
'On the Way to Guangning',
a poem, in running script

Undated

Hanging scroll, ink on paper, 125.7 × 51.5 cm

Imperial seals: *Kangxi chen han* (Kangxi imperial brush); *Jigu youwen zhi zhang* (Seal of examining the ancient to improve culture); *Yuanjian zhai* (Studio of Profound Discernment)

Collectors' seals: *Baoji sanbian* (Volume three of the *Precious Collection of the Stone Moat [Pavilion]*); *Shiqu baoji suo cang* (Collected in the *Precious Collection of the Stone Moat [Pavilion]*); *Xuantong zunqin zhi bao* (Treasure of the esteemed parents of the Xuantong Emperor); *Jiaoyubu dianyan zhi zhang* (Inspection seal of the Department of Education)

The Palace Museum, Beijing, Gu237967

126

The Kangxi Emperor (1654–1722)
'Composed at Zhaobeikou',
a poem, in running script

Undated

Hanging scroll, ink on gold-flecked paper, 135.5 × 57.1 cm

Imperial seals: *Kangxi chen han* (Kangxi imperial brush); *Jigu youwen zhi zhang* (Seal of examining the ancient to improve culture); *Yuanjian zhai* (Studio of Profound Discernment)

Collectors' seals: *Baoji sanbian* (Volume three of the *Precious Collection of the Stone Moat [Pavilion]*); *Shiqu baoji suo cang* (Collected in the *Precious Collection of the Stone Moat [Pavilion]*); *Xuantong zunqin zhi bao* (Treasure of the esteemed parents of the Xuantong Emperor); *Jiaoyubu dianyan zhi zhang* (Inspection seal of the Department of Education)

The Palace Museum, Beijing, Gu237959

127

The Kangxi Emperor (1654–1722)
'Appreciating Chrysanthemums on the Double Ninth Festival',
a poem, in running script

Undated

Hanging scroll, ink on paper, 125 × 51.4 cm

Imperial seals: *Kangxi chen han* (Kangxi imperial brush); *Chiji qing yan* (Pure repose from state affairs); *Yuanjian zhai* (Studio of Profound Discernment)

Collectors' seals: *Baoji sanbian* (Volume three of the *Precious Collection of the Stone Moat [Pavilion]*); *Shiqu baoji suo cang* (Collected in the *Precious Collection of the Stone Moat [Pavilion]*); *Xuantong zunqin zhi bao* (Treasure of the esteemed parents of the Xuantong Emperor); *Jiaoyubu dianyan zhi zhang* (Inspection seal of the Department of Education)

The Palace Museum, Beijing, Gu237966

The Kangxi Emperor
(1654–1722)
'Crossing the Frozen River',
a poem, in running script

Undated

Hanging scroll, ink on gold-flecked
paper, 131.2 × 53.3 cm

Imperial seals: *Kangxi chen han* (Kangxi
imperial brush); *Jigu youwen zhi zhang*
(Seal of examining the ancient to
improve culture); *Yuanjian zhai* (Studio
of Profound Discernment)

Collectors' seals: *Baoji sanbian* (Volume
three of the *Precious Collection of the Stone
Moat [Pavilion]*); *Shiqu baoji suo cang*
(Collected in the *Precious Collection of the
Stone Moat [Pavilion]*); *Xuantong zunqin
zhi bao* (Treasure of the esteemed parents
of the Xuantong Emperor); *Jiaoyubu
dianyan zhi zhang* (Inspection seal
of the Department of Education)

The Palace Museum, Beijing, Gu237951

129

Imperially commissioned Chinese encyclopaedia, *Synthesis of Illustrations and Books Past and Present* (*Qinding Gujin tushu jicheng*)

Composite bird with four legs

Pheasants

Lions

'Dragon-horse'

Ox and buffalo

Dragons

Carp

Fungus

Lotus

Peony

1726

Copper movable type and woodblock illustrations printed on light brown paper, threadbound, average original dimensions approximately 27.5 × 17.5 cm

The British Library, London, 15023.b.1

龍馬圖

詩經
周南卷耳

陟彼崔嵬我馬虺隤　　陟彼高岡我馬元黃　陟彼

砠矣我馬瘏矣

注朱虺隤馬罷不能升高之病元黃元馬而黃病極
而變色也瘏馬病不能進也

喬木

之子于歸言秣其馬　　之子于歸言秣其駒

傳六尺以上曰馬五尺以上曰駒　正義曰庾人

龍圖

鯉魚圖

詩經
陳風衡門章

豈其食魚必河之鯉

大山陰陸氏曰鯉魚之貴者故爾雅釋魚以鯉冠
至篇而神農書曰鯉為魚最

爾雅

釋魚

鯉

注今赤鯉魚　集赤鯉魚詩云豈其食魚必河之鯉

芍藥圖

詩經
鄭風溱洧

伊其相謔贈之以芍藥

傳芍藥香草　疏陸璣疏云今藥草芍藥無香氣非
也未審是何草　注朱芍藥香草也三月開花芳色可
愛全　本草注曰芍藥有二種有草芍藥木芍藥

山海經

北山經

繡山其草多芍藥

澤芝 古今注

水華 綱目

菱荷 綱目

130 ← ↓

Brushpot painted with bamboo
and inscribed with a poem in
the calligraphy of Gao Fenghan
(1683–1748/49), with two
painted seals reading *xi* and *yuan*

Kangxi period, Jingdezhen,
Jiangxi Province

Porcelain with overglaze enamels,
height 14.8 cm

The Palace Museum, Beijing, Gu148294

131 ↓

Wrist rest in the form of a
piece of bamboo, painted with
bamboo and inscribed with
a poetic line

Kangxi period, Jingdezhen,
Jiangxi Province

Porcelain with overglaze enamels,
1.5 × 6.9 × 18.5 cm

The Palace Museum, Beijing, Gu148290

132 →

Brushpot carved with the Seven Sages of the Bamboo Grove and attendants

Early Qing dynasty, Jiading, Shanghai

Bamboo with *zitan* wood fittings, height 17.3 cm

The Palace Museum, Beijing, Gu121129

135 →

Brushpot carved in the form of five bamboo stems and a prunus branch

Early Qing dynasty, Palace Workshops, Beijing

Boxwood (*huangyangmu*), height 15.5 cm

The Palace Museum, Beijing, Xin82297

133 →

Wrist rest carved with lotus flowers with one leaf sheltering a crab

Early Qing dynasty, Jiading, Shanghai

Bamboo, 23 × 7.8 cm

Inscribed *Song shan* (Pine Hill) in form of a square seal

The Palace Museum, Beijing, Xin124676

134 →

Box and cover carved in the form of a 'Buddha's hand' fruit (finger citron)

Early Qing dynasty, seventeenth century

Boxwood (*huangyangmu*) with blackwood stand, 7 × 19.5 × 12 cm

Shuisongshi Shanfang Collection, 32.1.198

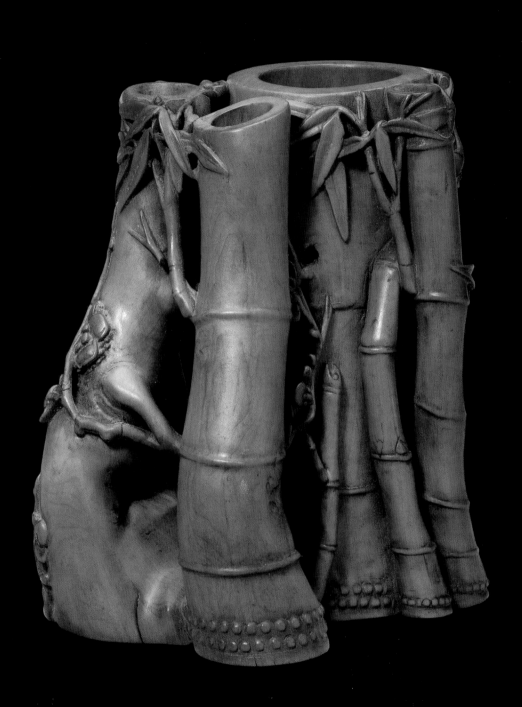

136 ↑

Inkstone with a dragon among waves, with fitted box and cover with archaistic dragon designs

Kangxi period, Palace Workshops, Beijing

Green Songhua stone with mother-of-pearl, and striated brown Songhua stone with glass, 5.5 × 13 × 19.2 cm

Kangxi chen han (Kangxi imperial pen) and *Kangxi yu ming* (Kangxi imperial inscription) engraved on the base

The Palace Museum, Beijing, Gu134706

137 ↓

Box of inksticks with mark of Wu Tian

Kangxi period

Lacquered wood and ink, 3 × 10 × 26 cm

The Palace Museum, Beijing, Xin109370, 1–10

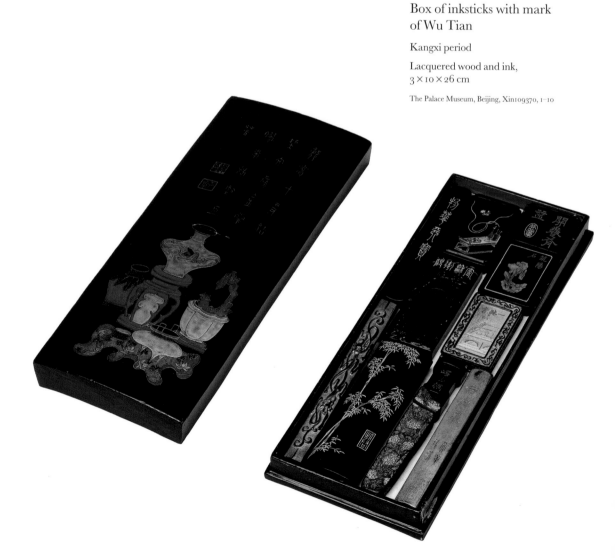

138 →

One of a pair of brushes

Kangxi period

Bamboo, rabbit hair,
27 × 1.2 cm

The Palace Museum, Beijing, Gu133201/6

140 ←

Wrist rest imitating
bamboo

Qing dynasty

Nephrite, 1.65 × 20 × 3.8 cm

Shuisongshi Shanfang Collection, 31.3.492

141 ↓

Brush washer in the shape
of a leaf

Kangxi period

Green-glazed porcelain,
1.5 × 7 × 12.8 cm

The Palace Museum, Beijing, Gu147675

139 ↑

Inkstick stand

Qing dynasty

Yellow jade, height 4.4 cm

The Palace Museum, Beijing, Gu92645

142 ←

'Peach-bloom' apple-shaped water pot (*pingguo zun*)

Kangxi period, Jingdezhen, Jiangxi Province

Porcelain with copper-red glaze, height 7.1 cm

Kangxi six-character reign mark in underglaze blue on the base

Anonymous loan

143 ←

'Peach-bloom' Taibo or chicken-coop water pot (*jizhao zun*)

Kangxi period, Jingdezhen, Jiangxi Province

Porcelain with copper-red glaze, height 8.5 cm

Kangxi six-character reign mark in underglaze blue on the base

The Palace Museum, Beijing, Gu147108

144 ←

'Peach-bloom' seal-paste box (*yinhe*)

Kangxi period, Jingdezhen, Jiangxi Province

Porcelain with copper-red glaze, diameter 7.2 cm

Kangxi six-character reign mark in underglaze blue on the base

Palace Museum, Beijing, Gu147129, 5

145 ←

'Peach-bloom' brush washer (*xi*)

Kangxi period, Jingdezhen, Jiangxi Province

Porcelain with copper-red glaze, diameter of mouth 8.2 cm, diameter of foot 7.7 cm

Kangxi six-character reign mark in underglaze blue on the base

The Palace Museum, Beijing, Gu147106

146 ←

'Peach-bloom' three string (*san xian*) or radish vase (*laifu ping*)

Kangxi period, Jingdezhen, Jiangxi Province

Porcelain with copper-red glaze, height 19.8 cm

Kangxi six-character reign mark in underglaze blue on the base

The Palace Museum, Beijing, Gu148318

147 ←

'Peach-bloom' chrysanthemum-petal vase (*juban ping*)

Kangxi period, Jingdezhen, Jiangxi Province

Porcelain with copper-red glaze, height 21.2 cm

Kangxi six-character reign mark in underglaze blue on the base

The Palace Museum, Beijing, Gu148272

148 →

'Peach-bloom' Guanyin or willow-leaf vase (*liuye ping*)

Kangxi period, Jingdezhen, Jiangxi Province

Porcelain with copper-red glaze, height 15.5 cm

Kangxi six-character reign mark in underglaze blue on the base

The Palace Museum, Beijing, Gu148337

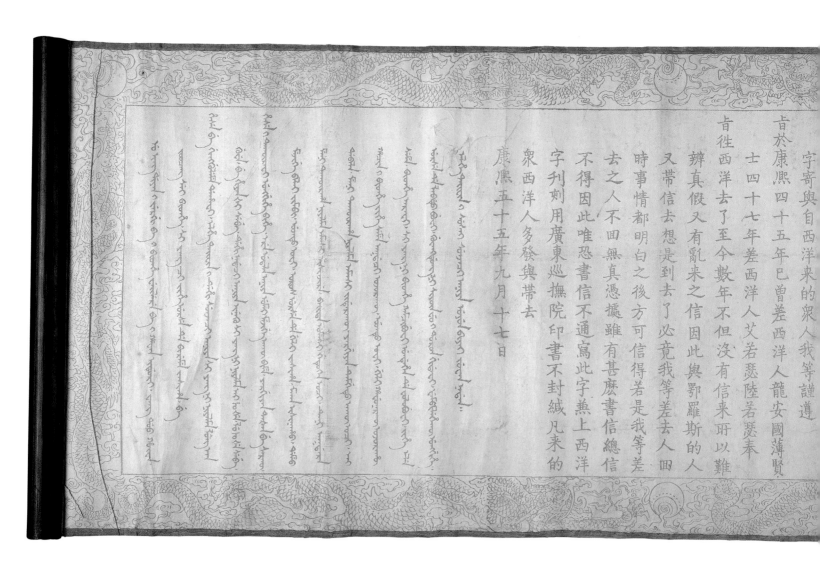

字寄與自西洋來的眾人我等謹遵

旨於康熙四十五年已曾差西洋人龍安國薄賢

士往西洋去了至今數年不但沒有信來冊以難

時事情都明白之後方可信得若是我等差

又帶信去想是到去了必竟我等差去人四

辨真假去了必竟我等差去人囬

去之人不囬無真憑據雖有甚麼書信總信

不得因此唯恐書信不通寫此字寄上西洋

字刊刻用廣東巡撫院印書不封緘凡來的

眾西洋人多發與帶去

康熙五十五年九月十七日

士四十七年差西洋人艾若瑟陸若瑟奉

149 ↑

Letter in Chinese, Manchu and Latin

31 October 1716 (Kangxi 55), Imperial Printing Office (Wuying dian), Beijing

One sheet, mounted on two wooden rollers, in a box; woodblock printed in red ink, Manchu on the left, Chinese in the middle and Latin on the right, 38 × 100 cm

On the reverse: 'Presented by the Rev. Mr. Cromp November 25, 1763'

Signed by Fathers Ripa (of the Sacred Congregation for the Propagation of the Faith), Pedrini, Kilian Stumpf, Suares, Bouvet, Foucquet, Parennin, de Tartre, Jartoux, Cardoso, Mourao, Baudino, Stadtlin, Brocard, da Costa and Castiglione (all of the Society of Jesus)

The British Library, London, 19954.c.12

150 →

Polyhedral proportional blocks

Kangxi period, Palace Workshops, Beijing

Hongmu or *zitan* wood, case 9.2 × 45.3 × 27 cm

The Palace Museum, Beijing, Gu142207

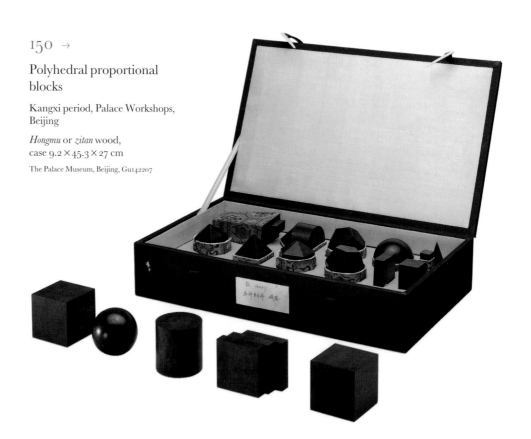

151 ↓

Hand calculator with paper
counting rods

Kangxi period, Palace Workshops,
Beijing

Brass, paper rolls and iron in
wooden case, 5 × 19 × 11.5 cm

The Palace Museum, Beijing, Gu228781

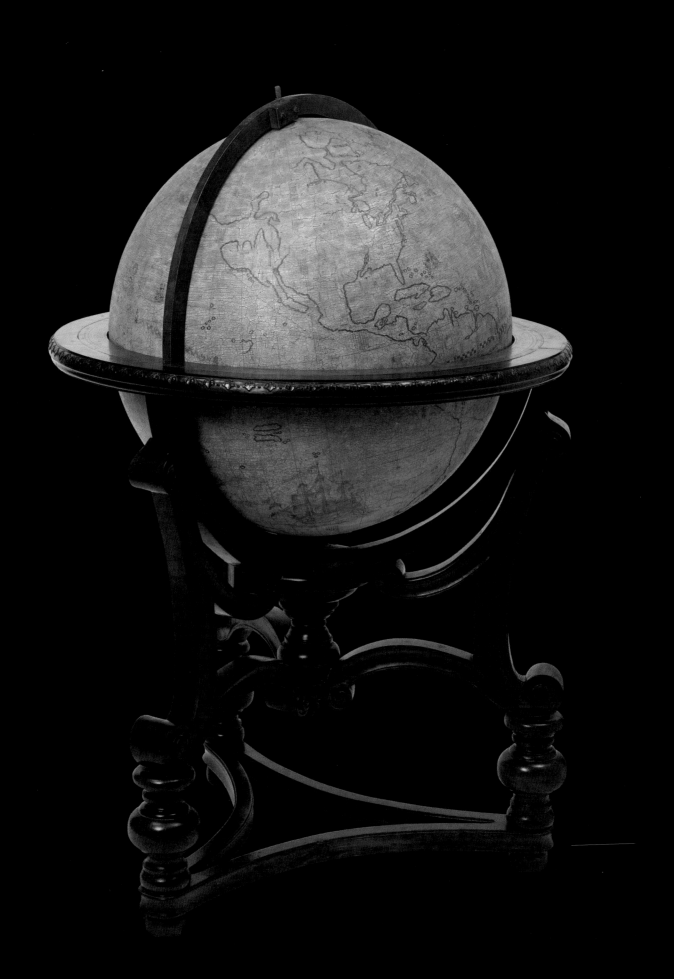

152 ←

Terrestrial globe

Kangxi period, Palace Workshops, Beijing

Moulded wood pulp covered in painted gesso, bronze, with a *zitan* wood stand, height 135 cm, diameter of globe 70 cm

The Palace Museum, Beijing, Gu141917

153 →

Shelving with lattice-style doors in the centre sections

Qing dynasty, seventeenth–eighteenth centuries

Zitan wood, 193.5 × 101.5 × 35 cm

The Palace Museum, Beijing, Gu207678

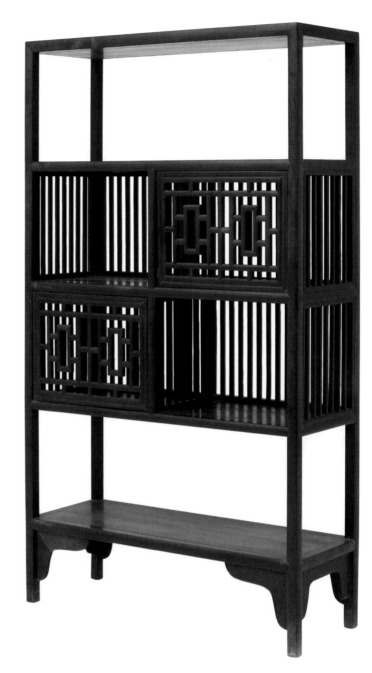

154 ↓

Side table with everted ends

Early Qing dynasty

Huali wood, 80 × 102 × 32.5 cm

C. and C. Bruckner

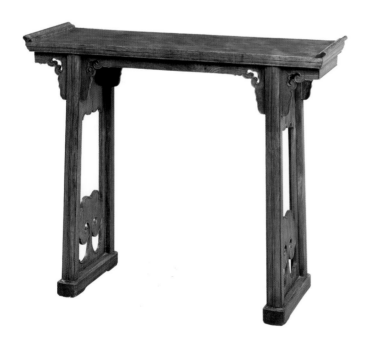

155 ↓

Carving of the Sixteen Lohan on a rocky mountain

Mid-Qing dynasty, eighteenth century

Bamboo root, height 30 cm

The Palace Museum, Beijing, Xin98421

156 →

Stone censer with three mountain peaks

Qing dynasty

Black Lingbi limestone with carved *jichimu* ('chicken-wing' wood) stand, 38.8 × 31 × 15.1 cm

Courtesy of The Metropolitan Museum of Art, New York. Promised gift of the Richard Rosenblum Family (L.1999.102.6a, b)

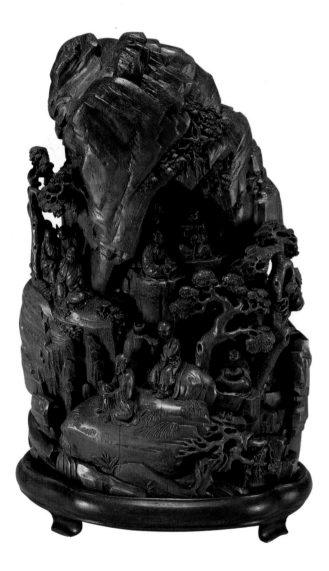

158 →

Taihu garden rock on a stand

Late Ming or early Qing dynasty, mid-seventeenth century, Suzhou, Jiangsu Province; the stand Fangshan, Beijing

Limestone and *hanbaiyu* marble, height including stand 188 cm

Staatliche Museen zu Berlin, Museum für Ostasiatische Kunst, no. 2003-4

157 →

Scholar's rock shaped like a bridge on a stand

Qing dynasty or earlier

Stone and *zitan* wood, 4 × 12 × 4.4 cm

Shuisongshi Shanfang Collection, 31.6.48

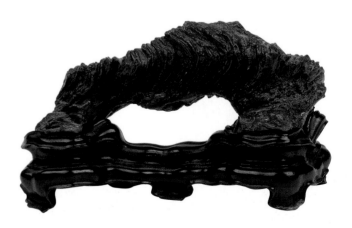

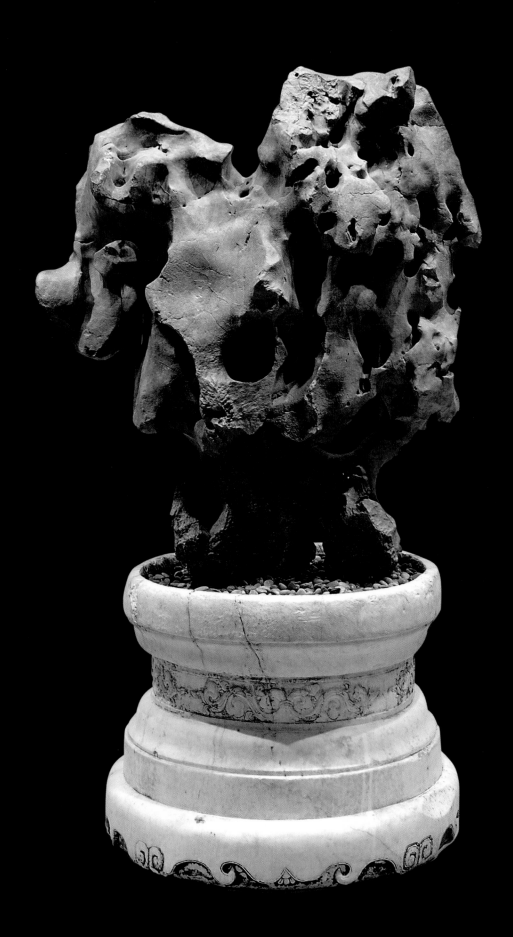

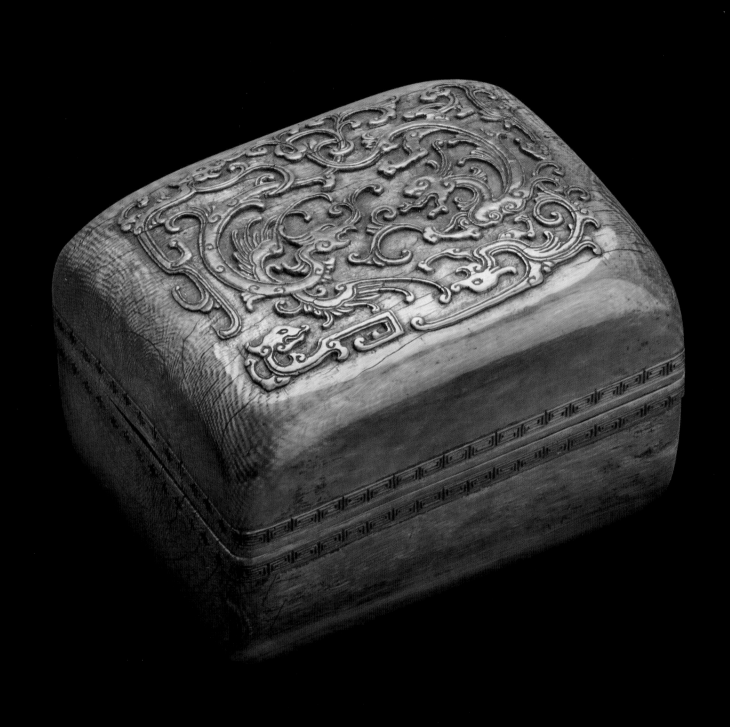

159 ←

Rectangular box and
cover with archaistic
dragon design

Kangxi period

Green stained ivory,
7.5 × 10.5 × 8.3 cm

Sir Victor Sassoon Chinese Ivories Trust, T63

161 ↑

Bowl with key-fret pattern
on the rim

Qing dynasty,
seventeenth–eighteenth centuries

Rhinoceros horn, diameter 15 cm

Victoria and Albert Museum, London,
FE.28-1983

160 →

Hu Sisheng
Tripod censer

Qing dynasty,
seventeenth–eighteenth centuries

Rhinoceros horn,
13.2 × 8.5 × 8 cm

Chester Beatty Library,
Dublin, CBC 2006

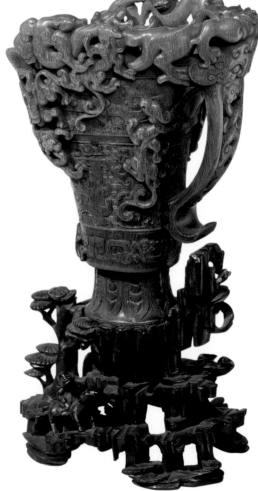

162 →

Cup on a wooden stand

Qing dynasty,
seventeenth–eighteenth centuries

Rhinoceros horn, height 15.8 cm

Victoria and Albert Museum, London, acc. no.
162-1879

164 →

Hexafoil 'garlic-head' vase
with formal lotus designs
in relief

Kangxi period, Palace
Workshops, Beijing

Mould-grown gourd,
height 23.5 cm

Mould-grown mark *Kangxi shang
wan* (for Kangxi's amusement)
on the base

The Palace Museum, Beijing, Gu125252

163 →

Vase with stylised floral
designs

Kangxi period, Palace
Workshops, Beijing, and
Jingdezhen, Jiangxi Province

Porcelain with enamels on
the biscuit, height 12.2 cm

Kangxi yu zhi mark (made by
imperial order of Kangxi) in
a square engraved on the base

The Palace Museum, Beijing, Gu148249

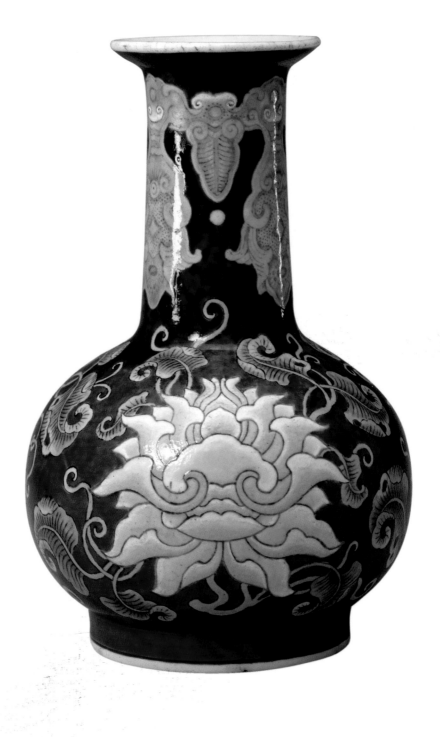

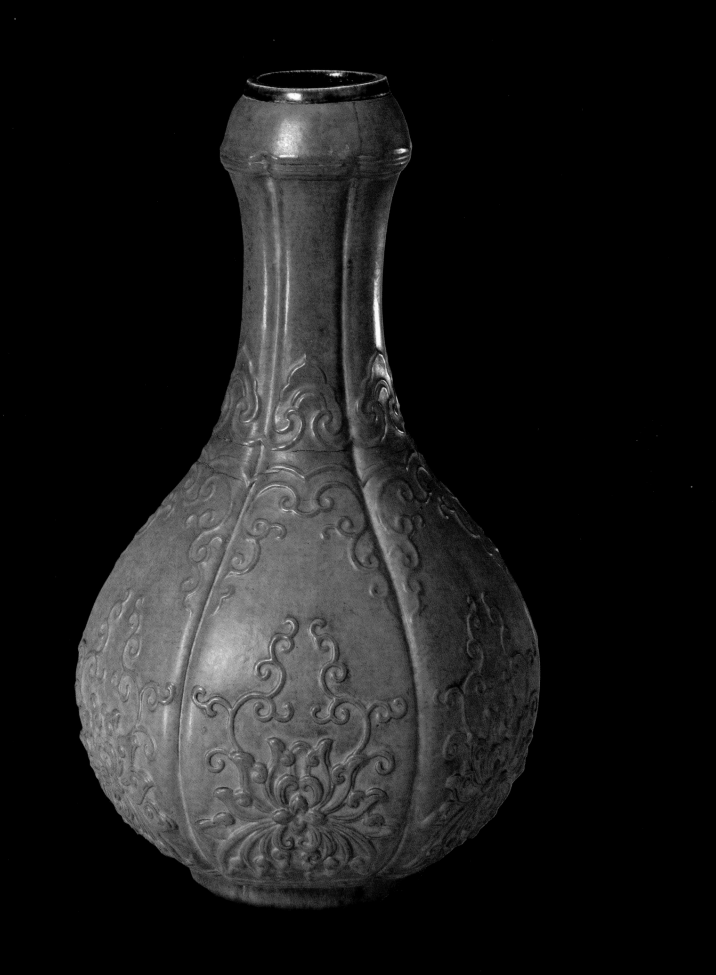

8

The Yongzheng Emperor:
Art Collector and Patron

REGINA KRAHL

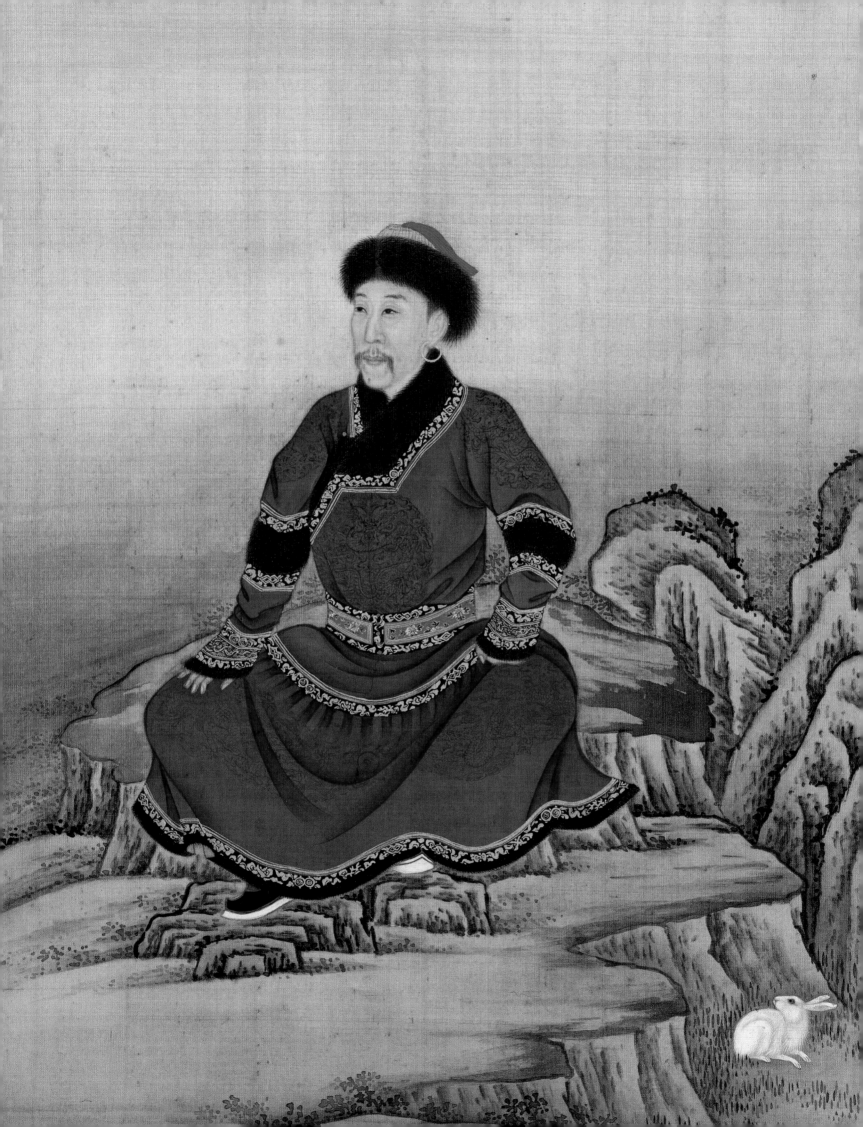

The Yongzheng Emperor's short reign has been overshadowed by the towering personality of his father, the Kangxi Emperor, the glamorous lifestyle of his son, the Qianlong Emperor, and by the strong bond between these two. The Kangxi Emperor's efficient rule laid the foundations for the enduring prosperity of the Qing dynasty; one serious obligation he neglected, however, was officially to name a successor. Since the Qing had no established line of succession, any heir to the throne would therefore have been confronted with questions of legitimacy, and throughout his rule the Yongzheng Emperor was faced with this problem.[1]

Because he rigorously eliminated enemies, collaborators and records of all sorts, lest they might prove destabilising, it is difficult to gain a rounded view of the Yongzheng Emperor's personality. Distrustful of Manchus, Chinese and Europeans alike, he developed special systems of organisation and communication, which helped him to circumvent established bureaucratic channels and their shortcomings.[2] Although these measures were rooted in his insecurity, they were to prove beneficial for the government, which seems to have functioned more efficiently and been less open to abuse

than before. As a result, China enjoyed a most prosperous period.

Historical appreciation of his personality and his politics, and even of his contribution to the arts, has suffered, however, because of a multitude of negative records dwelling on his cruelty, and a dearth of the grand public gestures by which both the Kangxi and Qianlong Emperors enhanced their official identities.[3] The Yongzheng Emperor's official persona was that of a distant, secretive and ruthless monarch, who is still considered not nearly as interesting a historical figure as his father or his son (cat. 2).

Although his reign is lacking in positive propaganda, it left a large number of uncommon testimonials to a fascinating, complex personality. His lengthy comments on over 20,000 official memorials preserved from his reign show the humorous, sardonic, whimsical side of an Emperor who might express himself 'in a quite unimperial manner' and 'in colloquialisms that he must have learned from ordinary city people …or from soldiers'.[4] Equally, the many unofficial portraits and pictorial records he commissioned indicate an eccentric yet sophisticated ruler who, unlike the Kangxi and Qianlong Emperors, dared to deviate from approved patterns and paths.

Since those seemingly intimate representations of the emperors at leisure, known as 'pictures of pleasurable activities' (*xingle tu*), were conscious manifestations of a personality,[5] the choice of activities depicted is emblematic. Different emperors presented themselves in different lights. As the role of the cultured literatus was important to the Kangxi Emperor (cat. 120), so was that of the collector or guardian of the antique to the Qianlong Emperor (cat. 216). The Yongzheng Emperor's message is less easy to read.

The series of fourteen 'costume portraits' (cat. 167) are surely the most idiosyncratic self-representations of any Chinese ruler. Including auspicious or otherwise significant creatures, these depict a man of different capacities: intellectual, spiritual, magical and physical. They show a Confucian scholar with books, writing brush, or *qin* (a long zither); a Buddhist itinerant monk; a Tibetan lama meditating in a cave; a Daoist immortal with a gourd hanging from his staff; a recluse listening to the waves; a fisherman dreaming; two figures in possession of magic charms: a

Fig. 60
Anonymous, album leaf from the series *Pictures of Tilling and Weaving Portraying Yinzhen* (*Yinzhen xiang gengzhi tu*), depicting Prince Yinzhen, the future Yongzheng Emperor, ladling manure onto rice paddies, late Kangxi period. Ink and colour on silk, 27 × 30 cm. The Palace Museum, Beijing, Gu6634-8/52

pearl for summoning a dragon (that is, rain), and a peach of immortality; and three foreigners: a Mongol nobleman, an archer perhaps of a nomadic tribe, and a European hunter wearing a wig.

The paintings have been interpreted as masquerades, somewhat comparable to the fashionable fancy-dress events indulged in by the European nobility at the time.[6] Yet such frivolity seems out of character for this conscientious ruler. The Kangxi Emperor made deliberate and exemplary efforts to master all roles that his vast and varied empire might demand of him by learning about different concepts, beliefs and interpretations of the world. The Yongzheng Emperor may have felt the same duty to present himself as the polymath he may not have been, and the commissioned paintings may be his visionary performance of different roles; and there were many roles he had to fulfil, to satisfy the wide-ranging expectations in his multi-cultural empire.

Already as a prince he had slipped – metaphorically – into the praiseworthy role of a peasant. He had himself and his wife painted as the main protagonists – a most unorthodox idea – of the *Pictures of Tilling and Weaving Portraying Yinzhen* (*Yinzhen xiang gengzhi tu*), which were considered fundamental occupations for the well-being of the empire.[7] Even if executed only on silk, the humble gesture of his performing any work, however menial (fig. 60), may have uplifted these activities more than the writings composed for that purpose by all three emperors. As Emperor he undertook real, unprecedented steps to improve the lot of menial labourers and social outcasts.[8]

In the rare informal pictures that feature the Yongzheng Emperor in Manchu dress he appears formal and ill at ease; for example, when depicted in the company of military officers, dutifully, so it seems, looking at flowers (cat. 272). Brought up in the Confucian tradition and with the values of the Han Chinese literati, whose literature he had eagerly studied, the Yongzheng Emperor was less concerned with his Manchu heritage.[9] In marked contrast to his father, he did not travel, nor go on hunting trips.

The many paintings showing the Emperor in Chinese attire, on the other hand, depict him at ease. His preferred residence was located in the cultured surroundings of his Garden of Perfect Brightness (Yuanming

yuan) on the outskirts of Beijing, a piece of land given to him by his father and then only a fraction of the size to which it was later to grow under his son. Frequently the Emperor is shown in idyllic landscape and garden settings in the ideal roles and poses of sagacious men: scholars, fishermen or immortals.[10] Aspects of private life are also illustrated: he appears playing with his children, entertaining friends, and enjoying art and antiques (fig. 61; see also cat. 15).

The emphasis on works of art, in addition to books and scrolls, in many paintings commissioned by the Emperor was a significant departure for imperial settings. The Yongzheng Emperor was the first true art-lover among the Manchu rulers. Unlike the more practically minded Kangxi Emperor, who believed himself duty-bound to look after items inherited from the past[11] and to uphold standards of craftsmanship, the Yongzheng Emperor passionately cared for and lived with works of art. He had the Jesuit court painter Giuseppe Castiglione (1688–1766) paint veritable 'portraits' of favourite porcelain vases, both ancient and modern (fig. 62).[12]

When the Manchus captured Beijing and the imperial palace, they also gained possession of the imperial collection of the

Fig. 61
Anonymous, detail of a hanging scroll from the series *Portraits of the Yongzheng Emperor throughout the Twelve Months*, depicting a palace gathering for viewing of antiques, Yongzheng period. Ink and colour on silk, 182.5 × 102 cm. The Palace Museum, Beijing, Gu6441-10/12

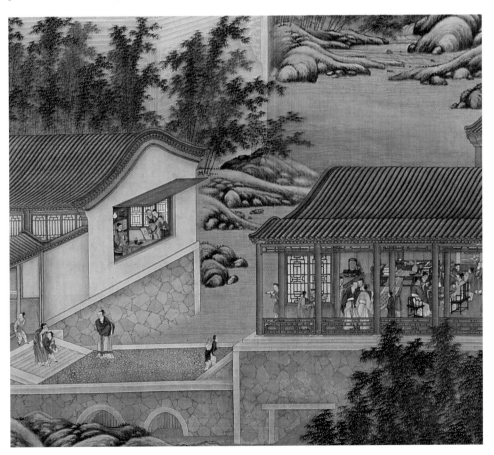

fallen Ming. What it contained and what they added, we do not know, but a selection of the Yongzheng Emperor's holdings was documented in a series of scroll paintings entitled *Pictures of Ancient Playthings (Guwan tu)* (cats 168, 169).[13] The archaic, archaistic and contemporary works recorded in these paintings, mostly shown on 'modern' wooden or silk-covered stands, are not representative of the whole collection but an eclectic personal choice.[14] The Emperor brought pieces out of storage for display and inspection; and his frequent commission for that purpose of stands and boxes from the Palace Workshops is well documented (cat. 173).[15]

The *Pictures of Ancient Playthings* and other paintings commissioned by the Emperor reflect an art collector's approach rather than that of a guardian of historically significant relics. Archaic bronze vessels, supplied with new wooden covers with ancient jade carvings as knobs, are juxtaposed with bronzes with Buddhist and Daoist connotations.[16] The ceramics are carefully chosen and include only the finest of Song and Ming wares.[17] Contemporary works, such as auspicious carvings in jade, agate, glass, coral or rootwood, and *ruyi* sceptres,

are equally excellent in craftsmanship. Only objects from the Kangxi period are often of a more practical nature.[18] Their choice may have been for sentimental rather than artistic reasons, since the Yongzheng Emperor held his father in high esteem.

From the very first year of his reign, the Yongzheng Emperor commissioned items from the Palace Workshops, whose output changed in nature as a result. Whereas his predecessor had been interested in the mastery of technical challenges, he took pride in the artistic aspect of their creations. Although Chinese artefacts were traditionally produced anonymously, the names of well over one hundred craftsmen are recorded from the Yongzheng period.[19] The Emperor knew his artisans by name, personally commented on their work and specially rewarded creations that he considered outstanding. Since Western science interested him less than it had the Kangxi Emperor, he reduced the number of foreigners working in the palace to a minimum, retaining only those who were indispensable, for instance those concerned with the construction of astronomical instruments, clocks and spectacles, together with a few in the painting workshops, most notably Castiglione.[20]

The range of works executed in the Palace Workshops was wide and highly specialised. Besides painters there were craftsmen working in jade, glass, bronze, wood, ivory, lacquer, silk, leather and other materials, engravers of inscriptions with particular skills in different scripts, and specialists for the mounting of paintings, for enamelling, for inlay (cat. 289), for making boxes, scientific instruments, clocks and weapons. The lacquer workshops mastered many techniques and had specialists versed in copying foreign (*fang yang*), namely Japanese, style (cats 175, 176). Particularly large was the enamel workshop, which dealt with porcelain, metal and glass, and had specialists for gilding. Court painters seconded there for painting and calligraphy introduced purely Chinese bird, flower and landscape motifs with poetic inscriptions, like those found in album paintings (cat. 183).

The quality of painting on the porcelains decorated in the Forbidden City has never been matched. To resurrect the wide spectrum of shapes, glazes and decorative effects reflected in the ancient works in the court collection, however, the Emperor had

Fig. 62
Giuseppe Castiglione (1688–1766), *Dragon Boat Festival*, Yongzheng period. Hanging scroll, ink and colours on silk, 140 × 84 cm. The Palace Museum, Beijing, Xin137132

Fig. 63
Anonymous, *Prunus branches and bamboo*, enamel decoration on a porcelain bowl of Yongzheng mark and period, taken with a peripheral camera. Au Bak Ling Collection

to turn straight to the imperial kilns in southern China, at Jingdezhen in Jiangxi Province. Tang Ying (1682–1756), a bondservant of the Plain White Banner who had served in the palace since the Kangxi reign, became Vice Director of the Imperial Household Department (Neiwu fu) upon the Yongzheng Emperor's accession. When in 1726 he was sent to Jingdezhen, he started a new era of Chinese ceramic production under imperial patronage. Himself a painter, poet, writer, calligrapher, seal-carver and connoisseur, and having in Beijing already devised designs for Jingdezhen, he now learned the potter's craft himself. Repeatedly the Emperor sent antiques from the palace to the kilns in the south as standards for quality, as models for archaistic designs and as inspiration for innovation. Styles of the Shang (*c.*1500–*c.*1050 BC) and Zhou (*c.*1050–256 BC), shapes of the Tang (618–907) (cat. 177), glazes of the Song (cats 178, 180, 292) and patterns of the Ming were rediscovered, and new fanciful ideas were tried out, such as *trompe-l'oeil* effects (cat. 180), or the use of vessels as a three-dimensional 'canvas' (cat. 181, fig. 63). The signature works of the Yongzheng period, however, are those whose deceptive simplicity made the greatest demands on the potters' aesthetic conception and technical ability (cat. 170).

The Yongzheng Emperor's fascination with antiquity, his collecting of antiques and the resulting passion for archaism on the one hand,[21] and his personal taste, demand for quality, and engagement of contemporary craftsmen on the other, gave Qing art its identity and shaped our idea of Chinese art in general. His legacy left little for his successors to develop, and the Qianlong Emperor concentrated on increasing works' scale and ostentation, and emphasising their message. As the son knew better than his father how to project his own image, it was

he who earned admiration for much that he merely copied; and by marking, stamping and inscribing works of art, he connected himself inseparably with a patrimony that he had inherited.

Paintings such as those depicting the Emperor plucking *lingzhi* (the fungus of longevity), enjoying himself in snowy weather, appreciating antiques and other staged appearances exist in both Yongzheng and Qianlong versions; but as the former focus less on the main protagonist, the latter are much better known.[22] Many objects were produced almost identically in both reigns, but since those commissioned by the Yongzheng Emperor are much scarcer, the style tends to be associated with the Qianlong period. The unusual scroll *Spring's Peaceful Message* (cat. 186), which depicts the Yongzheng Emperor together with Prince Hongli, the future Qianlong Emperor, has been attributed to either period for good reasons.[23] Even if we disregard the closeness of the Emperor's portrait to those of his lifetime, and the fact that the artefacts are known already from earlier paintings, the composition's cryptic message seems to tie in much better with the Yongzheng Emperor's personality than with that of his son, who rarely left us guessing about what he wanted to express.

The Yongzheng reign was a period of growth and prosperity. The Emperor was a highly cultured man, committed to his duties, and largely successful in his efforts. His aesthetic sensibility, assertive taste, demanding standards and intense personal interest in the arts pushed them to unprecedented levels of refinement and sophistication. What he may have neglected was the cultivation of his own image, which pales in comparison to that of his father and son. It seems that the Yongzheng Emperor's measure has not yet been fully taken.

165 ←

Anonymous court artists
*Portrait of the Yongzheng Emperor
Reading a Book*

Yongzheng period (or possibly later)

Hanging scroll, ink and colour on silk,
171.3 × 156.5 cm

The Palace Museum, Beijing, Gu6446

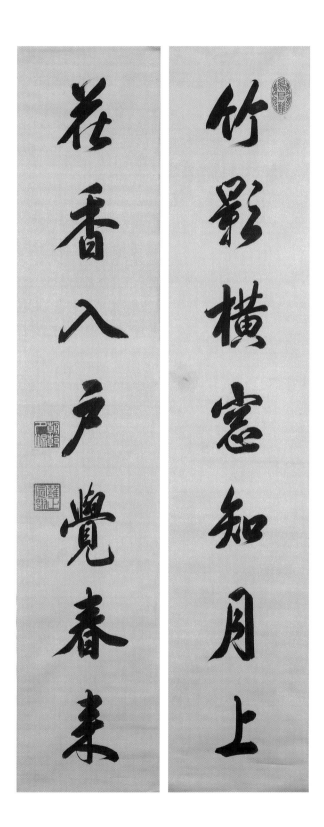

166 ←

The Yongzheng Emperor
(1678–1735)
Poetic couplet, in running script

Yongzheng period

Ink on gold-flecked green silk, 173.6 ×
33.3 cm

Imperial seals: *Wei jun nan* (Being a ruler
is difficult); *Zhao qian xi ti* (Perturbed day
and night); *Yongzheng chen han* (Yongzheng
imperial brush)

The Palace Museum, Beijing, Gu238457

167.

Anonymous court artists
Album of the Yongzheng Emperor in Costumes (14 leaves in all; 13 portraits, plus a second version of the image with a white rabbit)

Yongzheng period

Album leaves, colour on silk, each 34.9 × 31 cm

The Palace Museum, Beijing, Gu6635, 1–14

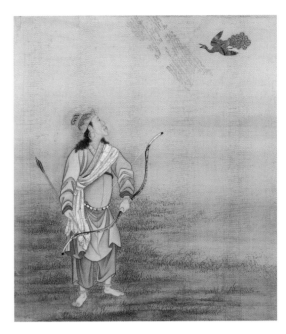

168

Anonymous court artists
Pictures of Ancient Playthings
(*Guwan tu*), scroll 6 (detail)

1728

Handscroll from a series, ink and
colour on paper, 62.5 × 1502 cm

By courtesy of the Percival David Foundation
of Chinese Art, London, PDF X01

169

Anonymous court artists
Pictures of Ancient Playthings
(*Guwan tu*), series B (or C),
scroll 8 (detail)

1729
Handscroll from a series,
ink and colour on paper,
64 × 2648 cm

Victoria and Albert Museum, London,
E.59-1911

172 →

Chrysanthemum dishes in twelve colours

Yongzheng period, *c*.1733, Jingdezhen, Jiangxi Province

Porcelain with different glazes and enamel coatings, diameter of each *c*. 17.8 cm

Yongzheng six-character reign marks in double rings in underglaze blue on the bases

The Palace Museum, Beijing, Gu150472, Gu149318, Gu150469, Xin76855, Gu149317, Gu149313, Gu149314, Gu151203, Gu150470, Gu149315, Xin142069, Gu149319

170 ↑

Teapot and cover

Yongzheng period, Jingdezhen, Jiangxi Province

Porcelain with monochrome celadon glaze, height 12.2 cm

Yongzheng six-character seal mark in underglaze blue on the base

The Palace Museum, Beijing, Gu151943

171 ↓

Teapot or wine ewer with attached cover

Yongzheng period, Palace Workshops, Beijing

Silver, height 10 cm

Yongzheng six-character mark in seal script, and *Kuang yin chengzao* (made from silver ore) engraved on the base

The Palace Museum, Beijing, Gu137924

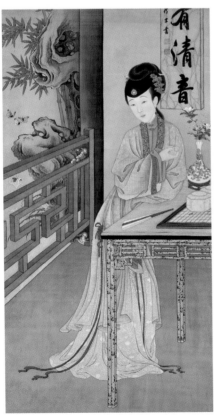

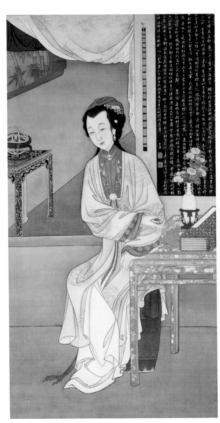

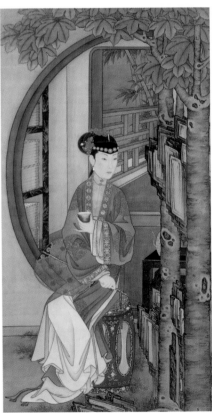

173

Anonymous court artists
*Twelve Beauties at Leisure Painted
for Prince Yinzhen, the Future
Yongzheng Emperor*

Late Kangxi period
(between 1709 and 1723)

Set of twelve screen paintings, ink
and colour on silk, 184 × 98 cm

The Palace Museum, Beijing, Gu6458, 1–12

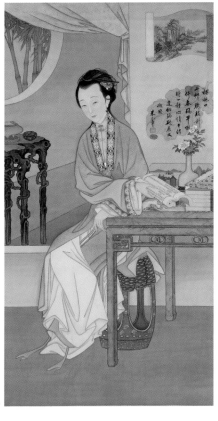
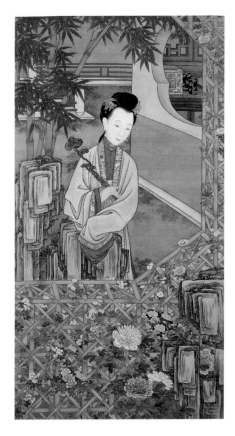
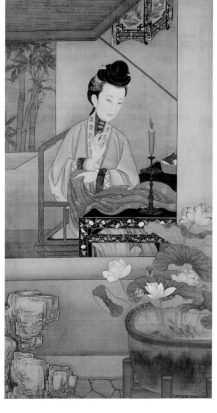
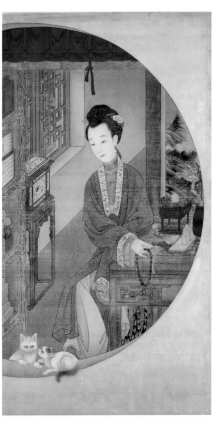
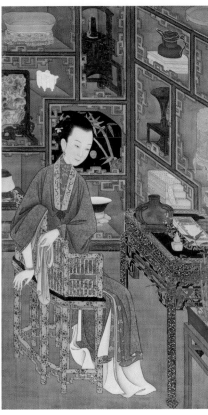
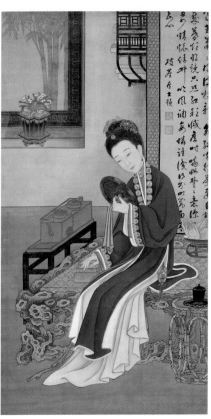

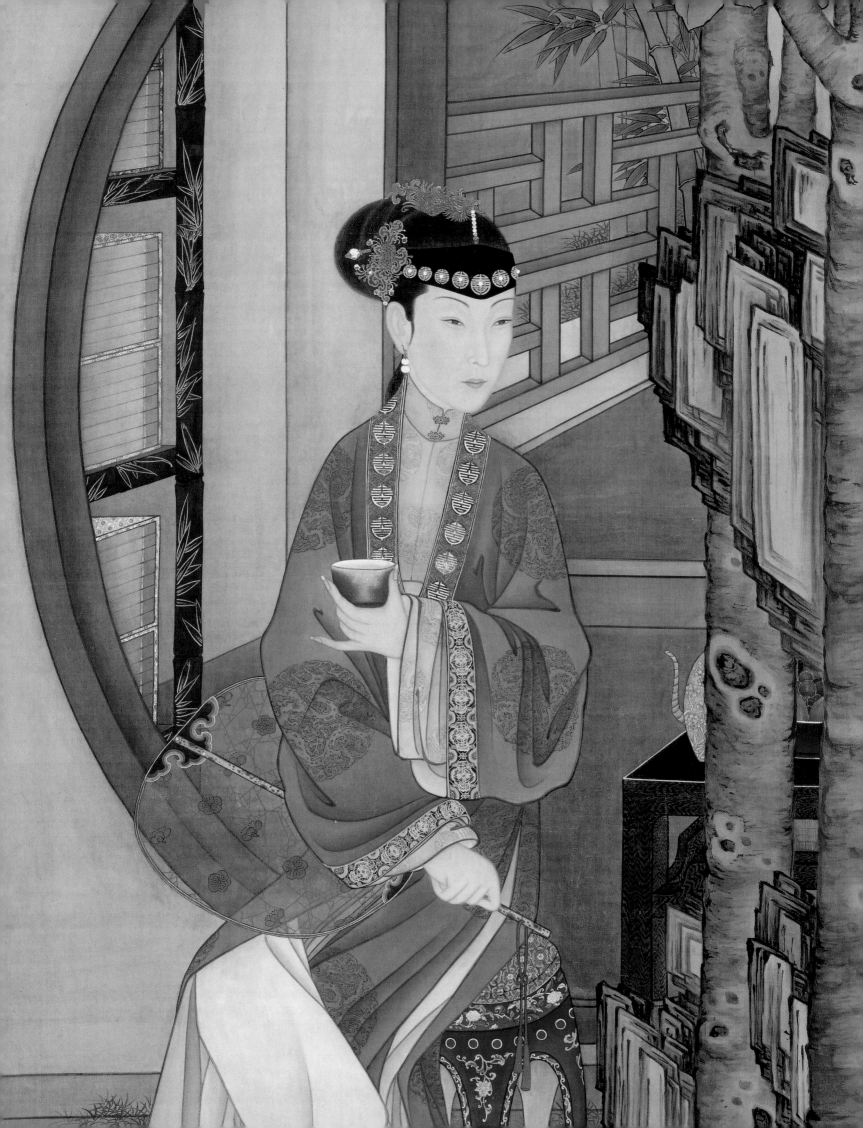

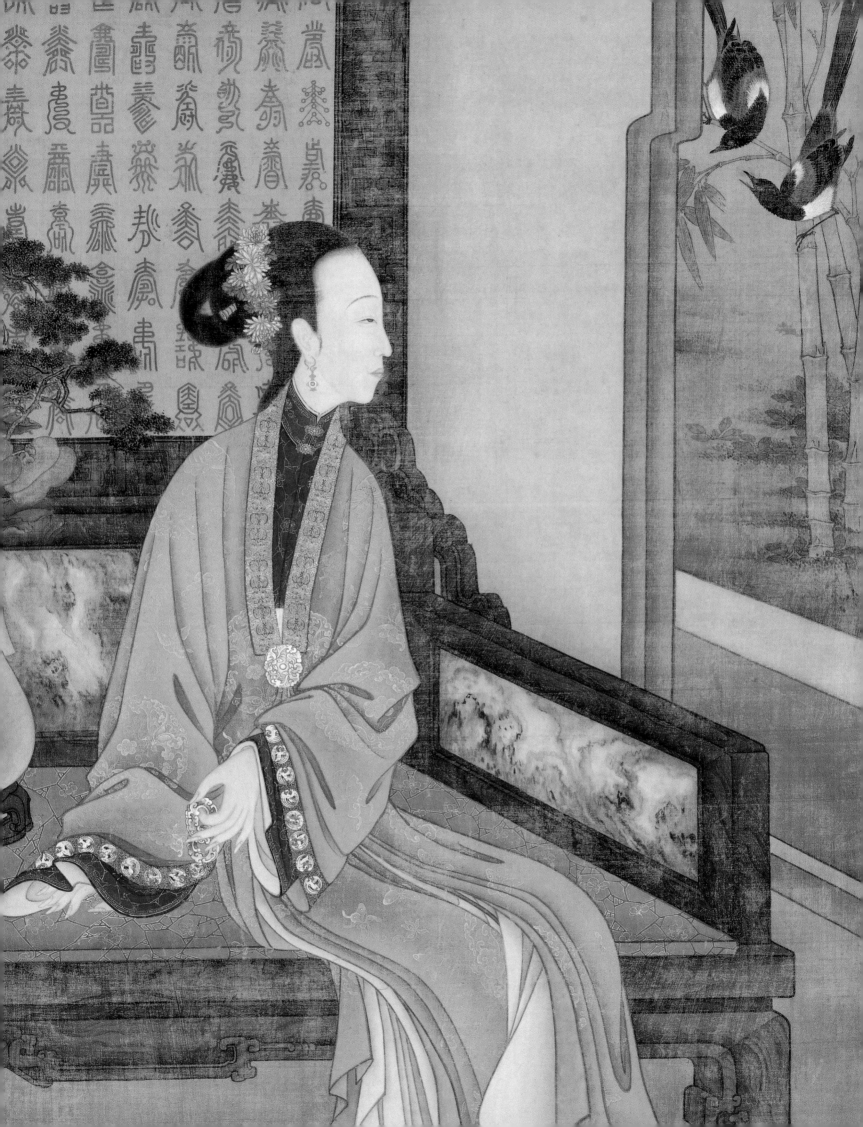

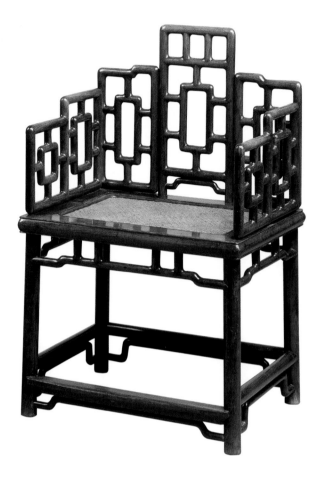

176 →

Imitation Japanese four-tiered box holding smaller boxes, contained within a framework with circular openings and supported on a stand

Yongzheng period, Palace Workshops, Beijing

Lacquered wood, coloured and gilded, 26 × 19.2 × 19.2 cm

The Palace Museum, Beijing, Gu114023

174 ↑

Pair of armchairs

Early Qing dynasty

Hongmu wood, 79.5 × 51 × 41.2 cm

C. and C. Bruckner

175 →

Rectangular lidded box imitating a Japanese lacquer box decorated in gold with fruits on a black ground and shaped as if wrapped in a cloth (Japanese: *furoshiki*)

Yongzheng period, Palace Workshops, Beijing

Lacquered wood, coloured and gilded, 12.4 × 11 × 21.8 cm

The Palace Museum, Beijing, Gu108743

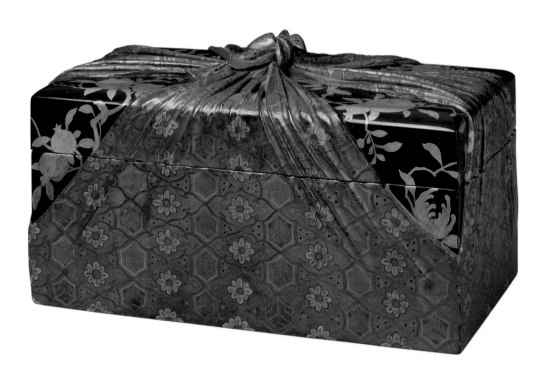

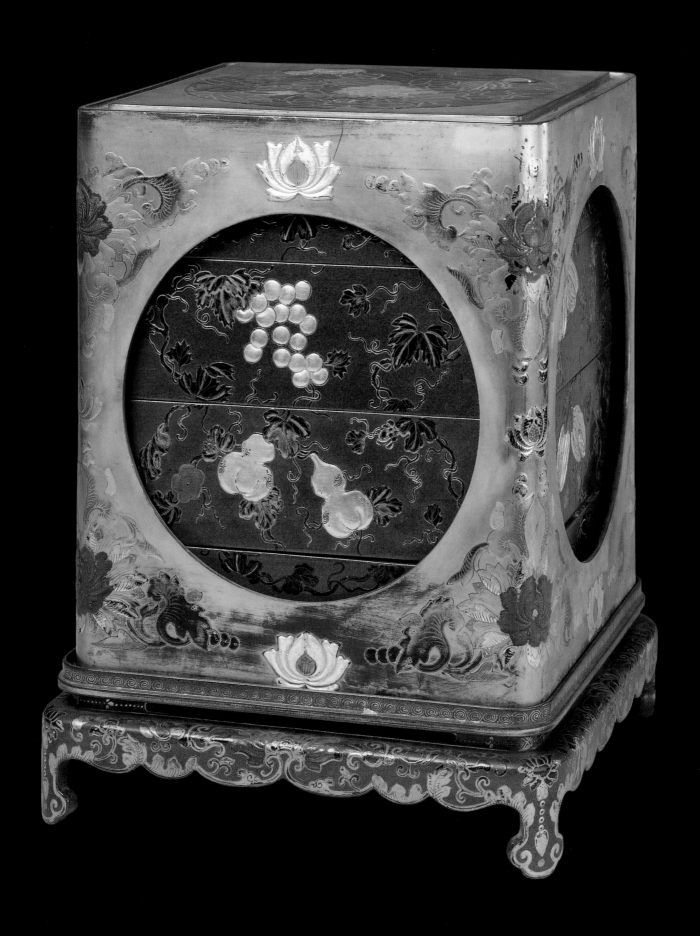

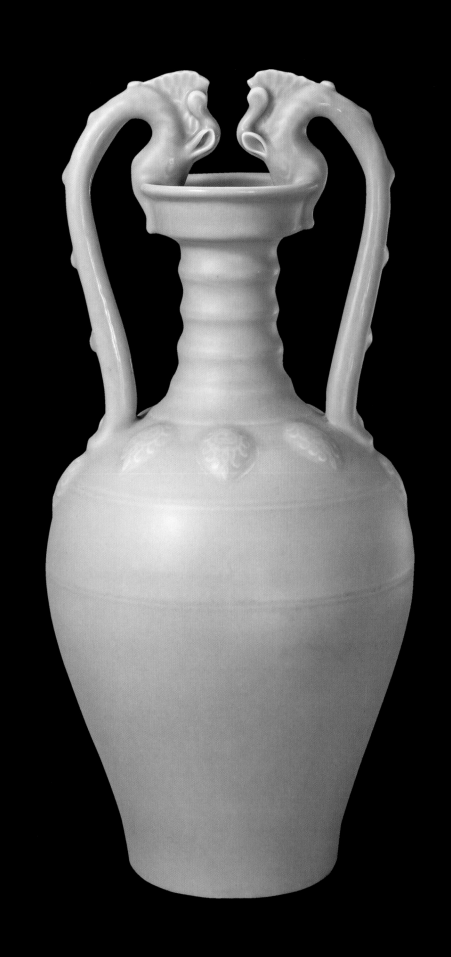

Jun-type jar with variegated glazes

Yongzheng period, Jingdezhen, Jiangxi Province

Porcelain with purple and turquoise-blue glazes, height 32 cm

Yongzheng four-character seal mark engraved on the base before firing

The Palace Museum, Beijing, Xin56606

177 ←

Tang-style amphora with 'clair-de-lune' (*tianlan*) glaze

Yongzheng period, Jingdezhen, Jiangxi Province

Porcelain with pale blue glaze, height 51.8 cm

Yongzheng six-character seal mark in underglaze blue on the base

The Palace Museum, Beijing, Xin136848

179 ←

Garlic-head vase imitating lazurite

Yongzheng period, Jingdezhen, Jiangxi Province

Porcelain with pale green, white and blue glazes, height 28 cm

Yongzheng four-character seal mark engraved on the base before firing

The Palace Museum, Beijing, Gu148964

180 ←

Ru-type basin fixed on a mock-wooden stand

Yongzheng period, Jingdezhen, Jiangxi Province

Porcelain with pale green and brown glazes, height 21.5 cm

Yongzheng six-character seal mark in underglaze blue on the base

The Palace Museum, Beijing, Gu148717

Dish with bats and fruiting and
flowering peach branches

Yongzheng period, Jingdezhen,
Jiangxi Province

Porcelain with *famille-rose* enamels,
diameter 51 cm

Yongzheng six-character reign mark
in a double ring in underglaze-blue on
the base

The Palace Museum, Beijing, Gu150245

182 →

Vase with butterflies and
flowering peach branches

Yongzheng period, Jingdezhen,
Jiangxi Province

Porcelain with *famille-rose* enamels,
height 38 cm

Yongzheng six-character reign
mark in a double ring in
underglaze-blue on the base

The Palace Museum, Beijing, Xin118001

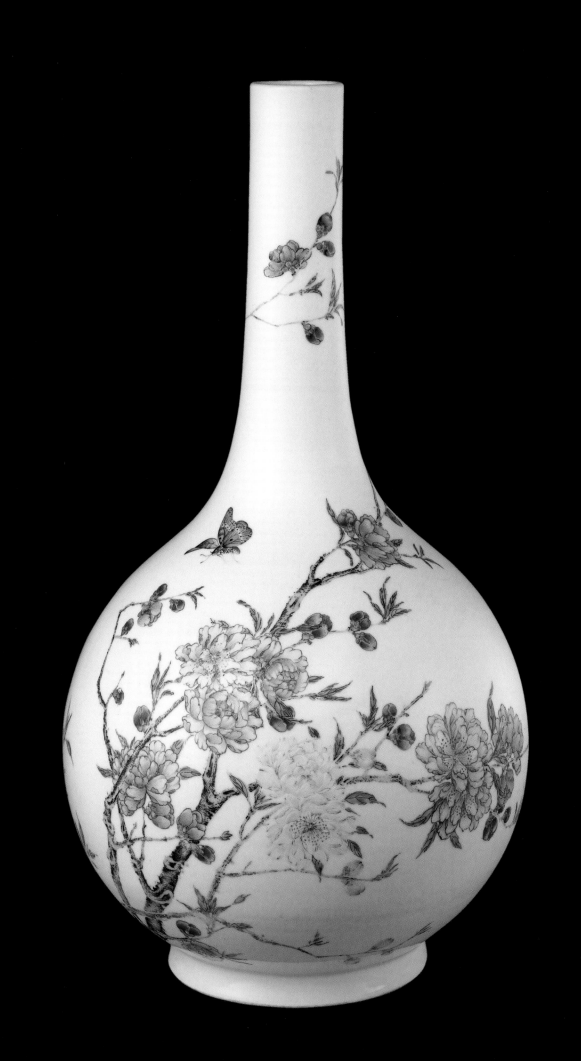

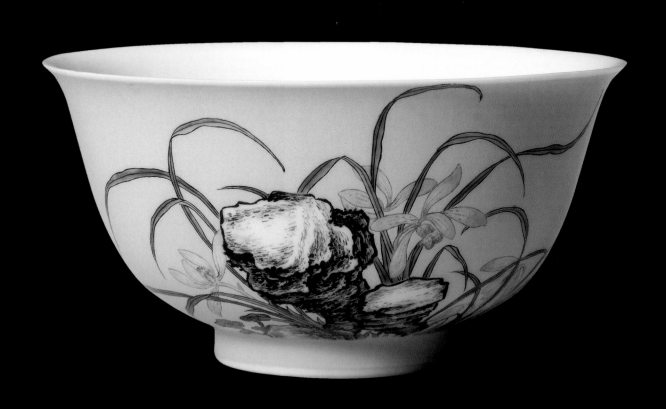

雲深瑤島開仙逕春暖芝蘭花自香

183 ←↙

Bowl painted with orchids, longevity fungus (*lingzhi*) and rocks, with a poetic inscription and seals

Yongzheng period, Palace Workshops, Beijing, and Jingdezhen, Jiangxi Province

Porcelain with overglaze enamels, height 5.5 cm

Yongzheng four-character mark in a square in blue enamel on the base

The Palace Museum, Beijing, Gu152022

184 →

Tea tray in the form of a roof tile with a bird on a cassia branch among hibiscus and asters

Yongzheng period, 1725, Palace Workshops, Beijing

Cinnabar lacquer on wood, with yellow, dark and pale green, reddish-brown and black colours and silver, 1.7 × 18.5 × 32.2 cm

Yongzheng four-character reign mark in a vertical line engraved and gilt on the black base

The Palace Museum, Beijing, Gu114658

185 ←

Tea tray in the form of overlapping circles, with 'long life' (*shou*) medallions and dragons among clouds

Yongzheng period, 1724, Palace Workshops, Beijing

Cinnabar lacquer on wood, with colours and gilding, 1.5 × 27.8 × 15.8 cm

Yongzheng four-character reign mark inscribed in gold on the outside

The Palace Museum, Beijing, Gu114840

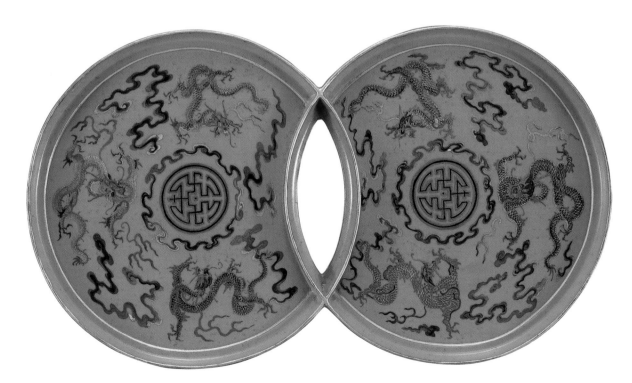

9

The Qianlong Emperor:
Virtue and the Possession of Antiquity

JESSICA RAWSON

During his exceptionally long reign of sixty years, the Qianlong Emperor assumed diverse roles in political, military and religious activities. This section documents his artistic and intellectual ambitions and the settings that these provided. This was a guise in which the Emperor modelled himself on much earlier rulers who had collected ancient relics, particularly jades and bronzes, but also books, calligraphies and paintings. From at least as early as the Qin period (221–207 BC), possession of such materials was deemed evidence of a ruler's legitimacy.[1] For a Manchu ruling as the Emperor, engagement with China's past through its finest artefacts and through its texts, paintings and calligraphy was necessary to reassure the educated élite that, although a foreigner sat on the Dragon Throne, the values embodied in China's past would be sustained and transmitted to future generations. At the same time the Emperor claimed his command of this heritage as part of his own glory.[2]

The Qianlong Emperor developed his understanding of China's antiquity through his long education in the Chinese classics. This had begun with his studies in the Princes' School, where he and other princes were tutored by erudite scholars from the Hanlin Academy who were masters of classical learning.[3] This early education and the Emperor's own adult ambition to emulate and outdo his imperial predecessors fitted well with a personal passion for learning and for the arts. Through his education, the Emperor no doubt became conscious that a sign of a legitimate ruler was the possession of the bronzes of the ancient dynasties.[4] Therefore, above and beyond his own personal enthusiasm for the arts, the Emperor must have had a keen interest in the power of collections of ancient artefacts as attributes of righteous rule. Together with military achievement and just administration, these possessions were evidence of a ruler's virtue, a virtue that was necessary to sustain legitimacy.

The Qianlong Emperor personally amassed numerous bronzes, porcelains, jades, paintings and calligraphy. These were much more than simply prized possessions; they were integral to his identity as a ruler who understood and valued the heritage of the country he dominated. A number

of paintings show the Emperor in informal poses viewing or handling objects from his collections (cat. 194). The painting entitled *One or Two?* (cat. 196) presents the Emperor dressed informally as a scholar and surrounded by his possessions; he literally surveys the past.

The Qianlong Emperor went much further than simply amassing antique works as a form of cultural treasure. He commented upon all these works and commended them in poems and prose, many of which were inscribed on the pieces themselves (cats 197, 198, 199). The Emperor frequently marked these works with his large imperial seals or with colophons and poetic comments from his own brush. Some modern connoisseurs have derided this practice, arguing that he compromised the integrity of the work of art through his conspicuous visual interventions.[5] However, we should not regret the Emperor's enthusiasms: his seals and inscriptions allow us to detect how he saw himself within a long lineage of China's rulers. The painting *Mount Pan* (cat. 191), for example, carries inscriptions that record the dates on which the Emperor visited the tombs of his ancestors and inscribed his comments on the painting. Here, the seals, comments and poems create a complex, composite work of art and a record of ritualised activities through which the Emperor demonstrated his piety toward his deceased relatives. The Qianlong Emperor's numerous inscriptions on works in his collections were compiled in anthologies, and many of the actual artefacts, as well as the poetic compositions they inspired, are preserved to this day.

For the Emperor, as for his predecessors, the golden age of China's ancient civilisation was reached during the period of the so-called Three Dynasties, the *sandai*, of the Xia, Shang and Zhou. Chinese archaeologists identify the latter part of the Neolithic in the central province of Henan as the Xia phase of dominance.[6] For the other two dynasties, the Shang (c.1500–c.1050 BC) and the Zhou (c.1050–221 BC), we have, today, abundant archaeological and textual evidence.[7]

The political and religious acts of the Shang and the Zhou were marked by the casting of bronze vessels used for offerings to the dead. These departed ancestors were thought to continue to exist in the afterlife and to require nourishment. If offered food

Fig. 64
One of the many immense bronze creatures to be found in the courtyards of the Forbidden City

Fig. 65
Ritual vessel known as the 'Song *ding*',
due to its inscribed dedication. Late
Western Zhou, ninth–eighth century BC.
Bronze, mouth diameter 30.3 cm.
The Palace Museum, Beijing, Gu77390

and wine on a regular cycle, they would reciprocate by providing benefits to their descendants. Some of the bronzes, especially those of the Zhou, carry long inscriptions recording the events that led to their casting (fig. 65). For the earlier Shang period, the much more limited inscriptions are supplemented by records of divinations carved on oracle bones.[8] These inscriptions provided eminent precedents for those that the Qianlong Emperor had carved or painted on antiquities he owned. One of the Chinese classics, the *Liji* (*Book of Rites*), undoubtedly known to the Qianlong Emperor, claimed quite explicitly that the inscriptions on bronzes were to extol the virtues of the patrons and thereby to instruct later generations.[9] It is very likely that the Emperor saw his own inscriptions on a multitude of different categories of artefact and painting in exactly the same light.

Ancient forms of bronze vessels had gone out of use by the time the first great unified states were created by the Qin (221–207 BC) and the Han (206 BC–AD 220). But ritual vessels were, from time to time, recovered from the ground, and such discoveries were often treated as auspicious omens.[10] This view of the near-magical properties of ancient vessels, together with the understanding that possession of the bronzes of the earlier emperors was a sign

of a legitimate rule, encouraged the retrieval of these objects. Before the era of the Qianlong Emperor, the collection of the Emperor Huizong (r. 1101–25) of the Song period (960–1279) had been the most significant. This earlier assemblage was recorded in an elaborate illustrated catalogue, the *Xuanhe bogu tulu* (*Illustrated Catalogue of the Antiquities of the Xuanhe Period*).[11] The bronzes were intended to serve not just antiquarian interests, but to provide models that would enable proper vessels to be made for the offerings to the ancestors. The Song Emperor's ambition was, thereby, to reform the rituals and to ensure good fortune for his rule. He was fated to fail. The Song fell before the invading Jin in 1127, and the bronzes were destroyed or carried away to the north. Few of Emperor Huizong's successors were as committed to collecting antiquities as he had been.[12]

The Qianlong Emperor's enthusiasm for bronzes surpassed even that of his Song predecessor. He assembled a vast number and revived the Song period enterprise of cataloguing imperial collections, which had languished in the intervening centuries under the Yuan and Ming dynasties. The scholar élite had continued to appreciate and to collect bronzes, but serious antiquarian studies had advanced little since the Song. Instead, collections of bronzes, jades,

Fig. 66
An incense burner in the shape of an
ancient bronze on a marble stand within
a courtyard of the Forbidden City

ceramics, paintings and calligraphy functioned as cultural capital, admired at gatherings of scholars and officials and elevating the status of those who owned them.[13] Interest in collecting antiquities also spawned the production and marketing of forgeries. As in so many of his other cultural enterprises, the Qianlong Emperor sought to bring regularity and order to the collecting and study of ancient art. To do so he sponsored authoritative catalogues of which the first and best known was the *Mirror of the Antiquities of the Western Apartments* (*Xiqing gujian*) (cat. 204).

Careful cataloguing, with illustrations of the bronzes and their inscriptions and notes on their sizes and origins, was just one of the several responses that bronzes engendered. As the vessels were known to have been used in the ancient rituals in which food and wine were offered to the ancestors, such bronzes were also taken as models for the ritual vessels in the eighteenth century, as had been the practice in the time of Emperor Huizong. Ceramic versions of some of the ancient shapes were used in the Qing State rituals, for offerings to Heaven, Earth, the Sun and the Moon and for offerings to the ancestors (cats 34, 35, 36, 37). These relatively faithful copies had rarely been achieved in earlier centuries. Most dynasties had been content to make food and wine offerings in vessels contemporary with their own time. Such

a return to the ancient forms was a consequence of the Qianlong Emperor's concern with detailed attention to the rites of previous eras. Like the Emperor Huizong, his ambition was to display his personal cultivation and to demonstrate his virtuous commitment to the high culture of the past.

A third consequence of the Emperor's acquisition of bronzes, jades and ceramics was the production of archaistic works in a wide range of media. Earlier imperial collections published in the eleventh and twelfth centuries had stimulated the creation of bronzes, ceramics and jades in antique forms and styles.[14] The principal uses of these replicas and free imitations had been for altar vessels. Incense burners and altar flower vases were made in bronze shapes in white porcelain, in porcelain decorated in under-glaze blue or in green celadon, in jade, lacquer, cloisonné (cat. 44) and iron, as well as in bronze. During the seventeenth and eighteenth centuries, however, these bronze forms were extended to decorative pieces of all types (fig. 66). Shapes never used on altars, such as the flattened flasks (cat. 203), were copied in cloisonné enamel (cat. 202), and bronze wine vessels (cat. 205) were rendered in bamboo (cat. 206). To refer to the eminence of the Zhou as rulers, writing sets and other everyday possessions for the desk were made in antique bronze forms (cat. 228). Jade artefacts were copied in the same precious mineral, but also in many other materials as well (cats 200, 201). These items were displayed in the numerous halls of the several palaces and, together with the auspicious images described on pages 358–61, formed a complex of ornament that ensured good fortune for those who lived or worked in these spaces and reminded them of the glories of China's past. One of the paintings of beautiful young women from a set made for the Yongzheng Emperor before his accession (cat. 173) demonstrates the ways in which such auspicious or archaistic objects were used to decorate palace rooms.

The Qianlong reign is famous for very fine ceramics. To complement the Emperor's interest in ancient objects, many items were made in shapes typical of earlier times, most especially of the Song, a period renowned then and now for refined ceramic wares made for the court. Many of these ancient pieces were collected, imitated and inscribed by the Emperor (cat. 197), who took a deep

interest in ceramic production and commissioned pieces personally.[15] These were made under imperial supervision, primarily at the great kilns at Jingdezhen, in southern China. Brightly glazed Qianlong period ceramics (cat. 217) were mixed with ancient pieces and archaistic replicas from other periods in the halls of the palace.

Although today we admire the intricacy of surface ornament and the superb craftsmanship of objects that filled the imperial palaces, affording visual pleasure was only one aspect of their function: archaistic works were intended to evoke the past and to signify the Emperor's all-encompassing role as preserver of Chinese cultural traditions. Indeed the Qianlong Emperor probably saw himself as embodying, both in his person and in comments that he wrote, the values of the ancient Chinese.

An interest in the material traces of the great dynasties and the decorative systems that they created was only one aspect of the Qianlong Emperor's commitment to reviving, preserving and furthering the virtues of the past. His practice of calligraphy displayed the skill which, more than any other, defined membership in the class of literate élite who were the guardians of China's cultural heritage (cats 188, 189). To ensure that his achievements as a calligrapher were well known, the Qianlong Emperor had issued in 1761 a forty-volume set of his own writing reproduced as rubbings. In addition, the Emperor assembled the largest collection of ancient calligraphy ever known in China; among these works, letters by the famous fourth-century calligrapher Wang Xizhi and his relatives were the Emperor's most prized possessions.[16] In this taste he emulated the great Tang emperor, Tang Taizong (r.626–49), who, it is said, was buried with the renowned *Preface to the Orchid Pavilion Collection* (*Lanting xu*) by Wang Xizhi.[17] The Emperor published deluxe sets of rubbings of famous ancient calligraphy that he acquired.

Indeed publication, as much as acquisition, was an essential aspect of the Emperor's projects. In this way, he propagated his own achievements and made his tastes the current fashion among the court and other members of the scholar class. Not only were the collections of calligraphy and bronzes reproduced in printed works, but

a catalogue of the paintings was made, the *Shiqu baoji* (*Precious Collection of the Stone Moat [Pavilion]*). So important was this collection to him, that the Qianlong Emperor took his most prized paintings with him on his journeys to the north or to the south.

The most famous and enduring of the Emperor's ventures to preserve and present the past was his enterprise to collect all the great texts of his empire in the *Siku quanshu* (*Complete Library of the Four Treasures*) (fig. 67).[18] The *Siku quanshu* has four sections: classics, history, miscellaneous philosophy and belles-lettres. A large bureaucracy, set up in 1773, was responsible for bringing together texts from throughout the empire and for organising their reproduction in seven hand-written copies, to make seven sets of the complete compilation. Eleven thousand texts were examined, and 3,500 were included in the final version. Works came from private individuals as well as from libraries of high officials.

The compilation of this great body of texts was a contested arena. The scholar officials sought to establish their interpretations of universal norms and beliefs as enduring standards. The Qianlong Emperor, on the other hand, wished to emphasise his own contribution in exploiting and in bringing to fruition in the eighteenth century the achievements, that is, the virtues, of the classical past. Indeed, the collections, the multitude of personally inscribed texts and inscriptions and the immense textual compilations were effective instruments to ensure that his contemporaries and future generations recognised the Qianlong Emperor as taking the pre-eminent role in preserving and transmitting the glories of China's classic heritage.

Fig. 67
Volumes from the *Siku quanshu* (*Complete Library of the Four Treasures*). The Palace Museum, Beijing, Xian49192-49197

寫真世寧擅繢我少
年時入室瞻然者不
知此是誰
壬寅暮春御筆

186 ←

Giuseppe Castiglione
(Chinese name Lang Shining,
1688–1766)
Spring's Peaceful Message

c. 1736

Hanging scroll (originally a *tieluo*
painting), ink and colour on silk,
68.8 × 40.6 cm

Inscription: inscribed by the Qianlong
Emperor 'In portraiture Shining is
masterful, he painted me during my
younger days; the white-headed one
who enters the room today, does not
recognise who this is. Inscribed by the
Emperor towards the end of spring in
the year 1782'

Seals: with five seals of the Qianlong
Emperor

The Palace Museum, Beijing, Gu5361

187 →

Anonymous court artist
*Prince Hongli Practising
Calligraphy on a Banana Leaf*

c. 1730

Hanging scroll, colour on silk,
diameter 106.5 cm

The Palace Museum, Beijing, Gu6481

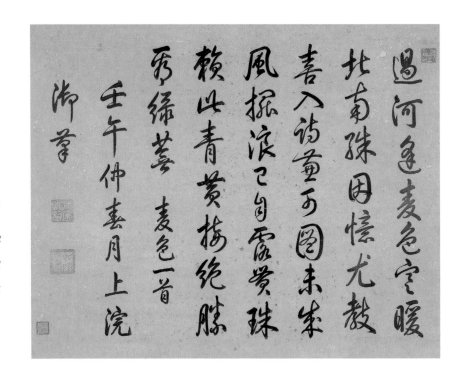

188 →

The Qianlong Emperor
(1711–1799)
'The Colours of Wheat',
a poem, in running script

1762

Hanging scroll, ink on paper,
75.7 × 94.8 cm

Imperial seals: *Suo bao wei xian*
(Only those virtuous and worthy
should be treasured); *Qianlong yu bi*
(Qianlong imperial calligraphy)

Collectors' seals: *Shiqu baoji suo cang*
(Collected in the *Precious Collection
of the Stone Moat [Pavilion]*); *Xuantong
zunqin zhi bao* (Treasure of the
esteemed parents of the Xuantong
Emperor)

The Palace Museum, Beijing, Diao026656

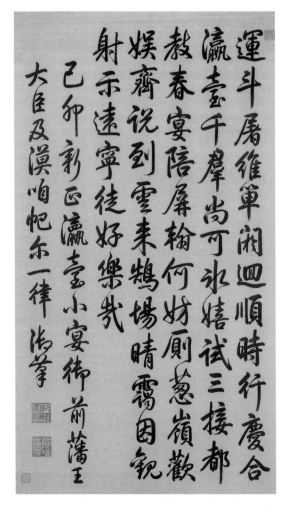

189 →

The Qianlong Emperor
(1711–1799)
'Small Banquet at Yingtai',
a poem, in running script

1759

Hanging scroll, ink on paper,
156.4 × 88 cm

The Palace Museum, Beijing, Gu239593

190 →

Deng Shiru (1743–1805)
Ancient prose from the
Xunzi, in seal script

Before 1796

Hanging scroll, ink on paper,
117 × 74 cm

Inscription: 'Transcribed for the
master of Yi Studio, Deng Yan'

Seals: below the inscription,
Deng Yan, *Shiru* (the artist's names)

The Palace Museum, Beijing, Xin187665

顧齋大人屬書

鄧琰

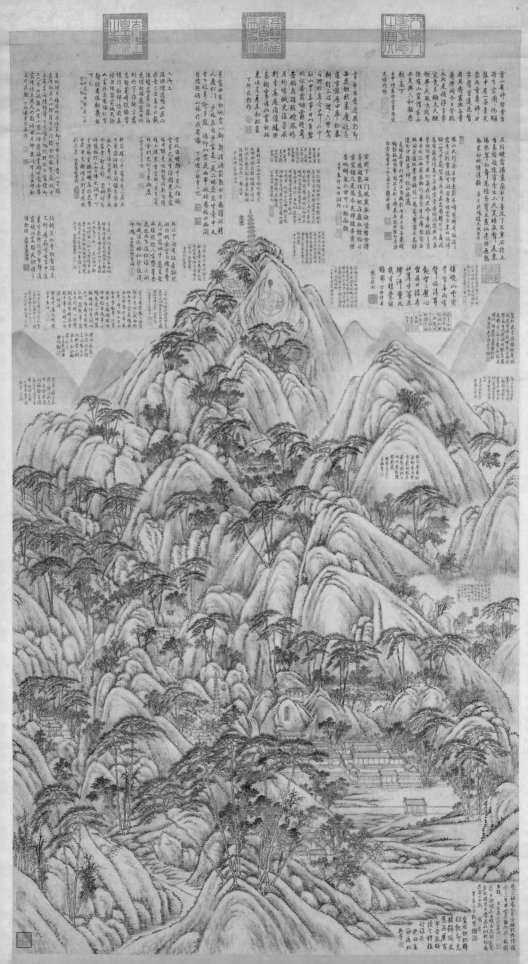

191 ←

The Qianlong Emperor
(1711–1799)
Mount Pan

1745

Hanging scroll, ink on paper,
162 × 93.5 cm

Inscriptions: signature, dated 1745, nine
place names, and 34 poetic inscriptions
by the Qianlong Emperor, dated 1745,
1747 (12), 1750, 1752 (3), 1755, 1760, 1763,
1764, 1766, 1769, 1770 (2), 1772, 1774, 1775,
1782, 1785, 1787, 1789, 1791, 1793

Seals: 69 seals by the Qianlong Emperor,
one seal by the Xuantong Emperor

The Palace Museum, Beijing, Gu237306

192 ↑

Seal of the Qianlong Emperor
carved to depict the boating
scene from 'Ode on the
Red Cliff'

1736 or later

Changhua stone,
12.5 × 6.9 × 6.9 cm

Seal: 'Be pure, be of one [mind]'
(*Wei jing wei yi*)

A yellow paper label glued to the seal
states: 'One imperial seal: "Be pure, be
of one mind"' (*Wei jing wei yi, yu bao yi
fang*)

The Palace Museum, Beijing, Gu166998

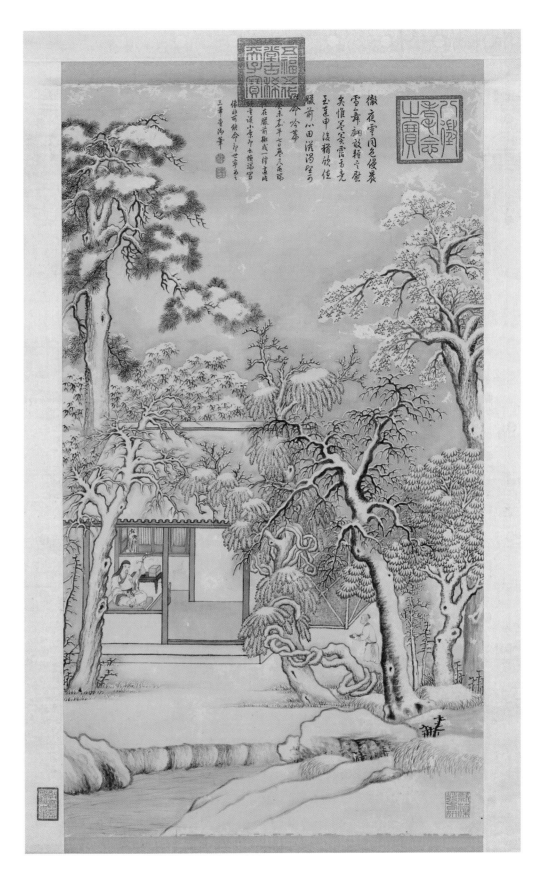

193 ↑

The Qianlong Emperor
(1711–1799) and Giuseppe
Castiglione (Chinese name
Lang Shining, 1688–1766)
Reading in the Snow

1764

Hanging scroll, ink on paper,
87.5 × 50.7 cm

Inscriptions: poem and commentary by
the Qianlong Emperor

Seals: five seals of the Qianlong
Emperor

The Palace Museum, Beijing, Gu237286

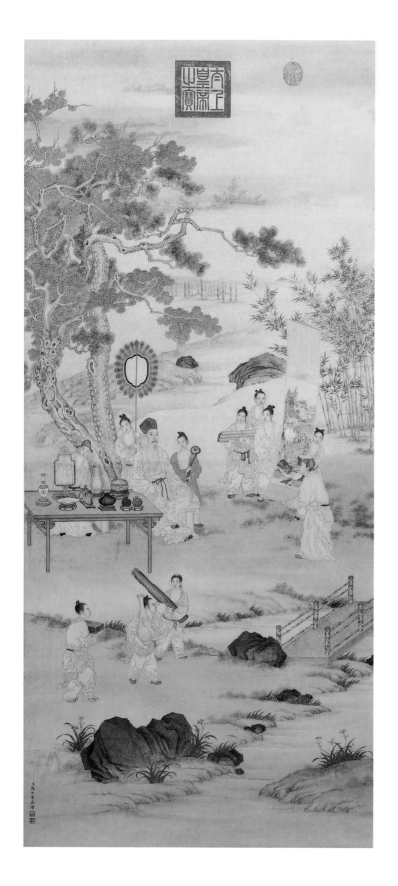

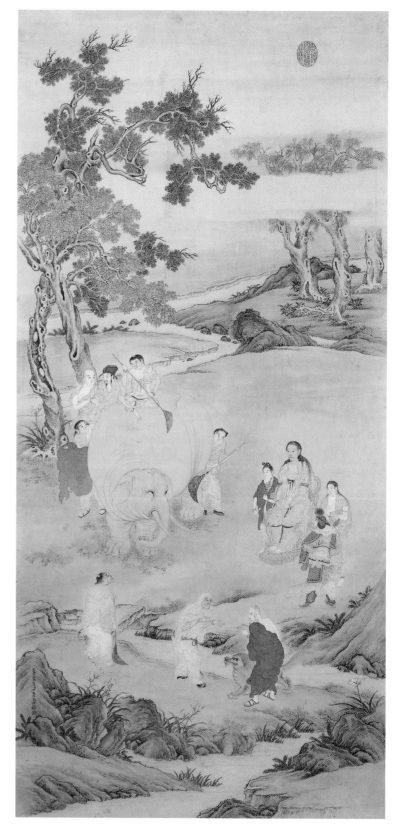

194 ←

Giuseppe Castiglione
(Chinese name Lang Shining,
1688–1766) and Ding Guanpeng
(fl. *c.*1738–1768)
*The Qianlong Emperor Viewing
Paintings*

1746–*c.* 1750

Hanging scroll, ink and colour on paper,
135.4 × 62 cm

Inscription: signature by Giuseppe
Castiglione, undated

Seals: two seals of Giuseppe Castiglione,
two seals of the Qianlong Emperor

The Palace Museum, Beijing, Gu5366

195 ←

Ding Guanpeng (fl. *c.*1738–1768)
Washing the Elephant

1750

Hanging scroll, ink and colour on gold-
flecked paper, 132.3 × 62.5 cm

Inscription: artist's signature, dated 1750

Seals: two seals of the artist, one seal of
the Qianlong Emperor

The Palace Museum, Beijing, Gu4794

196 ↓

Anonymous court artists
One or Two?

c. 1745–50

Hanging scroll, ink and colour on paper,
77 × 147.2 cm

Inscription: the Qianlong Emperor,
undated

Seals: five seals of the Qianlong Emperor

The Palace Museum, Beijing, Gu6493

199 →

Table screen mounted with fungus of longevity (*lingzhi*)

1774

Zitan wood and fungus (*lingzhi*), height 101 cm

Inscription: the Qianlong Emperor, dated 1774

The Palace Museum, Beijing, Gu209649

197 ↑

Ru-type basin on four bracket feet

Yongzheng period, Jingdezhen, Jiangxi Province

Porcelain with crackled celadon glaze, height 6.7 cm, mouth 23.3 × 17 cm, foot 13.2 × 19.7 cm

The base engraved after firing with a poem by the Qianlong Emperor dated 1772

The Palace Museum, Beijing, Gu153271

198 →

Table screen with inlaid bronze mirror

c. 1776

Zitan wood and bronze, height 92 cm

Inscriptions: the Qianlong Emperor, dated 1776; seven inscriptions by court ministers; inscription at the base: *Qianlong yuwan* (Imperial Gem of the Qianlong period), *Han chunsu jian* (Pure Mirror of the Han dynasty)

Seals: two seals by the Qianlong Emperor, fourteen seals by the court ministers

The Palace Museum, Beijing, Gu209652

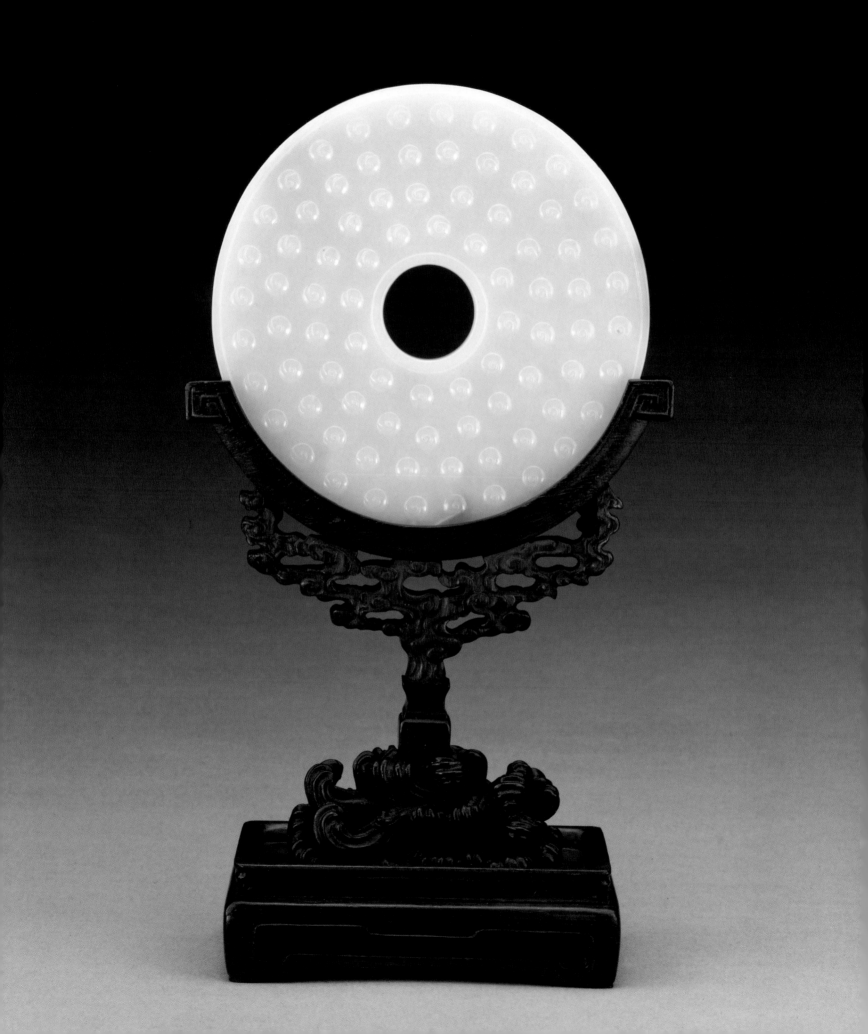

200 ←

Jade *bi* disc on a carved
wooden stand

Qianlong period

Jade, diameter 11.1 cm

The Palace Museum, Beijing, Gu103121

201 ↓

Jade *bi* disc

Eastern Zhou period,
third century BC

Jade, diameter 14.5 cm

British Museum, London, 1947.7-12.517,
Oppenheim Bequest

202 ↑

Decorative flattened flask
(*bianhu*) in the shape of an
ancient bronze

Qianlong period, Palace
Workshops, Beijing

Copper decorated with cloisonné
enamel with gilding,
21.9 × 23.3 × 8.5 cm

Qianlong four-character reign
mark cast in relief on the base

The Palace Museum, Beijing, Gu116412

203 ↓

Flattened flask (*bianhu*)
and cover for wine

Warring States period,
fourth century BC

Bronze with copper inlay,
35.3 × 31.8 × 8.6 cm

Compton Verney House Trust (Peter Moores
Foundation), 0218.1.A, 0218.2.A

204 →

*Mirror of the Antiquities
of the Western Apartments*
(*Xiqing gujian*)

Compiled at imperial behest
from 1749

Printed book, 42.9 × 26.8 cm

Collection of the Muban Foundation

205 →

Ritual wine vessel (*you*),
decorated with birds
with long plumes

Western Zhou period,
tenth century BC

Bronze, height to handles 24.8 cm

British Museum, London, 1988.4-22.1

206 →

Decorative vessel in the
shape of an ancient
wine vessel (*you*)

Eighteenth century, Jiading,
Shanghai

Carved bamboo root, 17 cm

The Palace Museum, Beijing, Gu121155

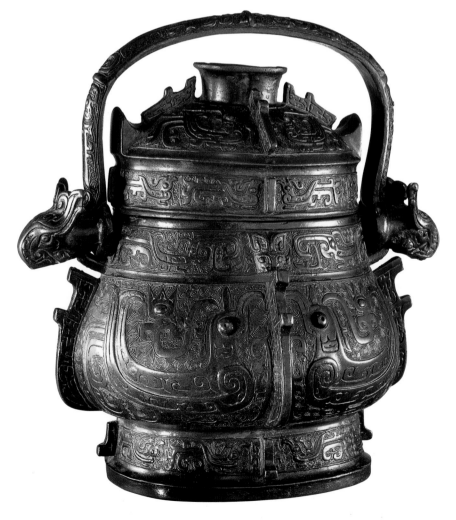

207 ←

Pear-shaped vase (*yuhuchun ping*) with Ming-style design of butterflies and lilies

Qianlong period, Jingdezhen, Jiangxi Province

Porcelain with underglaze copper red against a ground of overglaze yellow enamel, height 34 cm

The Palace Museum, Beijing, Gu152195

209 →

Cup in the shape of two tubes supported by a bird standing on an animal

Composition: Qing period, eighteenth century; two tubes: Western Han period, second–first centuries BC

Bronze inlaid with gold and silver, height 20 cm

Victoria and Albert Museum, London, M.730-1910

210 ↓

Vessel in the shape of an ox imitating a Han dynasty inlaid vessel (*zun*)

Qianlong period

Inscription: inscribed in red pigment, *Qianlong fang gu* (made in the Qianlong period imitating the ancient)

Bronze with champlevé enamels in cloud duster design and applied green surface imitating patina, 19 × 8 × 22 cm

The Palace Museum, Beijing, Gu116863

208 ↑

Pear-shaped vase (*yuhuchun ping*) painted with butterflies and lilies

Ming dynasty, Yongle period (1403–24), Jingdezhen, Jiangxi Province

Porcelain with underglaze cobalt blue, height 34 cm

By courtesy of the Percival David Foundation of Chinese Art, London, PDF 601

211 ↑

A Discussion of the Carriage with a League-recording Drum, in the hand of the Qianlong Emperor

1778

Two tablets of light grey-green nephrite from a book of four, 20.7 × 10.4 × 0.5 cm

Text in Chinese engraved and gilded on both sides, decoration in gold and silver

Chester Beatty Library, Dublin, CBC1005

212 ↑

Jade mortuary tablets announcing the ancestral name for the late Qianlong Emperor

1799

Two tablets of green nephrite from a book of seven, 28.9 × 12.8 × 1 cm

Text in Manchu engraved and gilded on one side only

Chester Beatty Library, Dublin, CBC1015

213 ←

Pictures of Tilling and Weaving (*Gengzhi tu*), with poems in four different scripts by the Qianlong Emperor, the second of four volumes

Qianlong period, Jingdezhen, Jiangxi Province, bound in the Palace Workshops, Beijing

Porcelain with black and red enamels, silk mounts, *zitan* wood covers with gilt title, 10.5 × 8.5 × 12 cm

The Palace Museum, Beijing, Gu154828

214 →

A pair of the Qianlong
Emperor's seals
commemorating his
seventieth and eightieth
birthdays, in a box

1780 and 1790

Seals: jade, 10.9 × 12.85 × 12.85 cm
(*Guxi tianzi zhi bao*), 10.9 × 10.6 ×
10.6 cm (*Bazheng maonian zhi bao*);
in double box of *zitan* wood,
carved with dragons in clouds,
19.5 × 32.1 × 18 cm

The Palace Museum, Beijing, Gu167304, 1–2

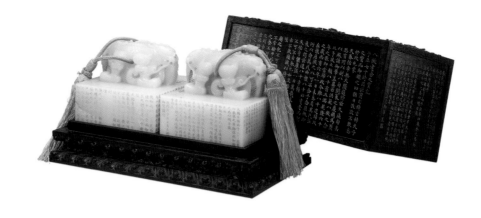

215 →

Book entitled *Encourage the
Full Use of the Five Blessings*
(*Xiangyong wufu*) in an
enamelled box, presented
to the Qianlong Emperor
on his eightieth birthday

Qianlong period

Box of cloisonné enamel,
12.5 × 15 × 21 cm

The Palace Museum, Beijing, Gu166711

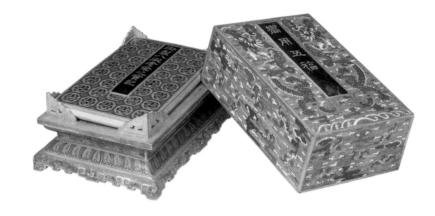

216 →

Jade cup and booklet with
imperial essay in a lacquer
box

Essay dated 1753

Box: lacquer, 12.9 × 12.9 × 12.6
cm; cup: jade, height 5.4 cm

The Palace Museum, Beijing, Gu87392

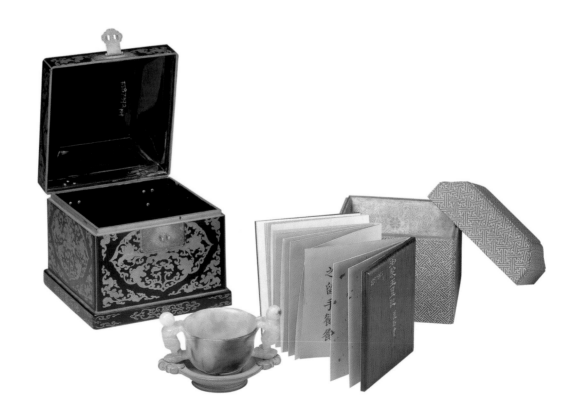

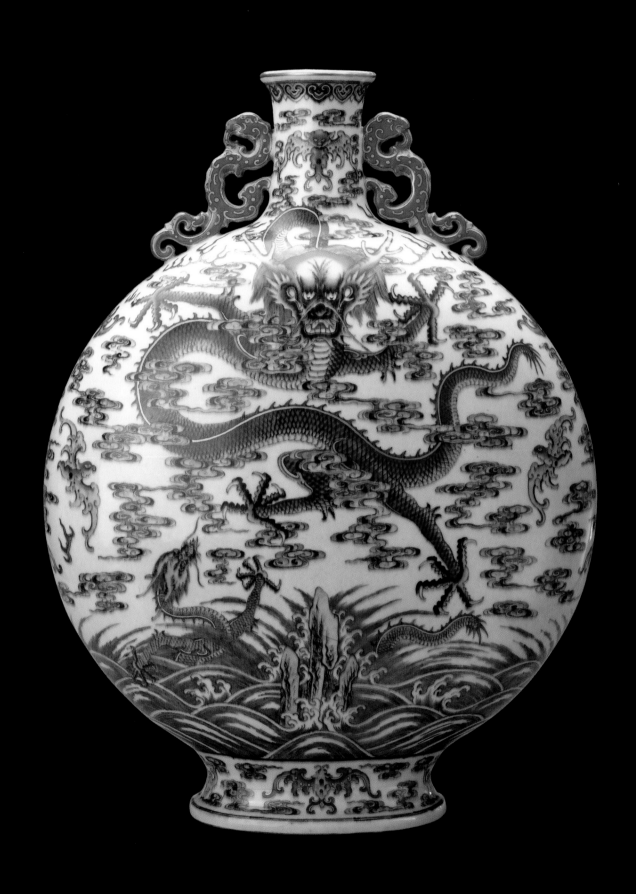

218 ←

Pair of double-gourd-shaped
wall vases with addorsed dragon
handles, painted with flowers
and rocks, among flower scrolls
and stylised bats

Qianlong period, Jingdezhen,
Jiangxi Province

Porcelain with overglaze enamels,
each 21.7 × 12.5 × 3.5 cm

The Palace Museum, Beijing, Gu152720, Gu152721

217 ←

Doucai moon flask with
dragons among clouds
and bats, above rocks
and waves

Qianlong period, Jingdezhen,
Jiangxi Province

Porcelain with underglaze cobalt-
blue, overglaze enamels and
gilding, height 49.5 cm

Qianlong six-character seal mark
in underglaze blue on white on the
base, reserved in turquoise enamel

The Palace Museum, Beijing, Gu152092

219 ←

Vase painted with flowers and
butterflies in Western style on
an engraved diaper ground

Qianlong period, Jingdezhen,
Jiangxi Province

Porcelain with overglaze enamels and
gilding, height 24.2 cm

Qianlong six-character seal mark in
underglaze blue reserved in turquoise
enamel on the base

Victoria and Albert Museum, London, Salting Bequest,
C.1461-1910

220 ←

Revolving vase with the
Eight Trigrams in openwork

Qianlong period, Jingdezhen,
Jiangxi Province

Porcelain with cobalt-blue glaze,
overglaze enamels and gilding,
height 20 cm

Qianlong six-character seal mark
in underglaze blue on the base

Victoria and Albert Museum, London, C.1484-1910

Pair of display cabinets

Qianlong period

Lacquered and gilt wood,
each 161 × 87 × 35 cm

The Palace Museum, Beijing, Gu207579,
Gu207580

Revolving vase with 'a hundred birds' seen through an openwork landscape

Qianlong period, Jingdezhen,
Jiangxi Province

Porcelain with overglaze enamels
and gilding, height 63 cm

Qianlong four-character seal
mark in iron-red reserved in
turquoise enamel on the base

Lin Jian Wei Collection, Singapore

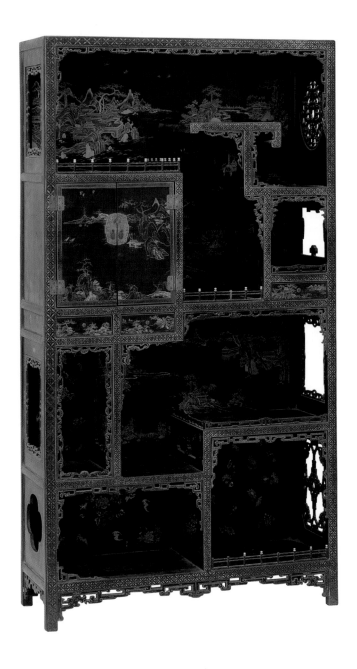

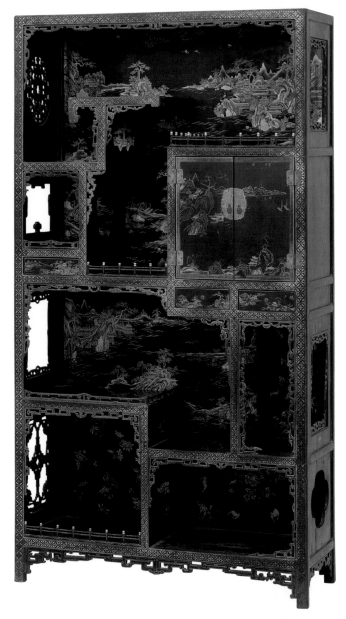

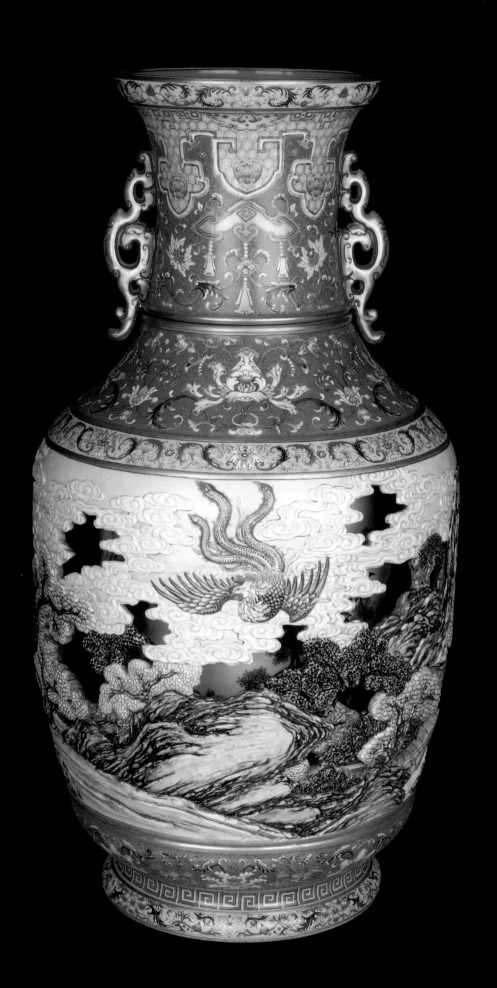

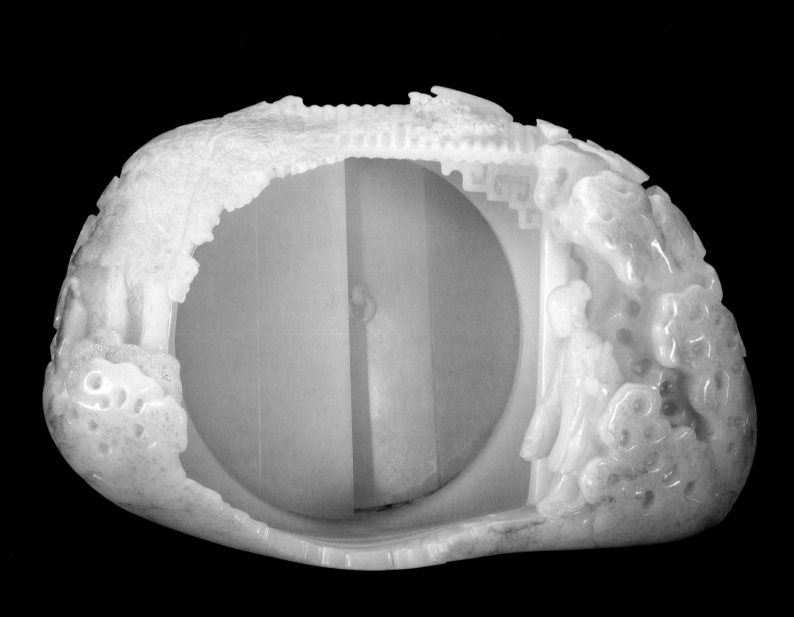

223 ←

Jade boulder with two ladies at a moon gate in a south Chinese garden

Qianlong period, *c.* 1773, Suzhou, Jiangsu Province

White jade with brown inclusions, 15.5 × 25 × 10.8 cm

The Palace Museum, Beijing, Gu103327

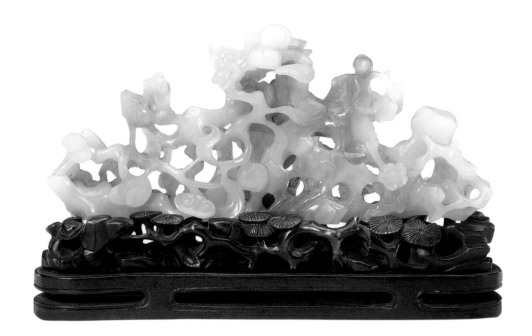

224 ↑

Brush rest in the shape of mountains and peach trees with phoenix

Qianlong period

Jade on stained ivory stand imitating wood, height 11.8 cm

Qianlong four-character reign mark

The Palace Museum, Beijing, Gu93944

225 ↓

Bridge-shaped brush rest

Mid-Qing dynasty

Jade with wooden stand, 7.3 × 22 cm

The Palace Museum, Beijing, Gu103086

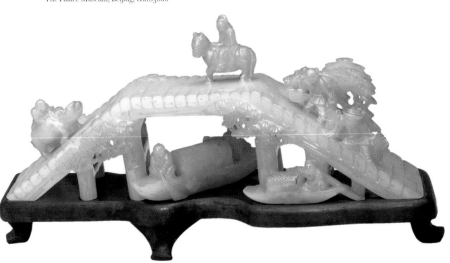

226 →

Carving of two crabs
with reeds

Mid-Qing dynasty,
eighteenth century

White jade with *zitan* wood stand,
11.2 × 16.8 × 11.2 cm

The Palace Museum, Beijing, Gu103767

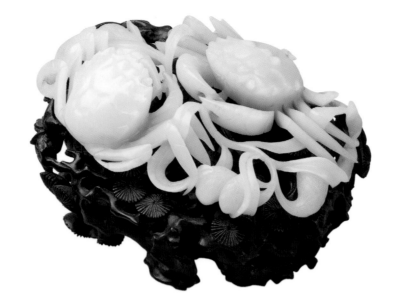

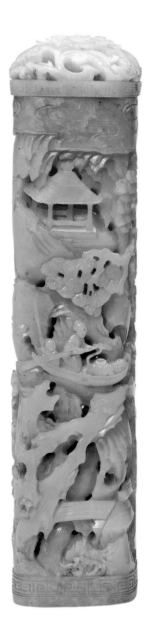

227 ←

Pair of perfumers with figures
in a landscape

Qianlong period

Jade, height 21.5 cm

The Palace Museum, Beijing, Gu89853, Gu89854

228 →

Openwork incense burner
and cover with scrolling
peony design

Qianlong period

Jade, height 13 cm

The Palace Museum, Beijing, Gu100440

229 ←

Table screen depicting 'one hundred' boys in a garden setting

Qianlong period, made at Suzhou

Carved polychrome lacquer, 49.3 × 58.2 cm

The Palace Museum, Beijing, Gu108955

230 →

The Qianlong Emperor (1711–1799)
Discourse on the Recognition of One's Faults (Zhi guo lun)

1782

Calligraphy in cursive script

Album with 32 pages, ink on *jinsu* paper; red lacquer covers (shown here), 41.1 × 27 cm; red lacquer box, 45.9 × 31.3 × 9.8 cm; wrapping cloth of yellow silk

Nine seals of the Qianlong Emperor: *Sanxi tang, Guxi tianzi zhi bao, You ri zizi, Wufuwudai tang guxi tianzi zhi bao, Bazheng maonian zhi bao* (twice), *Taishang huangdi zhi bao, Shiqu baoji suo cang, Yuanming yuan bao*

The British Library, London, Or 6682

231 ↘

Writing set

Qianlong period

Carved red lacquer, cloisonné enamel, ivory and other materials, 18.5 × 29 × 25.5 cm

The Palace Museum, Beijing, Gu109583

232 →

Plate with a crab surrounded
by fruit, nuts and seeds

Qianlong period

Porcelain with *famille-rose* enamels,
diameter 22.5 cm

Qianlong six-character mark in seal
script written in underglaze blue on
the base

The Palace Museum, Beijing, Gu154796

233 ←

Box in the shape of
a table of books

Qianlong period

Bamboo-veneered wood
(*zhuhuang*), 14.8 × 27.5 × 13.9 cm

The Palace Museum, Beijing, Gu120701

235 ↗

Faux-bois bucket

Yongzheng or Qianlong period,
Jingdezhen, Jiangxi Province

Porcelain with overglaze enamels,
height 18.2 cm

Meiyintang Collection, Switzerland

234 ←

Two hexagonal vases in
imitation of realgar

Qianlong period, pre-1753

Polychrome glass, 15.9 × 9 × 7 cm
and 16.8 × 9 × 7.1 cm

Shuisongshi Shanfang Collection, 34.2.293–4

236 →

Tripod drum-shaped
incense burner simulating
pudding-stone

Qianlong period, Jingdezhen,
Jiangxi Province

Porcelain with overglaze enamels,
height 8.5 cm

Qianlong four-character seal
mark in a square, inscribed in gold
on the base

The Palace Museum, Beijing, Gu152591

IO

Silent Satisfactions:
Painting and Calligraphy
of the Chinese Educated Elite

ALFREDA MURCK

含風翠辟孤煙細
昔日月楓薰木穩

Celebrating beneficent rule with both broadly recognised and subtle cultural symbols, Qing dynasty court paintings create the impression that the empire was peaceful and well governed with scarcely a ripple of contention. By contrast, paintings produced outside the court display a wider range of concerns, both private and social, inauspicious as well as auspicious. The paintings are more subdued in colour, often ink monochrome, more varied in style, bolder in brushwork and more individual in expressive content than court works. Not only did the educated élite share the materials and techniques of calligraphy when painting, they viewed it as an extension of composing poetry. In the hands of intellectuals, painting was imbued with sophisticated content that elevated it, in their eyes, above the work of professional practitioners.

Indirect expression was valued in genteel society and routinely practised by Chinese scholars, who often expressed ideas through historical anecdote and cultural symbols.[1] Because they were charged with providing rulers with practical and moral guidance, scholar-officials learned how to deliver critiques without causing offence or precipitating harsh punishment. Under scrutiny and with retribution a certainty, expression became ever more circuitous. Some of these paintings are examples of the 'hidden transcripts' that James Scott has described: a subordinate group's concealed discourse at variance with their public pronouncements.[2] For those who personally experienced the destruction wrought by the Manchu conquest, who mourned the lost dynasty of the Ming, or who opposed the literary inquisitions, painting could be a vehicle for expressing grief, loss, oblique

criticism or disdain.[3] Whether loyalists or not, most Chinese intellectuals actively mingled with each other.[4] For those who co-operated with the Manchus by taking positions in the Qing government, painting and its accompanying text could serve another purpose: collaborators could signal sympathy and negotiate a relationship with Manchu resistors. Understandably, most of these literati works were not in the Qing imperial collection, but were instead twentieth-century acquisitions of the Palace Museum.[5]

This selection of non-court paintings highlights the stylistic diversity of the seventeenth and eighteenth centuries and records some personal reactions to the Manchu presence. The paintings are not catalogued in the groupings developed by historians, but rather in chronological sequence to stress that painters' lives intersected. As they travelled and as these very portable works were carried about, painters and calligraphers became aware of each others' art despite differences of region, class, politics and style.

Orthodoxy: Dong Qichang and the Four Wangs

Qing dynasty scholar-painters inherited the legacy of the most forceful personality in late Ming painting and calligraphy, the official Dong Qichang (1555–1636). Navigating a successful if controversial career during a period of weak emperors and powerful eunuchs, Dong was a collector, painter, calligrapher and magisterial connoisseur.[6] He formulated a theory of painting history that scholars esteemed or refuted but could not ignore: it placed the educated élite in a lineage of inspired landscape painters but denigrated the polished, descriptive paintings of professionals. Painters who, in his judgement, were worthy of emulation included such famous figures as Huang Gongwang (1269–1354), a retired official who made his livelihood practising geomancy, teaching, writing and painting (fig. 68); Ni Zan (1306?–1374), a wealthy scholar who dispersed his possessions and lived on a boat painting austere landscapes devoid of people; and Wang Meng (1308–1385), an activist who strategised against the Mongols and painted densely configured mountains with feathery texture strokes.

Fig. 68
Huang Gongwang (1269–1354), detail of *Dwelling in the Fu Chun Mountains*, 1350. Handscroll, ink on paper, 33 × 636.9 cm. Collection of the National Palace Museum, Taiwan, Republic of China (1016-4)

The copying of earlier masterworks was the normal way to learn painting. Dong Qichang departed from the norm by promoting copying as a creative act not limited to exact imitation (fig. 69). His own painting and calligraphy provided examples of innovative linear and formal abstraction.[7] His principle of free transformation can be seen in Wang Jian's dense, inky version of Ni Zan's sparse style (cat. 242) which incorporated elements of Huang Gongwang's idiom as well.

Those painters who followed Dong Qichang's lead came to be called 'orthodox', with the connotations of correct and authentic. Dong's methodology was transmitted from teacher to student for four or five generations. Wang Shimin (1592–1680) studied with Dong as a youngster and later as an adult. His serene landscape of reclusion (cat. 237) shows a debt to Dong in the mountain structures even as the brushwork is his own. Wang Shimin taught Wang Jian (1598–1677) and Wang Hui (1632–1717) as well as his grandson Wang Yuanqi (1642–1715) (cat. 252). The latter three had opportunities to paint for the court (Wang Hui designed the Kangxi Emperor's *Southern Tour* scrolls, cat. 13). Rising to high posts in Beijing, Wang Yuanqi frequently pleased the Kangxi Emperor with his orthodox mountainscapes. Within a century, a style that had been conceived as an amateur mode for the educated élite was co-opted by the court as one of several acceptable painting styles and became commercially popular as well.

Individualists and Eccentrics

If orthodox painters occasionally slipped social critiques into their paintings, they did so with the Confucian decorum of 'indirect criticism' (*feng*) that avoided overt offence. 'Individualist' and 'eccentric' painters, by contrast, edged towards ironic, even irreverent expression. In the seventeenth century several Buddhist monks emerged as masterful and inventive painters. Among them, Kuncan was unique in having been deeply spiritual from childhood; he entered a monastery in the early 1630s, twelve years before the fall of the Ming (cat. 240). The other three became Buddhist monks as refugees from the chaos following the conquest. Zhu Da (Buddhist name Bada

Fig. 69
Dong Qichang (1555–1636), *Landscape Presented to Qu Shisi*, dated 1626, with a second inscription by Dong dated 1629. Hanging scroll, ink on paper, 101.3 × 46.3 cm. The Palace Museum, Beijing, Xin147091

Shanren, 1626–1705) and Zhu Ruoji (Buddhist name Yuanji, style name Shitao, 1642–1707) were members of the large clan of the Ming imperial family and as such were in grave danger following the conquest. Entering Buddhist monasteries removed them from the ferment of Manchu resistance and the possibility of their being used in a Ming restoration. Their paintings display uninhibited brushwork, quantities of ink, quirky, dynamic compositions and recondite content (cats 241, 247, 254, 255).

Like Kuncan, the scholar Wu Li was religious from childhood, but instead of Buddhism he gravitated towards Christianity.

Growing up next to a Jesuit church, he was baptised as a child and later studied Catholicism for six years in Macau before being ordained a priest. He studied painting with Wang Shimin, creating lyrical landscapes such as his remembrance of a Buddhist friend and teacher (cat. 244).

Yun Shouping is often grouped with the Orthodox masters because of his close friendship with Wang Hui. Unlike Wang Hui, however, Yun passionately resisted the Manchu régime. He specialised in painting birds and botanical subjects in a realistic manner, but his aim was private expression rather than scientific illustration. Of the thousands of blossoming plants growing in China, Yun painted only the several dozen that convey moral, romantic, political or auspicious messages (cat. 251).

Outstanding among regional art centres in central and southeast China were the cities of Nanjing and Yangzhou. Nanjing, the original capital of the Ming dynasty with a rich cultural heritage, suffered extensive damage and untold casualties during the conquest. Among the many Nanjing painters, the staunch loyalist Gong Xian (1620–1689) created dark brooding landscapes focused on mountains and rivers, pointedly omitting depiction of sky (that is, heaven, imperial authority). The destruction in Nanjing inspired Wu Hong to paint landscapes featuring ruined buildings, an ominous sight rarely recorded in Chinese painting (cat. 249). As a witness of the conquest, Wu perhaps shared information with the official Kong Shangren (1648–1718) who in the 1680s was interviewing witnesses of the conquest in preparation for writing *The Peach Blossom Fan*, a sophisticated historical drama set in Nanjing in 1643–46 that probes the causes of the Ming dynasty failure.[8]

In 1645, Yangzhou was sacked and pillaged for over a week. Thanks to the dedication of survivors and enlightened officials, its recovery led to a cultural efflorescence and a thriving art market in the eighteenth century.[9] 'Eccentric' (*guai*) painters such as Gao Xiang and Luo Ping were directly inspired by Bada Shanren and Shitao. Collaborating with the poet-playwright Jiang Shiquan, Luo Ping cleverly used birds, plants and insects to lampoon the destruction of books during the editing of the *Siku quanshu* (*Complete Library of the Four Treasures*; see fig. 67). Jiang hinted at this connection in a seal legend formed from the second character of his given name (*quan*) and the character 'inscribed' (*shu*) creating a pun on the word compendium (*quanshu*) (cat. 263).

Bannermen

Ethnic Chinese who were from families that served the Manchus in Han banner organisations had advantages over non-bannermen. Gao Qipei was a member of a military banner by virtue of an ancestor who enlisted. In recognition of his ancestors' and father's loyal service, Gao was promoted to the bordered yellow banner, and was given appointments in the bureaucracy under the Kangxi and Yongzheng Emperors. Not beholden to the brush culture or social context of the Chinese élite, he created his own style by painting with his finger-nails (cat. 257). Gao Qipei's nephew, Li Shizhuo, studied with Wang Hui and Wang Yuanqi, developing a more conventional literati style. He served in the Imperial Painting Academy from the late 1630s, occasionally fulfilling imperial commissions that the Qianlong Emperor might have painted had he possessed the skills (cat. 266).

Calligraphy

Each Chinese character is written in a specific order of strokes from upper left to lower right. Within this strictly prescribed system, remarkable stylistic expression is possible through manipulation of the flexible hair brush that transmits to paper and silk every nuance of movement and pressure. For formal documents such as court memoranda, the clarity of regular script was required, but even then stylistic choices might declare a political position.[10] In the early seventeenth century Fu Shan (1607–1684/85) admired the beautifully balanced regular script of the Yuan dynasty scholar Zhao Mengfu (1254–1322) (fig. 70). After the conquest, Fu Shan grew to despise Zhao because Fu (with many others) considered him a traitor for taking office under the Mongols even though Zhao was a member of the Song dynastic clan. For regular script, Fu Shan instead adopted the style of the Tang dynasty loyal official and martyr Yan Zhenqing (709–784). But Fu's greatest contribution was his truly bizarre (*qi*) mad-cursive script which loops and collides with illegible abandon (cat. 258).

Antiquarian interest in ancient stone-engraved inscriptions also stimulated explorations of the formal qualities of early scripts (see cats 190, 265). In the eighteenth century the bizarre scripts became less radical if still eccentric (cats 256, 260).[11]

Elegant Indirection

After the violence of the conquest, was there still cause for covert criticism? Besides the circumstance of a foreign people governing their country, did Chinese scholars have reasons for resentment? Degrees of acceptance of the Manchu régime and gratitude for the stability it brought alternated with waves of resistance. Manchu policies of conciliation and rewarding service were matched by actions meant to intimidate the population. Resentment was generated by arbitrarily ferocious punishments visited on thousands following the 1657 cheating scandal, the 1658 arrest of 108 Fujian scholars and judges,[12] the 'Jiangnan tax defaulters' case of 1661–63,[13] and by the Yongzheng and Qianlong literary inquisitions that aimed to expunge anti-Manchu sentiments from both Qing dynasty and earlier literature.[14] Unable to protest openly, those who dared to vent their feelings privately did so with caution. Diverse techniques of indirect expression, a few of which are given below, were ready-made for the situation.[15]

'Substitution' (*ji gu*) used a past person, event or period as a surrogate for one in the present.[16] Because the Song dynasty was conquered by alien northern Khitan and subsequently by the Mongols, it became an oft-used substitute for the vanquished Ming.[17] Fang Hengxian's painting of Song imperial garden rocks (cat. 239) was readily understood this way.

'Concealed phrase' (*cang ci*) consisted of quoting the first or last portion of a phrase, poem or aphorism, with the expectation that the knowledgeable audience could complete the passage. Used to test knowledge of the classics in official examinations, the technique was no less popular with poets and playwrights. Some messages and barbs lay even deeper, referencing an annotation to a poem or the usage of a cultural hero such as the poet Du Fu or Su Shi.[18]

Puns (*xie yin*), double-entendres (*shuang guan*) and rebuses abound in the Chinese language

Fig. 70
Zhao Mengfu (1254–1322), detail of *Record of Miaoyan Monastery*, undated (*c*.1309–10). Regular script, handscroll, ink on paper, 34.2 × 364.5 cm. The Art Museum, Princeton University (1998-53)

(cat. 270).[19] Puns might include such words as the aforementioned 'indirect criticism' *feng* 諷, homophonous with 'wind' *feng* 風; and the 'Man' 满 of Manchu that sounds the same as 'Man' 蠻, a word used to refer to the barbarous tribes of south China, and, in the Daoist philosophical text *Zhuangzi*, to a fictive belligerent country. A *double-entendre* used by poets and painters was *chan yuan* 潺湲, meaning both water flowing over rocks and tears trickling down cheeks[20] (see the second scene of Wang Hui's *Reclusive Scenes among Streams and Mountains* [cat. 250]). Bearing in mind Scott's admonition not to under-estimate the imaginative capacity of those lodging resistance,[21] it is not impossible that Shen Quan intended the water/tears *double-entendre* in his otherwise auspicious *Pine, Plum and Cranes* (cat. 268). Because of these literary techniques, Qing emperors were justified in being concerned that obscure affronts might be embedded in texts and images.

Under political pressure, most scholars chose life and career over vocal opposition. Among other things, poetry, painting and calligraphy were elegant outlets for releasing emotion. Requiring both physical and mental discipline, they involved body and spirit. Scholars knew that the allusive messages they exchanged were unlikely to change a policy or injustice, let alone overthrow the dynasty. The benefits of brushing calligraphy and painting come from entering a personal realm, gaining a sense of control, and taking action by recording ideas and feelings. In this there was pleasure and the not-inconsequential satisfaction of leaving traces of thoughts to be discovered and appreciated by later generations.

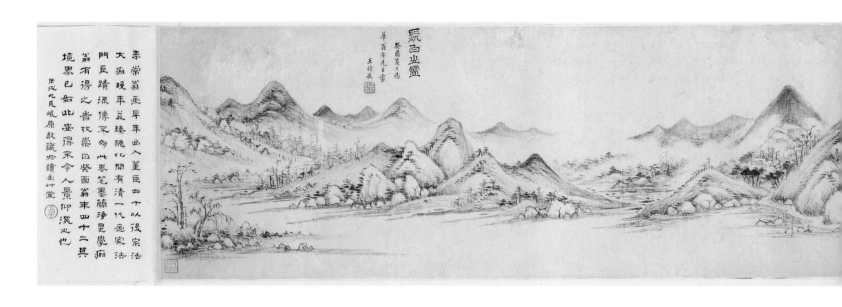

237 ↑

Wang Shimin (1592–1680)
Mount Changbai

1633

Handscroll, ink on paper,
32 × 201.5 cm

Inscription: 'Picture of Mount Changbai,
painted for Elder Huaweng on a summer
day in the *guiyou* year [1633] by Wang
Shimin'

Artist's seal: *Wang Shimin yin*

Collectors' seals: *Linshang zhai zhencang*
(Treasure of Linshang Studio),
Minyuan zhencang

The Palace Museum, Beijing, Xin126281

238 →

Hu Zao (fl. mid-seventeenth
century)
Ge Hong Moving His Residence

1653

Fan, ink and colour on gold-flecked
paper, 17 × 53.5 cm

Inscription: 'Picture of Ge Hong
moving his residence, seventh month,
autumn of the *guisi* year [1653] painted
for elder leader Dazong. Hu Zao'

Artist's seal: *Hu Zao*

The Palace Museum, Beijing, Xin10651

239 →

Fang Hengxian (fl. mid-
seventeenth century)
*Strange Stones of the Bianliang
Palace*

Mid-seventeenth century

Hanging scroll, ink on paper,
29.5 × 42 cm

Inscriptions: Fang Hengxian
and Liu Gao

Seals: one seal of Fang Hengxian,
Taicun zuohua; two of Liu Gao, *Yipian
bingxin, Zhupo*

The Palace Museum, Beijing, Xin145988

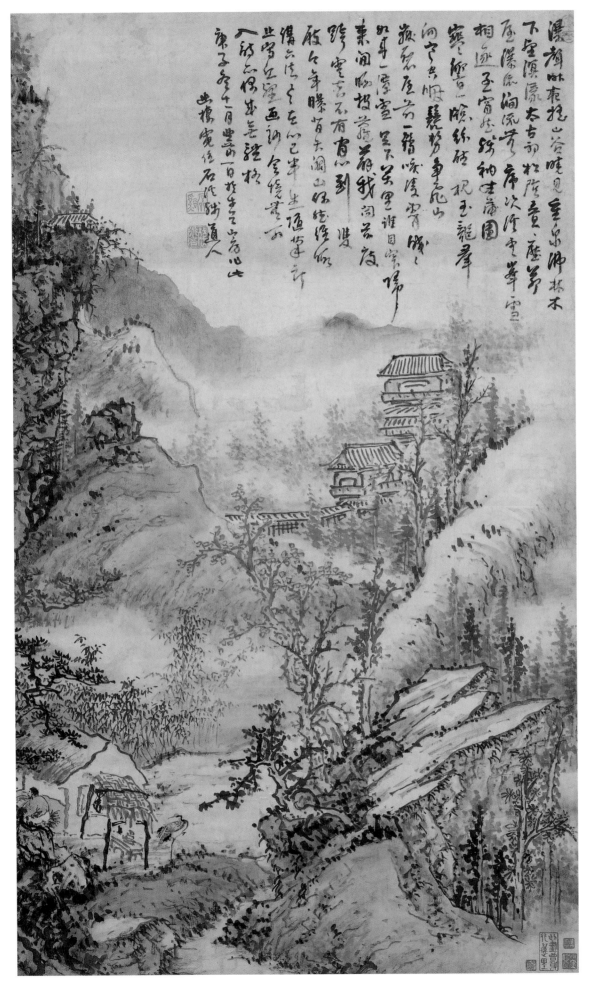

240 ←

Kuncan (1612–c.1673)
Landscape after Night Rain Shower

1660

Hanging scroll, ink and colour on paper,
96×58.5 cm

Inscription: seven-character verse of
eleven couplets. Signed: 'In the eleventh
month, winter of the *gengzi* year [1660],
the night before the full moon, I made
this at Ox Head Mountain Lodge,
Dianzhu Shiqi Candaoren of Lonely
Roost (Youxi) Temple'

Artist's seals: *Jieqiu, Shiqi, Candaozhe*

Collectors' seals: *Yousheng yinxin,
Ci huazeng shenxing wanli, Puyuan,
Xiaoke yinge*

The Palace Museum, Beijing, Xin82091

Shitao (Zhu Ruoji, 1642–1707)
Picking Chrysanthemums

1671

Hanging scroll, ink on paper,
206.3 × 95.5 cm

Inscription: "'Picking chrysanthemums
by the eastern hedge, I catch sight of the
distant southern hills." On the ninth day
[of the ninth month] of 1671, painted for
the pleasure of the old Daoist and elder
in poetry, Ji, called Shitao of Yue
Mountain'

Artist's seals: *Ji Shanseng, Laotao, Yiru buyou*

The Palace Museum, Beijing, Xin133993

Wang Jian (1598–1677)
*After Ni Zan's Pavilion by Stream
and Mountain*

Mid-seventeenth century

Hanging scroll, ink on paper,
80 × 41.1 cm

Inscriptions: transcription of two Ni Zan
quatrains and signature

Seals: two seals of the artist; two
collectors' seals, 'Treasure of the
Qianlong Emperor', 'Record of
Calligraphy and Painting of the Hall
of Embodied Treasures'

The Palace Museum, Beijing, Gu4905

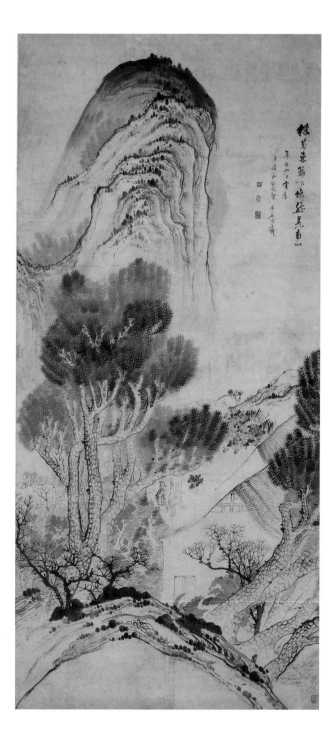

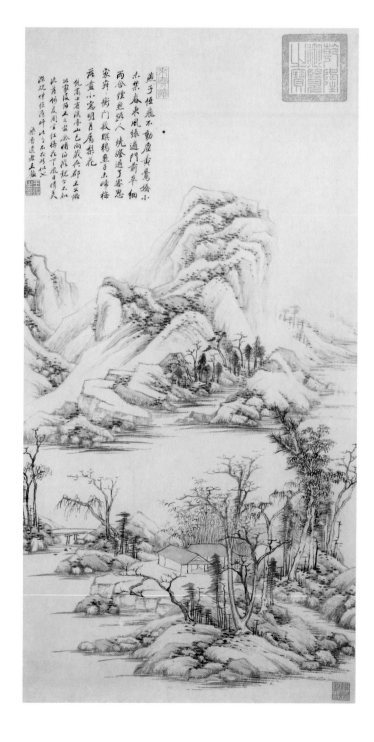

243

Wang Shimin (1592–1680)
*Scenes Described in Poems of
Du Fu*

1666

Twelve album leaves, ink and colour
on paper, each 38.8 × 25.6 cm

[Signed] In the *yisi* year, twelfth
month [1666], 74-year-old Shimin
sketched twelve leaves of Du Fu's
poetic ideas for Nephew Dong Xuxian

Seals: sixteen seals of the artist,
twenty collectors' seals including
eight imperial seals

The Palace Museum, Beijing, Gu4873, 1–12

317

244

Wu Li (1632–1718)
Thoughts on Xingfu Hermitage

1674

Handscroll, ink and colours
on silk, 36.6×85 cm

Inscription: a remembrance of the
artist's admired friend Morong
with ten-line poem, signed and
dated: 'Written two days before
"ascending heights" in the *jiayin*
year (seventh day of the ninth
lunar month, or 6 October 1674)
as rain is letting up. The Recluse
of Peach Spring, Wu Zili'

Seals: two seals of the artist,
eight collectors' seals

The Palace Museum, Beijing, Xin146408

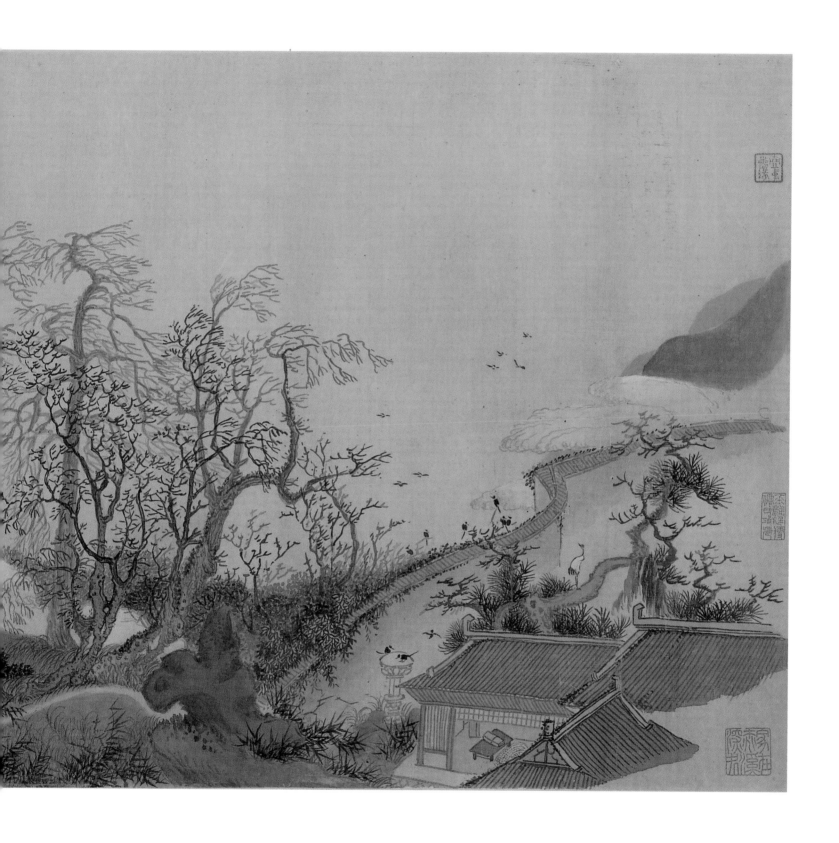

320

245 ←

Gong Xian (1619–1689)
Landscape Dedicated to Xi Weng

1674

Three hanging scrolls, ink on silk, 278 ×
79.5 cm, 278.1 × 83.7 cm, 278.1 × 78.7 cm

Inscription: 'Made for Xi Weng in winter
of the *jiayin* year [1674], Gong Xian
called Half Acre'

Artist's seals: *Gong Xian, Zhongshan yelao*

The Palace Museum, Beijing, Xin104281, 1

246 ←

Wang Shimin (1592–1680)
For Dragon Boat Festival

1676

Hanging scroll, ink on paper,
100.8 × 40.1 cm

Inscription: 'Playfully inked by old Xi Lu
on Duanwu [fifth day of fifth month] in
the *bingchen* year [1676]'

Artist's seals: *Wang Shimin yin, Xi Lu laoren*

Collectors' seals: *Tongyin guan yin* (Seal of
Hall of Paulownia Shade) belonging to
Qin Zuyong (1825–1884), *Lu Runzhi
jiancang* (Collected by Lu Runzhi)
belonging to Lu Shihua (1714–1779)

The Palace Museum, Beijing, Xin13894

321

狂喪翁

披喪公者吳人應延
下李子此遊見道中
豐金顧而觀之謂
聆目擲杖而言曰
笑阿不取之公投籧
子為之高視人
之畢無喪視我而
貫薪嘗飲遠
藏季子大顙間其
姓名曰戴余以蒼
之筆

鐵腳道人
鐵腳道人嘗赤腳走露中興發則朗誦南
華秋水篇又嘗嚼梅花數片和雪嚥之或問
此何為曰吾欲寒香沁入肺腑其後採藥衡
岳夜半登祝融峰觀月出仰天大叫曰雲海
盪吾心胸竟飄然而去余嘗登黃海始信
峰觀東海門曾為之下拜猶恨此身未能
去

篛菴和尚
和尚壯年劉髮走重
慶府之大竹善慶里
山水奇絕欲止之甚重
隱七柱景賢知和尚
非常人與之遊往未
白龍諸見山旁灘
柏灘瀧水清駛馬
篁森綽和尚欲寺馬
洪賢一力亞為之寺
青青同名觀音好讀
楚詞時遺一冊袖珍
小舟恩橫灘中流朗誦
一景飄投一葉千水投己
輒哭已巳又讀葉畫乃
返又善影呼棋人牧
壁和歌七竟顧焉而
賓

322

247

Shitao (Zhu Ruoji, 1642–1707)
Landscapes with Hermits

Late 1670s (?)

Handscroll, ink on paper, 27.7 × 313.5 cm

Inscriptions: five inscriptions by the artist

Seals: five seals of the artist, eleven collectors' seals

The Palace Museum, Beijing, Xin118735

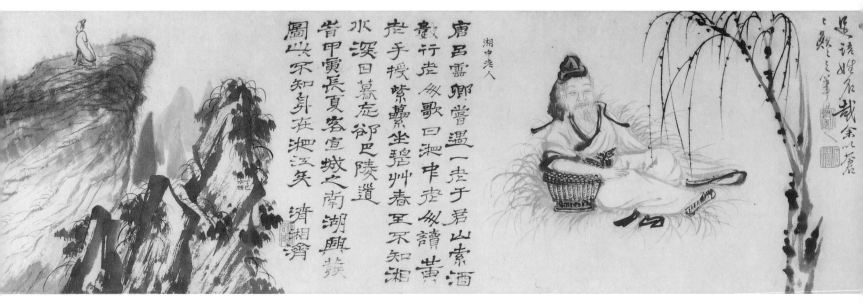

十三便懶殘畫矣五十年而力硯田
上朝耕暮穫僅足糊口可羞張糸先按
夢坤大生云予寫三撫四寓軍馳馬
觀選華門堂果以冊藏舊陵舊
青扶人昌稗酮接此冊藏重陵先
挂舫迎著雞祐友人席上陳蔡
黃司馬逸宗寵波下福搜舉凋
棟余曾中三飲宋生之手敷蔡叢
曰菲君見未顯私中壬申不灘三
春春平琵月給米五君䭾五諍兄
絡主身四五余懷山銘上由垂堪自
怡悅團志逐叹畢遂君劃雯两
與之方滿蔡叢堂年奇藏搜的後
人哎共寶燕作山美書芹切
半面蝶鷗記

Gong Xian (1619–1689)
Streams and Mountains without End

1680–82

Handscroll, ink on paper, 27.7 × 726.6 cm

Inscription: 'Painted by Gong Xian of Jiangdong'

Artist's seals: *Gong Xian*, *Yeyi* (Left-over citizen in the wilderness)

Collector's seals: three seals of Shen Xiangyun (d. 1913)

The Palace Museum, Beijing, Xin147340

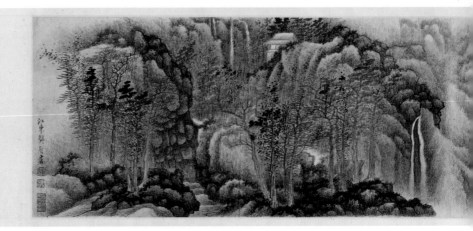

Wu Hong (*c.*1615–after 1683)
Grieve-Not Lake

Undated

Handscroll, ink and pale colour on paper,
30.8 × 150.5 cm

Inscription: title by Zheng Fu (d. 1693)
dated spring of the *dingmao* year [1687]

Artist's signature: 'Grieve-Not Lake. Wu Hong of
Jinqi, called Bamboo Historian, painted below the
thirty-six peaks of Yunlin Baima'

Seals: two seals of the artist, four collectors' seals

The Palace Museum, Beijing, Xin146380

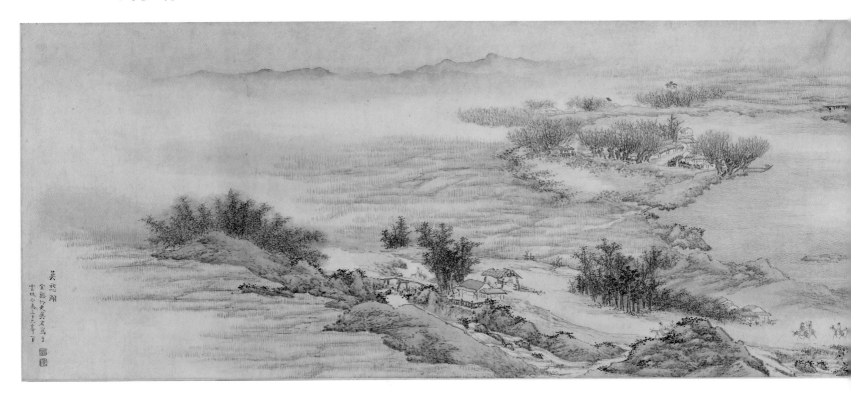

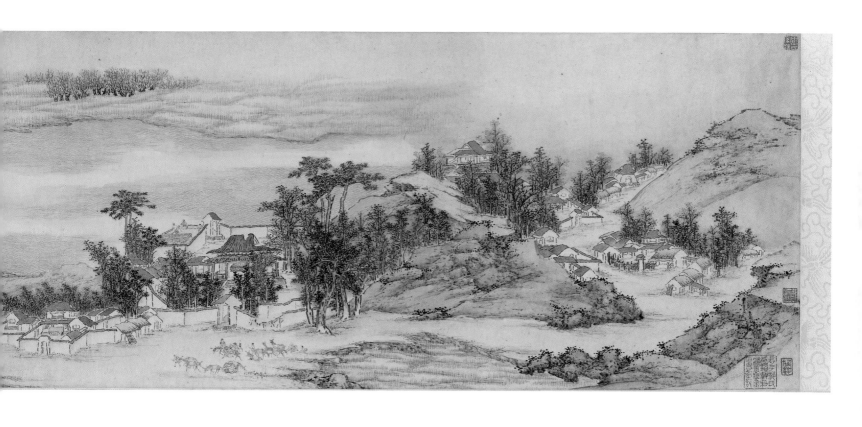

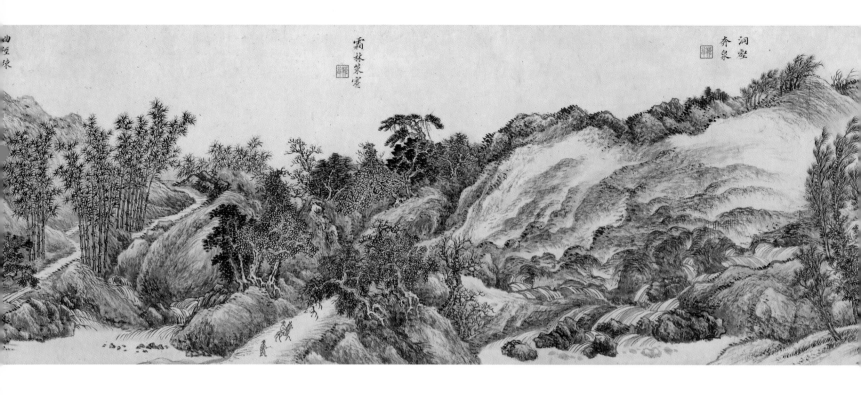

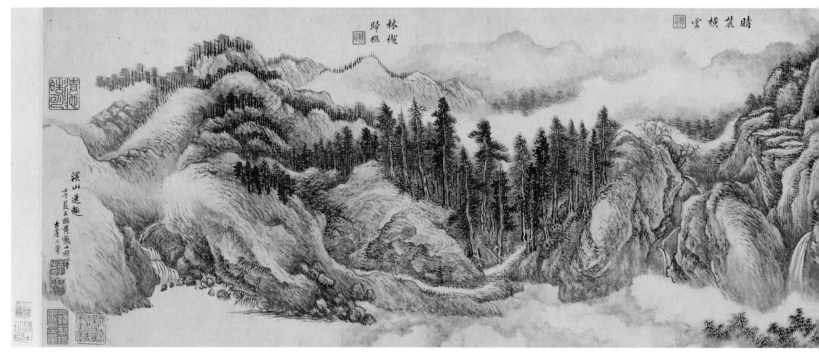

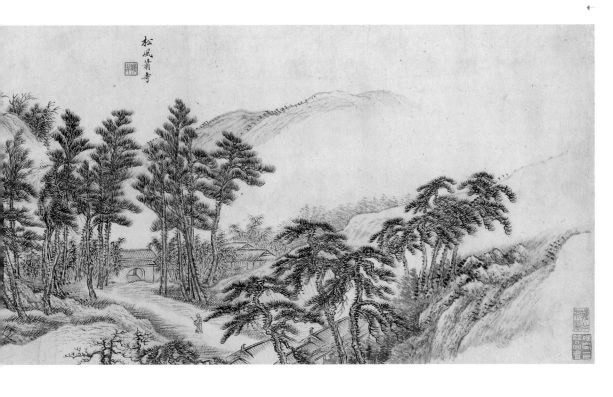

Wang Hui (1632–1717)
Reclusive Scenes among Streams and Mountains

1702

Handscroll, ink and colour on paper,
32.7 × 296.4 cm

Artist's inscription: 'Reclusive Scenes among
Streams and Mountains, fifth month,
summer of the *renwu* year [1702], Wang Hui
of Guyu imitating the brush of Huanghe
Shanqiao [Wang Meng]'

Titles inscribed by Cai Qi: Wind in the Pines
Monastery; Grotto in Valley with Tumbling
Spring; Feeble Horse in Cold Forest;
Winding Path, Thin Grove of Bamboo;
Heavenly Fragrance Book Studio; Yellow
Leaves Mountain Villa; Horizontal Clouds in
Clear Foothills; Woodcutter Returning
through Forest Shade

Seals: two seals of the artist, thirteen
collectors' seals

The Palace Museum, Beijing, Xin146116

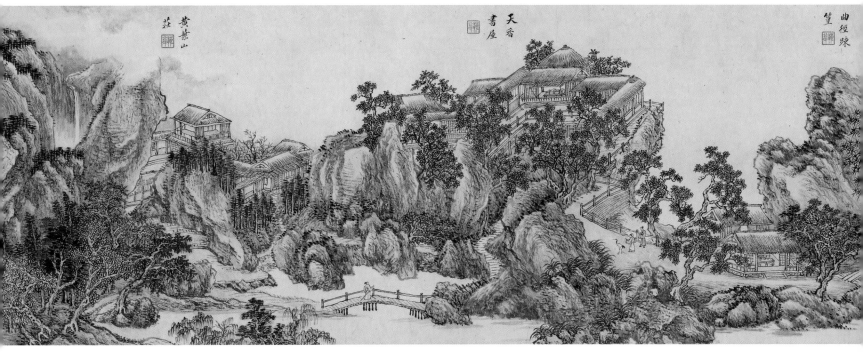

Yun Shouping (1633–1690)
Flowers and Plants

1685

Ten album leaves, ink and colour on paper, 25.5 × 34.8 cm

Inscriptions and identifications

Leaf 1: Japanese Pomegranate (no inscription)

Leaf 2: Blossoming Broad Bean, 'Barley mound at slight frost, spring days lengthen, / A bean plot filled with fragrance into summer; / The flowers blossom thickly, but not for the silkworms of Wu, / You are wrong if you think that Heaven loves silken threads. Nantian'

Leaf 3: Pine Tree (no inscription)

Leaf 4: Field Poppy (no inscription)

Leaf 5: Day-lily, 'How to make a peaceful courtyard? Often plant this. / Loving its bright foliage is enough to forget worries. / Yunxi waishi'

Leaf 6: Chrysanthemums, 'Painting chrysanthemums is difficult. Ink chrysanthemums are still more difficult. The skill of Yuan painter Wang Yuan and the fresh beauty of [the Song dynasty poet] Zhou Mi do not come up to the loftiness of Elder Baishi [the Ming dynasty scholar-painter Shen Zhou]. This picture follows [the Ming painter] Tang Yin and, although it is removed from the garden paths of Baishi, it still has not exhausted my ink flowers' special flavours. Nantian'

Leaf 7: Wisteria, 'Purple silk fringes – from where do they come? / Gem-like buds begin to open like a precious tower in dawn's light. / A wisteria vine of a thousand feet, half hanging from heaven / Bound by the spring wind – no one can teach this. / Nantian Shouping'

Leaf 8: Lily, 'Inking these two gilded vases / that perfume the breeze as they sway in the garden, / Like flutes playing the through a moonlit night, / Like a troupe of rainbow skirts dancing. / Shouping'

Leaf 9: Peach Blossoms, 'Li Bo has a line, "Wind blowing the willow flowers fills the inn with fragrance." Former men admired that fragrance. So why can't a painter wield a brush to transmit its spirit? Nantian'

Leaf 10: 'Ten sketches from life done at Tiaohua Hall, sending on to my elder friend Geng for evaluation; the beginning of the end of spring of the *yichou* year [1685], Shouping called Nantian.'

Seals: 32 seals of the artist, nine collectors' seals

The Palace Museum, Beijing, Xin146896, 1–10

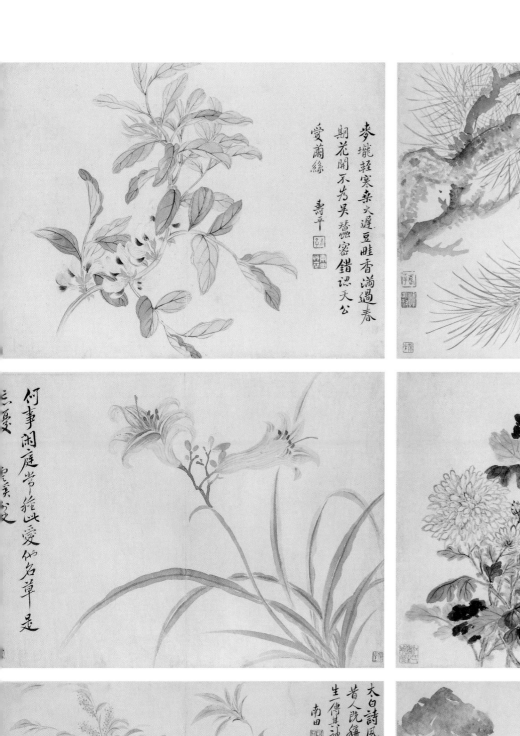

麥壠輕寒雜火遲豆畦香滿過春
期花開不為吳藷艷密錯認天公

愛蘭絲 壽平

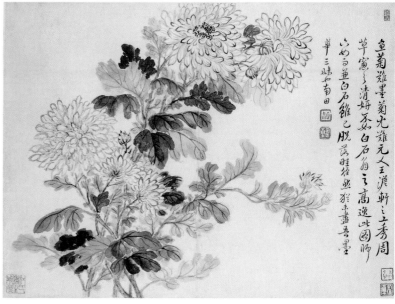

魯菊雜墨菊尤難元人王濩軒之立秀周
草窗之清姝不如白石翁之高逸此圖師
此妙之魯白石維乙脫茲畦疏猶未盡吾墨
華三昧仍南田

何事閒庭當擁此愛他名草
是

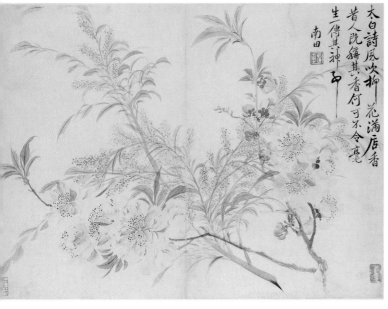

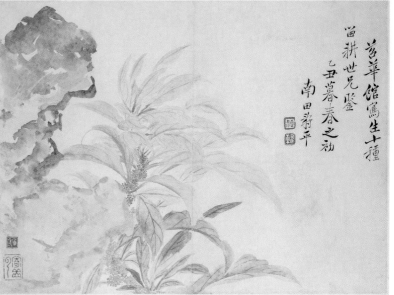

太白詩屬吹柳花滿店香
昔人既編其香何可不令亮
生傳其神仍

南田

菁華館寫生十種
苗耕世兄鑒
乙丑暮春之初

南田翁平

Wang Yuanqi (1642–1715)
Immortals' Abbey by Pine Stream

Undated

Hanging scroll, ink on silk, 118 × 54.5 cm

Inscription: 'Respectfully painted by your servitor Wang Yuanqi'

Seals: one seal of the artist, one seal of the Qianlong Emperor, three seals of collectors

The Palace Museum, Beijing, Gu4866

253 ↑

Yu Zhiding (1647–*c*. 1713)
Wang Yuanqi Cultivating Chrysanthemums

Early eighteenth century

Handscroll, ink and colour on silk,
32.4 × 136.4 cm

Inscription: 'Respectfully painted
by Yu Zhiding of Guangling
[Yangzhou]'

Seals: three seals of the artist,
two seals of inscribers, one
collector's seal

The Palace Museum, Beijing, Xin54038

254 →

Zhu Da (Bada Shanren,
1626–1705)
Poem about a painting,
in running cursive script

Undated

Hanging scroll, ink on paper,
77.9 × 166.8 cm

Inscription: *Bada Shanren ti hua*
(Bada Shanren, [poem] about a
painting)

Seal: below the inscription, *Bada
Shanren* ('Eight great mountain
man', the artist's literary name)

The Palace Museum, Beijing, Xin155879

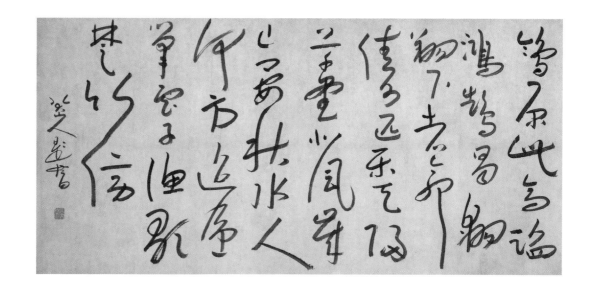

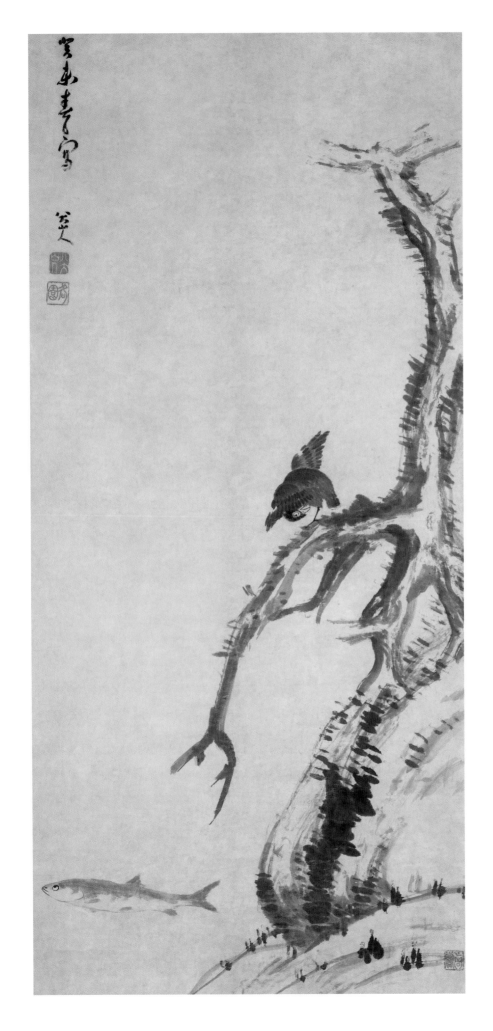

256 →

Zheng Xie (1693–1765)
Orchids, Bamboo and Rock

Before 1740

Hanging scroll, ink on paper,
128.3 × 58 cm

Inscription: 'Yin Niu Fourth Elder
Brother has the strength of bamboo, the
purity of the orchid and the resoluteness
of rock. He is unique in his generation.
He had frequently sought my painting
and I had yet to respond. In the autumn
of the fifth year of Qianlong [1740] he
came to my studio, so I scoured the house
and presented him with this old work.
The bamboo has no stalks, the orchid
leaves are drooping, the rock is cramped;
I'm afraid it is inadequate to convey the
idea of a Gentleman. Another day I
should paint a fine work to atone for
this offence. Zheng Xie called Banqiao'

Artist's seals: *Zheng Xie yin*, *Kerou*

The Palace Museum, Beijing, Xin92392

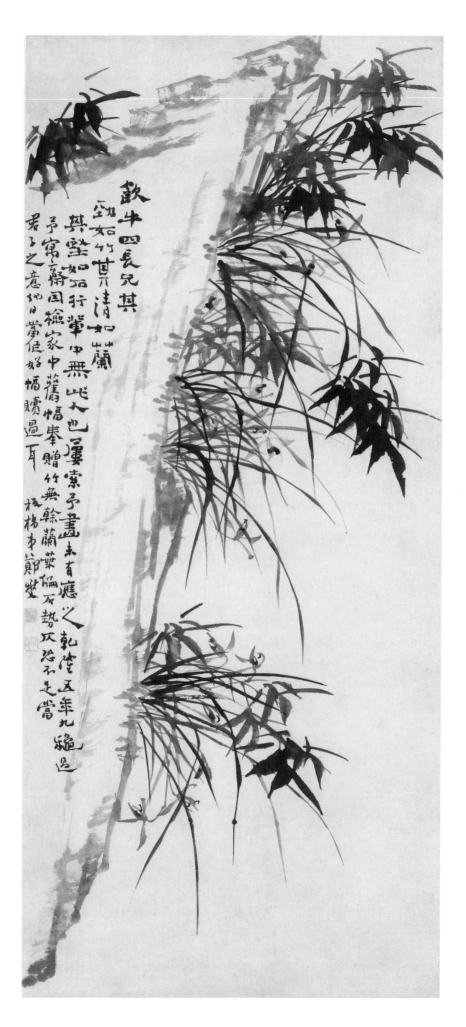

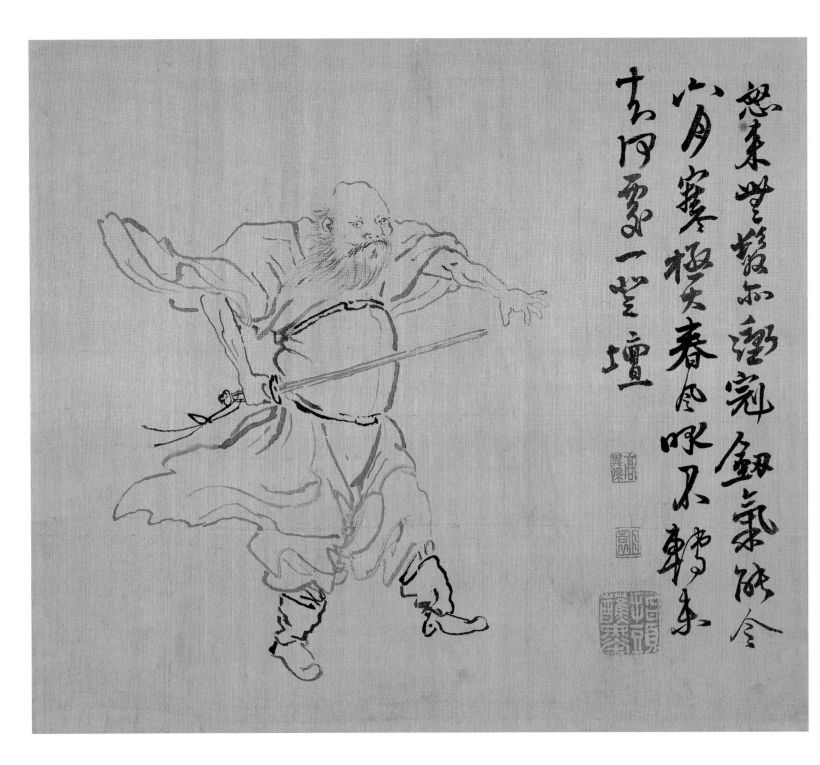

257 ↑

Gao Qipei (1660–1734)
The Demon Queller Zhong Kui

c. 1690

One of twelve album leaves, ink on silk,
26.6 × 30.6 cm

Inscriptions: quatrain on each leaf

Seals: 52 seals of the artist, six collectors'
seals

The Palace Museum, Beijing, Xin124240, 1–12

Fu Shan (1607–1684/85)
Running Cursive

c. 1682

Hanging scroll, ink on twill-weave silk,
194 × 51.8 cm

Inscription: four lines of poetry by Yang
Su (d. 606), signed 'The 76-year-old man
Fu Shan wrote in a small garden beneath
willows'

Artist's seal: *Fu Shan yin*

The Palace Museum, Beijing, Xin153139

259

Gao Xiang (1688–1754)
Eight Scenes of Yangzhou

Before 1743

Album of eight leaves, ink and colour
on paper, each 23.8 × 25.5 cm

Inscriptions: a poetic quatrain by a
different author inscribed on each leaf

Collector's title: on blue paper in clerical
script 'Master Gao Xitang's album of
eight fine scenes of Yangzhou. In the
fourth month of Qianlong 8 [1743]'

Seals: fourteen seals of the artist

The Palace Museum, Beijing, Xin187506, 1–8

午暖轉塘
正及晨畢
抹茶宣龜從
隨身治春
漫道盡流
晨歇剩有漁
洋一蜑人

新湖方
塘要蓄
時蒜花
香宵折
来蓬堤
邊早種
垂楊樹
好与列
人後列
雜

王晴江
明府招
同諸前
輩平山
雅集各
賦絕句
共八首

高情良會從舊事水榭及之章
六月天夫右臂偏枯答我之嬌時
兩者朋儔多上郭行船謂屬陜橋
梅講諸可學 陳竹嶼王

緇流誰
許列蠶
嚶内吏
家風禾
得俊吏
竟禮君
波衙鉢
暇讀鳴
明

Huang Shen (1687–1768)
Landscapes and Figures

1735

Twelve album leaves, ink and colour on paper, each 27.9 × 44.5 cm

Inscriptions by the artist on each leaf

Leaf 1: Ten Poems Written at Songnan Old Bamboo Hall

Leaf 2: Meng Changjun Interviewing the Elder Chu Qiu

Leaf 3: The Wise Daoist Recluse Chen Bo

Leaf 4: Night Rain, Misty Waves

Leaf 5: Sailing on Poyang Lake

Leaf 6: Han Qi Wearing a Yangzhou Shaoyao Peony

Leaf 7: Listening to Rain on Rivers and Lakes

Leaf 8: Scholar Su Shi Admiring a Natural-rock Inkstone

Leaf 9: Autumn Waters More Vast than the Sky

Leaf 10: Thinking of My Humble Home

Leaf 11: Old Friends

Leaf 12: Sending Off Friend. Quatrain

Signature: 'For more than ten years I have been travelling around the lower Yangzi River. In spring of the *yimao* year [1735] I took my family back to Fujian. While staying with old friend Lin Zhe, I reflected and wrote poems. When I sailed on Poyang, every detail of sending off a guest at River Mouth is as if before my eyes. Therefore I casually painted several sheets of paper and copied six figure compositions to make up two albums with inscriptions. Written in the ninth month, autumn, thirteenth year of Yongzheng [1735], Yingpiao Mountain Fellow, Huang Shen'

Seals: twelve double seals of the artist, twelve collector's seals

The Palace Museum, Beijing, Xin99557, 1–12

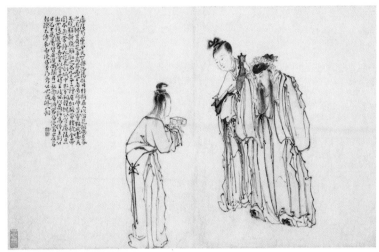

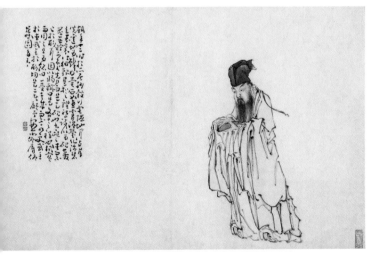

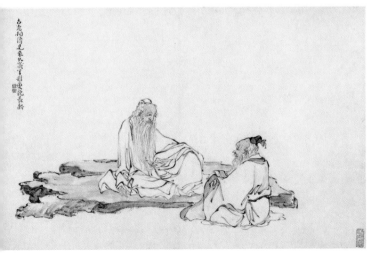

343

古老相傳見來久豈羊離復覲長新

Hua Yan (1682–1756)
Squirrels Competing for Chestnuts

1721

Hanging scroll, ink and colour
on paper, 145.5 × 57.4 cm

Inscription: 'The tree is hidden by
an unbroken band of mist, / Bees at
times sink to honeyed bramble-bed /
Lychee walled by grass are
intertwined with junipers, / In the
shadows of a rainy bamboo grove it's
hard to see the sun / Pines sigh with
the passing wind and let fall wisteria
blossoms. / Look up and see the
hungry flying squirrels competing
for mountain chestnuts / A winter
day of the *xinchou* year [1721] painted
by Hua Yan called Qiuyue'

Artist's seals: *Hua Yan zhiyin*, *Qiuyue*,
Qiukong yihao

Collector's seal: Pang Yuanji
(1864–1949)

The Palace Museum, Beijing, Xin146989

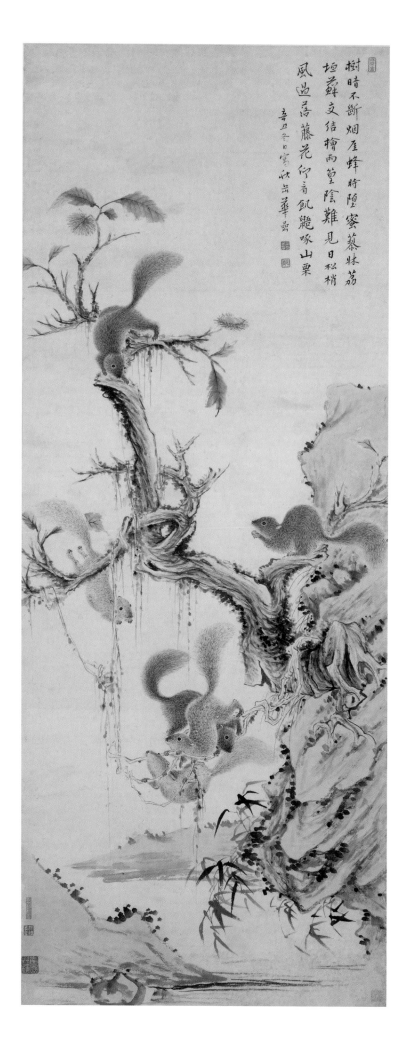

Jin Nong (1687–1773)
The Radiant Moon

1761

Hanging scroll, ink and colour on paper, 115.8 × 54 cm

Inscription: '*The Radiant Moon* painted and sent to Master Shutong for his refined appreciation by the old man of seventy-five, Jin Nong'

Seals: two seals of the artist, three collectors' seals

The Palace Museum, Beijing, Xin53964

Luo Ping (1733–1799)
Insects, Birds and Beasts

Leaf 1: Ox-herder with a Bird on a Stick

Leaf 2: Snail on a Rock

Leaf 3: Spiders

Leaf 4: Dragonfly and Unidentified Plant

Leaf 5: Hen and Chicks

Leaf 6: Ants

Leaf 7: Centipede Ascending Tree

Leaf 8: Bivalves

Leaf 9: Tree Monkeys

Leaf 10: Tadpoles and Crayfish

1774

Ten album leaves, ink on paper, each 20.8 × 27.5 cm

Inscriptions: poetic quatrain inscribed on each leaf by Jiang Shiquan (1725–1785). Signature of the artist on leaf ten: 'In the eighth month of the *jiawu* year [1774] younger brother Luo Ping, after getting drunk, painted ten leaves of insects, birds and animals by a rainy window, responding to Third Elder Teacher Zhupu'

Seals: Luo Ping: *Liangfeng*; Jiang Shiquan: five double seals reading *Quan shu* (Quan inscribed), five seals reading *Xin yu* (heart's overflow); ten collectors' seals

The Palace Museum, Beijing, Xin10512, 1–10

頸末必
化珠尾
則供自
食童子
能膠絲
豈但由
基弋

Weng Fanggang
(1733–1818)
The *Heart Sutra*, in regular
script

1801

Album, ink on bodhi-tree leaves
and paper, 16.5 × 9.2 cm

Inscription: Jiaqing sixth year
(1801), eighth month, seventh day;
respectfully written by Weng
Fanggang

Seals: below inscription *Chen
Fanggang* (Imperial servant,
Fanggang); *Jing shu* (Respectfully
written)

A one-line colophon by the
calligrapher appears after the
album on the border of the
mounting

The Palace Museum, Beijing, Xin155954

265 →

Jin Nong (1687–1773)
Excerpt from Tao Xiushi's
Qing Yi lu, in 'lacquer-script'
calligraphy

1743

Hanging scroll, ink on paper,
119 × 59.5 cm

Seals: *Jin Nong yin xin* (Seal of Jin Nong);
Liushi bu chu weng (Housebound old man
of sixty)

Collector's seals: *Xiao shuhua fang miwan*
(Secret amusement from Xiaofang's
collection of calligraphy and paintings);
Yan Xiaofang zhencang jinshi shuhua yin
(Seal on Yan Xiaofang's treasures of
metal, stone, calligraphy and painting)

The Palace Museum, Beijing, Xin155516

266 ←

Li Shizhuo (1690?–1770)
Meditation Retreat at Gaotu

1747

Hanging scroll, ink and colour
on paper, 83.7 × 48.4 cm

Inscriptions: inscriptions by the
Qianlong Emperor dated 1747,
1767, 1769. 'Poetry Hall'
inscription: 'Pleasure among
Forest and Springs'

Seals: thirteen seals of the
Qianlong Emperor, two seals of
the artist

The Palace Museum, Beijing, Gu8211

267 →

The Nine Elders of Huichang

1787

Nephrite (green jade) boulder,
height 114.5 cm

Inscription: Qianlong poem in
seven-character lines

Seals: the Qianlong Emperor

The Palace Museum, Beijing, Gu103157

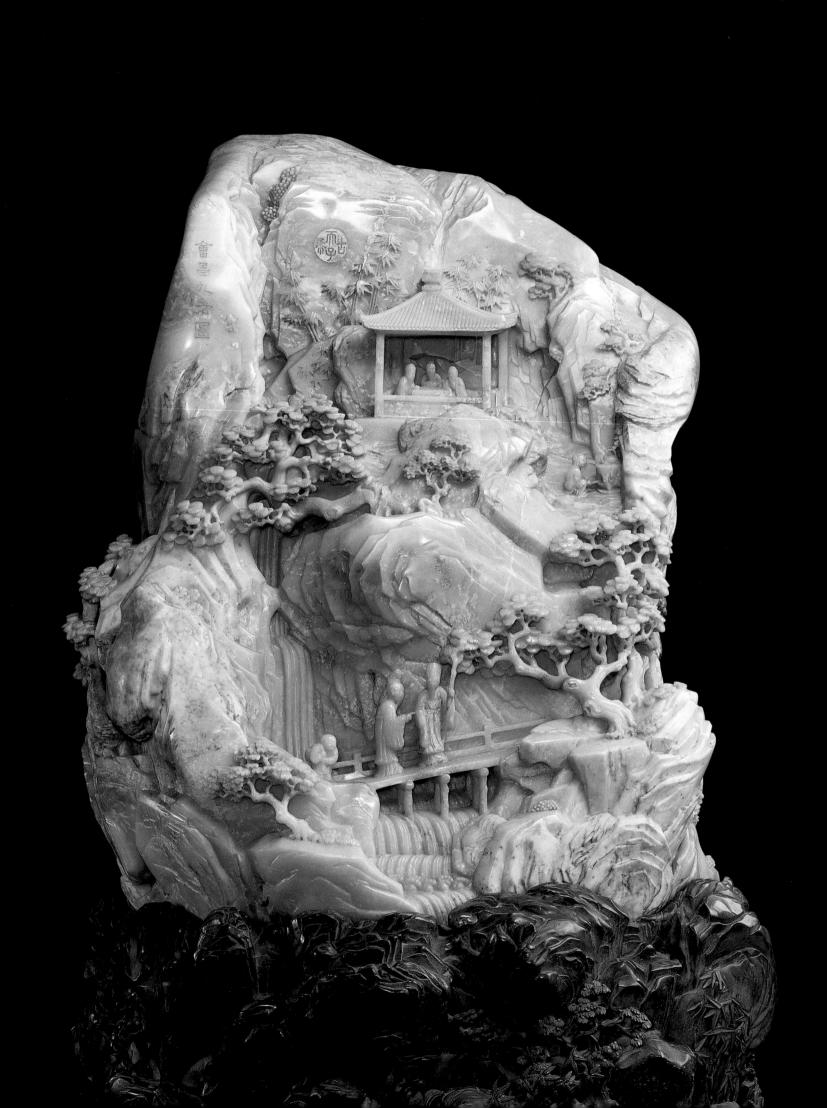

The Auspicious Universe

JESSICA RAWSON

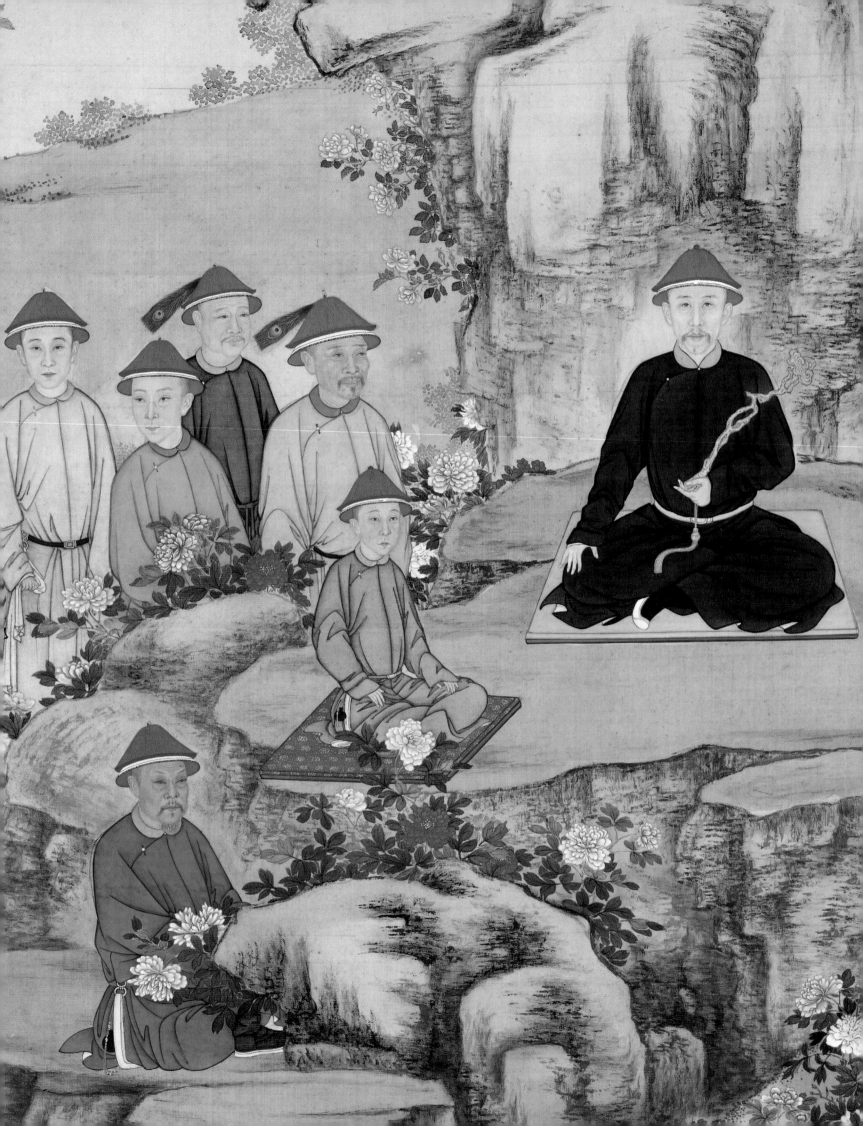

Auspiciousness and antiquity were the two principal decorative themes in the several palaces of the three Emperors. Antiquity is discussed on pages 272–75, auspiciousness here. Chinese characters expressing wishes for long life (cats 286, 303), intricately crafted on wooden screens and textile hangings; flowers and fruits, chrysanthemums and peaches, prunus and gourds in porcelain and lacquer, cloisonné, and semi-precious stones; and even whole landscapes miniaturised in gardens and in small pots – all embodied the Emperors' hopes for the future. For in ancient and modern China, these were and are all auspicious emblems. As such, they formed the principal components of a decorative system that was thought to bring good fortune to all who wore the clothes or lived in the spaces so ornamented. Westerners have become accustomed to buildings and rooms clad in the components derived from classical architecture and decorated with figural images from Greek and Roman mythology or the Christian religion; in China, by contrast, schemes comprising flowers, fruits, animals and birds have for many centuries formed the primary ornament of the élite and peasants alike.[1]

Several strands contributed over time to this system of decorative imagery. Underlying the whole development from the very beginning were the poems recorded in the famous classic, the *Shijing* (*Book of Poetry*). Collected around 600 BC, the poems are among the earliest of China's ancient transmitted texts. They include lyrics that liken blessings conferred on people in a society to phenomena in nature, and describe the beauty of women by reference to plants, fruits and flowers.[2] Long exegeses in later commentaries elaborated a complex interpretation that brought this imagery into the lives of the educated officials, who had to master the classics to obtain office, wealth and power.[3]

Yet it required a quite separate development to transfer this imagery from the written word to the visual environment. Many centuries, indeed, passed between the time when the *Shijing* was compiled and the widespread use of flower motifs in the decorative arts. This new development was encouraged by the introduction of Buddhism and by its support in northern China by non-Chinese rulers in the period of the third to

sixth centuries.[4] The birth of the Buddha was, it is recorded in texts, accompanied by the fragrance of flowers; appearances of Buddhist deities in visions were signalled by floral showers.[5] Temples, shrines and images were modelled on forms developed in the Indian subcontinent and Central Asia, and these examples brought with them some forms of flower motifs.[6] In the same period, the non-Chinese rulers were accustomed to moving between their capitals and territories, travelling in carts and sometimes living in tents. They were, themselves, depicted in natural environments, unlike their courtly predecessors (fig. 71).[7] These developments provided a visual vocabulary to represent flowers, birds and animals.

There was another, quite different, incentive that stimulated the choice of creatures and plants to embellish buildings and dress: namely the Chinese desire to understand and co-ordinate their activities with those of the universe. From very ancient times, the Chinese had taken storms and eclipses, good harvests and strange creatures as omens.[8] They developed a concept of the will of Heaven as a guiding principle and a description of the universe that treated it as an integrated system, in which all parts were related and interacted. Therefore, observation of all natural phenomena became of paramount importance to predict the future.[9] The movements of the planets and constellations, irregularities in the seasons, the appearance of unusual creatures, such as dragons and phoenixes, and unusual plants – such as the *lingzhi* fungus, thought to grant immortality – were all deemed to be aspects of Heaven's way of communicating with the earthly realm.[10] Carvings and paintings were made to record such phenomena and to capture for perpetuity their benign influences. The most comprehensive account was made at the command of the Emperor Huizong (r.1101–27) of the Northern Song dynasty, who ordered the compilation of some thousands of volumes of paintings to illustrate all the auspicious sightings.[11] The Emperor's project was in fact an attempt to control and manipulate such phenomena for future use.

Well before the Song period (960–1279), the ancient Chinese had also attempted to understand and control the universe through various forms of representation. Palaces and parks were models on a grand scale; gardens,

miniature landscapes (fig. 72), and tombs on a lesser one.[12] We know that such representations go back to at least the time of the First Emperor (Qin Shihuang, 221–210 BC), who built palaces in the form of constellations, and the great Han dynasty Emperor, Wudi (140–87 BC), whose Shanglin park is the subject of a long poem describing its wonders by the poet Sima Xiangru, recorded by Sima Qian in his *Records of the Historian* (*Shiji*).[13] Emperor Huizong, too, constructed a great park, named the Genyue (Northeast Marchmont), dominated by mountains created out of rocks brought from many regions and enriched by extraordinary plants and creatures.[14] In these great projects, the emperors re-created their own territories, which they envisaged as the whole world, with creatures and geographical features of the four directions. They were in effect creating analogues of the universe itself.

The Islands of the Immortals, thought to be in the eastern sea, also inspired many representations in models and paintings. The First Emperor had despatched groups of youths to these islands to seek the herbs that would grant him an escape from death. Again recorded by the famous historian Sima Qian, this episode generated innumerable landscape gardens and paintings of these islands and their immortal inhabitants. The Qianlong Emperor himself commissioned the construction of palaces of the immortals in the Yuanming yuan (Garden of Perfect Brightness) (see cat. 91).[15] Paintings of immortal palaces amidst tiers of mountains illustrate the kind of vision to which he aspired (fig. 73). An implication of all such works of architecture and art was that they gave their viewers privileged access to the Isles and their benefits.

Another paradise, to which reference was often made, was that of the Queen Mother of the West in the Kunlun Mountains. One of China's famous narratives, the *Journey to the West* (*Xiyou ji*), describes the difficult journey of the monk Xuanzang across Central Asia to the Indian subcontinent with some strange travelling companions, including the preternatural Monkey.[16] In one of the episodes Monkey attempts to steal peaches of immortality thought to be found in the Queen Mother's garden (cats 294, 296). Figural illustrations were added to boxes and screens to evoke such stories. Other individuals joined this imagery, including

Fig. 71
A section from the coffin bed found in Xi'an Province at the tomb of Anjia (d.571), a Sodian employed at the Northern Zhou court. Carved stone, gilt and paint. Shaanxi Provincial Institute of Archaeology, Xi'an. The slab depicts a group of figures in a tent of tiger skin amidst a landscape with trees and flowers.

the deities of the constellations in human forms; alongside a group of Daoist deities known as the Eight Immortals, they were popular images on decorative pieces.[17] These eight were recognised by their emblems and could indeed be represented by these alone (cat. 290).

Imperial ambitions to model and so control aspects of the universe in grand architectural projects, in parks and massive tombs have long been recognised. Less closely observed have been the same aims to decorate rooms in palaces and in more modest residences. Flowers and birds of the seasons could be painted on walls, as could supernatural creatures, dragons and phoenixes, and the Islands of the Immortals, of which the best known was named Penglai.[18] Indeed the texts that catalogue the subject-matter of early paintings indicate that it embraced the representation of the constellations and other heavenly bodies, birds and flowers, and figures of the major

Fig. 72
Miniature landscape representing the immortal island of Penglai, Qing period. Malachite, gold, pearls and precious stones, 41.5 × 43 × 38 cm. The Palace Museum, Beijing, Gu9931

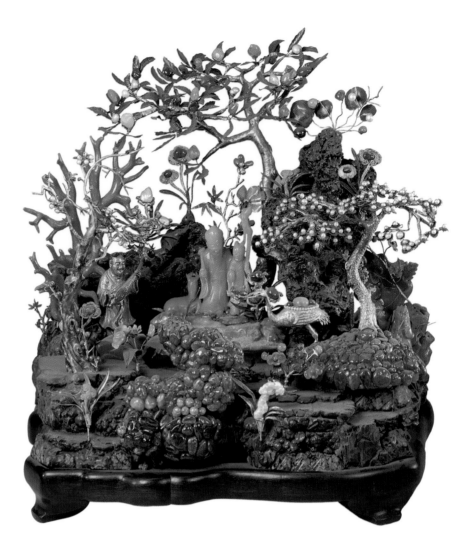

spirits and deities.[19] There was constant interplay between the subject-matter for paintings, and that for textile hangings, dress and decorative objects. Gardens with ornamental rocks and plants and interior furnishings such as carpets, hangings, woodwork and objects all carried these same images with the same messages. Such tastes were shared by the literate and official classes as much as by peasants.[20]

The many creatures and plants thought to signal auspiciousness were elaborated through the special capacity of the Chinese language to generate puns based on homophones.[21] Creatures whose names had the same sound as words connoting good luck were widely represented in the visual arts. For example, the word for bat, *fu* 蝠, is a homophone for the word *fu* 福, for happiness and good fortune (cat. 287) – hence the popularity of images of bats in many different media and art forms. The word for crane, *he* 鶴, is a homophone for *he* 和 (harmony), which, along with other beneficent associations of these birds, particularly longevity, explains the frequency with which they appear in paintings, on ceramic objects,

and on textiles (cats 268, 269). The word for cock, *ji* 鷄, is a homophone for *ji* 吉, auspicious, and goat, *yang* 羊, is recognised as a homophone for *yang* 陽, the positive force in the *yin-yang* 陰陽 balance (cat. 297) – further examples of auspicious homophones often translated into works of art. Such images inspired by homophones, as well as complex rebuses, could be amassed in a single picture or on a particular object, as exemplified by the embroidery showing three boys with goats (cat. 297), which contains not just one auspicious phrase but several.[22] Similarly an octagonal box carries a multitude of good wishes (cat. 289).

The different attributes of the system made it open-ended. New plants and animals were added over time, just as the plants in garden or park could be increased or changed. Some, such as gourds (cats 218, 283–87) and pomegranates (cat. 288), were regarded as natural examples of fecundity, with their many seeds, and so became emblems of many sons and many descendants.[23] At certain periods, particular plants were especially popular and acquired specific meanings. For example, during the

Tang period, under the rule of the Empress Wu Zetian (r.685–704), the peony became highly fashionable among the élites of the two capitals, Chang'an and Luoyang.[24] It was evidence of wealth and noble status, or *fu gui* 富貴, and so the plant became synonymous with *fu gui* and thus brought these words to mind when cultivated or represented.

Among the auspicious gifts most prized by the Qianlong Emperor, in particular, was the *ruyi* sceptre. This long-handled sceptre was crowned by a heart-shaped end that represented the curling growth of the auspicious *lingzhi* fungus. The term *ruyi* 如意 means 'as you like', or rather 'whatever you wish'. Thus the fungus-shaped sceptre was believed to bring good fortune to its owner. These sceptres were made in every material,

usually in sets of the auspicious number nine. Small groups from the numerous sets that were presented to the Emperor over his long career on the throne are shown here (cats 273–82).

In these bird, flower and animal motifs, the Chinese, therefore, had an extraordinarily successful system of design, sustained by their concepts of the universe and its auspicious phenomena. Its richness was further nourished by long traditions of ancient poetry and the flexibility of a language that made possible additions of new motifs and the combination and recombination of these motifs into ever more complex good wishes.[25] No one was unaffected by the system, which embraced Emperor and peasant alike.

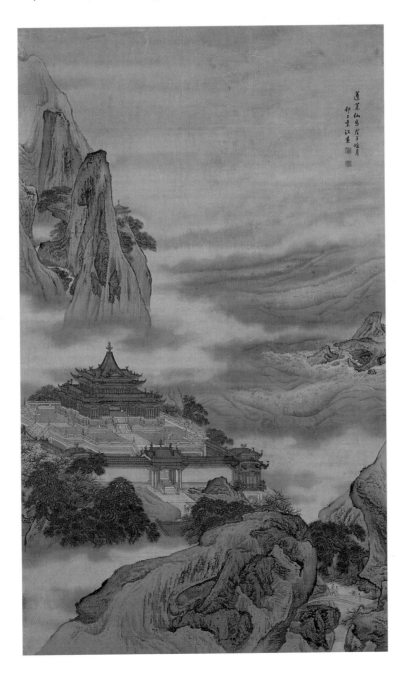

Fig. 73
Yuan Jiang (fl. *c*.1690–*c*.1740),
The Penglai Isle of the Immortals, 1708.
Hanging scroll, ink and colours on silk,
160 × 97 cm. The Palace Museum, Beijing,
Xin187505

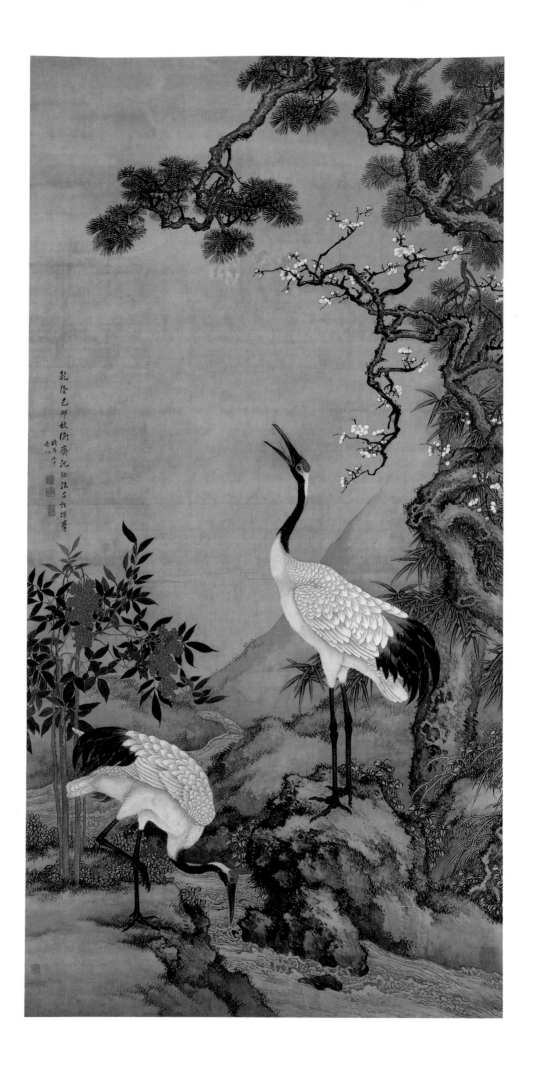

Shen Quan (1682–1760)
Pine, Plum and Cranes

1759

Hanging scroll, ink and colour on silk,
191 × 98.3 cm

Inscription: 'In the autumn of the *jimao*
year of the Qianlong reign [1759], Shen
Quan called Hengzhai, at age 78,
imitated Lü [Ji's] wielding of the brush'

Seals: three seals of the artist

The Palace Museum, Beijing, Xin63271

Yu Xing (1692–after 1767)
Cranes against Sky and Waters

c. 1747

Hanging scroll, ink, colour and shell
white on paper, 82.7 × 95.6 cm

Inscriptions: 'Respectfully painted by
your servitor Yu Xing' and inscription
by the Qianlong Emperor

Seals: two seals of the artist, twelve seals
of the Qianlong Emperor

The Palace Museum, Beijing, Gu5223

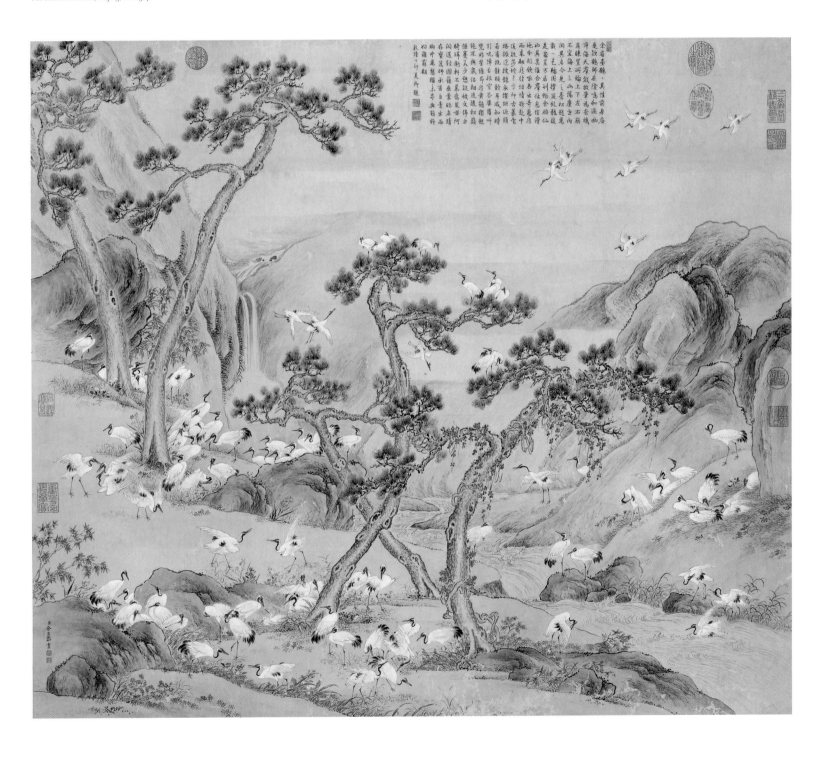

Chen Mei (1694?–1745)
Ten Thousand Blessings to the Emperor

1726

Hanging scroll, ink and colour on silk,
139.2 × 64 cm

Inscription: 'Ten-thousand blessings come to
the Emperor. Yongzheng fourth year, tenth
month 30th day [the Emperor's birthday,
23 November 1726], respectfully painted
by your servitor Chen Mei'

Artist's seals: two seals of the artist

The Palace Museum, Beijing, Xin156695

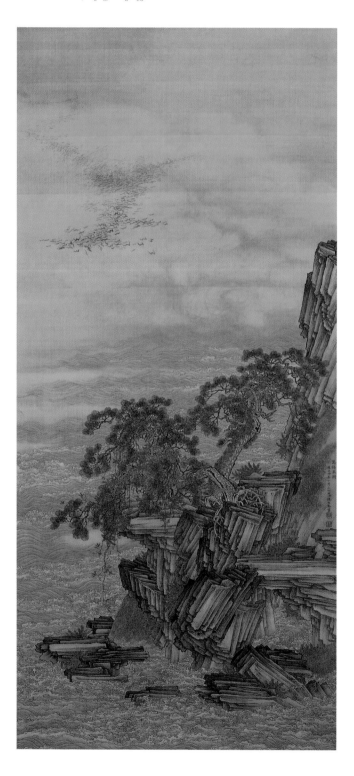

Chen Mei (1694?–1745)
Ten Thousand Blessings to the Emperor

Leng Mei (*c.* 1677–*c.* 1742)
Pair of Rabbits under a Paulownia Tree

Undated

Hanging scroll, ink and colour on silk,
175.9 × 95 cm

Inscription: 'Respectfully painted by your
servitor Leng Mei'

Artist's seals: *Chen Leng Mei, Suye Feixie*
(Unremitting [effort] from dawn to dusk)

Collectors' seals: one of the Qianlong Emperor
and one other

The Palace Museum, Beijing, Gu5183

Anonymous
*The Yongzheng Emperor
Admiring Flowers*

c. 1725–36

Hanging scroll, ink and colour
on silk, 204.1 × 106.6 cm

The Palace Museum, Beijing, Gu6435

273

Set of nine *ruyi* sceptres in the form of plants

Yongzheng or Qianlong period

Zitan wood, *hong* (red) wood, boxwood, sandalwood, *niao* (bird) wood, lengths *c.*33.5 cm

The Palace Museum, Beijing, Gu123392, 1–9

276 ←

Ruyi sceptre in the form of a flower, fitted with earlier jade pieces

Yongzheng or Qianlong period

Zitan wood, white jade, ruby and gold, length 40.7 cm

The Palace Museum, Beijing, G10014

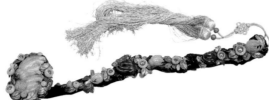

277 ←

Ruyi sceptre in the form of a 'Buddha's hand' fruit (finger citron) branch

Qianlong period

Zitan wood with jade and other hardstones, stained ivory and gold, length 41.5 cm; silk tassel with coral bead

The Palace Museum, Beijing, Gu123362, 5

278 ←

Ruyi sceptre carved in openwork, set with an earlier jade plaque with a 'long life' (*shou*) character

Yongzheng or Qianlong period, Palace Workshops, Beijing

Cinnabar lacquer on wood with colours and gilding inset with white jade, length 46.5 cm

The Palace Museum, Beijing, Gu115203

279 ←

Ruyi sceptre from a set of sixty

Qianlong period, 1770, made for the Qianlong Emperor's sixtieth birthday

Gold filigree on wood, inlaid with turquoise, length 42.7 cm

The Palace Museum, Beijing, Gu11686, 2

280 ←

Ruyi sceptre in the form of a leafy branch with longevity fungi (*lingzhi*)

Qianlong period

Zitan wood with agate, lapis lazuli, stained ivory and other semi-precious stones, length 42 cm; silk tassel with coral bead

The Palace Museum, Beijing, Gu123362, 8

281 ←

Ruyi sceptre in the form of a longevity fungus (*lingzhi*) with bats

Yongzheng or Qianlong period

Coral, length 32 cm

The Palace Museum, Beijing, Gu105840

282 ←

Ruyi sceptre engraved with dragons among clouds

Yongzheng or Qianlong period

Grey-green jade with gilding, length 44 cm

The Palace Museum, Beijing, Gu88923

274 ←

Ruyi sceptre with 'long life' (*shou*) and 'happiness' (*xi*) characters, lions, bats and the Eight Buddhist Emblems

Yongzheng or Qianlong period, Jiangning, Jiangsu Province

Bamboo veneer, length 46.5 cm

The Palace Museum, Beijing, Gu121029, 1

275 ←

Ruyi sceptre in the form of a gnarled fruiting and flowering peach branch with five bats

Qianlong period

Boxwood with white and green jade, rose quartz, rubies, gold and pearls, length 49 cm

The Palace Museum, Beijing, Gu10011

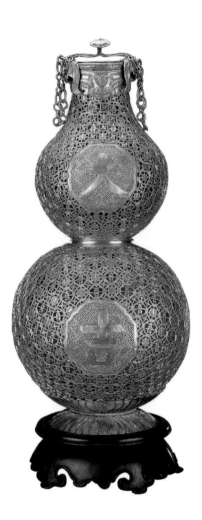

287 →

Double-gourd-shaped vase decorated with bats

Qianlong mark and period

Porcelain with red and blue-green enamels, height 33.3 cm

The Palace Museum, Beijing, Gu154692

283 ↑

Double-gourd-shaped ornament with linked chain

Qianlong period

Ivory with *zitan* wood stand and fitted box, height 18.5 cm

Victoria and Albert Museum, London, FE.10-1990

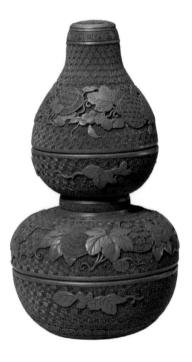

284 ↓

Double-gourd-shaped box decorated with smaller gourds and tendrils

Qianlong period

Carved bamboo, length 17.6 cm

The Palace Museum, Beijing, Gu121081

285 ↑

Double-gourd-shaped tiered box carved with melons on vines

Qianlong period

Carved lacquer with gilded interior, 24 × 13.7 cm

Qianlong six-character reign mark in relief on the base

The Palace Museum, Beijing, Gu110007

286 ↑

Perfumer in the shape of a double gourd with auspicious characters for happiness and longevity in openwork

Qianlong period

Gold, height 42 cm

The Palace Museum, Beijing, Gu225026

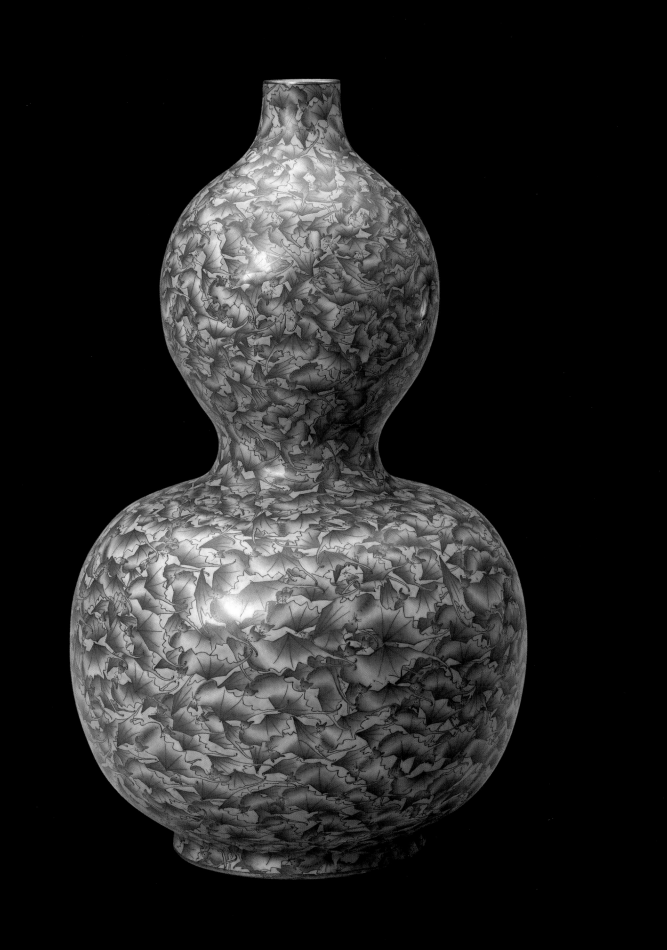

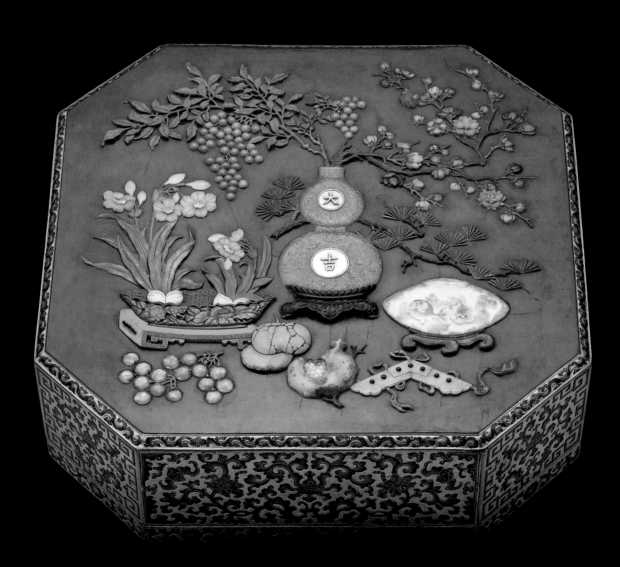

288 ←

Pomegranate-shaped box

Eighteenth century, made at Jiangning
(present-day Nanjing)

Bamboo-veneered wood with gold-
lacquered interior, height 9.9 cm

The Palace Museum, Beijing, Gu121322

290 ↑

**Diaper-shaped box decorated
with the emblems of the
Eight Immortals**

Eighteenth century, made at the
Qing court

Bamboo veneer inlaid with mother-of-
pearl, jade and stained ivory,
6.5 × 24.2 × 15.9 cm

The Palace Museum, Beijing, Xin136436

289 ←

**Octagonal box decorated with
a gourd-shaped vase holding
auspicious plants (prunus, pine
and nandinia), fruit (grapes,
pomegranate and apples),
bowl with narcissus, goldfish
bowl and a stone chime (*qing*)**

Eighteenth century, made at Suzhou

Gilded lacquer inlaid with ivory, coral,
turquoise, crystal, jade, amber, mother-
of-pearl and other semi-precious stones,
12.5 × 39.2 × 39.2 cm

The Palace Museum, Beijing, Gu115381

291 ↓

**Carving of an immortal in
a raft**

Early Qing dynasty, seventeenth
century

Bamboo root, 15 × 26 × 13 cm

The Palace Museum, Beijing, Gu120208

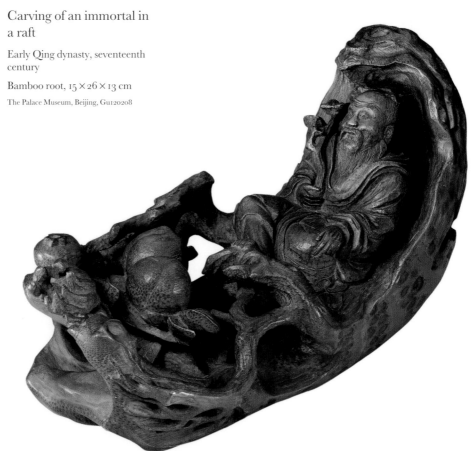

292 →

Peach-shaped brush washer glazed in imitation of Song dynasty 'official' (*guan*) ware

Yongzheng period, Jingdezhen, Jiangxi Province

Dark-stained porcelain with crackled celadon glaze, width 26.4 cm

The Palace Museum, Beijing, Gu151932

296 →

Peach-shaped lacquer box and cover with a branch and two peaches in relief, painted with fruiting and flowering peach branches, bamboo, longevity fungus (*lingzhi*) and five bats, containing nine cups in the form of peaches and one shaped like a peach blossom

Qianlong period, Palace Workshops, Beijing

Cinnabar lacquer on wood with colours and gilding, 17.5 × 53 cm

The Palace Museum, Beijing, Gu113491, 6

293 ↑

Teapot and cover in the form of a basket full of peaches

Kangxi period, Jingdezhen, Jiangxi Province

Porcelain with underglaze copper-red and cobalt-blue, height 12.8 cm

The Palace Museum, Beijing, Gu147356

295 ↑

Water pot for a writing table in the form of a peach branch bearing two fruit, painted with leaves and two bats

Yongzheng period, Palace Workshops, Beijing

Enamels on copper, 7.7 × 13.5 × 14 cm

Yongzheng four-character reign mark in black enamel on the base

The Palace Museum, Beijing, Gu116782

294 →

Peach-shaped box and cover carved with a 'long life' (*shou*) character among dragons and clouds

Qianlong period, 1790, commissioned by court officials for the Qianlong Emperor's eightieth birthday

Pieces of coral on gold, 19.5 × 23 × 20 cm

The Palace Museum, Beijing, Gu11647

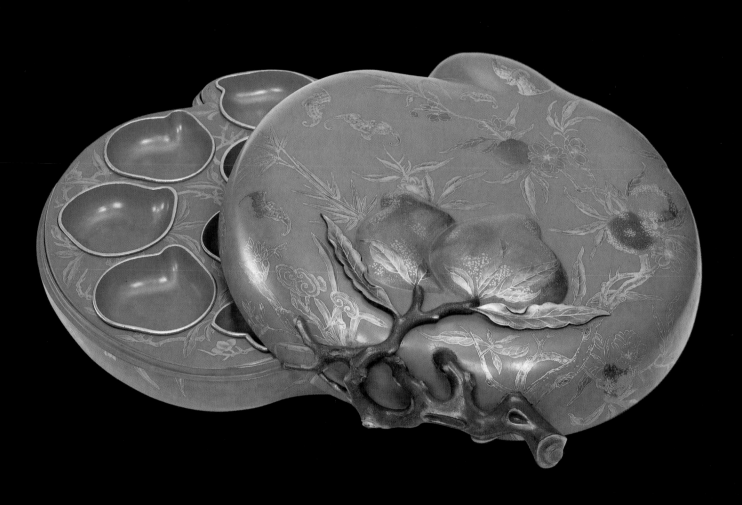

Tapestry with goats
and boys depicting 'the
auspicious beginning of
spring'

Qianlong period, made at Suzhou

Kesi 'cut silk' tapestry, 213 × 119 cm

Rhymed inscription in running
script (*xingshu*) by the Qianlong
Emperor

Eleven seals including *Guxi tianzi
zhi bao*, *You ri zizi*, *Shiqu baoji*, *Sanxi
tang jingjian xi*, *Jiaqing yu jian zhi bao*

The Palace Museum, Beijing, Gu72695

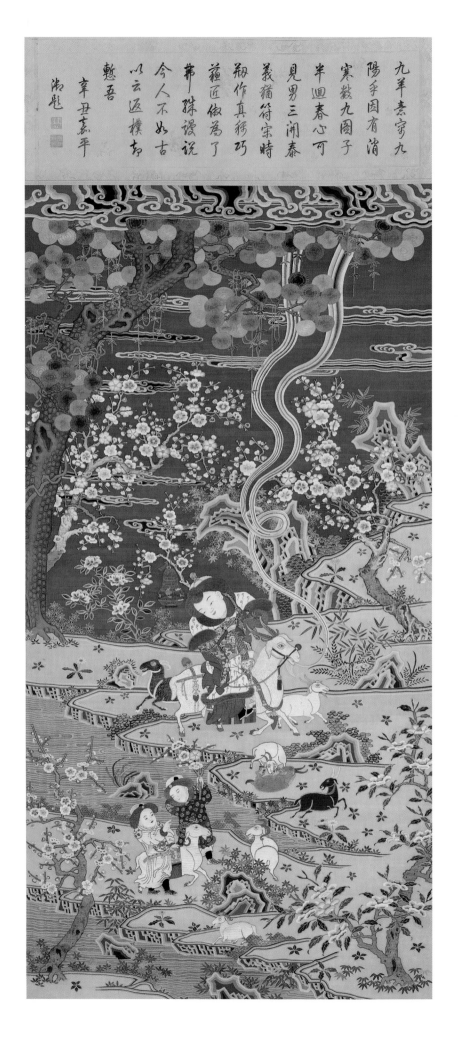

298 ↓

Carving of three goats
and a lychee branch

Mid-Qing dynasty

Jade with brown 'skin' markings
on *hongmu* (mahogany) base,
10.3 × 16.6 × 16.2 cm

The Palace Museum, Beijing, Gu103219

299 ↑

Carving depicting three goats
on a mountain

Qianlong period

Aventurine glass with fitted boxwood
stand, 21.6 × 13.6 × 24.8 cm

Qianlong four-character seal mark
engraved on the base

The Palace Museum, Beijing, Gu107221

300 →

Carving of two boys
washing an elephant

Eighteenth century

Greenish-white jade,
height 20.4 cm

The Palace Museum, Beijing, Gu90193

301 →

Vase decorated with
flower sprays and three
boys modelled in the
round

Qianlong period

Porcelain with *famille-rose* enamels,
height 21 cm

Qianlong six-character mark in
seal script written in underglaze
blue on the base

The Palace Museum, Beijing, Gu152323

302 ←

Blue-and-white jar with ten thousand 'long life' (*shou*) characters

Kangxi period, Jingdezhen, Jiangxi Province

Porcelain with underglaze cobalt-blue, height 77 cm

The Palace Museum, Beijing, Gu156997

303 →

Wall-hanging with auspicious emblems

Qianlong period

Embroidered silk, 250 × 360 cm

C. and C. Bruckner

304 →

One of a pair of incense burners

Qianlong period, second half of the eighteenth century

Cloisonné enamel, height 100 cm

British Museum, London, 1931.4-14.1

305

Summer robe for a woman

Qianlong period

Silk gauze with polychrome floss silk embroidery, trimmed with silk and metal thread brocade, length 135 cm

The Palace Museum, Beijing, Gu43307

306

Spring/autumn robe for a woman

Qianlong period

Silk with polychrome floss silk embroidery, length 134 cm

The Palace Museum, Beijing, Gu51176

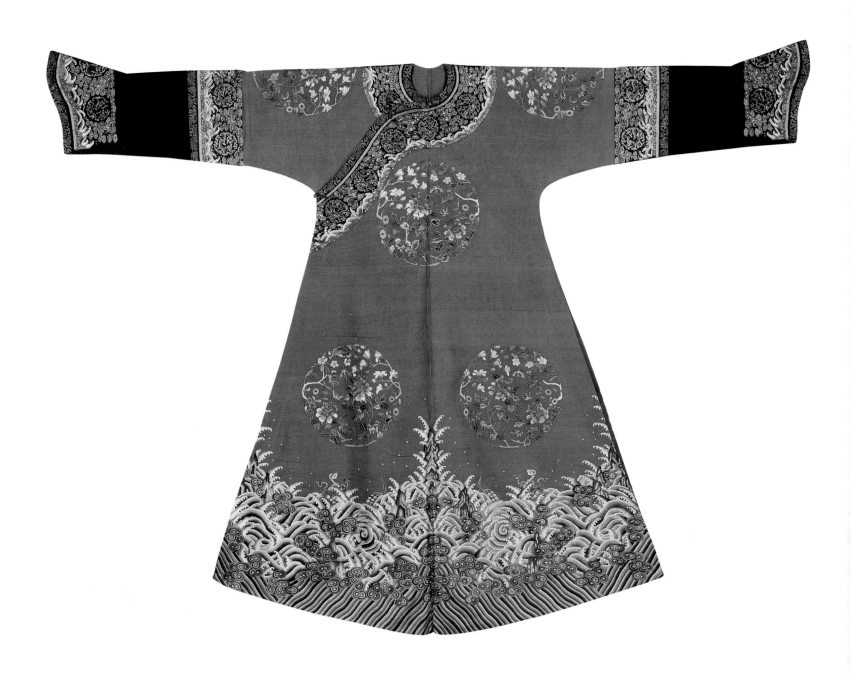

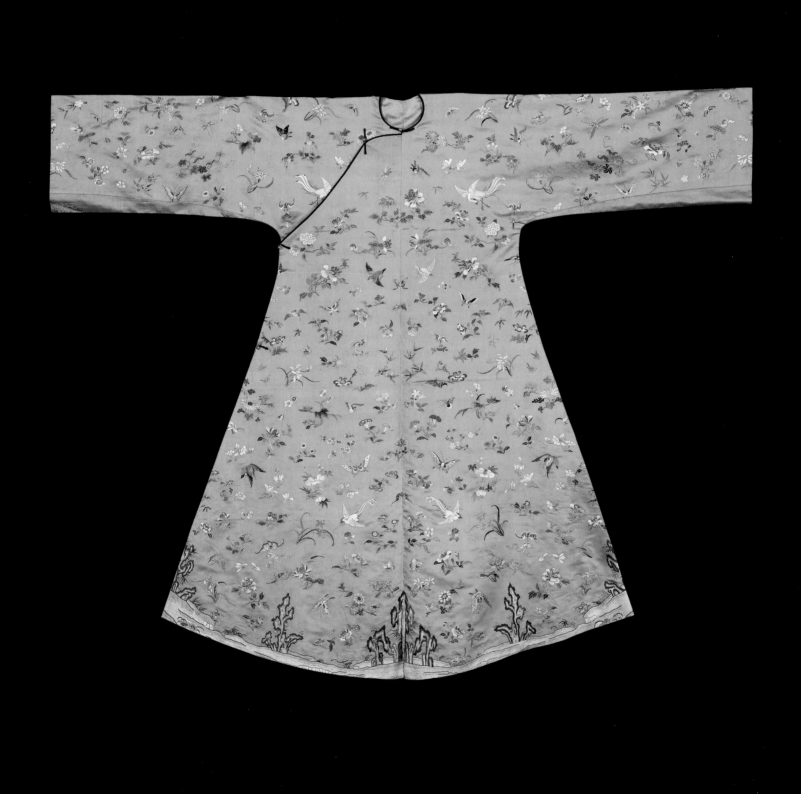

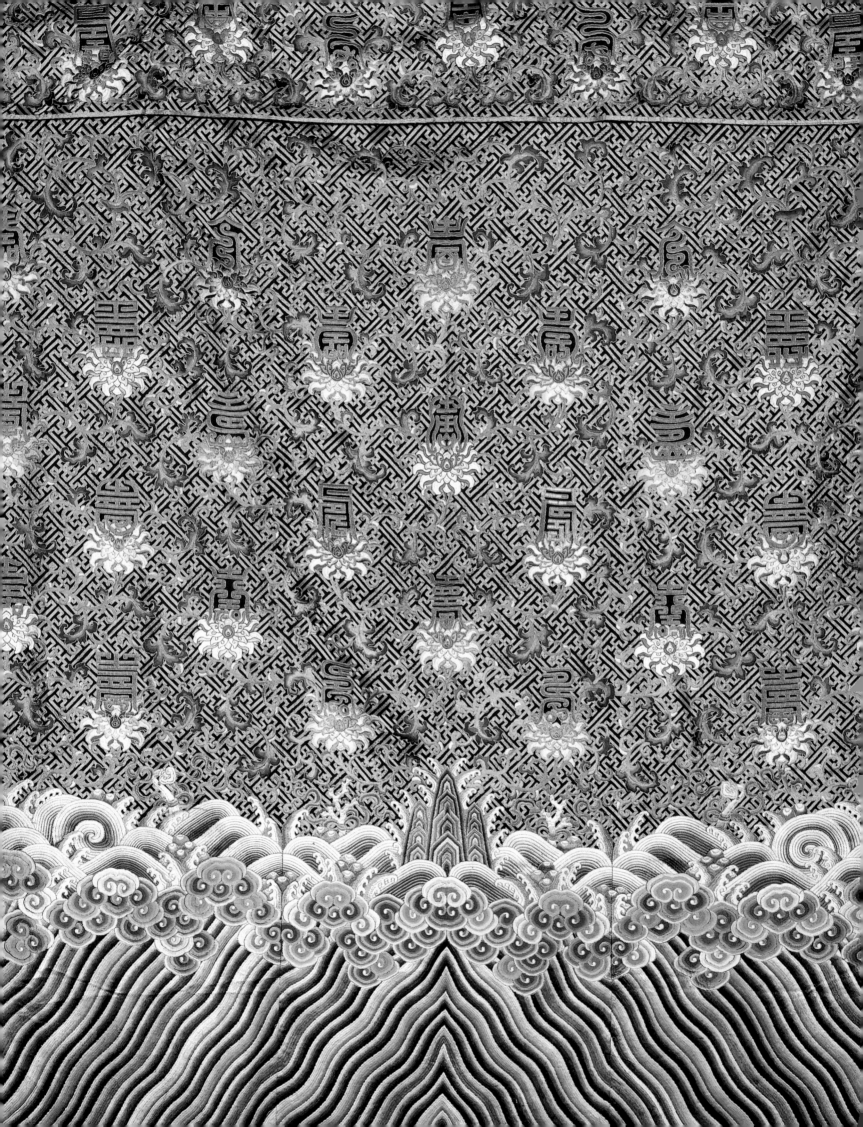

Catalogue Entries

Contributors

PB	Patricia Berger
RF	Rebecca Feng
FHZ	Fu Hongzhan
MKH	Maxwell C. Hearn
GHo	Gerald Holzwarth
HN	Hua Ning
GHu	Graham Hutt
HK	Hiromi Kinoshita
RK	Regina Krahl
LYX	Li Yanxia
SMcC	Shane McCausland
CJM	Carol Michaelson
AM	Alfreda Murck
NC	Nie Chongzheng
CP	Catherine Pagani
MPt'S	Michèle Pirazzoli-t'Serstevens
JVP	Jane Portal
ESR	Evelyn S. Rawski
JR	Jessica Rawson
HMS	Hsueh-man Shen
JS	Jan Stuart
JW-C	Joanna Waley-Cohen
WJX	Wen Jinxiang
VW	Verity Wilson
JY	Josh Yiu
YH	Yuan Hongqi

1

Anonymous court artists
*Portrait of the Kangxi Emperor
in Court Dress*

Late Kangxi period
Hanging scroll, colour on silk, 278.5 × 143 cm
The Palace Museum, Beijing, Gu6396
SELECT REFERENCES: Palace Museum 1992,
pl.15, p.53; Macau 1999, pl.5

The Kangxi Emperor died at
the age of 68. In this spectacular
portrait he is nearing the close of his
life; when compared to the fullness
of his young face (see cats 61 and
120), his cheeks are almost gaunt,
and the deep wrinkles around his
eyes and his wispy salt-and-pepper
beard further attest to his advanced
years. The Emperor's countenance
is impassive and dignified, the
required expression for all formal
imperial portraiture; but despite
the uniformity imposed by this code,
this likeness of the Kangxi Emperor
captures a distinctly personal
quality of gentlemanly, quiet
sagacity. Despite a strong family
resemblance, his sons invariably
seem slightly more vainglorious in
appearance (cats 2, 6). The Kangxi
Emperor's prominent cheekbones
were a true physiognomic feature,
but because the Chinese words for
them (*gao quan*) form a homonym
with the words 'elevated authority',
painters eagerly emphasised this
physical characteristic that accorded
with accepted signs of Heaven-
endowed pre-eminence.

In virtually all state portraits,
the Emperor wears a yellow *chaofu*
(court dress) and a formal hat
topped by a gold finial. Because
the giant, lustrous pearls of his
headgear were harvested from
waters in the Manchu homeland,
they were ranked as the highest
grade of precious gem; their use in
costume broadcast a subtle message
of Manchu ethnic superiority.

Although the flat plaque on the
front of the Kangxi Emperor's hat
features a Buddhist figure, thereby
announcing this important aspect of
his spiritual life, such large, formal
portraits as this were intended to
be hung near an altar dedicated to
Confucian rites. The ecumenical
complexity of the Qing Empire was
everywhere present at the court.

One more layer of pluralism is
present in the painting's style. The
introduction of Western perspective

into the depiction of the throne
demonstrates the court's interest in
the new pictorial traditions that had
been introduced by Western Jesuits,
but the portrayal of the Emperor's
body, which is relatively flat and
diagrammatic, hails from well-
ensconced Chinese traditions.
The treatment of the face is a
masterful combination of both
systems of painting. JS

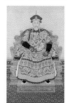

2

Anonymous court artists
*Portrait of the Yongzheng
Emperor in Court Dress*

Yongzheng period
Hanging scroll, colour on silk, 277 × 143.4 cm
The Palace Museum, Beijing, Gu6431
SELECT REFERENCES: Palace Museum 1992,
pl.39, p.93; Macau 1999, pl.10

This likeness of the Yongzheng
Emperor shares many features with
*Portrait of the Kangxi Emperor in Court
Dress* (cat.1). Both emperors wear
a similar yellow *chaofu* (court dress)
and identical headgear, and sit on
matching cushions and thrones
placed on nearly indistinguishable
rugs. The paintings' close
resemblance indicates that they
belong to a set intended to be hung
together on ritual occasions. At least
three other portraits, which portray
the three rulers preceding the
Kangxi Emperor, belong to the
same group. Those earlier rulers'
images must have been created
posthumously, perhaps at the same
time as this portrait of the
Yongzheng Emperor.

The practice of depicting the
same props in ancestor portraits of
successive family generations was
common in pre-Qing China. No
doubt the palace artists followed this
convention for the same reason as
other artists: to emphasise family
resemblance and unity by a
coherent visual scheme. Portrait
series were often created by
repeated use of a single stencil that
might be used to outline identical
chairs or even the bodies of the
figures in order to guarantee
uniform sizes and proportions in the
set. In the case of grand imperial
portraits, stencils may have been
used in a minor way, but most of the
details would have been executed
freehand.

The face of the Yongzheng
Emperor was painted with exquisite
fidelity and, according to typical
practice, was rendered by the best

artist in the workshop, a specialist in
faces. Typically the face was the last
detail completed in a Chinese
portrait, but some imperial
commissions called for the visage to
be finished first and approved before
the remaining details were executed.

During the Yongzheng Emperor's
brief thirteen-year reign, he
commissioned an exceptionally large
number of informal portraits (see
cat.167). This makes it possible to
gauge his maturity here, probably
close to his death at the age of 57.
When younger, he was thinner; but
the long, downward-sweeping
moustache, the small mole and tuft
of hair on his chin, and the high
forehead were distinguishing
physical traits throughout his life.

Unlike the many playful portraits
of the Yongzheng Emperor made
for other viewing contexts, this state
image presents him as an icon,
rather than a personable man. Yet,
our knowledge that history suspects
him of having surreptitiously altered
his father's will to be named his heir
creates the temptation to read a
degree of smug self-satisfaction in
his countenance. JS

3

Emperor's yellow court robe (*chaofu*)

Kangxi period
Patterned silk gauze with areas of brocaded
metal thread, length 145 cm; collar
embroidered with silk and metal thread and
trimmed with silk and metal brocade
The Palace Museum, Beijing, Gu41898
SELECT REFERENCES: Chen Juanjuan 1984;
Wilson 1986, pp.29–36; Rawski 1998, pp.17,
39–43; Zhang Qiong 2004

The Kangxi Emperor wore this
robe for one of the many ritual
observances that punctuated palace
life in the Forbidden City (Zijin
cheng). Its tailoring marks it out as
a *chaofu*, a 'court robe' or 'audience
robe'. Courtiers who attended
the Emperor or were required
to present themselves at imperial
audiences also wore robes in this
style, although the yellow colouring
of the Emperor's garment set him
apart. A specific shade, known
as *minghuang* ('bright yellow'), was
reserved for the ruler and, during
the Kangxi period, his empress
as well. The Emperor's essential
accessories – hat, belt, necklace,
boots and collar – were also
obvious imperial indicators.

The *chaofu* is a side-fastening
garment, buttoning along the right
collarbone and down under the

arm. The patterned silk trimmings and the bands of gold applied all around the robe's borders are a decorative solution to the finishing of the edges. The pleated skirt section has what appears to be a square pocket suspended from the waistband, although this seems to serve no useful purpose as it is merely a flap of material. It is neither found on other Qing garment types nor on the full-skirted robes of previous dynasties, the possible predecessors of these *chaofu*. The Manchu introduced curved cuffs, known as *matixiu* ('horse-hoof cuffs'), into China although their shape does not seem to have a long history prior to the conquest. Constantly anxious about their loss of identity, the Manchu emperors used such sartorial signs to bolster their distinctiveness. vw

4

Emperor's winter court hat

Qianlong period
Sable, freshwater pearls mounted on gilt bronze, gold, red silk floss, height 39 cm
The Palace Museum, Beijing, Gu59739
SELECT REFERENCE: Garrett 1994, pp.42–44

Distinctive headgear has the capacity to locate a moving person at a crowded parade or ceremony. The Qing emperors donned hats as a vital component of their ceremonial regalia and, like their Ming forebears, used such accessories to make status distinctions. Today the niceties of these distinctions are not always discernible. Surviving imperial attire does not uniformly match the descriptions in the Qing written rules. We can be sure, however, that hats such as this example made apparent the presence of the Emperor.

This hat was for winter wear, as its brim of sable fur indicates. This soft and valuable trimming, made from the pelt of a weasel-like mammal living along the Sino-Siberian frontier in the north, was a sought-after commodity; one that, at times, was enmeshed in intense border rivalry between China and Russia. Sable, which varies in colour, was also applied to some of the emperors' silk robes.

Massed strands of glossy red-floss silk form the hat's crown. From this rises a tall golden finial. This element, which the regulations

stipulate should have first-grade freshwater pearls and a requisite number of dragons, particularly seems to denote that the hat belonged to the Emperor. In use, the red silk strands, and to some extent the fur, would have ruffled with any breath of air, while the gilded and pearlescent pinnacle caught the light as the costumed Emperor performed the solemn rites. vw

5

Emperor's yellow dragon robe (*longpao*)

Qianlong period
Silk with polychrome floss silk embroidery, trimmed with silk and metal thread brocade, length 143 cm
The Palace Museum, Beijing, Gu41993
SELECT REFERENCES: Cammann 1952, pp.50–57; Wilson 1986, pp.12–18, 36–37; Washington 2001, p.135; Edinburgh 2002, p.45

During the Qing dynasty, large numbers of male state officials wore this style of garment. Several different names in Chinese, variously translated into English, are used to describe it. One of these, *longpao* (dragon robe), best characterises its design, although the cut is also an important element. The straight-seamed, tapering shape, the narrow sleeves ending in protective curved cuffs and the closure secured with spherical buttons pushed through silk loops, are all perceived as Manchu characteristics, Han Chinese styles being generally more voluminous. As can be seen in paintings of palace life, three-quarter-length, dark-coloured coats were sometimes teamed with dragon robes; in such combinations only their cuffs and hems would have been visible. We know that this particular dragon robe was reserved for imperial use because it is a special bright yellow (*minghuang*) and it incorporates twelve small motifs – emblematic of the supreme authority of the ruler – dispersed among the dragon and cloud design. Although these twelve devices have earlier precedents, the Qianlong Emperor was the first sovereign to use them in this form. On the front, hovering above the foaming waters, are a pair of cups and a square of green waterweed. Above waist level, at either side of the front-facing dragon, are an axe head and a *fu* (good fortune) symbol. Above this dragon a star

constellation consisting of three circles can be seen. Curling over the shoulders of the garment, at either side, are the red sun and white moon. Mountains, a small dragon, a pheasant, grain and fire adorn the back. vw

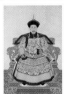

6

Anonymous court artists
Portrait of the Qianlong Emperor in Court Dress

Qianlong period
Hanging scroll, colour on silk, 205.5 × 133.5 cm
The Palace Museum, Beijing, Gu6465
SELECT REFERENCE: Paris 1997, pl.26, p.159

Resplendent in a winter-season, yellow silk *chaofu* (court dress) and seated upon a golden dragon-throne, the Qianlong Emperor is presented *en face* and in a manner appropriate for an ancestral or formal state portrait. Yet, because he commissioned so many images of himself at different ages throughout his sixty-year reign that follow this formula, it is difficult to imagine that all the portraits were actually intended for ritual display; but if they were not, their exact use is unknown. The Qianlong Emperor was aware of the power of portraits and devoted thought to their display, including once drafting instructions for his heir about how he wanted his portrait hung in the family ancestral temple. He said his likeness should be installed in the centre between an image of his grandfather, the Kangxi Emperor, on the right, and one of his father, the Yongzheng Emperor, on the left. While this directive was presumably intended to apply to a portrait of the Qianlong Emperor as an old man, not to this image of him in the late years of middle age, it sheds light on the palace practice of hanging imperial portraits in sets that document family and dynastic lineage, rather than treating them as independent, one-off works of art.

Despite the standardised composition of this portrait, its pronounced degree of Western influence is an innovation of the Qianlong court. The Qianlong Emperor's preference for a portrait style that incorporated foreign elements is evident in several features, including the drawing of the throne, following rules of European perspective, and its volumetric form, created by use

of highlights and shadows. The modelling of the Emperor's body with its substantial corporeality also reflects the degree to which painting techniques imparted by Jesuit court artists were assimilated into the imperial workshop. Even in small details, such as the detachable collar worn by the Emperor, a new approach to painting with light and shade is evident. This collar reads as a heavy silk garment that naturalistically rests on the Emperor's solid shoulders, but in imperial portraits from earlier reigns, his body typically reads as a two-dimensional form and the costume accessory of the collar is as flat as the cut-out clothing worn by paper dolls (see cats 1–2). JS

7

Blue court coat (chaogua) for an empress

Yongzheng period

Silk with metal thread and polychrome floss silk embroidery, trimmed with silk and metal thread brocade, red silk lining, length 140 cm

The Palace Museum, Beijing, Gu43484

SELECT REFERENCES: Garrett 1994, p.59; Washington 2001, pp.135–37, 160; Chicago 2004, pp.66–73; Zhang Qiong 2004

This sleeveless coat was the outermost garment of the formal court ensemble worn by the empress. It has deep armholes to accommodate the flaring shoulder sections of the robe beneath. Its dragon pattern with 'striped-water' hem repeats the design on the under-robe, although the dragons on the coat are placed differently and writhe sinuously up either side of the front. The coat fastens down the centre; the spherical buttons would have provided a fixing for silk braids hung with jewels and a long silk kerchief, in the shape of a pointed pennant, denoting rank. Three ceremonial strings of beads and a wide collar, like a short cape, were also part of the costume, as were a hat, headband, torque and earrings, all pearl-encrusted. The swish of the silk and the jangle of precious stones must have contributed to the splendour of the outfit's total effect. VW

8

Yellow court robe (chaofu) for an empress

Yongzheng period

Ribbed silk with floss silk and metal thread, brocade trimming around the edges; patterned blue silk gauze lining; cuffs lined with silk satin; shoulder wings lined with metal thread brocade, length 140 cm. Collar: embroidered with silk and metal thread and trimmed with silk and metal brocade

The Palace Museum, Beijing, Gu41902

SELECT REFERENCES: Wilson 1986, pp.40–41; Chicago 2004, pp.66–73, 180; Zhang Qiong 2004

Although women of the court were not present at every imperial ceremony, high-ranking ladies did attend some state rites and all family commemorations. Like the Emperor, imperial women wore specially designated clothes on these formal occasions. This court robe has raised blue shoulder seams repeating the shape and decorative styling of the blue cuffs. The sumptuous red and gold silk lining of these epaulettes matches that on the detachable collar and would have been glimpsed only occasionally. A profusion of accessories was layered over the full-length, yellow court robe. A hat with a tall finial added height to the outfit. High-soled shoes, which may have been worn with this robe, had the same effect. The act of getting dressed for such observances was itself a ritual, taking up a considerable amount of time. It transformed the wearer into a lofty being. VW

9

Pair of free-standing dragons emerging from waves among clouds, with flaming pearls rising from rocks

Qianlong period

Gilt bronze and cloisonné enamel on wooden stands, height 94 cm

Xing Shuan Lin Collection

The five-clawed dragon – emblem of the Chinese Emperor – was a ubiquitous motif in Qing art and architecture and could be seen throughout the Forbidden City: on roofs and stone steps, ceilings and pillars, thrones and furniture, silk coverings and carpets, as well as on robes and utensils. Representing imperial power, this lively pair would have been an impressive symbolic reminder to any palace visitor of the Emperor's might, vigour and strength.

As highly potent beasts, dragons, said to have features of nine different creatures, carried multiple auspicious associations. Usually represented in connection with water and clouds, dragons were believed to have the power to induce rain and were therefore revered as guardians of life-giving water supplies and protectors against destructive fires. Rainbow-coloured clouds signify virtuous behaviour. Dragons are often shown chasing flaming pearls, a motif probably derived from the Buddhist wish-granting jewel.

Purely sculptural, non-functional dragon figures such as this pair are extremely rare; cloisonné items as ambitious as these were rarely attempted, even in the Palace Workshops (Zaoban chu). RK

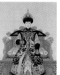

10

Anonymous court artists
Portrait of the Xiaosheng Empress Dowager

Qianlong period, 1751

Hanging scroll, colour on silk, 230.5 × 141.3 cm

The Palace Museum, Beijing, Gu6452

SELECT REFERENCES: Paris 1997, pl.23, p.154; Rawski 1998, p.273; Macau 1999, pl.11

This portrait presents the Xiaosheng Empress Dowager (1691–1771), the mother of the Qianlong Emperor, on her sixtieth birthday, a major celebration in China that signalled a person's entrance into a new phase of life (the traditional calendar was based on a repeating sixty-year cycle). The Qianlong Emperor honoured his mother with a full-scale imperial celebration which included *sutra* recitations at the Extended Long-life Temple (Yanshou si), an elaborate building that had been specially constructed at the Summer Palace for the occasion. Priests chanted wishes for her longevity and lavish gifts were presented, including a set of nine Buddhist images from the Emperor. Such elaborate festivities were consistent with the Emperor's personal devotion to his mother and his belief that the Imperial Mother, the *de facto* leader of all the palace women, was of greater importance to the State than the Imperial Wife and should therefore receive special commemoration.

This grand likeness follows the rigid codes – such as full frontality and elaborate dress – that were employed in all formal imperial portraits, including images made for ancestor worship. The Xiaosheng Empress Dowager is attired in full winter regalia, including a fur-

trimmed crown decorated with five pearl-studded golden phoenixes, an ornament restricted to women of exalted rank. Her three earrings signify Manchu ethnicity.

Although contact between women and unrelated men, including court painters, was rare, the extreme fidelity of the Empress Dowager's visage suggests that the Qianlong Emperor may have permitted a trusted artist to see her in person before completing the commission. The verisimilitude is convincing, down to the slight puffiness and sag of the Empress Dowager's facial features that are appropriate for her age. Her sharp, clear eyes correspond with recorded testimony about the Empress Dowager's exceptional lifelong health.

White dots on the pupils of her eyes indicating reflected light – a device also seen on the round beads of her court necklaces – are one of several indications that the artists who collaborated on this portrait possessed a solid proficiency in Western painting, and may have collaborated with Europeans to execute the face. It is likely that, in order to enhance their jewel-like intensity, some pigments were applied to the back of the silk to increase the richness of the colours applied to the front. No expense was spared in creating this portrait, which became a model for the almost identical image of a slightly more aged-looking Empress Dowager that was created on her eightieth birthday. JS

2 Qing Dynasty Court Painting

II

Xu Yang (fl. *c.* 1750–after 1776)
A Scene Described in the Qianlong Emperor's Poem 'Bird's-Eye View of the Capital'

1767
Hanging scroll, colour on silk,
255 × 233.8 cm
Twenty poems by the Qianlong Emperor on the theme of the coming of spring are transcribed onto the painting
The Palace Museum, Beijing, Xin146672
SELECT REFERENCES: Nie Chongzheng 1992, pl.106; Nie Chongzheng 1996, pl.65; Nie Chongzheng 1999B, pp.135–38; Macau 1999, pl.36; Chung 2004, pp.94–95

In 1751, during the Qianlong Emperor's first southern inspection

tour, Xu Yang, who was then a student at the imperial university, took the opportunity of the Emperor's visit to Suzhou, his native town, to present his paintings. The Qianlong Emperor admired them and summoned Xu Yang to Beijing to work at the Imperial Painting Academy. Xu Yang worked at the imperial palace from 1751 to 1776, specialising in extensive panoramas and topographical views. In 1766, he joined the Grand Secretariat as secretary, although he continued in his career as court painter.

This scene is a masterpiece of *jiehua*, or architectural painting, which reached its apogee during the Qianlong Emperor's reign. Illustrating one of the Emperor's poems, the painter depicted Beijing under snow at the lunar New Year. In a bird's-eye view that shows the liveliest part of the city, the painting shows Beijing on a north–south axis. In the foreground is the commercial district of the outer city, south of the Gate of the Mid-day Sun (Zhengyang men, now known as the Front Gate, or Qian men). The view stretches out northwards, with the series of spaces closed by walls and gates which mark this central axis: Zhengyang men and the southern part of the imperial city reserved for government offices, then the Gate of Heavenly Peace (Tian'an men), the Gate of Rectitude (Duan men), the Meridian Gate (Wu men), and the Forbidden City (Zijin cheng) flanked by the eastern and western quarters of the imperial city. Lastly, to the north, is Coal Hill (Mei shan). Emerging from the clouds in the right foreground, in a symbolic rather than realistic position, are the roofs of the Temple of Heaven (Qinian dian) and in the upper part on the left, is the white Dagoba on the northern lake of what is now North Sea Park (Beihai gongyuan). In this view, Xu Yang uses both traditional axonometric perspective, with an all-encompassing viewpoint high above the city, and European linear perspective. The latter is convincingly handled in the central part of the painting, particularly in the vanishing lines and the illusion of depth. Beijing, with its interlocking areas, exactly matches the 'ultimate geometric place' that Saint-John Perse described in a letter to André Gide of 10 May 1921.[1] In the importance given to the Chinese city in the foreground, this image of the capital also seems

like an idealised representation of a pacified and prosperous empire. MPt's

12

Anonymous court artists
Pearls of Chinese and Foreign Combination and *All Foreign Lands Paying Tributes to the Court* from *Album of Grand Celebration Paintings*

Second half of the eighteenth century
Two from a set of eight leaves, colour on silk, each 97.5 × 161.2 cm
INSCRIPTION: the title inscribed by the Qianlong Emperor on each leaf
SEALS: one seal of the Qianlong Emperor on each leaf
The Palace Museum, Beijing, Gu9198, 1–2/8
SELECT REFERENCES: Macau 1999, pl.38; Edinburgh 2002, no.24

The Kangxi, Yongzheng and Qianlong Emperors devoted much of their time to rituals and ceremonies, to which they attached great importance. As these celebrations extolled the Emperor's role and legitimacy to rule, signalled his generosity, and glorified the unity and cohesion of the empire, they were an instrument of propaganda and a tool of government. Thus, at the imperial court, the year was punctuated by ceremonies, including New Year festivities, celebrations of the birthdays of members of the imperial family, and seasonal rituals, as well as by the Emperor's travels and the diplomatic banquets that were accompanied by entertainments. Recording these celebrations was one of the most important tasks of artists of the Imperial Painting Academy, especially during the reign of the Qianlong Emperor. According to an ancient tradition of courtly painting in China, these paintings were usually executed by several artists working in collaboration, and were either signed by one or more of the chief painters, or not signed at all. From 1766, such paintings were rarely signed.

Pearls of Chinese and Foreign Combination shows the leaders of conquered peoples and the imperial officials who were posted to these outlying regions waiting to pay homage to the Emperor. *All Foreign Lands Paying Tributes to the Court* depicts envoys from foreign lands and vassal states coming to the imperial court for the New Year celebrations. In the foreground,

bearers with their gifts of precious or exotic objects and live animals are gathered outside the Gate of Supreme Harmony (Taihe men). Princes and high officials wait inside the gate, in the court in front of the Taihe dian, in which the Emperor will appear.

The theme of vassals and foreign peoples pledging their allegiance to the Emperor – a *mise en scène* for imperial power and for the affirmation of the Qing empire as a multicultural society – was enormously popular in the reign of the Qianlong Emperor. Accordingly, there are many paintings on this theme, both in the form of hanging scrolls and handscrolls, and as 'multiple' paintings in the form of albums. These were intended to be presented as gifts and thus to be disseminated.

Two types of perspective are used in these paintings. While there are elements of linear perspective (such as, for example, the vanishing points and the illusion of depth of the terraces and some of the buildings in *Pearls of Chinese and Foreign Combination*), the artist has made greater use of axonometric perspective: the viewer looks down on the scene from a height and the mist conceals the misalignment of the vanishing points in the distance. This is a common device in Chinese architectural painting. MPU'S

13

Wang Hui (1632–1717) and assistants
The Kangxi Emperor's Southern Inspection Tour, Scroll Eleven: Nanjing to Jinshan

1691–98

Handscroll, colour on silk, 67.8 × 2612 cm
The Palace Museum, Beijing, Gu9208
SELECT REFERENCES: Yang Xin 1981; Yang Xin 1981B; Hearn 1990, pp.108–13; Nie Chongzheng 1996, pp.40–51; Macau 1999, no.7

To consolidate Manchu authority over China, the Kangxi Emperor made a grand tour to the south in 1689. He later commissioned Wang Hui, the leading scholar-artist of the day, to record this momentous event. Breaking down the journey into episodes, the artist designed a series of twelve massive handscrolls, first creating full-scale drafts on paper and then the finished set on silk, leaving most of the routine work to his assistants. This scroll, the eleventh in the set, shows the route of the Emperor and his

entourage from the city of Nanjing – the former 'Southern Capital' of the Ming dynasty – along the Yangzi River to the island of Jinshan, a distance of about 85 kilometers that the Emperor covered between 21 and 22 March 1689.

The scroll highlights Nanjing's strategic importance and the value of maintaining a powerful naval force, facts that the Kangxi Emperor would have understood from two recent events: the naval attack on Nanjing by the rebel Zheng Chenggong (1624–1662) in 1659 and the key role of warships and supply boats built there for the defeat of the Three Feudatories rebellion (1673–83).[1] During this leg of his tour, the Emperor abandoned the relative safety of travelling by horseback or canal barge and braved the elements aboard a sailing ship. According to one account of the voyage, the wind and waves were so frightening that some members of the entourage put in to shore and followed the land route to Guazhou.[2] But Wang Hui's painting shows the Emperor calmly seated on deck, while the preface to the scroll waxes poetic in its description of the favourable winds that carried the Emperor downstream:

The eleventh scroll respectfully depicts his majesty setting forth from the Western Water Gate of Jiangning [Nanjing], passing Stone Citadel and travelling through the dense forests and beautiful scenery from Guanyin Gate to Swallow Cliff. Sailing down the Yangzi, the ornate banners shone across the river and mountains; the brilliance of the retinue outshone the sun and clouds. At the time, the spirit of the river proffered a favourable wind so the storied vessels and painted warships sailed smoothly downstream. In the middle of the silvery billows and jade-green waves the sails were hoisted and the rudders steadied allowing the boats to take off as if flying. The splendour of the naval forces may be seen by unrolling the scroll. After passing Yizhen [presently known as Yizheng] one can see Jinshan with the sand and water going round and round and the fishing boats coming and going. All of this made a pleasant scene and so has been put forth here in outline form on silk.[3]

Wang Hui organised the painting into three sections: cityscape, mountainscape and riverscape. The first section surveys the western perimeter of Nanjing. It features the 'porcelain pagoda' of the Proclaiming Grace Temple (Bao'en si), the Western Water and Land Gates, and the wall-topped natural rock fortress known as Stone Citadel (Shi cheng). Several large boats anchored along the stream between the Western Water and Land Gates suggest that it was here that the

Kangxi Emperor boarded a boat for this leg of his journey. Two new vessels under construction attest to Nanjing's importance as a ship-building centre and port. Beyond Stone Citadel a wide arc of shoreline forms an inviting harbour for the numerous ships that have come to anchor. This must represent Zhujiazui, where Kangxi stopped for the night of 21 March.[4] (This portion of the scroll is not illustrated.)

In the second section, the river disappears below the lower margin to make room for energised mountain forms rendered in vivid 'blue-and-green' pigments. A secluded cove filled with marsh grasses and water birds provides the serene setting for the Magnanimous Salvation Temple (Hongji si). Beyond the temple, Guanyin Gate – a strategic approach to the city – is guarded by the craggy promontory of Swallow Cliff (Yanzi ji).

The final and longest section is given over to the Yangzi River and the flotilla of ships escorting the Emperor downstream. Here, the roiling waves of the 'Great River' fill the entire height of the scroll. Across these turbulent waters sails the Emperor's fleet: not canal barges, but sailing ships with low bows, up-swept sterns and two masts. In the strong following wind the sails have been hoisted and some of the boats have pulled up their side-mounted leeboards, enabling them to plane across the water.

The Emperor's vessel, flying yellow pennants emblazoned with dragons, is positioned in the middle of the fleet (see detail on pp.88–89). The Emperor, seated ahead of the main mast, calmly strokes his beard, unruffled by the high winds and big waves. Accompanying him are members of the imperial bodyguard dressed in yellow tunics. Among them are bearers with the Emperor's sword, bow, quiver and parasol. Downstream from the flotilla, the walled city of Guazhou marks the northern mouth of the Grand Canal. The scroll draws to a close east of Guazhou with a view across the broad waters of the Yangzi. In the distance, the rocky island of Jinshan, the 'Golden Summit', appears as a final landmark in the midst of the vast river (not illustrated). The Kangxi Emperor spent the night of 22 March at Jinshan Temple before continuing northwards along the

Grand Canal. This dramatic finale, with Jinshan isolated in the middle of a limitless expanse of water, epitomises Wang Hui's manipulation of actual scenery to heighten the dramatic impact of his composition since, by this time, Jinshan stood fairly close to the southern shore to which it is now firmly attached. MKH

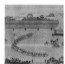

14

Xu Yang (fl. *c.*1750–after 1776) and assistants
The Qianlong Emperor's Southern Inspection Tour, Scroll Twelve: Return to the Palace

1764–70
Handscroll, colour on silk, 68.8 × 1029.4 cm
The Palace Museum, Beijing, Xin146673
SELECT REFERENCES: Hearn 1988; Nie Chongzheng 1996, pp.253–58

The Qianlong Emperor, emulating his grandfather the Kangxi Emperor, made six southern inspection tours during his long reign and also commissioned a pictorial record of one tour. In 1764 the Emperor enlisted the court artist Xu Yang to document his first southern tour of 1751. Following the precedent of the Kangxi set (see cat.13), Xu Yang divided the tour into twelve mammoth scrolls that together measure more than 150 metres in length. He completed the commission in 1770, in time for the Emperor's sixtieth birthday.

The twelfth scroll commemorates the Qianlong Emperor's ceremonial return to Beijing. Unlike the other scrolls in the series, which depict the imperial retinue progressing from right to left (the direction in which the scrolls unroll), the final scroll shows the Emperor moving in the opposite direction, symbolising his return journey. The scroll illustrates the final leg of the journey along the north–south axis of the city, from the Gate of Rectitude (Duan men) to the massive Meridian Gate (Wu men), the entrance to the Forbidden City (Zijin cheng). A ceremonial honour guard – including road-clearing elephants, state carriages and over 400 insignia-bearers carrying musical instruments, weapons, parasols, fans and pennants emblazoned with cosmic signs (imperial symbols of authority required for all formal royal progresses) – is arrayed within the long courtyard framed by these two gates (compare the similar array in cat.24). Court officials kneel behind the honour guard. The Emperor is shown riding in the state palanquin, escorted by a mounted detachment of the imperial bodyguard, dressed in yellow tunics (compare cat.25). The enclosed palanquin of the Empress Dowager, who accompanied the Emperor on the tour, is shown approaching the Gate of Rectitude. The uninterrupted lateral flow of the composition as well as the formality of the architectural setting all reinforce the ritualised character of the return ceremony.

Xu Yang's painting reveals the influence of European pictorial conventions introduced to the court by Jesuit missionaries. Unlike the Kangxi scrolls, which depict extensive segments of the tour route and which follow traditional schema for depicting landscape scenery, each of Xu Yang's scrolls is limited to a short section of the Emperor's journey that could be realistically represented as a unified panorama. Furthermore, Xu Yang's use of linear perspective and foreshortening and his anatomically accurate, theatrically posed figures show his familiarity with the work of Giuseppe Castiglione (Lang Shining, 1688–1766) and other European painters active at the Qianlong Emperor's court. Ironically, this approach had a stultifying effect. In contrast to the highly animated figures in the Kangxi scrolls, Xu Yang's figures appear stiff and his compositions static, not unlike many Rococo paintings, whose protagonists appear to be frozen in dramatic postures within stage-like tableaux.

The painting bears two inscriptions: a poem composed by the Qianlong Emperor and transcribed by the Grand Secretary Yu Minzhong (1714–1780) in the upper right corner of the scroll, and a flowery dedication at the end of the scroll by Xu Yang that attributes the inspiration for the twelve paintings in the set to the Emperor's poems. Seven imperial seals are impressed on the brocade border preceding the painting, further attesting to its imperial pedigree. MKH

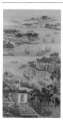

15

Anonymous court artists
Portraits of the Yongzheng Emperor Enjoying Himself throughout the Twelve Months: 1st, 4th, 5th, 8th, 9th and 12th lunar months

Yongzheng period
Six from a set of twelve hanging scrolls, colour on silk, each 187.5 × 102 cm
The Palace Museum, Beijing, Gu6441, 1, 4, 5, 8, 9, 12
SELECT REFERENCE: Nie Chongzheng 1996, pls 20.1–12, pp.126–39

These six selections from a set of twelve depictions of lunar-month festivities are complex interweavings of fact and fantasy. The Yongzheng Emperor repeatedly commissioned images of himself as an idealised Chinese scholar and he followed that practice here, appearing in all the paintings wearing Chinese dress while participating in Chinese annual customs.

The Fourth Lunar Month offers a lucid example of the pictorial programme. Here, the Emperor had himself portrayed in flowing robes playing the zither (*qin*), while below him gentlemen assemble for a poetry contest and take turns drinking wine from floating cups on the nearby stream. This activity re-enacts the Orchid Pavilion Gathering of AD 353 when a convocation of China's most famous literati enjoyed themselves in this manner. The Qing Emperor's delight in such a quintessentially Chinese celebration, as well as his fluency performing on the *qin*, the *sine qua non* of a morally cultivated, erudite Chinese literatus, signifies thorough assimilation of the Chinese tradition. The large number of court images that depict the Emperor happily assuming a Chinese persona may represent a level of true imperial relish in Chinese cultural activities, but it is just as likely that they also state his mastery over the conquered culture. The visual record deserves a careful reading to see if it contains information about the Emperor's private thoughts and views of rulership that are not found in mainstream historical documents.

A paradox of these and many paintings from the Yongzheng Emperor's reign is that despite their meticulous, realistic drawing, their basic premise is often a flight of imperial imagination and an exercise in self-fashioning with little tie to reality. Despite this, or perhaps specifically in order to impose an aura of believability on

the paintings, the monarch encouraged his artists to document the real environment faithfully, including its minutiae. Thus the settings of the lunar-month scrolls, each of which depicts a courtyard in the Yongzheng Emperor's private residence in the Yuanming yuan (Garden of Perfect Brightness, site of the imperial Summer Palace), are rich with evidence of eighteenth-century material culture.

To judge from their density and elaboration in the paintings, the buildings should postdate the Yongzheng Emperor's 1725 expansion of the property. One scroll offers new information about the introduction of Western architecture into the Yuanming yuan. The Western-style archway in *The Twelfth Lunar Month* reveals an early experiment with foreign architecture before the Qianlong Emperor's European building campaign there. In a later painting showing the same courtyard, but dating to the Qianlong reign, the same archway is reproduced, but now with the building behind also sheathed in a Western-style stone façade.

Many of the paintings are intriguing mixtures of fact and fiction. In *The First Lunar Month*, the New Year's Lantern Festival is depicted. The Emperor-as-scholar stands in a doorway marked by a temporary *huabiao* – a cloud-and-dragon-decorated pillar indicative of imperial precincts – to watch his sons explode a firecracker. In another area of the painting, men observe tall, dancing sprays of water. This detail must be a reference to the far-away Hangzhou tidal bore observed annually during the first and eighth lunar months; surely the man-made pond in the Yuanming yuan could not have produced such geysers. But in the medium of painting, it was easy to turn the imperial garden into a simulacrum of all China, with the Yongzheng Emperor presiding as the grand master of ceremonies.

Some ancillary figures in the paintings corroborate the paintings' basis in fantasy, or possibly theatre, drawing on the later example of the Qianlong Emperor, who is known to have ordered eunuchs to dress like people from different social milieus and enact street scenes in the garden to amuse him. But whether mind-images or actors, some of these characters fulfil specific stereotypes.

In *The Fifth Lunar Month* the Emperor watches the annual Dragon Boat regatta from a terrace surrounded by the women of his household (who, like the children in all the images, wear Chinese dress). The boats seem believable, but the white-bearded Daoist sage, accompanied by a boy with a giant calabash – a container of magic elixirs – seems to have stepped out of some literary tale. *The Eighth Lunar Month*, dedicated to the moon festival, seems more evenly grounded in reality.

But in *The Ninth Lunar Month* the element of fantasy is again important. In the background, a traditional celebration of Double Nine is represented by a group of scholars who have ascended a mountain precipice from whose vantage point they can metaphorically look back on the long past. In the foreground, the imagery is more complex. The Yongzheng Emperor sits behind a moon window in a pavilion that is bordered at one side by a chrysanthemum-lined fence. Sailing towards him is a tall figure holding a chrysanthemum-entwined staff and with the distinct demeanour of China's luminary poet, Tao Qian (also known as Tao Yuanming, 365–427). In this light, the flower-lined boundary recalls a poem by Tao in which he extols rustic living and describes picking chrysanthemums by his cottage's eastern fence (see cat.241). The court painter has artfully suggested a conflation of identity between the Emperor and the hero of Chinese culture, Tao Qian.

Whatever the Yongzheng Emperor ultimately thought of this set of lunar-month paintings, they had a lasting legacy. His son the Qianlong Emperor used each of the twelve paintings as close models for his own set of annual festival scrolls (in the collection of the National Palace Museum, Taipei). The later images do not include the Yongzheng Emperor's visage but are otherwise almost identical except for slight modifications of the architecture and landscape settings. All too often historians champion the artistic accomplishments of the Qianlong court without recognising the importance of the Yongzheng Emperor as an art patron *par excellence* and an imaginative ruler ready to make art serve his ideological goals. JS

16

Attributed to Giuseppe Castiglione (Chinese name Lang Shining, 1688–1766)
The Qianlong Emperor and the Royal Children on New Year's Eve

1736–37
Hanging scroll, ink and colour on silk, 275 × 160.2 cm
SEALS: three seals of the Qianlong Emperor (1784, 1790 and 1796)
The Palace Museum, Beijing, Gu6506
SELECT REFERENCES: Wan Yi, Wang Shuqing and Lu Yanzhen 1985, fig.365; Edinburgh 2002, no.35; Chicago 2004, fig.232

In a snow-covered courtyard framed by an ancient pine, a blossoming plum tree and bamboo, the Qianlong Emperor is shown enjoying New Year's Eve in the company of the royal children and two ladies. Nine boys set off firecrackers, scattering seed-heads of sesame and carrying auspicious symbols, such as a bowl of fruit and a lantern in the shape of a fish. The Emperor himself knocks at a jade chime hanging from a halberd held by one of the boys, a rebus for good fortune. In subject-matter and composition this monumental scroll belongs to the category of traditional New Year's painting. Almost certainly executed by the Jesuit painter Giuseppe Castiglione, it is unique in displaying the naturalistic poses of the figures and the individual facial features of the Emperor's family members. Although this harmonious gathering of the imperial family may be fictional, the painting remains the most intimate portrait of the Qianlong Emperor known.

There are at least two similar paintings in the Palace Museum, all with nearly identical figural poses, but in a more traditional style; these works, of lesser quality, have a modified setting, and contain more children.[1] One of these examples, signed by Giuseppe Castiglione and five Chinese court painters, is dated 1738. In that year the Emperor had three sons, aged ten, eight and three.[2] The three boys who wear the same golden crown-like headgear as the Emperor must portray these. Of them, only Yonglian (1730–1738) was a son of the Empress Xiaoxian (1712–1748), the other two being children of minor consorts. In 1736 Yonglian had secretly been chosen as heir to the throne and it is most likely that it is he who is depicted in the most prominent position holding the halberd and a seal. His face is

painted slightly larger than that of any of the other children. Behind him stands Yonghuang (1728–1750), the Emperor's eldest son; Yongzhang (1735–1760) sits on his father's lap. The two ladies behind the Emperor may portray the Empress Xiaoxian and the mother of little Yongzhang, holding a fan. The mother of the eldest son had died in 1735. The other boys may be nephews or cousins of the Emperor. In the painting dated 1738 the eldest son is depicted significantly taller than Yonglian, and both appear more mature. This indicates that the present painting must have been made at some earlier moment, and may be a commemorative painting of New Year's Day 1737, with the hidden presentation of the newly chosen, though secret, heir.[3] Unfortunately Yonglian died in December 1738; the Qianlong Emperor refused to nominate another successor until 1773. GHo

17
Screen

Qianlong period
Zitan wood and red lacquer,
259 × 322 × 70 cm
The Palace Museum, Beijing, Xin178206

18
Throne

Qianlong period
Zitan wood and red lacquer,
105 × 139 × 99 cm
The Palace Museum, Beijing, Gu208789

19
Footstool

Qianlong period
Zitan wood and red lacquer,
14 × 77.5 × 30 cm
The Palace Museum, Beijing, Gu208955

20
Pair of cranes

Qianlong period
Cloisonné enamel, height 136.5 cm
The Palace Museum, Beijing, Gu117096,
Gu117097

21
Pair of censers

Qianlong period
Dark green jade on gilt-metal base,
height 35.9 cm
The Palace Museum, Beijing, Gu103379,
Gu103380

22
Pair of incense burners with gilt pagoda finials

Qianlong period
Green jade with gilt-bronze finials,
height 96 cm
The Palace Museum, Beijing, Gu93307,
Gu93308

23
Pair of charcoal stoves

Qianlong period
Cloisonné enamel, height 83 cm
The Palace Museum, Beijing, Gu117282,
Gu117283

SELECT REFERENCES for cats 17–23:
Tokyo 1985, cat. 21-10, p. 66; Paris 1997,
pp.163–65

This group reconstructs one of the throne rooms in the Forbidden City (Zijin cheng), in which the Qianlong Emperor would have taken his seat facing south. The placing of the throne and all its accompanying objects was carried out with strict adherence to geomantic principles. The throne assemblage would have been set on a platform with three or five steps leading up to it, and the throne room itself would have been in one of the many halls of the Forbidden City, opulently decorated and adorned with auspicious emblems.

Only the finest materials were used for the throne and its accessories. Rare woods such as *zitan* were carved and inset with red lacquered panels; the throne would have had yellow silk cushions on the seat. The lacquer panels are carved with a trio of dragons, symbols of the Emperor, the central one being full face. The flaming pearl is an emblem of the Emperor's power. Behind the throne is a screen, carved with three dragons among waves, placed there to shield him from draughts and to protect him from evil spirits coming from the North. In addition, from the perspective of his relatives, eunuchs and officials, the screen and its imagery set the Emperor within a cosmic framework.

The cloisonné enamel stoves, of a tripod shape based on ancient bronze vessels, would have burned charcoal to warm the room. The presence of cranes, be they in white cloisonné, as here, or in life in gardens and parks, was an assurance that the Empire was at harmony with cosmic forces. Moreover,

cranes were emblematic of longevity. They are intricately decorated with fine feathers edged in black and realistic green scales on the legs. They stand on hexagonal bases in the form of mountains of blue and green. In their mouths they hold magic *lingzhi*, fungi which were thought to convey immortality.

The incense burners would have produced an auspicious perfume. They are made of jade and carved with coiling dragons and flaming pearls amid *ruyi*-shaped clouds. Their gilt-bronze finials are formed in the shape of pagodas which would have been hidden by the smoke of burning sandalwood. JVP

24
Anonymous court artists
Copy of the Kangxi Emperor's Sixtieth Birthday Celebration, Scroll One

Late eighteenth century
Handscroll, colour on silk, 45 × 3715 cm
The Palace Museum, Beijing, Gu8616/1
SELECT REFERENCES: Wang Yuanqi et al.
1718, *juan* 40–45; Hu Jing 1816, *juan* 2 (1963
reprint, p.65); Tokyo 1985, no.22; Hong
Kong 1989, pp.28–41; Macau 1999, no.6

The scale and scope of *The Kangxi Emperor's Southern Inspection Tour* (cat.13) inspired a new genre of grandiose historiographic paintings celebrating the Qing emperors. The second such commemorative work to be produced at the Qing court was *The Kangxi Emperor's Sixtieth Birthday Celebration (Kangxi liuxun wanshou qingdian tu)*. The painting depicted the festivities held along the fifteen-kilometre route that the Kangxi Emperor followed from the Garden of Joyous Spring (Changchun yuan) in the northwestern suburbs of Beijing to the Forbidden City (Zijin cheng) on 11 April 1713, the day before his sixtieth birthday. Consisting of two immense handscrolls that totalled nearly 80 metres in length, the painting was created by a team of artists. The project was initiated by Song Junye (*c.*1662–1713), who had been a key figure in organising *The Kangxi Emperor's Southern Inspection Tour* by Wang Hui (1632–1717) (see cat.13). He, in turn, designated Wang Yuanqi (1642–1715) to take artistic responsibility for the painting. Wang, a talented scholar and artist who served as adviser for the Emperor's art collections, was the grandson of Wang Hui's mentor, Wang Shimin (1592–1680).[1] A draft of the painting was ready in

1714, but the finished work was not completed until 1717, after Wang Yuanqi's death, and was signed by fourteen painters headed by the court artist Leng Mei (*c*.1677–*c*.1742) along with the professional artist Xu Mei (fl.*c*.1690–1722), who had worked on *The Kangxi Emperor's Southern Inspection Tour*.[2]

The original scrolls were lost – possibly in a fire. The present set is a replacement copy made during either the Qianlong or early Jiaqing era and based on the woodblock-printed version of the original painting that was included in the *Magnificent Record of the Emperor's Birthday* (*Wanshou shengdian*), a collection of poetic tributes in 120 chapters published in 1718.[3]

Because the imperial procession is returning to the capital, it is depicted moving from left to right, opposite to the direction in which the scrolls unroll. Thus, the first scroll in the set (illustrated here) begins with the Emperor's final destination, the Gate of Martial Spirit (Shenwu men), the rear entrance to the Forbidden City. It unrolls leftwards, tracing the route westwards past the Circular Citadel (Tuan cheng) and the White Dagoba (Bai ta) in what is now the North Sea Park (Beihai gongyuan), through the Gate of Western Tranquillity (Xi'an men) of the Imperial City (Huang cheng), then northwards through the Manchu city. The scroll ends with the Due West Gate (Xizhi men), the northwestern gate of Beijing (this portion not illustrated). The second scroll begins in the suburbs outside the Due West Gate and shows the Emperor and his entourage *en route* from the outer gate of the Garden of Joyous Spring.[4]

The entire way has been decorated with a total of fifty festive displays sponsored by various central government ministries, princes and banner military units as well as neighbourhood organisations, each identified by an inscription. Each sponsor has erected ornamental archways, arcades hung with bunting and lanterns, altar tables set with flowers, fruit, ornamental rocks or incense burners, and theatrical stages draped in painted cloth, where operatic performances have attracted crowds of onlookers. In between these temporary constructions the scroll affords delightful glimpses of city life,

including shops, trades and the constant parade of curious citizens.

Outside the Gate of Western Tranquillity we see elements of the Emperor's ceremonial honour guard in red livery: musicians, grooms and horses, state carriages and the elephants used to draw them or clear the road are arrayed on either side of the avenue. Near the end of Scroll One, as the route approaches the Due West Gate, galloping horsemen announce the approach of the Empress Dowager, who preceded the Emperor into the city. As the populace kneels, two columns of soldiers escort her state palanquin and the hand-pulled carriages carrying other members of the imperial family. After a final rank of imperial guardsmen passes, people rise to their feet and the happy hubbub of the street resumes. The scroll ends with the massive battlements of the Due West Gate. The Emperor does not appear until Scroll Two, where he passes similar displays erected by each of the provincial governments. MKH

25

Anonymous court artists
The Qianlong Emperor's Eightieth Birthday Celebration, Scroll Two

1797
Handscroll, colour on silk, 45 × 6347.5 cm
The Palace Museum, Beijing, Gu8617/2
SELECT REFERENCES: *Shiqu baoji sanbian*, pp.596–605

One of the many precedents established by the Kangxi Emperor and emulated by his grandson, the Qianlong Emperor, was the lavish celebration of important imperial birthdays. In 1770, on the occasion of his sixtieth birthday, the Qianlong Emperor was presented with a pictorial record of his first southern inspection tour (see cat.14) that recalls the set created for the Kangxi Emperor (see cat.13). The Qianlong southern tour paintings were accompanied by an enormous publication, the *Magnificent Record of the Southern Tours* (*Nanxun shengdian*), which rivalled in size the volume of eulogistic tributes prepared for the Kangxi Emperor's sixtieth birthday.

The Qianlong Emperor's eightieth birthday, celebrated on the thirteenth day of the eighth lunar month (21 September) of 1790, was commemorated with a monumental two-scroll painting modelled closely on the set recording the Kangxi

Emperor's sixtieth birthday celebration (see cat.24). As in the case of the Kangxi Emperor, the occasion was also marked by the preparation of an immense compendium of tributes, the *Magnificent Record of the Emperor's Eightieth Birthday* (*Bajun Wanshou shengdian*), published in 1792; this included a woodblock record of the scrolls. The present version of the Qianlong set, even grander in scale than the Kangxi scrolls, was created at the Imperial Textile Manufactury (Zhizao fu) in Suzhou, Jiangsu Province.

By the time of their completion in 1797 the Qianlong Emperor had already abdicated in favour of his son, the Jiaqing Emperor (r.1796–1820), although he remained the *de facto* ruler until his death in 1799.

As with the Kangxi set, the Qianlong paintings depict the imperial procession moving from left to right, opposite to the direction that the scrolls unroll. Thus, the first scroll in the set begins with the Emperor's final destination, the Forbidden City (Zijin cheng), and ends at the northwestern gate of Beijing, the Due West Gate (Xizhi men). Except for the fact that the Qianlong Emperor's route took him to the western entrance to the Forbidden City, the Western Flowery Gate (Xihua men), rather than to its rear entrance, the scroll depicts the same route chronicled in the Kangxi set. The second scroll (illustrated here), which begins outside the Due West Gate, shows the Emperor and his entourage en route from the Garden of Perfect Brightness (Yuanming yuan), a vast imperial garden-palace complex that was the Qianlong Emperor's preferred residence. This was located in the northwestern suburbs of Beijing, adjacent to the more modest Garden of Joyous Spring from whence the Kangxi Emperor had set forth for his celebration.

Since both surviving versions of the Kangxi and Qianlong sets were probably made at around the same time, in the late eighteenth century, there is little to distinguish them in terms of style. Instead, the most marked difference is one of content. The decorations depicted for the Qianlong Emperor's celebration are far more elaborate than those for his grandfather's birthday. Whereas the pavilions and stages illustrated in the Kangxi set have the look of

temporary structures constructed from wood and cloth, those depicted in the Qianlong set, while undoubtedly created of the same materials, appear at once more substantial and more fanciful. There are pavilions of every shape and size as well as two-storey edifices, Western-style buildings, gateways, arcades, galleries, towers, terraces, screen-walls and bridges. Many of the structures are landscaped with artificial mountains or complemented by ornamental rocks, planters filled with flowers, pools and even a pond with small boats. At one point in the scroll the artist reveals that most of these ornamental displays are nothing more than painted props, but their rendering as three-dimensional objects underscores the Qianlong Emperor's delight in *trompe l'oeil* illusions (see the upper band illustrated on p.106). In the Kangxi set, the elaborate displays erected by the various sponsors – each carefully labelled with the sponsors' names – are interspersed with long stretches of the route where the dwellings and shops of the populace are in view. In the Qianlong set, both sides of the route have been transformed into continuous decorated façades that hide most signs of daily life. Nor are any of the displays labelled; instead, both paintings in the set are followed by lengthy inscriptions that identify each display. Finally, in contrast to the springtime flowers and foliage of the Kangxi set, the Qianlong painting depicts the greenery and blossoms of late summer.

The section illustrated here depicts the Emperor's procession shortly after its departure from the main gate of the Garden of Perfect Brightness. The route passes beside the high walls of other imperial parks, glimpses of which may be seen in the distance. The populace kneels as members of the ceremonial honour guard approach. The Emperor, shielded from view within an elaborate palanquin, is accompanied by a host of high officials and a rank of imperial bodyguards in yellow tunics. A second palanquin probably bears the Empress. Additional ranks of guards on foot and on horseback follow while the mounts of the officials accompanying the Emperor's palanquin bring up the rear. MKH

26

Giuseppe Castiglione
(Chinese name Lang Shining, 1688–1766) and others
The Qianlong Emperor Hunting Hare

1755
Hanging scroll, colour on silk, 115.5 × 181.4 cm
INSCRIPTIONS: signed 'Respectfully painted by your servant Lang Shining'; on the upper part of the painting, a poem composed by the Qianlong Emperor and calligraphied by him
SEALS: two artist's seals, two imperial seals
The Palace Museum, Beijing, Gu5362
SELECT REFERENCE: Nie Chongzheng 1992, pl.56

An expert horseman and a skilled archer, the Qianlong Emperor went on hunting expeditions not only in Mulan but also in the game reserves that he owned in the Manchurian provinces of Jilin and Heilongjiang. He also owned the Nanyuan estate, near Beijing: it is a hunting expedition there that is the subject of Castiglione's painting and the Emperor's poem on this scroll. Accompanied by members of the imperial family, princes and government officials, the Qianlong Emperor shoots at a hare with a bow and arrow. Other hares that he has already shot lie on the ground.

Castiglione, whose signature is the only one to appear on the scroll, painted the horses, the horsemen and the hares, with certain details perhaps added by assistants. The landscape and the ground were then painted by a Chinese artist of the Imperial Painting Academy, who carefully left white space around the figures painted by Castiglione. The ground is somewhat mechanically painted, and the absence of shadows creates the impression that the horses are flying or floating.

This scene, like others by the artist, shows Castiglione's exceptional skill as a horse-painter. He was familiar with the great Chinese tradition of horse painting, but to it he added certain European qualities: firstly, his remarkable understanding of anatomy and perspective, which is heightened by a subtle chiaroscuro; secondly, his rendering of texture, which is seen, for example, in the tactile and natural manner in which the horses' manes and tails and the sheen of their coats are painted; and lastly, his emphasis on the expressiveness of the horses' faces, particularly their eyes.

Dating from 1755, the painting also reflects the development of

Castiglione's work at the Imperial Painting Academy. Such were the demands on him that he was increasingly forced to rely on the help of assistants. After the 1740s he was so heavily burdened that, except for the most important commissions, he was unable to produce paintings single-handedly. Instead he would simply sketch the outline of a composition, or paint only those parts of it that were best suited to his skills as a portraitist and animal painter. MPt's

27

Leng Mei (*c.*1670–1748)
Mountain Villa to Escape the Heat

1713
Hanging scroll, colour on silk, 254.8 × 172 cm
INSCRIPTION: signed 'Respectfully painted by your servant Leng Mei' in the lower right part of the painting
SEALS: two artist's seals lower right; in the upper part, at the centre, the seal of the Qianlong Emperor; on the left, four imperial seals
The Palace Museum, Beijing, Gu8210
SELECT REFERENCES: Hou Ching-lang and Pirazzoli 1979; Nie Chongzheng 1992, pl.6; Yang Boda 1993c, pp.109–30; Nie Chongzheng 1996, pl.9; Macau 1999, pl.9; Chayet 2004; Chung 2004, pp.84–87

In 1703 the Kangxi Emperor began building his summer residence, the Mountain Villa to Escape the Heat (Bishu shanzhuang) at Rehe (also called Jehol, now the city of Chengde in Hebei Province). The estate is set in wooded hills 256 kilometres (about 160 miles) northeast of Beijing, on the road to the Mulan hunting reserve. The residence was completed in 1711, and the Kangxi Emperor lived there from May until the end of September each year. The Yongzheng Emperor never stayed at the residence. The Qianlong Emperor, however, regularly spent two to four of the summer months there, and in 1741 he began to alter and enlarge the palace complex.

The Kangxi Emperor built the Mountain Villa not only to escape the heat of summer in Beijing and the formality of life in the Forbidden City (Zijin cheng), but more especially for a political purpose. The summer residence was somewhere he could entertain his allies and receive his vassals, but it also served as a northern outpost; here he could garrison a powerful army, which in 1711 consisted of 30,000 men, against the Mongolian

peoples of the northern frontier. It was also at the Mountain Villa to Escape the Heat that the Kangxi Emperor received the leaders of local peoples, who came to swear their allegiance to him. The Mountain Villa thus became the empire's second diplomatic capital, and the hub of Qing dynasty politics in Central Asia. Government officials would accompany the Emperor to the Villa, just as they travelled with him when he went on hunting expeditions in Mulan.

Leng Mei gave a bird's-eye view of the estate as it appeared in the Kangxi Emperor's time, except for the official quarters of the palace, to the south. The Kangxi Emperor wanted to preserve the estate's natural appearance, with lakes at the centre, and built relatively plain pavilions. On the right is the wall that encloses the estate and the Wulie River at the foot of the hills. On the highest hill, north of the lakes, is the Bangchui, a rock in the shape of an upended cudgel that towers over the plain. Thirty of the thirty-six views that the Kangxi Emperor extolled in a poem written in 1711 are contained within the painting. As Yang Boda suggests, this painting, which contains auspicious omens and symbols of longevity (cranes and white deer), was executed in 1713, in celebration of the Kangxi Emperor's sixtieth birthday. Since it shows the residence and its surroundings as they were in the second decade of the eighteenth century (before the alterations ordered by the Qianlong Emperor), this painting is of great historical interest.

Leng Mei was one of the three finest painters at the Kangxi Emperor's court. He almost certainly gained employment at the palace through an introduction from his teacher, Jiao Bingzhen (fl. *c*.1689–1726). Jiao Bingzhen taught Leng Mei certain principles of linear perspective, which he had learned from the European Jesuits, and these can be seen in several of Leng Mei's architectural paintings (*jiehua*). Leng Mei collaborated on and supervised the painters of the two huge scrolls which were made to mark the Kangxi Emperor's sixtieth birthday (see cat.24). The Qianlong Emperor also commissioned Leng Mei to paint views of his summer palace, the Garden of Perfect Brightness (Yuanming yuan). MPCS

28

Giuseppe Castiglione (Chinese name Lang Shining, 1688–1766) and Fang Cong (fl.1758–1795)
Illustration in the Spirit of the Qianlong Emperor's Poem 'Congboxing'

1758
Hanging scroll, colour on silk, 424 × 348.5 cm
INSCRIPTION: Yu Minzhong (1714–1780)
The Palace Museum, Beijing, Gu6514
SELECT REFERENCES: Hou Ching-lang and Pirazzoli 1979; Pirazzoli 1985; Nie Chongzheng 1996, pl.43; Liu Lu 2000; Elliott and Chia 2004

Both the Kangxi and Qianlong Emperors loved hunting and were skilled in the chase. But the autumn hunts were not so much an entertainment as a ritual. For the Manchus, as for the Khitans (Chinese: Qidan) and Mongols, who also inhabited the empire's northernmost regions, these autumn hunts were a sport, a military exercise and an instrument of government. For the Kangxi Emperor, and the Qianlong Emperor after him, hunting was intended to incite the Manchus to preserve their ethnic identity and hone their skill as warriors, preventing them from being softened by a sedentary, 'Chinese' way of life. For both Emperors, hunting was also a means of asserting their links with the culture of the steppe-lands and of upholding the ancient custom by which a ruler exercises his power through the hunt and his vassals fulfil their obligations by taking part in it.

In 1681 several Mongol leaders presented the Kangxi Emperor with the extensive Mulan hunting reserve, which covered 15,000 square kilometres to the north of the Mountain Villa to Escape the Heat (Bishu shanzhuang), his summer retreat. The Kangxi Emperor came to Mulan every year. Although the Yongzheng Emperor did not follow his example, Mulan became the Qianlong Emperor's favourite hunting ground. Leaving the Mountain Villa between the beginning of September and mid-autumn, the Qianlong Emperor stayed in Mulan for about three weeks, including the time it took him to reach the reserve and return from it. The hunting reserve was managed by Manchu princes, and only Manchus and Mongols participated in hunting parties there. Strictly organised and conducted like a military offensive, with military-style camps, these hunts allowed the Emperor to train, test and assess his men, to pick out future generals and choose an imperial heir. He was accompanied by up to 12,000 soldiers from the Eight Banners, as well as officers, princes and officials. This show of strength was also intended to impress the Manchu and Mongol aristocracy, as well as envoys from distant lands whom the Qianlong Emperor received there.

In a wide panorama of the landscape in which the autumn hunts at Mulan took place, this painting shows the return from the hunt, with the long procession winding through wooded mountains. The Emperor, on horseback, is presented with a tiger, while eight Burut leaders from Central Asia (see cat.65) stand before him. MPCS

29

Giuseppe Castiglione (Chinese name Lang Shining, 1688–1766) and others
The Qianlong Emperor Shooting a Deer

1742 (?)
Hanging scroll, colour on silk, 259 × 172 cm
SEALS: three seals of the Qianlong Emperor in the upper part of the painting
The Palace Museum, Beijing, Gu9204
SELECT REFERENCES: Wan Yi, Wang Shuqing, Lu Yanzhen 1988; Li Shi 2002

At Mulan, the Qing imperial hunting reserve north of Beijing, the Emperor and his courtiers practised several types of hunting. Usually the quarry was rounded up by beaters who, deployed in a semicircle, drove the prey into an enclosed space where the hunters could shoot at it more easily. Another method was known in Manchu as *muran*, 'the act of luring a deer by whistling during the chase'. This method, after which the hunting reserve of Mulan was named, involved the hunters donning a deerskin and head, and blowing a horn that sounded like the belling of a stag to attract the herd. The hunters would wait in the woods and when the herd approached they would begin to shoot. In both types of hunt, the Emperor was the first to shoot.

Here the Qianlong Emperor is shown in the crucial moment, shooting at his prey, a painterly motif used relatively frequently during his reign. Behind him stands his horse and further away, among trees, is the imperial yurt.

This scroll is the pendant to another in the Palace Museum, Beijing, *Qianlong Killing a Tiger (Hongli ci hu tu)*.[1] In both, the composition is identical, with the four main elements – the tent, the horse, the hunters and the hunted animal – arranged in similar fashion. The scrolls' dimensions and the seals that mark them are also identical. The two paintings form part of a series of depictions of the Qianlong Emperor hunting, all of identical size, that were probably painted in 1742. Each of these paintings, similarly to cat. 28, was executed in collaboration. In this example, a European artist, most probably the Italian Jesuit Giuseppe Castiglione, painted the portrait of the Emperor and his horse, and one or more Chinese artists painted the landscape and perhaps the deer. Such collaborations were customary in Chinese court painting. What was new about the Qianlong Emperor's Imperial Painting Academy is that Chinese and European painters worked together on the same scroll, conjoining Chinese and Western artistic conventions.

The portrait of the Qianlong Emperor in this painting is similar to other depictions of the Emperor hunting by Giuseppe Castiglione, particularly *Hunting for Deer by Whistling (Shaolu tu)*, also in the Palace Museum, Beijing, which is dated 1741,[2] and *Imperial Hunt at Mulan (Mulan tu)* (Musée Guimet, Paris), which is dated to the 1740s.[3] Stylistic similarities endorse a date of 1742, which has recently been suggested for this set of paintings. This was one year after the Qianlong Emperor inaugurated the autumn hunts in Mulan. MPts

30

Jin Kun, Cheng Zhidao and Fu Long'an (all active at the imperial court during the eighteenth century)
Ice Game on the Palace Lake

*c.*1760s
Handscroll, colour on silk,
35 × 578.8 cm
INSCRIPTION: poetic essay by the Qianlong Emperor, inscribed by Ji Huang (1711–1794)
SEALS: two by Jin Kun, two by Ji Huang, eight seals of the Qianlong imperial collection
The Palace Museum, Beijing, Gu6119
SELECT REFERENCES: *Shiqu baoji xubian*, p.2261; Berlin 1985, no.29; Rotterdam 1990, no.12; Nie Chongzheng 1996, no.61

The art of ice-skating has a long history in China. The *Songshi (Annals of the Song Dynasty)* report that in the Song period the Emperor used to watch ice-skating in the palace gardens. For the Manchus ice-skating was regarded as a kind of national sport. During the Qing dynasty it even became part of military training. At the annual winter inspection of the troops, the best skaters chosen from all over the country, a total of 1,600 bannermen, participated in ice games organised on the palace lakes before the Emperor and the entire court. The spectacle included ice races, with prizes for the first three winners, figure skating with acrobatic performances and a kind of football on ice, with two teams of ten men.

This handscroll shows the figure-skating performance on the Central Lake (Zhonghai) south of the Jade Rainbow Bridge (Jin'ao yudong qiao). To the east, the Hall of Ten Thousand Virtues (Wanshan dian) is depicted with the picturesque little Pavilion of Clouds Reflected in the Water (Shuiyun xie) projecting out into the lake. The yellow-covered sleigh of the Emperor is surrounded by court dignitaries and shielded by ten 'Leopard Tail' guards. Three wooden archways were erected on the ice, through which the long row of skaters pass following the skating track in the form of an auspicious cloud or a *ruyi* sceptre. Eight groups of seven or eight skaters, with flags attached to their backs, represent the Eight Banners: the three superior banners, Bordered Yellow, Plain Yellow, and Plain White, which belonged to the Emperor, leading the row; then Plain Red, Bordered White, Bordered Red, Plain Blue, and Bordered Blue. Alternating with them are archers, who try to shoot the brightly coloured balls hanging from the archways. The skaters strike acrobatic poses by spreading their arms, raising a leg and turning around.

On the occasion of his military winter inspection of 1745/46, the Qianlong Emperor had re-established the tradition of performing ice games as an important national custom. He composed a poetic essay (*fu*) in which he stressed their function as a military training as well as an entertaining pleasure at New Year's Eve. This he had printed and distributed among his high

officials. Furthermore he ordered the court painter Shen Yuan (fl.*c.*1744–1747) to paint an illustration to his essay. Both were mounted into a long handscroll together with related poems by his officials.[1] In the same year (1746) he had a hanging scroll on the subject painted by Shen Yuan and personally wrote his essay on it.[2] The handscroll under discussion and an almost identical example by Yao Wenhan (fl.*c.*1743–1790) and Zhang Weibang (fl.after 1723)[3] must have been painted some years later. Fu Long'an (1743–1784), a Manchu of the Fuca clan, entered the court in 1758, married a daughter of the Qianlong Emperor in 1760 and became president of the Board of War in 1768. Thus the painting was probably executed in the 1760s. It was stored in the Imperial Study (Yushu fang). The original poetic essay by the Emperor was inscribed at the end of the scroll by the high court official and noted calligrapher Ji Huang (1711–1794). GHo

3 Ritual

31

Set of sixteen sonorous stones (*bianqing*) with dragon and cloud motif

Qianlong 29th year (1764)
Nephrite with stand of gold-lacquered wood, height 350 cm
The Palace Museum, Beijing, Gu169354, 1–15/16
SELECT REFERENCES: *Daqing huidian tu, juan 37*, p.403; Wan Yi, Wang Shuqing and Lu Yanzhen 1985, no.44; Paris 1997, no.47

32

Set of sixteen bells (*bianzhong*) with dragon and cloud motif

Kangxi 52nd year (1713)
Gilt bronze with stand of gold-lacquered wood, height 350 cm
The Palace Museum, Beijing, Gu169500, 1–16
SELECT REFERENCES: *Daqing huidian tu, juan 36*, p.391; Kaufmann 1976, pp.102–07; Wan Yi, Wang Shuqing and Lu Yanzhen 1985, no.43; Falkenhausen 1993, p.14; Paris 1997, no.49

This set of sixteen jade sonorous stones suspended in a wooden frame in two neatly ordered rows has been described as *bianqing*, and the similarly suspended bronze bells are known as *bianzhong*. Both sets of chimes are decorated with gilded cloud and dragon designs. The

sonorous stones, which resemble the carpenter's square, vary in thickness according to their pitches. The bronze bells also differ in thickness, but their uniform size forms a sharp contrast with ancient bell chimes, which feature a range of sizes.

The wooden frames are highly ornamented. The frame for the bells shows a dragon on both ends of the beam, and the beam of the frame for the sonorous stones features two phoenixes. Walter Kaufmann observes that the vertical pillars of the frames for the stones are usually supported by figures representing ducks and those of the bell frames by figures representing tigers. As the bell chimes were juxtaposed with the stone chimes in a ceremony, the figures on the frames were probably regarded as complementary.

According to Lothar Falkenhausen, China was the first in the production of tuned sets of bells, which occupied a prominent position in ancient Chinese ritual orchestras. Kaufmann suggests that the sonorous stones were to 'receive and transmit' the sounds of the end of each verse to the beginning of the next when hymns were performed in the ritual. During the Qing period, sonorous stones made of dark green nephrite, such as those in this chime, were reserved for the Grand Sacrifices performed at the Altar to Heaven and the Altar of Land and Grain, whereas the sonorous stones used in other state rites were made of limestone. The music produced by these musical instruments was believed to facilitate communication between humans and deities. JY

33

Emperor's 'moon white' court robe (*chaofu*)

Yongzheng period
Silk satin with brocaded areas of polychrome silk and metal threads, length 143 cm. Collar embroidered with silk and metal thread and trimmed with silk and metal thread brocade
The Palace Museum, Beijing, Gu41893
SELECT REFERENCES: Chen Juanjuan 1984; Wilson 1986, p.33; Rawski 1998, pp.24–25

The distinctive colour of this robe is unusual in the formal wardrobe of the Qing imperial family. It is termed *yuebai* ('moon white') and was reserved for the sacrificial ceremony performed by successive emperors at the Altar of the Moon, in the west of the capital. Other altars of the state religion, each

situated at the four cardinal points outside Beijing's city walls, required the Emperor to don different colours according to a carefully coded set of rules. The shape of this robe is also commensurate with its use at a state ceremony. It is a *chaofu* ('court robe' or 'audience robe'), a type of garment characterised by a full skirt spreading out to the hem and caught in at the waistband with closely set pleats. This method of tailoring the silk exploited its potential to rustle as the Emperor moved in stately procession and performed the actions of the rite.

The patterning on the garment falls into well-defined sections, gold dragons flying above stylised striped and rounded waves being the main motifs. The robe was worn belted. A stiffened and bordered collar, also with a dragon design, was tied on over the robe, spreading out from the neck and shoulders to enhance the wearer's stature. Detailed texts set out the procedures and accoutrements required for the rituals, but we can never be entirely sure how the Emperor would have looked on such occasions. The precise interpretations of the written dress regulations are lost to us. VW

34

Pair of *dou* (altar food vessels) with patterns in light relief

Qianlong period
'Moon-white' porcelain, height 28 cm
The Palace Museum, Beijing, Gu186402, Gu186403
SELECT REFERENCES: *Huangchao liqi tushi*, *juan* 1, p.65; Beurdeley and Raindre 1987, pp.156–57; Liu Liangyou 1991, p.38; Zito 1997, p.46

35

Pair of *fu* (altar food vessels) with patterns in light relief

Qianlong period
'Moon-white' porcelain, height 23.5 cm
The Palace Museum, Beijing, Gu186476, Gu186477
SELECT REFERENCES: *Daming huidian*, *juan* 82, p.35a, *juan* 201, p.26a; *Huangchao liqi tushi*, *juan* 1, p.62; *Qing Gaozong shilu*, *juan* 306, p.2ab and *juan* 326, p.36a; Medley 1982, p.13; Beurdeley and Raindre 1987, pp.156–57; Liu Liangyou 1991, p.38

36

Pair of *xing* (altar soup containers) with patterns in light relief

Qianlong period
'Moon-white' porcelain, height 27 cm

The Palace Museum, Beijing, Gu186519, Gu186520
SELECT REFERENCES: *Huangchao liqi tushi*, *juan* 1, p.61; Beurdeley and Raindre 1987, pp.156–57; Liu Liangyou 1991, p.38

37

Pair of *gui* (altar food vessels) with patterns in light relief

Qianlong period
'Moon-white' porcelain, height 24 cm
The Palace Museum, Beijing, Xin7549, Xin7550
SELECT REFERENCES: *Huangchao liqi tushi*, *juan* 1, p.63; Beurdeley and Raindre 1987, pp.156–57; Liu Liangyou 1991, p.38

The *dou*, a lidded bowl with a tall, trumpet-shaped foot, has a dome-shaped lid that has sometimes been compared with the hat of an official. The *fu* has rectangular forms with flared sides, and its lid has an undulating rim on top. The *gui* has an oval cross-section, with four projections jutting out from its lid. The *xing* is a tall bowl with three legs, which correspond to the three pointed projections on its lid.

This group of porcelain ritual vessels was used at the Altar to the Moon. Their surface decoration, identical to that of the lacquered wooden vessels used at the Temple to the Ancestors, features stylised patterns of waves, clouds, interlocking keys, thunder, dragons, waterweed and honeycombs, among other elements. The bluish-white glaze on the porcelain vessels is known in Chinese as *yuebai*, literally, 'moon-white', though it differs from the *clair de lune* glaze known in the West. The altars in the other cardinal directions – the Altar to Heaven, the Altar to Earth and the Altar to the Sun – used ritual vessels of similar form but coated in blue, yellow and red glazes respectively.

Although this colour-coding system was instituted in 1530, the archaistic shapes of these objects were not designed until 1748. In the early Ming dynasty, the Hongwu Emperor (r.1368–98) had stipulated that ritual vessels should be made in conventional forms. Therefore, the *dou*, *fu* and *gui* were plates, and the *xing* was a bowl. Although the early Qing had perpetuated this practice, the Qianlong Emperor decreed that fashioning ritual vessels in conventional shapes was inconsistent with ancient practice. As the vessels had retained their ancient nomenclatures, the Emperor decided instead that their shapes ought to reflect those of archaic

ritual paraphernalia. He ordered the Grand Secretaries to consult classical texts when designing objects, and insisted that he approve their designs before manufacturing could begin. The objects were illustrated and described in the *The Illustrated Regulations for Ceremonial Paraphernalia of the Qing Dynasty* (*Huangchao liqi tushi*), which often cites classical texts concerning ritual and ceremony, such as *Erya, Zhouli, Liji, Yili, Lishu* and *Sanlitu*, to explain certain features.

The quantity of vessels and the offerings contained in them were also prescribed in detail. For the Altar to the Moon, there were ten *dou* for ten kinds of foodstuff: fragrant-flowered garlic, green vegetables, celery, bamboo shoots, minced pork seasoned with salt and wine, minced venison, minced rabbit, minced fish, beef tripe and pork shoulder. Moreover, there were two *fu* for rice and sorghum, two *gui* for broom-corns and millet, and two *xing* for a thick meat soup with salt and sauce. JY

38

Anonymous court artists
The Yongzheng Emperor Offering Sacrifices at the Altar of the God of Agriculture

1723–35
Handscroll, colour on silk, 61.8 × 467.8 cm
The Palace Museum, Beijing, Xin121320
SELECT REFERENCES: Lu Yanzhen, Li Wenshan and Wan Yi 1983, pp.110–11; Berlin 1985, no.26; Wan Yi, Wang Shuqing and Lu Yanzhen 1985, fig.460; Nie Chongzheng 1996, no.15; Macau 1999, no.18

Annually in the second month of spring (March–April), on a day determined by the court astronomers, the Emperor performed the necessary rites in the compound of the Altar of Agriculture (Xiannong tan) situated in the southern part of Beijing, to mark the onset of the farming season. The ceremonies were based on the rites of the Zhou dynasty (*c.*1050–256 BC) and included the sacrifice to the legendary inventor of Agriculture, Xiannong, and the ritual first ploughing by the Emperor. Both are depicted on a pair of large handscrolls by court artists portraying the Yongzheng Emperor.[1]

This first scroll illustrates the offering of sacrifices to the inventor of Agriculture, venerated as one of the mythical founders of Chinese civilisation. The Emperor has

entered the sacred area through the east gate and proceeds towards the altar. A brown carpet and red lanterns mark his way. Dressed in the yellow imperial robe and a blue overcoat he walks in the middle of the carpet, flanked by four high officials and an escort of courtiers. Ten military officials with swords precede him, and the imperial guard follows, forming a wide semicircle. The procession has just passed the entrance hall of the Temple of Jupiter (Taisui dian), visible at the upper edge of the scroll. Beautiful old cypress trees grow all over the compound, giving it a sacred atmosphere. In front of the square altar, the participating officials have already assembled in their blue robes and the red-clothed members of the imperial court orchestra and dancers with long feathers are ready to perform. On the altar a tent of yellow silk has been erected with the red ancestor tablet inscribed with the name of Xiannong, the First Farmer, in its centre. The sacrifice has been arranged in the form of a banquet meal. On a red table the meat of a bull, a sheep and a pig is displayed. Behind it thirty-six dishes of different cereals and vegetables and twenty cups of wine are offered to the god. At the upper end of the steps there is a yellow baldachin with a pillow beneath it. Here the Emperor will perform the three prostrations and nine kowtows before the tablet of the god, according to ritual. By showing his veneration to the Ancestor of Agriculture, the Emperor recognises the importance of farming as the fundamental base of the empire and of all human civilisation. GHo

4 Religion

39

Buddhas of the Five Directions and the 35 Buddhas of Confession

*c.*1772
Five hanging scrolls mounted together, colours and gold pigment on cloth, 137 × 51.5 cm
The Palace Museum, Beijing, Gu200538
SELECT REFERENCE: Macau 2003, no.106-1

These five scrolls were designed for display in the Qianlong's Emperor's chapel, the Buddha Sun Pavilion (Fori lou), completed in 1772, where they provided a backdrop and ritual

framework for the thirteenth-century Western Tibetan sculptures of the Buddhas of the Five Directions arrayed on the altar below (cat.41). Each scroll depicts one of the Buddhas of the Five Directions in the monastic robes of a *nirmanakaya* (worldly emanation body), surrounded by symmetrically arranged images of seven of the 35 Buddhas of Confession.[1]

The 35 Buddhas are the object of a regular ritual of repentance, performed monthly or even daily, in which the penitent visualises, names and honours each Buddha in a process that emphasises 'splitting open' (Tibetan: *shegpa*) in acknowledgment of past transgressions.[2] In painted representations, the 35 Buddhas most often surround the central figure of Sakyamuni, the Historical Buddha, who is also the first figure in the group. Here, however, the unusual combination of two interlinked groups of Buddhas heightens the sense of the presence of Buddha nature in all places and times, and corresponds to a ritual practice that, for ease of memory, advocates dividing the larger group into seven parts around each of the Five Buddhas. Like the Five Buddhas, each of the 35 Buddhas symbolises a different aspect of enlightenment and also provides a way to overcome a specific obstacle encountered in Buddhist practice. PB

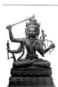

40

Manjusri Namasamgiti

Eighteenth century
Partial-gilt copper, height 77.5 cm
The Palace Museum, Beijing, Gu203380
SELECT REFERENCE: Palace Museum 2002c, no.234

Manjusri Namasamgiti (Chinese: Zhenshimingzun Wenshu; Tibetan: Jampal tsanjod) is a form of the bodhisattva of wisdom that embodies a text of the same name, meaning 'Paying Homage to the Names of Manjusri'.[1] Manjusri in all his forms was especially significant to the Qing emperors, who were believed to be his emanations and who regularly visited the bodhisattva's field of enlightened activity at Wutai shan (Mount Wutai), near the Mongolian border.

Manjusri Namasamgiti is identified by his four arms, three faces and multiple attributes.

His inner right hand brandishes a flame-tipped sword to cut through obstacles to enlightenment, his left hand holds the stem of a lotus bearing a *Prajnaparamita* (*Perfection of Wisdom*) *sutra* and his two outer hands carry a bow and arrow. His benign faces, three-point crowns, slightly swaying body and beaded, double-lotus throne recall Manjusri images made during the reign of the Ming dynasty Yongle Emperor (r.1403–24), who maintained close relations with the Tibetan Buddhist establishment.

An image of Tiksna-Manjusri ('Quick-Witted' Manjusri), similar in form save for his single face, appears in the Beijing edition of the *Kanjur*, a sumptuous woodblock-printed version of the Tibetan-language canon that the Yongle Emperor commissioned in 1410 for distribution in Tibet. Among the Yongle Emperor's other gifts to Tibetan monasteries were gilt-bronze images of Tiksna-Manjusri, several of which survive in Lhasa and elsewhere.[2] Manjusri Namasamgiti, complete with three faces, appears in the mid-eighteenth-century *Zhufo pusa shengxiang zan* (*Eulogies and Sacred Images of All the Buddhas and Bodhisattvas*, commonly known as the *360 Icons*), a painted pantheon designed by the Qianlong Emperor's personal guru and Zhangjia National Preceptor, Rolpay Dorje.[3] PB

41

The Buddhas of the Five Directions: Amitabha, Amoghasiddhi, Vairocana, Ratnasambhava and Aksobhya

Thirteenth century, Western Tibet
Bronze, height 47 cm
The Palace Museum, Beijing, Gu200606,
1–5
SELECT REFERENCES: Palace Museum 1992B, no.41; Macau 2003, no.106-2

In Vajrayana Buddhism, the Five Buddhas, Amitabha, Amoghasiddhi, Vairocana, Ratnasambhava and Aksobhya, represent the five directions or regions (west, north, centre, south and east respectively) and together symbolise the pervasiveness of Buddha nature throughout the cosmos. In this thirteenth-century Tibetan set, the Five Buddhas are differentiated by their hand gestures and wear elaborate crowns and jewellery

in their *sambhogakaya* form, the esoteric body-of-enjoyment visible only to enlightened bodhisattvas or during meditation.

The Five Buddhas' stiff, triangular torsos and their three-petal, thread-linked crowns and wide lotus thrones are typical of sculptures produced in Western Tibet between the late twelfth and fifteenth centuries.[1] Tibetan monasteries regularly sent such venerable, ancient images to the Qing court as a part of a regular diplomatic exchange that reached its height during the Qianlong reign. The Buddhas were installed on an altar in the Fori lou (Buddha Sun Pavilion), a chapel built in 1772 in the northern part of the Ningshou gong (Palace of Tranquil Longevity), the Qianlong Emperor's retirement villa, which was situated in the northeast section of the Forbidden City (Zijin cheng). PB

42

Palden Lhamo with Images of All the Buddhas of Great Benefit for Everything

1777
Thangka, gold pigment on black layered paper, 120 × 70 cm
INSCRIPTIONS: poem by the Qianlong Emperor, date and inventory tag, all in Chinese, Manchu, Mongolian and Tibetan
The Palace Museum, Beijing, Gu200645
SELECT REFERENCES: Palace Museum 2002B, no.143; Macau 2003, no.66

Palden Lhamo, the Tibetan name of the Indian deity Sridevi, is the single female among the Eight Great Protectors (*dharmapala*) of the Tibetan Gelugpa (Yellow Hat order) and a special protectress of the holy city of Lhasa, the Dalai Lama, the Panchen Lama and the Zhangjia National Preceptor of Beijing. Lhamo was a pre-Buddhist goddess with both wrathful and benevolent attributes, associated with the propagation of disease as well as healing, but she was later brought into the Buddhist pantheon and revered as a deity of wisdom and good fortune. The story of Lhamo's transformation relates that in a previous existence she was married to a king of Lanka who viciously persecuted Buddhism. Lhamo vowed to stop him and threatened to kill their equally wicked son if he did not desist. In the end, she not only murdered their son, but she also drank his blood from his own skull, ate his flesh, and flayed his skin for a saddle blanket. Her

enraged husband tried to kill her as she escaped but managed only to shoot her mule with an arrow. Lhamo removed the arrow and healed the mule's wound into a third eye that allowed him to see in all directions, the better to protect the Buddhist dharma.[1]

Lhamo is often depicted, as here, in black-ground thangkas, which are not meant for public display. This image was painted in 1777 by artists in the Zhongzheng dian (Hall of Central Righteousness), the centre of Tibetan Buddhism in the Forbidden City during the Qing period.[2] Following iconographic norms, Lhamo has one face, two arms, three eyes, fangs and a flaming aureole. She wears a five-skull crown, a garland of decapitated heads and a snake as her belt. She carries a blood-filled *kapala* skull cup and rides her faithful mule, which is equipped with the saddle blanket made of her son's flayed skin and a pest-filled pouch.

The Qianlong Emperor's lengthy poetic eulogy to Lhamo, inscribed at the top of the thangka in Chinese, Manchu, Mongolian and Tibetan, enumerates, by his count, a total of 29 figures, as well as four small 'hidden images' in Lhamo's hair. At the very top are (left to right) Guhyasamaja, Vajrabhairava, and Cakrasamvara, the three main objects of Gelugpa practice, all with their consorts. The three couples are protected by two dragons in the clouds below. In the centre, Lhamo (here identified by her alternative Sanskrit name, Remati) and her mule charge through a sea of blood, accompanied by Makaravaktra, who has the head of a crocodilian *makara*, and the lion-headed Simhavaktra. The group of Images of All the Buddhas of Great Benefit to Everything (Chinese: *wanshi da liyi zhuxiang fo*), mentioned in the Zhangjia National Preceptor Rolpay Dorje's inventory tag of 1778, consists of eighteen figures: a more benign form of Lhamo as the goddess of the Four Seasons, who sits just below her main horrific figure, the Five Long Life Sisters in a row along the bottom, and the Twelve Goddesses who are part of Lhamo's regular retinue. Two of the twelve flank her, with ten arrayed below.

The thangka's painted frame is decorated at the top with the Seven Treasures of the Cakravartin-World

Ruler, the Eight Buddhist Treasures on both sides, and dragons chasing pearls on the outer borders. The date, in accordance with 1777, is written in Chinese, Manchu, Mongolian and Tibetan in the outer side borders. PB

43

Embroidered table skirt with the Eight Auspicious Symbols and the Seven Royal Treasures

Eighteenth century

Embroidered silk, 80 × 224 cm

The Palace Museum, Beijing, Gu76642

SELECT REFERENCES: Robinet 1990; T 1050, p.61a–c; Macau 2003, no.106.6

This large table skirt is made of yellow fabric and decorated with embroidered patterns with couched gold thread. At its very centre is a sizeable *vajra* thunderbolt in the shape of a cross set on a lotus throne. At the intersection of the crossed-*vajra* is a Daoist *taiji* (Supreme Ridgepole) emblem. While crossed-*vajras* are an emblem of supreme power and equilibrium, the *taiji* diagram symbolises the unity of the forces of *yin* and *yang* within the Dao (Way). This combination of a crossed-*vajra* and *taiji* represents a synthesis of Buddhism and Daoism.

Surrounding the *vajra* are the Seven Royal Treasures floating among flower scrolls. Beside the *vajra* and suspended from the top are two bands embroidered in Tibetan alphabets with the 'Six-Syllable Mantra': Avalokitesvara Bodhisattva's mantra *om mani padme hum* that promises merits and blessings. Each syllable has its own lotus pedestal, emphasising the sacredness of these words. The top register of the skirt is embroidered with the Eight Auspicious Symbols flanking three flaming jewels in the centre. HMS

44

Altar set: a pair of flower vases, a pair of candlesticks and a censer

Qianlong mark and period

Flower vases: cloisonné enamel, silver, stained ivory and semi-precious stones, height 58 cm; candlesticks: cloisonné enamel and lacquered wood, height 43 cm; censer: cloisonné enamel on copper alloy, height 22.7 cm

Qianlong four-character reign mark

The Palace Museum, Beijing, Gu200662, 1–5

SELECT REFERENCES: Brinker and Lutz 1989, pp.133–42, no.267; Palace Museum 1992B, nos 100, 109.1, 114; Watson 1993, p.161; Taipei 1999B, no.82; Macau 2003, no.106-4

This five-piece altar set comprises one censer in the form of a *ding* tripod, two candlesticks and two flower vases. The exteriors of these vessels are decorated with floral patterns in cloisonné enamels. During the Qianlong era, large quantities of enamelled wares were commissioned and manufactured at the imperial cloisonné workshops under the supervision of the Palace Workshops (Zaoban chu).

The set is likely to have been used on an altar in front of Buddha images in a Buddhist ceremony. Incense and flowers are mentioned in the *Lotus Sutra* as two of the ten offerings to the Buddha. Lamps and candles are common offerings in Buddhist worship for they are metaphors for the Buddhist wisdom that lights up darkness and dispels all ignorance. The two vases hold artificial flowers, which guarantee a perpetual supply of offerings. HMS

45

Set of Seven Royal Treasures: Golden Wheel, Horse, Elephant, Loyal General, Able Minister, Woman, Divine Pearls

Eighteenth century

Dark green jade, gold and semi-precious stones on sandalwood, jade and silver-inlaid stands, height 32 cm

The Palace Museum, Beijing, Gu93237, 1–7

SELECT REFERENCES: Tokyo 1985, no.39; Yen Chuan-ying 1986; Palace Museum 1992B, no.138; Zhang Guangwen 1995, no.114; Taipei 1999B, no.80; Zhu Renxing 1999

The Seven Royal Treasures consist of a golden wheel (here apparently wrapped in a piece of luxurious cloth), dark swift horses, white elephants, loyal generals, able ministers of the Treasury, jewels of women, and divine pearls.

According to the Indian myth, only the 'wheel-turning sage king' (Sanskrit *cakravarti-raja*) possessed the Seven Treasures, which would aid him in ruling his domain. Later, the Seven Royal Treasures were inherited by Buddhism and taken as offerings presented to Sakyamuni Buddha. Besides, the association of the Seven Treasures with the sage kings, with whom the Chinese emperors often liked to identify themselves, made the symbols a popular motif for decoration in the imperial palace.

These representations of the Seven Treasures are carved out of blocks of dark green jade, and inlaid with gold and small plaques of semi-precious stones, such as lapis lazuli and turquoise. The pedestals are made of sandalwood with silver inlays and furnished with jade plaques of openwork. HMS

46

Set of Eight Auspicious Symbols: Wheel of the Law, Conch Shell, Victory Banner, Parasol, Lotus, Vase, Paired Fish, Endless Knot

Eighteenth century

Dark green jade, gold and semi-precious stones on sandalwood, jade and silver-inlaid stands, height 32.5 cm

The Palace Museum, Beijing, Gu100739, 1–8

SELECT REFERENCES: Tokyo 1985, no.40; Palace Museum 1992B, nos 99.1, 103, 108.1, 109.1, 139; Zhang Guangwen 1995, no.116; Taipei 1999B, no.81; Zhu Renxing 1999B

The Eight Auspicious Symbols of Buddhism represent eight aspects of the Buddhist blessings. The wheel represents the auspiciousness of the turning of the wheel of the Dharma or spreading the Buddhist teachings. The white conch symbolises the profound and far-reaching sound of the Dharma teachings. The precious parasol refers to the protection provided by Buddhism to preserve beings from myriad sufferings. The treasure vase symbolises an endless rain of all the benefits of this world and liberation. The lotus flower is a symbol of purification and full blossoming of good deeds. The golden fish, usually swimming freely in pairs, represent the freedom from all restraint on attaining Buddhahood. While the victory banner symbolises the complete victory of the Buddhist doctrine over all destructive forces, the endless knot is an emblem of the eternal union of wisdom and great compassion at the time of enlightenment.

Free-standing sculptures of the Eight Auspicious Symbols, along with votive stupa miniatures, form a larger group of offerings that were often displayed on the altar table of various Buddhist chapels in the Qing imperial palace. HMS

47

Anonymous
The Qianlong Emperor in Buddhist Dress, Puning si

c. 1758

Thangka, colours on cloth, 108 × 63 cm
Inscription in Tibetan
The Palace Museum, Beijing, Gu6485
SELECT REFERENCES: Palace Museum 1992B, no.32; Nie Chongzheng 1996, no.46; Macau 2003, no.56

At least eight paintings survive in which the Qianlong Emperor appears at the centre of an assembly of Buddhist deities. In all eight, he assumes a multifaceted spiritual and political identity as monk, bodhisattva and world-ruler. He wears the monastic robes and hat of the Tibetan Gelugpa (Yellow Hat order), while the lotuses that rise above his shoulders bear a sword and *Prajnaparamita (Perfection of Wisdom)* sutra, the attributes of Manjusri, the bodhisattva of wisdom. He holds the *cakra*-wheel of a Buddhist wheel-turning world-ruler in his left hand and forms the *vitarka mudra* (discussion gesture) with his right.[1] In this version, he is flanked by the green Earth-Treasure bodhisattva Ksitigarbha (left) and the golden Samantabhadra, bodhisattva of perfect goodness (right). A field of assembly, with each figure identified by Tibetan inscription, fills the upper part of the painting, headed at the top by the historical Buddha Sakyamuni. The Zhangjia National Preceptor, Rolpay Dorje, the Emperor's guru and the direct conduit for the descent of the dharma from Buddhism's founder to the Qianlong Emperor, appears in a roundel immediately above the Emperor's head. Seventeen red-robed monks sit around a lotus pond below the Emperor's seat and three great protectors (Sridevi, the Tibetan Lhamo, right; Dharmaraja, left; and Mahakala, centre) occupy the bottom register. The painting was a collaborative effort, involving artists trained in the Tibeto-Mongol and Chinese traditions of the Qing court, and, perhaps, the Italian Jesuit painter Giuseppe Castiglione (1688–1766), who may have been responsible for the startling and vividly realised rendition of the Qianlong Emperor's face.

The Tibetan inscription, written on the front of the Emperor's seat, reads: 'Manjusri, sharp-witted sovereign of men; Playful,

unexcelled, great dharma king; On the diamond (*vajra*) seat, feet firm; May your wishes spontaneously meet good fortune!' The first words of verses 1–3 contain a separate, hidden message: (1) Manjusri and (2–3) the name Rolpay Dorje (literally, 'Playful Vajra'), aligning the Manjusri Emperor securely with his guru.[2]

This portrait was once kept in the Puning si (Temple of Universal Tranquillity), one of the Eight Outer Temples at the Qing imperial summer retreat in Rehe (present-day Chengde). The Puning si was constructed between 1755 and 1758 and was ultimately dedicated in commemoration of the submission of the Zunghar Mongols to the Qing empire.[3] PB

48

Ceremonial costume for an imperial lama: collar, sleeves, skirt and beaded apron

Eighteenth century

Polychrome floss silk and metal thread embroidery on silk satin ground, silk and metal thread brocaded binding around the edge, and stained ivory, length of skirt 96 cm, collar 122 × 95 cm
The Palace Museum, Beijing, Gu59529
SELECT REFERENCES: Taipei 1971, nos 3–4; Taipei 1999B, nos 33–35; Macau 2003, no.93; Chicago 2004, nos 153–55

This multi-part outfit is made from red silk-satin, and comprises a collar, a skirt and sleeves. It would have been worn by a monk with a diadem and under a net of beads and plaques. The collar consists of four large cloud-shaped panels, the remaining space in each of which is filled with the Eight Auspicious Symbols. A Buddha portrait and an additional cloud hang from the bottom of the collar. The skirt is embroidered with an ocean at the bottom in addition to two pairs of gold fish and auspicious symbols such as bats and sea horses among flowing clouds. The beaded apron is made of twenty-eight strings of stained ivory beads hung from the waistband of the skirt. The long strings of beads are further interspersed and interconnected with plaques carved with various symbols. Gilt bells and tassels hang at the ends of the long strings. The costume is completed by bead earrings, arm bands and a girdle. Similar costumes may be seen on the images of a variety of deities.

Such costumes were worn by lamas chiefly during ceremonies for exorcising demons. The embroidered image of Sakyamuni Buddha making the earth-witness gesture serves as a reminder to the devotee of the possibility of resisting the temptation of evil and attaining enlightenment. In the twentieth year of the Qianlong Emperor's reign (1755), lamas were summoned to the court from Tibet to teach sacred dances. Thereafter costumes were prepared for them and for court lamas at the imperial workshops for performances in rituals and ceremonies. HMS

49

The Qianlong Emperor (1711–1799)
On Tibetan Buddhism (Lama shuo)

1792

Handscroll, ink and colour on paper, 35 × 230 cm
Chinese, Manchu and Mongolian (?) inscription
The Palace Museum, Beijing, Gu238658
SELECT REFERENCES: Lessing 1942; Rawski 1998, pp.244–63; Wang Xiangyun 2000; Berger 2003

The text of this handscroll, in the Emperor's own hand, seems to be the same text that was carved in Chinese, Manchu, Mongolian and Tibetan on a stele in the courtyard of the Yonghe gong (Palace of Harmony) in the northeast quadrant of the Forbidden City, and translated into English by Ferdinand Lessing. In 1744 the Qianlong Emperor transformed this former princely residence into a teaching centre and academy for the Gelugpa order of Tibetan Buddhism, which had five to six hundred Mongol, Manchu and Tibetan monks in residence during the eighteenth and early nineteenth centuries.

Lama shuo is often cited as proof that the Qianlong Emperor's patronage of Tibetan Buddhism was solely motivated by state policy, the desire to 'maintain peace among the Mongols', one of the five peoples whom he identified as the primary subjects of his empire. Qing patronage of Tibetan Buddhism began in the 1620s, but the assumption that the Qianlong Emperor had no personal interest or commitment to this belief system has been challenged by recent scholarly works. The Chinese translation of a biography of the Qianlong Emperor's spiritual teacher, Rolpay Dorje (1717–1786),

the Zhangjia National Preceptor, and Zhangjia Hutuktu ('Incarnate Zhangjia', a Buddhist spiritual leader of the Gelugpa order) shows that the Qianlong Emperor was a serious student of the religion and assiduous in his Buddhist practice. He built Tibetan Buddhist altars within the Forbidden City for his personal meditation. Unlike his uncle, Yinli (Prince Guo, 1697–1738), the Qianlong Emperor was not a noted Tibetan Buddhist scholar but is best known for the enormous body of Tibetan Buddhist religious works, in a wide variety of media, that he commissioned. The recent analysis of some of these works by Patricia Berger persuasively lays a case for the Emperor's deep involvement with 'a Buddhist view of the world'. ESR

50

Scripture of Great Perfections (Dadujing)

1743

Unbound leaves, gold on paper, each 21.6 × 62.7 cm; boards: painted lacquer on wood, each 12.9 × 49.5 cm

The Palace Museum, Beijing, Zong23678

SELECT REFERENCES: Pal 1983, p.114, nos M1–M7; Palace Museum 1992B, pp.112–13, nos 83–93

Just as the image represents the body of the Buddha, the texts are a manifestation of the Buddha's teachings. Reading the sacred texts is as important as venerating Buddha images. Written in Mongolian by hand with wet gold powder on both sides of leaves of rectangular blue-dyed paper, this *Scripture of Great Perfections* is clipped by two lacquer-painted wooden protectors and wrapped in fine silk. The concave interior of the top protector is decorated with the figures of Sakyamuni Buddha and the great lama Tsongkhapa (1357–1419), flanking the name of the sutra. The interior of the bottom protector is painted with the images of four Heavenly Kings, Buddhist protective deities. All the figures are covered with three layers of silk brocades. On the side of the pile of sutra text are lotus scrolls painted in gold.

The particular format of the manuscript is adopted from Tibetan books, which in turn followed the Indian type of birch-bark or palm-leaf manuscripts. Unlike Indian and Nepali prototypes of the tenth to twelfth centuries, Tibetan books were written on paper, whose man-made flexibility permitted them to

be considerably larger. Also, as in Indian manuscripts, representations of divine figures are placed either in the centre or at the end of a page, and often on the wooden covers as well. Such images may or may not relate to the text. However, it was believed that they would protect the manuscripts from harm, and further increase the potency of the text. HMS

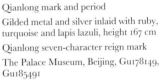

51

The Zhangjia National Preceptor

1786

Partial-gilt silver, height 75 cm

The Palace Museum, Beijing, Gu203431

SELECT REFERENCES: Palace Museum 1992B, no.36; Macau 2003, no.13

The Zhangjia National Preceptor, Rolpay Dorje (1717–1786), one of the main incarnations of the Tibetan Buddhist Gelugpa, was charged by the Qing court with authority over Buddhist affairs in China and Inner Mongolia. He was brought to Beijing from Tibetan Amdo (now Qinghai Province) in 1724. As a student at the princely academy in the Forbidden City, he became fast friends with his classmate, Hongli, the Yongzheng Emperor's fourth son, who ascended the throne in 1736 as the Qianlong Emperor. Rolpay Dorje eventually served as the Qianlong Emperor's National Preceptor and guru. He was an acclaimed linguist and iconographer who translated the Tibetan canon and commentaries into Manchu, wrote a perceptive treatise on translation, compiled a pentaglot dictionary and designed numerous pantheons of Tibetan Buddhist deities. The Qianlong Emperor entrusted Rolpay Dorje with delicate diplomatic assignments, including the discovery of the Eighth Dalai Lama in 1757, negotiations concerning the reincarnation of the Jebtsundamba Hutuktu ('Incarnate Jebtsundamba') in Outer Mongolia in the 1770s, and arrangements made for the Sixth Panchen Lama's visit to the Qing court in 1780.

According to court records, this keenly observed portrait sculpture of Rolpay Dorje, depicted in the prime of life, was made at the Qianlong Emperor's order by artists in the Forbidden City's main manufactory, the Zaoban chu (Palace Workshops), immediately after the lama's death in 1786. It was enshrined in the east

side hall of the Pavilion of the Rain of Flowers (Yuhua ge), which Rolpay Dorje reconfigured in the 1750s as a meditation chapel for the Emperor's use. A few years before Rolpay Dorje's death, in 1780, the Qianlong Emperor enshrined a stylistically similar portrait of the Sixth Panchen Lama in the side chamber on the west side of the compound, after the latter died of smallpox in Beijing. PB

52

Stupa

Qianlong mark and period

Gilded metal and silver inlaid with ruby, turquoise and lapis lazuli, height 167 cm

Qianlong seven-character reign mark

The Palace Museum, Beijing, Gu178149, Gu185491

SELECT REFERENCES: Palace Museum 1992B, no.119; Rhie and Thurman 1999, pp.413–14, 416; Berger 2003, p.109, fig.30; Chicago 2004, nos 158, 173

A burial mound of Indian origin, the stupa was subsequently developed by Indian Buddhists to contain relics or mark sacred sites. When Sakyamuni Buddha was cremated, his bodily remains were divided and enshrined in stupas. In Buddhist practice, to construct a stupa is a meritorious act.

Invested with a strong Tibetan flavour, this gilt-bronze stupa has a dominant bell-shaped dome body and a tall upper structure comprising a square platform, thirteen wheels and a central post. Further decorations of the sun and moon on a lotus bud and two flanking banners are placed on top of the stupa, adding to its grandeur. While strings of beads stemming from bull-heads decorate the upper part of the dome body, an additional row of *vajra* thunderbolts adorns the lower rim of the body. The sandalwood throne is carved into the shape of Mount Sumeru and decorated on each side with two gilt lions flanking flaming jewels.

The goddess of long life, Usnisavijaya (Triumph of the Buddha's Usnisa Crown-dome), appears within the niche of this ornate stupa. Usnisavijaya is one of the three deities of longevity of Tibetan Buddhism, the other two being Amitayus Buddha and White Tara. She has three faces and eight arms. The front pair of her eight hands holds a *vajra* cross in her right and a rope in her left; the second pair of her hands holds the golden

vase of the elixir of immortality in her left; the third pair holds the arrow and bow, symbols of the universal reach of compassion and wisdom; and the top pair holds in her right a miniature Amitayus. HMS

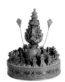

53
Mandala

Eighteenth century
Gilt bronze and cloisonné enamels, height 56 cm
The Palace Museum, Beijing, Gu185348

Mandalas (*tancheng*) are schematic representations of sacred space used as supports in Buddhist initiation and consecration rituals. They can be subtle or material in nature, imagined in the mind or given actual visual form as deliberately transient constructions made of coloured sand, as complex paintings or as three-dimensional architectural models.

This three-dimensional mandala is a typical product of the cloisonné workshops of the eighteenth-century Qing court. Brilliant enamels and gilt emulate the slabs of gold, diamond, lapis and other gems described in canonical texts. The mandala is envisioned as a group, Chinese-style and gathered around a central shrine. This round palace, the inner sanctum of the lord of the mandala, sits on top of Mount Sumeru, which resembles a closed lotus rising from the ocean and marks the cosmic axis. Smaller square pavilions, bodhisattvas, guardians and auspicious offerings line the edge of the base. Monstrous faces, interspersed with the syllables of the most widely disseminated of all mantras, *om mani padme hum*, ring the foundation wall. Two clouds, held aloft by wires, bear the Chinese characters for 'sun' (*ri*) and 'moon' (*yue*). This element and the overall design suggest that this mandala was intended to emulate another three-dimensional mandala in the Qing imperial collection, given as a gift by a Dalai Lama.[1] PB

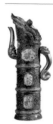

54
Buddhist tea ewer and cover (*duomuhu*)

Qianlong period, Palace Workshops, Beijing
Gold body inlaid with stones and cloisonné, inset with framed raised panels showing scenes of flowers, figures and landscapes in painted enamel, 50.4 × 14 cm

Qianlong four-character mark engraved on a cartouche at the foot
Private collection

The opulence of the Qianlong court can hardly be illustrated more impressively than by a piece such as this ewer. Unlike most cloisonné pieces, this ewer is not made of gilt-bronze, but of solid gold. A similar combination of cloisonné and painted enamels, which required different production processes, was also rarely undertaken. The piece is shaped after a wooden vessel with metal bands, probably used for buttered tea in Tibetan Buddhist ceremonies (see the *faux-bois* copy, cat.55). The transformation of a humble ritual utensil into an item of the utmost imperial splendour was one of the Emperor's many deliberate manifestations of his deep personal commitment to the patronage of Tibetan Buddhism.

Spout and handle issue from dragon's heads and the handle terminates in a dragon's tail. The horizontal bands, which echo the metal bands that hold wooden ewers together, are decorated with chased floral scrolls inlaid with jewels. Set into the cloisonné are nine variously shaped plaques of painted enamel, with gold wire details, which display the characteristic painting style and pastel colours of the Palace Workshops at the time. They depict Chinese landscapes and seasonal flower scenes – roses, peonies, chrysanthemums and hibiscus – as known from painted album leaves, together with Western genre scenes of ladies with children, as introduced by Jesuit painters working at the court. This iconographical drift from the religious to the mundane may seem surprising for a ritual ewer. It suggests that the Jesuit transformation of the romantic pastoral scenes of the French Rococo into demure pictures of mothers with children made the subject acceptable even in this context. Two very similar ewers are recorded, but vessels of such lavish execution were otherwise extremely rare, even in a palace context. RK

55
Duomuhu ewer simulating wood with gilt-bronze hoops

Yongzheng or Qianlong period, Jingdezhen, Jiangxi Province
Porcelain with enamels and gilding, height 45 cm
The Palace Museum, Beijing, Gu152677
SELECT REFERENCES: Qing Porcelain 1989, p.422, pl.104; Chicago 2004, cat.239

56
Buddhist longevity vase (*bumpa*) simulating pewter with gilding and jewels

Qianlong period, Jingdezhen, Jiangxi Province
Porcelain with enamels and gilding, height 26.4 cm
Qianlong six-character seal mark inscribed in gold on the base
Victoria and Albert Museum, London, Salting Bequest, c.499-1910
SELECT REFERENCE: Kerr 1986, pl.59

These two vessels are high-quality imperial versions of modest utensils used in Tibetan Buddhist rituals. The ewer, with its phoenix spout, dragon handle and lion knob, imitates a wooden vessel with metal hoops and mounting, such as would have been used for buttered tea in Lamaist monasteries. The longevity vase successfully simulates a hammered, parcel-gilt pewter vessel set with pieces of turquoise and coral. Such vases, emblems of the Buddha Amitayus and thus associated with eternal life, occupied a central role in Buddhist rituals, in which they were used for holy water. In both cases porcelain versions provided more elegant and hygienic alternatives to the original materials, and were made in many designs. The present vessels, however, which are based on Tibetan originals, were intended to bring the rituals actually performed in Tibetan monasteries closer to the court. True luxury versions of these vessel shapes also existed, however, fashioned of precious materials. Examples include a bejewelled gold ewer (cat.54) and a silver-gilt vase (cat.57).

Trompe-l'oeil effects were first explored by the Jingdezhen kilns under the Yongzheng Emperor (see cat.180), but were much more frequently employed in the Qianlong reign (see cat.236). RK

57

**Buddhist longevity vase (*bumpa*)
for dried Tibetan herbs**

Eighteenth century

Silver gilded in parts, inlaid with
turquoise and another semi-precious
stone, height 32 cm

The Palace Museum, Beijing, Gu141464

SELECT REFERENCES: Palace Museum 1992B,
no.146; Taipei 1999B, no.88; Macau 2003,
no.86

The constricted bottom of this
silver vase spreads upwards and
connects with a narrow neck
curving outwards at the rim.
The mouth of the vase is gilt and
decorated with lotus scrolls and lotus
petals in relief. A *bumpa* vase was
originally a water container used
in Tibetan Buddhist ceremonies.
Offerings of *bumpa* vases were often
found in the Buddhist temple halls
of the Qing palace. Archives at the
court show that the *bumpa* was
also used to contain holy herbs or
peacock feathers. A similarly shaped
vase in the collection of the National
Palace Museum in Taipei has an
additional tube inserted to the
mouth and holds a bunch of dried
Tibetan herbs.

From the fifty-seventh year of the
Qianlong era (1792), the Qing court
practised the drawing of lots from
the Golden Urn to determine the
succession of the highest Tibetan
and Mongolian incarnate lamas of
the Gelugpa (Yellow Hat) order.
A *bumpa* was, in this case, used as
the Golden Urn. HMS

58

Kapala **skullcup**

Eighteenth century

Human skull with silver-gilt pedestal and
cover inlaid with semi-precious stones,
height 26.5 cm

The Palace Museum, Beijing, Gu185717

SELECT REFERENCES: Taipei 1971, nos 24–25;
Pal 1983, no.R5; Paris 1997, no.56; Taipei
1999B, nos 97–100

Kapala skullcups, which serve as
emblems of terrifying deities, are
one of the principal ritual
implements of Tibetan Buddhism.
They are made from the skulls of
donors, usually persons of special
rank, wisdom or holiness. Only after
meeting the approval of the lamas
can a skull be made into an offering
vessel for presentation to the divine
beings. Rules regarding colour,
markings and texture of the skull
govern the lamas' selection of skulls
found in cemeteries and elsewhere.
The interior of the cup is plated

with a hammered sheet of silver.
The edge of this human skullcup
is fitted with a gilt-silver rim. The
cover, also fashioned of gilt silver,
has a crossed-*vajra* thunderbolt
symbol on top, surrounded by the
Eight Auspicious Symbols and floral
patterns worked in relief and inlaid
with small pieces of semi-precious
stones. The cup is set on a gilt
triangular stand with human heads
placed at the three corners. HMS

59

**Alms bowl incised with the
*Heart Sutra***

Eighteenth century

Green jade, height 8.6 cm

The Palace Museum, Beijing, Gu103516

SELECT REFERENCES: Taipei 1971, nos 26–28;
Palace Museum 1992B, no.134; Zhang
Guangwen 1995, no.117; Taipei 1999B,
nos 84–87

A *patra* (in Sanskrit) is a bowl or
a dish used by a monk or a nun as
a receptacle for food at mealtimes,
or for alms received during begging.
Monks and nuns traditionally have
only a few basic possessions. As
one of these, alms bowls became
a symbol of the simple life of the
monastic community.

This deep, round example, flat-
bottomed and curving inwards at
the rim, is cut from a large piece
of dark green jade, which is flecked
with a number of white spots. The
exterior of the bowl is covered with
inscriptions of the complete text
of the *Heart Sutra*. Executed in
standard-script Chinese, these are
carved into the surface and filled
in with gold.

The *Heart Sutra* (in Sanskrit
Prajnaparamita-hrdaya) is a very short
Mahayana sutra that articulates the
meaning of emptiness. Of the seven
Chinese translations, by far the
most popular is the rendition by
the Tang period monk Xuanzang
(602–664), which is transcribed
on this bowl. HMS

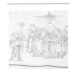

60

*Scripture of the Yellow Court
(Huangtingjing)*

Qianlong mark and period

Ink on paper, box: carved red lacquer
on wood, 34.4 × 15.5 × 8.6 cm

Seven-character Qianlong reign mark

SEALS: *Qianlong chen han*, *Wei jing wei yi*

The Palace Museum, Beijing, Yu2298,
Yu2299

SELECT REFERENCES: Schipper 1975; Robinet
1993; Kroll 1996; Chicago 2000, no.128

The *Scripture of the Yellow Court
(Huangtingjing)* is a fourth-century
Chinese meditational text that
survives in two different versions,
the *neijing* (inner scripture) and the
waijing (outer scripture). The text
encompasses several layers of
doctrines and practices in the Daoist
tradition, including the notions of
cosmology, theories related to
classical medicine, and views of the
human body. The human body
is perceived as an administrative
system governed by inner gods
who inhabit the brain and organs.
Visualising these inner gods is one
of the methods to cultivate one's
body, so as to ensure the production
within and ultimate escape from
one's mortal frame of a refined and
purified embryo, in order to gain
eternal life.

The scripture book consists of
two volumes with each sheet of
paper folded in two. The covers
and slipcase are pasted with floral-
pattern quality brocade, and the
slipcase lined with yellow paper.
The book is further packed in a
carved red lacquered box, which
is decorated with the assembly of
Daoist celestial beings on one side,
and an inscription reading *Da Qing
Qianlong nian jing zao* (Made with
reverence in the Qianlong era of
the Great Qing) on the other.
The duplication of scriptures is
considered a meritorious practice
in both Buddhism and Daoism.
The most well-known example of
a transcription of the *Scripture of the
Yellow Court* is that by Wang Xizhi
(303–361), who was not only an
acclaimed calligrapher but also a
devout practitioner of Daoism. The
present copy, executed in the ninth
year of the Qianlong Emperor's
reign (1744), shows the Emperor's
interest in Daoist self-cultivation
practices. HMS

5 Territories of the Qing

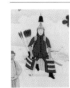

61

Anonymous court artists
*Portrait of the Kangxi Emperor in
Military Attire*

Kangxi period

Hanging scroll, ink and colour on silk,
112.2 × 71.5 cm

The Palace Museum, Beijing, Gu6415

SELECT REFERENCES: Palace Museum 1992,
pl.12, p.50; Yu Hui 1995, p.43; Nie
Chongzheng 1996, vol.14, pl.2, p.4; Macau
1999, pl.1; Edinburgh 2002, pl.1, p.28

This portrait and the painting of the Kangxi Emperor holding a brush (cat.120) are rare depictions of the monarch at a relatively young age, around thirty years old. Although not a pair, the two works together exemplify the dichotomous traits expected of every ideal ruler: that he should possess both a literary (*wen*) and a martial (*wu*) persona. As word of both paintings spread around the still-youthful Emperor's court, their polar imagery would have served him well, since balance between *wen* and *wu* had long been part of the Chinese conception of statecraft.

For the early Qing monarchy, the balance between these two imperial roles was especially critical and potentially dangerous if out of line. Since the Chinese literati were the backbone of the Qing empire, their support was an essential part of an emperor's power-base, and holding a calligraphy brush was an effective pictorial means to communicate identification with that group.

But the Kangxi Emperor, heir of the conquest generation and himself a voracious advocate of territorial expansion, had a stronger sense of personal identity as a martial emperor. Manchus were skilled archers and this image of the Emperor wearing a ceremonial helmet and armour with crossbow and sword at hand projected a sense of his Manchu identity and his talent as an able military commander-in-chief.

It is unlikely that the Emperor 'sat' for this portrait in the Western sense. He may have been shown the painting with the figures – the Emperor and attendant officials, swordsmen on his right and archers on his left – completed as stock images. After approval of this stage, the highly individualised faces would have been inserted, before the portrait's presentation to the monarch for his final approval.

In traditional Chinese portraiture the Emperor always appears significantly larger than anyone else. Unlike in early Manchu practice in which princes conferred with each other on more or less equal terms, the Kangxi Emperor is here shown having adopted the distinctly Chinese hieratic view of imperial position. Since the monarch is positioned further away than his officials, and he is seated, he should appear smaller, but does not. But in a slight nod towards the adoption of new Western systems of perspective

for group portraiture, the imperial presence is not inordinately larger. JS

62

Mineral-blue armour with silk lining decorated with a pattern of clouds and dragons

Kangxi period, seventeenth century
Silk satin with floss silk embroidery, lined in silk and padded, gilt bronze bosses and epaulettes bordered with gilt dragon motifs inlaid with coral, agate and malachite, tunic length 78 cm, apron length 92 cm
The Palace Museum, Beijing, Gu44498

Tradition decreed the emphasis of military achievements in the Qing dynasty. Emperors needed to practise the arts of using the spear and mounted archery in order to be vigilant in peacetime, and to remember their ancestors' teachings. From the twenty-first year of his reign (1682), the Kangxi Emperor had organised several large-scale military training events each year to enhance the combat skills of his armies. He also listed hunts and the protocols, formats, locations and correct dress for great military reviews in his decrees and regulations. Emperors frequently took the opportunity to review military equipment and the martial skills of their armies. The troops of the Eight Banners were divided according to their flags and armour-colours, and were required to demonstrate their various skills in turn, including use of cannon, spear, mounted archery, battle-array distribution, 'cloud' ladders (for scaling walls during sieges), among other skills. Emperors and royal household officials of the Qing dynasty all wore helmets and armour when participating in such activities.

The Kangxi Emperor's armour was made by the Suzhou Imperial Textile Factory. It consists of a tunic and apron. At the shoulders is a cord and connected shoulder protector. The borders of the shoulder protectors are decorated with gilded copper with a gold-engraved dragon pattern. The armour has protectors at the armpits, and is equipped with a trapezoidal *qian dang* (front protector) section at the front seam, designed to protect the stomach, and a *zuo dang* (left protector) to the left of the waist for wearing a sword. The apron section is divided into left and right parts, and is tied at the

waist with a cord. The silk surfaces of the tunic, apron and accessories are all decorated with gilded copper studs, and embroidered with a five-colour cloud dragon, waves and river cliffs, and precious emblems. Note especially that the dragon patterns of the tunic and apron are of a rising dragon, and that the accessory decorations are all frontal images of dragons, denoting the particularly high status of emperors in the Qing dynasty.

The tunic, apron and accessories are all connected to one another with buttons, except the shoulder protectors, which are connected with cords. The apron is put on first, followed by the tunic, and lastly the accessories. This set of cotton armour lacks a helmet. YH

63

Sedan chair

Qianlong period
Lacquered wood, partially gilded, 400 × 110 × 110 cm
The Palace Museum, Beijing, Gu169033, 1

This sedan chair would have been used to transport the Qianlong Emperor around the palace and its gardens during the summer and autumn months. Although it is more than two hundred years old, the chair's lacquer is in remarkable condition and retains the lustrous shine that is the result of repeated polishing.

The back and arms are in the form of a large horseshoe, with curved armrests carved in the shape of life-like and vigorous dragons emerging from the sea with heads held high. The bowed back splat is decorated in relief with a design of dragons, clouds and waves in gold lacquer. The areas beneath the seat are decorated with dragon and cloud designs in gold lacquer against a black lacquer ground, and supported by incurved legs carved with deep grooves resting on a base stretcher. Two poles, which four bearers would have supported on their shoulders providing a smooth and comfortable ride, are fastened to the flanks of the seat.

The piece was made by the Palace Workshops (Zaoban chu) during the Qianlong period. The Qianlong Emperor paid great attention to lacquer articles made by the Imperial Household Department (Neiwu fu); before any article was made for palace use, he

would personally examine and revise designs, and look over, admire and comment on the finished product. As a result lacquer craft improved rapidly. YH

64

Imperial patent of nobility (*Fengtian gaoming*) in Manchu and Chinese scripts awarded to Qiu Lianhui and his wife, He

1722
Roll, ink on coloured woven silk panels backed with paper, retained by a polychrome silk braid and bronze (?) toggle, 31.2 × 365.1 cm
The British Library, London, Or.5427
SELECT REFERENCES: Simon and Nelson 1977, no.I.35, p.36; New York 2000, no.64, pp.234–36

This imperial patent was awarded in the 61st year of the Kangxi Emperor's reign (1722) to a certain Qiu Lianhui. His wife, whose maiden name was He, received the title of Gongren.

In keeping with countless other such patents, or ordinances, issued in recognition of loyalty during the Qing period, this example is composed of panels of white, dark grey, red, mustard and dusky pink woven silk. The retaining braid has yellow, white, blue and red stripes, recalling the colours associated with the banners, administrative divisions into which the Manchus and other members of the conquest group were organised. Two vertical 'imperial' confronting dragons with five claws are woven into the beginning and the end of the roll at either side of the title –'Patent by ordinance [of the Emperor] entrusted by heaven' (*Fengtian gaoming*) which is also woven. Stylised clouds, the natural abode of these auspicious animals, are arranged across the surface.

Six of the panels bear parallel text handwritten in black and red ink (the latter often indicated the Kangxi Emperor's involvement) in the Manchu and Chinese scripts. The large, indistinct red seal, impressed over the date in Manchu, may read *zhi gao* ('proclaiming of a patent') *zhi bao* (imperial seal) and is probably of the type reserved for the authentication of such awards. Following the establishment of the dynasty, Manchu was regarded as an official language of the court. Therefore, unlike most Chinese horizontal scrolls and other documents, such patents are

opened and read from the left. The Chinese translation in vertical columns of characters reads as normal from the extreme right. GHu

65

Giuseppe Castiglione (Chinese name Lang Shining, 1688–1766)
The Qianlong Emperor in Ceremonial Armour on Horseback

1739 or 1758
Hanging scroll (originally a *tieluo* painting), ink and colour on silk, 322.5 × 232 cm
The Palace Museum, Beijing, Gu8761
SELECT REFERENCES: Zhu Jiajin 1988b, pp.82–83; Nie Chongzheng 1996, pl.29; Liu Lu 2000; Edinburgh 2002, no.16

This fine equestrian portrait of the Qianlong Emperor is neither signed nor dated. It was originally a *tieluo* (a painting pasted onto a wall) in a room of the Xinyamen xinggong, the palace at Nanyuan, the imperial hunting reserve south of Beijing. Although the painting is clearly by Castiglione, opinion is divided as to its date. It would have been painted to mark either the first grand military inspection of the Qianlong Emperor's reign, which took place in 1739, or that of 1758, when Burut leaders, who had come from Turkestan to pay homage to the Emperor, were his guests (see cat.28). By entertaining these Muslim cattle breeders first at Mulan (the imperial hunting grounds north of Beijing), then in the Forbidden City (Zijin cheng) and finally on this second great military inspection of his reign, the Qianlong Emperor aimed to impress them, particularly at a time when the outcome of the war in what is now Xinjiang was still uncertain.

This portrait of the Qianlong Emperor shows him as a young man. It is very similar to portraits of him painted at the beginning of his reign, in which he is depicted without the bloated face that marked his appearance from the late 1750s. The clouds rolling across the sky and the meticulously painted clumps of vegetation in the foreground, which are given volume by the use of light and shade, betray the artist's Italian training. Elements like these are typical of Castiglione's work of the 1720s, but are not seen in his paintings from the 1740s onwards. If this portrait does indeed date from 1739, the Grand Inspection that Castiglione was commissioned

to paint in 1758 (as is recorded in the archives) must have been another painting on the same theme.

In this equestrian portrait, the horse and its rider are shown almost life-size. In three-quarter view and gazing at us, the Emperor is dressed in the armour that he customarily wore on his great inspections. In the subject's pose and the horse's attitude, the painting is clearly related to European equestrian portraits. It also has a monumental quality that places it directly in line with ancient Roman equestrian statues. Although he was working in the grand tradition of Chinese horseman painting, Castiglione gave the portrait the ideological dimension which is characteristic of Western equestrian portraiture. In so doing he glorified the Qianlong Emperor as a military commander and a ruler. MPuS

66

Quiver and bow case

Qianlong period
Leather covered with embroidered satin brocade, gilded brass fittings, quiver length 36 cm, bow case length 76 cm
The Palace Museum, Beijing, Gu222011
SELECT REFERENCES: Hu Jianzhong 1990; Wang Zilin 1994; Chicago 2004, no.115

67

Bow

Qing dynasty
White birch wood, sinew, horn, shagreen, length 161 cm
The Palace Museum, Beijing, Xin48694
SELECT REFERENCES: Hu Jianzhong 1990; Wang Zilin 1994; Chicago 2004, no.115

68

Pi (iron-tipped) arrows

Qing dynasty
Wooden shafts, iron and feathers, length 90 cm
The Palace Museum, Beijing, Gu171010/1–5
SELECT REFERENCES: Hu Jianzhong 1990; Wang Zilin 1994; Chicago 2004, no.115

The Manchus took pride in distinguishing themselves from the Han Chinese and other tribes by the traditional Manchu code that they followed: a complete Manchu was skilled in archery, horse-riding, retained the Manchu language and was frugal.[1]

The Qianlong Emperor was especially skilled in archery and this set of quiver and bow case was said

to have been used by him.[2]
The emperors would have worn assemblages such as these not only during hunts in Mulan, the imperial hunting grounds north of Beijing, but also for the military review.

Strict sumptuary rules governed the types of bows and arrows to be used according to both rank and occasion: the Emperor's bow was made of mulberry wood and his arrow shafts of poplar; palace bows and arrow shafts were made of willow; and soldiers used elm bows and birch and willow arrow shafts. Wang Zilin records more than twenty-five different types of arrowheads used during the Qing: some could pierce armour, while those used for hunting emitted a whistling sound as they flew through the air.[3] HK

69
Saddle with ornaments and saddle cloth

Qianlong period

Saddle: brass and silk satin embroidered with floss silk with velvet trimming, damask-weave silk lining and wool wadding, 32.5 × 30 × 67 cm; saddle cloth: damask-weave embroidered silk with velvet trimming, wool wadding and brown cotton lining, 150 × 73.5 cm; tackle: brass, iron, red-dyed horsehair and silk backed with twill-weave cotton

The Palace Museum, Beijing, Gu171546, Gu212430

Emperors of the Qing dynasty were known as 'Emperors on Horseback' (*mashang tianzi*) because of their skill in riding and archery. In order to maintain the status of the Manchu ruling class, they upheld the view that 'Manchu language and archery on horseback were the foundations of Manchuria'.

They also appreciated the beauty of saddle decorations. Among the twenty-four imperial Palace Workshops (Zaoban chu) set up in the imperial palace, one was given over to the production of saddles for the Emperor. This type of saddle decorated with dragons in gilded openwork was made during the Qianlong period for use by the Emperor. The saddle, tall at the front and low at the back, is made of wood and covered with ornaments made from gilded metal cast with a design of densely packed dragons and clouds. The saddlebow is decorated with two rising dragons leaping among clouds, the cantle with two dragons lingering in a sea of clouds. The stirrups are made of

gilded iron. The saddle cushion is made of bright yellow (*minghuang*) and dark blue (*shi qing*) satin embroidered with a design of a five-coloured dragon playing with a pearl. The saddle cloth is also made of bright yellow satin with a five-clawed dragon in the centre surrounded by a border embroidered with the Eight Auspicious Symbols including a wheel, a conch shell, a parasol, a victory banner, a lotus, a vase, a fish and an 'endless knot'.

This saddle, fashioned from precious materials and of the finest workmanship, is considered to be the best of its type. YH

70
Straight sword

Qianlong period

Steel blade, gilt-iron fittings, scabbard covered in red-stained shagreen, length 100 cm

Blade inlaid with Qianlong four-character reign mark in silver, the reverse with *di zi yihao* (no.1 of the Earth category) and *chu yun* (emerge from cloud)

Palace inventory label in Manchu and Chinese: *di zi yihao, chu yun*, weight 26 *liang* (ounces), made in the Qianlong period

The Palace Museum, Beijing, Gu170428
SELECT REFERENCES: Hu Jianzhong 1990; Chicago 2004, p.113

71
Sabre

Qianlong period

Jade handle with Songhua stone- and coral-beaded tassel, steel blade decorated near the hilt with inlaid gold, silver and copper wire, scabbard covered in trefoil-patterned lacquered peach-tree bark, length 95 cm

Blade inlaid with Qianlong four-character reign mark in silver, the reverse with *han feng* (Cold Edge)

The Palace Museum, Beijing, Gu170406
SELECT REFERENCES: Hu Jianzhong 1990; Tokyo 1995, no.11

72
Dagger

Qianlong period

Steel blade, Mughal-style jade hilt inlaid with precious stones, leather scabbard, gilt-iron fittings, length 44.5 cm

The Palace Museum, Beijing, Gu170627
SELECT REFERENCES: Hu Jianzhong 1990; Paris 1997, p.141

73
Sabre

Qianlong period

Steel blade, scabbard covered in green-

stained shagreen, inlaid with dragon design in gilt and silver beads and metal fittings, length 104 cm

The Palace Museum, Beijing, Gu171086
SELECT REFERENCES: Hu Jianzhong 1990; Rotterdam 1990, no.85; Paris 1997, no.14

74
Sabre

Qianlong period

Steel blade inlaid with silver, copper and gold, gilt-iron fittings inlaid with turquoise, scabbard covered in trefoil-patterned lacquered peach-tree bark, length 98 cm

Blade inlaid with Qianlong four-character reign mark in silver, the reverse with *tian zi liuhao* (the 6th of the Heaven category) and *yue ren* (Moon Blade)

The Palace Museum, Beijing, Gu170451
SELECT REFERENCES: Hu Jianzhong 1990; Rotterdam 1990, no.86; Paris 1997, no.13

Although firearms were available during the Qing period, the Manchus favoured the use of so-called 'cold weapons' (*leng bingqi*), such as swords, sabres, spears, bows and arrows, which were effective for fighting at close quarters. All weaponry for the imperial court, from pieces used by the imperial army to *bijoux* daggers made for the enjoyment of the Emperor, were made in the Forbidden City in the Palace Workshops (Zaoban chu) of the Imperial Household Department (Neiwu fu). Pieces such as these were collected, given as gifts and sometimes used as items of regalia – a section of *The Illustrated Regulations for Ceremonial Paraphernalia of the Qing Dynasty* (*Huangchao liqi tushi*) illustrates 139 different types of 'cold' weapons. The Qianlong Emperor, like his grandfather, the Kangxi Emperor, was a keen collector of swords and these examples were made during his reign.

The straight sword, with a double-edged blade, and sabre, with a single-edged blade, are decorated near the hilt with a poetic two-character name and inventory number on one side and a pictorial image of the name on the reverse using gold, silver and copper-wire inlay. Swords made during the Qianlong Emperor's reign were inventoried and stored in three categories: heaven (*tian*), earth (*di*) and man (*ren*). The swords themselves were divided into four categories: sun, moon (cat.74), stars and celestial bodies. The scabbards are covered in exotic sting-ray or shark skin dyed red, or in patterned golden peach-tree bark (*jintaopi*), a material thought to be effective

in warding off evil spirits. The dagger has a jade hilt embellished with gilding and set with precious stones in a floral pattern, a north-Indian Mughal style of decoration which the Qianlong Emperor particularly liked. HK

75

The Relief of the Black River Camp (Heishui ying jiewei) and *Victory at Khorgos (Heluohuosi jie)* from *Quelling the Rebellion in the Western Regions*

1771, 1774
Two leaves from a set of sixteen copperplate engravings on paper, each 55.4 × 90.8 cm, the first engraved by J. P. Le Bas in 1771 after a drawing by Giuseppe Castiglione (1688–1766), the second engraved by the same hand in 1774 after a drawing by Jean-Denis Attiret (1702–1768)
Musée national des arts asiatiques Guimet, Paris, MG17005, MG17008
SELECT REFERENCES: Nie Chongzheng 1992, pl.131; Nie Chongzheng 1996, pl.41; Nie Chongzheng 1996B, pp.253–66

For almost a century, the Zunghar, a western Mongolian people, were in conflict with the Manchu empire over supremacy in eastern Turkestan. The war that brought this struggle to an end took place in 1755, when the Zunghar were crushed. It was followed by an uprising of Muslims from the southern Tian shan mountains, which was put down in 1759. As a result of these campaigns, the Qing emperors gained control of extensive territories. The Qianlong Emperor immortalised his victories in several ways. He wrote many poems about them, ordered stele to be carved and commissioned portraits (in several versions) from his court painters of 100 deserving soldiers and civilians who had taken part in the campaigns of 1755–59. He also ordered paintings to record the receptions to which he invited the Mongols, as well as the outstanding actions of his soldiers in battle. Finally, the Qianlong Emperor commissioned the Jesuit painters in his service – Giuseppe Castiglione, Jean-Denis Attiret and Ignaz Sichelbarth, as well as a missionary of the Propaganda, the Italian Giovanni Damasceno Salutti (or Salusti; 1727–1781) – to make drawings for a series of paintings that would record his conquests. They produced sixteen sketches, and in 1765, court painters working from these sketches started on the paintings. That same year, the Qianlong Emperor decided to

send a set of these drawings to Europe so that copperplate engravings could be made from them. French merchants in Canton (Guangzhou) ensured that the job went to their countrymen. The drawings, in two consignments, reached Paris in 1766 and 1767, and Charles-Nicolas Cochin (1715–1790) was appointed to oversee the platemaking, for which he was to select the most skilled engravers. The work was completed in 1774, and 200 prints from each plate, together with the copper plates, were despatched to Beijing, where further prints were made and distributed throughout the empire.

The Relief of the Black River Camp (Heishui ying jiewei), engraved by J. P. Le Bas in 1771 after a drawing by Castiglione, shows the siege of the camp at Qara usu (the Black River), near Yarkand. The Chinese troops were blockaded there over the winter of 1758 and were saved only by the arrival of the army led by the Manchu general Fude, which allowed the siege to be lifted. The camp is shown in the far left of the engraving. *Victory at Khorgos (Heluohuosi jie)*, engraved by Le Bas in 1774 after a drawing by Attiret, commemorates the defeat of the supporters of Amursana, the Zunghar chief, in 1758.

Paintings or prints of battles were a novelty in China, and Cochin's team of engravers would have carried out a great deal of stylistic remodelling. One of the sources of reference that they used for this remodelling of the sketches they were sent was probably the set of prints of Louis XIV's battles made by Adam Frans Van der Meulen (1632–1690) in the late seventeenth century, which were widely available at the time. MPU'S

76

Attributed to Giuseppe Castiglione (Chinese name Lang Shining, 1688–1766), Jean-Denis Attiret (Chinese name Wang Zhicheng, 1702–1768), Ignaz Sichelbarth (Chinese name Ai Qimeng, 1708–1780) and Chinese court painters
Imperial Banquet in the Garden of Ten Thousand Trees

Completed in 1755
Horizontal wall-scroll, ink and colour on silk, 221.5 × 419 cm
The Palace Museum, Beijing, Gu6275

This horizontal wall-scroll depicts a reception at the imperial summer retreat at Rehe (modern Chengde) that was given by the Qianlong Emperor for the leaders of the Torghut Mongols, who had recently submitted to Qing authority. It can be considered a companion to the scroll *Horsemanship (Mashu tu)* (fig.40).

In the painting, the Qianlong Emperor, accompanied by high-ranking civil and military officials, is slowly being carried in a sedan chair (see cat.63) by sixteen palace eunuchs. The Torghut Mongol leaders kneel to greet him. Over forty figures, including the Emperor, his important officials and the leaders of the Mongols are each individually and vividly rendered in a portrait-like manner, based on sketches the painters made from life. The depiction of the surroundings, the various objects and the clothing is evocative of a strong desire to inject realism into the painting, to give the viewer a keen sense of what it was like to be present. Unfortunately, the section of silk bearing the signature(s) has been damaged and lost, so that we cannot confirm the identity of the artists. However, according to the records of the Palace Workshops (Zaoban chu) of the Qing Imperial Household Department (Neiwu fu), as well as analysis of the overall painting style, we can be fairly sure that the wall-scroll was chiefly painted by Giuseppe Castiglione, assisted by the Frenchman Jean-Denis Attiret and the Bohemian Ignaz Sichelbarth, as well as various Chinese court painters.

The composition is in the European style, which clearly defines the depth and spatial relationships of objects and figures; the tents, frame of the swing and so on are all rendered according to the technique of vanishing-point perspective, which creates a unified receding ground plane. The facial features of the important figures are all quite distinct as shading has been used to describe surface and volume. The depiction of the faces also accurately portrays their underlying anatomical structure. The painting possesses a distinctive sense of light-play across the scene. All these characteristics point to the hands of Castiglione and his fellow Europeans.

A work as large as this was unsuitable for mounting as a hanging scroll, and would instead

have been affixed as decoration directly onto a palace wall at one of the imperial summer retreats. The painting can be regarded as a classic example of the hybrid Chinese-Western style of Qing court painting in the eighteenth century. NC/SMcC

77

Anonymous court artists
Qing Imperial Illustrations of Tributaries, Scroll Four: Minorities from Yunnan, Guizhou, Guangxi

Qianlong period, c.1748–80
Handscroll, ink and colour on paper,
33.5 × 1603 cm
INSCRIPTIONS: title sheet by the Qianlong Emperor with *Qianlong yu bi* seal; inscriptions by Qian Weicheng and Qian Rucheng; colophon by Yu Minzhong and others
The Palace Museum, Beijing, Gu6306/4
SELECT REFERENCES: Wei Dong 1992; Wei Dong 1995; Nie Chongzheng 1996, no.75; Hostetler 2001, pp.41–49

Qing Imperial Illustrations of Tributaries (*Huangqing zhigong tu*) was a cataloguing project commissioned by the Qianlong Emperor in 1750–51. Its purpose was to depict the diversity of peoples who paid tribute to the Qing court with the implicit aim of portraying and documenting the vast territories controlled by the Qing government. Information about each minority was compiled in relative secrecy by the governor-generals of each area. The geographical scope was far-reaching and included not only groups of non-Han ethnicity under direct control of the Qing, but also peoples from countries such as Korea who would have considered themselves completely independent.[1]

Numerous versions of the *Tributaries* were painted in scroll form and printed in book form. This colourful handscroll depicts 78 minority peoples from Yunnan, Guizhou and Guangxi Provinces (in today's southwest China) rendered in fine line drawing filled in with coloured pigment. The figures, grouped in male/female pairs, are carefully detailed wearing ethnic costume and engaged in various activities. Commentary in both Chinese and Manchu was written above each pair, describing the different peoples, their region, national dress, customs, local products, taxes and tributes they paid and their relationship with the Qing court. An inscription at the front of the scroll is signed by the

official Qian Rucheng (1722–1779) and a second inscription signed by Qian Weicheng (1720–1777), a senior official and artist whose paintings were particularly appreciated by the Qianlong Emperor. A colophon by court ministers including Fuheng (d.1770), Liu Lun (1711–1773), Liu Tongxun (1700–1773) and Yu Minzhong (1714–1780), the powerful political advisor to the Qianlong Emperor in the middle of his reign, graces the end of the scroll.

This is the last in a set of four such handscrolls. The other three depict officials as well as common people from foreign countries and minority groups from Xinjiang and Tibet (scroll one), minority groups from the northeast, Fujian, Taiwan and southern China (scroll two) and northwestern China, Gansu and Sichuan (scroll three). HK

78

Yao Wenhan (fl.from 1743)
New Year's Banquet at the Pavilion of Purple Brightness

1761 or later
Handscroll, ink and colour on paper,
45.8 × 486.5 cm
Artist's signature
SEALS: two seals of the artist, eleven seals of the Qianlong imperial collection, one seal of the Jiaqing Emperor and one collector's seal
The Palace Museum, Beijing, Gu8242
SELECT REFERENCES: *Shiqu baoji xubian*, p.790; Berlin 1985, no.30; Rotterdam 1990, no.11; Nie Chongzheng 1996, no.58; Edinburgh 2002, no.23

The Pavilion of Purple Brightness (Ziguang ge), situated at the Central Lake in the park just west of the palace, was the place where the Qing emperors held their military-service examinations as well as contests in archery, riding and other martial arts twice a year, in mid-autumn and in winter. The colour purple was associated with martial bravery, a purple glow in the eyes or face being considered a hallmark of the fearless hero. Purple was also the colour of the Pole Star, which remains in the centre with all other stars revolving around it, thus symbolising the Emperor.

After the successful completion of three military campaigns against the Zunghars in Yili and the Muslim Uighurs in Eastern Turkestan from 1755 to 1759 and the annexation of these new territories, the Qianlong Emperor celebrated his victory by transforming the Pavilion of Purple

Brightness into a memorial hall of military fame. In 1760 he had the old building restored and added a second hall, the Hall of Military Success (Wucheng dian). In the covered galleries connecting the two buildings, stone slabs, engraved with 224 poems by the Emperor praising the merits of his warriors, were arranged. Inside the halls he displayed one hundred hanging scrolls with life-size portraits of Manchu, Chinese and Mongol officers and soldiers who had distinguished themselves in battle. The scrolls, too, were adorned with laudatory poems by the Emperor. In addition, sixteen large paintings depicting famous battle scenes of the war were affixed to the walls. Weapons and banners captured in battle were also displayed. At New Year 1761 the victory was celebrated with a state banquet in front of the newly completed hall of fame. Officers of outstanding merit, the lords of the Zunghars and the Muslim leaders of Eastern Turkestan were among more than a hundred guests. It is quite possible that the handscroll depicts this very event.[1]

The banquet was accompanied by ice games on the Central Lake, which from 1745 were organised annually.[2] Flanking the approach to the pavilion, long rows of red-clothed members of the imperial escort carry parasols, banners, ritual weapons and musical instruments. In front of the pavilion a large group of ninety Mongol and Turkestan leaders in national clothing sit in three rows at small tables laden with dishes. Opposite them sit two rows of sixty Manchu and Chinese dignitaries. In an elevated position inside the hall, flanked by groups of the highest court dignitaries and priests, sits the Qianlong Emperor, who liked to be depicted larger than everybody else and with an especially large face, in which we can read his deep satisfaction with the successful event.[3] GHo

79

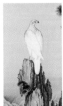

Giuseppe Castiglione (Chinese name Lang Shining, 1688–1766)
Pine, Hawk and Glossy Ganoderma

1724

Hanging scroll, colour on silk,
242.3 × 157.1 cm

INSCRIPTION: '*Picture of a Pine, Hawk and Glossy Ganoderma* respectfully painted by your servant Lang Shining, the tenth month of the second year Yongzheng'

SEAL: the Qianlong Emperor

The Palace Museum, Beijing, Gu5357

SELECT REFERENCES: Nie Chongzheng 1992, pl.45; Nie Chongzheng 1996, pl.27; Macau 1999, pl.19

Dating from 1724, the second year of the Yongzheng Emperor's reign, this painting of homage and good wishes was commissioned to mark the Emperor's birthday. A white hawk, proudly gazing into the distance behind it, is perched on the highest of the rocks that rise above a rushing stream, in the shadow of old pine trees. A flowering wisteria grows up the trunk of one of the trees; crimson *lingzhi* (*Ganoderma lucidum*), known as the fungus of immortality, sprout from rock crevices and from one of the tree trunks.

In China, the rare white hawk is considered an auspicious sign sent from Heaven to signal the sovereign's virtue and to confirm his right to rule. White hawks were therefore highly prized by Qing rulers, and these birds were presented to them as tribute. The pine tree, meanwhile, is a symbol of wisdom and longevity. Another sign of good omen and a symbol of longevity are the *lingzhi*. Growing at the foot of a pine tree, or sprouting from its trunk, *lingzhi* ward off evil and evoke vigour. The painting thus expresses several birthday wishes. However, the presence of the white hawk also gives it an ideological connotation that fits the difficult context of the early years of this reign. Charges that the Yongzheng Emperor had killed his father, the Kangxi Emperor, and usurped the imperial throne by forging his will were still very strong in 1724, and they were to dog this Emperor for the rest of his life.[1] Thus the need to affirm his legitimacy as Emperor, as well as that of the Qing dynasty itself, was at the heart of the Yongzheng Emperor's political

strategy. Superstitious and strongly influenced by omens, the Yongzheng Emperor was also an enthusiastic believer in Daoist recipes for long life.

It is in this dual context – that of the Emperor's birthday and of his political strategy – that this painting must be seen. However, although the painting's symbolism is Chinese, its execution is Western. The two trees on the right frame the composition, a device common in seventeenth-century European painting. Other European touches can be seen in the way the effects of light are used to give volume to the twisted tree trunks and jagged rocks, and in the meticulous depiction of the roots at the base of the trees, of their bark and of the clumps of vegetation in the foreground. MPU's

80

Giuseppe Castiglione (Chinese name Lang Shining, 1688–1766)
Birds and Flowers

c. 1724–30

Hanging scroll, colour on silk, 63.7 × 32.3 cm

INSCRIPTION: signed 'respectfully painted by your servant Lang Shining'

SEALS: two seals of the artist (*Shining* and *gonghua*), five seals of the Qianlong Emperor and two seals of the Jiaqing Emperor

The Palace Museum, Beijing, Xin146607

SELECT REFERENCES: *Shiqu baoji sanbian*, p.4199; Nie Chongzheng 1996, pl.40

In 1724 the Yongzheng Emperor decided to extend his summer residence at the Garden of Perfect Brightness (Yuanming yuan). From that time, as is recorded in the archives of the Palace Workshops (Zaoban chu), Castiglione was regularly commissioned to execute *trompe l'oeil* paintings and decorative schemes of flowers and birds for the interiors of the palaces at the Yuanming yuan. This kind of work, together with 'seasonal' painting, took up most of Castiglione's time as a court painter during the reign of the Yongzheng Emperor. Although nothing now remains of these paintings, some idea of their appearance is given by a few scroll and album paintings that on stylistic grounds can be dated to the 1720s.

One such painting is *Birds and Flowers*. It may originally have been part of a *tieluo* (a painting pasted to a wall) that was later removed and turned into a scroll painting. The theme is nature, though with the additional significance of auspiciousness.

Each plant carries particular meanings and has symbolic significance in a discourse of good wishes. Although its subject-matter, composition and bright colours are still in the tradition of court painting of the Song (960–1279) or Ming (1368–1644) periods, the individual treatment and three-dimensional quality of each element within it are in the Western style that Castiglione introduced to Chinese court painting. Light and shade are used to suggest modelling, and the range of tonal nuances and contrasts gives the plants and birds volume, solidity and a sense of temporality: the artist has caught the fleeting instant in which the subject is captured in paint. Each of these qualities became progressively less apparent in Castiglione's work as, over many years, he was exposed to Chinese artistic traditions and became increasingly sinicised. MPU's

81

Louis de Poirot (Chinese name He Qingtai, 1735–1813)
Beautiful Deer

1790

Hanging scroll, colour on paper, 195.5 × 93 cm

INSCRIPTION: signed 'Respectfully painted on imperial order by your servant He Qingtai on the ninth month of the fifty-fifth year of [the reign of] Qianlong'

SEALS: two seals 'gong' and 'hua' 'respectfully' 'painted', six seals of the Qianlong Emperor and a seal of the Jiaqing Emperor

The Palace Museum, Beijing, Gu5604

SELECT REFERENCES: *Shiqu baoji xubian*, p.1271; Nie Chongzheng 1992, pl.123; Nie Chongzheng 1996, pl.66

Louis de Poirot, a French Jesuit from Lorraine, started his novitiate in Rome in 1756. He arrived in Beijing – as a painter 'even though he had never learned the principles of this art' – in 1771, a few years before word that the Jesuit Order had been suppressed reached the Chinese capital. Poirot spent the rest of his life at the Manchu court, a time when the Imperial Painting Academy had lost much of its brilliance. His work as a painter seems to have left him enough spare time to acquire some remarkable linguistic skills. He is noted for his annotated translation of the Bible into Chinese and Manchu. He was made an official of the sixth rank on 19 August 1793, and soon afterwards served as one of the interpreters appointed by the Qianlong Emperor for Lord Macartney's embassy that

summer. Poirot, the last Jesuit in China, died in Beijing in 1813.

Beautiful Deer, one of Poirot's very few surviving paintings, is among his finest. It probably shows a deer that was presented to the Emperor on his eightieth birthday, in 1790, a white deer being a symbol of longevity. The painting also indirectly refers to the autumn hunts that the Qianlong Emperor enjoyed so much. However, only the deer seems to be by Poirot's hand. The landscape in which the animal is set is the work of an anonymous Chinese artist.

The importance given to the vegetation, and the colours used to depict it, are part of the painting's appeal. The style of the leaves and tufts of grass resembles those on a scroll by Guan Huai (second half of the eighteenth century), *A Beautiful Forest Beyond the Great Wall* (*Shang sai jin lin tu*), also in the collection of the Palace Museum in Beijing, which similarly depicts an autumn landscape north of the Great Wall.[1]
MPL'S

82

Zhang Weibang (active as a court painter, *c*.1726–61)
The Spring Festival

Yongzheng or Qianlong period
Hanging scroll, colour on silk,
137.3 × 62.1 cm

INSCRIPTION: signed 'Respectfully painted by your servant Zhang Weibang'

SEALS: two seals of the artist (?), five seals of the Qianlong Emperor and two seals of the Jiaqing Emperor

The Palace Museum, Beijing, Gu5541

SELECT REFERENCES: *Shiqu baoji sanbian*, p.2454; Nie Chongzheng 1992, pl.68; Nie Chongzheng 1996, pl.60

The paintings of 'quiet objects' (*jingwu*), which correspond more or less to the Western still-life tradition, most often express good wishes and are paintings of good omen associated with a celebration such as New Year, as here. These paintings were extremely popular in the seventeenth and eighteenth centuries. *The Spring Festival* depicts several sprigs of arborescent peony in a porcelain vase – a copy of the Ge ware of the Song dynasty – that is placed on a carved wooden stand. Behind the vase is a jardinière (a copy of Song dynasty Jun ware) that incorporates a miniature landscape with a strangely shaped rock, some plants and *lingzhi* fungi (*Ganoderma lucidum*), symbols of long life and prosperity.

A native of Yangzhou, in Jiangsu Province, Zhang Weibang was introduced to the imperial palace by his father, Zhang Zhen, and in turn he introduced his own son, Zhang Tingyan (fl.*c*.1744–1771). This was not unusual, as other dynasties of painters worked at the imperial court during the Qing period. Zhang Weibang and his son had been pupils of the Italian Jesuit court artist Giuseppe Castiglione (1688–1766), and they passed on the Western techniques that they had learnt from him to the professional painters of their native region.

The Spring Festival features both Chinese and European traditions. The bare background, the flowering sprigs (rather than cut flowers), the precious vases imitating prized ancient ceramics and the near-absent shadows of the greenery are Chinese. By contrast, the highlights on the belly of the vase and the shadow on its right-hand side are taken from Castiglione's 'season paintings'. These techniques enabled the painter to give the vase weight and volume, and capture the sheen of its glaze and craquelure. MPL'S

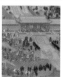

83

Anonymous court artists
Envoys from Vassal States and Foreign Countries Presenting Tribute to the Emperor

1761
Hanging scroll, colour on silk, 322 × 216 cm

INSCRIPTION: imperial poem

SEALS: the Qianlong Emperor

The Palace Museum, Beijing, Gu6274

SELECT REFERENCES: Nie Chongzheng 1996, pl.64; Rawski 1998; Macau 1999, pl.29; Chicago 2004, pl.80

This large painting depicts foreign envoys gathering in the courtyard between the Meridian Gate (Wu men) of the Forbidden City and the Gate of Supreme Harmony (Taihe men) to present gifts to the Emperor during the New Year celebrations at the Hall of Supreme Harmony (Taihe dian). This hall, seen within, was the main location for important state rituals; its stateliness was intended to enhance the atmosphere of awe surrounding such occasions. In this painting foreign delegates carry identifying flags and bring typical native products to offer in tribute. In accordance with state protocol, they have dismounted as a mark of respect. On one side of

the bridge, Thai envoys marshal their elephants and carry packages presumably containing ivory tusks, while on the other, envoys from other countries await their turn. To the right of the Taihe dian, court eunuchs are preparing the gifts that the Emperor will bestow on the envoys. Although this system of ritualised exchange applied to Europeans as well as to those neighbouring states whose cultures had absorbed some features of Chinese civilisation, the depiction here of representatives of the Netherlands as well as those of Thailand, Korea and various Southeast Asian states may well indicate wishful imagining rather than precise description.

The production of documentary art of this kind expanded hugely during the Qianlong reign, although the genre dates back at least to the Tang era (618–906) – the last time that Chinese forces had penetrated almost as far west as did the Qing armies in the eighteenth century. Almost certainly this painting, by its scale as well as its subject-matter, was intended to imply that Qing achievements had surpassed those of the Tang. Such claims became a mantra of the Qianlong reign, when the Emperor relentlessly broadcast imperial expansion and the military power upon which it rested both to his subjects and, whenever possible, to foreigners whom he wished to impress. JW-C

84

Ignaz Sichelbarth (Chinese name Ai Qimeng, 1708–1780)
Ten Fine Dogs

c.1745–58
Album of ten leaves, colour on paper, each 24.5 × 29.3 cm

INSCRIPTION: signed 'Respectfully painted by your servant Ai Qimeng'

SEALS: two seals of the artist, with eleven imperial seals from the Qianlong Emperor to the Xuantong Emperor

The Palace Museum, Beijing, Xin146201, 1–10

SELECT REFERENCES: *Shiqu baoji xubian*, pp.3054–55; Nie Chongzheng 1992, pl.91; Nie Chongzheng 1996, pl.57

Rare or exotic animals were an important category among the gifts that high officials, conquered peoples and foreign envoys brought as tribute to the imperial family. The Qianlong Emperor took pleasure in receiving horses from Central Asia, dogs from Tibet or

Europe – the subject of these paintings – and birds of prey from Mongolia, all of them animals connected with hunting. The Qianlong Emperor also commissioned the artists of the Imperial Painting Academy – especially the Jesuits, whose knowledge of anatomy and mastery of perspective he admired – to paint likenesses of his favourite animals.

Each of these ten album leaves is inscribed with the dog's name and with a panegyric written either by Liang Shizheng (1697–1763) or by Wang Youdun (1692–1758), two great literati and high officials of the imperial court at the apex of the Qianlong Emperor's reign. The poems are written by Ji Huang (1711–1794) in a calligraphic style in keeping with the paintings. Together, the paintings, poems and calligraphy form a sophisticated souvenir album, for the creation of which the Emperor, as was his custom, made use of his court officials.

Ignaz Sichelbarth, who was born in Nejdek in western Bohemia (now part of the Czech Republic), entered his period of probation in the Jesuit order, his novitiate, in 1736. He arrived in Beijing in 1745 and remained at the imperial court until his death in 1780. He became an official of the third rank in 1777. A pupil of Castiglione, Sichelbarth was a skilful portraitist and animal painter. *Ten Fine Dogs*, which can be dated to 1745–58, is a classic example of his miniature painting; the natural, elegant way in which he captured the animals' movements and rendered the tactile quality of their coats owes much to Castiglione. Sichelbarth also contributed a drawing to the series *Engravings of the Conquests of Qianlong* and collaborated with the Frenchman Jean-Denis Attiret (1702–1768) on the plans and elevations for the European palaces that the Emperor commissioned the Jesuits employed at his court to build (see cat.91). MP t's

85

Instrument for celestial observation

1746
Made in the Palace Workshops, Beijing
Gilt bronze, height 72 cm
INSCRIPTION: 'Made in the *bingyin* year of the Qianlong reign' (1746)
The Palace Museum, Beijing, Gu141709

SELECT REFERENCES: *Huangchao liqi tushi, juan* 3, pp.36a–37a; Needham 1959; Liu Lu 1998, pl.11; Macau 1999, pl.88

Sometimes called a 'sun-moon-stars dial', this instrument tells the time by means of observation of the sun, moon and other stars. With its three rings pivoted on a polar axis, it is in effect a version of an armillary sphere. Forms of this instrument were recorded in early Chinese histories, and the type was not necessarily derived from Jesuit models. The outer circle is fixed; the middle one rotates to right and left; while the inner one can spin all the way round. The instrument is supported on pillars decorated in a hybrid Chinese-Western style. These stand on a cross-shaped base, on each cross-piece of which is a water-channel which can be filled to check the levelling of the instrument. This particular piece is illustrated in the astronomy section of the eighteenth-century compendium *Illustrated Regulations for Ceremonial Paraphernalia of the Qing Dynasty* (*Huangchao liqi tushi*), with an essay referring to centuries-earlier indigenous models. Its inclusion in this text indicates its importance for ritual as well as strictly practical use. JW-C

86

Armillary sphere inscribed with name of Ferdinand Verbiest (Chinese name Nan Huairen, 1623–1688)

1669
Made by the Imperial Directorate of Astronomy, Beijing
Silver-gilt and sandalwood, height 37.5 cm
INSCRIPTION: carved in Manchu and Chinese on one of the rings, 'Made in the second summer month of the year Kangxi 8 (1669) by Nan Huairen and others'
The Palace Museum, Beijing, Gu141931
SELECT REFERENCES: Berlin 1985; Liu Lu 1998, pl.4; Macau 1999, pl.87

The armillary sphere was the most important instrument used for astronomical observation from antiquity until the series of discoveries, most notably the telescope, made in the later sixteenth and early seventeenth centuries. The precise origins of such spheres are uncertain, but they were known in China from at least as early as the Han dynasty (221 BC–AD 220). An armillary sphere consists of a number of interlocking rings (*armillae*) arranged to illustrate the circles of the celestial sphere.

It was not unusual to find them made of precious materials as *objets d'art* for the collections of princes and emperors; this example can be seen behind one of the Prince Yinzhen's *Twelve Beauties* (cat.173).

This piece was intended for demonstration rather than observation; it can show the movements of the sun, the moon and the earth as well as eclipses of the sun and moon when revolving. It was probably based on a design by the Danish astronomer Tycho Brahe (1546–1601), the last astronomer in the West to make extensive use of armillary spheres for celestial observation. JW-C

87

Arc quadrant for calculating zenith distance

Kangxi period
Made in the Palace Workshops, Beijing
Copper, height 66 cm, arc disc radius 35 cm
The Palace Museum, Beijing, Gu141971
SELECT REFERENCES: *Huangchao liqi tushi, juan* 3, pp.70a–b; Liu Lu 1998, pl.101

From the Kangxi period, emperors added to their collection of painting and decorative arts both by gathering objects from around the globe and by having fine objects made within the workshops they established within the palace. In these workshops, which were divided up into specialist units, skilled artisans produced fine textiles, ceramics, metal, glass, enamels and other objects of art for use at court and to be given as gifts in diplomatic and other political exchanges. Workshop employees were as diverse as the subjects of the empire, including not only Manchus and Chinese, bannermen and commoners, but also Tibetans, Uighurs and members of other ethnic groups subject to the Qing. European Jesuits also worked among these artisans, themselves giving technical instruction and producing objects for the imperial collections.

This quadrant, rotating on its stem and with two handles that could be lined up for sighting purposes, would have been used to determine the altitude of celestial bodies and to measure the angle of the sun. Its inclusion in prescribed texts suggests a blurred distinction between its practical and ritual or symbolic use. JW-C

88

Peacock-tail-shaped travelling sundial and compass

Qianlong period
Made in the Palace Workshops, Beijing
Champlevé enamel, 2.2 × 3.8 × 4.8 cm
The Palace Museum, Beijing, Gu141763
SELECT REFERENCES: Needham 1959,
pp.302–10; Liu Lu 1998, pl.19

Sundials were known in China from at least the second century BC, when the great historian Sima Qian wrote of one in connection with a gathering of astronomers who met to determine various matters relating to the calendar, the directions and the movement of the planets. The small compass included in this example has a needle pointing south and marks inscribed with the characters for the two-hour periods of the day. It permitted its user both to tell the time and determine latitude. JW-C

89

Ferdinand Verbiest (Chinese name Nan Huairen, 1623–1688)
Astronomical Instruments in the Observatory (*Lingtai yixiang zhi*), page depicting instruments at the Beijing Observatory

1674
Woodblock print on paper, 38 × 38.5 cm
The British Library, London, 15268.b.3
SELECT REFERENCES: Witek 1994; Golvers 2003; London 2004, pp.298–99

Astronomy and control of the calendar were key aspects of Qing rule, both from a scientific perspective and politically, because they provided a means for Manchu emperors to affirm their legitimacy as rulers of China. The Belgian missionary Ferdinand Verbiest arrived in Beijing in 1659. Ten years later he succeeded his fellow Jesuit Adam Schall von Bell (1591–1666), a confidant of the Shunzhi Emperor (r.1644–61, father of the Kangxi Emperor), as Director of the Imperial Bureau of Astronomy, a post he held until his death. Between them, Jesuit missionaries occupied this position for 150 years.

This work, published by Verbiest in 1674, sets out in detail the theory, usage and construction methods of astronomical instruments, whose casting Verbiest supervised at the behest of the Kangxi Emperor, on the basis of designs made by the Danish astronomer Tycho Brahe (1546–1601). Verbiest composed the work in partial response to criticism – perhaps justified given Church restrictions on full disclosure of such recent discoveries as heliocentric theory – that he was concealing his full knowledge from his Chinese colleagues.

Six of Verbiest's instruments can still be seen at the Jesuit observatory in central Beijing against the backdrop of the modern city. They include an ecliptic armillary sphere (shown front left in the woodcut of the observatory); an equatorial armillary sphere (front right); a horizon circle and azimuth (centre left); and, in the rear left corner: a quadrant; a sextant (centre back); and a celestial globe (centre front). Neither the ecliptic armillary sphere nor the sextant had previously been known in China. These instruments were used by Chinese astronomers in compiling star catalogues over the next two hundred years. JW-C

90

Ferdinand Verbiest (Chinese name Nan Huairen, 1623–1688)
Map of the Eastern Hemisphere from *Complete Map of the World* (*Kunyu quantu*)

1674
One map (of two), nine separate sheets, woodcut on white paper, each sheet average approximate dimensions 57.5 × 51 cm
The British Library, London, Maps 183.p.41(1)
SELECT REFERENCES: London 1973, C.11; Walravens 1991; Li Xiaocong 1996, pp.11–12

This half of the *Complete Map of the World* (*Kunyu quantu*) by the Belgian Jesuit Father Ferdinand Verbiest SJ would have been placed to the left of its counterpart, with China at the centre, the whole presenting an imposing composition.

Sources for the map seem to have included both Chinese and Western models, demonstrating the stated enthusiasm of the Kangxi Emperor for adopting only Western knowledge that was useful for China. It was produced for Chinese (as opposed to foreign) use by Verbiest, who had taught the young Emperor the new mathematics and astronomy. His Chinese name and official title (Nan Huairen, of the Far West, Director of the Astronomy Bureau) appears in a colophon in the bottom left-hand corner. As part of the large-scale geographical surveys carried out with Jesuit help at the request of the Kangxi Emperor (these were completed in 1718), the first edition was printed from woodblocks, probably in 1674, possibly incorporating elements of the world map of Joan Blaeu (Amsterdam, 1648). Verbiest's version shows the hemispheres contained within two circles bounded by a key-fret border, with the first meridian cutting through Beijing, viewed as the centre of the world. Geographical descriptions in oval cartouches and illustrations of animals presumed to be little known in China are also included. Further editions were issued periodically down to the early twentieth century.
GHu

91

The Southern Façade of the Palace of the Delights of Harmony (*Xieqiqu*), *The Western Façade of the Palace of the Calm Sea* (*Haiyan tang*), *Fountains* (*Dashuifa*) and *Ornamental Lake* (*Hudong xianfu*) from *The Yuanming yuan European Palaces*

1781–86
Four copperplate engravings on paper (plates 1, 10, 15 and 20) from a set of twenty leaves, after drawings by Yi Lantai (fl.*c*.1738–1786), each 50 × 88 cm
INSCRIPTIONS: inscribed with the name of the palace or of the landscape unit and the number of the leaf in the set
Staatliche Museen zu Berlin, Kunstbibliothek, OS 2783
SELECT REFERENCES: Nie Chongzheng 1992, pl.134; Macau 1999, pl.37; Pirazzoli 2002

The Qianlong Emperor's taste for the exotic and his desire to be a universal ruler led him to build a complex of European-style palaces, complete with fountains and gardens, in the northeastern corner of the Garden of Perfect Brightness (Yuanming yuan), the estate where he had his summer residence. The architect was the Italian Jesuit artist Giuseppe Castiglione (1688–1766). The French Jesuit Michel Benoist (1715–1774), the Emperor's court mathematician and astronomer, was commissioned to design the fountains.

The complex was constructed in three stages. In the first (1747–51), the Palace of the Delights of Harmony (Xieqiqu) was built, together with a cistern, a building to house the mechanism that worked the fountains, an aviary and a maze. The southern façade of the Palace of the Delights of Harmony is shown in plate 1. In the second stage (1756–59), several landscaped gardens were laid out in the narrow

strip of land reserved for the European Palaces in the northern part of the Garden of Perfect Brightness, and these landscaped gardens centred around *fabriques* (small garden constructions), and above all fountains, which were the most important elements in the design. Plate 10 shows the western façade of the Palace of the Calm Sea (Haiyan tang), with its water clock, and plate 15 the Fountains (Dashuifa). The complex ended with an ornamental lake and an open-air theatre, complete with *trompe l'oeil* paintings of a street, as seen in plate 20.

Finally, another palace, to house the Beauvais tapestries that the Jesuit missionaries had presented to the Qianlong Emperor, was begun in 1767 and completed only in 1783. To immortalise his European-style palaces, the Emperor commissioned a set of twenty copperplate engravings after drawings by the Manchu painter Yi Lantai. These engravings, made in Beijing between 1781 and 1786, are the only visual record of the complex before it was sacked and burned by French and English troops in 1860. The surviving ruins at the site itself, as well as photographs taken after 1860, give some idea of this remarkable combination of Chinese and Western architecture.

The palaces combined Chinese building techniques and European decoration: a wooden structure supported the roof; the walls were of grey brick, coated with reddish or veined facing, and decorated with applied stone columns, pilasters and entablatures in the European Rococo style. Other ornaments, in glazed ceramic, were set into the walls, and the rooms were decorated with *trompe l'oeil* paintings and filled with European-style furniture. The grounds around the palaces were planted with trimmed shrubs, European-style knot gardens were laid out and Chinese rock gardens constructed.

This Emperor's Western 'folie' was used for outings, concerts, private celebrations and plays. The pavilions, which were too small to be lived in, were used as cabinets for the Qianlong Emperor's European curiosities, such as hangings, paintings, clocks, mechanical toys and mirrors. MPL'S

92

Timothy Williamson (fl.1769–1788)
Clock in the shape of a pavilion

Eighteenth century
Gilt bronze and coloured stones,
height 77 cm
The Palace Museum, Beijing, Gu182774
SELECT REFERENCES: Baillie 1969, p.344; Lu Yanzhen 1995, p.143; Pagani 2001, pp.140–41, 202–03, figs 18, 29

Of European elaborate clocks associated with eighteenth-century China, the vast majority were the products of London makers. Included among them is Timothy Williamson, and although his name is found on a large number of clocks and watches in the imperial collection, little is known of this maker.

Many of the European clocks in China were made in the second half of the eighteenth century when an exotic style in the decorative arts, known as chinoiserie, was at its height. Chinoiserie had very little to do with China *per se* – it was a combination of elements from China, Japan and India that roughly signified the 'Orient' – and its products were based more on the European imagination than on actual Chinese aesthetics. Because of their strikingly unusual forms, Chinese architectural structures appealed to the Western love of the exotic. With their upturned eaves, often embellished with bells hung from each corner, pagodas and pavilions found their way into a variety of art-forms, from Anglo-Chinese gardens to elaborate clockwork.

This clock, one of a pair, shows an imaginative European interpretation of Chinese architecture. In typical chinoiserie fashion, the clock makes use of a number of decorative elements to create an image of the East. Palm trees support the roof of a two-storeyed pavilion and at the eaves, oversized dragons dangle bells from their jaws. Entertainment is provided through the clever use of mechanisms. At the appropriate time, animals parade around the glass-rod waterfall in the centre of the pavilion. CP

93

James Cox (d.*c*.1791)
Clock in the shape of a crane carrying a pavilion on its back

Eighteenth century

Gilt bronze, glass stones and silk; silk velvet with silk braid and metal thread on stand, height 40 cm
The Palace Museum, Beijing, Gu182887
SELECT REFERENCES: Le Corbeiller 1970; Pagani 1995; Kane 1996; Pointon 1999; Pagani 2001, pp.100–12, 135–37

James Cox is the best documented of the British clockmakers who participated in the Chinese market in the late eighteenth century. Although he operated primarily out of his London shop on Shoe Lane, Fleet Street, between 1772 and 1774, he also exhibited his most prized work at his Spring Gardens museum at Charing Cross, which was open to the public. The museum was closed in 1774, when the collection was disposed of by lottery. Among the items sold was Cox's famous life-size mechanical silver swan, now in the Bowes Museum, Barnard Castle.

Cox's association with the Qing court began in 1766, when he was commissioned by the East India Company to construct an elaborate pair of clockwork automata in the form of chariots that were to be a gift for the Qianlong Emperor. From that time on, his 'pieces of ingenuity' were extraordinarily popular at the Chinese court, comprising the largest number of signed pieces in the collection. Encouraged by his success in China, Cox established a branch of his business in Guangzhou in the early 1780s. This, the predecessor of the trading firm of Jardine, Matheson & Co., was managed by his son, John Henry Cox (d.1791).

Among Cox's work, this musical clock in the form of a crane supporting a two-storeyed pavilion on its back is unusual for its heavy reliance on Chinese motifs. The red-crowned crane, the single branch of *lingzhi* (the fungus of immortality) it carries in its beak, and the pair of peaches on the saddle-flap are traditional Chinese symbols that offer wishes for longevity. CP

94

Four-sided gilt bronze and yellow enamel clock

Qianlong period, made in Guangzhou
Gilt bronze and enamel, 111 × 47 × 47 cm
The Palace Museum, Beijing, Gu183086
SELECT REFERENCES: Shang Zhinan 1986; Yang Boda 1987, p.55; Pagani 2001, pp.78–79, 154–57

Many of the Chinese clocks in the Qing imperial collection were produced in the southern city of

Guangzhou, an important clock-making centre in the eighteenth century. Because Guangzhou served as a main contact point for foreign trade, the craftsmen there had access to foreign clocks and watches that served as models for their own pieces. The Guangzhou clock-makers were impressed by both the forms and the embellishments of these clocks, particularly in the use of coloured glass-paste stones, mechanical features and gilt metal in the forms of swags, rocailles and blind frets. Guangzhou clocks, therefore, show a greater similarity to European clocks than do those made in the Palace Workshops (Zaoban chu). They do, however, differ from their European counterparts in their lavish use of painted enamels and the addition of distinctly Chinese motifs.

This musical clock, with its European form and Chinese decorative elements, shows the clever blending of West and East that is characteristic of Guangzhou clocks. The clock's four-sided shape with urn finials is derived from the European table (or lantern) clock, and its pointed dome corresponds roughly to the table clock's large top-mounted bell that was suspended from supporting metal bands. The clock's design contains some distinctly Chinese elements as well. Gilt-bronze dragons decorate the corner pillars, and on the hour, an official in red robes appears in the opening above the dial, while on either side of him, three couplets of good wishes change in sequence. CP

95

Clock in the form of a double-eaved pavilion with revolving figures of the Eight Immortals

Qianlong period, made in the Palace Workshops, Beijing

Zitan wood and enamel, 88 × 51 × 40 cm

Qianlong reign mark

The Palace Museum, Beijing, Gu183184

SELECT REFERENCES: Ju Deyuan 1989; Liu Yuefang 1989; Guo Fuxiang 1995, fig.3; Pagani 2001, pp.35–56, 181–84

The Jesuit missionaries at court played a pivotal role in the development of European-style clock-making in China by introducing both the theory and the practical aspects of Western horological principles. In the early seventeenth century, Matteo Ricci (1552–1610), along with other missionaries, was assigned by the Wanli Emperor (r.1573–1620) of the Ming dynasty to instruct four eunuchs from the College of Mathematics in the arts of clock maintenance and repair. This was the beginning of nearly two centuries of Jesuit involvement with clock-making at the palace. However, the history of a formalised imperial clock-making workshop did not begin until the late seventeenth century when the Kangxi Emperor, inspired by Jesuit reports of Louis XIV's Académie Royale des Sciences, established a number of *zuofang* (workshops) to manufacture goods for imperial use. One of these, the Office of Self-Sounding Bells (Zimingzhong chu) was devoted to Western-style clocks. This office was succeeded by the Office of Clock Manufacture (Zuozhong chu), which operated under the Palace Workshops (Zaoban chu) of the Imperial Household Department (Neiwu fu) and was active from 1723 until at least 1879.

The skills of the palace makers and their attention to detail are seen in this finely worked *zitan*-wood clock with its delicately painted enamels. Clocks produced in the imperial workshops show a restraint not seen in those from Guangzhou: they have fewer auxiliary features and make less use of gilt bronze and coloured glass stones. The double-roofed pavilion containing revolving figures of the Daoist Eight Immortals shows strong ties to other Chinese art forms and less direct European influence, another characteristic of palace-made clocks. CP

96

Anonymous court artist or Giuseppe Castiglione (Chinese name Lang Shining, 1688–1766)
Portrait of Huixian, Imperial Honoured Consort (huangguifei)

Qianlong period

Wall screen, oil on paper, 53.5 × 40.4 cm

The Palace Museum, Beijing, Gu9206

SELECT REFERENCES: Palace Museum 1992, pl.97, p.175; Nie Chongzheng 1996, vol.14, pl.52, p.208; Hu Guanghua 2001, pl.97, p.96; Macau 2002B, no.14, p.98

According to custom, the Qianlong Emperor's consorts, who numbered around forty, were differentiated into eight ranks headed by the Empress. The next rank was Imperial Honoured Consort (*huangguifei*), a status the subject of this portrait achieved as a posthumous honour granted in 1745, the year of her death. Before that she had served for eight years as a third-rank consort (*guifei*).

The Palace Museum collection contains several portraits of Huixian *huangguifei*, including a large, formal portrait suitable for ritual veneration that belongs to a set with a likeness of the Empress. This portrait, however, belongs to a set of images of the Qianlong Emperor's consorts that was made for casual enjoyment and which notably was painted using oil pigments. Typically, works in that medium were inserted into frames and hung closely together to create the effect of a decorative screen mounted on the wall. Like most oil paintings of the period, the consorts' portraits were painted on heavy paper. Although oil pigments were imported from Europe, canvas was not, and paper supports have often proven a liability in terms of preserving the paintings.

Oil painting was introduced into China by Jesuit priests in the late Ming dynasty and by the time of the Qing had taken hold as an exotic art form. The subtle play of light and shadow on this consort's face and her well-modelled physiognomy, including her soft, fleshy lips, have led scholars to presume the artist was the Italian Jesuit Giuseppe Castiglione. Expertise in oil painting was gradually assimilated at the Qianlong court, but this work, executed in 1745, already demonstrates a superior mastery of foreign technique; thus it is likely that the artist in charge was European.

An interesting note about portraits of the Qianlong Emperor's consorts is the almost uncanny resemblance among his favourites, suggesting that he possessed an extremely narrow view of feminine beauty. But this phenomenon also brings a cultural dilemma to the fore. Because male portrait painters were not allowed to gaze closely upon female subjects, they struggled to balance the competing goals of convincing realism, acceptable decorum and idealised beauty. Only elderly consorts (cat.10) were presented with ruggedly individualised visages. JS

97

Heptafoil dish painted in twelve colours with peony and lotus, and sprigs of ginkgo on the reverse

Kangxi period, Palace Workshops, Beijing

Enamels and gilding on copper, diameter 17.2 cm

Kangxi yu zhi mark (made by imperial order of Kangxi) in a double ring in blue enamel on the white-enamelled base

The Palace Museum, Beijing, Gu116843, 5

SELECT REFERENCES: Yang Boda 1987B, pl.319; Nakamura and Nishigami 1998, fig.233; Macau 1999, cat.61; Li Jiufang 2002, pl.182

98

Box and cover painted with a Western lady and child holding a Chinese book, archaistic dragons and flower scrolls

Qianlong period, Palace Workshops, Beijing, and Jingdezhen, Jiangxi Province

Enamels and gilding on porcelain, 3.7 × 5.7 × 6.8 cm

Qianlong four-character mark in a double square in blue enamel on the base

The Palace Museum, Beijing, Gu152669

SELECT REFERENCES: Beijing 1991, no.1206; Ye Peilan 1999, pl.36; Wang Qingzheng 2000, vol.2, pl.74

99

Vase in the form of a silk pouch tied with a ribbon, painted with dragons among scrolling flowers

Qianlong period, Palace Workshops, Beijing

Enamels on glass, height 18.8 cm

Qianlong four-character mark in blue enamel inscribed on one of the flowers

Collection of the Hong Kong Museum of Art, c.1995.002

In China enamel wares had been produced for centuries in the form of cloisonné. Since this technique requires metal wires to separate colours from each other, it allows only for silhouette patterns (cats 23, 202). In Italy and France enamels had meanwhile been used for delicate painting. Painted enamel wares like those from Limoges were introduced to the Chinese court by Jesuit missionaries, and inspired the Kangxi Emperor to open a workshop specialising in enamelling inside the Forbidden City (Zijin cheng). At first, enamels were imported from Europe and the Jesuits even sent a trained enameller, Jean-Baptiste Gravereau, to Beijing to develop the craft. Although the workshops soon trained their own artisans and produced their own enamels, the technique is even today still referred to as 'foreign' (*falang*).

The court enamellers tried out the new technique on any material they deemed suitable, not only on copper, but also on white porcelain, both ancient and new, from Jingdezhen in Jiangxi Province; on brown stonewares from Yixing in Jiangsu Province; and, more rarely, on milky-white glass from Beijing. The metal vessels, which were fully coated with enamels, also created a new style for porcelain and glass, where designs were often set against a coloured ground (cats 99, 163, 183).

Porcelain styles changed fundamentally with the introduction of new enamel colours. An opaque white derived from lead arsenate, suitable for mixing with other colours, immensely enlarged a palette which had hardly changed since the fifteenth century; and a rose-pink derived from colloidal gold added a soft, feminine touch. Debate continues about which enamels were introduced from the West and which were developed in the glass workshops of the Forbidden City. The wide spectrum now available allowed for proper paintings to be executed on objects and for court painters to be recruited for the task – to the artists' dismay and the artefacts' benefit.

The earliest pieces, from the late Kangxi period, are typically decorated with regular flower designs on a coloured ground (see also cat.163), whose formality is uncharacteristic of Chinese styles and suggests Western participation. They tend to display the richest variety of colours, as the workshops still experimented with different recipes. The Yongzheng period, when the number of Jesuits in the Palace Workshops had been drastically reduced, saw the closest assimilation to album painting in Chinese taste as well as the greatest maturity and perfection of this technique (cat.183). In the Qianlong reign, Western styles became highly influential again. Pastoral landscapes (cat.119) and Western figure scenes were introduced by French Jesuits such as Jean-Denis Attiret (1702–1768), who had been trained in the painting style of French Romanticism, propagated by François Boucher, Antoine Watteau and others. Naturally, the sensual aspects of this style were toned down to a more sober imagery to conform both with imperial and Jesuit taste. RK

100

Snuff bottle with painted enamel design of plum blossoms

Kangxi period

Copper and painted enamel, 6 × 4.5 cm

Kangxi yu zhi mark (made by imperial order of Kangxi)

The Palace Museum, Beijing, Gu120097

SELECT REFERENCES: Xia Gengqi, Zhang Rong, Chen Runmin and Luo Yang 1995, no.1, p.41; Palace Museum 1998, no.1, p.37; Palace Museum Snuff Bottles 2002, no.127, p.80

101

Snuff bottle with painted enamel design of plum blossoms

Yongzheng period

Copper and painted enamel, 6 × 4 cm

Yongzheng four-character reign mark

The Palace Museum, Beijing, Gu120098

SELECT REFERENCES: Xia Gengqi, Zhang Rong, Chen Runmin and Luo Yang 1995, no.5, p.43; Palace Museum 1998, no.4, p.39; Palace Museum Snuff Bottles 2002, no.129, p.82

102

Pouch-shaped snuff bottle with painted enamel design of lotus scrolls

Yongzheng period

Copper and painted enamel, 3.5 × 3.2 cm

The Palace Museum, Beijing, Gu116478

SELECT REFERENCES: Xia Gengqi, Zhang Rong, Chen Runmin and Luo Yang 1995, no.8, p.45; Palace Museum 1998, no.6, p.40; Palace Museum Snuff Bottles 2002, no.134, p.86

103

Peacock-tail-shaped snuff bottle in painted enamel

Qianlong period

Copper and painted enamel, 4.6 × 3.7 cm

Qianlong four-character reign mark

The Palace Museum, Beijing, Gu116467

SELECT REFERENCES: Xia Gengqi, Zhang Rong, Chen Runmin and Luo Yang 1995, no.10, p.46; Palace Museum 1998, no.7, p.40; Palace Museum Snuff Bottles 2002, no.136, p.88

104

Snuff bottle with enamel painting of a landscape

Qianlong period

Copper and painted enamel, 6.5 × 4.4 cm

Qianlong four-character reign mark

The Palace Museum, Beijing, Gu116439

SELECT REFERENCES: Xia Gengqi, Zhang Rong, Chen Runmin and Luo Yang 1995, no.15, p.50; Palace Museum 1998, no.10, p.43; Palace Museum Snuff Bottles 2002, no.174, p.121

105

Snuff bottle with painted enamel design of flowers and birds

Qianlong period

Copper and painted enamel, 5.6 × 4 cm

Qianlong four-character reign mark

The Palace Museum, Beijing, Xin77299

SELECT REFERENCES: Xia Gengqi, Zhang Rong, Chen Runmin and Luo Yang 1995, no.16, p.51; Palace Museum 1998, no.11, p.44; Palace Museum Snuff Bottles 2002, no.146, p.95

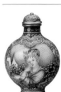

106

Snuff bottle with painted enamel design of graceful women

Qianlong period

Copper and painted enamel, 5 × 3.5 cm

Qianlong four-character reign mark

The Palace Museum, Beijing, Gu116846

SELECT REFERENCES: Xia Gengqi, Zhang Rong, Chen Runmin and Luo Yang 1995, no.20, p.55; Palace Museum 1998, no.12, p.45; Palace Museum Snuff Bottles 2002, no.165, p.113

107

Fish-shaped snuff bottle with overlay design

Qianlong period

Glass, 7.5 × 3 cm

Qianlong four-character reign mark

The Palace Museum, Beijing, Gu107616

SELECT REFERENCES: Xia Gengqi, Zhang Rong, Chen Runmin and Luo Yang 1995, no.81, p.94; Palace Museum Snuff Bottles 2002, no.65, p.45

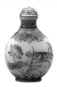

108

Snuff bottle with painted enamel design of lotus pond

Qianlong period

Glass and painted enamel, 5.5 × 4 cm

Qianlong four-character reign mark

The Palace Museum, Beijing, Gu107621

SELECT REFERENCES: Xia Gengqi, Zhang Rong, Chen Runmin and Luo Yang 1995, no.104, p.115; Palace Museum 1998, no.64, p.90; Palace Museum Snuff Bottles 2002, no.9, p.8

109

Gourd-shaped snuff bottle with painted enamel design of flowers, gourds and bats

Qianlong period

Glass and painted enamel, 6.4 × 3.2 cm

Qianlong four-character reign mark

The Palace Museum, Beijing, Gu107622

SELECT REFERENCES: Xia Gengqi, Zhang Rong, Chen Runmin and Luo Yang 1995, no.107, p.118; Palace Museum 1998, no.65, p.91; Palace Museum Snuff Bottles 2002, no.12, p.11

110

Snuff bottle with painted enamel design of Western figures

Qianlong period

Glass and painted enamel, 4.6 × 3.5 cm

Qianlong four-character reign mark

The Palace Museum, Beijing, Xin98788

SELECT REFERENCES: Xia Gengqi, Zhang Rong, Chen Runmin and Luo Yang 1995, no.109, p.120; Palace Museum 1998, no.67, p.93; Palace Museum Snuff Bottles 2002, no.18, p.16

111

Gourd-shaped snuff bottle

Qianlong period

Mutton-fat jade, 5.1 × 3 cm

Qianlong four-character reign mark on lower bulb

The Palace Museum, Beijing, Gu103693

SELECT REFERENCES: Xia Gengqi, Zhang Rong, Chen Runmin and Luo Yang 1995, no.121, p.132; Palace Museum 1998, no.76, p.101; Palace Museum Snuff Bottles 2002, no.191, p.132

112

Snuff bottle carved with rope design

Qianlong period

Jasper, 6.7 × 4.5 cm

Qianlong four-character reign mark in seal script

The Palace Museum, Beijing, Gu93252

SELECT REFERENCES: Xia Gengqi, Zhang Rong, Chen Runmin and Luo Yang 1995, no.122, p.133; Palace Museum 1998, no.77, p.102; Palace Museum Snuff Bottles 2002, no.202, p.138

113

Jujube-shaped snuff bottle

Mid-Qing dynasty

Green agate, 4 × 2 cm

The Palace Museum, Beijing, Gu106115

SELECT REFERENCES: Xia Gengqi, Zhang Rong, Chen Runmin and Luo Yang 1995, no.140, p.143; Palace Museum Snuff Bottles 2002, no.254, p.164

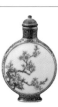

114

Snuff bottle with *famille-rose* design of plum and imperial poem

Qianlong period

Porcelain, 5.8 × 4 cm

Qianlong yu zhi mark (made by imperial order of Qianlong)

The Palace Museum, Beijing, Gu152768

SELECT REFERENCES: Xia Gengqi, Zhang Rong, Chen Runmin and Luo Yang 1995, no.160, p.157; Palace Museum 1998, no.105, p.121; Macau 2002c, no.92

115

Snuff bottle with 'long life' (*shou*) characters in asparagus fern

Mid-Qing dynasty

Bamboo skin, 6.5 × 5.5 cm

The Palace Museum, Beijing, Gu121242

SELECT REFERENCES: Xia Gengqi, Zhang Rong, Chen Runmin and Luo Yang 1995, no.186, p.181; Palace Museum Snuff Bottles 2002, no.385, p.250

116

Walnut-shaped snuff bottle with design of Westerners, inscribed with a poem about snuff bottles and followed by the two characters *zhen shang* (to keep and appreciate)

Qianlong period

Wood, 5 × 3.5 cm, with bamboo stopper

The Palace Museum, Beijing, Gu135261, 23

SELECT REFERENCES: Xia Gengqi, Zhang Rong, Chen Runmin and Luo Yang 1995, no.188, p.182; Palace Museum 1998, no.121, p.135; Palace Museum Snuff Bottles 2002, no.386, p.251

117

Snuff bottle shaped like a 'Buddha's hand' fruit (finger citron)

Possibly the example recorded in the Yongzheng records of bottles produced in the imperial ivory workshops: Yongzheng period, c.1725

Ivory, 5.9 × 2.1 cm

Private collection

SELECT REFERENCES: Zhu Jiajin 2003

Snuff is tobacco ground into powder form and infused with aromatic substances. It was introduced to China by Europeans in the mid-seventeenth century. Soon afterwards the Chinese were making decorative bottles with special stoppers to contain it. Based on existing medicine-bottle prototypes, these were more suitable in the humid Chinese climate than European boxes because their stoppers, which were interchangeable, made them airtight. As the Chinese did not have pockets, bottles were carried within the sleeves of robes or hung in pouches from belts.

After the Kangxi Emperor and his officials adopted the habit of taking snuff, the Palace Workshops began to produce bottles of the very highest quality for the court. Eighteenth-century snuff bottles are a microcosm of the finest wares produced by Qing dynasty craftsmen. Their miniature forms span the gamut of materials and techniques used in most of the traditional arts. Many were

presented as gifts, and were eagerly collected. Others were specifically made for the imperial court and connoisseurs, and were valued for their intrinsic beauty, as well as acting as indicators of social status, as did snuff boxes in Europe.

Enamelled bottles are perhaps the rarest of all snuff bottles and were generally worked on copper or glass bodies. Such enamelling was undoubtedly inspired by the European enamel-painted objects brought from Limoges by missionaries to the imperial court in about 1715. The Kangxi Emperor ordered the Italian Jesuit painter Giuseppe Castiglione (1688–1766) and his colleagues to teach his imperial artisans the use of Western colours and techniques of enamelling in a workshop which he set up for the purpose. The Emperor's direct interest in these wares is confirmed by the existence of several enamelled porcelains and snuff bottles bearing the imperial mark 'made to imperial order of the Kangxi Emperor' (see cat.100). Many of the designs on these bottles also show a pronounced Western influence (cats 106, 110 and 116).

Snuff bottles were made in a variety of materials, including most commonly porcelain and glass, but also in organic substances, such as ivory, and minerals, such as jade. As a form of inverted snobbery, several were exquisitely fashioned from very cheap materials. The Qianlong Emperor was an avid collector of jade, and several jade bottles are recorded bearing his reign mark; many of these were produced in the Palace Workshops in Beijing.

Many shapes or decorative motifs incorporate symbolic meanings, such as the fish (cat.107), denoting abundance; the *shou* character, representing long life (cat.115); and the 'Buddha's hand' fruit, which in this context denotes riches (cat.117). CJM

118

Snuff dish in the shape of a lotus leaf with a crab clasping a chrysanthemum spray

Qianlong period

Painted enamel on copper, 7.6 × 4.5 cm

Qianlong four-character reign mark in a square in blue enamel on the underside

The Palace Museum, Beijing, Gu116619

SELECT REFERENCES: Xia Gengqi, Zhang Rong, Chen Rumin and Luo Yang 1995, no.36; Li Jiufang 2002, no.179

Snuff stored in a bottle tends to form lumps, and a dish was needed on which to place the snuff so as to break these up. The design of a crab on a lotus leaf is often found on items for the scholar's desk such as inkstones and brush washers, and denotes the wish for success in the civil service exams (see cat.226). HK

119

Rococo-style vase with animal-mask ring handles, painted with European landscapes

Qianlong period, Guangzhou, Guangdong Province

Enamels and gilding on copper, height 50.5 cm

Qianlong six-character seal mark in blue enamel in a square on the base

The Palace Museum, Beijing, Gu116624

SELECT REFERENCES: Yang Boda 1987B, pl.347; Nakamura and Nishigami 1998, fig.229; Macau 1999, cat.80; Li Jiufang 2002, pl.215

This ornate vase may at first glance seem more Western than Chinese: the enamel panels on both sides depict pastoral European landscapes in soft pastel colours and the surrounding gilt-bronze scrollwork, densely strewn with pink roses and other blooms, reflects the height of French Rococo taste. The shape of the vase, however, with its quatrefoil ('begonia-shaped') section, and the animal-mask ring handles inspired by archaic bronzes, are purely Chinese; the piece comes from the famous enamelling workshops of Guangzhou (Canton).

While in Europe the Rococo style was deemed Chinoiserie, since it played on Chinese imagery, depicting Chinese figures and exotic birds, pagodas and pavilions, and exploiting Chinese rock forms, it looked completely exotic when it returned to China. Vessels as eccentric as this were rarely produced. RK

7 The Kangxi Emperor: Horseman, Man of Letters, Man of Science

120

Anonymous court artists
Portrait of the Kangxi Emperor in Informal Dress Holding a Brush

Kangxi period

Hanging scroll, ink and colour on silk, 50.5 × 31.9 cm

The Palace Museum, Beijing, Gu6402

SELECT REFERENCES: Palace Museum 1992, pl.13, p.51; Nie Chongzheng 1996, vol.14, pl.1, p.3; Stuart 1998, fig.7; Macau 1999, pl.3

This portrait of the Kangxi Emperor at the age of about thirty represents a complementary aspect of his identity to that pictured in an image of roughly the same date that depicts him wearing military attire (cat.61). In this example the Emperor raises an exquisitely decorated brush of unusually large – or imperially grand – size to write calligraphy, one of his favourite pastimes. The work straddles the line between formal and informal portraiture: the forward-facing pose of the Emperor implies a degree of ceremony, while his casual dress and active pose relate to a less official category of portrait known as *xingle tu* (pictures of pleasurable activities).

Paintings of leisurely pursuits that seem to depict a specific moment in time, such as this portrait, are usually 'mind images' or staged constructions that represent how an emperor wanted to be envisioned. In fact, the modern concept of 'pleasurable activity' is not entirely germane. The Kangxi Emperor recorded that he assiduously practised calligraphy every day, but in the context of a Han-dominated empire, this might have been as much a political strategy to ally himself with the Chinese literati as a personal pleasure. The answer to that question is unknowable.

The painting contains a curious hybrid of Chinese and Western systems of perspective. Somewhat unexpectedly these co-exist without disrupting the visual splendour of this lavishly detailed painting. The table is rendered in a traditional Chinese manner, with the point of convergence at an imaginary point in front of the Emperor, but the legs of the screen follow Western perspective with a point of convergence behind the Emperor. Moreover, the carpet – which would recede in Western visual schema – reads parallel to the picture plane, almost like wallpaper. The marriage of these opposing visual systems is another indication of the frequent pairing of polarities in Chinese thought and its visual expression. JS

121

The Kangxi Emperor (1654–1722)
A Tang poem about the lotus in bloom, written in running script in the style of Dong Qichang

c. 1703

Hanging scroll, ink on silk, 186.7 × 85.3 cm

IMPERIAL SEALS: *Guiwei zai he* (*Guiwei* year [1703] in harmony); *Yuanjian huihao* (Wielding the brush in the Studio of Profound Discernment); *Sanwu jiuyou* (Three lacks, nine haves)

COLLECTORS' SEALS: *Baoji sanbian* (Volume three of the *Precious Collection of the Stone Moat [Pavilion]*); *Shiqu baoji suo cang* (Collected in the *Precious Collection of the Stone Moat [Pavilion]*); *Xuantong zunqin zhi bao* (Treasure of the esteemed parents of the Xuantong Emperor); *Jiaoyubu dianyan zhi zhang* (Inspection seal of the Department of Education)

The Palace Museum, Beijing, Gu237978

This scroll of calligraphy records a twelve-line verse of five characters to a line by the poet Chen Zhi (dates unknown) of the Tang dynasty (618–907):

> The blooming lotus greets the autumn,
> Swaying gently, its reflection lines the shore.
> The flash of a sword opens the treasure case,
> The peaks' shadows fall across the rush ford,
> Below shine the water lilies,
> High above, the apple's leafy boughs begin to droop.
> One should nest in its kingfisher-green shell,
> And play endlessly with the timid fish.
> Put aside the 'early' and 'late' of the calendar,
> Speak instead of its fresh or fading colours.
> Its fragrant scent will truly satisfy one's leisure,
> Who will return to pay the ferryman?

'A song of the blooming lotus by Chen Zhi of the Tang, written in the style of Dong Qichang.'

The composition of characters in this calligraphy is open and expansive, while the individual brush strokes have a rounded energy and elegance to them. The overall mood of the piece is fresh, relaxed and elegant. The calligrapher's inscription indicates that it was done 'after Dong Qichang', the great artist and theorist of the Ming period. In his early years, Dong Qichang (1555–1636) had studied the calligraphy of the Tang statesman Yan Zhenqing, before progressing to the Jin, Tang and Song masters, and finally, in his later years, returning to Yan Zhenqing.

This piece of calligraphy shows rather obvious characteristics of Yan Zhenqing's rugged, forthright style; thus, by association, it is likely to have been a product of close study of Dong Qichang's early calligraphy during the Emperor's middle years. HN/SMcC

122

The Kangxi Emperor (1654–1722)
A Tang poem in praise of chrysanthemums, written in the standard running script in the style of Mi Fu

1703

Hanging scroll, ink on silk, 186.5 × 83.5 cm

IMPERIAL SEALS: *Guiwei zai he* (*Guiwei* year [1703] in harmony); *Yuanjian huihao* (Wielding the brush in the Studio of Profound Discernment); *Sanwu jiuyou* (Three lacks, nine haves)

COLLECTORS' SEALS: *Baoji sanbian* (Volume three of the *Precious Collection of the Stone Moat [Pavilion]*); *Shiqu baoji suo cang* (Collected in the *Precious Collection of the Stone Moat [Pavilion]*); *Xuantong zunqin zhi bao* (Treasure of the esteemed parents of the Xuantong Emperor); *Jiaoyubu dianyan zhi zhang* (Inspection seal of the Department of Education)

The Palace Museum, Beijing, Gu237980

This scroll of calligraphy was executed in the 42nd year of the Kangxi Emperor's reign (1703). It is a transcription of a poem by the Tang period poet Gongsheng Yi (dates unknown), entitled 'Prose-poem on How Autumn Gives Chrysanthemums Their Fine Colours', a twelve-line verse of five characters to a line. The chrysanthemum, also known as the 'ninth month flower' because it flowers in September, was famously beloved of the great early poet Tao Yuanming (or Tao Qian, 365–427). The poem reads:

> Along Prefect Tao's [the poet Tao Yuanming] fence,
> As autumn comes, the chrysanthemums colour and bloom.
> From jadeite came a thousand leaves;
> Out of gold cut one blooming flower.
> Pistils curve after flying bee's beard;
> Blossom tilts along with butterfly's wings.
> Carrying the fragrance, the breeze wafts through the greenness.
> Tranquil shadows play across the window.
> Resolutely wavering, the frosty hues,
> Fresh and graceful, flowers open to the sun.
> Such scent and beauty were seen at Pengze [where Tao Yuanming was briefly Prefect],
> What higher praise is there than this?

'A song of chrysanthemums by Gong Chengyi of the Tang, written in the style of Mi Fu.'

The Kangxi Emperor did not limit himself to any particular school when he studied specimens of calligraphy, but applied himself equally to emulating masters from throughout the classical tradition: famous early masters such as the Two Wangs, Wang Xizhi and his son Xianzhi, the Tang statesmen Yan Zhenqing and Liu Gongquan, and the Song literati Su Dongpo (Su Shi), Huang Tingjian and Mi Fu. It is recognised that he was particularly successful at writing in the style of Mi Fu.

This piece of calligraphy, which according to the inscription was done after Mi Fu, features robust, attenuated characters composed of bold, clearly defined strokes. As a whole, the piece does evoke the naturalism and freedom of Song calligraphy, demonstrating that the Emperor did indeed capture something of the spirit and flavour of Mi Fu's calligraphy. HN/SMcC

123

Seal of the Kangxi Emperor

1662–1722

Sandalwood, 11 × 11 × 11 cm, with cord of yellow silk

The Palace Museum, Beijing, Gu166445

SELECT REFERENCE: Palace Museum 1996, no.165

The form and material of this seal correspond closely with one of the twenty-five state seals of the Qing dynasty, which the Qianlong Emperor established in 1746 and had recarved in 1748.[1] Indeed, the present example may have provided a model for one of them. With its knob carved in a square, compact form, depicting an archaic mythical beast, the seal exhibits imperial strength and power. The characters quote a slightly modified passage from the *Book of Changes* (*Yijing*),[2] which the Qing rulers chose as a motto for self-admonishment: 'Nourishing Virtue and Diligently Caring for the People' (*yu de qin min*).

The seal was probably used by the Kangxi Emperor as a personal seal to be impressed under his imperial signature or on pieces of calligraphy by his own hand. The archaic seal script characters are round and fleshy, and more vivid than the characters in the seals of the Qianlong Emperor. Besides jade and gold, sandalwood was used as one of the three main materials for the seals of state in China. GHo

124

Imperial Prose and Poetry of the Kangxi Emperor (*Yuzhi wenji/ Shengzu wenji*), 140 *juan*

1711

Woodcut edition printed on fine white paper in 78 fascicles, 28 × 17.5 cm

The British Library, London, 15316.c.193

SELECT REFERENCE: Hummel 1943, pp.142–43, 331

This compilation, known as *Yuzhi wenji* or *Shengzu wenji*, comprising works attributed to the Kangxi Emperor and others, was edited by Jiang Chenxi (1635–1721) and revised by Jiang Lian (dates unknown) of the imperial Hanlin Academy, in 1711.

A palace edition printed at the Hall of Military Eminence (Wuying dian), the printing office in the Forbidden City, it is considered to be one of the most beautifully produced books of the eighteenth century. The characters were meticulously cut and printed with the utmost care on thin white paper. This copy still retains its original covers of self-patterned cream-yellow silk with five-clawed dragons or phoenixes. Gold brushpen inscriptions (collection 3, fascicule 1), dated to the twenty-second year of the Jiaqing reign (1817), may indicate the time when some volumes were repaired and given bright yellow paper covers at the back. The slim thread-bound (*xianzhuang*) volumes are enclosed in six blue cloth wrappers (*tao* or *han*), possibly made in 1817, which are secured by toggles in the traditional manner. Since these would have been stored flat on their 'sides', the volume (*ce*), collection (*ji*) and section (*juan*) numbers, along with the title, were printed in minute characters along the bottom edges, which faced out from the shelf, for ease of reference and retrieval. The simple yet elegant title pages of the three sections are particularly striking, having superbly executed characters in regular script (*kaishu*) printed over a ground of white paper flecked with gold leaf. GHu

125

The Kangxi Emperor (1654–1722) 'On the Way to Guangning', a poem, in running script

Undated

Hanging scroll, ink on paper, 125.7 × 51.5 cm

IMPERIAL SEALS: *Kangxi chen han* (Kangxi imperial brush); *Jigu youwen zhi zhang* (Seal of examining the ancient to improve culture); *Yuanjian zhai* (Studio of Profound Discernment)

COLLECTORS' SEALS: *Baoji sanbian* (Volume three of the *Precious Collection of the Stone Moat [Pavilion]*); *Shiqu baoji suo cang* (Collected in the *Precious Collection of the Stone Moat [Pavilion]*); *Xuantong zunqin zhi bao* (Treasure of the esteemed parents of the Xuantong Emperor); *Jiaoyubu dianyan zhi zhang* (Inspection seal of the Department of Education)

The Palace Museum, Beijing, Gu237967

This scroll of calligraphy is inscribed with a four-line verse of five characters to a line by the Kangxi Emperor entitled 'On the Way to Guangning'. The poem reads:

Along a hoary vista the colour of cold clouds,
The lookout towers have nothing to report all day.
Starved crows caw at the dawn moon
By the road out of the Thirteen Mountains.

This text is recorded in the *Second Volume of Imperial Prose and Poetry of the Kangxi Emperor (juan 7)*. The Emperor executed the calligraphy holding his brush at an oblique angle using pale ink. The composition is elegantly drafted and the style is at once both charming and classical. HN/SMcC

126

The Kangxi Emperor (1654–1722) 'Composed at Zhaobeikou', a poem, in running script

Undated

Hanging scroll, ink on gold-flecked paper, 135.5 × 57.1 cm

IMPERIAL SEALS: *Kangxi chen han* (Kangxi imperial brush); *Jigu youwen zhi zhang* (Seal of examining the ancient to improve culture); *Yuanjian zhai* (Studio of Profound Discernment)

COLLECTORS' SEALS: *Baoji sanbian* (Volume three of the *Precious Collection of the Stone Moat [Pavilion]*); *Shiqu baoji suo cang* (Collected in the *Precious Collection of the Stone Moat [Pavilion]*); *Xuantong zunqin zhi bao* (Treasure of the esteemed parents of the Xuantong Emperor); *Jiaoyubu dianyan zhi zhang* (Inspection seal of the Department of Education)

The Palace Museum, Beijing, Gu237959

Aixinjueluo Xuanye, known as the Kangxi Emperor, was the third son of the Shunzhi Emperor (r. 1644–61). He received a strict and systematic education in traditional Han Chinese culture, and developed a strong affinity for it. Not only did he promote Han education, he was also himself well-versed and diligent in the pursuit of Han learning. Practising calligraphy was an important part of his education and self-cultivation. In his spare time he improved his hand by studying and transcribing ancient masterpieces with his advisors. Among the calligraphers of the past, he most admired the late Ming period master Dong Qichang (1555–1636), whose art theory and styles in both calligraphy and painting assumed the position of orthodoxy under the early Qing rulers. The Emperor worked tenaciously to model his calligraphy on Dong Qichang's, and, in the end, became one of the most celebrated masters practising in Dong's style. The early Qing period style became suffused with the spirit and style of Dong Qichang's followers, demonstrating the Emperor's direct influence on the development of calligraphic style in his own time.

Inscribed on this scroll is an eight-line verse of five characters to a line, entitled 'Composed at Zhaobeikou':

We came to inspect Zhaobeikou, and heard about the ancient battle of Yannan.
Smoke from the people's fires rose over the dawn market; the shadows of the bridges rippled under bright clouds.
Bathing birds greeted departing boats by weeping willows bordering the shorelines.
Our delight pure as the middle current, while flute and drum sounded along the streams.

The verse is recorded in *juan* seven of the *First Volume of Imperial Prose and Poetry of the Kangxi Emperor*. Zhaobeikou (literally, 'gateway north of Zhao'), also known as Tangxingkou and Zhaobaokou, lies 50 Chinese miles north of the county town of Renqiu in Zhili Circuit (due east of Baoding in modern Hebei Province). Zhaobeikou is situated along Baiyang Lake (Baiyong dian); in ancient times dykes and bridges were found there, and the area is still an important crossing point. The inscription on a bridge there makes this clear: 'Yan nan Zhao bei' (literally 'South of Yan and North of [the ancient state of] Zhao). The Kangxi Emperor once observed the reservoir system there during the mid-spring. Composed on that inspection tour to Zhaobeikou, this poem records the peaceful scenes he took in, and was moved to write verse about, at the ancient town in the south of Yan. The execution of this running-script calligraphy is assured and fluent, with the characters showing a full, rich harmony of brush movement and ink effects, for instance, between the vigorous thick brush strokes and finely pointed ligatures connecting them.

Recorded in *Shiqu baoji sanbian* and inventoried by the Department of Education during the Republican era (1912–49), this scroll of calligraphy has been treasured in the collections for nearly three hundred years. HN/SMcC

127

The Kangxi Emperor (1654–1722)
'Appreciating Chrysanthemums
on the Double Ninth Festival',
a poem, in running script

Undated

Hanging scroll, ink on paper,
125 × 51.4 cm

IMPERIAL SEALS: *Kangxi chen han* (Kangxi
imperial brush); *Chiji qing yan* (Pure repose
from state affairs); *Yuanjian zhai* (Studio of
Profound Discernment)

COLLECTORS' SEALS: *Baoji sanbian* (Volume
three of the *Precious Collection of the Stone Moat
[Pavilion]*); *Shiqu baoji suo cang* (Collected in the
Precious Collection of the Stone Moat [Pavilion]);
Xuantong zunqin zhi bao (Treasure of the
esteemed parents of the Xuantong Emperor);
Jiaoyubu dianyan zhi zhang (Inspection seal
of the Department of Education)

The Palace Museum, Beijing, Gu237966

This scroll presents a four-line
verse of five characters to a line
on the subject of appreciating
chrysanthemums at the Double
Ninth Festival (the ninth day of the
ninth month). Composed by the
Kangxi Emperor, the poem is
recorded in the *First Volume of
Imperial Prose and Poetry of the Kangxi
Emperor* (*juan* 8):

> Not competing with other flowers,
> The chilled buds more fragrant late
> in the year.
> How the stems stand stiff and straight:
> I admire their disdain for wind and frost.

The calligraphy was clearly
executed in a most expansive spirit,
with the characters widely spaced.
There is something of the brusque
manner of the Northern Song
master Huang Tingjian (1045–1105)
to these characters, although the
strokes lack the same naturalistic
tensile strength, seeking instead an
inner suppleness consonant with
the Emperor's regard for the more
polished aesthetics of calligraphy
by the late Ming period orthodox
master Dong Qichang (1555–1636),
who was one of the Emperor's
principal models. Speaking of the
style as a whole, one could say that
the characters are 'hard' without
and 'soft' within, while the layout
and spacing, both in columns and
between characters, are controlled
and balanced. All this well illustrates
the calligrapher's visual experience,
and indeed his studious industry in
front of calligraphic specimens by
his models, Huang Tingjiang and
Dong Qichang. HN/SMcC

128

The Kangxi Emperor (1654–1722)
'Crossing the Frozen River',
a poem, in running script

Undated

Hanging scroll, ink on gold-flecked paper,
131.2 × 53.3 cm

SEALS: *Kangxi chen han* (Kangxi imperial
brush); *Jigu youwen zhi zhang* (Seal of
examining the ancient to improve culture);
Yuanjian zhai (Studio of Profound
Discernment)

COLLECTORS' SEALS: *Baoji sanbian* (Volume
three of the *Precious Collection of the Stone Moat
[Pavilion]*); *Shiqu baoji suo cang* (Collected in the
Precious Collection of the Stone Moat [Pavilion]);
Xuantong zunqin zhi bao (Treasure of the
esteemed parents of the Xuantong Emperor);
Jiaoyubu dianyan zhi zhang (Inspection seal of
the Department of Education)

The Palace Museum, Beijing, Gu237951

This scroll of calligraphy is inscribed
with a poem by the Kangxi
Emperor entitled 'Crossing the
Frozen River', recorded in *juan* five
of the *Second Volume of Imperial Poetry
by Qing Shengzu*. The poem reads:

> Deep clouds hang over ten thousand
> cavalry,
> A thousand flags echo in the teeth of the
> gale.
> By midnight the river has iced over,
> The imperial armies cross without fear.

Below the poem is an added note,
reading: 'For a time the river was
not completely frozen over. No
sooner had the marching orders
been given to cross the river than it
could be crossed as if by walking on
flat ground.' The scroll is undated.

Combining regular and running
scripts, this calligraphy has a
profound vigour, as well as an
untrammelled, heroic kind of
beauty. HN/SMcC

129

Imperially commissioned Chinese
encyclopaedia, *Synthesis of Illustrations
and Books Past and Present* (*Qinding
Gujin tushu jicheng*)

1726

Copper movable type and woodblock
illustrations printed on light brown paper,
threadbound, average original dimensions
approximately 27.5 × 17.5 cm

The British Library, London, 15023.b.1

SELECT REFERENCES: Giles 1911; Hummel
1943, pp.93–95, 142–43

Reproduced here are illustrations
from the imperial encyclopaedia
Qinding Gujin tushu jicheng/*Gujin tushu
jicheng*, first edition (1728).

One of the greatest feats ever
undertaken in the history of
printing and publishing, the work
was initiated during the Kangxi
period by Chen Menglei (b.1651),
a former scholar in the imperial

Hanlin Academy. Banished as
a traitor for involvement in the
southern rebellions (suppressed
1681), he subsequently regained
the Kangxi Emperor's favour and
support for his project (hence the
Qinding, 'imperially commissioned',
prefix in the alternative title).

Building on a tradition of
compilation in China stretching
back nearly two millennia,
production involved the use of
a vast number of copper types
(unverified estimates vary from
230,000 to 250,000), probably cut
rather than cast, together with finely
cut woodblocks for the illustrations.
Maps and diagrams of all kinds were
reproduced together with pictures
of, for example, the natural world,
the latter incorporating techniques
associated with traditional
Chinese brush-and-ink painting.
Approximately 5,000 thread-bound
(*xianzhuang*), paper-covered volumes
(*ce*) were then encased in batches in
some 523 wrappers (*tao* or *han*), each
of these secured with two toggles.
The wide-ranging subject-matter,
divided into 10,000 sections (*juan*),
could be considered a synthesis
of the contemporaneous Chinese
world picture and elements of
Western learning embodying the
Kangxi Emperor's thirst for all
knowledge that would benefit
China.

Under the new Yongzheng
Emperor, Chen was disgraced
in 1723 and forced into a second
exile where he died. Jiang Tingxi
(1669–1732), an official and
respected painter, was ordered
to make revisions. Officially, 64
sets were produced in 1726. Several
subsequent editions have been
produced, the most recent being
a digitised version.

The following are woodblock
illustrations, from the 'Animal'
(XIX) and 'Vegetable' (XX) sections
of the *Qinding Gujin tushu jicheng*.
Mythical animals are included in
the former category, as traditionally
they were regarded as part of the
natural world. All of these subjects
were depicted frequently in the arts.

Composite bird with four legs
SELECT REFERENCE: Giles 1911, XIX, p.30

Strange animals and birds such as
the one shown here with four legs
are often included as part of the
natural world. Descriptions of them
often appear in such early works
as the *Classic of Mountains and Seas*
(*Shanhai jing*), a quasi-geographical
work of unknown authorship

compiled more than two thousand years ago.

Pheasants
SELECT REFERENCE: Giles 1911, XIX, p.30

The variety of long-tailed pheasant shown here (*he*) earned a reputation for a fondness for fighting and, therefore, came to represent courage.

Lions
SELECT REFERENCE: Giles 1911, XIX, p.59

Not indigenous to China, lions are usually depicted in a characteristically Chinese fashion. The term 'Levantine lion' (*Liwei Yazhou shi tu*) in the left-hand illustration, probably refers to the biblical lion which roamed parts of the ancient Near East. On the right, a more traditional type (*suan ni*) of spaniel-like adult plays with a cub.

'Dragon-horse'
SELECT REFERENCE: Giles 1911, XIX, p.89

This composite beast, the auspicious 'dragon-horse' (*longma*), bears a diagram containing the Eight Trigrams on its side. It is similar in appearance to the *qilin*, a more commonly encountered animal of good omen.

Ox and buffalo
SELECT REFERENCE: Giles, 1911, XIX, p.105

Oxen and water buffaloes were fundamental to the agricultural system, the basis of the traditional economy. As such, they were a frequent theme in both literature and the arts.

Dragons
SELECT REFERENCE: Giles 1911, XIX, p.127

Two dragons (*long*) are shown here. One with wings (*yinglong*) writhes amid clouds and water, the natural abode of both types. Both are typical of the kind of auspicious dragon that came to be almost inextricably associated with China and with the power and authority of the Emperor.

Carp
SELECT REFERENCE: Giles 1911, XIX, p.139

Carp are often shown as leaping up waterfalls symbolising the struggle for success in the examination system, the path to a career as a government official.

Fungus
SELECT REFERENCE: Giles 1911, XX, p.48

In addition to their culinary uses, fungi were highly prized for their health-giving qualities. For example, the magical 'fungus of immortality' (*lingzhi*), similar in shape to the one illustrated here, lies at the heart of

the traditional Chinese concern with long life and 'immortality'. It is frequently found with Daoist subject matter and stylised as decorative motifs.

Lotus
SELECT REFERENCE: Giles 1911, XX, p.93

All of the lotus plant (*lian*) is included here to indicate that most of its parts could be used in medicine and cooking. Beyond its domestic uses, the lotus also held a spiritual symbolism: standing tall above the mud it represented Buddhist purity and Confucian integrity.

Peony
SELECT REFERENCE: Giles 1911, XX, p.115

Herbaceous and tree peonies are native to China. The former is mentioned for its medicinal purposes in the *Book of Poetry* (*Shijing*) of the eighth to seventh century BC. Cultivated in the Tang period (618–907) as garden plants, peonies were subsequently incorporated into the arts as decorative motifs, scrolling floral patterns and subject matter in painting. GHu

130

Brushpot painted with bamboo and inscribed with a poem in the calligraphy of Gao Fenghan (1683–1748/49), with two painted seals reading *xi* and *yuan*

Kangxi period, Jingdezhen, Jiangxi Province
Porcelain with overglaze enamels, height 14.8 cm
The Palace Museum, Beijing, Gu148294
SELECT REFERENCES: Qing Porcelain 1989, p.77, pl.60; Beijing 1991, no.1193; Wang Liying 1999, pl.90

131

Wrist rest in the form of a piece of bamboo, painted with bamboo and inscribed with a poetic line

Kangxi period, Jingdezhen, Jiangxi Province
Porcelain with overglaze enamels, 1.5 × 6.9 × 18.5 cm
The Palace Museum, Beijing, Gu148290
SELECT REFERENCE: Beijing 1991, no.1192

Xiyuan (West Garden) was the style name of Gao Fenghan (1683–1748/49), painter of plants, rocks and landscapes, calligrapher and seal-carver. A close friend of Jin Nong (see cats 262, 265), Gao was renowned for his eccentric brushwork and his 'grass' or 'concept script' (*cao shu*). His paintings were much sought after, particularly his later left-handed work, which he began after his

right hand had become paralysed. A native of Shandong, he resided for many years in the Jiangnan region southeast of the Yangzi River, at times serving as a minor official, at times living from his art.

The calligraphy on the brushpot in particular, which bears Gao's seals, shows the characteristics of his hand. Whether he would have inscribed and painted the piece(s) himself, or whether they simply reproduce his style, is not easy to determine. Literati painters are not otherwise known to have executed paintings on porcelain. However, Gao is recorded to have travelled to Jiangxi Province in the autumn of the year 1709, visiting the city of Nanchang and Poyang Lake, both very close to the porcelain city of Jingdezhen, to meet with a relative and another painter. The colour scheme of these pieces, which does not make use of any 'foreign' enamels, conforms with a Kangxi date.

The poetic lines on the brushpot compare the movement of the bamboo to that of 10,000 dragons, its humming to that of the colourful phoenix. The line on the wrist rest refers to it as a branch of reddish jade. RK

132

Brushpot carved with the Seven Sages of the Bamboo Grove and attendants

Early Qing dynasty, Jiading, Shanghai
Bamboo with *zitan* wood fittings, height 17.3 cm
The Palace Museum, Beijing, Gu121129
SELECT REFERENCE: Palace Museum 2002, pl.29

133

Wrist rest carved with lotus flowers with one leaf sheltering a crab

Early Qing dynasty, Jiading, Shanghai
Bamboo, 23 × 7.8 cm
Inscribed *Song shan* (Pine Hill) in the form of a square seal
The Palace Museum, Beijing, Xin124676
SELECT REFERENCES: Li Jiufang 2002B, pl.40; Palace Museum 2002, pl.18

Bamboo, a cheap, unpretentious material in plentiful supply, was most popular for items for the scholar's desk, whether imperial or otherwise. The excellence of bamboo utensils is derived from their workmanship, and the present pieces, made in workshops in the Shanghai region, are outstanding

for their deeply undercut, three-dimensional carving. The craftsmen are not known, although the wrist rest is signed with the (unidentified) style name Songshan.

Wrist rests were used to support the hand when writing with a brush, affording more freedom of movement than a hand resting on the desk.

The Seven Sages of the Bamboo Grove (*zhulin qixian*) were a group of scholars of the Wei dynasty (220–265) who had renounced their official careers and retired to rural surroundings in protest against a corrupt regime. Their propagation of freedom of individual beliefs, inspired by Daoist philosophy, became a model for scholars disenchanted with official policies throughout Chinese history, and a symbol of the incorruptible scholar ideal. Their gatherings at the country home of one member, Xi Kang, in Shandong Province are generally depicted as jovial occasions for drinking and composing poetry. Yet their heretical ideas were considered a serious threat to the state, and Xi was sentenced to death, reputedly tuning his lute as he walked to his execution. RK

134

Box and cover carved in the form of a 'Buddha's hand' fruit (finger citron)

Early Qing dynasty, seventeenth century
Boxwood (*huangyangmu*) with blackwood stand, 7 × 19.5 × 12 cm
Shuisongshi Shanfang Collection, 32.1.198
SELECT REFERENCE: Hong Kong 1986, p.258

This box was probably made to contain an auspicious gift, such as medicine or a longevity potion. It is carved in the shape of a 'Buddha's hand' finger citron, a fruit with erotic connotations that was used to perfume the study and was, therefore, often placed on a scholar's desk. The groove around one end suggests that the boxwood was constrained by a cord during growth, allowing a ribbon to be tied around the finished box, just as a real 'Buddha's hand' fruit was often tied with a cord for presentation. The blackwood stand, carved to resemble interlocking roots, was probably made especially for the piece, which would not stand independently. JVP

135

Brushpot carved in the form of five bamboo stems and a prunus branch

Early Qing dynasty, Palace Workshops, Beijing
Boxwood (*huangyangmu*), height 15.5 cm
The Palace Museum, Beijing, Xin82297
SELECT REFERENCES: Palace Museum 2002, pl.66

This eccentric artefact with its distorted, asymmetric form is meant to look as if it was organically formed by nature. In fact, it is an intricate sculpture, superbly carved from a beautifully textured but oddly shaped piece of boxwood. Such joint creations of nature and man, ingeniously conceived from a humble material, were favourite items for the writing table. Like most Qing crafts, this piece is anonymous.

Five twisted stems of bamboo of varying thickness are joined by a branch of prunus to form a brushpot with four openings of different sizes. Bamboo and prunus are symbols of endurance, as the former remains green during the cold season, and the latter flowers even before sprouting leaves. RK

136

Inkstone with a dragon among waves, with fitted box and cover with archaistic dragon designs

Kangxi period, Palace Workshops, Beijing
Green Songhua stone with mother-of-pearl, and striated brown Songhua stone with glass, 5.5 × 13 × 19.2 cm
Kangxi chen han (Kangxi imperial pen) and *Kangxi yu ming* (Kangxi imperial inscription) engraved on the base
The Palace Museum, Beijing, Gu134706
SELECT REFERENCES: Zhou Nanquan 1980, p.87; Shizuoka 1988, cat.44: 1; Shi Shuqing 1994, p.452, no.39; Versailles 2004, cat.19

> Venerable age has made the material unctuous,
> Green in colour, clear in sound.
> It enhances the ink, benefits the brush
> That's why we treasure it so highly.

Inscribed with a poem by the Kangxi Emperor, this inkstone was made in the Beijing palace workshops, which employed famous stone-carvers from different regions. The Songhua stone, named after the Songhua River of Jilin, comes from the Manchu homeland in the far northeast of the empire. The Kangxi Emperor was therefore particularly fond of it and introduced it to the court. Being hard but extremely smooth, it is ideally suited for inkstones;

and its even brown and green striations provide unique decorative possibilities. Reputedly, only traces of red ink – the ink reserved for the Emperor – are found on Songhua inkstones in the Palace Museum.

On the present piece, an irregular piece of mother-of-pearl was inlaid as a small mountain rising from the ink pool, surrounded by a dragon and waves. A very similar piece with the colours reversed can be seen in a painting commissioned in the Kangxi period by the future Yongzheng Emperor (cat.173, no.11 in the series). RK

137

Box of inksticks with mark of Wu Tian

Kangxi period
Lacquered wood and ink, 3 × 10 × 26 cm
The Palace Museum, Beijing, Xin109370, 1–10
SELECT REFERENCES: Hong Kong 1986, p.78; New York 1987, pp.185–87; Versailles 2004, cat. 18, p.242

Ink was one of the four prerequisites of a true scholar, one of the 'four treasures of a scholar's studio', together with paper, inkstone and brush. Made of pine soot mixed with animal glue, ink was usually formed into either long sticks like these or round cakes. They often had moulded or gilt decoration and were inscribed with the maker's name. In the sixteenth century, albums of designs for inksticks were published, such as the *Fangshi mopu* by Fang Yulu (1570–1619). Inksticks and cakes were treasured and collected and many were made as gifts rather than for use. By the time this set was made, interest in collecting inksticks and cakes was so great that elaborate boxes were provided to contain them. This Kangxi period example is decorated with archaistic bronze vessels and scholarly collectors' items. JVP

138

A pair of brushes

Kangxi period
Bamboo, rabbit hair, 27 × 1.2 cm
The Palace Museum, Beijing, Gu133201/6, Gu133201/8
SELECT REFERENCE: Versailles 2004, no.17

Each brush's plain cylindrical handle is fashioned from bamboo and decorated with the auspicious phrase 'Long live the Emperor' (*Tianzi wannian*, literally 'may the

Son of Heaven [live] ten thousand years') written vertically in regular script (*kaishu*) and filled in with gold. The characters *Chen Bai Huang gong jin* appear underneath in smaller characters in blue, indicating that the brushes were respectfully presented as a gift by a certain Bai Huang.

Bamboo was one of the most popular materials for brush-making as it was light and comfortable in the hand. The balance of the brush was very important in order to control the flow of ink and produce the desired effects. The material for the tip was also carefully chosen. This tip, shaped like a bamboo shoot tapering to a sharp point, is made from rabbit hair, although the hair of other animals, such as deer, wolf, tiger, fox and goat, were also used. HK

139

Inkstick stand

Qing dynasty

Yellow jade, height 4.4 cm

The Palace Museum, Beijing, Gu92645

SELECT REFERENCE: Zhang Guangwen 1995, no.174

Ink was one of the four 'treasures' of the scholar's studio, together with paper, inkstone and brush. Calligraphers gradually added a variety of other accessories to act as a support cast to these basic treasures. Once the calligrapher had finished grinding his ink on the inkstone he needed somewhere to place his wet inkstick so that it could dry slowly in the air, before it could be stored. In Chinese, inkstick rests are known as inkstick 'beds' as they provide a flat surface.

Most such stands are made of bronze or porcelain; a jade stand such as this example, with its ends elegantly curling under into a scroll form, would have been made primarily to be appreciated and displayed by emperors and the élite. CJM

140

Wrist rest imitating bamboo

Qing dynasty

Nephrite, 1.65 × 20 × 3.8 cm

Shuisongshi Shanfang Collection, 31.3.492

Chinese calligraphy is traditionally written from top to bottom and in rows from right to left. Unless the characters are very large, the calligrapher usually needs to rest his wrist or arm for added support while writing as the previous row of characters is easily smudged if the hand rests directly on the paper.

Wrist rests, which elevate the wrist above the paper, solve this problem, and were therefore essential accoutrements of the scholar's desk. They were made in a variety of materials, but bamboo was most frequently used as it provided the necessary amount of natural curve to elevate the wrist. Bamboo also stays cool to the touch even during the hottest days. Jade has a similar coolness in summer (although it would be cold to the touch during winter), and was particularly appreciated by the literati for whom such objects were mostly made.

In this example the jade-carver has very carefully and ingeniously incorporated some of the skin of the jade pebble into the design, which skilfully imitates bamboo, whose flexibility and toughness symbolised the integrity of the scholar. CJM

141

Brush washer in the shape of a leaf

Kangxi period

Green-glazed porcelain, 1.5 × 7 × 12.8 cm

The Palace Museum, Beijing, Gu147675

SELECT REFERENCE: New York 1987, p.165

Brush washers were a necessary component of the scholar's desk assemblage as water was essential to writing and painting in ink. A lip was vital for shaping the brush end into a point and controlling the amount of water left on it. Most brush washers were broad and shallow in shape, as is this example. Leaves were often associated with Daoism, but in this case the leaf shape is probably more directly reflective of the scholarly delight in nature, in the same way that miniature mountains and rocks were placed on desks and fruit shapes were used for water droppers. Brush washers were often foliate in shape.

In this piece, the porcelain has been intricately moulded and carved in a naturalistic way, showing details such as the veins on the leaves. It is possible that the green glaze on this porcelain brush washer was intended to imitate jade, and indeed many brush washers were made of this material. JVP

142

'Peach-bloom' apple-shaped water pot (*pingguo zun*)

Kangxi period, Jingdezhen, Jiangxi Province

Porcelain with copper-red glaze, height 7.1 cm

Kangxi six-character reign mark in underglaze blue on the base

Anonymous loan

SELECT REFERENCE: Chait 1957, p.135 bottom

143

'Peach-bloom' Taibo or chicken-coop water pot (*jizhao zun*)

Kangxi period, Jingdezhen, Jiangxi Province

Porcelain with copper-red glaze, height 8.5 cm

Kangxi six-character reign mark in underglaze blue on the base

The Palace Museum, Beijing, Gu147108

144

'Peach-bloom' seal-paste box (*yinhe*)

Kangxi period, Jingdezhen, Jiangxi Province

Porcelain with copper-red glaze, diameter 7.2 cm

Kangxi six-character reign mark in underglaze blue on the base

The Palace Museum, Beijing, Gu147129, 5

SELECT REFERENCES: Qing Porcelain 1989, p.141, pl.124

145

'Peach-bloom' brush washer (*xi*)

Kangxi period, Jingdezhen, Jiangxi Province

Porcelain with copper-red glaze, diameter of mouth 8.2 cm, diameter of foot 7.7 cm

Kangxi six-character reign mark in underglaze blue on the base

The Palace Museum, Beijing, Gu147106

SELECT REFERENCES: Versailles 2004, cat.55

146

'Peach-bloom' three string (*san xian*) or radish vase (*laifu ping*)

Kangxi period, Jingdezhen, Jiangxi Province

Porcelain with copper-red glaze, height 19.8 cm

Kangxi six-character reign mark in underglaze blue on the base

The Palace Museum, Beijing, Gu148318

SELECT REFERENCES: Qing Porcelain 1989, p.137, pl.120; Versailles 2004, cat.53

147

'Peach-bloom'
chrysanthemum-petal vase
(*juban ping*)

Kangxi period, Jingdezhen, Jiangxi
Province

Porcelain with copper-red glaze,
height 21.2 cm

Kangxi six-character reign mark
in underglaze blue on the base

The Palace Museum, Beijing, Gu148272

SELECT REFERENCES: Qing Porcelain 1989,
p.138, pl.121; Versailles 2004, cat.54

148

'Peach-bloom' Guanyin or
willow-leaf vase (*liuye ping*)

Kangxi period, Jingdezhen, Jiangxi
Province

Porcelain with copper-red glaze,
height 15.5 cm

Kangxi six-character reign mark in
underglaze blue on the base

The Palace Museum, Beijing, Gu148337

Copper-red glazes represented
a challenge for potters, since the
fugitive pigment tends to turn grey,
brown or black rather than red in
the high firing temperatures of
porcelain, and can even turn
green. It was used successfully,
on a very small scale, in the
Xuande period (1426–35), and
then again in the Kangxi reign,
but hardly otherwise. Lang Tingji
(1663–1715), as supervisor of the
imperial kilns, created not only
masterful deep, even copper-red
glazes known as *sang-de-boeuf*, or
Lang ware, but also these delicate
mottled glazes which make
decorative use of the pigment's
natural variation rather than
trying to suppress it. The
technique probably involved
blowing copper pigment onto a
clear glaze and covering it with
another clear layer, i.e. sandwiching
it between colourless glazes. The
resulting soft liver-reds and greyish
pinks, with occasional spots of
green, are known as peach bloom
in the West, and as cowpea red
(*jiangdou hong*) in China.

Since the range of peach-bloom
vessels is limited to a few small vases
and writing utensils, they have been
considered as sets designed for the
scholar's desk. Some shapes,
however, are much more common
than others, and one single peach-
bloom box in the collection of the
Yongzheng Emperor is depicted
in the *Pictures of Ancient Playthings*
(cat.169). Production did not
continue into the Yongzheng reign.

While most shapes are descriptively
named, the Guanyin vase is named
after the Goddess of Mercy, who is
often shown holding a vase such as
this, and the Taibo water pot after
the poet and famous drinker Li
Taibo (701–762, in the West also
known as Li Po), often depicted
leaning against a large wine jar
of that form. RK

149

Letter in Chinese, Manchu
and Latin

31 October 1716 (Kangxi 55), Imperial
Printing Office (Wuying dian), Beijing

One sheet, mounted on two wooden rollers,
in a box; woodblock printed in red ink,
Manchu on the left, Chinese in the middle
and Latin on the right, 38 × 100 cm

On the reverse: 'Presented by the Rev.
Mr. Cromp November 25, 1763'

Signed by Fathers Ripa (of the Sacred
Congregation for the Propagation of the
Faith), Pedrini, Kilian Stumpf, Suares,
Bouvet, Foucquet, Parennin, de Tartre,
Jartoux, Cardoso, Mourao, Baudino,
Stadtlin, Brocard, da Costa and Castiglione
(all of the Society of Jesus)

The British Library, London, 19954.c.12

SELECT REFERENCES: Pfister 1932, p.583;
Cordier 1968, vol.II, p.918; Simon and
Nelson 1977

The Kangxi Emperor initially
tolerated Christianity in China in
return for services rendered by
court Jesuits, who hoped to convert
him to their religion. But he insisted
that Jesuits follow the policy of
accommodation, permitting Chinese
converts to continue to venerate
their ancestors and Confucius in
rites defined as essentially civic,
not religious. Many Catholics
objected profoundly, believing
that accommodation radically
undermined Church integrity.
Following an unsuccessful papal
embassy to China in 1705–06, the
Pope forbade missionaries to obey
imperial orders, under pain of
excommunication. The Emperor
compelled missionaries to sign
an order of compliance or accept
expulsion from China, finding
unacceptable the possibility that
Qing subjects might owe allegiance
to some authority other than
himself. Christianity was later
banned altogether in China,
although Jesuits remained in court
service. On the papal side, from
1707 a series of decrees refused
Chinese Christians permission to
continue the traditional reverences.

This document, dated 31
October 1716, is an imperial decree
countersigned in Latin translation

by sixteen Jesuit missionaries of
various nationalities.[1] The
document refers to two sets of
missionary envoys sent by the
Kangxi Emperor to the Pope, in
1706 and 1708. Noting that in the
intervening years nothing further
had been heard of the emissaries,
and that further communication had
been attempted via some Russians,
the decree, which was to be given to
all new missionary arrivals, declared
that no further communication from
Rome would be countenanced until
the return of the missionary envoys.
Unfortunately, the first two
emissaries had drowned before
reaching Rome: one died at home
in Spain, and the last died near
the Cape of Good Hope on his
way back to China. His remains
were embalmed and brought to
China, where the Emperor had a
mausoleum erected in his memory.
After this, Jesuit influence declined
in China as in Europe: missionaries'
contributions became largely limited
to the secular sphere and their hopes
of a mass conversion to Christianity
were doomed to failure. JW-C

150

Polyhedral proportional blocks

Kangxi period, Palace Workshops,
Beijing

Hongmu or *zitan* wood,
case 9.2 × 45.3 × 27 cm

The Palace Museum, Beijing, Gu142207

SELECT REFERENCES: Liu Lu 1998, pl.89;
Versailles 2004

The regular polyhedra, also called
Platonic Solids, consist of five
convex polyhedra with equivalent
faces composed of congruent regular
polygons. First discovered and
studied by Pythagoras in the fifth
century BC, they consist of the cube,
the octahedron, the tetrahedron,
the dodecahedron and the
icosahedron. Plato's description
in *Timaeus*, two centuries later,
associated each polyhedron with
one of the elements: the cube with
earth; the octahedron with air; the
tetrahedron with fire; the
dodecahedron with ether; and the
icosahedron with water. Euclid, in
Book VIII of his *Elements* (Books
I–VI of which were translated into
Chinese by Matteo Ricci), addresses
the question of these five types of
regular polyhedra and shows that
no other exists. The pieces in this
boxed set with accompanying
explanatory document were used
as mathematical instruments in the

imperial palace when the Kangxi Emperor was learning about western mathematics from the Jesuit missionaries at his court. JW-C

151

Hand calculator with paper counting rods

Kangxi period, Palace Workshops, Beijing

Brass, paper rolls and iron in wooden case, 5 × 19 × 11.5 cm

The Palace Museum, Beijing, Gu228781

SELECT REFERENCES: Needham 1959, pp.69–74; Liu Lu 1998, pl.85

Counting rods and the abacus have been the main mechanical calculating aids available to Chinese mathematicians since ancient times. In Europe in the early 1600s, a Scottish mathematician named John Napier invented a method of performing arithmetical operations by manipulating rods printed with numbers. The rods were often made of bone. His technique essentially reduced complicated multiplication and division problems to addition and subtraction. The introduction of numbers onto counting rods in China, based on 'Napier's Bones', followed soon afterwards and for some time seem to have been in fairly wide use. This particular calculator has ten rods, each with a six-toothed gear, two middle ones in between the two on the top, and two on the bottom, so that pairs of rods can move in conjunction. Not only can this machine perform multiplication and division but it can also calculate squares, cubes, square roots and cubic roots. JW-C

152

Terrestrial globe

Kangxi period, Palace Workshops, Beijing

Moulded wood pulp covered in painted gesso, bronze, with a *zitan* wood stand, height 135 cm, diameter of globe 70 cm

The Palace Museum, Beijing, Gu141917

SELECT REFERENCES: Liu Lu 1998, pl.93; Macau 1999, pl.93; Versailles 2004

This terrestrial globe is held between two rings: one horizontal, made of wood, and one bronze meridian, on which are marked the 360 degrees. It is decorated with a combination of accurate markers of physical geography and information drawn from astronomy, and depictions of boats sailing along navigation routes past fantastical sea

creatures. The equator is painted in red, with the ecliptic in yellow, as well as its co-ordinates, and meridians marked by a line every ten degrees. At the North Pole is a small disk engraved with the twelve two-hour divisions of the day. The Tropics of Cancer and of Capricorn and the Arctic and Antarctic Circles are also marked. The globe shows the continents, with administrative regions, waterways and lakes, as well as various major Chinese cities such as Beijing, Hankou and Xiamen, and landmarks such as the Great Wall. Many places can be identified, including Japan, the Philippines, Java, New Guinea, Australia and New Zealand. JW-C

153

Shelving with lattice-style doors in the centre sections

Qing dynasty, seventeenth–eighteenth centuries

Zitan wood, 193.5 × 101.5 × 35 cm

The Palace Museum, Beijing, Gu207678

SELECT REFERENCES: Clunas 1988, pp.40–41 and 86–90; Zhu Jiaqian 2002, p.273

This beautiful piece of furniture is a combined storage and display unit, of the sort which became popular in the eighteenth century. Not only paintings, but also three-dimensional objects in a collection would be displayed in rotation, according to the owner's mood. The scholarly Kangxi Emperor would have stored and displayed books and curios on this piece's shelves. The central sections have vertical strips forming walls and are enclosed by lattice-work carved doors, to form cupboards, whose contents would have been quite clearly visible. The relatively simple design refers back to the furniture of the Ming dynasty (1368–1644).

Zitan wood, sometimes called red sandalwood, was an imported timber and very much prized for its purplish-brown colour. Since the time of the Ming, stores of the wood had been kept in the imperial palace for use in producing furniture fit for an emperor, such as this piece. JVP

154

Side table with everted ends

Early Qing dynasty

Huali wood, 80 × 102 × 32.5 cm

C. and C. Bruckner

SELECT REFERENCES: Clunas 1988, p.53; Chuang 1998, pp.72–73

Side tables of this type were very popular as part of the interior setting, and are depicted in many sixteenth- and seventeenth-century illustrations and paintings. Flower vases, scholar's rocks or incense burners were usually placed on the table tops. Sometimes they also displayed sets of spirit tablets and ritual utensils for food and beverage offerings.

With everted ends, the table top is of a single plank of highly figured wood. The small, rounded everted flanges are inset into the plank top. The edge of the frame is moulded gently downwards and inwards to end in a narrow flat band. The recessed rectangular legs, with beaded edges and moulding in the middle, are cut to house the beaded apron with carved open double-cloud-head spandrels. The legs are fitted into the table top and shoe-type feet. Openwork panels, carved with beaded *lingzhi* fungus, an auspicious plant that symbolises longevity and immortality, are inset into the space between the legs and the feet. RF

155

Carving of the Sixteen Lohan on a rocky mountain

Mid-Qing dynasty, eighteenth century

Bamboo root, height 30 cm

The Palace Museum, Beijing, Xin98421

SELECT REFERENCES: Rawson 1992, pp.39–40, 179–80; Edinburgh 2002, pp.14–15, 161

The Chinese term for landscape, *shanshui*, literally meaning 'mountains and water', is linked with the philosophy of Daoism, which emphasises harmony with the natural world and the natural balance of *yin* and *yang* elements in the universe. In the same way that naturally eroded rocks were carried into gardens and placed among streams and ponds to re-create a natural landscape, so small representations of mountains like these were often placed on a scholar's desk. There they provided a reference to the features and values of the natural world into which the scholar could escape from the busy world of official duties. In China, mountains were regarded as sacred, and figured in the State Ritual. Important Daoist and Buddhist sites were thought to be located in mountainous areas, and monasteries and temples were

constructed on many of China's famous mountains.

Representations of mountains were carved out of many materials, such as rootwood, lapis, soapstone, bamboo root and jade. The most famous carved mountain is the 224 cm jade example ordered by the Qianlong Emperor in 1787, now in the Forbidden City (Zijin cheng). In these carvings, just as in a Chinese landscape painting, the eye is drawn upwards along paths carved through peaks and crags and lined with gnarled trees and small grottoes containing figures. The intricate carving cleverly resembles the different brush strokes used for mountains, rocks and trees in landscape painting.

In some mountain carvings (such as an example in the British Museum, London), Daoist immortals can be seen, living as hermits among the peaks and crags and examining a scroll painted with the *yin-yang* symbol. In the example under discussion, the figures are the Sixteen Lohan or disciples of the Buddha. Carvings of miniature mountains such as this thus offered a glimpse of a route to understanding the true character of the universe. JVP

156
Stone censer with three mountain peaks

Qing dynasty
Black Lingbi limestone with carved *jichimu* ('chicken-wing' wood) stand,
38.8 × 31 × 15.1 cm
Courtesy of The Metropolitan Museum of Art, New York. Promised gift of the Richard Rosenblum Family (L.1999.102.6a, b)
SELECT REFERENCES: New York 1985; Cambridge 1997, no.6

Rocks have been collected and appreciated in many different ways by both the court and literati for more than two thousand years. Large specimens were placed in imperial parks since the Han dynasty (206 BC–AD 220) and smaller versions were displayed in the scholar's studio from the Song period, or earlier.

Made of Lingbi limestone, the most prized type of stone from Lingbi county in Anhui Province which is naturally resonant, this piece, in its orientation and display, is reminiscent of an early Qing literati painting of a twisting mountainscape rising to towering peaks. Following each nook and

cranny on the surface of the stone, onlookers are soon transported in their imaginations to scaling ravines and gorges formed by mountain streams and waterfalls.

Rocks were often worked with tools to enhance and bring out certain features. This rock is distinctive in that it was also fashioned into a censer. The interior has been hollowed out to allow the smoke from burning incense to escape. Wispy clouds of incense smoke hovering around the three mountain peaks may have been intended to evoke an image of Penglai, the legendary isles located in the Eastern Sea where Daoist immortals were said to live in a haven of paradise. HK

157
Scholar's rock shaped like a bridge on a stand

Qing dynasty or earlier
Stone and *zitan* wood, 4 × 12 × 4.4 cm
Shuisongshi Shanfang Collection, 31.6.48
SELECT REFERENCE: Hong Kong 1986, pp.46, 172

Naturally eroded rocks (*guaishi* or 'strange stones') were collected by scholars and placed either in their gardens or on their desks, for contemplation. Like mountains, rocks were associated with the *yang* or male half of the *yin-yang* balance which made up the universe. A love of rocks is also associated with Confucianism and was regarded as a proper pastime for a gentleman. Stones shaped like creatures such as dragons carried auspicious connotations, and folk tales exist about haunted stones or rocks. With the development of landscape painting in the Song dynasty (960–1279), interest in rocks grew. In the twelfth century, the Emperor Song Huizong (r.1101–26) built a palace with artificial lakes and fantastic rocks, and the scholar Du Wan compiled the *Stone Catalogue of Cloudy Forest (Yunlin shipu)*, classifying 116 different stones from different parts of China. By this time, bizarrely shaped rocks had become highly prized and collected by scholars, painters and calligraphers, such as the celebrated rock aficionado Mi Fu (1051–1107), as well as becoming the subject of paintings.

The shape and serrated edges of this rock are quite unusual. Although it is difficult to date

antique scholar's rocks, this piece is similar to one in the *Stone Catalogue of the Plain Garden (Suyuan shipu)*, the seventeenth-century set of woodblock illustrations of Emperor Huizong's collection. JVP

158
Taihu garden rock on a stand

Late Ming or early Qing dynasty, mid-seventeenth century, Suzhou, Jiangsu Province; the stand Fangshan, Beijing
Limestone and *hanbaiyu* marble, height including stand 188 cm
Staatliche Museen zu Berlin, Museum für Ostasiatische Kunst, no.2003-4
SELECT REFERENCES: Ren 2002, no.273; Veit 2005, p.51

A fascination with rocks pervades Chinese history. Mountains in miniature evoked mythical islands and sacred peaks as early as the Han dynasty (206 BC–AD 220) and interestingly shaped rocks themselves were collected to embellish gardens. The Huizong Emperor (r.1101–25), one of China's great art collectors, assembled a massive collection of exotic and quaint stones in a park outside the capital. Rocks formed an integral part of a Chinese garden, representing the mountain element in landscape (Chinese: *shanshui*, literally 'mountains and water'). Whether revered like animated beings or collected as abstract sculptures, rocks brought the concepts of eternity and infinity associated with mountains into the private realm.

Rocks were also admired indoors, as decorative mountain-shaped carvings in various materials (cats 155, 267), as writing utensils (cats 192, 233), or just on their own. Stones collected by connoisseurs ranged from indoor rocks such as tiny desk items (cat.157) and medium-sized 'scholar's rocks' (cat.156), to large garden rocks such as the present example, and monumental mountain-like assemblies of rocks, as in the Imperial Flower Garden (Yuhua yuan) at the back of the Forbidden City, which might include grottoes, passageways, terraces and pavilions.

Taihu, 'Grand Lake', close to Suzhou, China's classic 'garden city' in Jiangsu Province, produced China's most desirable garden rocks. The water and the grinding action of smaller pebbles in the lake turned limestones into wondrously contorted, craggy, hollowed-out

and pierced shapes. Because of the high demand, stones were deliberately planted in the lake, to be harvested by later generations. To speed up the process and to make the result more predictable, shapes were often predetermined or 'improved' by stone-carvers and then immersed again to soften the outlines and make them look natural.

The present rock was probably mounted for a palace setting, to be placed against a wall (its reverse is comparatively plain). The sumptuous stand is carved of a type of marble known as *hanbaiyu* (white Han jade) from the imperial quarries at Fangshan, southeast of Beijing. The same material was used for the platforms, balustrades, steps and dragon-decorated ramps in the Forbidden City, and rocks on similar pedestals can still be seen in the Yuhua yuan today. RK

159
Rectangular box and cover with archaistic dragon design

Kangxi period
Green stained ivory, 7.5 × 10.5 × 8.3 cm
Sir Victor Sassoon Chinese Ivories Trust, T63

This box is remarkable for its large size, and its angular shape which does not lend itself naturally to being cut from a tusk. Its green staining may have been applied in an attempt to make it look like jade. The highly stylised dragon design – two larger animals in the centre surrounded by four smaller ones at the corners – is derived from archaic bronze and jade decoration and appears similarly on the cover of the Songhua inkstone (cat.136). Although the use of the present box is not immediately obvious, ivory was much used for writing accessories; for a similarly shaped box containing ink sticks, see cat.231.

Ivory carving of high quality was undertaken in many workshops in southern China as well as in the imperial workshops of the Forbidden City. Since scholar's objects in more humble materials such as wood, bamboo, horn and tusk were not reign-marked, however, work from the Palace Workshops (Zaoban chu) is not easy to identify. RK

160
Hu Sisheng
Tripod censer

Qing dynasty, seventeenth–eighteenth centuries
Rhinoceros horn, 13.2 × 8.5 × 8 cm
Chester Beatty Library, Dublin, CBC 2006

This censer, intricately carved by Hu Sisheng, takes the form and style of an ancient bronze tripod ritual vessel, and therefore carries references to the ancient dynasties of the Xia, Shang and Zhou. It would have been placed on the desk or in the study, in the same way as archaistic bronze, jade or ceramic vessels. Larger censers would have been used to hold incense sticks, standing upright in sand, to perfume the study. It is likely, however, that this small rhinoceros horn censer was a collector's item, an example of the delight taken in the eighteenth century in works made in one material imitating those made in another. JVP

161
Bowl with key-fret pattern on the rim

Qing dynasty, seventeenth–eighteenth centuries
Rhinoceros horn, diameter 15 cm
Victoria and Albert Museum, London, FE.28-1983

Like the other two rhinoceros horn items in this group, this bowl has archaistic decoration, the key-fret pattern around the rim and foot echoing that used on ancient bronzes. The vessel's shape, however, is based on that of a ceramic bowl. It is unusual to find a bowl made of rhinoceros horn, which was more usually employed to make drinking cups in ancient bronze shapes, and sometimes to make seals or sculptures. The colour of this bowl is particularly fine and unusual, the warm brown colour being streaked with black. Rhinoceros horn appealed to collectors also for its tactile qualities, and this bowl would have been picked up and handled repeatedly. JVP

162
Cup on a wooden stand

Qing dynasty, seventeenth–eighteenth centuries
Rhinoceros horn, height 15.8 cm
Victoria and Albert Museum, London, acc. no.162-1879

SELECT REFERENCES: Hong Kong 1986, pp.180–82, 262; New York 1987, pp.176–77

Rhinoceros horn was associated with Daoist practices; it was also thought to have the power of neutralising poison as well as having aphrodisiac qualities. It had, therefore, been used and collected by scholars and officials from at least the Tang dynasty. Examples of Chinese rhinoceros horn items dating from the Tang dynasty, such as rulers, dice, plaques, plectrums and sceptres, are stored in the Shōsō-in, the treasury of the Tōdai-ji Temple, in Nara, Japan. In the Ming dynasty (1368–1644), the connoisseur Wen Zhengheng thought it appropriate to have a rhinoceros horn cup on a desk together with a jade one. At the same time, the Ming period *Guide to the Study of Antiquities (Gegu yaolun)* discusses the ideal type of rhinoceros horn – which should be translucent, and yellow and black in colour with cloud-like mottling at the top and raindrop-like spots at the bottom. New rhinoceros horn is usually a greyish-yellow colour; the warmer, darker brown colour is the result of years of handling and polishing.

Cups such as this example were used for drinking and were also given as gifts from one person to another, particularly as congratulatory presents for passing official examinations. The classic text *Liji (Book of Rites)* records that a rhinoceros horn cup was used in ancient times for the game of throwing arrows into a vase, which may account for their great popularity among later scholars. This extravagantly decorative cup is in the shape of an archaistic bronze *gu*, with carved dragons and mythical beasts seeming to spill over the rim and handle. The dark wood stand, carved to resemble a rocky landscape, has been especially made to fit this cup, which is clearly a collector's item and not intended for use. JVP

163
Vase with stylised floral designs

Kangxi period, Palace Workshops, Beijing, and Jingdezhen, Jiangxi Province
Porcelain with enamels on the biscuit, height 12.2 cm
Kangxi yu zhi mark (made by imperial order of Kangxi) in a square engraved on the base
The Palace Museum, Beijing, Gu148249

SELECT REFERENCES: Qing Porcelain 1989, p.98, pl.81; Peng Qingyun 1993, p.421, no.863; Ye Peilan 1999, pl.1; Wang Qingzheng 2000, vol.1, pl.93

In a recent publication by the Palace Museum this small vase has been called as rare as 'phoenix feathers and unicorn horn' (*fengmao linjiao*). It is one of the earliest pieces of porcelain decorated in the Palace Workshops in the Forbidden City (Zijin cheng), around 1720, where metal pieces had already been enamelled in a similar style (cat.97). High failure rates probably explain the rarity of such early examples, since stringent imperial quality controls rejected even the slightest imperfections.

The undecorated porcelain had to be ordered from the porcelain centre of Jingdezhen in southern China, since its production, which required high firing temperatures, was not feasible within the palace precincts. For the first pieces, unglazed (biscuit-fired) blanks were specially commissioned to make the enamels adhere better. The present vase therefore has a rough base, into which the mark was engraved. Once the technique had been fully mastered, in the Yongzheng period, glazed porcelains were used, but forms were almost always restricted to bowls and dishes, and their marks were inscribed in enamel (cat.183).

The golden arabesques at the neck of this vase, depicted in a three-dimensional manner like architectural ornament, and the emphatically shaded fanciful flowers betray the influence, if not the hand, of a Western artist. RK

164

Hexafoil 'garlic-head' vase with formal lotus designs in relief

Kangxi period, Palace Workshops, Beijing
Mould-grown gourd, height 23.5 cm
Mould-grown mark *Kangxi shang wan* (for Kangxi's amusement) on the base
The Palace Museum, Beijing, Gu125252
SELECT REFERENCES: Beijing 1991, no.1383; Wang Shixiang 1993, pl.7

The technique of growing gourds into decorated moulds placed around the young fruit has a long tradition as a Chinese folk craft. It became of imperial interest under the Kangxi Emperor who for that purpose had fields specially planted with gourd vines in the West Garden (Xi yuan) adjacent to the Forbidden City (Zijin cheng), alongside rice paddies and

mulberry groves cultivated to represent the country's fundamental farming activities (see cat.213).

This sophisticated piece with its modest material, seemingly grown by nature into an elegant Chinese form adorned with Western Rococo motifs, would have appealed to several of the Kangxi Emperor's predilections: his love of austerity, concern for concord with nature, interest in practical experiment, and admiration of European styles. RK

8 The Yongzheng Emperor: Art Collector and Patron

165

Anonymous court artists
Portrait of the Yongzheng Emperor Reading a Book

Yongzheng period (or possibly later)
Hanging scroll, ink and colour on silk, 171.3 × 156.5 cm
The Palace Museum, Beijing, Gu6446
SELECT REFERENCES: Zhongguo shudian chubanshe 1998, p.26; Zhu Jiapu 2004, pl.110

This portrait of the Yongzheng Emperor holding a Chinese book is more of a trope than a personal reflection. Beginning with the Kangxi Emperor and continuing throughout the Qing, most of the Manchu emperors had themselves portrayed in an elegantly appointed study reading or writing to display their mastery of the Chinese literati tradition. Judging from details in the painting, the Yongzheng Emperor possessed a flair for displaying antiquities. He has placed a Neolithic jade *cong* (a tube round on the interior and square on the exterior) inside a lacquer stand so that it functions as an exquisite brushpot.

Stylistically the painting follows a syncretic Sino-European mode. Western influence is most apparent in the definition of architectural space depicted by the lines and shading indicating the intersections between the side and back walls and the ceiling. The setting of this portrait and the dragon robe worn by the Emperor are closely related to similar depictions of the Kangxi, Qianlong and Jiaqing Emperors presented in their studies as scholars. In each of these portraits in the Palace Museum the emperors sit cross-legged on a cushion atop what is presumably a wooden-fronted *kang*

(a raised platform heated from below).

The paintings seem to belong to a set, but whether they were painted at a single point in time is unclear. It is possible that the set was created in the Jiaqing reign with portraits of the earlier emperors rendered posthumously, a practice not uncommon in Chinese tradition. Also, another version of *Portrait of the Yongzheng Emperor Reading a Book* exists in private hands outside China. This is a more tightly cropped painting without any sense of depth to the room and few objects portrayed on the side tables. The question arises, is this an original draft, a second copy made simultaneously with the Palace Museum's portrait, or a more recent forgery? Because portrait paintings often legitimately exist in multiple versions, such perplexing questions about this genre will continue to arise. JS

166

The Yongzheng Emperor (1678–1735)
Poetic couplet, in running script

Yongzheng period
Ink on gold-flecked green silk, 173.6 × 33.3 cm
IMPERIAL SEALS: *Wei jun nan* (Being a ruler is difficult); *Zhao qian xi ti* (Perturbed day and night); *Yongzheng chen han* (Yongzheng imperial brush)
The Palace Museum, Beijing, Gu238457

Aixinjueluo Yinzhen (1678–1735) was the fourth son of the Kangxi Emperor and the third Qing emperor since the conquest of China. His posthumous temple name was Shizong (literally, 'ancestor of generations'). He succeeded as Emperor in 1722 after his father's sixty-one year reign. He gave his reign the title Yongzheng (literally, 'harmonious rectitude'), and reigned for thirteen years.

The Yongzheng Emperor was competent at both painting and calligraphy, and his artistic sensibility is well demonstrated in this paired couplet, whose poetic text reads:

> Bamboo shadows criss-cross the window – the moon must have risen.
> The scents of flowers waft indoors – spring must be coming.

Stylistically, this couplet recalls both the pleasing, well-articulated calligraphy of the early Yuan master Zhao Mengfu (1254–1322), and the more brittle, dynamic hand of the

late Ming calligrapher Dong Qichang (1555–1636). The piece represents one of the finest examples of calligraphy by the Yongzheng Emperor's hand. wjx/smcc

167

Anonymous court artists
Album of the Yongzheng Emperor in Costumes (14 leaves in all; 13 portraits, plus a second version of the image with a white rabbit)

Yongzheng period
Album leaves, colour on silk, each 34.9 × 31 cm
The Palace Museum, Beijing, Gu6635, 1–14
SELECT REFERENCES: Wu Hung 1995; Nie Chongzheng 1996, pl.18, pp.118–23; Rawski 1998, pp.53–55; Stuart 1998, p.63; Berger 2003, pp.59–60; London 2004, pp.340–43

This exquisite portrait album of the Yongzheng Emperor is among the most intriguing of all Qing court paintings. Depicted with unmistakable fidelity, the monarch assumes thirteen distinct identities, including several different ethnicities and certain legendary and historical persons. Examples include the Emperor as a Tibetan monk, a Mongolian noble, a nomadic archer (perhaps a Zunghar), a European tiger-slayer, and a Daoist magician summoning a dragon out of hibernation. Some of the paintings cast the monarch in the role of famous figures, including the semi-legendary Han dynasty hero Dongfang Shuo stealing the peaches of immortality, and the famous Chinese calligrapher Mi Fu (1051–1107) inscribing a rock cliff. In each scene the Yongzheng Emperor assumes a new role with poise and no hint of irony.

The Emperor's visage is rendered with layers of colour washes and light and shadow, indicating that the artist was familiar with Western techniques of anatomical modelling. Unusually animated facial expressions, such as the reverie noticeable in the eyes of the zither-playing Emperor or his consternation when confronting the toothy smirk of a tiger, also suggest an assimilation of European portraiture. Yet overall, the painting style is grounded in Chinese practice, deploying luscious, light colouring and superb linear drawing (an example is the delicate web of brush lines creating the gauze robe of the zither player).

The complexity of the album's subject-matter continues to elicit speculation about the motivation behind the painting programme. As a small-scale work, the album was destined mostly for viewing by the Emperor or perhaps his family in an intimate setting. What was in his mind when he commissioned it? Was the album created as a calculated political strategy to reinforce Manchu subjugation of other ethnic groups; was it creative recreation, with the ruler engaging in fantasy, perhaps inspired by knowledge of European masquerade; or was it a sincere reflection of the ruler's belief that as the supreme monarch he truly embraced the entire spectrum of humanity within his own person? All are possible and it is clear that the Yongzheng Emperor enjoyed this kind of visual 'play-acting' in painting. He commissioned several portraits of himself wearing Chinese-style dress while striking poses borrowed from famous early Chinese paintings, but this album is the most complicated of his exercises in self-fashioning.

It is generally agreed that the Yongzheng Emperor never actually owned or wore the costumes depicted: he never pierced his earlobe like a Mongol or wore a European wig. Confusion about Western dress corroborates the supposition that the painter did not see these exotic clothes firsthand; for example, the European waistcoat and overcoat are not rendered faithfully and moreover are paired with a Chinese belt and shoes. However, this foreign dress, in particular, led Wu Hung to postulate that the practice of masquerade as European court entertainment may have provided the basic premise for the entire album. Western rulers sometimes disguised themselves as gods or wore 'character dress' to act out the role of a historical, allegorical, literary or theatrical character. At the end of a masked ball they would reveal their own identity and sometimes commission portraits of such events. Although this creates a striking parallel, and the Yongzheng Emperor may well have known of the practice, there is a closer precedent at hand in the history of Chinese painting.

Art historians have uncovered literary references that as early as the Tang dynasty some emperors had their faces inserted into paintings of famous cultural heroes. More evidence comes to light from the practice of the Southern Song Emperor Lizong (r.1225–64), who commissioned a set of scrolls of *Thirteen Sages and Rulers of the Orthodox Lineage* depicting Daoist and Confucian sages with his own imperial countenance. Is the unusual number of thirteen leaves in this portrait album of the Yongzheng Emperor coincidental, or does it signal a conscious borrowing from this Song dynasty precedent?

Several layers of intricacy exist in the portrait album. If the images were politically motivated by policies of cultural dominance over other ethnic groups, is it possible that there is simultaneously an element of personal belief? In the leaf in which the Emperor appears as a Gelugpa Tibetan lama in the hollow of a craggy mountain, he probably felt a level of personal identification. Withdrawn in meditation, the emperor-as-monk is unperturbed by the threatening snake ready to strike him. This trope may have been borrowed from a painting of a Chan monk attributed to the thirteenth-century artist Muqi, but here invested with an obviously Tibetan identity. The Yongzheng Emperor was a devout Buddhist who wrote his own Buddhist riddles, or *gong'an* (Japanese: *koan*). This portrayal surely reflects some level of deep spiritual connection.

The album does not easily reveal its secrets. Some images at first seem simple to decode, but in fact may not be straightforward. An example is the zither-playing Emperor who probably represents the Chinese Daoist musician Ruan Ji, a member of the Seven Sages of the Bamboo Grove. But how should we account for the bird his music summons to flight? Its face is human: is this a *kinnara* of Hindu and Buddhist traditions? Is the meaning cross-cultural or just an auspicious device?

Several other scenes include imagery designed to associate the Emperor's persona with good blessings. The Emperor role-playing as Mi Fu is accompanied by a deer, emblem of long life and wealth; the Emperor as a waterfall-watching poet is joined by a red bat signifying vast blessings; and the daydreaming fisherman is positioned with a badger scampering behind him (the Chinese name for this animal, *huan*, is a homonym of the word for happiness).

This portrait album sums up the versatility of the Yongzheng Emperor as ruler. By presenting himself in the dress associated with multiple ethnic groups, he integrated into his body – at least the metaphysical, imperial body – the multiplicity of his empire and all the peoples he wished to subjugate. Painted with a masterful blend of fantasy and seeming reality, the album is not just an exercise in magic realism, but it attests to the complicated truth of imperial selfhood. For the Yongzheng Emperor, the Ultimate Reality of his personal identity was multicultural and atemporal – an existence linked across geopolitical space to include Mongols, Zunghars, Tibetans, Chinese and Europeans and linked in time with past cultural heroes and sages. JS

168

Anonymous court artists
Pictures of Ancient Playthings (Guwan tu), scroll 6

1728
Handscroll from a series, ink and colour on paper, 62.5 × 1502 cm
By courtesy of the Percival David Foundation of Chinese Art, London, PDF XOI
SELECT REFERENCES: Whitfield 1986; McCausland 2001–02

169

Anonymous court artists
Pictures of Ancient Playthings (Guwan tu), series B (or C), scroll 8

1729
Handscroll from a series, ink and colour on paper, 64 × 2648 cm
Victoria and Albert Museum, London, E.59 1911
SELECT REFERENCES: Whitfield 1986; McCausland 2001–02

These *Pictures of Ancient Playthings*[1] were made for the secretive Yongzheng Emperor in 1728–29 as a kind of pictorial inventory of his palace collections, symbolic of his kingship in China. The present scrolls are the only two of this group to have come to light since the fall of the Manchu Qing dynasty in 1911. On the title-slip, one of the scrolls is named *Guwan tu* (literally, 'a picture of ancient playthings') and numbered 'scroll 6' in elegant calligraphy representative of the reign style. The other scroll is similarly named, and numbered 8 in a second or a third series (the series numbering is ambiguous). It is likely

that the entire *Guwan tu* project comprised at least 16 and possibly 24 or more similar rolls, each depicting some 250 'antiquities', including ceramics, jade and hardstone carvings, bronzes, rootwood and other kinds of curios, all with bespoke hardwood, usually *zitan* (purple sandalwood), or polychrome-decorated stands. The objects are neatly arranged in sequence – paired, stacked, alone or in clusters, as appropriate – apparently according to shape and design rather than type. The smaller objects may be life-size.

The appearance of empty gilt black display cabinets in the middle and at the end of cat.169, and of a throne, table and screen ensemble laid out for viewing at the end of cat.168, indicate that the painters went about their task by proceeding from room to room within the imperial precincts of the Forbidden City and of the Yongzheng Emperor's beloved retreat, the summer palace of the Garden of Perfect Brightness (Yuanming yuan). The absence of the imperial presence in the scene seems appropriate and to be expected, but it may also be contrived to suggest how little time the Emperor had left over from the serious business of government to enjoy his imperial playthings (*wan*).

The majority of the objects depicted are indeed ancient (*gu*), and represent the moments most revered in China's long cultural heritage. Among the ceramics, for instance, most of which were made under imperial patronage, is an emphasis on the monochrome stonewares believed to date from the native Chinese Song dynasty (960–1279), including Ru, *guan* and Ge wares, as well as blue-and-white, and polychrome-enamelled (*doucai*) porcelains from the prestigious Xuande (1426–35) and Chenghua (1465–87) reigns of the Ming dynasty (1368–1644). A counterpoint to this is the inclusion of a pair of puce-ground *famille rose*-enamelled (*fencai*) jars in cat.168. This exciting new technology was introduced in China in the decoration of imperial ceramics at the very end of the Kangxi reign, about 1720 – making the jars not so much 'ancient' as perhaps 'classic'.

The painting in the scrolls is executed in an academic blend of time-honoured Chinese and cutting-edge European techniques, which

reflected this Manchu emperor's patronage of artists from both ends of the Eurasian continent, and the cosmopolitan appeal of his court in China. It seems that both painting traditions were required to achieve a penetrating level of 'truth' in the portrayal of the collection. The handscroll format and the painting media, for instance, are Chinese. So are the method of colour wash and the ink-outline technique, by which even the finest glaze crackles and nuances of shape are exactingly depicted. In one case, the unique structure of the glaze crackle on a Ru-ware bowl of the late Northern Song dynasty (960–1127) depicted in cat.168 has been matched to the actual bowl – which incidentally bears a Qianlong imperial inscription – in the Percival David Foundation (PDF 3). Many other objects await similar identification.

Integrated into this Chinese system of picture-making are the European techniques of perspective and *chiaroscuro*, or shading. Throughout the scrolls, a light source behind the viewer's left shoulder is indicated by the use of graded washes or grey hatching strokes as if to suggest the fall of light across the surfaces of the objects portrayed, to define their volume and shape, and their position in space. Although Chinese sources suggest this hybrid style, pioneered by leading court painters like the Italian Jesuit Giuseppe Castiglione (1688–1766), often had a cold reception among critics, its appearance in these scrolls indicates that the Emperor must have felt otherwise. While the painters of the *Pictures of Ancient Playthings* were not sufficiently eminent to have signed their names, their brush traces provide these insights into the workings and values of the Imperial Painting Academy, or Ruyi guan, where they worked under the unseen Emperor's gaze. SMcC

170

Teapot and cover

Yongzheng period, Jingdezhen, Jiangxi Province
Porcelain with monochrome celadon glaze, height 12.2 cm
Yongzheng six-character seal mark in underglaze blue on the base
The Palace Museum, Beijing, Gu151943
SELECT REFERENCES: Qing Porcelain 1989, p.255, pl.84; Yang Jingrong 1999, pl.134

From the Tang dynasty (618–907) onwards tea drinking was an activity celebrated in style, but the infusion of tea leaves in a teapot dates only from the Ming period (1368–1644). Until then, powdered tea was mixed with hot water, as in the Japanese tea ceremony, which required different utensils.

The striking modernity of this teapot, with its harmoniously proportioned, elliptic dome shape and its clear, geometric lines of handle and spout, is probably derived from its being designed on paper rather than developed on the potter's wheel. The design may be by Tang Ying (1682–1756), later supervisor of the Jingdezhen kilns, who developed styles for Jingdezhen already in the early Yongzheng period, while still working at the Beijing workshops. Simplicity of form and absence of decoration were stylistic trends introduced by him and endorsed by the Emperor, but the radical functionality of this piece, which is not based on earlier models, is remarkable. Its precise shape and even glaze would have made the highest demands on the potters' skills. RK

171

Teapot or wine ewer with attached cover

Yongzheng period, Palace Workshops, Beijing

Silver, height 10 cm

Yongzheng six-character mark in seal script, and *kuang yin chengzao* (made from silver ore) engraved on the base

The Palace Museum, Beijing, Gu137924

SELECT REFERENCE: Beijing 1991, no.1273

Gold and silver were rarely used in the Qing dynasty for items other than Buddhist images and paraphernalia, or for ladies' jewellery; silverware made in the imperial workshops is otherwise practically unknown.

This small and seemingly plain ewer has many echoes of earlier periods. Its shape is a copy of an archaic bronze, and its reign mark is written in a script derived from inscriptions on archaic bronzes and oracle bones. This script was used for the imperial reign mark only once before, on porcelains of the Yongle reign (1403–24). RK

172

Chrysanthemum dishes in twelve colours

Yongzheng period, c.1733, Jingdezhen, Jiangxi Province

Porcelain with different glazes and enamel coatings, diameter of each c.17.8 cm

Yongzheng six-character reign marks in double rings in underglaze blue on the bases

The Palace Museum, Beijing, Gu150472, Gu149318, Gu150469, Xin76855, Gu149317, Gu149313, Gu149314, Gu151203, Gu150470, Gu149315, Xin142069, Gu149319

SELECT REFERENCES: Qing Porcelain 1989, p.316, pl.145; Yang Jingrong 1999, pl.257

On the twenty-seventh day of the twelfth month of the year 1733 the Yongzheng Emperor ordered Nian Xiyao (d.1738), then supervisor of the imperial kilns at Jingdezhen in Jiangxi Province, to make twelve differently coloured chrysanthemum-shaped dishes. Nian is recorded to have delivered forty pieces of each colour. The range of enamel colours available for porcelains had been enlarged by the introduction of new pigments from Europe, and by experiments made at the glass workshops of the palace in Beijing and the porcelain workshops of Jingdezhen. In order to fulfil the imperial order satisfactorily, the Jingdezhen kilns appear to have tried out an even greater range of colours, since chrysanthemum dishes are known in more than these twelve shades. Full sets of twelve dishes, however, are not otherwise preserved. RK

173

Anonymous court artists
Twelve Beauties at Leisure Painted for Prince Yinzhen, the Future Yongzheng Emperor

Late Kangxi period (between 1709 and 1723)

Set of twelve screen paintings, ink and colour on silk, 184 × 98 cm

The Palace Museum, Beijing, Gu6458, 1–12

SELECT REFERENCES: Rotterdam 1990, pls 16–17, p.159; Palace Museum 1992, pl.41, pp.95–97; Wu Hung 1996, pp.201–21; Palace Museum on-line-exhibition by Li Shi (www.dpm.org.cn), 2004

These twelve gorgeously coloured paintings instantly command attention for their wealth of descriptive detail and enthralling subject: beautiful, seductively posed, lovelorn women. Each of the exquisitely dressed and coiffed females is depicted in an illusionistically rendered setting that welcomes the viewer into their private, enclosed quarters, providing titillating glimpses into

garden courtyards and boudoirs, both sites of romantic rendezvous in Chinese tradition. The paintings were commissioned between 1709 and 1723 by Prince Yinzhen, the future Yongzheng Emperor, when he was living in the Garden of Perfect Brightness (Yuanming yuan), the imperial residence presented to him by his father, the Kangxi Emperor. They were made as adornments for a multi-panel screen to surround a couch in his private study, the Deep Willows Reading Hall (Shenliu dushu tang).

This set of paintings has proven provocative in the study of Chinese art history not because of the works' sexual innuendo, which is hinted at with much delicacy and reserve, but rather because of possible concealed references within the images. Wu Hung persuasively argues that they embody a discourse on Manchu-Chinese dualism and issues of political dominance and subjugation.

To explore the full significance of these artworks, an outdated but stubbornly reoccurring misidentification of the subject-matter as portraits of the Yongzheng Emperor's concubines must be put to rest. An edict by the Yongzheng Emperor has come to light that refers to the paintings as images of *meiren*, a term that refers to idealised or fantasised 'beautiful women' in a well-established genre of Chinese painting made for male delectation. The Emperor wrote this ten years into his reign, in 1732, when he learned that the screen had been dismantled and he ordered the paintings to be carefully stored away. They were not rediscovered until the 1950s.

Extremely talented but anonymous court artists created the twelve paintings following a style connected to the manner of Zhang Zhen (fl.late sixteenth–early seventeenth century), who served at the Kangxi Emperor's court. Zhang was recruited from the south where he had a reputation for painting scenes of refined courtesan culture, a style carried into court circles. But *Twelve Beauties* also contains an unexpected contribution from Prince Yinzhen himself. The passages of calligraphy in a few of the compositions are signed with his sobriquets and the brushwork may be his own. Moreover, Wu Hung has discovered indivisible links between the paintings' subject-

matter and twelve poems by Prince Yinzhen about Deep Willows Reading Hall. The amount of attention the prince devoted to these images suggests that they reflected deep personal ruminations.

A theme of love and longing is expressed in the paintings. One woman watches two coquettish cats intensely while marking the passage of time counting her Buddhist rosary and listening to the chiming clock. Another beauty watches butterflies flit above a day-lily, a flower symbolic of a woman's desire to bear sons. One woman is courted by a pair of magpies who call to her through the window; together the magpies represent a conventional sign for 'double happiness', a symbol of a wedded couple, but the woman sits alone waiting. Another scrutinises her face in a mirror. Behind her on the bed is a ruby-coloured dish of dried citron (Buddha's hand fruit) that perfumes the room, but also carries an erotic suggestion, since the fruit is associated with the female genitalia. She too is meekly passing time waiting for her lover, whose identity is implied by the calligraphy on the wall signed by the future Yongzheng Emperor.

The beauties all wear the Chinese, or Han, clothing that the Manchu rulers dismissed as inappropriate for their countrymen and women. Displayed in the future Emperor's private quarters, what did these Chinese women symbolise? They are surrounded by signs of cultivation and accomplishment, such as needlework, reading, tea-tasting and chess-playing. Might they not, as Wu Hung suggests, symbolically represent the educated, urbane culture of the Yangzi River valley, and by extension, China itself? As a feminine embodiment of exquisite Chinese culture – a body of learning and customs that the future Yongzheng Emperor admired and assimilated – these female figures also warned against over-indulgence and over-refinement. The love-struck women in the paintings need their lovers in order to feel complete. Was the future Yongzheng Emperor contemplating the thought that the Chinese population was also equally pleased to be ruled by Manchu overlords? A political reading of the screen paintings is corroborated by a long history in Chinese art that

loads both poetry concerned with women and paintings of them with allegorical meanings.

The politically charged subject-matter of the paintings does not strip them of their value as rich documents of material culture for the early Qing court. The detailed descriptions of collected Chinese antiquities and new-fangled wonders that decorate the women's quarters – including an imported Western clock, pocket watch and astrolobe – closely correspond to items in the Palace Museum. The styles of interior design represented here provide important evidence about early eighteenth-century practices.

Questions of fashion are more complicated. Although the women's personal adornments match jewellery in the Palace Museum, the reliability of their Han dress and hairstyles is less certain. Was Han fashion perhaps more widely seen at the Qing court than the often-cited imperial edicts against it might suggest? Some scholars have suggested that the *Twelve Beauties* are informative about perceptions of women at the Qing court. Should they be understood to suggest that Manchu men truly admired Chinese fashion, and perhaps that some palace women wore it? The complex interweaving of fantasy and reality in this series of paintings ensures that no easy answer is available. Scholars will continue to be able to mine these images for new information about the late Kangxi and early Yongzheng courts for some time to come. JS

174

Pair of armchairs

Early Qing dynasty
Hongmu wood,
79.5 × 51 × 41.2 cm
C. and C. Bruckner

SELECT REFERENCES: Wang Shixiang 1990, pp.148–52; Tian Jiaqing 2001, pp.98–121

The style of this pair of armchairs is normally referred to as the Suzhou school, which is known for its light and elegant design. The modelling shows a transition from the style of the Ming period (1368–1644) to that of the Qing, the latter being famous for heavily carved decoration. Armchairs like the present example were likely to be placed and used in reception halls or a householder's study.

Hongmu was the most common hardwood used extensively in China during the second half of the Qing dynasty. It emits a sour odour similar to vinegar when cut, and is therefore also given the name *suanzhi* or 'sour bough'. It is generally believed to be another name for peacock pea (*Adenanthera pavonina*); some trees of genera *Pterocarpus* and *Dalbergia* are also said to be *hongmu*.

The back and arms of this pair of chairs consist of seven latticework panels. The centre piece in the back is the highest, with two struts on the top section and a humpback stretch at the lower part. Round, short members are mitred, mortised and tenoned to make geometric patterns and connect to each panel. The seats are made of old cane mat, and the edge of the seat frames start and end with a narrow flat band. The four round legs are tenoned into the frame top. Between the legs are humpback stretchers with struts, four in the front and two on the sides. A shaped footrest is supported by a humpback stretcher underneath tenoned into the front legs. Round stretchers run between the legs on the side and rear with humpback stretch aprons beneath. RF

175

Rectangular lidded box imitating a Japanese lacquer box decorated in gold with fruits on a black ground and shaped as if wrapped in a cloth (Japanese: *furoshiki*)

Yongzheng period, Palace Workshops, Beijing

Lacquered wood, coloured and gilded, 12.4 × 11 × 21.8 cm

The Palace Museum, Beijing, Gu108743

SELECT REFERENCES: Zhu Jiajin 1988, fig.6; Nakamura and Nishigami 1998, pl.259; a similar box in the Palace Museum is published in Palace Museum 2000, no.64; Macau 2000, no.43; Wang Jianhua 2003

176

Imitation Japanese four-tiered box holding smaller boxes, contained within a framework with circular openings and supported on a stand

Yongzheng period, Palace Workshops, Beijing

Lacquered wood, coloured and gilded, 26 × 19.2 × 19.2 cm

The Palace Museum, Beijing, Gu114023

SELECT REFERENCES: Nakamura and Nishigami 1998, fig.193; Palace Museum 2000, no.74; Macau 2000, no.46

Many Japanese lacquers were imported into China during the sixteenth and seventeenth centuries. Numerous examples were acquired by the court and still survive in the collections of the Palace Museum in Beijing and the National Palace Museum, Taipei. During the reign of the Yongzheng Emperor, the court workshops were encouraged to make lacquers in the Japanese style, known in Chinese as *yangqi* (foreign-style lacquers). Both the examples shown here have extensive decoration in gold. Although originally techniques for embellishing lacquers in gold were developed in China, they were particularly lavishly exploited in Japan. Hence the Chinese court associated strong emphasis on gold decoration, as here, with that country. In addition, the forms of the two boxes refer to Japanese originals; in Japan boxes were sometimes composed of a number of interlocking parts, as in cat.176, which consists of four tiers of smaller containers within an overall cover, pierced with two round holes to reveal the auspicious decoration underneath; others were often wrapped in a textile for carrying. In cat.175, the wrapping is not of cloth but of a lacquered material imitating cloth. JR

177

Tang-style amphora with 'clair-de-lune' (*tianlan*) glaze

Yongzheng period, Jingdezhen, Jiangxi Province

Porcelain with pale blue glaze, height 51.8 cm

Yongzheng six-character seal mark in underglaze blue on the base

The Palace Museum, Beijing, Xin136848

SELECT REFERENCES: Tokyo 1985, cat.51; Qing Porcelain 1989, p.266, pl.95; Peng Qingyun 1993, p.433, no.906

178

Jun-type jar with variegated glazes

Yongzheng period, Jingdezhen, Jiangxi Province

Porcelain with purple and turquoise-blue glazes, height 32 cm

Yongzheng four-character seal mark engraved on the base before firing

The Palace Museum, Beijing, Xin56606

SELECT REFERENCES: Qing Porcelain 1989, p.282, pl.111; Geng Baochang 1993, pl.438

179

Garlic-head vase imitating lazurite

Yongzheng period, Jingdezhen, Jiangxi Province

Porcelain with pale green, white and blue glazes, height 28 cm

Yongzheng four-character seal mark engraved on the base before firing

The Palace Museum, Beijing, Gu148964

SELECT REFERENCES: Yang Jingrong 1999, pl.194; Wang Qingzheng 2000, vol.1, pl.205

180

Ru-type basin fixed on a mock-wooden stand

Yongzheng period, Jingdezhen, Jiangxi Province

Porcelain with pale green and brown glazes, height 21.5 cm

Yongzheng six-character seal mark in underglaze blue on the base

The Palace Museum, Beijing, Gu148717

SELECT REFERENCES: Qing Porcelain 1989, p.268, pl.97; Yang Jingrong 1999, pl.214; Wang Qingzheng 2000, vol.1, pl.228

The Yongzheng Emperor commissioned many copies of ancient ceramic styles from the imperial kilns at Jingdezhen in Jiangxi Province. In China copying was always considered a virtue and not a vice, since it challenged the artists – whether painters or craftsmen – to equal the masters of the past. Since fine ceramics from previous reigns would not have been easily available for the potters to consult, as they worked far from the centres of power and wealth, the Yongzheng Emperor sent ancient pieces from the imperial collection to southern China to provide guidelines. Precise imitations are rare (cat.197); more common were new creations for which the models provided inspiration and a standard of quality.

These four vessels are exemplary of this work. The fine pale-blue-glazed amphora with dragon-head handles is a faithful copy only in shape of a much coarser Tang (618–907) pottery vessel made for burial. Items of this kind would not normally have been part of the imperial collection, but may have been chance archaeological finds. The unusual shape also provided the model for blue-and-white versions.

Jun, the most colourful of the Song dynasty wares, with bright milky turquoise-blue glazes and deep contrasting crimson patches, appears to have fascinated the Emperor in particular, who sent many Jun pieces to Jingdezhen to

be copied. Tang Ying (1682–1756), the kiln supervisor, sent his assistant to Junzhou in Henan to research on site the glazes formerly produced there. The present jar copies Jun ware in colouring, but not in shape, nor in its striped design.

The most celebrated of all Song dynasty wares was Ru, for some time the official ware of the court. Its unobtrusive pale blue-green glaze with an attractive faint crackle reminded connoisseurs of fine jade. For the Yongzheng Emperor, who displayed every object on a stand, a Ru basin was here created complete with a mock-wood stand made of porcelain – one of the first examples of the *trompe-l'oeil* work that became so popular in the Qianlong period (cat.236).

Occasionally, experiments yielded unexpected results. The combination of white and celadon-green glazes with blown-on cobalt-blue, reputedly again an attempt to imitate Jun ware, led to speckled glazes reminiscent of lazurite. Only a few pieces of this type are preserved in the Palace Museum, as the style does not seem to have been advanced beyond these trials of the Yongzheng period. RK

181

Dish with bats and fruiting and flowering peach branches

Yongzheng period, Jingdezhen, Jiangxi Province

Porcelain with *famille-rose* enamels, diameter 51 cm

Yongzheng six-character reign mark in a double ring in underglaze-blue on the base

The Palace Museum, Beijing, Gu150245

SELECT REFERENCES: Shizuoka 1988, cat.31; Ye Peilan 1999, pl.56

182

Vase with butterflies and flowering peach branches

Yongzheng period, Jingdezhen, Jiangxi Province

Porcelain with *famille-rose* enamels, height 38 cm

Yongzheng six-character reign mark in a double ring in underglaze-blue on the base

The Palace Museum, Beijing, Xin118001

SELECT REFERENCES: Qing Porcelain 1989, p.208, pl.37; Ye Peilan 1999, pl.47

These sensitive nature studies in pastel shades – known in China as 'powder colours' (*fencai*), in the West as *famille rose* – display the essential characteristics of Yongzheng imperial porcelain. Fine painting was introduced to

433

the provincial workshops of Jingdezhen from the Palace Workshops in Beijing by Tang Ying (1682–1756), a painter, calligrapher, poet and connoisseur who had worked at the court. He was familiar with the Emperor's personal taste and the sensibilities of Chinese painting, as well as the quality of enamelling done at the palace. When he moved south during the Yongzheng reign, he brought with him new ideas and set new standards.

On both these pieces two different types of peach, one pink-flowering, the other white, their branches with differently coloured, moss-covered bark, are encompassing the vessel, growing from the outside over the rim onto the inside on the dish, and twisting upwards from the foot to the neck on the vase. This manner of treating a porcelain vessel as a three-dimensional canvas invites handling, necessitating the movement of the object to reveal the full picture. In the Yongzheng period, works of art were rarely meant merely for ostentatious, stationary display and many items reveal their full beauty only on intimate inspection. This dish, for example, bears nine peaches and five bats, a wish for long life and happiness, which can only be appreciated when the piece is turned over (see cat.296). RK

183

Bowl painted with orchids, longevity fungus (*lingzhi*) and rocks, with a poetic inscription and seals

Yongzheng period, Palace Workshops, Beijing, and Jingdezhen, Jiangxi Province

Porcelain with overglaze enamels, height 5.5 cm

Yongzheng four-character mark in a square in blue enamel on the base

The Palace Museum, Beijing, Gu152022

SELECT REFERENCES: Qing Porcelain 1989, p.233, pl.62; Beijing 1991, no.1201; Ye Peilan 1999, pl.16; Wang Qingzheng 2000, vol.1, pl.202

The poem inscribed on this bowl can be translated:

'Like immortals revealed in the distance, on a beautiful island deep in the clouds, The blooms of the orchid release their fragrance on a warm day in spring.'

It is preceded by a seal reading *guili* (beautiful as the cassia), and followed by the seals *jincheng* (golden perfection) and *xuying* (brightness of dawn).

During the Yongzheng reign, porcelains enamelled in the Palace Workshops were painted by artists trained in ink painting. Unlike traditional porcelain decorators, they treated the three-dimensional vessel surface like a flat piece of paper or silk. A bowl such as this was meant to be turned, as a handscroll would be unrolled, from right to left, to reveal its picture and the accompanying calligraphy and seals.

The Yongzheng Emperor was more immediately interested in the production of imperial porcelain than either his father or son, and personally selected painters and commented on their work. The style and quality of porcelain painting exemplified by this bowl are unique to the Yongzheng period. The plant motifs and landscape scenes selected belong to the standard repertoire of Chinese painting. The asymmetric composition without any indication of space and the depiction of volume through a variation of brush strokes rather than graded washes follow the Chinese classical painting tradition, rejecting any painting theories that had been introduced by the Jesuits. Like paintings, these porcelains are generally unique pieces. RK

184

Tea tray in the form of a roof tile with a bird on a cassia branch among hibiscus and asters

Yongzheng period, 1725, Palace Workshops, Beijing

Cinnabar lacquer on wood, with yellow, dark and pale green, reddish-brown and black colours and silver, 1.7 × 18.5 × 32.2 cm

Yongzheng four-character reign mark in a vertical line engraved and gilt on the black base

The Palace Museum, Beijing, Gu114658

SELECT REFERENCES: Zhu Jiajin 1988, fig.2; Zhu Jiajin 1993, pl.74

185

Tea tray in the form of overlapping circles, with 'long life' (*shou*) medallions and dragons among clouds

Yongzheng period, 1724, Palace Workshops, Beijing

Cinnabar lacquer on wood, with colours and gilding, 1.5 × 27.8 × 15.8 cm

Yongzheng four-character reign mark inscribed in gold on the outside

The Palace Museum, Beijing, Gu114840

SELECT REFERENCES: Zhu Jiajin 1988, fig.1; Zhu Jiajin 1993, pl.73

The Yongzheng Emperor's keen interest in lacquerware is documented through the records of many commissions, but lacquer of this period is extremely rare outside the Palace Museum. Lacquer had been produced in southeastern China since prehistoric times. In the Qing dynasty experienced craftsmen were called to the Palace in Beijing to train local apprentices in the laborious process. Lacquer is derived from the sap of a tree (*Rhus vernicifera*), often coloured with cinnabar, and applied in thin layers to a body, requiring careful polishing between applications, before it is decorated. Work in the Qing Palace was highly specialised and partly carried out in a purpose-built dark and humid underground room. Around twenty different types of lacquer are recorded, distinguished by their bodies, polishes, decoration techniques, forms of gilding, and types of inlay, and included copies of Japanese work (cats 175, 176).

Pieces such as these trays are documented to have been commissioned in 1724 and 1725 respectively. The tile-shaped tray with its subtle flower-and-bird painting is of characteristic Yongzheng taste, similar in style to contemporary porcelains from the imperial workshops. The tray of overlapping circles was ordered as a copy of a 'foreign', that is Japanese, tea tray presented to the Emperor by the Chief Eunuch. RK

9 The Qianlong Emperor: Virtue and the Possession of Antiquity

186

Giuseppe Castiglione (Chinese name Lang Shining, 1688–1766) *Spring's Peaceful Message*

c. 1736

Hanging scroll (originally a *tieluo* painting), ink and colour on silk, 68.8 × 40.6 cm

INSCRIPTION: inscribed by the Qianlong Emperor 'In portraiture Shining is masterful, he painted me during my younger days; the white-headed one who enters the room today, does not recognise who this is. Inscribed by the Emperor towards the end of spring in the year 1782'

SEALS: with five seals of the Qianlong Emperor

The Palace Museum, Beijing, Gu5361

SELECT REFERENCES: Honolulu 1988, no.55; Nie Chongzheng 1992, pl.46; Nie Chongzheng 1996, pl.24; Wu Hung 1996, pp.223–31; Bi Meixue 2004, pp.97–99

This political and highly symbolic double portrait, originally in the form of a *tieluo* (a painting pasted onto a wall), dates from the earliest years of Qianlong's reign. The young Emperor, on the right, respectfully receives a sprig of flowering apricot from his father, the Yongzheng Emperor, on the left. As Wu Hung has shown, this is not so much a portrait of the two men as a portrayal of the relationship between them and the notion of transmission that it embodied.[1] In this context, transmission – symbolised by the flowering sprig – is synonymous with succession. Spring, which the flowering sprig symbolises, evokes in this context both the start of a new reign (Qianlong) and a positive omen for this reign.

This painting was originally pasted onto the wall of a room adjoining the Qianlong Emperor's study at the Hall of Mental Cultivation (Yangxin dian), the palace that his father and he had made the centre of imperial power within the Forbidden City. There, the Emperors granted audiences, consulted members of the Cabinet and signed edicts. It was thus to be expected that a painting on the theme of the transmission of power, and a sincere act of filial piety, should decorate the Yangxin dian. The painting was later removed and turned into a hanging scroll, to which the Emperor added an inscription in 1782.

In this three-quarter-view portrait, the Yongzheng and Qianlong Emperors are dressed as Confucian sages and are surrounded by Chinese symbols (in the form of the objects arranged on the table). Indeed, the Qianlong Emperor saw himself as the legitimate heir of Chinese civilisation and as a model ruler and man of letters.

Castiglione portrayed the two men in a garden setting. In this simple and effective scheme, more than half of the painting is taken up by an intense blue background, which was unprecedented in Chinese painting. Here the artist used the blue background, a device typical of European illumination and miniature painting, to set off the sitters' faces and the bamboo. Another highly individual touch is the three-quarter view, the finely graduated, overlapping tones used for the sitters' faces, and the treatment of the bamboo, in which Castiglione used light and shade to suggest the volume of the trunks. MPuS

187

Anonymous court artist
Prince Hongli Practising Calligraphy on a Banana Leaf

*c.*1730

Hanging scroll, colour on silk, diameter 106.5 cm

The Palace Museum, Beijing, Gu6481

SELECT REFERENCE: Nie Chongzheng 1996, no.26

Prince Hongli, the future Qianlong Emperor, sits at a table in a garden pavilion practising calligraphy on a banana leaf. The round format of the painting resembles a moon gate (see cat.223) through which the spectator looks at the young prince at the age of about twenty. Inkstick and inkstone to his right, he holds his brush ready to begin writing, looking attentively at the viewer as if he has been disturbed in this solemn activity. He wears the ancient costume of a Chinese scholar with an elaborately colourful design of a blossoming tree and a pair of phoenixes. To one side a lotus pond is visible, and a large screen with the red sun rising out of a turbulent sea shields the Prince's back. A blue curtain and a bamboo roller-blind held by two blue ribbons add to the impression that we are looking through a window.

The scene is an idealised image of the young prince and is highly programmatic. The banana leaf is one of the fourteen treasures of the scholar and an emblem for self-cultivation. The famous calligrapher Huaisu (*c.*735–*c.*799) is said to have used banana leaves for practising calligraphy because he was too poor to buy paper. This painting may thus be the first image in which the future Qianlong Emperor assumes the role of an archetypal Chinese scholar as he was to do so often later in his reign. The rising sun behind him may even hint at his ambition to be the future Emperor. Outstanding is the blossoming tree depicted on his garment. In 1732 his father, the Yongzheng Emperor, bestowed on him his first style name, 'Hermit of Eternal Spring' (Changchun jushi), which he used until the first years of his reign. It is possible that the painting is connected with that event, and that the garment gives a hint of his new style name.[1]

The unusual format and size of the painting are strong indicators that it was originally attached to a wall. From the time of his marriage in 1727 to Lady Fucha, the future Xiaoxian Empress, Prince Hongli had his living quarters in a palace compound called Residence of the Hidden Dragon (Qianlongdi). It was renamed Palace of Double Glory (Chonghuagong) after he ascended to the throne. It is probable that the painting adorned one of the rooms of this palace compound. GHo

188

The Qianlong Emperor (1711–1799)
'The Colours of Wheat', a poem, in running script

1762

Hanging scroll, ink on paper, 75.7 × 94.8 cm

IMPERIAL SEALS: *Suo bao wei xian* (Only those virtuous and worthy should be treasured); *Qianlong yu bi* (Qianlong imperial calligraphy)

COLLECTORS' SEALS: *Shiqu baoji suo cang* (Collected in the *Precious Collection of the Stone Moat [Pavilion]*); *Xuantong zunqin zhi bao* (Treasure of the esteemed parents of the Xuantong Emperor)

The Palace Museum, Beijing, Dia026656

This piece of calligraphy records an eight-line verse of five characters to a line composed by the Qianlong Emperor on the subject of 'the colours of wheat'. It describes how in spring, in the second month of the year, it is still chilly in northern China, but south of the Yellow River the wheat begins to turn delightful colours as it grows with renewed vigour. The text of the poem reads:

> Crossing the Yellow River we find the wheat colouring,
> how different the temperature is between the north and south!
> Thus recalling this especially instructive pleasure,
> I enter into poetry and sketch it out.
> The wind bends the young wheat in waves,
> to reveal threads of pearl-like grains.
> Greens and yellows mingle here,
> a superb view over green fields.

'A poem on the colours of wheat. The first ten days of mid spring [the second month] in the year *renwu* (1762), written by the imperial brush.'

This piece of calligraphy was written in the 27th year of the Qianlong Emperor's reign (1762) when he was 52 years old. With the script tending towards cursive, the style is unrestrained and yet robust,

and full of the fervour so characteristic of the Qianlong Emperor's hand. We can see here the results of the Emperor's exhaustive study of the fluent, graceful style of the Yuan master Zhao Mengfu (1254–1322; see also cat.189), as well as the Emperor's imitation of the distinctive calligraphy of his grandfather, the Kangxi Emperor. This example, therefore, combines features of both Emperors' models: Zhao Mengfu, and the late Ming period orthodox master Dong Qichang (1555–1636; see also cats 121, 125, 126, which explain the Kangxi Emperor's debt to Dong Qichang). One of the Qianlong Emperor's outstanding works in large-size running script, this work is also a fine example of the more mature calligraphic style of his middle years. HN/SMcC

189

The Qianlong Emperor (1711–1799)
'Small Banquet at Yingtai', a poem, in running script

1759
Hanging scroll, ink on paper, 156.4 × 88 cm
The Palace Museum, Beijing, Gu239593

Aixinjueluo Hongli is better known as Qing Gaozong, the Qianlong Emperor. He was the fourth son of the Yongzheng Emperor and succeeded to the throne when he was 25, reigning for a period of 60 years. His civil and military achievements ensured his was a long and peaceful reign: indeed, the Qing empire was then at its mightiest. He ruled China during the latter part of a period of history known as the high Qing or 'the long eighteenth century', that prolonged highpoint of the Qing dynasty under the Kangxi, Yongzheng and Qianlong Emperors.

Heir to the throne of a Manchu dynasty, the Qianlong Emperor was nevertheless very well versed in Han Chinese culture. Able to speak and read Manchu, Mongol and the Han Chinese languages, he was an ardent student of the traditional categories of Chinese writings, including the classics, histories and philosophers. He was capable of writing Chinese prose, fond of composing Chinese poetry, and a competent painter, although he devoted his greatest efforts to the study and practice of Chinese calligraphy. He derived great pleasure from calligraphy

throughout his life, and his surviving calligraphic writings number more than those by any other emperor of China.

The present piece of calligraphy is an eight-line poem of seven characters to a line (*qiyan lushi*). The poem text reads:

Carrying forth the struggle, we crushed the enemy in the new year *jimao*,
How timely, as we have come to celebrate, meeting at Yingtai.
A thousand people try ice-skating for fun, Linking arms in threes, everyone gets a lesson at this double spring feast.
What is the harm in putting aside my brush beside the Onion Range [the Belaturgh mountains in Turkestan]?
Such delight gives order to words, coming from the clouds.
The archery field is so clear and bright, one can see each shot,
See how far they go – how could our pleasure be merely at this!

The Emperor added an inscription to the poem, as follows: 'In the first month of the year *jimao* we held a small banquet at Yingtai. Lined up before the imperial presence were foreign princes, ministers and Muslim officials (*mozapa'er*). [Written by] the imperial brush.' The year *jimao* was the 24th year of the Qianlong Emperor's reign (1759) when he was 49. According to the *Veritable Records* of his reign (*Gaozong shilu*), on the fourth day of the new year of 1759, the Qianlong Emperor held a banquet at Yingtai for the Mongol princes, dukes and other aristocrats and the Muslim *mozapa'er*. On the third day of the new year the Emperor had given orders to General Zhao Hui and his other generals then campaigning to pacify the border regions: 'When pacifying the Muslim territories, any mobilisation or resistance to pacification in these areas organised by the Yili Mohammedans must be utterly destroyed.'

This calligraphy may be described as well-articulated, graceful and appealing, with a richness and fullness given to each character. The handling of the brush is honest and skilful, imbuing the piece with a hearty and abundantly spirited quality. This is a fine example of the Emperor's large-size running-script calligraphy. The distinctive calligraphic style was cultivated through extensive study of the graceful style of the early Yuan dynasty master Zhao Mengfu (1254–1322), a pivotal figure in the classical tradition of Chinese calligraphy. FHZ/SMcC

190

Deng Shiru (1743–1805)
Ancient prose from the *Xunzi*, in seal script

Before 1796
Hanging scroll, ink on paper, 117 × 74 cm
INSCRIPTION: 'Transcribed for the master of Yi Studio, Deng Yan'
SEALS: below the inscription *Deng Yan*, *Shiru* (the artist's names)
The Palace Museum, Beijing, Xin187665

The original given name of Deng Shiru was Yan, but he dropped it in observance of the taboo on the Jiaqing Emperor's names, and went by his style name (*zi*), Shiru. Another style name was Wanbo, and he also had a literary name (*hao*), Wanbai shanren. He was a native of Huining in Anhui Province, and one of the famous Qing masters of stele-style calligraphy.

Deng Shiru was accomplished in all scripts of calligraphy, but especially so in seal and clerical scripts, and was a skilled seal-carver as well. He broke the traditional mould to develop his own individual styles in both seal and clerical scripts. His seal script is noted for its lively, spirited appearance, and his clerical script for its heavy thick brush strokes, which are, similarly, full of energy. His regular and running scripts derive in large measure from the styles of northern steles (monumental calligraphy from north China between the Han and Tang empires). Deng Shiru's animated personal style exerted a powerful influence on calligraphy during the middle to late Qing dynasty.

This calligraphic excerpt is from a chapter entitled 'On Ritual Vases' in the ancient text *Xunzi* (written by the philosopher Xunzi, third century BC):

One day, Confucius went to visit the ancestral temple of Duke Huan of Lu. In the temple were some of the tilting vases that tip over when they are full. The Master asked the temple keeper, 'What purpose do these vases serve?' The keeper replied, 'These are the vases that are placed to the right of the seat of honour.' The Master resumed: 'I heard that such vases tilt when they are empty, stand up straight when they are half-full and fall over when they are full. The enlightened ruler takes this to be a supreme caution, which is why he will often have the vases positioned beside his throne as a reminder.' And he added, for the benefit of his disciples: 'Pour water into them.' They did so after having gone to fetch some. And, indeed, the tilting vases stood up straight once half-full, fell over when full. The Master then said with a sigh, 'Ah! What vessel is there that may be filled and does not fall over!' His disciple Zi Lu approached:

'Dare I ask how their filling accords with the *dao* (the Way)?' Confucius answered him: 'Retain keenness of mind, perceptiveness, high wisdom and intelligence by means of innocence; retain the merits that shine throughout the Empire by means of a self-effacing manner; retain a courageous strength to shake the world by means of prudence; conserve the wealth of the four seas by means of humility. That is what is called the way of discretion and reserve.

Transcribed for the master of Yi Studio, Deng Yan.

Deng Shiru's seal script, seen here, stands out for its multi-dimensional style, which integrates diverse calligraphic effects and forms. He employed the centred-tip technique, standard in seal script, using a goat-hair brush. The individual brush strokes are unusually long, and appear the more so for being thin and even. The actual characters are consequently slender and attenuated. As a whole, the calligraphy may be described as rounded and appealing, and the execution skilful and fluent, and full of vital energy, very much in the spirit and style of the Tang period seal-script master Li Yangbing.

LYX/SMcC

191

The Qianlong Emperor (1711–1799)
Mount Pan

1745

Hanging scroll, ink on paper, 162 × 93.5 cm

INSCRIPTIONS: signature, dated 1745, nine place names, and 34 poetic inscriptions by the Qianlong Emperor, dated 1745, 1747 (12), 1750, 1752 (3), 1755, 1760, 1763, 1764, 1766, 1769, 1770 (2), 1772, 1774, 1775, 1782, 1785, 1787, 1789, 1791, 1793

SEALS: 69 seals by the Qianlong Emperor, one seal by the Xuantong Emperor

The Palace Museum, Beijing, Gu237306

SELECT REFERENCES: *Shiqu baoji xubian*, pp.1311–16; Macau 1999, no.32; Edinburgh 2003, no.50

Mount Pan, situated some eighty kilometres northeast of Beijing, is considered one of China's most beautiful mountainous areas and was highly praised by men like the poet Yuan Hongdao (1568–1610) and the art critic and collector Gao Shiqi (1645–1704). The route from Beijing to the Eastern Tombs of the Qing emperors passed through this area and the Qianlong Emperor decided to build a mountain villa at this lovely site, where he could stay during his regular visits to the tombs of his ancestors. He called it Mountain Villa of Peaceful Lodging (Jingji shanzhuang) and was so happy with it that in 1745, the year

after the villa was built, he painted this large hanging scroll depicting the villa and the eight famous sights which were enclosed by its outer wall. As he states in his signature, he used an especially precious kind of paper for the painting: 'This painting I have begun in the first decade of the fourth month and have finished in the first decade of the seventh month. The Yusujian-paper is very hard to get and I am ashamed that my brushwork is so weak that it doesn't match it. When, from now on, I come again to Mount Pan and compose a poem on its scenery, I will inscribe it on this painting every time. Written on the seventh day, in the *yichou* year [4 August 1745].'

This special type of landscape painting with a topographic rendering of a villa and its famous sights reaches back to Wang Wei in the eighth century; it was especially popular in the Ming (1368–1644) and Qing dynasties. The Emperor used the dry scholarly style inspired by Huang Gongwang (1269–1354), which he preferred, and lavished care on his depiction of the tall pines, strange rocks and numerous temples for which the site was praised. He wrote the place names in standard script and impressed one of his many motto-seals over each. The villa proper is situated at the foot of the mountain, while to the left rises the pagoda of the Shaolin Temple and up the path are Zhongpan and the Temple of Ten Thousand Pines (Wansong si). The central summit is adorned with the Dingguang Pagoda.

Whenever the Emperor visited the villa, once every two or three years, he inscribed the painting with a poem he had composed while wandering through the local scenery, as he had promised in his signature. In 1747 he even added twelve poetic inscriptions. Altogether there are 34 poems by the Emperor, ranging from 1745 to 1793 and occupying every bit of empty space in the picture. The last inscription, at the very bottom of the painting, is squeezed beneath the bank of the river. This practice of inscribing a painting regularly over a long period of time and thus filling it totally with poetic impressions was followed by the Emperor in many other examples. Like a diary they document the Emperor's visits and his way of thinking, even his private feelings:

An old apricot tree leans against the mountain slope,
 sparkling dew on its red flowers, two or three branches.
Just like in the little story of the song of the lute,
 in the deep of night I suddenly come to think of the time of my youth.
'A poem on an old apricot tree, written in middle spring in the *jiawu* year (1774).'

When composing a poem, one must have a painting in mind,
 when doing a painting one must compose a poem.
This saying I have already heard very often,
 but if one does not go to a tower's window and let the eye wander about,
 one does not know how to pair these wonderful things.
'In the spring of the *dingwei* year [1787], written in the tower for viewing paintings.'

The day before yesterday it was slightly cold, today it is warm.
 Everywhere the apricot blossoms have opened, on myriads of branches all over the cliffs.
 That makes me consider, that if a ruler governs with benevolence,
 he will transform the people just like this.
'A poem on warmth, written in the third month of the *xinhai* year (1791).'

GHo

192

Seal of the Qianlong Emperor carved to depict the boating scene from 'Ode on the Red Cliff'

1736 or later

Changhua stone, 12.5 × 6.9 × 6.9 cm

SEAL: 'Be pure, be of one [mind]' (*Wei jing wei yi*)

A yellow paper label glued to the seal states: 'One imperial seal: "Be pure, be of one mind"' (*Wei jing wei yi, yubao yi fang*)

The Palace Museum, Beijing, Gu166998

SELECT REFERENCE: Palace Museum 1996, no.205

Changhua stone, found in the county of Changhua in Zhejiang Province, is one of three favoured types of stone used for seal-carving in China. Its most celebrated feature is the bright red colour sprinkled over its surface, for which reason it is also called chicken-blood stone (*jixue shi*). This seal of the Qianlong Emperor is carved in the form of a three-dimensional landscape, using the red dots to indicate the redness of the cliff and autumn trees. It illustrates 'Ode on the Red Cliff' by Su Shi (1037–1101), one of the most famous poems in Chinese literature, and depicts the boat trip of the poet with his friends to this site on the Yangzi River in the autumn of 1082.

The seal reads 'Be pure, be of one [mind]'. This is a quotation from the ancient *Book of Documents*

(*Shangshu*), in which the Sage Emperor Yao gives advice to Yu, whom he had chosen to be his successor to the throne, on how to rule over the people and spread the 'true Way': 'The mind of man is restless, prone to err; its affinity for the true Way is small. Be pure, be of one mind, that you may sincerely hold fast the Mean (the course, which neither exceeds nor comes short of what is right).'[1] From the beginning of his reign in 1736, the Qianlong Emperor used personal seals of different sizes with this quotation for signing his texts and pieces of calligraphy. It was employed together with the seal 'Imperial brush of the Qianlong period' (*Qianlong chen han*), forming a pair with it. The carving of the present example is especially beautiful. The four characters form a strong, strictly balanced pattern, with the red square of the seal almost dissolving under the fleshy white strokes. GHo

193

The Qianlong Emperor (1711–1799) and Giuseppe Castiglione (Chinese name Lang Shining, 1688–1766)
Reading in the Snow

1764

Hanging scroll, ink on paper, 87.5 × 50.7 cm
INSCRIPTIONS: poem and commentary by the Qianlong Emperor
SEALS: five seals of the Qianlong Emperor
The Palace Museum, Beijing, Gu237286
SELECT REFERENCES: Edinburgh 2002, no.53; Macau 2002B, no.20

When enjoying the paintings in his collection the Qianlong Emperor not only adorned them with inscriptions or art-historical comments, but also found pleasure in copying works which had a special appeal to him. This example is such a painting by the Emperor, who was a passionate dilettante; it is executed with a sensitive brush and a love of pictorial detail. At the top of the painting the Emperor added a poem describing the dancing snow in the morning and a commentary in which he explains how he came to paint the work. He notes that it is the seventh day of the twelfth month of the *guiwei* year (9 January 1764) and that the earth is covered with a deep layer of snow, an auspicious sign for successful farming in the coming spring. This was his reason for copying a small snowscape by Xiang Shengmo (1597–1658), a

scholar painter of the Ming dynasty, and composing the poem. He goes on to say that he asked Castiglione to paint the figures for him because he didn't trust his own abilities in figure painting sufficiently. Finally he states that he has completed the work in the Studio of the Three Rarities, Sanxi tang (fig.15), his small private study in a corner of the Hall of Mental Cultivation, where he used to lodge in winter.

An interesting feature of this work is the fact that the Emperor ordered Castiglione to substitute the main figure in the original with a portrait of himself. Although he frequently had his portrait inserted into copies of old masterworks, it was unusual for him to have himself included in a painting by his own hand. The work thus becomes a kind of self-portrait of the Emperor sitting, like his model Xiang Shengmo, as a recluse in his small boxroom in the midst of snow-covered trees, making paintings and writing poems in praise of the snow. He is known to have paid much attention to the observation of snowfall, which was essential for the cultivation of the new crop, and stressed that it was his duty as ruler to care about such matters. In the Studio of the Three Rarities he regularly noted the amount of snowfall every year. No doubt he enjoyed the beauty of snow scenes too. GHo

194

Giuseppe Castiglione
(Chinese name Lang Shining, 1688–1766) and Ding Guanpeng (fl.*c*.1738–1768)
The Qianlong Emperor Viewing Paintings

1746–*c*.1750

Hanging scroll, ink and colour on paper, 135.4 × 62 cm
INSCRIPTION: signature by Giuseppe Castiglione, undated
SEALS: two seals of Giuseppe Castiglione, two seals of the Qianlong Emperor
The Palace Museum, Beijing, Gu5366
SELECT REFERENCES: Berlin 1985, no.41; Edinburgh 2002, no.57; Macau 2002B, no.1; Berger 2003, p.63, pl.9

This painting shows the Qianlong Emperor in the guise of a Chinese connoisseur enjoying objects from his collection in a beautiful garden setting. He sits in a casual pose by a table, on which bronze, jade and ceramic antiquities are displayed, while viewing a painting which is unrolled before him. Young servants approach with more scrolls, a

stringed instrument, a big vase and other objects.

The composition does not depict a real scene, however. On the contrary, it is a sophisticated play with words and images and as such is typical of the taste of the Qianlong Emperor. The Emperor looks at the painting *Washing the Elephant* by the Ming period artist Ding Yunpeng (1547–after 1628), painted in 1588, which he had acquired for his collection and provided with a poetic inscription in the winter of 1745–46 (see cat.195).[1] This painting plays on the pun of 'elephant' and 'image', which have the same pronunciation in Chinese (*xiang*), thus containing the Buddhist message of sweeping away the illusory images of the phenomenal world.[2] A comparison of the present composition with the painting by Ding Yunpeng reveals that the Qing work is a remodelled copy of the latter, with the landscape setting remaining the same but with the Emperor taking the role of the bodhisattva and a painting taking the place of the elephant. The eleven attendant figures in Ding Yunpeng's painting are exchanged for ten young servants and a scholar holding the hanging scroll. The latter apparently takes the place of the monk in the red robe. The garments of the figures too are shown with the wavy lines in the archaic style employed in the Ming painting. The Emperor thus views an image (*xiang*) of an elephant (*xiang*), which is in itself a symbol for an illusory image. In a clever pictorial comment the Emperor thus expands the message of the original painting to the sphere of art itself. The painting can thus also be interpreted as a self-critical or ironical comment of the Qianlong Emperor concerning his own obsession with collecting things and his lasting preoccupation with his own portrait by Giuseppe Castiglione (cat.196). The striking illusionism of the latter seems to have much fascinated him. GHo

195

Ding Guanpeng (fl.*c*.1738–1768)
Washing the Elephant

1750

Hanging scroll, ink and colour on gold-flecked paper, 132.3 × 62.5 cm
INSCRIPTION: artist's signature, dated 1750

SEALS: two seals of the artist, one seal of the Qianlong Emperor

The Palace Museum, Beijing, Gu4794

SELECT REFERENCES: Berlin 1985, no.40; Edinburgh 2002, no.58

Sitting on a lotus-based throne with his hands in the gesture of meditation the Qianlong Emperor is depicted as the bodhisattva of wisdom, Manjusri, watching four young grooms wash an elephant with long brushes. The composition is a close copy of a picture by Ding Yunpeng, dated 1588, which the Emperor acquired for his collection in the winter of 1745/46 (see cat.194).[1] The painting's message is contained in a pun based on the fact that the pronunciation of 'elephant' and 'image' is the same in Chinese (*xiang*). It illustrates the Buddhist concept of sweeping away the phenomena of the outside world, which are thought to be mere illusions. The Emperor was so fascinated with this work that he summoned his favourite painter of Buddhist figures, Ding Guanpeng, to copy it, with the face of the bodhisattva being substituted by his own portrait done in realistic style by Giuseppe Castiglione. He played this game with many paintings in his collection.

However, the depiction of the Emperor as Manjusri also had a profound religious and political background. In Tibet, the Emperor was considered to be an emanation of this bodhisattva and was addressed as such by the Tibetan religious authorities. Moreover, recognising Tibet as an important part of his Inner Asian empire, the Emperor had studied Tibetan Buddhism with his spiritual tutor, Rolpay Dorje (1717–1786), the Zhangjia National Preceptor and the religious leader of Inner Mongolia (Zhangjia Hutuktu) from the early 1740s; in 1745 he received his first initiation in tantric Buddhism with brilliant success.[2] In his poetic inscription on the original painting by Ding Yunpeng the Emperor demonstrates his competence in religious questions: 'When [Buddha] preached his sermons in Deer Garden, there was originally not a single character written. When in the formal period of Buddhism the doctrine was expounded in *sutras*, the Three Vehicles came into existence. After the Three Vehicles had been summarised into the One [Buddha Vehicle of the *Huayan Sutra*], how

can there still be the negation of the non-existence [of an independent reality]! If one sees something being an elephant (illusory image), why not sweep it away! Those thirty-two forms [of that bodhisattva] really do have a poisonous message too!'[3]

As was his wont, at the end of the text the Emperor makes a clever point by turning his criticism towards an idea of the doctrine itself which he considers unconvincing.

The iconography of the composition is probably closely connected with the Madhyamika school of Tibetan Buddhism, which the Qianlong Emperor studied with Rolpay Dorje and which interprets material forms as empty manifestations of one coherent, constantly shifting whole. It seems to correspond with a traditional iconographic group depicting Manjusri arriving in China on an elephant accompanied by four legendary figures of Buddhist thought: the prominent monk in the red robe holding a book in his hands would accordingly be identified with Buddhapalita, a disciple of Nagarjuna, the founder of the Madhyamika school.[4] The man in Chinese court dress behind the elephant may depict King Udayana, who had the first image of the Buddha made of sandalwood, and the young man at his side Sudhana, the young pilgrim seeking for truth, as recorded in the *Avatamsaka sutra*. The old man with the headscarf would correspond to the Supreme Holy Old Man (Dasheng laoren) mentioned in the group. GHo

196

Anonymous court artists
One or Two?

c. 1745–50
Hanging scroll, ink and colour on paper, 77 × 147.2 cm
INSCRIPTION: the Qianlong Emperor, undated

SEALS: five seals of the Qianlong Emperor

The Palace Museum, Beijing, Gu6493

SELECT REFERENCES: Berlin 1985, no.42; Macau 2000, no.106; Edinburgh 2002, no.59; Berger 2003, pp.51–54

In this fascinating double portrait the Qianlong Emperor sits casually on a couch with brush and paper ready for writing, surrounded by objects from his art collection and with his own portrait watching attentively from a screen behind him.

This extraordinary composition is not of his own invention or that of

his court painters, however; it is an enlarged and 'modernised' copy of a small album leaf, probably dating from the early Ming period, which had been in the Emperor's collection since his youth. The leaf depicts a Chinese scholar in the same position and garment, with the same servant pouring tea and with objects similarly arranged. When, during the cataloguing of his collection around 1745, the Emperor again viewed the album leaf he decided to have a large version painted after it and mounted as a screen, presenting his own image in place of the two portraits of the main figure. The idea was to use this puzzling image of a screen as a real screen to place on the couch of his study and to create a double-play on the illusion of the mirror effect between image and reality. The Emperor enjoyed playing such sophisticated games with the paintings in his collection, and many similar examples exist.[1] The game is continued with a poem inscribed on the screen, in which the Emperor raises questions concerning doubling and identity:

Are they one or are they two?
Neither contingent nor separate.
Maybe Confucian, maybe Mohist.
Why should I worry, why think about it?

As Patricia Berger has convincingly shown, these somewhat mysterious lines have their source in the Emperor's involvement from the early 1740s with the philosophy of Tibetan Buddhism, especially with the Madhyamika or Middle Way philosophy of Nagarjuna.[2] According to this school of thought, all forms of the material world are empty and inter-related in a non-dualistic whole. In a preface of 1742 to the *Sutra of Iconometry*, whose translation the Qianlong Emperor had ordered, this concept is formulated in the form of questions and answers: '…The Buddha's form and the form of all creatures – are they one or are they two? They are not one and they are not two…'[3] The Qianlong Emperor used this formula on many more occasions and the Madhyamika philosophy intrigued him throughout his life.

In addition to this philosophical game, the Emperor here assumes the role of an educated Chinese scholar writing poems and enjoying his collection of antiques. In fact the two large vessels placed prominently on high wooden stands on both sides of the screen can be precisely

identified as treasured objects from the Emperor's art collection: to the left a famous bronze standard measure commissioned in AD 9 by Wang Mang (r. AD 9–23), now in the National Palace Museum, Taipei; and to the right a blue-and-white porcelain jar with the seed syllables in Nagari script on its body, made in the Xuande period (1426–35) of the Ming dynasty, now in the Palace Museum, Beijing.

There are three versions of this painting, all in the Palace Museum in Beijing, and all originally mounted as screens with identical dimensions. All three also bear the same poem by the Qianlong Emperor, differing only in his signature. The earliest version, badly worn,[4] is signed with the study name, Eternal Spring Study (Changchun shuwu), that he used before 1746. This is the most realistic version and the Emperor's portrait is very close to a preparatory drawing by the Italian Jesuit court painter Giuseppe Castiglione (1688–1766), for his painting *Qianlong Receiving Tribute from the Zunghars*, dated 1748.[5] Although the painting is attributed by the museum to Yao Wenhan, it is more likely that it was the work of Castiglione. The perspective used is thoroughly European too. The present version bears the place name Hall of Mental Cultivation (Yangxin dian) in the signature and was probably executed only slightly later, around 1750. The third version[6] is the most different in style and must have been painted considerably later. Its inscription is signed with the study name 'Naluoyan ku' (Narayana's Cave), which appears famously in the *Avatamsaka sutra*, an essential text in the Madhyamika school, and which was also the study name of Hanshan Deqing, a famous monk in the late Ming dynasty whose writings the Qianlong Emperor admired. GHo

197

Ru-type basin on four bracket feet

Yongzheng period, Jingdezhen, Jiangxi Province

Porcelain with crackled celadon glaze, height 6.7 cm, mouth 23.3 × 17 cm, foot 13.2 × 19.7 cm

The base engraved after firing with a poem by the Qianlong Emperor dated 1772

The Palace Museum, Beijing, Gu153271

SELECT REFERENCES: Yang Jingrong 1999, pl.210; Chicago 2004, cat.291

This basin was made to imitate the most celebrated and rarest ceramic ware of China, 'Ru' ware from Henan Province, the official ware of the Northern Song court (960–1127). The basin's shape, pale blue-green glaze and decorative crackle all copy the Song original so closely that the piece could be called an ancient fake. The Qianlong Emperor had at least three genuine Song bowls of this type in his collection and composed a poem for each. All four poems similarly talk about 'official' (*guan*) ware – here probably meant literally rather than referring to the Southern Song (1127–1279) ware commonly known as *guan* – and call the vessels bowls for cat food, although the Emperor preferred to use them as basins for washing the hands. He also comments on the spurmarks (unglazed spots characteristic of Ru which was fired standing on small stilts) on the base.

The parallel treatment of the inscriptions on all four pieces strongly suggests that the Qianlong Emperor took this piece for a genuine work of the Song dynasty. It is therefore unlikely to date from his own reign and was probably commissioned by the Yongzheng Emperor (like cat.180). It could either be an inherited piece or else have been acquired from outside the Palace. Since the Qianlong Emperor was known as an avid collector, officials were eager to source ancient works of art to bestow upon the imperial collection. The Emperor was well aware of the problem of fakes and frequently discussed it with other connoisseurs. RK

198

Table screen with inlaid bronze mirror

c. 1776

Zitan wood and bronze, height 92 cm

INSCRIPTIONS: the Qianlong Emperor, dated 1776, seven inscriptions by court ministers; inscription at the base: *Qianlong yuwan* (Imperial Gem of the Qianlong period), *Han chunsu jian* (Pure Mirror of the Han dynasty)

SEALS: two seals of the Qianlong Emperor, fourteen seals of the court ministers

The Palace Museum, Beijing, Gu209652

SELECT REFERENCE: Zhu Jiaqian 2002B, no.168

This table screen is a beautiful example of the Qianlong Emperor's way of enjoying objects from his vast

art collection. The antique bronze mirror especially appealed to him, and he showed it to his ministers and scholars and discussed it with them. Together they formed a scholarly art circle in which the Emperor could communicate with the educated élite of the empire. On this occasion the Emperor composed a poem and all the participants had to do likewise, using the same rhyme. This was the most common sport at literary gatherings. In commemoration of the meeting, the Emperor had the mirror inlaid in a table screen and his poem engraved in decorative characters in clerical-script style on the front, surrounding the mirror. At the back of the screen the poems of the seven participating ministers were engraved. They included Yu Minzhong, at that time the mightiest minister in the empire, Wang Jihua, Liang Guozhi, Dong Gao, Chen Xiaoyong, Shen Chu, and Jin Shisong.

In his poem the Emperor ponders the beautiful lady who might have used this mirror in distant antiquity:

Pure and with a big knob it has the form of a mirror of the Han dynasty,
a round disc with a diameter exceeding one foot.
At the reverse of the precious bronze there are carved several motifs,
an elegant adornment of dispersed horses of the sea and grapes.[1]
Brought out of the earth after a thousand years, it is of a bright green colour,
which lady used it in her fragrant dressing case we cannot know.
Was she a singer at the theatre accompanied by fans of silk,
declining the splendid and virtuous regulations of the Inner Palace?
Or was she of peace and harmony, attached to a prince,
striving for beauty with rouge and powder and jealously adhering to virtue?
In the end their beautiful eyebrows were reflected all alike,
if virtuous or not, as far apart as the sky and sea, she had to decide by herself.
Alas, mirror! Alas, mirror! What was entrusted to you, you don't know!
How can you wait for the beautiful and ugly alike to turn their face to you!

'Imperial inscription in the spring of the *bingshen* year (1776) of the Qianlong period.'

GHo

199

Table screen mounted with fungus of longevity (*lingzhi*)

1774

Zitan wood and fungus (*lingzhi*), height 101 cm

INSCRIPTION: the Qianlong Emperor, dated 1774

The Palace Museum, Beijing, Gu209649

SELECT REFERENCE: Zhu Jiaqian 2002B, no.169

Mounted at the centre of this screen is a large woody fungus. Its strange form and beautiful purplish colour is connected by the Chinese with the *lingzhi*, the mythical plant of immortality, which was thought to grow on the imaginary islands in the Eastern Sea, named Penglai. Such fungi were not only used as medicine for curing different diseases, but also became a very popular emblem of longevity. If dried, they keep for a long time, so they were collected and appreciated like other strange natural objects, such as bizarrely shaped rocks. The largest and most beautiful fungi were considered very precious and had to be presented to the court, appearing regularly in the list of tributes for the Emperor. In the collection of the Palace Museum four such table screens exist with inlaid fungi, all dating from the time of the Qianlong Emperor, who seems to have been especially fond of them. He added an inscription in praise of the screen, which is engraved on the back:

It bade farewell to the mountains and marshes of its old homeland to became part of a new screen for the table. In painting it is difficult to depict and in sculpture it has never been achieved. For the purpose of viewing, its sandalwood-like purple colour is praised most, for practical use only the simple white one is suitable. Its body is more than a square-foot tall, its age may be several thousand years. At the age of Emperor Shun auspicious clouds shaded it, at the time of Emperor Yao precious dew nourished it. Its neatly connected strands have the lustre of the divine plant, its curled ornaments are delicate like ten thousand flowers. At the base [of the screen] a band of auspicious symbols is carved, but I still laugh at the opening of the book of old age. I come to think it looks as though the divine tortoise is dragging its tail through the midst of mud.

Such screens were designed not only for aesthetic purposes but were also believed to have a positive influence on health and longevity. But the Qianlong Emperor was a rational thinker and often made critical remarks against such superstitious beliefs in his writings. In a poem on another screen of this kind he stated in 1767: 'I use it only as a screen and do not claim the pretension of prolonging life. I only admire its beauty which seems ageless and its lofty character in departing from its homeland and becoming a piece of furniture.'[1]
GHo

200

Jade *bi* disc on a carved wooden stand

Qianlong period

Jade, diameter 11.1 cm

The Palace Museum, Beijing, Gu103121

SELECT REFERENCE: Zhang Guangwen 1995, no.126

201

Jade *bi* disc

Eastern Zhou period, third century BC

Jade, diameter 14.5 cm

British Museum, London, 1947.7-12.517, Oppenheim Bequest

SELECT REFERENCE: Jenyns 1951, pl.17

Jade discs were first made during the Neolithic period. The most impressive pieces date from the third to second millennium BC and have been found in burials of the Liangzhu culture (*c.*3400–2250 BC) near modern-day Shanghai. Many of these discs are rather thick and have central holes that are small relative to the diameter of the whole. During the succeeding centuries, jade discs continued to be made, but sources of jade were clearly difficult to access during some stages in the periods of the great historic dynasties of the Shang (*c.*1500–*c.*1050 BC) and Zhou (*c.*1050–221 BC). It seems probable that, when supplies of jade were not abundant, ancient pieces were reused. Indeed, it is likely that the large, but rather thin, discs of the late Warring States period (*c.*475–221 BC) and early Han (206 BC–100 AD) were sometimes recut from ancient pieces. The third-century BC disc displayed here may have been one of these reworked examples, or it may have been carved anew from a boulder. The small spirals on the disc are derived from the relief bronze patterns of the sixth and fifth centuries BC. They have the added value of sparkling in the light.

We have no idea of the meanings that the Neolithic jades carried in their own time. In the sixth to fourth centuries, discs were clearly valued in life and death. Texts record the offering of jade discs to rivers and mountains, and such discs have also been excavated from many tombs. By the early Han period it was customary to include a number of discs in the jade suits in which the princes of the imperial family were buried. On occasion these discs included earlier pieces.

Ritual texts compiled in the Han period and based on much earlier commentaries describe *bi* discs as the symbol of Heaven. However, as Han scholarship was already remote in time from when such ritual jade discs were first used, we cannot be sure whether this was indeed the way in which such pieces were originally understood. The Qianlong period disc displayed on a wooden stand is a copy of this earlier category of jade. There are indications, both textual and ritual, that in the Qing period the association of the *bi* with Heaven was taken seriously. The display of such a disc on a fine carved stand thus would have referred both to the high values of antiquity and to this symbolism, ideas central to the Qianlong Emperor's notions of rulership. JR

202

Decorative flattened flask (*bianhu*) in the shape of an ancient bronze

Qianlong period, Palace Workshops, Beijing

Copper decorated with cloisonné enamel with gilding, 21.9 × 23.3 × 8.5 cm

Qianlong four-character reign mark cast in relief on the base

The Palace Museum, Beijing, Gu116412

SELECT REFERENCES: Macau 1999, no.86; Li Jiufang 2002, no.101

203

Flattened flask (*bianhu*) and cover for wine

Warring States period, fourth century BC

Bronze with copper inlay, 35.3 × 31.8 × 8.6 cm

Compton Verney House Trust (Peter Moores Foundation), 0218.1.A, 0218.2.A

An ancient bronze has provided the model for a later archaistic version. As with two other such pairings (cats 205 and 206, and 209 and 210), the later piece deviates markedly from the original, for the eighteenth-century works belong to the decorative phase of copies named as archaism. Large numbers of pieces were made in the forms of ancient bronzes in a wide range of materials, from soft, easily carved materials, such as bamboo (cat.206), to the very hard ones, including crystal and jade.

The ancient flattened flask (*bianhu*, cat.203), the form upon which the later cloisonné version is based, is an example of a bronze made under the influence of the nomadic pastoralists on the borders of the

region now known as China during the period of the fifth–third centuries BC. These peoples, who travelled with all their possessions by horse and cart, carried flasks in wood and leather, often bound with thongs. On the bronze version these thongs are rendered as strips inlaid with silver, while on the eighteenth-century cloisonné piece the rectangular grid has become a dense, repetitive ornament. The rectangles, being filled with cloisonné enamels, emphasise the pattern.

The Qing period cloisonné copy conveys a meaning very different from that of the original. Ancient bronzes were intended for rituals in which offerings were made to the ancestors. The use of a very precious material, bronze, the traditional vessel shapes and very intricate, carefully executed designs confirmed the value that their owners placed upon performing the ceremonies accurately, fully and with no expense spared – an index of their respect for their ancestors. The Qing pieces, on the other hand, were intended merely to refer generally to the past, and were not for use in any ceremony. Such pieces indicated their owners' respect for the past as an exemplary period, rather than the worship of particular ancestors. Moreover, the lively nature of the copy suggests that the value of the past lay in making it vividly present among the possessions of the palace. JR

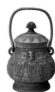

204

Mirror of the Antiquities of the Western Apartments (*Xiqing gujian*)

Compiled at imperial behest from 1749
Printed book, 42.9 × 26.8 cm
Collection of the Muban Foundation

The catalogue of antiquities in forty volumes was prepared under the supervision of Liang Shizheng (1697–1763). Liang was awarded the *jinshi* degree in 1730 and became a compiler in the Hanlin Academy at the imperial court in Beijing.[1] Towards the end of his career, after holding many offices he was appointed Chancellor of the Hanlin Academy. He participated in the compilation of a number of the major works commissioned during the reign of the Qianlong Emperor.

The *Xiqing gujian*, commissioned in 1749 and completed in 1751, contains descriptions of 1,529 items,

primarily bronze ritual vessels, but also other bronzes, such as mirrors, lamps and weapons. The arrangement of the volumes followed the examples of the two Song period catalogues of ancient bronzes, the *Illustrations for the Study of Antiquity* (*Kaogu tu*), compiled in 1092 by Lü Dalin, and the *Illustrated Catalogue of the Antiquities of the Xuanhe Period* (*Xuanhe bogu tulu*), the catalogue of bronzes in the collection of Emperor Huizong (r. 1100–25). Each bronze is illustrated in a woodblock print, accompanied with a woodblock copy of the inscriptions where relevant. Brief descriptions are also given of the size and origins of the bronzes. Two supplements were ordered in 1780 and completed in 1793.

The *you* shown below (cat. 205) is illustrated in the *Xiqing gujian*, as is a vessel in the shape of an ox, attributed in the catalogue to the Tang period (618–906), but more typical of the Han (206 BC–AD 220), and taken as the model of the ox-shaped vessel also included here (cat. 210). JR

205

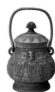

Ritual wine vessel (*you*), decorated with birds with long plumes

Western Zhou period, tenth century BC
Bronze, height to handles 24.8 cm
British Museum, London, 1988.4-22.1
SELECT REFERENCES: *Xiqing gujian*, 15:13; Rawson 1992, fig. 36

206

Decorative vessel in the shape of an ancient wine vessel (*you*)

Eighteenth century, Jiading, Shanghai
Carved bamboo root, 17 cm
The Palace Museum, Beijing, Gu121155
SELECT REFERENCE: Palace Museum 2002, no. 57

As with cats 202 and 203 above, an ancient piece is here used as the model for a later archaistic version; as before, the Qing period bamboo copy conveys a very different meaning from the that of the original.

Here an early wine vessel (*you*) in bronze and a later bamboo carving imitating its form illustrate the very different visual effects available in the two materials. Precision bronze-casting made for fine surfaces, and sharp profiles were of necessity softened when replicated in

bamboo. On the other hand, the bamboo piece is a fairly exact copy of the form of this bronze. The original function of the vessel category as a liquid container, however, would not really have been appropriate in the bamboo version, a fact which emphasises the decorative nature of the latter piece. JR

207

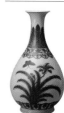

Pear-shaped vase (*yuhuchun ping*) with Ming-style design of butterflies and lilies

Qianlong period, Jingdezhen, Jiangxi Province

Porcelain with underglaze copper red against a ground of overglaze yellow enamel, height 34 cm

The Palace Museum, Beijing, Gu152195
SELECT REFERENCES: Peng Qingyun 1993, p. 435, no. 916; Geng Baochang 2000, pl. 185; Wang Qingzheng 2000, vol. 2, pl. 15

208

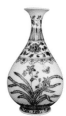

Pear-shaped vase (*yuhuchun ping*) painted with butterflies and lilies

Ming dynasty, Yongle period (1403–24), Jingdezhen, Jiangxi Province

Porcelain with underglaze cobalt blue, height 34 cm

By courtesy of the Percival David Foundation of Chinese Art, London, PDF 601

SELECT REFERENCE: London 2004B, no. 601

The Yongzheng Emperor started the practice of sending treasured antiques from the imperial collection to the Jingdezhen kilns to be copied, and the Qianlong Emperor, a fervent collector of ancient porcelains, increased the commissions of wares following ancient styles. Among the ancient ceramics, the most highly appreciated types were certain colour-glazed wares of the Song (960–1279) (see cats 178, 180) and cobalt-blue painted porcelains of the early Ming dynasty. Blue-and-white porcelain in early Ming style, more or less closely following the original, was made in large quantities in both the Yongzheng and Qianlong reigns, but the present piece is unique in transforming the underglaze-blue design into underglaze red and in covering the white ground with yellow enamel. This colour scheme was not otherwise used. RK

209

Cup in the shape of two tubes
supported by a bird standing
on an animal

Composition: Qing period, eighteenth
century; two tubes: Western Han period,
second–first centuries BC

Bronze inlaid with gold and silver,
height 20 cm

Victoria and Albert Museum, London,
M.730-1910

SELECT REFERENCES: Koop 1924, pl.107;
Kerr 1990, fig.57

210

Vessel in the shape of an
ox imitating a Han dynasty
inlaid vessel (*zun*)

Qianlong period

INSCRIPTION: inscribed in red pigment,
Qianlong fang gu (made in the Qianlong period
imitating the ancient)

Bronze with champlevé enamels in cloud
duster design and applied green surface
imitating patina, 19 × 8 × 22 cm

The Palace Museum, Beijing, Gu116863

SELECT REFERENCES: *Xiqing gujian*, 38:29;
Li Jiufang 2002, no.121

In another pairing of an early
bronze piece with a later archaistic
version produced by the Qing,
we see a rather different form of
comparison. The archaistic ox-
shaped stand or vessel, inlaid in
gold and silver, refers to lamps
and vessels made in animal shapes
from the fourth to first centuries BC.
However, the small projections on
the back of the creature suggest that
the craftsmen used a stand rather
than a vessel as a model. It seems
to be one of a set of similar pieces,
other single examples of which are
in the Victoria and Albert Museum
in London, and in the National
Palace Museum in Taipei,
respectively. All three carry the
same scroll patterns, imitating the
designs common in the early Han
period (206 BC–AD 100) on both
lacquer and inlaid bronzes. Early
examples appear on the bronze
double-tube cup (cat.209), formed
of two separate, ancient tubes joined
together in the eighteenth century,
by the use of mountings in the shape
of a bird standing on an animal
head. The tubes, which originally
probably belonged to a chariot,
feature scroll patterns with small
rounded foliations surrounded by
minute incised lines. These patterns
are inhabited by tiny, mysterious
figures, also a characteristic of
some rare Han inlaid and lacquer
examples. This double-tube cup
joined to bird-shaped mountings

reproduces a form also employed
in the Han period, although at that
time it was more usual for the tubes
to be made of jade, even if the bird
and animal were of bronze. The
double-tube cup and the ox-shaped
vessel illustrate, therefore, different
ways of adapting Han dynasty
inlaid designs in the eighteenth
century. JR

211

*A Discussion of the Carriage with
a League-recording Drum*, in the hand
of the Qianlong Emperor

1778

Two tablets of light grey-green nephrite
from a book of four, 20.7 × 10.4 × 0.5 cm

Text in Chinese engraved and gilded on
both sides, decoration in gold and silver

Chester Beatty Library, Dublin, CBC1005

SELECT REFERENCE: Watson 1963, no.5

212

Jade mortuary tablets announcing
the ancestral name for the late
Qianlong Emperor

1799

Two tablets of green nephrite from a set
of seven, 28.9 × 12.8 × 1 cm

Text in Manchu engraved and gilded on
one side only

Chester Beatty Library, Dublin, CBC1015

SELECT REFERENCE: Watson 1963, no.15

Although books of jade are recorded
in China as far back as the Tang
dynasty, most extant examples
were made at the command of Qing
emperors, notably the Qianlong
Emperor, for whom the opportunity
to hand down to posterity many
examples of cherished words
inscribed into this most Chinese
of precious materials proved
irresistible. The most prized jades,
in fact, came from lands to the west
of China Proper, but it is notable
that these areas were brought into
the Qing empire following the
Qianlong Emperor's military
campaigns of the 1760s, eulogised
in several sets of engravings.

The Emperor's disquisition
on the notion of a carriage bearing
a drum capable of marking the
Chinese miles (*li*) it had covered,
a characteristic display of erudition
on a puzzling historical subject,
was composed in 1778.[1] The
running-cursive calligraphy is in
the style of the Emperor's later
years. According to the inscription
on the book's original wood box
(now lost), the Emperor's inscription

was 'faithfully imitated by the
official Cao Wenzhi'. A former
Hanlin academician, Cao Wenzhi
would have transcribed the
Emperor's writing in four columns
to a page, before it was engraved
and gilded by hand over both sides
of each folio, or tablet, by jade
workers in the Palace Workshops
(Zaoban chu). As on most of the
Qianlong Emperor's jade books, the
front and back pages are decorated
with cavorting dragons, an imperial
symbol; unusually, however, the
engraved lines are not simply gilded,
but filled with different shades of
silver and gold.

The second object is a set of jade
mortuary tablets (*yuce*) conferring a
posthumous or ancestral name on
the deceased, used in the elaborate
death rituals for the late Qianlong
Emperor. During the rituals,
such tablets were required to be
ceremoniously placed on the coffin,
on the grave stele and on state
altars at various temple sites.[2] The
text would have been composed
following the Emperor's death on
7 February 1799, in the Qing rulers'
native but, by this date, little-used
language, Manchu. The carving
into jade tablets would have been
approved by the Qianlong
Emperor's successor, his son the
Jiaqing Emperor (r.1796–1820),
in whose favour the Qianlong
Emperor had abdicated a few years
earlier after a reign of sixty years.

The text itself speaks at length
of 'the excellence of [the late
Emperor's] merits and the
splendour of his culture [which]
achieved the supreme perfection of
a hundred emperors',[3] before finally
proposing the Qianlong Emperor's
temple name, Gaozong (Lofty
Ancestor), suitable for the afterlife.
Inscribed over seven large, heavy,
dark-green jade tablets, and
engraved and gilded to a high
degree of precision with the text
and a motif of dragons contesting
flaming pearls, this set of jade tablets
embodies the solemnity and gravitas
appropriate to their function in the
Qing imperial death ritual. SMcC

213

Pictures of Tilling and Weaving (*Gengzhi
tu*), with poems in four different
scripts by the Qianlong Emperor,
the second of four volumes

Qianlong period, Jingdezhen,
Jiangxi Province, bound in the
Palace Workshops, Beijing

443

Porcelain with black and red enamels,
silk mounts, *zitan* wood covers with gilt title,
10.5 × 8.5 × 12 cm
The Palace Museum, Beijing, Gu154828
SELECT REFERENCE: Qing Porcelain 1989,
p.418, no.100

From antiquity, agriculture and
sericulture were considered the
fundamental occupations for men
and women, as they assured the
provision of food and clothing, and
thus the country's wealth and the
ruler's power. Every spring the
Emperor performed a ceremonial
ploughing in a sacred field and the
Empress a ritual cutting of mulberry
leaves – food for the silk worms –
to set visible examples.

Of the many specialist works
published on agriculture and
sericulture over the centuries, the
Gengzhi tu became one of the most
popular. It comprised 45 short
poems compiled in 1145 by the
official Lou Shou, accompanied
a century later with woodblock
illustrations. The original is lost, but
the book was continually reprinted,
probably with only minor variations.

When the Kangxi Emperor
received a copy of the book on
one of his southern tours, he
commissioned a new edition from
the court painter Jiao Bingzhen
(fl.*c.*1689–1726). It was published
in 1696 with the paintings cut in
wood and with poems by the
Emperor, who was interested in
its wide distribution, both as a
practical handbook and a reminder
to his subjects of their vital duties.
The Yongzheng Emperor, while
still a prince, commissioned painted
versions with his own poems,
featuring himself and his wife as
the main protagonists in each
scene (fig.60); and the Qianlong
Emperor contributed his poems
to further printed versions as well
as this porcelain edition. He also
commissioned a porcelain copy of
another similar treatise, the *Pictures
of Cotton* [*Production*] (*Mianhua tu*).
The art of creating a book in a
precious, durable medium probably
originated with jade books, which
are less rare (cats 211, 212).

The present volume shows the
following activities pertaining to
the cultivation of rice: weeding
the fields; watering the fields;
harvesting; bringing in the harvest;
threshing the ears; beating the
ears; sifting the grains; winnowing;
hulling; storing the rice; and
sacrificing to the divinity. RK

214

A pair of the Qianlong Emperor's
seals commemorating his seventieth
and eightieth birthdays, in a box

1780 and 1790

Seals: jade, 10.9 × 12.85 × 12.85 cm
(*Guxi tianzi zhi bao*), 10.9 × 10.6 × 10.6 cm
(*Bazheng maonian zhi bao*); in double box of
zitan wood, carved with dragons in clouds,
19.5 × 32.1 × 18 cm
The Palace Museum, Beijing, Gu167304,
1–2
SELECT REFERENCES: Macau 2000, no.18;
Edinburgh 2002, no.74

When in September 1780 the
Qianlong Emperor celebrated
his seventieth birthday, one of his
favourite ministers, Peng Yuanrui
(1731–1803), presented him with a
congratulatory hymn, in which he
quoted a line from a poem of the
famous Tang poet Du Fu (712–770):
'Since ancient times it has been
rare for a man to reach the age of
seventy years.' In his poem Peng
Yuanrui used this phrase to call
the Emperor a 'Son of Heaven,
rare since ancient times' (or: seldom
[equalled] since antiquity) (*Guxi
tianzi*), which effectively translates
as 'Seventy-year-old Son of Heaven'.
This pleased the Emperor so much
that he took this designation as his
new pen name and had seals of all
sizes carved with it. The first seal
of the present pair commemorates
this event: 'Seal of the Son of
Heaven, Rare Since Antiquity'
(*Guxi tianzi zhi bao*) (see fig.24). At the
sides of the seal the Emperor had
carved an essay, composed one
month after his birthday, in which
he tells us that, although he is
determined to abdicate at the age
of eighty-six, after sixty years on
the throne, he will work hard daily
to the last. He further notes that
only six emperors in Chinese history
reached the age of seventy, and that
only two of them achieved as much
merit as he has.[1]

The Emperor had the second
seal of the pair carved ten years
later to commemorate his eightieth
birthday in 1790: 'Seal of the
Eighty-Year-Old Who Concerns
Himself with the Eight Tasks of
Government' (*Bazheng maonian zhi
bao*) (see fig.24). He had composed
the essay accompanying it and
engraved into its sides at the New
Year of 1790. In the essay the
Emperor connects the eight decades
of his life to the eight tasks of
government (*bazheng*) mentioned in
the Great Plan which the Great Yu
received from heaven, as recorded
in the *Book of Documents* (*Shangshu*).[2]

He states with confidence that
although he is now an old man of
eighty years (*mao*), he still will not
rest for one day and will execute the
eight duties of government until his
projected retirement six years later.
Only three emperors in history
reached the age of eighty, he notes,
and only one of them, the founder
of the Yuan dynasty (1271–1368),
was meritorious.

After 1780 and 1790, respectively,
these seals were impressed on the
most important paintings and
pieces of calligraphy in the Palace
collection.[3] Several versions of
this pair were carved, but only
one version was actually used,
the others being intended for
commemoration only, such as
this example. A very similar pair
is preserved in the National Palace
Museum, Taipei. GHO

215

Book entitled *Encourage the Full Use
of the Five Blessings* (*Xiangyong wufu*)
in an enamelled box, presented to
the Qianlong Emperor on his
eightieth birthday

Qianlong period
Box of cloisonné enamel,
12.5 × 15 × 21 cm
The Palace Museum, Beijing, Gu166711
SELECT REFERENCE: Macau 2000, no.9

The title of the book is derived from
the *Book of Documents* (*Shangshu*).[1] This
text describes how the Great Yu, the
cultural hero and Sage Emperor of
high antiquity, was given a plan
with nine divisions by Heaven to
guide him in his rule. The ninth
of these divisions was taken as the
title. The Qianlong Emperor, who
regarded the Great Yu as the model
for his own idealised rule, wished
to emulate him as promoter of
culture and ruler of a prosperous
and peaceful empire. In 1776 he
composed an ode on the Five
Blessings (*wufu*), which he inscribed
on a screen to admonish his sons
and grandsons.[2] The Five Blessings
include longevity (*shou*), wealth (*fu*),
health (*kangning*), love for virtue
(*youhao de*) and the enjoyment of life
to its allotted span (*kao zhongming*).
The Emperor stresses that, although
they are bestowed by Heaven, these
blessings will only come about if he
and his people strive for virtue.

On the Emperor's eightieth
birthday in 1790 this book
containing his admonitions on
the promotion of the Five Blessings

was presented to him in an elaborate cloisonné box with a pedestal of lotus flowers and two dragons flying among clouds above the swirling sea. GHo

216

Jade cup and booklet with imperial essay in a lacquer box

Essay dated 1753

Box: lacquer, 12.9 × 12.9 × 12.6 cm; cup: jade, height 5.4 cm

The Palace Museum, Beijing, Gu87392

<small>SELECT REFERENCES: *Shiqu baoji xubian*, pp.2342ff.; Macau 2000, no.38; Chicago 2004, p.245</small>

Essays by the Emperor concerning objects from his art collection which could not be inscribed on the works themselves were written into small albums and stored with the object in elaborate boxes. This double box of gilded black lacquer, holding a little jade cup with handles in the form of small boys and an album containing the imperial essay, is such a set documenting the Emperor's study of his collection. Composed in the third month of 1753, the essay, 'Record on a Jade Cup' ('Yubei ji'), relates how the Emperor discovered that the cup was a Qing dynasty fake and how he enjoyed a discussion with a master craftsman of the Palace Workshop on the matter:

When carefully examining the cup the Emperor noticed its unusual colour and curious signs of damage on its surface; he rubbed it and a substance was left on his hand. Thereupon he showed the cup to the jade worker Yao Zongren, who smiled at seeing this and informed the Emperor that in fact his own grandfather, another master of jade carving, had made the cup. The Emperor asked him why it did not resemble the many other fakes of Han dynasty jade he knew, and the jade master explained to him in detail the secret procedure his grandfather had employed to make the fake, a process which had taken an entire year. The cup was pickled, boiled and treated with fire, before small holes were drilled into it like bee stings which were then filled with amber. Zongren went on to remark that modern forgers no longer use such lengthy procedures for producing fakes because they want to sell them quickly. The Emperor was deeply impressed by this conversation and concluded: 'Although Zongren is a jade worker, he frequently reports on artistic matters and can make a reasonable conversation. Even though workers are low servants, their work is worthy of praise and what they say can be inspiring. There is no hindrance to recording this.'

In the imperial catalogue two handscrolls and an album are listed with this essay executed by the Emperor. In the present album, the essay was penned by Dong Gao (1740–1818), who in 1779 became

Grand Councillor, and whose painting and calligraphy were highly prized by the Emperor. Much of the calligraphy attributed to the Emperor in his old age was in fact done by Gao. The present album and the box for the cup were thus probably produced after 1780. A jade cup with handles in the form of dragons, now in the National Palace Museum, Taipei, has the same essay by the Qianlong Emperor engraved into the sides of its box.[1] GHo

217

Doucai moon flask with dragons among clouds and bats, above rocks and waves

Qianlong period, Jingdezhen, Jiangxi Province

Porcelain with underglaze cobalt-blue, overglaze enamels and gilding, height 49.5 cm

Qianlong six-character seal mark in underglaze blue on white on the base, reserved in turquoise enamel

The Palace Museum, Beijing, Gu152092

<small>SELECT REFERENCES: Wang Liying 1999, pl.254; Wang Qingzheng 2000, vol.2, pl.55</small>

While making this flask the potters borrowed extensively from ancient styles, but combined the different elements into a new design. Shape, motif and colour scheme echo fifteenth-century porcelains, which themselves borrowed the form from archaic bronzes – references the Qianlong Emperor would have much appreciated.

The '*doucai*' colour scheme, which uses underglaze-blue outlines with overglaze enamel washes, became most popular during the Ming period, under the Chenghua Emperor (r.1465–87), but was then used for small items only. The precise meaning of the term is still under debate, as it can be translated as 'contrasting', 'contending' as well as 'fitted' or 'joined colours'.

The five-clawed dragon is the symbol of the Emperor and appears similarly depicted on imperial robes and other imperial artefacts (cats 1, 2, 3, 6, 17, 19). The present flask would have been one of a pair, designed with the dragons confronting each other, for use as decoration in palace rooms. RK

218

Pair of double-gourd-shaped wall vases with addorsed dragon handles, painted with flowers and rocks, among flower scrolls and stylised bats

Qianlong period, Jingdezhen, Jiangxi Province

Porcelain with overglaze enamels, each 21.7 × 12.5 × 3.5 cm

The Palace Museum, Beijing, Gu152720, Gu152721

<small>SELECT REFERENCE: Macau 1999, cat.63</small>

Vases made in pairs, flattened at the back as if cut in half, and with a small recess permitting them to be hung on a wall, were an invention of the Qianlong period. They were intended for use as flower vases inside sedan chairs. One example can also be seen in a painting, adorning the Qianlong Emperor's sledge from which he observes an ice game (cat.30). In a poem reproduced on one porcelain wall vase the Emperor comments on the pleasure provided by these vases when filled with wild flowers, letting him enjoy their fragrance while the 'red dust' (i.e. the cares of the world) cannot reach him. RK

219

Vase painted with flowers and butterflies in Western style on an engraved diaper ground

Qianlong period, Jingdezhen, Jiangxi Province

Porcelain with overglaze enamels and gilding, height 24.2 cm

Qianlong six-character seal mark in underglaze blue reserved in turquoise enamel on the base

Victoria and Albert Museum, London, Salting Bequest, C.1461-1910

<small>SELECT REFERENCES: Honey 1945, pl.137b; Ayers 1980, col.pl.69; Kerr 1986, pl.99; Geng Baochang 1993, col. pl.120</small>

This vase is unique in its combination of Chinese and Western elements. The shape, the detailed painting of the flowers with their subtle colour gradations, the textured brocade-like ground with a pattern incised into the enamel, the turquoise-coloured interior and base, and of course the reign mark are all exclusive to porcelains made for the court by the imperial workshops of Jingdezhen. The opulent, three-dimensional effect created by small shiny pearls with reflecting highlights in the border designs is rarely encountered and would have required an experienced porcelain painter trained in Western technique.

Yet the Western-style flowers and garlands appear not to be due to Jesuits working for the court, but to European merchants. The designs are similarly known from porcelain plates made for export

in a style attributed to Cornelis Pronk (1691–1759), who in 1734 was employed by the Dutch East India Company on a three-year contract to create designs for porcelains to be ordered in China. On the plates, which seem to be slightly earlier than this vase but are far inferior in quality, the main flowers appear together with a butterfly and caterpillars, and the borders are more simply executed and lacking the pearls. The flower design has been traced to drawings of the Swiss-Dutch botanist Maria Sybille Merian (1646–1717), who in 1705 published a book on insects in Surinam.

Imperial and export wares were made in different workshops and otherwise never share motifs. The designs of imperial porcelains were well-guarded secrets; those of export wares on the whole would not have seemed desirable to the court. RK

220

Revolving vase with the Eight Trigrams in openwork

Qianlong period, Jingdezhen, Jiangxi Province

Porcelain with cobalt-blue glaze, overglaze enamels and gilding, height 20 cm

Qianlong six-character seal mark in underglaze blue on the base

Victoria and Albert Museum, London, C.1484-1910

By the Yongzheng period the potters and painters at the Jingdezhen porcelain workshops had mastered their craft and could create outstanding, flawless works of art in virtually any shape and colour, which seemed hard to surpass. In the Qianlong reign they aimed at performing small miracles.

Reticulated vases, such as cat.222, with openings affording a glimpse onto a differently decorated inner core, were a first step in the creation of elaborate porcelain compositions. In the case of the present piece an inner vase is joined to the neck and sits – freely movable – inside the outer pierced body, and can therefore be rotated. The ultimate step in this development were vases with an additional mechanism inside which made the core rotate.

The intricacy of the workmanship involved in such pieces, which also combine a wide range of colours and would have required several firings, defies the imagination. To please an Emperor spoiled for novelties, and to show off the full extent of their virtuosity, the craftsmen of the Qianlong period created *tours de force* which at times can be overwhelming in their effect.

The Eight Trigrams, composed of eight different combinations of three broken or unbroken lines, are ancient symbols of divination that in later centuries were linked to alchemical processes that were thought essential to a pursuit of immortality. In works of art, however, they are frequently used as decorative motifs of a generally auspicious and vaguely archaising nature. RK

221

Pair of display cabinets

Qianlong period

Lacquered and gilt wood, each 161 × 87 × 35 cm

The Palace Museum, Beijing, Gu207579, Gu207580

This kind of display cabinet, developed particularly in the eighteenth century, was called a *duobaoge* or 'shelf for displaying many treasures'. The irregular shapes of the alcoves within the unit allowed for collected works of different shapes and sizes to be displayed. Variety of both material and age was also a feature of such displays, with ancient jades and bronzes, for example, being mixed with contemporary porcelains or glass, enamels or lacquer.

Units such as these can be seen in many of the pavilions of the Forbidden City (Zijin cheng), particularly those where the emperors lived and worked. This pair is richly and quite ostentatiously decorated with black lacquer painted in gold with landscape scenes. The edges of the shelves are elaborately carved and covered with gold lacquer to emphasise the outlines of the compartments and thus act as a kind of frame for each object. The openwork sides of the cabinets allow some of the objects displayed to be viewed in profile.

The Qianlong Emperor would have used this magnificent pair of cabinets to display a small part of his vast collections, which included a huge variety of objects of many different materials and periods. JVP

222

Revolving vase with 'a hundred birds' seen through an openwork landscape

Qianlong period, Jingdezhen, Jiangxi Province

Porcelain with overglaze enamels and gilding, height 63 cm

Qianlong four-character seal mark in iron-red reserved in turquoise enamel on the base

Lin Jian Wei Collection, Singapore

Revolving vases with a pierced outer wall and a second, rotatable inner core joined to the neck, were first made in the Qianlong period. Early examples, such as the vase with pierced trigrams (cat.220), were much less ambitious in their overall concept, much smaller in size, and had simply shaped openings and less elaborate decoration inside. The present vase is one of the most complicated and largest examples ever executed, which points to a later date in the Qianlong reign. Such a dating is also suggested by the overglaze iron-red reign mark, which in the later years of the Qianlong period often replaced the usual underglaze-blue mark.

The vase is painted on the outside with a single multi-coloured phoenix in a mountainous landscape, partly enveloped in clouds, and on the inner core with a waterside landscape with a splendid array of different auspicious birds, which can be seen through the openings, flying past in the distance, as the neck of the vase is turned. Although this landscape design, in which the openings represent the sky between mountains, trees and clouds, is particularly successful, it is unique, probably as a result of the work involved. The multitude of birds is used as a symbol of harmony, as evoked in the expression 'a hundred birds flying together' (*bai niao qi fei*). RK

223

Jade boulder with two ladies at a moon gate in a south Chinese garden

Qianlong period, *c.*1773, Suzhou, Jiangsu Province

White jade with brown inclusions, 15.5 × 25 × 10.8 cm

The Palace Museum, Beijing, Gu103327

SELECT REFERENCES: Beijing 1991, no.1307; Li Jiufang 1991, pl.277; Chicago 2004, cat.208

This carved jade boulder particularly enchanted the Qianlong

Emperor, who had a poetic inscription engraved on the underside, with a date equivalent to 1773, in which he praises the masterful use made of this piece of tribute jade from Khotan (Chinese: Hetian, in present-day Xinjiang Province), left over after a jade bowl had been cut from it.

The circular recess left in the stone was cleverly adapted to depict a 'moon gate' in a roofed garden wall, with one door slightly ajar, its loose ring handle inviting the touch. Outside the gate, among decorative pierced rocks and branches of paulownia (*wutong*), a lady has arrived with a longevity fungus (*lingzhi*); inside the gate, where banana plants, a stone table and seats evoke the famous gardens of Suzhou in southern China, home of the artisan himself, another lady awaits the visitor. The brown tints of the stone were carefully utilised to highlight rockwork and plants.

The topos of the half-open door with a figure peering through the gap is encountered from the Han dynasty (206 BC–AD 220) onwards. Symbolising the transition from one world to another, it can refer to the passage from an earthly existence to a paradisiacal world, the transfer from reality to dream, or more generally, any connection between an outer realm and an inner.

This small masterpiece aimed to appeal to the Qianlong Emperor in a multitude of ways: through its geographic and historical allusions; its unique, novel conception; its outstanding craftsmanship; and its demonstration of the moral that a good craftsman can transform even waste material into a masterpiece. RK

224

Brush rest in the shape of mountains and peach trees with phoenix

Qianlong period
Jade on stained ivory stand imitating wood, height 11.8 cm
Qianlong four-character reign mark
The Palace Museum, Beijing, Gu93944
SELECT REFERENCE: Tokyo 1985, no.43

Calligraphers would often pause while writing, and at such times a brush stand would serve as a temporary resting place for a brush still wet with ink. The most popular style of stand is in the shape of a group of mountain peaks; five was most common, representing the

Five Sacred Mountains of China. The 'valleys' in between provided a convenient resting place for the brush.

This example depicts mountains, pine trees, bamboo, plum and phoenix, all of them carrying auspicious connotations. Many scholars dreamt of escaping the worldly life of officialdom to retire to the peace of the countryside. They favoured depictions of mountains on their desks to remind them of the natural world and the harmony associated with the Daoist view of the universe. The pine, bamboo and plum, the so-called 'three friends of winter', are often shown together to remind people of the constancy of nature. Bamboo also suggested the moral integrity of the scholar, as it sways in the wind but never breaks under stress. Peaches were associated with immortality because Xiwangmu, the Queen Mother of the West, grew peaches which only ripened every few thousand years in her paradise in the Kunlun mountains.

The phoenix, often paired with the dragon, is the most important bird in Chinese symbolism. A beautiful bird, it combined the features of a pheasant and a peacock, and supposedly only appeared in times of peace and prosperity. Appropriately it came to be recognised as an emblem of the empress in ceremonial usage. CJM

225

Bridge-shaped brush rest

Mid-Qing dynasty
Jade with wooden stand, 7.3 × 22 cm
The Palace Museum, Beijing, Gu103086
SELECT REFERENCE: Zhang Guangwen 1995, no.159

This green openwork jade brush rest is carved in the shape of a bridge with two sloping approaches. On the surface of the bridge are pedestrians carrying goods; one is depicted on a donkey. A cowherd is also shown riding a buffalo. There are shrubs on either side of the bridge and a small boat is depicted beneath it. In one of the boats two men are shown, one rowing while the other is casting his net and fishing. A further boat is moored near the bridge, all of which activities are typical of a southern Chinese rural scene. The four activities of fishing, woodcutting, farming and reading

were much eulogised during the Qing dynasty and are often depicted on works of art of the period.

Many such designs of everyday life were commonly copied from woodblock illustrations in catalogues of both private and imperial art collections. From the Ming period (1368–1644), if not earlier, the widespread use of books with woodblock illustrations affected the manufacture of all types of utensils. Such books circulated images based on famous paintings and calligraphy, as well as antiquities generally. As a result, forms and decoration developed in one material were readily copied in another. Jade-carvers, no less than craftsman working in other media, followed this route. Complex landscapes and figure subjects were copied from printed illustrations onto jade. The fact that jade-carvers could transpose what would originally have been two-dimensional pictures and carve them in the round is testimony to their great skill in working such a hard material. CJM

226

Carving of two crabs with reeds

Mid-Qing dynasty, eighteenth century
White jade with *zitan* wood stand, 11.2 × 16.8 × 11.2 cm
The Palace Museum, Beijing, Gu103767
SELECT REFERENCES: Liu 1981; Li Jiufang 1991, no.308

This fanciful carving of two crabs confronting each other atop some reeds is a rebus bearing wishes for success in the civil service exams. From the seventh century onwards this set of arduous and competitive exams was designed to recruit the most able officials to help to govern the state. Through written essays candidates were tested on their knowledge of the classic texts of Confucian philosophy and history, poetry, national policy issues and official document writing. So effective was this system of testing that it was adopted in different forms by various countries including Korea and England.

The hard shell of a crab (*jia*) is the same character as that used to denote the rank in the results of the palace exams, the last set of exams held in the imperial capital which was set and judged by the Emperor himself. Thus two crabs signify a second class (*erjia*) degree (the top

three candidates were in the first class). The character for reeds (*lu*) is a homonym for the second character in the term *chuan lu*, meaning 'reading out the results'. Success in the palace exams ensured a candidate a government position and with it, prestige and wealth for him and his extended family. HK

227

Pair of perfumers with figures in a landscape

Qianlong period
Jade, height 21.5 cm
The Palace Museum, Beijing, Gu89853, Gu89854
SELECT REFERENCES: Li Jiufang 1991, no.84; Wilson 2004, pp.52–54

These jade perfumers are decorated with landscape and figural scenes. As in contemporary Europe, unpleasant smells were a feature of everyday life. The use of perfumes to dispel them was a common practice. Either incense or perfume sticks would be stuck into the container through one of the removable end plugs and the perfume or smoke would then be released through the openwork design.

In the palace and in wealthy households, incense, in stick or powder form, was burnt not only to perfume a room but also to repel insects. Camphor or other insect-repellents would be used inside such reticulated perfume-holders which would then have been placed among clothes or quilts to protect them from moths. Perfume holders were most often made of bamboo, but for an emperor jade would have been considered more appropriate.

These examples are carved with scenes depicting trees, mountains, rocks, a little bridge and running water, and woods. One shows a woodcutter and a fisherman, and the other has a pavilion and depicts a rural scene with scholars reading books. Rustic scenes were often described by the Qianlong Emperor in his poetry and were therefore popularly depicted on such objects. CJM

228

Openwork incense burner and cover with scrolling peony design

Qianlong period
Jade, height 13 cm
The Palace Museum, Beijing, Gu100440

SELECT REFERENCES: Li Jiufang 1991, no.80; Paris 1997, no.136, p.288

This style of openwork vessel became particularly popular towards the end of the Qianlong Emperor's reign, despite the fact that he promulgated an edict in 1794 deploring the lack of practicality of such vessels because the openwork design meant that no liquids or incense ash could be placed in them.[1]

The spirit of antiquarianism during the Qing dynasty included a reinterpretation of the function of antiquities. The basic shape of this vessel refers back to the Western Zhou period (1050–770 BC), but such shapes were assimilated and translated into an entirely new and highly original idiom during the Qing dynasty when they were used for perfume or incense. Interest in the jade carvings of Mughal India was also responsible for some novel developments in jade decoration during the latter part of the Qianlong Emperor's reign. Such an unprecedented facility in adapting ancient shapes and incorporating foreign techniques and design elements constitutes one of the main contributions of the jade workshops patronised by the Qianlong Emperor. The high quality of the finish is also remarkable.

The main design feature of this vessel is the peony, which is regarded by the Chinese as an emblem of wealth and distinction. As one of the four flowers of the seasons, together with the lotus, plum tree and chrysanthemum, the peony is the flower of spring. The three handles and the knob on the lid are all carved into peonies and this vessel, with its openwork carving, is a *tour de force* of the jade-carver's art. CJM

229

Table screen depicting 'one hundred' boys in a garden setting

Qianlong period, made at Suzhou
Carved polychrome lacquer, 49.3 × 58.2 cm
The Palace Museum, Beijing, Gu108955
SELECT REFERENCE: Bartholomew 2002

Designs featuring large groups of boys engaged in playful activities in a garden setting were popular particularly during the Ming (1368–1644) and Qing dynasties. The theme was often used to decorate objects intended to convey

wishes for success in the civil service examinations (cats 226, 232), as well as items for the bridal chamber, to bestow wishes for more sons. The reverse, with a design of dragons cavorting in waves, may allude to the legend of 'carp leaping through Dragon Gate', symbolising great achievement, often with reference to passing the civil service exams, while red bats hovering in the sky imbue 'vast good fortunes'. HK

230

The Qianlong Emperor (1711–1799)
Discourse on the Recognition of One's Faults (Zhi guo lun)

1782
Calligraphy in cursive script

Album with 32 pages, ink on *jinsu* paper, red lacquer covers, 41.1 × 27 cm; red lacquer box, 45.9 × 31.3 × 9.8 cm; wrapping cloth of yellow silk

Nine seals of the Qianlong Emperor: *Sanxi tang, Guxi tianzi zhi bao, You ri zizi, Wufuwudai tang guxi tianzi zhi bao, Bazheng maonian zhi bao* (twice), *Taishang huangdi zhi bao, Shiqu baoji suo cang, Yuanming yuan bao*

The British Library, London, Or 6682
SELECT REFERENCES: *Shiqu baoji xubian*, p.3870; Berlin 1985B, pp.354ff.

In the autumn of 1781, a year after the celebration of his seventieth birthday, the Qianlong Emperor composed this discourse on the recognition of one's faults. The theme, 'having recognised one's faults one must correct them' (*zhi guo bi gai*), is common in Chinese political thought and goes back to the early historical text, the *Zuozhuan*, which describes Duke Ling of Jin in the seventh century BC.[1] The Emperor uses this traditional formula to express his worries about the enormous scope of his many building projects, especially the many palaces which were constructed for his accommodation on his travels throughout the country, and which consumed much of the wealth of the state. He regards the competition between governors to surpass one another in building these palaces as a misguided development, and holds himself responsible. This he declares as his main fault. Regarding the faults which traditionally characterise bad government, such as pressure from border peoples, foreign invasions, overbearing or treacherous ministers, ambitious relatives, eunuchs and flatterers, he states with satisfaction that nothing of that kind is to be found under his rule.

On the other hand, he lists proudly all the building works he has completed and for which he has paid in full without using forced labour or increasing taxes. These works he does not regard as faults. The essay is therefore much more a document of self-affirmation than one of self-criticism.

The essay is written in cursive script on *jinsu* paper. This very superior paper, with its glazed surface and yellow-brown colour, is said to date from the Tang dynasty (618–907) and came originally from the Jinsushan monastery at Haiyan in Zhejiang Province, where it was used for Buddhist sutras. It was highly prized by calligraphers from early times, and was particularly favoured for the title labels of valuable scrolls of painting and calligraphy. In the Qing dynasty an imitation of the paper was produced to meet persistent demand from collectors and artists. Each character of the text has been cut out and pasted into the album separately. This imitates the form of a calligraphic model-book. Rubbings taken from stone stelae had to be cut apart and pasted into albums in small pieces for convenient use. Thus the imperial calligraphy was given an aura of a rare and precious model script.

Three versions of this text are listed in the imperial catalogue *Shiqu baoji*. The first, dated 1781, was written in the form of a handscroll and was stored in the Palace of Tranquil Longevity (Ningshou gong).[2] This album, written in the fifth month of 1782, and a second handscroll written in the seventh month of the same year[3] were both stored in the Hall of Careful Cultivation and Considering Eternity (Shenxiu siyong) in the imperial summer palace of the Garden of Perfect Brightness (Yuanming yuan). This corresponds with the seal of the Yuanming yuan at the end of the album.[4]

The album is furnished with a magnificent cover of red lacquer carved with the imperial emblem of the cosmos, a pair of dragons floating in clouds above rocks and waves. It was wrapped in a cloth of yellow silk, furnished with a beautiful decorated ribbon and an ivory clasp, and placed in a corresponding red lacquer box with the same carved design as the cover. All these are superb products of the imperial workshops. GHo

231
Writing set

Qianlong period
Carved red lacquer, cloisonné enamel, ivory and other materials,
18.5 × 29 × 25.5 cm
The Palace Museum, Beijing, Gu109583
SELECT REFERENCES: Paris 1997, cat. 117, p.255

This carved red lacquer writing set consists of a low table on which is placed a tray of writing utensils. It conforms with the passion of the Qianlong Emperor for painting and calligraphy and also his delight in camouflaging objects and hiding them in surprising ways. The lacquer book covers, with ivory sides carved to resemble pages, are in fact a box which opens to reveal a copy of the celebrated *Peiwen yunfu*, the vast rhyming dictionary compiled during the Kangxi period. The cylindrical 'brushpot' turns out to hold five cloisonné enamel paperweights. Inside the two square boxes with lions carved on the lids are a cloisonné seal paste box and a jade seal. The bell-shaped lacquer box contains a green inkstone and the shallow rectangular box holds two inksticks of red and black ink, respectively, each decorated with gilt and inscribed 'Sanxi tang' (Studio of the Three Rarities), the name of the Qianlong Emperor's study (fig.15) at his primary residence in the Forbidden City, the Hall of Mental Cultivation (Yangxin dian). Two carved red lacquer writing brushes complete the set.

The surface and sides of the lacquered tray are carved with different geometric patterns, while the table has four curved feet and sculpted sides decorated with deeply carved lotus scrolls in typical Qianlong period style. JVP

232
Plate with a crab surrounded by fruit, nuts and seeds

Qianlong period
Porcelain with *famille-rose* enamels,
diameter 22.5 cm
Qianlong six-character mark in seal script written in underglaze blue on the base
The Palace Museum, Beijing, Gu154796
SELECT REFERENCE: Ye Peilan 1999, no.151

Through the use of puns and rebuses, this seemingly whimsical arrangement of a crab surrounded by various fruits, nuts and seeds conveys the wish not only for

examination success but also for the birth of a line of successful and clever sons.

As the character for 'seed', *zi*, is the same as that for 'son', the pomegranate (see cat.288) with its many seeds is associated with fecundity. The jujube or Chinese date (*zaozi* 枣子) is a homonym for *zaozi* (早子) meaning 'the early arrival of sons'. The hard-shelled water caltrop is also called 'buffalo horn fruit' (*lingjiao* 菱角) in Chinese, and the first character of this word, combined with the first character in the word for lychee (*lizhi* 荔枝) creates a pun for clever (*lingli* 伶俐). The second character in the word for peanut (*huasheng* 花生) is a homonym for 'giving birth' (*sheng* 生) and the lotus seed (*lianzi* 莲子) implies wishes for a succession of sons.

Having many sons to continue the family line was considered good fortune, especially clever sons who would be able to pass the set of tough civil service examinations and serve as government officials. Attaining such a prestigious position would not only bring honour to the individual but also wealth and high status to his entire family. HK

233
Box in the shape of a table of books

Qianlong period
Bamboo-veneered wood (*zhuhuang*),
14.8 × 27.5 × 13.9 cm
The Palace Museum, Beijing, Gu120701

During the Qianlong period there was a great interest in producing objects which looked like something else or which looked as if they were made from another material. The technical skills available enabled the Qianlong Emperor to order more or less anything he desired to be made out of any material available. Many ceramics were made to look like glass, wood or lacquer (see cats 235, 236). Here *zhuhuang* bamboo veneer has been carved in the shape of a pile of books resting on a small table, of the type which would have been placed beside a couch or on a desk. The details of the brocade book covers, the pages of the books and the title panels on the covers are all carved exquisitely and realistically. The books suggest the Emperor's scholarship and learning. Beside them is a small box in the shape of the head of a *ruyi* sceptre, with relief-scrolled decoration on the surface. The *ruyi* ('as you wish')

shape signifies the desire for the Emperor to have everything he could wish for, as well as having phallic overtones, suggesting his ability to produce many sons. JVP

234
Two hexagonal vases in imitation of realgar

Qianlong period, pre-1753
Polychrome glass, 15.9 × 9 × 7 cm and 16.8 × 9 × 7.1 cm
Shuisongshi Shanfang Collection, 34.2.293–4

Realgar is a highly attractive but unstable and poisonous mineral that was used in China for medicinal purposes and admired as a magical substance. This sulphide of arsenic has a red to orange-yellow colour and a transparent resinous appearance when fresh, but deteriorates through prolonged exposure to light, and eventually disintegrates into a yellow powder. Due to these mysterious qualities, it attracted the attention of alchemists. Daoists, in their attempts to find longevity drugs or to make gold, made repeated experiments to turn the mineral into a metal.

Realgar was used for decorative carvings, but imitations in glass, more durable and harmless to use, would obviously have provided a welcome alternative with similarly auspicious associations. Glass making did not have a strong tradition in China, even though it can be traced back to the Bronze Age. In the late seventeenth century the Kangxi Emperor, who was particularly interested in its development, appointed the German Jesuit Kilian Stumpf to set up a glass workshop as part of the imperial workshops in the Forbidden City. Early Qing glass was mainly monochrome and prone to crizzling. Fine quality and some multicoloured creations were achieved in the Yongzheng period, and many different varieties, including variegated glass such as this, were produced under the patronage of the Qianlong Emperor. The Palace Museum holds a number of glass items imitating realgar which are inscribed with that Emperor's reign mark.

A pair of vases of identical form and design was in the collection of Sir Hans Sloane, which formed the basis of the British Museum's

collection when he died in 1753. His vases thus provide a useful *terminus ante quem* for the present pieces. RK

235
Faux-bois bucket

Yongzheng or Qianlong period, Jingdezhen, Jiangxi Province
Porcelain with overglaze enamels, height 18.2 cm
Meiyintang Collection, Switzerland
SELECT REFERENCE: Krahl 1994, vol. 2, pl. 947

236
Tripod drum-shaped incense burner simulating pudding-stone

Qianlong period, Jingdezhen, Jiangxi Province
Porcelain with overglaze enamels, height 8.5 cm
Qianlong four-character seal mark in a square, inscribed in gold on the base
The Palace Museum, Beijing, Gu152591
SELECT REFERENCE: Qing Porcelain 1989, p. 423, pl. 105

In the eighteenth century, the imperial porcelain manufactures at Jingdezhen produced an immense variety of styles and constantly devised further novelties. Once a large palette of enamel colours was available, the possibilities were virtually unlimited.

The idealisation of rural life and the love of seemingly modest materials were traits particularly developed by the Manchu emperors of the Qing. *Trompe-l'oeil* effects were therefore generally used to imitate inferior rather than more luxurious materials. For the imperial porcelain workshops to reproduce a humble wooden bucket of the type that would have been used throughout China's countryside required the utmost craftsmanship. Stone censers equally would have been used in modest homes, although actual vessels of this conglomerate rock are hardly preserved from the Qing dynasty. RK

10
Silent Satisfactions: Painting and Calligraphy of the Chinese Educated Elite

237
Wang Shimin (1592–1680)
Mount Changbai

1633
Handscroll, ink on paper, 32 × 201.5 cm

INSCRIPTION: 'Picture of Mount Changbai, painted for Elder Huaweng on a summer day in the *guiyou* year [1633] by Wang Shimin'
ARTIST'S SEAL: *Wang Shimin yin*
COLLECTORS' SEALS: *Linshang zhai zhencang* (Treasure of Linshang Studio), *Minyuan zhencang*
The Palace Museum, Beijing, Xin126281
SELECT REFERENCE: Shao Yanyi 1996, no. 12.5

Wang Shimin was born into a distinguished family. His grandfather, Wang Xijue (1534–1611), was placed second in the *jinshi* examination of 1562 and served at the highest levels of government of the Ming dynasty (1368–1644); his principled administration and his efforts at resolving political conflicts earned him enemies and twice led to his retiring from court. Wang Shimin's father was a talented scholar who waited until his father was retired from office before taking the civil service examination. Nonetheless, his high marks brought accusations of nepotism.

Wang Shimin was thus alerted early on to the hazards of political life. He was given an honorary appointment in honour of his grandfather's merit, and, judging from his career at court, he operated skilfully and was scrupulously polite to all comers.

As a child Wang Shimin was educated in the classics and poetry by his retired grandfather and tutored in painting by his grandfather's friend, the influential official and painting theorist Dong Qichang (1555–1636). Pleased with the boy's progress, his grandfather assembled fine paintings for his grandson to study. Later in life, when Wang Shimin admired younger scholars, he generously shared his insights on uses of the brush. The painter Wang Hui (1632–1717) and Wang Shimin's grandson, Wang Yuanqi (1642–1715), were among the beneficiaries.

The most elegant of literati gifts, this handscroll depicts an idyllic retreat in quiet mountains, the retirement home of the Imperial Censor for whom it was painted. The Changbai range in Shandong Province was so named for its frequent production of puffy white clouds, a motif included in the painting. With a centred brush and soft washes, Wang Shimin evokes the painting style of the fourteenth-century Daoist master Huang Gongwang. AM

238

Hu Zao (fl. mid-seventeenth century)
Ge Hong Moving His Residence

1653
Fan, ink and colour on gold-flecked paper,
17 × 53.5 cm

INSCRIPTION: 'Picture of Ge Hong moving his residence, seventh month, autumn of the *guisi* year [1653] painted for elder leader Dazong. Hu Zao'

ARTIST'S SEAL: *Hu Zao*

The Palace Museum, Beijing, Xin10651

SELECT REFERENCE: Shan Guoqiang 2000, no. 207

This handsome folding fan depicts the story of the impoverished scholar and renowned Daoist Ge Hong (283–343). During a period of war, he moved his family to Mount Luofu where he could pursue his theory that the path to immortality was through alchemy.[1] His extensive writings, collected under the title *The Master Who Embraces Simplicity* (*Baopuzi*), are a rich source of Daoist lore. The painter depicts Ge Hong riding on a water buffalo with possessions piled on a type of wheelbarrow. His wife, with a child on her lap, travels over the bumpy terrain in a wheelchair.

A native of Nanjing, the painter Hu Zao is included in the grouping the Eight Masters of Jinling (another name for Nanjing). In 1653, thoughts on reclusion may have been a response to the chaos that had beset the city during the previous decade. Even before the 1644 Manchu conquest, refugees were set in motion by roving bandit rebels at the end of the Ming dynasty. When news of the Manchu conquest reached Nanjing, that in turn precipitated social unrest, strikes, urban riots and clashes between local militias. Then, in the summer of 1644, an effort to reconstitute the Ming government led to the enthronement of Zhu Yousong in Nanjing, making that city a sure target for the Manchu military. When they arrived in June 1645, some citizens submitted to the conquering troops while others committed suicide. The most prudent course of action was to emulate Ge Hong and retreat deep into the mountains. Hu Zao painted this work within a decade of the violent conquest. AM

239

Fang Hengxian (fl. mid-seventeenth century)
Strange Stones of the Bianliang Palace

Mid-seventeenth century
Hanging scroll, ink on paper,
29.5 × 42 cm

INSCRIPTIONS: Fang Hengxian and Liu Gao

SEALS: one of Fang Hengxian, *Taicun zuohua*; two of Liu Gao, *Yipian bingxin*, *Zhupo*

The Palace Museum, Beijing, Xin145988

SELECT REFERENCE: Shan Guoqiang 2000, no. 33

The illustrious seventeenth-century patron and connoisseur Zhou Lianggong deemed Fang Hengxian one of three great literati painters of his day. While history has not embraced his opinion, this painting with its artful commentary has the qualities that Zhou would have admired.

The affable Fang served as an imperial censor in the early Qing, but a disciplinary exile soured his interest in government. After returning to Nanjing, he focused his energies on the activities of an aesthete: painting, calligraphy, connoisseurship and collecting.[1]

Above the rocks, Fang wrote a note to the recipient Daoist Xuejiao: 'There is a forest of strange stones standing around the mountain behind Bianliang's old palace. They are the remnants of Gen Yue [Emperor Huizong's palace garden]. Each stone has an engraved inscription in the style of Song Huizong. Some are legible.' The tall perforated rock is labelled 'Perch for the Luan' (*qi luan*), a fabulous bird akin to the phoenix. The boulder on the right is 'Singular Crown' (*duguan*). Fang Hengxian adds a couplet describing the Emperor's lavish garden. For Qing dynasty readers, the Northern Song collapse in 1127 at the hands of non-Chinese conquerors was readily equated with the loss of the Ming dynasty to the Manchus. In that context, the stones could be imagined as displaced personalities, neglected remnants of a former dynasty.

The painting is mounted together with an inscription on separate paper. The scholar Liu Gao transcribed an essay by Luo Dajing (fl. thirteenth century). The essay begins with a couplet by the scholar-official Tang Geng (1071–1121) who fell from imperial grace in 1110. The succeeding commentary reads like an advice column for the dispirited official: brew a cup of bitter tea; as you sip it, read certain authors; take leisurely strolls on mountain paths; touch the pine and bamboo; rest with deer and their offspring; near a bright window take up a brush and write some calligraphy; chat with friends about the weather and crops. The recommended readings eschew the Confucian classics in favour of stories, poems and essays about and by the most renowned banished intellectuals of antiquity: Qu Yuan, Sima Qian, Li Bo, Du Fu, Han Yu and Su Dongpo. AM

240

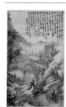

Kuncan (1612–c.1673)
Landscape after Night Rain Shower

1660
Hanging scroll, ink and colour on paper,
96 × 58.5 cm

INSCRIPTION: seven-character verse of eleven couplets. Signed: 'In the eleventh month, winter of the *gengzi* year [1660], the night before the full moon, I made this at Ox Head Mountain Lodge, Dianzhu Shiqi Candaoren of Lonely Roost (Youxi) Temple'

ARTIST'S SEALS: *Jieqiu, Shiqi, Candaozhe*

COLLECTORS' SEALS: *Yousheng yinxin, Ci huazeng shenxing wanli, Puyuan, Xiaoke yinge*

The Palace Museum, Beijing, Xin82091

SELECT REFERENCE: Yang Xin 2000, p. 73

Within the peaceful moisture-saturated landscape, a monastery dominates the valley. The building perched on the cliff at the left may be the Ox Head Mountain Lodge of Kuncan's inscription. In the foreground, the mountains fall away to the right while on the left is the artist's hermitage. A pet crane looks over its shoulder, past a small altar in a makeshift shelter, to the monk chanting sutras. The dense, interlocking composition is painted in Kuncan's characteristic range of dry, wobbly and discontinuous brushwork, enhanced with soft washes in colour and ink.

The artistic process was triggered by a night-time downpour that transformed the mountainside with cascades and waterfalls. Today we might use a camera to capture the scene. In the seventeenth century the first response was to write a poem; a secondary response, if one had the skill, was to paint an image on which the poem could be recorded. Kuncan's poem moves from description of the landscape, to his identification with Buddhist law, to the self-effacing comment that his painting has not reached the miraculous and his poem is without style or rules.

Unlike Bada Shanren and Shitao, who sought sanctuary within the Buddhist community, Kuncan became a Chan Buddhist monk about twelve years before the fall of the Ming dynasty. For Kuncan, Buddhism was his life's calling: born on the Buddha's birthday (eighth day of the fourth lunar month), Kuncan from the age of nine loved reading sutras. In his late teens, against his parents' wishes, he abandoned preparations for the civil service examinations. Devoting himself to Chan study and practice, he was deeply respected for his spiritual insight.

In 1660 Kuncan declined to head a prestigious monastery and instead built a small hermitage, depicted here, near the Zutang Monastery. He chose to distance himself from bureaucratic duties and sectarian squabbles. As he explained, 'It is not to get away from others that I live in isolation but rather because I want my inner being to become lofty and profound, and my vision to be clear and insightful…'[1] AM

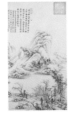

241

Shitao (Zhu Ruoji, 1642–1707)
Picking Chrysanthemums

1671

Hanging scroll, ink on paper,
206.3 × 95.5 cm

INSCRIPTION: '"Picking chrysanthemums by the eastern hedge, I catch sight of the distant southern hills." On the ninth day [of the ninth month] of 1671, painted for the pleasure of the old Daoist and elder in poetry, Ji, called Shitao of Yue Mountain'

ARTIST'S SEALS: *Ji Shanseng, Laotao, Yiru buyou*

The Palace Museum, Beijing, Xin133993

SELECT REFERENCES: Honolulu 1988, no.45; Yang Xin 2000, p.174; Macau 2004, vol.2, no.59

Picking Chrysanthemums evokes the soothing effects of working in the garden, and, through reference to a classic poem, it conveys a deep sense of calm and clarity. The poem is by one of China's most beloved poets, Tao Yuanming (also known as Tao Qian, 365–427). Because of its impact on the culture of eremitism, it merits full quotation:

I built my hut beside a travelled road
 Yet hear no noise of passing carts
and horses.
 You would like to know how it is done?
 With the mind detached, one's place
becomes remote.
 Picking chrysanthemums by the eastern
hedge
 I catch sight of the distant southern hills:
The mountain air is lovely as the sun sets
And flocks of flying birds return together.
In these things is a fundamental truth
I would like to tell, but lack the words.[1]

The painter situates us on the crest of a hill looking down past thick pine trees into a country garden. As the figure in the garden picks chrysanthemums to make a longevity tonic, he glimpses the southern mountain, a metaphor for long life.

The ambitious composition is dated 1671 when Shitao was living in Xuancheng, Anhui Province, not far from Huangshan (Yellow Mountain). At the time he was developing a clientele among the local gentry and officials and was participating in a poetry and painting society whose members included the older painter Mei Qing (1623–1697). The ink spread on damp paper or liberally dotted on dry paper shows the young painter experimenting with the media to beautiful effect. The brushwork shares characteristics with his mentor Mei Qing.

As a descendant of the Ming imperial clan and close relative of a man who in 1645 had declared himself emperor of the expiring Ming state, Shitao was hiding his identity as he lived within the Buddhist community. He nonetheless travelled widely around the Yangzi delta region and three times climbed the beautifully strange peaks of Huangshan. AM

242

Wang Jian (1598–1677)
After Ni Zan's Pavilion by Stream and Mountain

Mid-seventeenth century

Hanging scroll, ink on paper, 80 × 41.1 cm

INSCRIPTIONS: transcription of two Ni Zan quatrains and signature

SEALS: two seals of the artist; two collector's seals, 'Treasure of the Qianlong Emperor', 'Record of Calligraphy and Painting of the Hall of Embodied Treasures'

The Palace Museum, Beijing, Gu4905

SELECT REFERENCE: Shao Yanyi 1996, no.12.39

One of the orthodox masters known as 'the Four Wangs', Wang Jian was born into a well-to-do family and inherited a fine painting collection from his great-grandfather, the literatus and official Wang Shizhen (1526–1590). Because of his grandfather's service to the Ming dynasty during the reign of the last Ming emperor, Wang Jian was made head of a prefecture in Guangdong where he served briefly.

Wang Jian was close friends with Wang Shimin who shared his

conviction that a scholar painter had to be thoroughly trained in literature as well as painting. He meticulously copied the paintings in his own collection and generously shared his expertise with his students, such as Wu Li and Wang Hui.

Following the precepts of the influential scholar-painter Dong Qichang (1555–1636), he grounded his painting in the landscape art of Dong Yuan (tenth century) and the four masters of the Yuan dynasty: Ni Zan, Wu Zhen, Huang Gongwang and Wang Meng. All four were admired for their principled withdrawal from government service under Mongol rule and for their landscape paintings that were dominated by themes of Daoist harmony and reclusion.

Here we see Wang Jian's free interpretation of a Ni Zan painting that he had formerly seen in a friend's collection. Ni Zan was renowned for his unpopulated landscapes brushed in such a sparse manner that he was said to use ink like gold. Wang Jian's brushwork is wetter than Ni's and the landscape more densely configured. In the soft texturing and rounded dots some of Wu Zhen's idiom can also be seen.

A large seal of the Qianlong Emperor is affixed at the upper right corner and at the lower right there is a seal reading 'Record of Calligraphy and Painting of the Hall of Embodied Treasures' (*Baoyun lou shuhua lu*). The Hall of Embodied Treasures is an Italianate villa that was built inside the West Gate of the Forbidden City about 1915 as the official residence of Yuan Shikai, the military despot who had briefly served the new Republic. Following his failure to restore the dynastic system and death in 1916, the building was used as a site for collecting, sorting and cataloguing the objects left in the Qing palace. AM

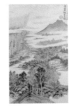

243

Wang Shimin (1592–1680)
Scenes Described in Poems of Du Fu

1666

Twelve album leaves, ink and colour on paper, each 38.8 × 25.6 cm

INSCRIPTIONS

LEAF 1: Blue water drops from a thousand distant cascades, Jade Mountain rises as high as the two frozen peaks.[1]

LEAF 2: Dusk at the river village: white sand and green bamboo dimly seen,
By the light of a new moon: taking leave at the brushwood gate.[2]

LEAF 3: Never before have I swept the flower-strewn path for a visitor,
Today the brushwood gate opens for the first time for you, sir.[3]

LEAF 4: Clouds moving past precipitous cliffs reveal embroidered scenes,
A few pines separating the water are played like wind instruments.[4]

LEAF 5: Breeze against the green cliff, isolated clouds are thin,
Afternoon sun on vermilion maples, a myriad leaves are thick.[5]

LEAF 6: An infinity of trees bleakly divest themselves, their leaves falling, falling,
Along the endless expanse of river the billows come rolling, rolling.[6]

LEAF 7: A lone city reflects evening light, reds about to gather,
A nearby market floats in mist, greens ever pile up.[7]

LEAF 8: For hundreds of years an isolated place, my brushwood gate is distant,
In the fifth month the river is deep, the thatched cottage is cool.[8]

LEAF 9: Look! The moon that lit the ivy-clad rocky cliff
Is now shining on the reed poppi on the beach![9]

LEAF 10: Rocks protrude from the river, and above, the sound of maple leaves falling,
The boat's sweeping oar points to blossoming chrysanthemums.[10]

LEAF 11: At the Shaman gorge on the Chu river: half clouds, half rain,
Clean bamboo mats, thin bamboo blinds: watching a chess game.[11]

LEAF 12: Along the mountain torrent lingering cold, by turns ice and snow,
At stone gate the slanting sun touches woods and hills.[12]

[Signed] In the *yisi* year, twelfth month [1666], 74-year-old Shimin sketched twelve leaves of Du Fu's poetic ideas for Nephew Dong Xuxian

SEALS: sixteen seals of the artist, twenty collectors' seals including eight imperial seals
The Palace Museum, Beijing, Gu4873, 1–12
SELECT REFERENCES: *Shiqu baoji*, pp.851–52; Shao Yanyi 1996, no.12.16

At the age of 73 Wang painted this album – homage to China's greatest poet, Du Fu (712–770) – for his nephew.[13]

Du Fu lived during an extended rebellion that ruined his political prospects but forged his literary reputation. Like Shakespeare, he redefined how language was used as he wrote about death, love, loyalty and life as a refugee. In the seventeenth century, admiration for Du Fu inspired scholars to collect and annotate his poems. Editions were compiled by Wang Shimin's contemporaries Qian Qianyi and Qiu Zhao'ao.[14]

For Wang Shimin and others familiar with Du Fu's poems, the couplets lead to a world within the poem. For example, leaf eleven was inspired by a poem written after attending a banquet given by a county official. The poet is uncomfortable at the boisterous party. He doesn't fault the young men for their heroic ambitions but is aware of the rebellion that has made him a traveller in a remote town above the Three Gorges of the Yangzi River. Leaving the music and noise, he watches the rain over the river, then finds a quiet, clean place where two are playing chess. There he watches the game, still an observer, not a participant.

The eleventh-century Buddhist monk Canliao quoted the same couplet to his contemporary, the poet Su Shi and declared, 'These lines could be painted!' Then, on reflection, he added, 'But I'm afraid a painting could not capture the feeling.' The emotional power of the couplet (and of Wang's painting) comes from knowing the entire poem.

These couplets were selected from poems written in a lofty literary form, regulated verse. 'Regulations' included limiting the verse to eight lines, limiting each line to seven characters (or to five characters), and, within each couplet, creating conceptual contrasts and complements between characters in analogous positions: red in one line was juxtaposed with green in the next; rising was contrasted to descending. The balance and restraint inherent in the form enforced a sense of decorum. For a millennium, regulated verse was almost always tested in the civil service examinations. Within this rigid form, Du Fu expressed himself with breathtaking freshness.

Because of his family's history of service to the Ming dynasty, Wang Shimin did not take a role in the Manchu government. Many of the poems in this album deal with reclusion, a euphemism for declining government service.[15] AM

244
Wu Li (1632–1718)
Thoughts on Xingfu Hermitage
1674

Handscroll, ink and colours on silk, 36.6 × 85 cm

INSCRIPTION: a remembrance of the artist's admired friend Morong with ten-line poem, signed and dated: 'Written two days before "ascending heights" in the *jiayin* year (seventh day of the ninth lunar month, or 6 October 1674) as rain is letting up. The Recluse of Peach Spring, Wu Zili'

SEALS: two seals of the artist, eight collectors' seals
The Palace Museum, Beijing, Xin146408
SELECT REFERENCE: Shao Yanyi 1996, no.12.96

Wu Li records his grief at the death of his friend, the Chan Buddhist monk Morong. Wu Li relates that he was returning from north China when he heard the news of Morong's death. In the painting the study at the Xingfu hermitage is empty. A sutra book rests on the low table. A pet crane stands expectantly on a pine branch. All is quiet except for the flitting birds and the wind moving through leafless trees. The elegiac scene is surrounded by white clouds. In contrast to the hermitage's dust-red tints, a small path leads to a lush green hillock, intimating that the monk's spirit lives on.

Wu Li and the more famous painter, Wang Hui, were born in the same year and in the same town, Changshu, north of Suzhou, Jiangsu Province. Talented in music and literature as well as painting, Wu Li played and studied with Wang Hui, sharing painting teachers Wang Jian and, later, the much older Wang Shimin. As adults the two followed markedly different careers. Wang Hui became arguably the most prominent artist of the day, painting for the Kangxi Emperor. Wu Li pursued a lifelong spiritual quest that led him to study neo-Confucian philosophy, Buddhism with Morong who resided at a monastery on Mount Yu close to Wu's hometown, and finally, Catholicism, which was to dominate his life from around 1670.

Since Jesuit missionaries were active in Changshu and their church was near Wu Li's home, he had probably heard about Christian doctrines from childhood. Baptised Simon-Xavier, in 1682 he began serious study at the novitiate of the Society of Jesus in Macau, and received ordination as a priest in 1688. During this period the Kangxi Emperor was tolerant of Jesuit activities and actively sought information from several Jesuits at court. After ordination Wu Li concentrated on missionary work and created an unprecedented genre of Christian poetry, expressing his deep devotion to the faith.[1] AM

245

Gong Xian (1619–1689)
Landscape Dedicated to Xi Weng

1674

Three hanging scrolls, ink on silk,
278 × 79.5 cm, 278.1 × 83.7 cm,
278.1 × 78.7 cm

INSCRIPTION: 'Made for Xi Weng in
winter of the *jiayin* year [1674], Gong
Xian called Half Acre'

ARTIST'S SEALS: *Gong Xian, Zhongshan yelao*

The Palace Museum, Beijing, Xin104281, 1

SELECT REFERENCES: Beijing 1986–2001,
no.1-4049; Shan Guoqiang 2000, no.50

Gong Xian wrote that landscapes
should be natural but, more
importantly, must be surprising.
This composition surprises by its
sheer scale and rewards viewing
with unexpected details. At the
bottom of the right panel a gate
leads into a monastery where
courtyards are overgrown with
grass. In the middle panel a village
clings to the mountainside. Within
the mountains slender waterfalls
plunge vast distances. With his
distinctive hatching brushwork
and the full range of ink tonalities,
Gong Xian has created his idea
of a monumental landscape of the
Northern Song period (960–1127).
But instead of the antique models –
notably the early tenth-century
masters Dong Yuan and Juran –
promoted by Dong Qichang
(1555–1636), the doyen of the
orthodox school, Gong was taking
his lead from the eleventh-century
painters Fan Kuan and Li Cheng.

A native of the culturally
flourishing Nanjing, Gong Xian
fled the city before it was attacked
by Manchu forces and stayed away
for more than ten years. By contrast,
his good friend Zhou Lianggong
(1612–1672) decided early on to take
a role in the Manchu government.
These choices were complicated and
personal. Gong Xian's absence from
Nanjing was possibly necessitated
by enemies made in factional battles
at the end of the Ming.[1] Gong Xian
eventually resettled in Nanjing,
relying on income from instructing
students and from the sale of his
paintings. Zhou Lianggong
remained a friend and loyal patron.

Whether a Ming loyalist or a
Qing collaborator, seventeenth-
century Chinese viewers would
have seen in the huge mountains
of this painting the message of the
enduring land of China. The idea
was captured in a poetic line by Du
Fu written during a rebellion in the
eighth century that laid waste to the

capital then at Xi'an: 'The state is
ruined, but mountains and rivers
remain.'[2] AM

246

Wang Shimin (1592–1680)
For Dragon Boat Festival

1676

Hanging scroll, ink on paper,
100.8 × 40.1 cm

INSCRIPTION: 'Playfully inked by old Xi Lu
on Duanwu [5th day of 5th month] in the
bingchen year [1676]'

ARTIST'S SEALS: *Wang Shimin yin, Xi Lu laoren*

COLLECTORS' SEALS: *Tongyin guan yin* (Seal of
Hall of Paulownia Shade) belonging to Qin
Zuyong (1825–1884), *Lu Runzhi jiancang*
(Collected by Lu Runzhi) belonging to Lu
Shihua (1714–1779)

The Palace Museum, Beijing, Xin13894

SELECT REFERENCE: Shao Yanyi 1996,
no.12.18

The festival day on which Wang
Shimin was painting fell at the
middle of summer and was therefore
called Duanyang (upright sun) or
Duanwu (upright noon). In south
China, dragon boat races were held
and packets of glutinous rice were
thrown into rivers in remembrance
of Qu Yuan, the legendary poet
and wronged official. Mugwort
and calamus leaves were fastened
to the front gates of homes to deflect
evil influences, including summer
disease. The choice was inspired by
visual correspondence, in the case
of mugwort leaves, to a tiger, and,
in the case of the long calamus
leaves, to swords.

In 1676 Wang Shimin was eighty-
four years old and retired to his
family estate at Taicang, which lies
half way between Shanghai and
Suzhou. He took pleasure in
supervising gardening, overseeing
the building of belvederes and
pavilions, and hosting gatherings
of prominent intellectuals and poets.
Outside the peaceful world of
Taicang, however, a war was raging
to the south. The Rebellion of the
Three Feudatories began in 1673
and expanded during the years
1674–76. With a military base to
the north in Shandong and major
battles to the south in Fujian,
Wang probably painted this scroll
as a fervent prayer for peace and
protection. The charm must have
appeared to work: in mid-1676
Qing forces began to succeed in
suppressing the rebels and the
threat gradually receded.

Here we see an old man still
in full command of his artistic
technique – painting an elegant,

forceful composition in masterfully
controlled ink wash – and using it all
to a meaningful end. The auspicious
painting remained in Jiangsu
Province and in the next century
entered the collection of another
Taicang resident, Lu Shihua
(1714–1779), whose seal is affixed
at the lower right. AM

247

Shitao (Zhu Ruoji, 1642–1707)
Landscapes with Hermits

Late 1670s (?)

Handscroll, ink on paper, 27.7 × 313.5 cm

INSCRIPTIONS: five inscriptions by the artist

SEALS: five seals of the artist, eleven
collectors' seals

The Palace Museum, Beijing, Xin118735

SELECT REFERENCES: Yang Xin 2000, no.72;
Hay 2001, figs 49, 50, 86, 160; Macau 2004,
vol.2, no.57

Born Zhu Ruoji, Shitao was a
member of the Ming royal family.
At the fall of the Ming dynasty in
1644, his family was living in Guilin
as part of the Prince of Jingjiang's
clan. In 1645, the Prince declared
himself emperor of the Ming
dynasty which precipitated the
family's massacre, not by Manchus,
but by other claimants to the throne.
A family retainer, Hetao, rescued
the child and hid him in a Buddhist
monastery. Thus at the age of four,
Shitao was an orphan whose life
was threatened both by family
enemies and Manchu forces.
Raised in Buddhist temples, he took
monastic vows. As Jonathan Hay
has demonstrated, his paintings
record his lifelong effort to come to
terms with his royal, religious and
artistic identities.[1]

In this autobiographical
handscroll, probably painted in
the late 1670s, Shitao depicted five
hermits who lived incognito. He
linked each story, summarised
below, to a period in his life for
reasons that are sometimes obscure.

1) 1664: When the Hermit of the
Stone Abode was offered the
empire he angrily rejected the idea,
retreating to a cave to pursue self-
cultivation. (Shitao's note, probably
written in the late 1670s, shows him
acknowledging the Qing dynasty:
over-estimating his importance
during the dynastic transition, he
suggests that his remaining
incognito had rendered a service
to the child Kangxi Emperor.[2])

2) 1668: The Man Clothed in
Animal Skins was a wood-gatherer.
He encountered an official who

asked why he hadn't picked up some money lying in the road. The woodcutter chastised him for misjudging him based on looks. (Hay interprets the story as Shitao resisting payment for paintings done for an official even though that was the main source of his income.[3])

3) 1674: The Old Man of the Xiang is the story of the recluse Lü Yunqing who played a flute particularly well when tipsy. He was overheard by another flute player who recognised an exceptional tone.

4) 1677: 'The Iron-Feet Daoist' went barefoot even in the snow and ate plum blossoms, anticipating that the fragrance would penetrate his innards. Climbing a peak at sunrise, he shouted to Heaven, 'The cloud sea warms my heart and breast,' then floated away.

5) The Monk Xue'an, who entered the priesthood for political reasons, liked reading the *Songs of Chu* while floating in a skiff. Finishing a page, he would tear it off, toss it in the water and sob.[4] (Ever since the Han dynasty historian Sima Qian wrote about Jia Yi tossing a poem into the Xiang River, this was a way to communicate with the soul of the wronged but loyal official Qu Yuan.[5])

For each hermit and landscape, Shitao adopted a different style, perspective and scale. Similarly, his personal notations are written in deliberately varied calligraphic scripts that bespeak a personality of many parts. AM

248

Gong Xian (1619–1689)
Streams and Mountains without End

1680–82

Handscroll, ink on paper, 27.7 × 726.6 cm

INSCRIPTION: 'Painted by Gong Xian of Jiangdong'

ARTIST'S SEALS: *Gong Xian, Yeyi* (Left-over citizen in the wilderness)

COLLECTOR'S SEALS: three seals of Shen Xiangyun (d. 1913)

The Palace Museum, Beijing, Xin147340

SELECT REFERENCES: Beijing 1986–2001, no.22.4052; Shan Guoqiang 2000, no.52

Formerly in the collection of the painter Huang Binhong (1864–1955), this ambitious landscape is exceptional for its water-level view of the sides of mountains. On separate paper, Gong wrote a note explaining its unique design:

In the spring of the *gengshen* year [1680], I happened to acquire a piece of Song imperial paper. I wished to make a handscroll but feared it would be difficult to unroll and roll up again. Then I wanted to make album leaves, but that would not have permitted expansive rivers or long mountain ranges. Finally, I decided to mount it as an album but to paint as if it were a handscroll. There would be about twenty leaves, each with a beginning and an end. It could be called a folded handscroll or it could be called a continuous album. Much thought was given to the composition which was to follow basic principles: beginning and end had to take countenance of each other, the sparse and dense had to be in proportion.

I feel that drawing level distance is easy, while high and deep distances are difficult. But those who have not circled the Five Sacred Mountains and walked ten-thousand *li* will not know that a mountain has roots and branches and that a river has a source and tributaries. That year I spent two months with moistened brush, taking 'ten days for one mountain, five days for a rock'.[1] When I had leisure time, I playfully brushed away. When affairs came up, I'd put [the painting] aside. In the darkness of wind and rain, no knock was heard at my door. Gradually the sequence increased; flourishing summer turned to winter. Who was there to pressure me? The year and seasons changed. Now in the eleventh month of the *renxu* year [1682], I have just finished it. I have titled it 'Streams and Mountains without End...'[2]

Gong Xian further writes of taking the scroll to Yangzhou. The wealthy and cultured Xu Songling offered to pay five bushels of rice and five barrels of wine monthly for the rest of Gong Xian's life for this and future paintings.[3] Gong, with polite protestations, accepted the offer. The colophon thus served as a record of agreement between painter and patron. AM

249

Wu Hong (*c.*1615–after 1683)
Grieve-Not Lake

Undated

Handscroll, ink and pale colour on paper, 30.8 × 150.5 cm

INSCRIPTION: title by Zheng Fu (d. 1693) dated spring of the *dingmao* year [1687]

ARTIST'S SIGNATURE: 'Grieve-Not Lake. Wu Hong of Jinqi, called Bamboo Historian, painted below the thirty-six peaks of Yunlin Baima'

SEALS: two seals of the artist, four collectors' seals

The Palace Museum, Beijing, Xin146380

SELECT REFERENCE: Nakamura and Nishigami 1998, no.50

As a young man, Wu Hong travelled to the north where he met several distinguished private collectors. Although the notable collector Liang Qingbiao (1620–1691) commissioned Wu Hong to copy some of his works of the Yuan period, it was the detailed Northern Song monumental

landscapes that caught Wu's interest and transformed his style. In his mature style, this painting recalls the figure-to-landscape scale of Northern Song pictures while the vertical hatching and simple cottage motif were learned from his contemporary Gong Xian.

'Grieve-Not Lake' (Mochou hu) is a small body of water lying outside the west watergate of Nanjing's city wall. It was named after a songstress who had lived there more than a millennium earlier. In the late seventeenth century, however, the lake was made a motif in the play *The Peach Blossom Fan (Taohua shan)*, a historical drama on the collapse of the Ming dynasty set in Nanjing from 1643 to 1645. In the 1680s the author Kong Shangren (1648–1718) was gathering stories of the city's devastation and survival.[1] *The Peach Blossom Fan* opens with the line 'Grieve-Not Lake beside the Poet's Tower', and soon the hero puns on the lake's name: 'Grieve Not, Grieve Not! How can I fail to grieve?' A few songs later he mourns the loss of Nanjing's past glory: 'In the forsaken garden, a withered pine leans over a broken wall.'[2]

Since antiquity poets had written of ravaged temples and capitals, but painters rarely depicted this troubling subject.[3] Wu Hong broke the taboo. In the middle of the painting, two gentlemen sit on a terrace at a dilapidated shrine viewing the lake. The wall of the compound is collapsing as well as a section of the roof. Further to the left a damaged shelter stands by the road, all blunt reminders of the violence and devastation that Nanjing had suffered. *Grieve-Not Lake* is mounted in a handscroll with a painting of another Nanjing scenic spot, the Swallow Cliff (Yanji), a natural rock formation on the northeast side of the city. AM

250

Wang Hui (1632–1717)
Reclusive Scenes among Streams and Mountains

1702

Handscroll, ink and colour on paper, 32.7 × 296.4 cm

ARTIST'S INSCRIPTION: 'Reclusive Scenes among Streams and Mountains, fifth month, summer of the *renwu* year [1702], Wang Hui of Guyu imitating the brush of Huanghe Shanqiao [Wang Meng]'

TITLES INSCRIBED BY CAI QI: Wind in the Pines Monastery; Grotto in Valley with Tumbling Spring; Feeble Horse in Cold Forest; Winding Path, Thin Grove of Bamboo; Heavenly Fragrance Book Studio; Yellow Leaves Mountain Villa; Horizontal Clouds in Clear Foothills; Woodcutter Returning through Forest Shade

SEALS: two seals of the artist, thirteen collectors' seals

The Palace Museum, Beijing, Xin146116

SELECT REFERENCE: Beijing 1986–2001, no.22.4470

Wang Hui painted this landscape for a man named Cai Qi (fl. late seventeenth–early eighteenth century) who, delighted with the results, inscribed eight titles along the top. In a colophon, Cai praised Wang's seamless blending of scenes. The correspondence between the landscape design and Cai's titles suggests that the two men had agreed on the programme in advance.

Since the eleventh century, artists had painted sets of scenes with titles inspired by poetry.[1] The eight titles of Wang Hui's handscroll are a well-conceived set with multiple poetic references. For example, the first title, 'Wind in the Pines Monastery', recalls the compassionate official Su Dongpo (Su Shi, 1037–1101). Funny, audacious and outspoken, Su Dongpo was sent into exile more than once for his frank criticism of imperial policy. During his second exile, he wrote an essay in which a mountain hike became a metaphor for his career:

Once when I was staying temporarily in the Jiayou Monastery in Huizhou, I went out walking beneath Wind in the Pines Pavilion. Soon I had exhausted all the strength in my legs, and I longed to stretch out on a bed and rest. Looking up to the pavilion, which stood at the tips of the trees, I wondered how I would ever climb back to it. After some time, suddenly I thought, 'What is there to prevent me from resting right here?' My heart was like a fish that had been hooked and all at once swam free…[2]

Su Dongpo's insight was liberating, both for himself and for later scholars who followed his example of detachment.

In his signature, Wang Hui wrote that he was evoking the brush of the Yuan dynasty master Wang Meng (c.1308–1385). The tribute was as much conceptual as stylistic: the landscape is in Wang Hui's mature style that blends half a dozen sources. Wang Hui's hand is most evident in the complicated and well-structured composition; his assistants probably helped with the figures and the application of colours. AM

251

Yun Shouping (1633–1690)
Flowers and Plants

1685

Ten album leaves, ink and colour on paper, 25.5 × 34.8 cm

INSCRIPTIONS AND IDENTIFICATIONS

LEAF 1: Japanese Pomegranate (no inscription)

LEAF 2: Blossoming Broad Bean, 'Barley mound at slight frost, spring days lengthen, / A bean plot filled with fragrance into summer; / The flowers blossom thickly, but not for the silkworms of Wu, / You are wrong if you think that Heaven loves silken threads. Nantian'

LEAF 3: Pine Tree (no inscription)

LEAF 4: Field Poppy (no inscription)

LEAF 5: Day-lily, 'How to make a peaceful courtyard? Often plant this. / Loving its bright foliage is enough to forget worries.[1] / Yunxi waishi'

LEAF 6: Chrysanthemums, 'Painting chrysanthemums is difficult. Ink chrysanthemums are still more difficult. The skill of Yuan painter Wang Yuan and the fresh beauty of [the Song dynasty poet] Zhou Mi do not come up to the loftiness of Elder Baishi [Ming dynasty scholar painter Shen Zhou]. This picture follows [Ming painter] Tang Yin and, although it is removed from the garden paths of Baishi, it still has not exhausted my ink flowers' special flavours. Nantian'

LEAF 7: Wisteria, 'Purple silk fringes – from where do they come? / Gem-like buds begin to open like a precious tower in dawn's light. / A wisteria vine of a thousand feet, half hanging from heaven / Bound by the spring wind – no one can teach this. / Nantian Shouping'

LEAF 8: Lily, 'Inking these two gilded vases / that perfume the breeze as they sway in the garden, / Like flutes playing the through a moonlit night, / Like a troupe of rainbow skirts dancing. / Shouping'

LEAF 9: Peach Blossoms, 'Li Bo has a line, "Wind blowing the willow flowers fills the inn with fragrance."[2] Former men admired that fragrance. So why can't a painter wield a brush to transmit its spirit? Nantian'

LEAF 10: 'Ten sketches from life done at Tiaohua Hall, sending on to my elder friend Geng for evaluation; the beginning of the end of spring of the *yichou* year [1685], Shouping called Nantian.'

SEALS: 32 seals of the artist, nine collectors' seals

The Palace Museum, Beijing, Xin146896, 1–10

SELECT REFERENCE: Beijing 1986–2001, no.22.1-4585

Yun Shouping's father had openly resisted the Manchu invasion, fighting with other Ming loyalists in Fujian and Guangdong. When Guangdong fell to Manchu troops in 1647, Yun's father became a monk. With his wife and sons in tow, he continued to contribute to the resistance. In a subsequent battle, it appeared that both sons were lost. Yun Shouping, however, had been captured and taken in by a Manchu general's wife. In 1648 the father chanced to see him at a temple in Hangzhou. His release was secured

when the temple's abbot persuaded the foster mother that the boy would die early if he did not surrender to the Buddhist faith. The ruse worked: Yun was left behind at the monastery, father and son were reunited. Although educated in the classics and poetry, Yun Shouping vowed to his father that he would never serve the alien regime.[3]

Yun Shouping begins his album with a branch of pomegranate, whose fruit can be a wish for many offspring because of its many seeds. Here, however, Yun Shouping depicts the tree in blossom and with an uncommonly long thorn (*ci*). If he was thinking like a poet, then the first leaf may hint that admonitions (*fengci*) are in the offing. The poem on the second leaf contains what may be a barb. The flowering broad beans that are depicted were popularly called 'silkworm beans' (*can dou*), and the 'silken threads' that end the quatrain were a euphemism for extorting cash like winding threads out of a cocoon. The Jiangnan region bore the heaviest share of taxes for supporting the court and the Three Feudatories in the south.

The album is executed in the artist's trademark 'boneless' style, emphasising wash and colour over line. His calligraphy is simple, elegant and relaxed, quite different from writing for official purposes.

Floral imagery is complicated by the tradition of likening beautiful women, especially courtesans, to flowers, and further, of likening lonely, neglected palace women to officials out of imperial favour. These paintings may simultaneously be of botanical, seasonal, erotic and political interest. Yun's clever visual and verbal allusions as well as his superb brushwork and artistry guaranteed the popularity of his painting. However, his insistence on painting only for those who empathised with his politics compromised his income and left him financially insecure. AM

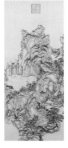

252

Wang Yuanqi (1642–1715)
Immortals' Abbey by Pine Stream

Undated

Hanging scroll, ink on silk, 118 × 54.5 cm

INSCRIPTION: 'Respectfully painted by your servitor Wang Yuanqi'

SEALS: one seal of the artist, one seal of the Qianlong Emperor, three seals of collectors

The Palace Museum, Beijing, Gu4866

SELECT REFERENCES: Nie Chongzheng 1992, nos 8–9; Shao Yanyi 1996, no.90

In *Immortals' Abbey by Pine Stream* we can see at work the geomantic compositional principles about which Wang Yuanqi wrote: in a successful landscape space should open and close, forms should rise and fall rhythmically, the vitality and strength of a 'dragon vein' should carry through the mountain.

As the grandson of Wang Shimin (1592–1680, see cats 243, 246), Wang Yuanqi was raised on his grandfather's estate at Taicang, Jiangsu Province, and received a privileged education in the arts of literature and painting. His grandfather trained the boy in painting techniques as well as the connoisseurship of recent and ancient paintings. Wang Yuanqi was fortunate to meet the many distinguished scholars and artists who visited the estate.

After earning the highest degree in 1670, unlike his Ming-loyalist father and grandfather, Wang willingly served in the Qing government. After several provincial postings in which he demonstrated his abilities, he was called to the capital. For a quarter of a century, he not only carried out his various bureaucratic assignments, but also interested the Kangxi Emperor in the art of painting. He was frequently summoned to the Forbidden City (Zijin cheng) to paint. From 1713 until his death, Wang collaborated on the production of a long handscroll to commemorate the Emperor's sixtieth birthday (cat.24), a precedent for the mammoth handscrolls celebrating the eightieth birthdays of the Kangxi and Qianlong Emperors (cat.25).

Wang's precepts on painting record his thoughts on the literati amateur ideal: 'It is of the greatest importance in painting that reason, vitality and attractiveness should be combined…Those painters who simply comply with the rules and express no ideas beyond such formulas have since antiquity been considered worthless. When a painting student has begun his career, he should strive for gradual daily progress. He must convey between the lines and in the ink that which the skilled cannot give but the unskilled give; only then can he obtain the secrets of the Song and Yuan masters. And he should never be too satisfied with himself.'[1] AM

253

Yu Zhiding (1647–c.1713)
Wang Yuanqi Cultivating Chrysanthemums

Early eighteenth century
Handscroll, ink and colour on silk, 32.4 × 136.4 cm
INSCRIPTION: 'Respectfully painted by Yu Zhiding of Guangling [Yangzhou]'
SEALS: three seals of the artist, two seals of inscribers, one collector's seal
The Palace Museum, Beijing, Xin54038
SELECT REFERENCE: Barnhart et al. 1997, fig.252

Portrait painter to the rich and famous, Yu Zhiding excelled at capturing handsome likenesses of his subjects and complementing them with an assemblage of telling objects and environs.

Here Yu's contemporary, the official and amateur painter Wang Yuanqi (cat.252) is posed as a refined connoisseur of tea and chrysanthemums. Of substantial girth, he is depicted as a prosperous gentleman, assured of his taste and status. He is dressed not in his court robes with insignia but in a scholar's gown with the voluminous sleeves then fashionable. Scholar's paraphernalia is on the couch next to him: boxed books, scrolls and an album. At far right a servant arrives carrying a jar, which may contain fresh water to brew more tea or possibly a stronger beverage. Either tea or wine in combination with chrysanthemums evoked the memory of the poet Tao Yuanming (also known as Tao Qian, 365–427), who drank chrysanthemum-petal infusions to extend his years (see cat.241). Tao – who resigned office after only 80 days – was a model for refined if impoverished reclusion. Wang Yuanqi got on well with the Kangxi Emperor, who was unwilling to let him retire. At the age of 72 Wang was made director of a bureau that was constituted to assemble eulogistic texts and paintings in commemoration of the Emperor's sixtieth birthday. He died while still working on the project.

A native of Yangzhou, Yu Zhiding studied painting with the professional Lan Ying (1585–c.1664) and spent most of his career in Beijing. Yu's official job in the capital was as usher in the Court of State Ceremonial, guiding participants, including foreign dignitaries, through the protocol of court ritual. Many foreigners in Beijing as well as court officials sat for his portraits. In 1690 Yu Zhiding retired to Mount Dongting at Lake Tai in Jiangsu Province, but after a few years returned to Beijing and his successful career as a portraitist. AM

254

Zhu Da (Bada Shanren, 1626–1705)
Poem about a painting, in running cursive script

Undated
Hanging scroll, ink on paper, 77.9 × 166.8 cm
INSCRIPTION: *Bada Shanren ti hua* (Bada Shanren, [poem] about a painting)
SEAL: seal below the inscription, *Bada Shanren* ('Eight great mountain man', the artist's literary name)
The Palace Museum, Beijing, Xin155879

Zhu Da (1626–1705), who is equally well known by his literary name (*hao*) Bada Shanren, also went by various style names, such as Xuege, Geshan and Lüwu. He was born in Nanchang, Jiangxi Province, a scion of the Ming royal house, surnamed Zhu. He was in fact a ninth-generation descendant of Zhu Quan, who, as the sixteenth son of the founding Emperor of the Ming dynasty, Zhu Yuanzhang, had been enfeoffed as the Prince Ningxian of Jiangxi.

After the fall of the Ming in 1644, Zhu Da, like many 'left-over subjects' of the defunct dynasty, became a Chan Buddhist monk, but soon left the monastery to return to secular life. Later, however, he became a Daoist priest, called Chuangqing, and spent most of the latter half of his life in a secluded Daoist temple. He was a brilliant painter of landscapes and flower-and-bird paintings and his works are known for their stark power, the suggestiveness of their brushwork and their bold and highly original compositions. His is a most individualistic style, characterised by clarity, strangeness and eccentricity. With Shitao, Kuncan and Hongren, he was one of the so-called four monk-painters of the early Qing period.

In calligraphy, Zhu Da modelled his style on the Two Wangs, Wang Xizhi (303–361) and his son Wang Xianzhi (344–386), on the Tang statesman Yan Zhenqing (709–785), and the Song literatus Su Shi (Su Dongpo, 1037–1101). He also emulated the hand of the mid-Ming calligrapher Wang Chong (1494–1533). He was in the habit of using a worn-down writing brush, which gave both form and expression to the naïve beauty and

fluid vitality he conceived in his mind. By eschewing the traditional literati notion of *dan* (mildness) for an altogether more vigorous approach, he created rich new layers of meaning in his art. The associations and allusions that gave his painting and poetry their meaning were often quite complex or even obscure.

This scroll of calligraphy is inscribed with a 'poem about a painting' (*tihua shi*) of five characters to a line. Such poems were usually, but not always, inscribed on the painting to which they referred, as is the case here. The poem reads:

How high above this scene does the wagtail dance? Where do the wild geese soar off to from here?
 Down below, we see lives commanded by fate, the heavenly delight of returning to one's thatched cottage.
 The north wind blows as the year is dwindling; autumn's waters make one miss one's dearest.
 Far off, those birds nest among clouds; a fisherman sings by the bamboos of Chu.

[Signed:] Bada Shanren, a poem about a painting.

The text was executed with the brush held vertically and the tip centred within the stroke to give 'rounded', tubular calligraphic lines. The brush was moved along steadily so that the lines are both coarse and delicate in equal measure, and appear visually to be both rounded in space and flowing. Compositionally, some characters are large and some small, while their spacing in columns and rows is self-consciously awry. Although the work is not dated, judging from the calligraphic style it is likely to belong to the artist's later period.

LYX/SMcC

255
Zhu Da (Bada Shanren, 1626–1705)
Mynah Bird on an Old Tree

1703
Hanging scroll, ink on paper, 149.5 × 70 cm
INSCRIPTION: Written on a spring day of the *guiwei* year[1703], Bada Shanren
ARTIST'S SEALS: *Bada Shanren, Heyuan, Zhenshang*
The Palace Museum, Beijing, Xin99523
SELECT REFERENCES: San Francisco 1990, p.276; Xie Zhiliu 1991, p.197; Yang Xin 2000, no.50; Macau 2004, vol.1, no.54

How should we read this beautifully cryptic painting? It combines many of the motifs that Zhu Da used throughout his life. The mynah bird stands on the branch of what was once a robust tree, now withered. The bending tree branch seems to

join the mynah bird in bowing to the fish but also seems to reach out as if to catch him.

Born into the Nanchang, Jiangxi Province, branch of the Ming imperial clan, Zhu Da enjoyed an education in the classics and had passed the first level examination before the Manchu conquest. Hiding his identity, in 1648 he entered a Buddhist monastery, took training and eventually became head of a temple. Unknown factors led to an emotional crisis in 1680: he burned his monk's robe and returned to Nanchang where he led a secular life supporting himself with his painting and calligraphy. In 1684 he adopted the name Bada Shanren that is inscribed here. The two-character seal in the lower-right corner of the painting meaning 'genuine appreciation' (*zhenshang*) was used by Zhu Da from 1700 to 1705.[1]

Zhu Da's skill in handling ink is abundantly evident in the feathers of the bowing mynah bird. The rough brushwork and inky blotches of the tree and bank are antithetical to the disciplined brushwork of contemporary Orthodox painters such as Wang Hui and Wang Yuanqi. The freely brushed ink, bold composition and quirky humour characteristic of Zhu Da's art was a precedent for the 'eccentrics' of Yangzhou who were to flourish a generation later. His casual brushwork might seem easy to imitate – indeed generations of copyists have tried – but few have captured the incisive gestures and subtle glances of Zhu Da's fish and fowl.

As an opponent of the Manchus, Zhu Da's reputation surged in popularity in the early twentieth century when the Qing dynasty was in decline. 'Bada Shanren' was inscribed on scholar's objects to signal resistance to the Manchus and support for Chinese nationalism. AM

256
Zheng Xie (1693–1765)
Orchids, Bamboo and Rock

Before 1740
Hanging scroll, ink on paper, 128.3 × 58 cm
INSCRIPTION: 'Yin Niu Fourth Elder Brother has the strength of bamboo, the purity of the orchid and the resoluteness of rock. He is unique in his generation. He had frequently sought my painting and I had yet to respond. In the autumn of the fifth year of Qianlong [1740] he came to my studio, so I scoured the

house and presented him with this old work. The bamboo has no stalks, the orchid leaves are drooping, the rock is cramped; I'm afraid it is inadequate to convey the idea of a Gentleman. Another day I should paint a fine work to atone for this offence. Zheng Xie called Banqiao'
ARTIST'S SEALS: *Zheng Xie yin, Kerou*
The Palace Museum, Beijing, Xin92392
SELECT REFERENCES: Hong Kong 1984, no.75; Xie Zhiliu 1991, p.244

Each of the elements in Zheng's painting – dashed off with practised ease – are weighty cultural symbols. Delicately fragrant orchids were seen blossoming in the wild among grasses and thorns. The orchid was therefore likened to the gentleman who cultivated his mind and character without regard for worldly gain. The legendary loyal official Qu Yuan, rejected by his king and sent into exile, saw the flower in a slightly different light: the orchid, growing among weeds, represented his unappreciated talent. The orchid also became an emblem of a man maintaining loyalty despite difficult circumstances.

Bamboo was also an emblem of the gentleman, more tenacious than the orchid. It was strong but humble (the hollow stems were likened to an egoless heart/mind), it was principled (did not change colour with cold weather) yet flexible (could bend without breaking just as bamboo bends in a storm).

Rock has interesting lore as well, its geological character linking it to primordial creation. Emblematic of mountains, rocks come in unique shapes and textures which invited comparison with the individuality and eccentricity of a man.

Raised in genteel poverty, Zheng Xie empathised with people in distress. Belatedly he passed the civil service examinations. In 1742, at almost fifty, he accepted an appointment as magistrate of a county in Shandong, offending the local élite when he energetically urged donations for famine relief. After retiring in 1753, Zheng Xie supplemented his income by selling his work. Annoyed by requests for paintings, he posted a price list by his door. The jocular message turned on its head the social convention by which a scholar practised art not for profit but for refining his character.

The dedication is written in the artist's inventive style, blending archaic with modern script types. With exemplary manners, Zheng deprecates his artistic production

while elevating the recipient, who, Zheng writes, has the strength of bamboo, the purity of the orchid and the resoluteness of rock. AM

257

Gao Qipei (1660–1734)
The Demon Queller Zhong Kui

c.1690

One of twelve album leaves, ink on silk, 26.6 × 30.6 cm

INSCRIPTIONS: quatrain on each leaf

SEALS: 52 seals of the artist, six collectors' seals

The Palace Museum, Beijing, Xin124240, 1–12

SELECT REFERENCE: Beijing 1986–2001, no.23.1–5106

The well-known figure of Zhong Kui embodied characteristics least espoused by the Confucian literati: he was muscular, lacked discipline (quick to anger, readily drunk and disorderly), had dark skin, dishevelled appearance and a certain uncouthness. The anti-hero's unruly behaviour was precisely what made him a champion protector; that, and his sincere loyalty.

Legend tells us that Zhong Kui originated in a feverish dream of the Tang dynasty emperor Minghuang (r.712–56). Minghuang dreamt that he saw a goblin stealing a perfume bag and a jade flute. The little thief didn't flee but cavorted around the palace courtyards. Suddenly a powerful man appeared, grabbed the goblin, dislodged his eyes, pulled him apart and ate him. The ferocious hero explained that in a previous reign he had passed the civil service examinations but had been defrauded of his position. To demonstrate sincerity he had committed suicide by breaking his skull on the jade steps of the palace. The Emperor honoured him with a burial in the blue-green robes of the imperial family, upon which the spirit of the wronged scholar swore to defend the ruler. Minghuang awoke from his dream with his illness cured.[1]

Pictures of Zhong Kui were painted as early as the Song dynasty (960–1279) and inexpensive prints were pasted at doorways during the Spring Festival to seek a trouble-free year. Zhong Kui also appeared during the annual summer Duanwu celebration (Dragon Boat Festival). Images of the Demon Queller and of the Five Poisonous Creatures were pasted on gates as charms to ward off demons, diseases and soldiers.

Using his fingernails as pen nibs, Gao Qipei humorously records Zhong Kui's feats and foibles. Zhong Kui is readily identified by his official's hat, whose horizontal extensions should be starched straight: Zhong Kui's are invariably crumpled. In leaf seven, his hat is removed for a reason: it outdoes the old story of a hero fuming with anger such that his hair stood on end and raised his hat. The poem explains:

> When anger rises, without hair, his hat lifts off his head,
> The vital spirit of his sword flashes making summer cold,
> Powerful spring gales cannot budge him,
> And you never know where he is going to pop up!

The imaginative sketches and poems are delightfully entertaining. The bound format of the album is a reminder that these paintings were not intended to be displayed, but rather to be read as a book and then stored away. Gao Qipei's album vividly captures the spirit and ubiquitousness of the Zhong Kui figure in both mythology and everyday life. AM

258

Fu Shan (1607–1684/85)
Running Cursive

c.1682

Hanging scroll, ink on twill-weave silk, 194 × 51.8 cm

INSCRIPTION: four lines of poetry by Yang Su (d.606), signed 'The 76-year-old man Fu Shan wrote in a small garden beneath willows'[1]

ARTIST'S SEAL: *Fu Shan yin*

The Palace Museum, Beijing, Xin153139

Fu Shan was 37 years old when his world was turned on its head by the Qing conquest. Using calligraphy to express his distress at the fall of the Ming dynasty, Fu rejected the balanced proportions of classical calligraphy in the model-book tradition and instead eloquently advocated an aesthetic of deformity (*zhili*). Beyond connotations of fragmentation and brokenness, 'deformity' had political implications of something unsuitable for use.[2] Part of the aesthetic of the bizarre (*qi*), 'deformity', when applied to calligraphy, could result in totally illegible writing.

Fu Shan's loyalty to the Ming was intense. However, at the end of his life when this scroll was brushed, he was more accepting of the Manchu régime. A turning point came in 1678 when friends

persuaded him to accept the Kangxi Emperor's invitation to travel to Beijing to sit for the special *boxue hongci* examination. Reluctantly, he made the trip but stopped short of entering the capital. Instead he stayed at a dilapidated temple in the suburbs where for over six months scholars and officials called on him to discuss literature, aesthetics, art and politics. The art historian Qianshen Bai highlights the importance of these exchanges for the artistic ferment of the period.[3] Fu Shan maintained his principle of resisting Qing rule, but was also mollified.

Throughout his maturity, Fu Shan faced many requests for his calligraphy. His principled refusal to sit for the examination only enhanced his reputation and the demands for his writing. Because he brushed calligraphy both as a source of income and to meet requests from high-placed officials who could not be refused, he produced indifferent as well as successful pieces.

These four poetic lines that Fu Shan transcribed late in his life were extracted from a long poem by the early seventh-century poet Yang Su. The quatrain captures a period of quietude:

> Sitting alone, facing a low couch
> No guest, but there is a crying zither;
> Quiet solitude in remote mountains,
> Who understands a heart without worries?[4]

AM

259

Gao Xiang (1688–1754)
Eight Scenes of Yangzhou

Before 1743

Album of eight leaves, ink and colour on paper, each 23.8 × 25.5 cm

INSCRIPTIONS: a poetic quatrain by a different author inscribed on each leaf

COLLECTOR'S TITLE: on blue paper in clerical script 'Master Gao Xitang's album of eight fine scenes of Yangzhou. In the fourth month of Qianlong 8 [1743]'

SEALS: fourteen seals of the artist

The Palace Museum, Beijing, Xin187506, 1–8

SELECT REFERENCES: Hong Kong 1984, no.73; Yuan Liezhou 1997, pls 130–33

A native of Yangzhou, Gao Xiang read widely and enjoyed writing poetry. His home was in the neighbourhood where the individualist master Shitao (Zhu Ruoji, 1642–1707) built his Hall of Great Cleansing. As a youngster Gao Xiang befriended Shitao, his elder by almost half a century (cats 241, 247). After Shitao's death

in 1707, Gao Xiang honoured his friend's memory for the rest of his life, every spring sweeping Shitao's grave and performing sacrifices.

Fundamental to Gao Xiang's vision of art was the tenet (shared by, and perhaps learned from, Shitao) that painting is an extension of learning and writing. Both men rejected the concept formulated by Dong Qichang (1555–1636) that artists belong to either inspired or workaday lineages. To his mind, classifying artists into two schools was irrelevant to the creative process.[1]

Best known for his paintings of plum blossoms, Gao Xiang was equally accomplished at small-scale landscapes such as these. The album commemorates poets and famous sights associated with Yangzhou. Many of these sights were destroyed in the ten-day massacre of 1645 and subsequently restored. The eight poems that occasioned the paintings were composed at the elegant gatherings at the Pingshan Hall in the leisure zone on the north side of the city.[2] The pre-eminent tourist sight, the Pingshan Hall was a reconstruction of the hall established by the Song dynasty official and poet Ouyang Xiu (1007–1072). Among the poets active there was Wang Shizhen (1634–1711), the charismatic Qing dynasty official who served in Yangzhou and organised memorable parties at Red Bridge (leaf six). Seeking out and including Ming loyalists at his parties, he created camaraderie through poetics of memory and loss.[3] AM

260

Huang Shen (1687–1768)
Landscapes and Figures

1735

Twelve album leaves, ink and colour on paper, each 27.9 × 44.5 cm

Inscriptions by the artist on each leaf

LEAF 1: Ten Poems Written at Songnan Old Bamboo Hall

LEAF 2: Meng Changjun Interviewing the Elder Chu Qiu

LEAF 3: The Wise Daoist Recluse Chen Bo

LEAF 4: Night Rain, Misty Waves

LEAF 5: Sailing on Poyang Lake

LEAF 6: Han Qi Wearing a Yangzhou Shaoyao Peony

LEAF 7: Listening to Rain on Rivers and Lakes

LEAF 8: Scholar Su Shi Admiring a Natural-rock Inkstone

LEAF 9: Autumn Waters More Vast than the Sky

LEAF 10: Thinking of My Humble Home

LEAF 11: Old Friends

LEAF 12: Sending Off Friend. Quatrain

SIGNATURE: 'For more than ten years I have been travelling around the lower Yangzi River. In spring of the *yimao* year [1735] I took my family back to Fujian. While staying with old friend Lin Zhe, I reflected and wrote poems. When I sailed on Poyang, every detail of sending off a guest at River Mouth is as if before my eyes. Therefore I casually painted several sheets of paper and copied six figure compositions to make up two albums with inscriptions. Written in the ninth month, autumn, thirteenth year of Yongzheng [1735], Yingpiao Mountain Fellow, Huang Shen'

SEALS: twelve double seals of the artist, twelve collector's seals

The Palace Museum, Beijing, Xin99557, 1–12

SELECT REFERENCE: Yuan Liezhou 1997, figs 65–76

Huang Shen was a professional painter who worked in an amateur literati style. As a teenager Huang took up portrait painting to support his widowed mother and six siblings. The realistic mode of painting, however, was less marketable than the monochrome literati style. His training in meticulous realism is still visible in the confident rendering of faces and gestures, but the figure style of scribbly strokes was Huang's own invention, inspired by the wild cursive script of the oft-inebriated monk Huaisu (725–785). Huang learned enough poetry to write credible poems and inscribed them on his minimalist paintings.

Although a professional, Huang adopted a literati stance: words were as important as the painting. Without the text, the landscape or figure painting is diminished, even inconsequential. For example, the simple landscape of the ninth leaf is freighted with poetic references to recluses and unappreciated talent:

> Autumn waters more vast than the sky
> The song of the recluse fisherman comes;
> On the river, calling to the returning cranes,
> Next to a hedge, asking after the wild plum;
> Thatched huts are deep in the evening mist,
> Green moss is visible in the autumn moon light;
> I sweep the ground but the leaves continue to fall,
> I close the gate but the wind blows it open.

The second line recalls the song that a wise fisherman sang to the wronged official Qu Yuan urging him to withdraw from government. The seventh line prompts a recollection of the leaves that fell in a couplet written by the Tang dynasty poet Wang Wei (698–759) during the bloody An Lushan rebellion. Wang Wei's line, and

Huang's almost a millennium later, refer to an annotation to a line of poetry in the ancient *Songs of the Chu* (*Chuci*), equating falling leaves with talent being wasted. In 1735, a literary inquisition was underway and many scholars accused of sedition had lost their lives.

Painted for a host during a sojourn near Poyang Lake, this album has an inscription recording that in the spring of 1735 Huang had taken his family back to their home in Fujian. His mother preferred her hometown over the strangeness of Yangzhou (for a Fujian native the Yangzhou dialect was a foreign tongue). After returning to Fujian, Huang Shen continued to support the family through painting, often travelling around south China to sell his art. Huang Shen's aesthetic and commercial success with these compositions is confirmed by the many extant variations.[1] AM

261

Hua Yan (1682–1756)
Squirrels Competing for Chestnuts

1721

Hanging scroll, ink and colour on paper, 145.5 × 57.4 cm

INSCRIPTION: 'The tree is hidden by an unbroken band of mist, / Bees at times sink to honeyed bramble-bed / Lychee walled by grass are intertwined with junipers, / In the shadows of a rainy bamboo grove it's hard to see the sun / Pines sigh with the passing wind and let fall wisteria blossoms. / Look up and see the hungry flying squirrels competing for mountain chestnuts / A winter day of the *xinchou* year [1721] painted by Hua Yan called Qiuyue'[1]

ARTIST'S SEALS: *Hua Yan zhi yin, Qiuyue, Qiukong yihe*

COLLECTOR'S SEAL: Pang Yuanji (1864–1949)

The Palace Museum, Beijing, Xin146989

SELECT REFERENCES: Hong Kong 1984, no.31; Honolulu 1988, no.60

Three hefty squirrels tussle on a vine precariously attached to an old chestnut tree. With the grace of a trapeze artist, a fourth squirrel has launched himself in their direction. Will the impact of the squirrel in flight precipitate a collapse? Although this playful scene was inspired by nature, the painting may have had other meanings for the artist. In the fourteenth century squirrels were painted as an image of fame without substance.[2] This is the earliest of eleven squirrel paintings that Hua Yan is known to have done.

This painting displays the flair and technical skill for which Hua Yan became famous. It combines

freely brushed rocks, bamboo and river bank with meticulous rendering of the winning animals. Inexplicably, his realistic style did not find a receptive audience when Hua Yan visited the capital in 1717. Although he passed a painting examination to serve at court, he was discouraged by the insignificant post that he was offered. The scholar and painter Dai Xi (1801–1860) later wrote that Hua Yan was confident in his art, but in the capital he met only indifference. The ultimate discouragement came when Hua Yan noticed a vendor of fake paintings wrapping his wares with paper on which Hua had painted.[3] In 1730 Hua Yan settled his family in Yangzhou where he became one of the most acclaimed painters of his generation. Although he lived in Hangzhou and elsewhere, in history he became permanently associated with Yangzhou, its eccentric artists and rich merchant patrons. AM

extensively around Shandong, Hebei and Shanxi, making ink rubbings whenever possible. At the beginning of the Qianlong era, Jin was recommended for the 1736 examination by imperial invitation. Although he declined to sit for the examination, his trip to the capital afforded him the opportunity to meet other scholars and to view private collections.

About 1736, Jin Nong began painting and, although he created charming garden scenes and small landscapes, he is best remembered for his branches of plum blossoms and bamboo, in which one can see chiselled brushwork inspired by stone-engraved inscriptions. Jin Nong's students in poetry and painting, Xiang Jun and Luo Ping, were both proficient in his style and helped him to meet the demand for paintings in these two popular genres while he typically added the signature.[1] This work, however, is entirely the master's. AM

of the vulnerability of Chinese lives under Manchu military power.[1]

In the literary world, insects and animals provided a rich archive of fables on greed, predation and fate. In painting, the Northern Song scholar Su Shi (1037–1101) established an illustrious precedent when he wrote quatrains for a set of eight paintings of garden creatures. Each lampooned a well-known contemporary. A snail that got stuck on the wall when it ran out of juice allegedly satirised the powerful official Wang Anshi (1021–1086) whose ambition over-reached his resources. Carved into stone in the twelfth century, the popular poems and images are now preserved only in a copy painted in the fourteenth century.[2]

This album of minimalist paintings was a collaboration with the erudite official and playwright Jiang Shiquan (1725–1785), who inscribed the poems.[3] A snail on a rock in the second leaf is accompanied by a poem that adopts the language of Su Shi's quatrain and a story from the Daoist philosophical text, *Zhuangzi*:

> Upon its feelers states can be established,
> Its trailing slime looks like seal script.
> One morning it sticks on the wall dried out,
> Then who can discriminate dark from light?

The first line comes from the story of a snail whose two horns hold countries prepared to go to war. One is named Chu; the other, serendipitously, is Man, which sounds like Manchu.[4] The quatrain is all the more cutting since 'morning' (*chao*) of line three can also be read as 'dynasty'.

Leaf eight ridicules the folly of a fight that benefits a third party. The clams (in the painting) fought with a snipe (in the poem), which resulted in both being caught by the fisherman.

Jiang Shiquan's poems are playfully inscribed. In leaf five his inscription is tucked under the nest like another chick. The characters in leaf six march across the page like a platoon of ants, orderly in contrast to the disarray of the 'real' ants below. On leaf seven, where centipede and spider are about to meet in mortal combat, the inscription hangs like a thread.

The album reveals two scholars negotiating contradictory positions: publicly seeking patronage from the court but privately mocking it. AM

262
Jin Nong (1687–1773)
The Radiant Moon

1761

Hanging scroll, ink and colour on paper, 115.8 × 54 cm

INSCRIPTION: '*The Radiant Moon* painted and sent to Master Shutong for his refined appreciation by the old man of seventy-five, Jin Nong'

SEALS: two seals of the artist, three collectors' seals

The Palace Museum, Beijing, Xin53964

SELECT REFERENCE: Honolulu 1988, no.64

Jin Nong's vision of the moon is unprecedented in Chinese painting. For millennia poets had celebrated the moon, its radiance and the idea that it shines on family and friends distantly separated. A tiny orb representing the moon appears in innumerable landscape paintings. However, prior to Jin Nong, no painter had conceived such a bold and direct portrait. Within the orb of the moon one can make out the grey silhouette of the proverbial rabbit, standing on his hind legs grinding cinnamon sticks with mortar and pestle. The moon radiates light of many hues including yellow, green, purple and light blue.

Jin Nong signed the painting in a blocky seal script that he evolved from the study of antique stone-cut inscriptions. His enthusiasm for early script types led him to travel

263
Luo Ping (1733–1799)
Insects, Birds and Beasts

LEAF 1: Ox-herder with a Bird on a Stick
LEAF 2: Snail on a Rock
LEAF 3: Spiders
LEAF 4: Dragonfly and Unidentified Plant
LEAF 5: Hen and Chicks
LEAF 6: Ants
LEAF 7: Centipede Ascending Tree
LEAF 8: Bivalves
LEAF 9: Tree Monkeys
LEAF 10: Tadpoles and Crayfish

1774

Ten album leaves, ink on paper, each 20.8 × 27.5 cm

INSCRIPTIONS: poetic quatrain inscribed on each leaf by Jiang Shiquan (1725–1785). Signature of the artist on leaf ten: 'In the eighth month of the *jiawu* year [1774] younger brother Luo Ping, after getting drunk, painted ten leaves of insects, birds and animals by a rainy window, responding to Third Elder Teacher Zhupu'

SEALS: Luo Ping: *Liangfeng*; Jiang Shiquan: five double seals reading *Quan shu* (Quan inscribed), five seals reading *Xin yu* (heart's overflow); ten collectors' seals

The Palace Museum, Beijing, Xin10512, 1–10

SELECT REFERENCE: Beijing 1986–2001, no.1-5893

Luo Ping continues a small but vibrant tradition of insect painting. A century earlier, in the early Qing period, the Ming loyalists Bada Shanren (Zhu Da, 1626–1705) and Yun Shouping (1633–1690) had painted fragile creatures in works which were seen as embodiments

264

Weng Fanggang (1733–1818)
The *Heart Sutra*, in regular script

1801
Album, ink on bodhi-tree leaves and paper,
16.5 × 9.2 cm

INSCRIPTION: Jiaqing sixth year (1801),
eighth month, seventh day; respectfully
written by Weng Fanggang

SEALS: below inscription *Chen Fanggang*
(Imperial servant, Fanggang); *Jing shu*
(Respectfully written)

A one-line colophon by the calligrapher
appears after the album on the border of the
mounting

The Palace Museum, Beijing, Xin155954

The style-name (*zi*) of Weng
Fanggang was Zhengsan, and his
literary names (*hao*) were Tanxi,
and later Suzhai and Yizhai. He was
born in Daxing in Zhili Circuit
(modern Beijing). He passed the
highest level of the civil service
exams (*jinshi*) in the seventeenth year
of the Qianlong Emperor's reign
(1752). His highest rank in office
was secretary of the Grand
Secretariat (Neige daxueshi). He was
an accomplished poet and essayist;
and an expert in epigraphic research
on the images and inscriptions on
metal and stone (*jinshixue*) in the
'evidential scholarship' style of his
day. He was also a fine connoisseur
of calligraphic rubbings and
manuscripts.

In his calligraphy, he was first
a follower of the great Tang
statesman and Confucian martyr
Yan Zhenqing (709–785), and later
of the early Tang court calligraphers
Ouyang Xun (557–641) and Yu
Shinan (558–638), and he also
studied the various styles to be
found in ink rubbings from early
stone steles. He is noted for his
deeply conservative approach to
standards in calligraphy, and for a
style characterised by its powerful
inner (or 'bone') structure. Together
with Liu Yong (1720–1804), Yong
Xing (1752–1823), and Tie Bao
(1752–1824), he was one of the so-
called Four Great Calligraphers of
the Qianlong reign.

This album, written when Weng
Fanggang was 69 years old, records
a passage of the *Heart Sutra* (Sanskrit:
Prajnaparamita-hrdaya Sutra). Some of
the work is executed on a rare and
unusual medium: leaves, laid out
on rectangular sheets and left to
dry, from a bodhi tree, the tree the
Buddha is said to have meditated
under when he achieved his spiritual
awakening or enlightenment. The
coarse vein structure of the dried
leaves necessitates the brush being
handled with some delicacy. The
awkwardness of the medium imparts
something of a dull, clumsy look to
the calligraphy, but also allows
what might be called the 'heroic
graciousness' of the styles of the
Tang masters Ouyang Xun and Yu
Shinan to shine through. LYX/SMcC

265

Jin Nong (1687–1773)
**Excerpt from Tao Xiushi's *Qing Yi
lu*, in 'lacquer-script' calligraphy**

1743
Hanging scroll, ink on paper, 119 × 59.5 cm

SEALS: *Jin Nong yin xin* (Seal of Jin Nong);
Liushi bu chu weng (Housebound old man
of sixty)

COLLECTOR'S SEALS: *Xiao shuhua fang miwan*
(Secret amusement from Xiaofang's
collection of calligraphy and paintings);
Yan Xiaofang zhencang jinshi shuhua yin (Seal
on Yan Xiaofang's treasures of metal, stone,
calligraphy and painting)

The Palace Museum, Beijing, Xin155516

Jin Nong's original given name was
Sinong; his style-name (*zi*) was
Shoumen, and he had various
literary names (*hao*), including
Dongxin. A native of Renhe
(modern-day Hangzhou, Zhejiang
Province), he studied under the
instruction of He Zhuo (1661–
1722). During the first year of the
Qianlong Emperor's reign (1736), he
was recommended as a commoner
for the civil-service exams in Beijing,
but failed. He subsequently travelled
widely throughout China before
finally settling in the thriving
mercantile city of Yangzhou, where
he worked as a professional painter
and calligrapher. He was talented in
a number of literary and artistic
fields, including in poetry and prose,
and he was a respected connoisseur
and an obsessive antiquarian. He
only started to paint in his fifties but
became an important painter of the
Yangzhou School. He developed his
personal calligraphic style from ink-
rubbings of stele inscriptions from
the Han (206 BC–AD 220), Wei
(220–265), and Northern and
Southern Dynasties (420–589),
that is, the 'heroic' public style of
calligraphy preserved in engraved
stone monuments in medieval north
China. Jin Nong created a unique,
eccentric style unprecedented in the
tradition of Chinese calligraphy,
which he called 'lacquer script'
(*qishu*).

This example of his work is an
excerpt from a book called *Qing Yi lu*
by Tao Xiushi (also known as Tao
Gu, 903–970) of the Song dynasty.

Selected and compiled by Tao
Xiushi, *Qing Yi lu* is a collection of
suggestive literary 'jottings' from the
Sui (581–618) and Tang (618–907)
to the Five Dynasties (907–960).
The passage throws light on the
artistic activities of one of China's
great imperial patrons of the arts,
the Southern Tang ruler Li Houzhu
(r. 961–76), himself a celebrated poet
who was notoriously distracted from
government by his passion for
literature and the arts:

First day of the fifth year of Baoda,
heavy snow:

Li Houzhu ordered the younger brothers
of the Emperor to attend a banquet and
compose poems, and sent attendants into the
imperial apartments to present them to Li
Jianxun for him to compose matching verses.
At the time Jianxun was in a meeting at the
Xi Pavilion with Xu Xuan of the Central
Secretariat, and Scholar of the Qinzheng
dian, Zhang Yifang. He immediately
composed a verse to match them and sent it
to the Emperor. The Emperor commanded
Jianxun, Xuan and Yifang to attend the
banquet, detaining them until late into the
night. The officials all wrote poems and
Xu wrote a preface to the set.
 Furthermore, the Emperor summoned the
best-known artists [to be court painters].
Gao Chonggu was charged with imperial
portraiture; Zhou Wenju with paintings of
officials and musicians; Zhu Cheng with
depicting the palace buildings; and Dong
Yuan with paintings of bamboos in snow
and wintry forest scenes.

Written in the year *guihai* (1743), summer,
the fifth month. An excerpt from *Qing Yi lu*
by Tao Xiushi for the edification of elder
brother Daya. Jin Nong of the ancient
capital Hangzhou.

In Jin Nong's 'lacquer-script'
calligraphy, the horizontal strokes
are markedly flat and thick, and the
brush's entry and exit points at the
ends of each stroke are noticeably
abrupt. The perpendicular, oblique
and hooking strokes are thin and
sharp; and the structure of the
characters is square, thick and
heavy. The intense black of the ink
sets up a powerful visual contrast
with the white 'negative' spaces
between and within characters.

The piece was written in the
eighth year of the Qianlong
Emperor's reign (1743), when Jin
Nong was 57. The characteristics of
the newly invented 'lacquer script'
style are obvious to see, but are not
over-emphasised. The characters
are still square and frontal in form,
as in the monumental calligraphy
in stone from north China, but the
brush strokes generally have a
rounded quality, a trait of brush
calligraphy on paper in the southern
epistolary tradition. The overall
effect is of a kind of hoary strength
melded with a lightness of spirit.
HN/SMcC

266

Li Shizhuo (1690?–1770)
Meditation Retreat at Gaotu

1747

Hanging scroll, ink and colour on paper,
83.7 × 48.4 cm

INSCRIPTIONS: by the Qianlong Emperor
dated 1747, 1767, 1769. 'Poetry Hall'
inscription: 'Pleasure among Forest and
Springs'

SEALS: thirteen seals of the Qianlong
Emperor, two seals of the artist

The Palace Museum, Beijing, Gu8211

SELECT REFERENCES: *Shiqu baoji sanbian*,
pp.1023–24; Beijing 1986–2001, no.23.1-
5556

The Qianlong Emperor cultivated
his image as a Chinese literatus.
He practised what the Chinese
educated élite called the Three
Perfections: poetry, calligraphy and
painting. Rarely, however, did he
personally execute all three arts
in combination. More often he
achieved 'three perfections' by
writing his poems on existing
paintings.[1] He also produced
'literati' painting by imperial fiat.
Here Li Shizhuo served as his brush,
creating a pleasing landscape upon
which the Emperor could inscribe
his poetic musings.

Like his grandfather, the
Qianlong Emperor spent much of
the year outside the Forbidden
City. The Gaotu meditation retreat
depicted here was at the Jade
Flower Monastery (Yuhua si),
possibly one of the temples built
in the Fragrant Hills to the west of
Beijing in the eighteenth century.

As if looking down from
a nearby hilltop, we see the
retreat surrounded by fruit trees.
A viewing pavilion is perched
on a promontory to the left. The
sketching of the mountain shows a
painter familiar with the volumetric
modelling that was practised by the
Jesuit painters then at court. Li
Shizhuo discreetly signed the
painting in the lower-left corner
leaving a generous expanse of sky
for the imperial brush.

The Qianlong Emperor
inscribed the painting three times.
In the spring of 1747 he wrote a
poem above the highest peak at the
right. He attributes his fine lines of
poetry to the beautiful countryside
and quiet meditation in Jade Flower
Monastery. Twenty years later he
inscribed the scroll twice at the far
left, praising Li Shizhuo's ability to
capture the retreat's poetic qualities.
In 1669, he squeezed in another
poem on the authenticity of the
depiction and his friendship with

Li. The Emperor further wrote
an inscription of three large
characters – Pleasure among Forest
and Springs – which was mounted
above the painting in a panel
dedicated to inscriptions and thus
called the 'poetry hall'.

Li Shizhuo came from a Chinese
family that lived in a far northern
region that was incorporated into
the Manchu state in 1621. His
ancestors became bannermen in
the Chinese-martial (*Hanjun*) part
of the Qing army. Li was tutored
in painting by his uncle Gao Qipei
(1660–1734) and when he travelled
to Jiangsu he also received
instruction from master painters
Wang Hui (1632–1717) and
Wang Yuanqi (1642–1715). AM

267

The Nine Elders of Huichang

1787

Nephrite (green jade) boulder,
height 114.5 cm

INSCRIPTION: Qianlong poem in seven-
character lines

SEALS: the Qianlong Emperor

The Palace Museum, Beijing, Gu103157

SELECT REFERENCES: Weng and Yang Boda
1982, pl.167; Chicago 2004, pls 304–05

Jade holds a pre-eminent position in
China's philosophy and aesthetics.
In the West the term jade designates
two distinct minerals: a silicate of
calcium and magnesium called
nephrite, and a silicate of sodium
and aluminum called jadeite. The
Chinese term *yu* embraces a wider
variety of finely grained stones that
have attractive colour, take a high
polish and are rare enough to be
elevated above ordinary rocks and
pebbles. In its purest form nephrite
is white. Impurities lend tints of
green, yellow, grey and lavender.
The hardness of nephrite (about
6.5 on the Mohs scale) means that
it cannot be scratched by steel;
instead it has to be worked by
abrasion with sand or corundum.[1]
The reward for this arduous work
is a lustrous surface with tactile
softness and a depth that is lent
by the stone's translucence.

Working jade became the
perfect metaphor for the difficult
process of training a mind and
building character. Cutting and
polishing was compared to
sustained self-cultivation that
produced refinement, discipline
and intellectual depth. Uncut
and unpolished jade represented
potential not yet used.

Before the Qianlong era, jade
was carved in a wide variety of ritual
implements and vessels, musical
chimes, personal ornaments and
playful forms, including charms
and objects for the scholar's studio.
However, carving jade boulders into
three-dimensional landscapes was
an innovation of the Qianlong era.
This departure was stimulated by
fresh sources of jade that came
about as a result of the expansion
of the Qing empire into central Asia
and imports from border regions:
spinach nephrite from the Lake
Baikal region, and jadeite from
the Mogaung mines in Burma.[2]
After the pacification of rebels
in Xinjiang in 1758, excavation
of jade in Hetian (Khotan) began
on a massive scale with several
thousand workers employed.
Once a boulder was located, it
took months to free it and still
longer to ship it in a cart pulled
by horse teams to the east coast.
There the boulders were carved
at a workshop in Yangzhou,
Jiangsu Province.

The finest of the four carved
mountains in the Palace Museum
collection, this boulder weighs
more than 820 kilos. Its title refers
to a party that the poet Bo Juyi
(772–846) held in the spring of 845
in honour of longevity. The group
of friends was known as the Nine
Elders of the Huichang reign
(841–846). Seven of the celebrants
were septuagenarians and two were
over sixty. In the pavilion high on
the mountain two elders are playing
chess. On the path below, a servant
prepares water for tea. Others stroll,
chat and enjoy the landscape.

The boulder was completed
and delivered to the Forbidden
City (Zijin cheng) in 1786 when
the Qianlong Emperor was
himself 75. The following year it
was engraved with the Emperor's
poem acknowledging the labour
of the craftsmen and noting the
superior permanence of stone over
ink on paper. Although rendering
a landscape in jade contradicts
the function of literati landscape
painting (the spontaneous
expression of feelings), the jade
mountain is a grand monument
to the Qianlong Emperor and
to the ideal of respect for the
aged. AM

268

Shen Quan (1682–1760)
Pine, Plum and Cranes

1759
Hanging scroll, ink and colour on silk,
191 × 98.3 cm
INSCRIPTION: 'In the autumn of the *jimao* year of the Qianlong reign [1759], Shen Quan called Hengzhai, at age 78, imitated Lü's [Ji's] wielding of the brush'
SEALS: three seals of the artist
The Palace Museum, Beijing, Xin63271
SELECT REFERENCES: Sydney 1981, no.66; Barnhart et al. 1997, fig.274

The red-crowned cranes stand in a thoroughly auspicious landscape. No weeds or thorns grow in this idealised world. On the right are the 'Three Friends of Winter', exemplifying endurance and longevity. The pine tree was canonised by Confucius as a principled tree: when the weather turns cold, evergreens are the last to change colour.[1] The bamboo entered the pantheon of virtuous plants not only for its ability to stay green in winter, but also because – in contrast to the inflexible pine – it could bend in adversity without breaking. The plum was admired for its purity and rejuvenation: when snow is still on the ground, before any leaves appear, gnarled trees send forth blossoms demonstrating a tenacity beyond expectation.[2] On the left, auspiciousness culminates in the robustly fruiting nandinia bush, a wish for long-lasting youth.

The carefully observed red-crowned cranes grow to a height of 140 centimetres. Shen Quan depicts one crane with its head raised, crying with open beak. The second leans down as if in a bow, beak closed. Open and closed mouths are sometimes contrasted in auspicious and protective pairs, from guardians at temple gates to lions flanking palace doors.

A native of Zhejiang Province, Shen Quan travelled to Japan in 1731 at the invitation of a Japanese admirer. He worked and taught in Nagasaki for over two years, substantially influencing painting styles there. Back in China, he was an itinerant painter who worked in the colourful court idiom, but never actually served in the Imperial Painting Academy. In the inscription on the left edge of the scroll he names the well-respected Ming dynasty court painter Lü Ji (*c*.1440–*c*.1505) as his inspiration. AM

269

Yu Xing (1692–after 1767)
Cranes against Sky and Waters

c.1747
Hanging scroll, ink, colour and shell white on paper, 82.7 × 95.6 cm
INSCRIPTIONS: 'Respectfully painted by your servitor Yu Xing' and inscription by the Qianlong Emperor
SEALS: two seals of the artist, twelve seals of the Qianlong Emperor
The Palace Museum, Beijing, Gu5223
SELECT REFERENCES: *Shiqu baoji xubian*, p.1852; Nie Chongzheng 1992, no.76

The long legs of these splendid red-crowned cranes were said to resonate with the harmonies of nature and heaven. Because of their willingness to be domesticated, the birds were sometimes kept as pets. Living for several decades, cranes became a symbol of longevity.

It is therefore appropriate that the cranes have descended into a grove of pines, another symbol of long life. The gathering is an auspicious event, as the Qianlong Emperor noted in his inscription: 'They rest in a place where they feel secure and engage in every sort of activity, all of which Yu Xing recorded.' The Emperor's inscription is dated summer 1747, which was probably the same year as the painting.

This painting had a precedent at the Song dynasty court in Kaifeng, when, in 1112, a flock of cranes circled above a palace gate. Emperor Huizong (r.1101–25) deemed it a singularly auspicious occasion and illustrated the magical happening.[1] Whereas twenty cranes visited the twelfth-century palace, in this painting the artist has assembled 97 cranes and two chicks, with 99 implying a full 100.

Yu Xing was from Changshu, the home town of Wang Hui (1632–1717), the artist who painted the grand southern tour scrolls for the Kangxi Emperor. Yu studied painting with Jiang Tingxi (1669–1732), a distinguished painter at the imperial court. For many years he lived at the home of the Minister of the Board of Revenue who recommended him for court service. In 1737 he entered the Imperial Painting Academy with his younger brother. The influence of the Jesuit painters is evident in the sculptural trunks of the trees and the stage-set-like composition. AM

270

Chen Mei (1694?–1745)
Ten Thousand Blessings to the Emperor

1726
Hanging scroll, ink and colour on silk, 139.2 × 64 cm
INSCRIPTION: 'Ten-thousand blessings come to the Emperor. Yongzheng fourth year, tenth month 30th day [the Emperor's birthday, 23 November 1726], respectfully painted by your servitor Chen Mei'
ARTIST'S SEALS: two seals of the artist
The Palace Museum, Beijing, Xin156695
SELECT REFERENCE: Nie Chongzheng 1992, no.37

In the sky, black and red bats (*bian fu* 蝙蝠) arrive in a thick cloud. The bat (*fu* 蝠) is a homonym for 'blessings' (*fu* 富), and adding the word 'returning' (*gui* 歸) creates a phrase that sounds like 'blessings and honour' (*fu gui* 富貴). Red bats are particularly auspicious because red is a joyful colour that wards off malevolent spirits. The bat was a favoured image in imperial costumes, decorative objects, and architectural embellishments in the Forbidden City (Zijin cheng). Visitors can still see carved wooden door panels that feature five bats encircling a stylised version of the character for long life (*shou*), a combination which is read 'five blessings supporting longevity'. Lists of the five blessings typically include riches, health, longevity, peace and a natural death.

Chen Mei created the painting for an auspicious occasion: the Emperor's forty-eighth birthday. (In China cycles of twelve years are more important than the decades of Western figuring.)

This then is an elaborate birthday card with the ancient pine trees representing a wish for long life. The fantastic rocks on which they grow are surrounded by water, suggesting that this is one of the islands of the Immortals, that is, a Daoist paradise. The association with paradise is reinforced by the use of malachite mineral pigment.

Chen Mei became a court painter during the reign of the Yongzheng Emperor on the recommendation of artist Chen Shan. He earned the Emperor's trust and was subsequently made assistant director of the Imperial Household Department (Neiwu fu). Around 1740 Chen Mei retired and returned to his home near Shanghai. AM

271

Leng Mei (*c.*1677–*c.*1742)
Pair of Rabbits under a Paulownia Tree

Undated

Hanging scroll, ink and colour on silk,
175.9 × 95 cm

INSCRIPTION: 'Respectfully painted by
your servitor Leng Mei'

ARTIST'S SEALS: *Chen Leng Mei, Suye Feixie*
(Unremitting [effort] from dawn to dusk)

COLLECTORS' SEALS: one of the Qianlong
Emperor and one other

The Palace Museum, Beijing, Gu5183

SELECT REFERENCES: Honolulu 1988,
no.57; Yang Boda 1993c, pp.109–15;
Nie Chongzheng 1996, no.21; Edinburgh
2002, no.61

This alert pair of rabbits is
meticulously observed, down to
the fur of their white coats and
black-tipped ears. The rabbits
gaze at each other under a sturdy
paulownia tree. The rendering of
the knotty tree trunk in rich colours
and thick brushwork is a clear
stylistic reference to the late
Ming to early Qing painter Chen
Hongshou (1598–1652). The 'tear-
stained' bamboo railings indicate
that the rabbits are romping in a
garden. The hint of desiccation on
the paulownia leaves points to the
autumn season as do the osmanthus
and small white blossoms.

From antiquity, when the
Chinese looked at the moon,
they saw a white rabbit standing
in profile to the left. Thus a painting
of rabbits might celebrate the
Mid-autumn Festival which featured
moon-viewing with family and
friends. In addition to associations
with the moon, the rabbit is the
fourth of the twelve annual animals
of the Chinese zodiac. Since the
Qianlong Emperor was born in a
rabbit year (1711) and in the autumn,
this colourful painting may have
been a birthday present for the
young prince.

Leng Mei was probably
recommended to the court by
his teacher Jiao Bingzhen
(fl.*c.*1689–1726). When Giuseppe
Castiglione (1688–1766) and other
Jesuit missionary painters arrived
at the court of the Kangxi Emperor,
Jiao Bingzhen and Leng Mei would
have introduced them to Chinese
painting. The glint in the rabbits'
eyes suggests that Leng Mei in turn
learned a few techniques from the
Europeans. Leng Mei painted, at
least for a time, under the Kangxi,
Yongzheng and Qianlong
Emperors, working both in the
Forbidden City and at the summer
palace of the Garden of Perfect

Brightness (Yuanming yuan). He is
best known for his handsome figure
paintings which include beautiful
palace ladies and erotica, delicately
termed 'spring pictures'. AM

272

Anonymous
*The Yongzheng Emperor Admiring
Flowers*

c. 1725–36

Hanging scroll, ink and colour on silk,
204.1 × 106.6 cm

The Palace Museum, Beijing, Gu6435

SELECT REFERENCES: Wan Yi, Wang
Shuping, and Lu Yanzhen 1985, no. 285;
Nie Chongzheng 1996, p.19

The Emperor sits on a mat
surrounded by seventeen princes
and high officials. Four of the
gentlemen wear hats with single-
eyed peacock feathers, a reward for
valour. Their individualised faces
are unquestionably portraits. The
only boy is given prominence by his
red mat, the unique golden colour
of his robe and his position at the
sovereign's right hand.

The glade is pictured with
geomantic correctness: following
good *fengshui* practice, a mountain-
like boulder is at the Emperor's back
and water flows at the bottom of the
scene. Blossoming magnolia and
peach trees spread umbrella-like
over the group. Combined with the
festive peonies (symbolising wealth
and high birth), an auspicious pun
is created: flourishing good
fortune and high position. Picnic
paraphernalia is visible at the
right, but there is no convivial
consumption. Instead we have a
tableau in which only the Emperor
looks directly out at the viewer.

The Yongzheng Emperor,
looking youthful, wears informal
dress and holds an as-you-wish *ruyi*
sceptre worked from gnarled root.
For what was he wishing? For
longevity? For family and state-
wide harmony? Did his wish have
to do with the boy? Not long
after ascending the throne, the
Yongzheng Emperor secretly
designated his fourth son Hongli
as his successor, which was the
wish of his own father, the Kangxi
Emperor. At the time, the future
Qianlong Emperor, Hongli, would
have been eleven to twelve years
old. It is possible that the undated
painting was commissioned after the
Qianlong Emperor was enthroned
in 1735. It would then have been
a filial tribute to his father and an

assertion of their special
relationship. AM

273

Set of nine *ruyi* sceptres in the
form of plants

Yongzheng or Qianlong period

Zitan wood, *hong* (red) wood, boxwood,
sandalwood, *niao* (bird) wood, lengths
*c.*33.5 cm

The Palace Museum, Beijing, Gu123392,
1–9

274

Ruyi sceptre with 'long life' (*shou*) and
'happiness' (*xi*) characters, lions, bats
and the Eight Buddhist Emblems

Yongzheng or Qianlong period,
Jiangning, Jiangsu Province

Bamboo veneer, length 46.5 cm

The Palace Museum, Beijing, Gu121029, 1

275

Ruyi sceptre in the form of a gnarled
fruiting and flowering peach branch
with five bats

Qianlong period

Boxwood with white and green jade, rose
quartz, rubies, gold and pearls, length 49 cm

The Palace Museum, Beijing, Gu10011

SELECT REFERENCE: Liu Jing 2004, p.25 top

276

Ruyi sceptre in the form of a flower,
fitted with earlier jade pieces

Yongzheng or Qianlong period

Zitan wood, white jade, ruby and gold, length
40.7 cm

The Palace Museum, Beijing, G10014

SELECT REFERENCE: Liu Yue 2004, p.11 right

277

Ruyi sceptre in the form of a
'Buddha's hand' fruit (finger citron)
branch, from a set of nine
comprising four pairs of fruiting
branches (finger citron, peach,
pomegranate and melon) and one
branch growing fungi (see cat.280)

Qianlong period

Zitan wood with jade and other hardstones,
stained ivory and gold, length 41.5 cm; silk
tassel with coral bead

The Palace Museum, Beijing, Gu123362, 5

SELECT REFERENCE: Tokyo 1985, cat.27

278

Ruyi sceptre carved in openwork,
set with an earlier jade plaque
with a 'long life' (*shou*) character

Yongzheng or Qianlong period, Palace Workshops, Beijing

Cinnabar lacquer on wood with colours and gilding inset with white jade, length 46.5 cm

The Palace Museum, Beijing, Gu115203

SELECT REFERENCE: Zhu Jiajin 1993, pl.245

279

Ruyi sceptre from a set of sixty inscribed with different cyclical dates and the legend 'ten thousand years according to your wishes' (*wan nian ru yi*), the present one inscribed '*jiazi*', equivalent to 1744

Qianlong period, 1770, made for the Qianlong Emperor's sixtieth birthday

Gold filigree on wood, inlaid with turquoise, length 42.7 cm

The Palace Museum, Beijing, Gu11686, 2

280

Ruyi sceptre in the form of a leafy branch with longevity fungi (*lingzhi*), the central piece of a set of nine, the others all bearing fruit (see cat.277)

Qianlong period

Zitan wood with agate, lapis lazuli, stained ivory and other semi-precious stones, length 42 cm; silk tassel with coral bead

The Palace Museum, Beijing, Gu123362, 8

281

Ruyi sceptre in the form of a longevity fungus (*lingzhi*) with bats

Yongzheng or Qianlong period

Coral, length 32 cm

The Palace Museum, Beijing, Gu105840

282

Ruyi sceptre engraved with dragons among clouds

Yongzheng or Qianlong period

Grey-green jade with gilding, length 44 cm

The Palace Museum, Beijing, Gu88923

Ruyi means 'as-you-wish' and a *ruyi* sceptre is a talisman presented to bestow good fortune. Its shape and symbolism developed over a long period of time and its auspicious association appears to be connected with Buddhism. Following Indian iconography, in China early Buddhist deities were often depicted holding simple back-scratchers, as, for example, Manjusri (Chinese: Wenshu), the Bodhisattva of Wisdom.

By the Tang period (618–907), these functional items, which often terminated in a small cupped hand, had become ornamental and auspicious. Sceptres of the characteristic *ruyi* shape (such

as cats 274, 279, 282) – as well as proper back-scratchers – are among the effects of the Japanese Emperor Shōmu (reg. 724–49, died 756) preserved in the Shōsō-in at the Tōdai-ji in Japan. Among them is a set of nine, conveying good wishes forever (九 *jiu*, 'nine' being homophone with 久 *jiu*, 'endless'). A silver sceptre of AD 872, donated to a Buddha bone relic in the Famen Temple near Xi'an in Shaanxi province, is already called a '*ruyi*' in its inscription.

With the temporary decline of Buddhism in the latter half of the Tang, the *ruyi* sceptre's popularity spread and its shape changed. Being adopted by Daoists, it turned into a longevity fungus (*lingzhi*), and any shape was suitable for its use as a secular good luck charm.

The Yongzheng Emperor revived its auspicious tradition by commissioning examples in various materials and made the sceptre imperial. He himself and ladies at his court are depicted with wooden sceptres (cats 173, 272) and the *Pictures of Ancient Playthings* (cats 168, 169) illustrate several examples in his collection, of jade, of wood inlaid with jade, and of gold filigree set with jewels. When the Qianlong Emperor officially called upon courtiers to present *ruyi* sceptres upon imperial birthdays and New Year celebrations, their number and opulence increased, and since their only function now was to serve as auspicious objects, free rein was left to the artisans' imaginations. RK

283

Double-gourd-shaped ornament with linked chain

Qianlong period

Ivory with *zitan* wood stand and fitted box, height 18.5 cm

Victoria and Albert Museum, London, FE.10-1990

284

Double-gourd-shaped box decorated with smaller gourds and tendrils

Qianlong period

Carved bamboo, length 17.6 cm

The Palace Museum, Beijing, Gu121081

SELECT REFERENCES: Palace Museum 2000, no.45; Palace Museum 2002, no.33

285

Double-gourd-shaped tiered box carved with melons on vines

Qianlong period

Carved lacquer with gilded interior, 24 × 13.7 cm

Qianlong six-character reign mark in relief on the base

The Palace Museum, Beijing, Gu110007

SELECT REFERENCE: Palace Museum 1985, pls 304 and 305

286

Perfumer in the shape of a double-gourd with auspicious characters for happiness and longevity in openwork

Qianlong period

Gold, height 42 cm

The Palace Museum, Beijing, Gu225026

SELECT REFERENCES: Chicago 2004, fig.217; Xu Qixian 2004, no.46

287

Double-gourd-shaped vase decorated with bats

Qianlong mark and period

Porcelain with red and blue-green enamels, height 33.3 cm

The Palace Museum, Beijing, Gu154692

SELECT REFERENCE: Feng and Geng 1994, pp.299–330

Double gourd-shaped containers were favoured in China from at least the Tang period (618–906). References to gourds in general occur first in the earliest surviving Chinese poetry, the *Book of Poetry* (*Shijing*, c.600 BC). Here they were evidence of abundance and fertility. This connection with fertility, an association based upon the tendrils and seeds of the gourds, remained an enduring element of their popularity as metaphors and motifs.

Many types could be grown in moulds to produce a variety of shapes. *Lagenaria siceraria* was the one favoured to be grown as a double bulb. Research by Rolf Stein and Maggie Wan, among others, has suggested that the double gourd gained its specific value from the notion that a universe could be discovered in it. The two bulbs were thought to reproduce the double structure of the universe, providing the heavens and the earth. Stories that described the universe inside the gourd were first recorded in a fourth-century AD text, the *Stories of Immortals* (*Shenxian zhuan*), and in the fifth-century text, the *History of the Later Han dynasty* (*Hou Hanshu*). The story of Fei Changfang in the latter

text indicates that the gourd was recognised as a vehicle through which people with miraculous powers could enter a separate world not bounded by the physical size of the gourd, in which marvellous buildings could be discovered. Over the centuries, further texts gave instruction on to how to enter a gourd and elaborated upon the different paradises that would be found there. The gourd also came to be linked with the preparation of elixirs of immortality by Daoist alchemical processes.

Vessels in gourd shapes are, in the main, post-Tang in date. The greatest enthusiast for the double gourd was the Jiajing Emperor (1522–1566), who was obsessed with the pursuit of immortality. His palace was decorated with hundreds of gourd-shaped vessels. Enthusiasm for gourds remained embedded in all auspicious imagery thereafter. When a vase is in a gourd shape, it further contributes a rebus, or visual pun, wherein the character for vase, *ping* 瓶, suggests the word for peace, *ping* 平, as seen also on cat.289. In addition to their auspicious shapes, the gourds illustrated here feature auspicious motifs in their decoration. The characters for wealth and prosperity in large and miniature forms appear on the gold openwork gourd, while several visual puns appear on the other examples: red bats (*hongfu* 紅蝠), as a rebus for vast good fortune (*hongfu* 宏福), decorate the porcelain vase, while visual puns for numerous progeny are represented by melons on vines on the lacquer vase, and multiple gourds on the bamboo box (cat.284). JR

288

Pomegranate-shaped box

Eighteenth century, made at Jiangning (present-day Nanjing)
Bamboo-veneered wood with gold-lacquered interior, height 9.9 cm
The Palace Museum, Beijing, Gu121322
SELECT REFERENCE: Palace Museum 2002, no.47

289

Octagonal box decorated with a gourd-shaped vase holding auspicious plants (prunus, pine and nandinia), fruit (grapes, pomegranate and apples), bowl with narcissus, goldfish bowl and a stone chime (*qing*)

Eighteenth century, made at Suzhou
Gilded lacquer inlaid with ivory, coral, turquoise, crystal, jade, amber, mother-of-pearl and other semi-precious stones, 12.5 × 39.2 × 39.2 cm
The Palace Museum, Beijing, Gu115381
SELECT REFERENCE: Nakamura and Nishigami 1998, pl.258

290

Diaper-shaped box decorated with the emblems of the Eight Immortals

Eighteenth century, made at the Qing court
Bamboo veneer inlaid with mother-of-pearl, jade and stained ivory, 6.5 × 24.2 × 15.9 cm
The Palace Museum, Beijing, Xin136436
SELECT REFERENCES: Tokyo 1985, pl.68; Chicago 2004, fig.348

Certain materials used in China were particularly appropriate for boxes. Primary among these was lacquer, employed in abundance from the sixth century BC. Tombs in the south, in present-day Hubei and Hunan Provinces, have revealed numerous examples. Lacquer, wood and bamboo remained the central materials for boxes down to the present day. All three could be shaped and carved. In addition all three, but most especially lacquer, could be painted and inlaid. These techniques are displayed in the boxes discussed here.

Boxes were employed to store food, precious items and ordinary possessions. They had a particular function as containers for gifts. Once used to convey a gift, the box was often returned to the giver, the contents rather than the box having been the gift.[1] The boxes discussed here all convey auspicious messages, and these suggest that they may indeed have been intended to hold gifts. Two feature auspicious double-gourd motifs in their decoration.

The eight-sided box (cat.289) may have been made to celebrate the eightieth birthday of the Qianlong Emperor. The decorative inlay of plants and objects can be 'read' in several separate combinations to compose distinct sayings that offer good wishes. A double-gourd vase inscribed with the characters for 'great fortune', 大吉 (*da ji*), holds auspicious plants and fruits, while plants, a goldfish bowl and a stone chime are scattered around it. The double-gourd vase (*ping* 瓶) together with its inscription, constitute a visual pun for *pingan da ji* 平安大吉, peace and good fortune; while the box itself, *he* 和, and the prunus blossoms, *mei* 梅, in the vase stand

for *he he mei mei*, 和和美美, harmony and beauty. Wishes for longevity and endurance are expressed in metaphors both visual and semantic: the pine traditionally symbolises long life, while the Chinese name for the red-berried nandinia, *tianzhu* 天竹 (literally, heavenly bamboo), provides a homophone for *zhu* 祝, to wish: the two plants, therefore, evoke the traditional wish *wannian changqing* 萬年長青 (may you have eternal youth for ten thousand years). In other auspicious combinations, the pine, prunus and nandinia present the 'three friends of winter', plants that flourish in extreme conditions; while the goldfish, *jin yu* 金, in a bowl can be read as *jin yu man tang* 金玉滿堂 (may gold and jade fill your hall [household]). The word for fish, *yu* 魚, also presents a homophone for the word for plenty, *yu* 餘; while the name for the stone chime, *qing* 磬, puns for *qing* 慶, meaning to celebrate or congratulate: when combined together, these two images form a rebus evoking the saying, *ji qing you yu* 吉慶有餘, meaning to overflow with auspiciousness.

The decorative motifs on the box include green apples, *qing pingguo* 青苹果, evoking the auspicious saying *qingping wufu* 清平五福 (peace and tranquillity with the five blessings); and the narcissus, *shuixian* 水仙 (literally, immortal of the water), which stands for early spring and eternal youth. Grapes and pomegranates suggest wishes for many offspring, explaining the significance of the pomegranate-shaped box (cat.288).

The diaper-shaped box (cat.290) carries the emblems of the group of deities known as the Eight Immortals. These Daoist adepts were said to have lived in the Tang period (618–907) and are represented by emblems as follows: Zhongli Quan – a fan; Lü Dongbin – a flywhisk; Li Tieguai – a crutch and a gourd; Zhang Guolao – a mule and a tube drum with iron sticks; Han Xiangzi – a flute; Cao Guojiu – castanets or a flywhisk; Lan Caihe – percussion instrument; He Xiangu (the only woman) – a basket of *lingzhi* (longevity fungus), peaches or a lotus flower. JR

291

Carving of an immortal in a raft

Early Qing dynasty, seventeenth century
Bamboo root, 15 × 26 × 13 cm
The Palace Museum, Beijing, Gu120208
SELECT REFERENCES: Hong Kong 1978,
p.355; New York 1983, p.91; Hong Kong
1986, p.90; New York 1987, p.175

Bamboo has been associated with
scholars since the time of the famous
Seven Sages of the Bamboo Grove,
the celebrated group of scholars of
the third century AD. It had also
been used for writing on bamboo
slips in the Han dynasty (206 BC–
AD 220). Bamboo painting has
connotations of integrity, as the
plant is able to bend in the wind
without breaking. While the curved
stem of the bamboo tree was ideal
for use as a brushpot when hollowed
out, the denser root, which spreads
quickly underground when growing,
was often used for carvings in the
round such as this.

The figure reclining in the boat
may be one of the Eight Daoist
Immortals, or possibly Dongfang
Shuo. He wears a leaf as a hat
and carries the magic fungus of
immortality, *lingzhi*, on which the
shape of *ruyi* sceptres is based.
Dongfang Shuo, whose real name
was Zhang Shaoping (b. 160 BC),
was a humorous figure who was
reputed to have stolen the peaches
of immortality – which ripened only
once every three thousand years –
from Xiwangmu, the Queen
Mother of the West. He is often
depicted in paintings, carvings and
ceramics because of his association
with immortality. The peaches can
be seen in the boat, together with
other auspicious fruit such as
pomegranates and a 'Buddha's
hand' finger citron. JVP

292

Peach-shaped brush washer glazed
in imitation of Song dynasty
'official' (*guan*) ware

Yongzheng period, Jingdezhen,
Jiangxi Province
Dark-stained porcelain with crackled
celadon glaze, width 26.4 cm
The Palace Museum, Beijing, Gu151932
SELECT REFERENCES: Qing Porcelain 1989,
p.254, pl.83; Peng Qingyun 1993, p.431,
no.900; Yang Jingrong 1999, pl.207

293

Teapot and cover in the form of
a basket full of peaches

Kangxi period, Jingdezhen, Jiangxi Province
Porcelain with underglaze copper-red and
cobalt-blue, height 12.8 cm
The Palace Museum, Beijing, Gu147356
SELECT REFERENCES: Qing Porcelain 1989,
p.32, pl.15; Peng Qingyun 1993, p.420,
no.857; Geng Baochang 2000, pl.186; Wang
Qingzheng 2000, vol.2, pl.17

294

Peach-shaped box and cover carved
with a 'long life' (*shou*) character
among dragons and clouds

Qianlong period, 1790, commissioned by
court officials for the Qianlong Emperor's
eightieth birthday
Pieces of coral on gold, 19.5 × 23 × 20 cm
The Palace Museum, Beijing, Gu11647
SELECT REFERENCES: Shizuoka 1988, cat.13;
Tokyo 1995, cat.20; Santa Ana 2000, p.64,
top; Xu Qixian 2004, pl.24

295

Water pot for a writing table in
the form of a peach branch bearing
two fruit, painted with leaves and
two bats

Yongzheng period, Palace Workshops,
Beijing
Enamels on copper, 7.7 × 13.5 × 14 cm
Yongzheng four-character reign mark in
black enamel on the base
The Palace Museum, Beijing, Gu116782
SELECT REFERENCE: Li Jiufang 2002, pl.194

296

Peach-shaped lacquer box
and cover with a branch and
two peaches in relief, painted with
fruiting and flowering peach
branches, bamboo, longevity fungus
(*lingzhi*) and five bats, containing
nine cups in the form of peaches
and one shaped like a peach
blossom

Qianlong period, Palace Workshops, Beijing
Cinnabar lacquer on wood with colours and
gilding, 17.5 × 53 cm
The Palace Museum, Beijing, Gu113491, 6
SELECT REFERENCES: Tokyo 1985, cat.62;
Zhu Jiajin 1993, pl.42

'Peaches of immortality' are among
China's most important auspicious
symbols. Clearly recognisable by its
asymmetric heart shape, often with
a curved ridge down one side, the
peach appears in a wide range of
contexts and was the favoured motif
for birthday wishes, for the Emperor
as well as for commoners. It was
popular under all three emperors as
the present objects show, but its use
in Chinese decorative arts pervades
many dynasties.

Peaches feature in innumerable
popular stories, often of Daoist

connotation, as the search for
immortality was one of the Daoists'
main concerns. The God of
Longevity (Shou Lao) is generally
shown holding a peach. Peaches
bestowing immortality, which flower
once every 3,000 years and require
another 3,000 to bear fruit, are said
to grow in the garden of the Queen
Mother of the West (Xiwangmu),
the main Daoist female deity. In the
popular novel *Journey to the West*
(*Xiyou ji*) by Wu Cheng'en (c.1500–
c.1582) the naughty but resourceful
protagonist, Monkey, steals these
peaches and becomes immortal, and
is therefore often seen with a peach
(see cat.167).

The popularity of the peach,
however, probably goes back much
further. Peach blossoms as symbols
of spring are already linked to
marriage in the *Book of Poetry*
(*Shijing*), an anthology attributed
to Confucius (551–479 BC); and, in
his *Record of the Peach Blossom Spring*
(*Taohuayuan ji*), the poet Tao Qian
(365–427) describes a peach orchard
where a fisherman enters through
a gap discovered by chance into a
paradisiacal world.

In the Yongzheng and Qianlong
periods, the wish for 'endless long
life and the five blessings' –
sometimes listed as longevity,
wealth, tranquillity, virtue, and
a natural death – was expressed
through combinations of nine
peaches (*jiu* 九, 'nine', as
homophone for *jiu* 久, 'endless')
and five bats (*fu* 蝠, 'bat', as
homophone for *fu* 福, 'blessing')
(see also cat.181). RK

297

Tapestry with goats and
boys depicting 'the auspicious
beginning of spring'

Qianlong period, made at Suzhou
Kesi 'cut silk' tapestry, 213 × 119 cm
Rhymed inscription in running script
(*xingshu*) by the Qianlong Emperor
Eleven seals including *Guxi tianzi zhi bao*,
You ri zizi, *Shiqu baoji*, *Sanxi tang jingjian xi*,
Jiaqing yu jian zhi bao
The Palace Museum, Beijing, Gu72695
SELECT REFERENCES: Zhu Jiajin 1986, no.98;
Cleveland 1997, no.59; Bickford 1999

298

Carving of three goats and
a lychee branch

Mid-Qing dynasty
Jade with brown 'skin' markings on *hongmu*
(mahogany) base, 10.3 × 16.6 × 16.2 cm

The Palace Museum, Beijing, Gu103219
SELECT REFERENCE: Li Jiufang 1991, no.307

299

Carving depicting three goats on a mountain

Qianlong period
Aventurine glass with fitted boxwood stand, 21.6 × 13.6 × 24.8 cm
Qianlong four-character seal mark engraved on the base
The Palace Museum, Beijing, Gu107221
SELECT REFERENCES: Shi Shuqing 1994, pl.128; Zhang Rong 1998, p.40

Goats and sheep are collectively called *yang* (羊) in Chinese. Often, the two animals are not always clearly distinguishable from each other; what matters, however, is that the image is sufficiently recognisable as a goat/sheep to convey the visual pun intended. Sheep appear early in Chinese imagery as *yang* sounds like *xiang* (祥), meaning auspicious or lucky. As early as the Han dynasty (206 BC–AD 220), tombs were decorated with the sheep motif to assure good fortune for the deceased.

Later, in the Qing period, images of goats and sheep were more specifically associated with *yang* (陽), the masculine, positive or warm principle in nature, whose opposite is *yin*, the female, negative or cold element in *yin/yang* cosmology. Using a special weaving technique called *kesi*, which was introduced into China by Uighurs living in the northwest regions at around the time of the Tang (618–907) to Song (960–1279) dynasties, and was especially popular during the Qianlong Emperor's reign, the monumental silk tapestry (cat.297) depicts nine goats and three male children in a garden, on its front and on its back in mirror image. The design, modelled after a Song dynasty archetype, is a visual pun for dispelling the cold, and welcoming spring. The tapestry would have hung in the palace during the first month of the lunar year. Maggie Bickford shows that the nine rams refer to the nine *yang* (陽), the nine nine-day periods that begin from the winter solstice (22 December). The end of this period, eighty-one days later, signals the end of winter and the propitious beginning of spring. Pictures depicting nine nines, or nine goats, are therefore rebuses for counting down this period of time. A second auspicious rebus is

signified by the three male children playing with goats. Playing with goats (*xiyang* 戲羊) is a rebus for propitiousness (*jixiang* 吉祥). Three boys (*sanyang* 三陽) refers to the favourable arrival of spring, as the phrase *sanyang kai tai* (三陽開泰) refers to the period between the winter solstice and New Year, when the *yin* is in decline and the *yang* emergent, as is detailed in the hexagram chart based on the *Yijing* (易經) or *Book of Changes*. The aventurine glass (cat.299) and jade carvings of three goats (*san yang* 三羊, cat.298) also allude to the auspicious approach of spring. HK

300

Carving of two boys washing an elephant

Eighteenth century
Greenish-white jade, height 20.4 cm
The Palace Museum, Beijing, Gu90193
SELECT REFERENCE: Zhang Guangwen 1995, no.98

301

Vase decorated with flower sprays and three boys modelled in the round

Qianlong period
Porcelain with *famille-rose* enamels, height 21 cm
Qianlong six-character mark in seal script written in underglaze blue on the base
The Palace Museum, Beijing, Gu152323
SELECT REFERENCE: Tokyo 1995, no.90

Images of boys abound in Chinese art as they were intended to encourage and celebrate the birth of sons. The strong desire for sons was related to the Confucian injunction to have male heirs in order to perform the ancestral sacrifices and ensure the continuation of the family line.

Boys were depicted with a number of different objects to create a variety of auspicious visual puns. The porcelain vase (cat.301) with three playing boys may be a rebus for the phrase *zisun ping'an* (子孫平安 'peace among sons and grandsons'), as the word for vase (*ping* 瓶) sounds like the first character of the word for peace (*ping'an* 平安). The jade carving depicting two boys washing an elephant (cat.300) is a visual pun, as the term for washing an elephant (*xi xiang* 洗象) is a homonym for the term *jixiang* (吉祥 lucky or propitious). HK

302

Blue-and-white jar with ten thousand 'long life' (*shou*) characters

Kangxi period, Jingdezhen, Jiangxi Province
Porcelain with underglaze cobalt-blue, height 77 cm
The Palace Museum, Beijing, Gu156997
SELECT REFERENCES: Geng Baochang 2000, pl.5; Versailles 2004, cat.64

This monumental jar, a birthday gift for the Kangxi Emperor, represents a *tour de force* of both the potters and the calligraphers of the imperial kilns at Jingdezhen. Blue-and-white porcelain, which is painted before the porcelain is glazed and fired, could not be made in the Palace Workshops. Developed in Jingdezhen in the fourteenth century, it remained popular throughout the Qing period, even if other, newer types were then receiving more attention.

One hundred *shou* (long life) characters (*baishou zi*) written in different forms, some adhering more closely to conventional seal script than others, are a popular decorative birthday motif, but the variety here devised for writing this character is unique. Precisely 10,000 different characters are inscribed on this jar: 48 each around rim and foot, two rows of 77 on top of the rim, and 75 times 130 on the body. The figure 10,000 (*wan*), the highest number for which a special term and character exist in Chinese, is generally used to indicate an infinite number, 10,000 *shou* characters signifying eternal life. RK

303

Wall-hanging with auspicious emblems

Qianlong period
Embroidered silk, 250 × 360 cm
C. and C. Bruckner
SELECT REFERENCE: London n.d., no.17

This wall hanging may have been created for an imperial birthday. Sixty *shou* characters embroidered in red and in various archaic styles sit atop open lotus blossoms against a dark blue ground embroidered with a swastika design in gold thread. *Shou* (壽) means longevity and sixty of these characters depicted in red, an auspicious colour, suggest that this hanging was made to celebrate a sixtieth birthday. The swastika motif, an ancient symbol from West Asia which was introduced into China

through Buddhism, means 'ten thousand' and thus reinforces the wish for longevity. The lotus is a symbol of purity and rebirth, and because the Chinese names for lotus, *hehua* (荷花) and *lianhua* (蓮花), sound like the characters for peace (*he* 盒) and continuity (*lian* 連), its inclusion in the design suggests a wish for many more peaceful years to come. The lower edge of the hanging resembles Qing court robes and depicts a three-peaked mountain in the centre (representing the Earth), rising above multicoloured water and crested waves and flanked by coral branches, cloud-scroll head sceptres, scrolls and rhinoceros horns. From the Ming dynasty onwards, these objects were often put together in groups of eight, called *babao*, to symbolise wealth and good fortune. Coral is a symbol of longevity and ground rhinoceros horn was believed to have beneficial medicinal properties. Scrolls are a symbol of learning and good fortune and the sceptre with the cloud-scroll head is called *ruyi* 如意, which means 'as you wish'. HK

304

Pair of incense burners

Qianlong period, second half of the eighteenth century

Cloisonné enamel, height 100 cm

British Museum, London, 1931.4-14.1, 1–2

SELECT REFERENCES: Brinker and Lutz 1989, no.323 and pp.133–36; Rawson 1992, fig.142; Taipei 1999, pp.26–33, 48–50; Li Jiufang 2002, pp.22–24

The Qianlong Emperor was an avid collector of treasures from the past (see pp.272–75), and objects made during his reign are often archaistic pieces modelled after relics from antiquity (see cats 202, 206, 210). These flamboyantly decorated censers take their tripod form from an ancient bronze *ding* whose use in the Shang (*c*.1500–*c*.1050 BC) and Zhou periods (*c*.1050–221 BC) was as a ritual food vessel. Here the vessels have been modelled into incense burners, each fitted with a domed openwork cover through which fragrant smoke from burning incense could escape. What normally would be cabriole legs have been replaced by three long-legged cranes, illustrating the inventiveness of the cloisonné artisans during this period. Decorating the entire body and pendant lappets on the cover are

cavorting deer and cranes perched in pine trees in a landscape setting. Deer, cranes and pines are all associated with longevity.

Cloisonné enamel was a foreign technique introduced into China in the Yuan dynasty (1271–1368). Metal strips, called 'cloisons', were bent and arranged on a metal body and the spaces between them filled with a glass paste coloured with metallic oxides which when fired at low temperature fused together to produce enamel. Upon cooling, the enamel shrank so that this firing process had to be repeated several times. The surface was then polished down until the cloisons were visible. In the early stages of cloisonné production, surfaces tended to be pitted with air bubbles due to poor firing control and polishing techniques. By the time of the Qianlong Emperor's reign, artisans were in full control of the technique and were able to produce large-size ornamental pieces, such as incense burners, decorative hanging panels and standing screens. HK

305

Summer robe for a woman

Qianlong period

Silk gauze with polychrome floss silk embroidery, trimmed with silk and metal thread brocade, length 135 cm

The Palace Museum, Beijing, Gu43307

SELECT REFERENCE: Wilson 1986, pp.47–48, 58–59

Women of Manchu descent wore this style of robe. Both the cut and the decoration echo men's styles, but the eight floral roundels, spaced out across the front, back and shoulders, are a distinguishing feminine feature. The deep hem, a schematic representation of the waters and mountains of the earth, is much used as a design element. It is particularly well rendered here, with curling wave crests buffeting the rocks and flinging white spray high into the air. Blooming flowers are nicely captured in the circular format, as are the butterflies. Several stories and puns are associated with the butterfly, and its joyful connotations make it a favourite emblem for women's robes of all kinds.

Another distinctively Chinese motif, associated with best wishes, appears to rise out of the turbulent water at either side of the central mountain on this garment. The beribboned sceptre is known as

a *ruyi* (see cats 273–82), which means 'as you wish'. Examples carved in a variety of materials, as well as depictions of them, were widespread during the Qing dynasty. They were part of a visual vocabulary understood by Chinese people to carry auspicious messages for future prosperity and good fortune. VW

306

Spring/autumn robe for a woman

Qianlong period

Silk with polychrome floss silk embroidery, length 134 cm

The Palace Museum, Beijing, Gu51176

SELECT REFERENCES: Wilson 1986, pp.47–48, 58–59; Chicago 2004, pp.66–67, 70–71

This woman's robe is of the type deemed appropriate for spring or autumn wear. The fact that the garment is lined, rather than padded or unlined, gives us a clue to the seasons for which it was intended.

The green silk surface is strewn with felicitous emblems from the natural world and the hem is edged with gnarled rock formations limited to tones of blue and white. Although the decorative scheme appears symmetrical on either side of the centre seam, there are minor differences in colouring, perhaps because several different hands were at work in the embroidery studio. The two long lengths of green silk that make up each side of the finished gown would have been fixed into frames for embroidering, with artisans sitting on either side of each one. The outlines of the motifs were indicated, but the precise way in which the embroiderers filled them in varied.

Although many women living within the inner imperial palace, whether attendants or members of the élite ruling clan, were accomplished needleworkers, robes such as this were decorated and tailored by professionals. They were worn unbelted and almost reached the floor. An upswept coiffure, with hairpieces and ornamental pins, and high shoes for unbound feet would have completed the ensemble. VW

Endnotes

1 The 'Prosperous Age':
China in the Kangxi, Yongzheng
and Qianlong Reigns
(pp.22–40)
EVELYN S. RAWSKI

1 For a review of this scholarly trend,
see Guy 2002.

2 Court agencies dealing with Tibetan
prelates and Mongol nobles also used
Mongolian as a major language of
communication. On the role of Manchu
in the Qing dynasty, see Crossley and
Rawski 1993.

3 The court gave offices, honours and
Manchu brides to Mongol nobles who
allied themselves to the Qing. Muslim
notables and high-ranking Tibetan
Buddhist prelates were also partially
incorporated into the conquest élite.

4 In the Qing dynasty, present-day Beijing
was called the 'capital' (Jingshi,
Jingcheng) and not 'northern capital'
(Beijing). See Naquin 2000 for
chronologies of name changes for
Beijing.

5 Ding 1999 finds that it was very rare for
bannermen daughters to marry Han
civilian men and the exceptions to the
prohibition were of male bannermen
marrying Han civilian women.

6 See Rawski 1998, pp.31–34, on the
spatial arrangement of the inner court.

7 Bartlett 1991, part one, traces the
evolution of the inner court during the
Yongzheng reign.

8 'Kangxi' is the reign name of the man
whose personal name was Xuanye, so,
strictly speaking, it is incorrect to refer to
this person as 'Kangxi'. The personal
name of an emperor was taboo; the
characters of the personal name could
not be written. See fig.2 for the various
names of emperors.

9 The Chinese customarily put the age of
newborn infants at age one: throughout
this essay, ages will be given in Western
reckoning.

10 Lee et al. 2002, p.594.

11 Wu 1970.

12 See Chia 1993 on the significance of
Rehe/Chengde for the throne's relations
with Mongol, Tibetan and Uighur élites.

13 On the 1780 meeting of the Panchen
Lama and the Qianlong Emperor, see
Zito 1995; see Hevia 1995 for a fresh new
analysis of the Qing response to the
Macartney Embassy.

14 Wu 1970B.

15 According to the Chinese lunar calendar,
the Qianlong reign ended in 1795 but
according to the Western calendar he
did not abdicate until 9 February 1796.
See Hummel 1943, p.372.

16 A detailed examination of the Manchu
conquest is provided in Struve 1984
and Wakeman 1985.

17 On the Zhengs, see Carioti 1996.
Zheng Chenggong later became a
popular deity and a nationalist hero.
Croizier 1977 studies this phenomenon.

18 Dott 2004.

19 For a history of the Qing Imperial
Household Department, see Torbert
1977.

20 Rawski 1998, pp.98–103.

21 Hummel 1943, vol.1, p.328.

22 See Wu 1979 for details on the succession
struggle.

23 Hummel 1943, vol.2, p.916.

24 Zelin 1984.

25 On these reforms, see Herman 1997.

26 Rowe 2001.

27 Bartlett 1991, part one.

28 Hummel 1943, vol.1, p.369.

29 Mote 1988, p.24.

30 Guy 1987; Kuhn 1990.

31 Crossley 1992, p.1468.

32 Bartlett 1991, p.178.

33 Rawski 2004, pp.224–25.

34 Deng 1997; Mazumdar 1998, p.114.

35 Adshead 1997, p.17.

36 Wang 1973.

37 Zhou Bodi 1981, p.420.

38 Chang 1972, p.244; Torbert 1977.

39 Johnson et al. 1985, p.xi.

40 Sommer 2000.

41 Ni Yibin 2003B.

42 Brokaw and Chow 2005.

43 Crossley 1999, pp.297–311.

44 Wadley 1991.

45 Rawski 2005.

46 Dai Yi et al. 1993.

47 Dai Yi et al. 1993, p.4.

48 Gao Xiang 1993, p.14.

49 Frank 1998, p.52.

50 Pomeranz 2000.

51 Perdue 1996; Perdue 1998.

52 Rawski 2004, pp.220–23.

11 The Qianlong Emperor as Art Patron
and the Formation of the Collections
of the Palace Museum, Beijing
(pp.41–53)
GERALD HOLZWARTH

1 When an inventory of the palace
holdings was drawn up in 1914–25, over
7,000 porcelain items were discovered in
two halls, stored in wooden cabinets with
drawers and arranged chronologically.
They were apparently never once taken
out during the Qing dynasty. See Chang
Lin-sheng 1996, p.8.

2 This term is often used on collectors'
seals. The first and last characters in the
titles of the two parts of the imperial
catalogue – Bidian zhulin and Shiqu baoji –
likewise convey this meaning.

3 The National Palace Museum in Taipei
owns 72 such collectors' cabinets, each of
which can hold up to 100 different items.

4 At that time objects in the palace
collection had supernatural functions and
manifested the legitimacy of the rulers.
On the political and religious character
of the palace collections in Chinese
antiquity, see Ledderose 1978–79 and
Ledderose 1985.

5 He modified the seal 'Suitable for Sons
and Grandsons' (Yi er zisun) of Geng
Zhaozhong to produce a seal of his own

with almost the same caption (Yi zisun)
and of very similar appearance.

6 Sanxitang ji. See Qing Gaozong yuzhi shiwen
quanji, vol.1, Yuzhi wen chuji, juan 4,
pp.6a–7b.

7 'Shi xi xian, xian xi sheng, sheng xi tian.'

8 The Qing Gaozong yuzhi shiwen quanji
(Complete Collection of the Poetry and Prose
Composed by Gaozong [the Qianlong Emperor],
of the Qing Dynasty) was published between
1749 and 1800.

9 Wang Xizhi's Kuai xue shi jing tie, one
of the 'Three Rarities', is now in the
National Palace Museum, Taipei.

10 Private collection; see Kansas City 1992,
vol.1, pl.3.

11 Dong Qichang painted the picture for
his friend Chen Jiru (1558–1639) on the
occasion of his visit to the latter's studio,
which was named 'Wanluan Cottage'
and situated at Mount Kun. The
similarly picturesque mountain scenery
on Mount Pan seemingly inspired the
Qianlong Emperor to associate one of the
buildings there with that painting and
with the studio of the famous painter and
art critic.

12 Shiqu baoji sanbian, pp.2067–2070.

13 For both essays see Shiqu baoji xubian,
pp.320–324. The painting is now in
the Liaoning Provincial Museum.

14 Xu Bangda 1984, vol.1, pp.21–26.
A detailed study of the numerous
versions of the composition is given in
Chen Pao-chen 1987. A short discussion
with comparison figures of the two main
versions can be found in Barnhart et al.
1997, pp.49–55. See also Lawton 1973.

15 In 51 BC the famous 'Shique Congress',
at which scholars from all over the
empire attempted to unite the various
schools of Confucianism, was held in
this building.

16 A surrounding moat appears to have
been the distinguishing feature of an
imperial library. The library building
which the Qianlong Emperor had built
in 1776 in the imperial palace for the
storing of the Siku quanshu (Complete Library
of the Four Treasuries) also has a moat and
a bridge in the entrance area. The moat
presumably originally served to protect
the imperial library from the danger of
fire. See also Frances Wood in
this catalogue, pp.61–62.

17 According to a quotation in the
Wenxuan, the term xiqing denotes the
private apartments situated to the west
of the main hall, which were set aside for
leisure and recreation. In the Qing palace
it denoted specifically the imperial
secretariat (Nanshu fang), which was
located in the west wing of the Qianqing
gong. The catalogues of the palace
collection were compiled here and
in the adjoining Hall of Vigorous
Industry (Maoqin dian).

18 Comprehensive guides to this branch
of collecting already existed, the most
famous being the Lun guyan (Dissertation
on Inkstones) of 1388 by Cao Zhao.

19 Shiqu baoji xubian, p.3865.

20 For the inkstones in this catalogue see
Taipei 1997.

21 The complete seal reads 'Dianli jicha si
yin' ('Seal of the Office of Ceremony and
Inspection'). It was placed over the seam
in such a way that half of it was stamped

onto the painting and the other half over the inventory. Hence we are familiar only with the left-hand half of this seal with the last two characters, which is why it is generally known as the 'Siyin half-seal'.

22 Cat. 195 has the oval version of the seal. The painting was not included in the imperial catalogue, so this remained the only seal on it. When the first series of the catalogue was being compiled, the large square version was preferred, but from 1745 the more discreet oval version was used almost exclusively.

23 The works listed in the first series of the catalogue were mainly kept in four halls, each of which had its own seal: the Palace of Heavenly Purity (Qianqing gong), the Hall of Mental Cultivation (Yangxin dian), the Palace of Double Glory (Chonghua gong) and the Imperial Study (Yushu fang). In the second series a fifth main hall was added: the Palace of Tranquil Longevity (Ningshou gong).

24 All eight seals are to be seen, for example, on cats 30 and 78.

25 One of the most prominent seal-cutters for the Qing court was Zhang Zhao, a minister and the Qianlong Emperor's calligraphy tutor.

26 'Rare since antiquity' (guxi) is a quotation from a poem by the Tang poet Du Fu (712–770), which denotes the age of seventy years. On the Emperor's seventieth birthday Peng Yuanrui (1731–1803) wrote a eulogy to him in which he quoted this concept. Thereupon the seal was commissioned, and the Qianlong Emperor wrote a detailed account of the matter. See Shiqu baoji xubian, pp.1403aff.

27 For the Emperor's essay on the seal, see Shiqu baoji xubian, pp.2515ff.

28 The seal gives a quotation from the Book of Documents (Shangshu), Book IV: Grand Plan (Hongfan). The Qianlong Emperor mixes various quotations from the Book: from the nine sections of the Grand Plan he refers to the third, which names the eight tasks of government (bazheng). He also refers to the eighth section, which requires the Emperor to concern himself with all phenomena (shuzheng), meaning natural phenomena such as rain. The Qianlong Emperor takes this to mean concern for the welfare of the people. He relates everything to the eight decades (baxun) of his age. Compare his account in Shiqu baoji xubian, p.246b, and Legge 1960, vol.3, pp.324, 339.

29 Compare the Emperor's account of the matter in Shiqu baoji xubian, p.393.

30 The dates of the Chinese reign periods follow the Chinese system, which is of course based on the lunar calendar. Based on the latter, the year '1795' lasted until the Western calendrical date of 8 February 1796.

31 This title, denoting the father of the Emperor, was first used by China's First Emperor, Qin Shihuang (r.246–210 BC), who bestowed it on his father posthumously. However, the model for the Qianlong Emperor was rather the Emperor Gaozong (r.1127–62) of the Song dynasty. He likewise abdicated voluntarily in 1162 and went on to live for a further 25 years.

32 Compare, for example, cats 16, 78 and 191. In addition to the seals discussed above, some others were more rarely used, such as the 'Seal of the Imperial Appreciation of the Qianlong Era' (Qianlong yushang zhi bao), which were used mostly before 1746, or the seal 'Subsequent Assessment of the Stone Moat [Pavilion]' (Shiqu jijian). This latter was placed alongside inscriptions by the Emperor which he added after 1754 (when the seal was made) on works which had already been included in the first series of the catalogue. These inscriptions, therefore, do not appear in the catalogue. Works from the hand of the Emperor were not given the usual set of six or eight imperial seals, but only a single special seal, 'Kept in the Precious Collection of the Stone Moat [Pavilion]' (Shiqu baoji suo cang), and in 1816 the seal of the third series (Baoji sanbian). After the Qianlong Emperor, the Jiaqing (r.1796–1820) and Xuantong (r.1909–11) Emperors added their imperial collectors' seals.

III Imperial Architecture of the Qing: Palaces and Retreats
(pp.54–62)
FRANCES WOOD

1 Nurgaci (1559–1626) is regarded as the founder of the Qing dynasty though he died before the conquest of China. He was succeeded by his eighth son Hongtaiji (1592–1643). When Hongtaiji died, he was succeeded by his ninth son Fulin (1638–1661) who became the Shunzhi Emperor. Because of Fulin's extreme youth, two regents were appointed to rule, one of whom was Dorgon (1612–1650).

2 Wakeman 1979, p.74, and Duhr 1936, pp.92–94.

3 The major descriptive work on the history of the Forbidden City as a complex of buildings was published by Yu Zhuoyun in 1982; it was translated into English by Graham Hutt (Yu Zhuoyun and Hutt 1984). The best source for the way the Qing emperors used the Forbidden City is Rawski 1998. The most difficult aspect of the Forbidden City's history is attempting the distinction between what is 'Ming' and what is 'Qing'. Though most of the timber structures were rebuilt, often several times, during the Qing, owing to various restrictions such as rules of proportion and design laid out in architectural manuals, the constraints of neighbouring buildings within the walls and the symbolism of the enclosure as the Emperor's residence, it is likely that many buildings were effectively rebuilt and that only subtle changes in interior and exterior decoration distinguished the new from the old.

4 Jiang Shunyuan 2001 sets out the orders for thousands of tree-trunks from Sichuan made throughout the seventeenth and eighteenth centuries.

5 Yu Zhuoyun and Hutt 1984, p.23.

6 Yu Zhuoyun and Hutt 1984, pp.21–22.

7 Liu Lu 2002, p.151.

8 Yu Zhuoyun and Hutt 1984, p.326.

9 Mote 1999, p.620. Mote does not give the source for this statement. It rather conflicts with Liu Lu's assertion that the Qing changed the Forbidden City considerably; I would suggest that, with the exception of certain complexes, such as the Qianlong Emperor's Palace

of Tranquil Longevity, the Qing were constrained by the Ming complex they had inherited.

10 Yu Zhuoyun and Hutt 1984, pp.326–27.

11 Guo Fuxiang 2003, p.33.

12 Liu Lu 2002, p.33. Though called a 'gate' this was, like the other 'gates' in the Forbidden City, a hall.

13 Yu Zhuoyun and Hutt 1984, p.273.

14 Wang Jiapeng 1996, pp.135–52.

15 Chayet 1985, fig. 45.

16 Spirit walls or screens were free-standing walls erected either outside or inside a courtyard entrance, to prevent the entry of evil spirits. Since it was believed in China that evil spirits could only fly in straight lines, they were unable to pass such obstacles.

17 Kang are hollow brick platforms commonly found in houses in north China. Built beneath the windows, they serve as a seating area by day and a bed at night, and are often heated by placing small braziers or the kitchen stove flue beneath them.

18 Guo Fuxiang 2003, p.32.

19 Wang Xizhi, Wang Xianzhi and Wang Xun were collectively known as the 'three rarities' and this sobriquet was later applied to the side wing of the Yangxin dian where rare and highly prized examples of their calligraphy were kept.

20 A similar pavilion was constructed at the Tanzhe Temple, southwest of the city, which was favoured by imperial patronage. This pavilion was illustrated in the memoirs of the late Qing official, Linqing. See Wood 2001, pp.210–11.

21 Liu Lu 2002, p.159.

22 Malone 1934, p.120, states that a glass window was installed for the Emperor in the Changchun yuan summer palace to offer an unrestricted view over the lake.

23 The work included copies of books in the imperial library and others collected all over the country; see Hummel 1943, pp.121–23. An aspect of the project was a search for seditious literature; see Goodrich 1966.

24 Yu Zhuoyun and Hutt 1984, p.49.

25 It is an almost unvarying rule that Chinese buildings have an uneven number of bays.

26 See Hummel 1943, p.330; Chicago 2004, p.35.

27 Yu Zhuoyun and Hutt 1984, pp.207–09.

28 Malone 1934, pp.23–25.

29 Hedin 1932, p.146.

30 Malone 1934, p.76.

31 Malone 1934, pp.72–101.

32 Staunton c.1800, vol.2, p.109.

33 The design was probably based upon paintings of the Tibetan palace which may partly account for its theatricality; Chayet 2004, p.44.

34 Chayet 1985, pp.41–46, 48–50. No one has yet explained the theatricality of these 'Tibetan-style' temples. Many of their side buildings are solid and many of the 'windows' on the Putuozongcheng miao are false, reflecting its solid core. It is interesting to reflect on the possible effect that these decorative but somewhat

misleading complexes had upon their visitors.

35 The painting, Spring Morning in the Han Palace, by Zhou Kun (fl.c.1737–1748) and others, is illustrated in Chung 2004, pp.113–14.

I Images of Imperial Grandeur
(pp.66–68)
JAN STUART

1 Fong 1996, p.555.

2 Nie Chongzheng 1980.

3 Kahn 1985, p.296.

4 Yang Boda 1991, p.347.

5 Washington 2001, p.38.

6 Ebrey 1997.

7 Mette Siggstedt was among the first Western scholars to draw attention to the fears of Cheng Yi (1033–1107) about lack of verisimilitude if a portrait were to be used for a ritual sacrifice. See Siggstedt 1991, p.724.

8 For the power of images, see Freedberg 1989.

9 Washington 2001, p.44.

2 Qing Dynasty Court Painting
(pp.78–83)
NIE CHONGZHENG

1 Nie Chongzheng 1984.

2 Nie Chongzheng 1979; Zeng Jiabao 1990.

3 Zhaolian 1909.

4 In the ninth year of the Qianlong Emperor's reign (1744), Files of Various Kinds of Exquisite Objects under the Imperial Household Department recorded, 'The painters from Chunyu shu (Studio of Spring Shower) and Ruyi guan (As-You-Wish Studio) shall be combined together. Afterwards they are to be called painters instead of artisans. Respect this.'

5 Nie Chongzheng 1982.

6 Xiang Da 1957; Li Ruli 1979.

7 Nie Chongzheng 1995.

8 Nie Chongzheng 1980.

9 Xiang Da 1957B; Nie Chongzheng 1989.

10 Nie Chongzheng 1989B.

11 Yang Boda 1993.

12 Yang Boda 1993B.

3 Ritual
(pp.118–21)
PATRICIA BERGER and YUAN HONGQI

1 Da Qing Shizu Zhang huangdi shilu (Veritable Records of Emperor Shizu Zhang [the Shunzhi Emperor] of the Great Qing), 9.1a–5b.

2 As quoted in Rawski 1998, pp.211 and 213.

3 Arlington and Lewisohn 1935, pp.110–11.

4 Rawski 1998, pp.265–66.

5 Yuzhi gengzhi tu, with images by the court artist Jiao Bingzhen, was published by the Neifu, Beijing, in 1696.

4 Religion
(pp. 130–33)
PATRICIA BERGER

1 Di Cosmo 1999, p. 368.

2 Compiled in 1747 as a manuscript in Manchu entitled *Hesei toktobuha Manjusai wecere metere kooli bithe* and later published in 1782 in Chinese as *Qinding Manzhou jishen jitian dianli*, in *Wenyuange Siku quanshu* (*Complete Library of the Four Treasures* (*Wenyuan ge* edition), v. 657. See Di Cosmo 1999, pp. 354–61.

3 See Farquhar 1978 for the events leading to the *rapprochement* between the Qing emperors and the Tibetan Gelugpa.

4 There is no consensus about the origins of the name 'Manchu'. However, Qing court documents often render 'Manjusri' in Chinese as 'Manshu', rather than as the more usual 'Wenshu', suggesting that the Qing wished subtly to underscore the link between the bodhisattva and the Emperor through the similarity of their names. On the etymology of 'Manchu', see, for example, Huang 1967.

5 See Farquhar 1978.

6 See Nie Chongzheng 1996, no. 18.13.

7 The term *hutuktu* (incarnate) is a Mongolian honorific, while the term 'Zhangjia' is a Sino-Tibetan title, possibly originally referring to a place name, and is untranslatable.

8 Wang Jiapeng 1990, pp. 57–58.

9 For a history of the Zhongzheng dian, see Wang Jiapeng 1991.

10 Among them were the Pavilion of the Rain of Flowers (Yuhua ge), the Hall of Precious Forms (Baoxiang lou), the Hall of Buddhist Brilliance (Fanhua lou), and the Hall of the Buddha Sun (Fori lou), all of which the Qianlong Emperor commissioned for his own and his family's use. See Palace Museum 1992B, pp. 132–65; and Berger 2003, pp. 96–110.

11 On the planning and expansion of the imperial compound at Chengde/Rehe, see Forêt 2000.

12 Chayet 1985, pp. 25–51.

13 Li Guoying 1996.

14 The court carried out Daoist rituals to invoke rain during times of drought. A painting by the Kangxi period court artist Jiao Bingzhen depicts the rite; see Chicago 2000, cat. 44.

5 Territories of the Qing
(pp. 156–60)
EVELYN S. RAWSKI

1 Khordakovsky 1992; Bergholz 1993; and Paine 1996.

2 Rawski 1998, pp. 247–49.

3 It should be noted that the use of the name 'Beijing' in this context is actually an anachronism, as in the Qing dynasty present-day Beijing was called 'the capital' (Jingshi, Jingcheng) and not the 'northern capital' (Beijing). See Naquin 2000 for chronologies of name changes for Beijing.

4 Crossley 1997, pp. 101–04.

5 Millward 1998, p. 28.

6 According to the Chinese lunar calendar the Qianlong reign ended in 1795 but according to the Western calendar the abdication of the Qianlong Emperor did not take place until 9 February 1796: see Hummel 1943, p. 372.

7 Rawski 1998, pp. 67, 69.

6 Diplomats, Jesuits and Foreign Curiosities
(pp. 180–82)
JOANNA WALEY-COHEN

1 On Chengde/Rehe, see Forêt 2000 and Millward et al. 2004. On the Yuanming yuan, see Barme 1996 and Palace Museum 1992, pp. 219–25.

2 Waley-Cohen 1996; Millward 1998; and Crossley 1999.

3 Waley-Cohen 1999, chapters 2 and 3.

4 Clunas 1991.

5 Uitzinger 1993.

7 The Kangxi Emperor: Horseman, Man of Letters, Man of Science
(pp. 210–14)
REGINA KRAHL

1 The full conquest of the Ming empire took several decades and came about through interrelated efforts of Manchu troops, Ming deserters and rebel bands. Beijing was conquered by the regent Dorgon (1612–1650), who became the first de-facto ruler of the Qing. After Dorgon's death, the young Emperor was variously influenced by Chinese and Manchu advisors, Christian and Buddhist teachers, and eunuch, concubine and other interest groups in the palace.

2 The Manchu were a Jurchen tribe, and Nurgaci (1559–1626), the Shunzhi Emperor's grandfather, had in 1616 founded his own Later Jin dynasty. His son, Hongtaiji (1592–1643), had commissioned translations of the Chinese histories of the Liao, Jin and Yuan dynasties (Crossley 1999, p. 190), but deliberately dissociated his dynasty from the tribal past by renaming the Jurchen 'Manchu' in 1635 and the Jin state 'Qing' in 1636.

3 Confucianism guided state rituals; Shamanism and Buddhism were used for political ends to facilitate the interplay between Manchus, Mongols and Tibetans, and together with Daoism also dictated more private religious ceremonies in the inner court; see Rawski 1998.

4 Muslim chiefs had been rewarded with Manchu titles after having helped in the defeat of the Eleuths in the far northwest.

5 The Jesuit missionaries became very influential under the Kangxi Emperor, who admired their scientific knowledge, and had even been able to build a church inside the Forbidden City. The Emperor's tolerance was overstretched, however, when the Papal Legate Charles de Tournon (1668–1710) came to Beijing in 1705 to prohibit the worship of ancestors by Chinese converts, whereupon he insisted that his subjects should not take orders from Rome.

6 The way of 'becoming an emperor' is discussed in Mote 1998, pp. 12ff.

7 Rawski 1998, p. 59, stresses the division in Qing society between conquerors and conquered population, with the bannermen representing a conquest élite. Both bannermen and Han Chinese fulfilled a role in Qing administration.

8 Schmidt-Glintzer 1990, p. 450; and Spence 1990, p. 86.

9 Most Chinese characters are composed of a semantic component, called a 'radical', which indicates the topic of the character and generally derives from a pictograph, and a phonetic component, which indicates its pronunciation. The arrangement of Chinese characters by radicals was devised by Mei Yingzuo (1570–1615) in his *Collection of Characters* (*Zihui*), a dictionary published only after his death, in 1671. The *Kangxi Dictionary*, and most dictionaries thereafter, have been arranged by radicals.

10 Spence 1966, pp. 82ff.

11 Not all the Palace Workshops were located in the Yangxin dian all the time; the enamelling workshops, for example, were at times located in the Hall of Military Eminence (Wuying dian), together with the printing works; but the Yangxin dian appears to have been their core location, so that the department itself became known as the Yangxin dian Zaoban chu.

12 Needham 1959, p. 585.

8 The Yongzheng Emperor: Art Collector and Patron
(pp. 242–45)
REGINA KRAHL

1 Crown Prince Yinreng, the second son of the Kangxi Emperor and Empress Xiaocheng's eldest surviving son, was twice demoted because of unsuitable behaviour, but only pardoned once, with the result that the state had no heir-apparent during the last decade of the Kangxi period, and a power struggle set in among the princes. When the Emperor died, his fourth son, Yinzhen, claimed to have been designated successor on his father's deathbed. The Emperor's will, however, was rumored to have been falsified, so that Yinzhen's accession as the Yongzheng Emperor had the air of a usurpation.

2 He expanded and adapted to his own requirements, for example, the system of secret palace memorials which his father had introduced but had used as a more informal source of information.

3 Such as, for example, the Kangxi Emperor's introduction of state examinations to select scholars to compile the Ming history, or the Qianlong Emperor's donation of archaic bronzes from the imperial collection to the ancestral temple of Confucius in Qufu.

4 Mote 1999, pp. 890ff.

5 See Stuart 1998.

6 Wu Hung 1995.

7 The full series of *Pictures of Tilling and Weaving Portraying Yinzhen* [the later Yongzheng Emperor] (*Yinzhen xiang gengzhi tu*) is illustrated and discussed in Fuchs 1959, illustrated again in Nie Chongzheng 1996, no. 11, and discussed with selected illustrations in Wei Dong 1995, p. 22, and figs 2 a–d. This series of paintings, which was commissioned at least in duplicate, one version inscribed with his own poems, is closely based on the woodblock edition commissioned by the Kangxi Emperor, but the protagonists bear the likeness of the future Emperor and his wife; when no suitable figures appeared in the scenes, they were added. For a Qianlong version of this book, painted on porcelain, see cat. 213.

8 Spence 1990, pp. 88–89.

9 Whereas his father had often written in Manchu, the Yongzheng Emperor seems to have preferred Chinese, and his calligraphy is considered as accomplished.

10 Many of his poses are standard topics of the period. The scholar writing on a cliff face (see cat. 167) – sometimes interpreted as the Song artists Mi Fu (1051–1107) or Su Dongpo (1037–1101) – or leaning against a pine tree (Nie Chongzheng 1996, no. 16.12), for example, are stereotypes found in contemporary painting manuals; the immortal floating on a rootwood raft (Nie Chongzheng 1996, no. 16.9) was a frequent subject of contemporary crafts (see cat. 291).

11 See Stuart 1998, p. 59.

12 For a list of such paintings see Beurdeley 1971, pp. 161ff.

13 Roderick Whitfield elsewhere has translated *Guwan tu* as *Scrolls of Antiquities*. See Whitfield 1986.

14 Ancient cloisonné and lacquer wares, for example, are completely absent.

15 Commissions for stands in different woods or in lacquer, and for boxes, are listed in the Palace Workshop (Zaoban chu) records from the first year of the Yongzheng reign onwards (Zhu Jiajin 2003, passim).

16 The *Pictures of Ancient Playthings* show a Buddhist holy water bottle (*kundika*), of either Tang (618–907) or Koryŏ (Korean, 918–1392) origin, and a figure of Laozi, the founder of Daoist thought, riding on a water buffalo. As soon as he ascended the throne, the Emperor commissioned wooden covers with jade knobs for archaic bronzes in his collection (Zhu Jiajin 2003, pp. 9ff.).

17 The selection of Song ceramics consists almost exclusively of the wares made for the court, Ru and *guan*; the group of Ming porcelains includes virtually the full range of Xuande (1426–35) wares and a few pieces from the Chenghua reign (1465–87) but little else.

18 Pieces such as a Songhua inkstone (shown in cat. 173), a wooden brushpot, a small polychrome (*doucai*) porcelain water pot, blue-and-white teapots (all to be seen in cat. 168), and a 'peach-bloom' seal-paste box (see cat. 169), for example, could all have been used in the palace during the Kangxi reign. They do not quite seem to fit in with the rest in terms of rarity and taste.

19 Zhu Jiajin 2003, pp. 4–6, lists 160 artisans known by name who worked in the Palace Workshops during the Yongzheng reign.

20 Among the 160 artisans known by name (see note 19) only four are foreigners: Castiglione in the painting workshop, two others in the spectacle workshop, and one working on clocks.

21 Archaism was not the Yongzheng Emperor's invention; on the contrary, his rediscovery of archaism itself could be

called a manner of echoing the past, since the imitation of the antique (*fang gu*) was a stylistic trend identified in particular with the Song dynasty.

22 Compare Nie Chongzheng 1996 nos 12.4 and 25 (plucking *lingzhi*), Nie Chongzheng 1996, nos 20.12 and 30 (snowy weather) and fig. 2, and Wu 1995, fig. 18 (antiques); in each case the Yongzheng version is dominated by scenery, the Qianlong version by the Emperor himself.

23 To the Yongzheng period, for example, in Chicago 2004; to the Qianlong period in Wu Hung 1995.

9 The Qianlong Emperor:
 Virtue and the
 Possession of Antiquity
 (pp. 272–75)
 JESSICA RAWSON

1 Ledderose 1978–79 discusses the origins of the imperial collections in objects, texts and maps that were thought to be integral to the legitimacy of the rulers. The most famous ruler, who was said to have lost the bronzes of his predecessors, was the First Emperor (r. 221–210 BC) of the Qin dynasty.

2 See Rawski 1998, pp. 51–55 for an account of the contribution of works of art to the rulership of the eighteenth-century emperors.

3 Kahn 1971, pp. 144–67, describes some of the scholars who instructed Hongli when a prince.

4 The failure of the First Emperor to retrieve the bronze vessels of the Zhou was renowned through the record made by Sima Qian in the chapter on the First Emperor in the *Shiji* (*Records of the Grand Historian*); see Watson 1993B, p. 49. In Han times, when Sima Qian was writing, this failure was deemed evidence that the First Emperor lacked the proper moral character to be accepted as Emperor by Heaven.

5 See comments by Jan Stuart in Chicago 2004, p. 221.

6 A major chronological project is underway in which the Xia dynasty is included; Beijing 2000. However, the archaeological finds are not accompanied by contemporary texts.

7 For a general introduction to the archaeology of ancient China and especially the ancient ritual vessels, see Rawson 1996, pp. 15–22, 85–162.

8 Keightley 2000.

9 See James Legge's translation of the *Liji*, 11, 'The inscriber discourses about and panegyrises the virtues and goodness of his ancestors, their merits and zeal, their services and toils, the congratulations and rewards (given to them), their fame recognised by all under heaven; in the discussion of these things on his spiritual vessels, he makes himself famous; and thus he sacrifices to his ancestors. In the celebration of his ancestors he exalts his filial piety. That he himself appears after them is natural. And in the clear showing (of all this) to future generations, he is giving instruction' (Legge 1885, part IV, p. 251).

10 Ancient textual references are fully annotated and discussed in Barnard 1973.

11 Taipei 2003, no. II–05. Song antiquarian study had an early exponent in the work of Li Gonglin (*c*. 1041–1106); see Harrist 1995.

12 For discussions of the different ways in which the bronzes were viewed, collected and understood, see Rawson 1993 and Rawson 2004.

13 Ming period paintings illustrating such gatherings are shown in Taipei 2003, nos 1–44, 1–45, 1–46. For a discussion of collecting in the Ming period, see Clunas 1991, pp. 91–116.

14 For comments on Song period archaism see Erickson 2001 and Rawson 2001.

15 See Peter Lam's translation of a memorial to the Emperor in 1772; Chicago 2004, pp. 228–29.

16 Chang Lin-sheng 1996, p. 21, reports that the Qianlong Emperor viewed *Clearing after Snowfall* by Wang Xizhi 32 times between 1746 and 1792. On each occasion he wrote a colophon in the album.

17 Ledderose 1979, p. 20.

18 Woodside 2002, pp. 282–89.

10 Silent Satisfactions:
 Painting and Calligraphy of
 the Chinese Educated Elite
 (pp. 308–11)
 ALFREDA MURCK

1 A precedent was established by Confucius who was said to have worded historical commentaries to convey moral evaluations (literally praise and blame, *baobian*) in editing the *Spring and Autumn Annals* (*Lushi Chunqiu*). On criticism see Owen 1992, pp. 46, 261.

2 Scott 1990.

3 Kim 1996, pp. 61–65, 109–12; and Murck 2000.

4 Silbergeld 1981; Kim 1996; Meyer-Fong 2003, pp. 32–34; and Bai 2003.

5 Of the 26 paintings, one was painted for an emperor (cat. 266) and three have Qianlong imperial seals (see cats 242, 243); the others entered the Palace Museum, Beijing, after it was established in 1925.

6 Riely 1992.

7 Bai 2003, pp. 40–46.

8 Li 1995.

9 Meyer-Fong 2003.

10 McNair 1998.

11 Bai 2003, pp. 102–03, 260.

12 Kim 1996, pp. 93–102.

13 Mote 1999, pp. 863–65.

14 Goodrich 1966; and Spence 2001.

15 See Kao 1986, pp. 130–31, for a summary of these and other devices.

16 Allusive substitution in colloquial language can be called 'Pointing to the mulberry and lambasting the cassia' (*zhi sang ma huai*); criticism, because it is directed at a proxy, can be bolder.

17 The author of the brilliant novel *Plum in the Golden Vase* (*Jinpingmei*, published *c*. 1617) hints that the sleazy protagonist Ximen Qing is a surrogate for Emperor Huizong (r. 1100–25) of the story's time, who, in turn, is a surrogate for the self-

indulgent Wanli Emperor (r. 1573–1615) of the author's time. Roy 1993, p. xxxi.

18 Gong Xiaowei 1993, pp. 14–20.

19 Bartholomew 1985; and Ni Yibin 2003.

20 See Murck 2000, p. 167–73, on Huang Tingjian evoking water/tears to grieve for his friend Su Shi.

21 Scott 1990, p. 139.

11 The Auspicious Universe
 (pp. 358–61)
 JESSICA RAWSON

1 Rawson 2004B compares the ornamental systems in China and in the Mediterranean area.

2 Waley 1954, nos 87 and 169 for example.

3 The history and widespread currency of this text is discussed in Nylan 2001.

4 For general references to the links between flowers and Buddhism, see Goody 1993, p. 329. Compare Nakamura 1958. I am indebted for these references to Josh Yiu.

5 This argument has been made by Ellen Laing as the principal support for her views on the emergence of flower motifs and designs; see Laing 1994.

6 The lotus flower appears as early as the Han period, first–second centuries AD, in the ceilings of tombs. Henan 1993, p. 207, illustrates a ceiling with an imitation wooden framework painted on the ceiling and a lotus at the centre. For the flower scrolls that permeate Buddhist cave temples, see Rawson 1984, pp. 64–88. These were a direct import from Central Asia and sites much further west.

7 The images that we have come from paintings and carvings in tombs of the fourth and sixth centuries AD; see a late fifth-century decorated house-shaped coffin from a tomb at Datong in Shanxi Province (Wang Yintian and Liu Junxi 2001) and the sixth-century tomb of Anjia (Shaanxi 2001 and Shaanxi 2003).

8 For some observations on the divinations of the Shang period (*c*. 1200 BC), see Keightley 2000.

9 For discussions of the conceptions of the universe, see Wang 2000 and Rawson 2000.

10 As Sturman 1990, p. 34, points out, the concept of communication was particularly well illustrated by 'literal messages occasionally discovered on rocks or in tree trunks'.

11 Sturman 1990, p. 36; and Bickford 2002–03.

12 The seminal discussion of this practice is Stein 1990. See also Ledderose 1983.

13 For Sima Qian's mention of the palace in the form of a constellation, see Watson 1993B, p. 56. The First Emperor also had made models in the form of the halls and palaces of the states the Emperor had conquered; see Watson 1993B, p. 45. This activity is reminiscent of the Qing Emperors' constructions at Chengde of temples in the forms of those of their conquered territories. For the Shanglin park, see Watson 1961, vol. 2, pp. 308–18.

14 Hargett 1988–89.

15 Chung 2004, pp. 117–19.

16 *Xiyou ji* (*Journey to the West*) is best known in the West in Arthur Waley's shortened translation, *Monkey* (Waley 1942).

17 See Chicago 2000, nos 76, 79, 91, 117.

18 We have some impression of the ways in which walls of palaces and mansions were decorated from texts and from tombs. For a fine Tang painting of a peony and ducks in a tomb, see Beijing 1995. Wall paintings in the Song palace are discussed in Jang 1992.

19 Ledderose 1973.

20 Maggie Bickford's work has been innovative here, showing that subjects that were previously thought to be the province of the literati élite were originally part of an auspicious enterprise shared by élite and peasant alike (Bickford 1999).

21 These puns proved an especially effective way of linking a large number of diverse motifs; see Bartholomew 1985 and Bai 1999.

22 Bickford 1999 provides a full and detailed discussion of the piece and the rebus contained within it.

23 For a discussion of the gourd as a bearer of many meanings, see Wan forthcoming.

24 Li Shutong 1967.

25 Nozaki 1980 illustrates a very large variety of combinations.

Endnotes to the catalogue entries
(pp. 384–470)

11
1 André Gide, *Oeuvres complètes*, Paris, 1972, pp. 893–94.

13
1 For the Three Feudatories rebellion, see Hummel 1943, pp. 108–10.

2 Zhang Ying 1968.

3 Hearn 1990, p. 109.

4 *Kangxi qijuzhu*, p. 1845.

16
1 Giuseppe Castiglione, Tang Dai, Chen Mei, Shen Yuan, Sun Hu and Ding Guanpeng, *Enjoying Snow Scenery* (*Xuejing xingle tu*), dated 1738, with eleven children depicted (see Wan Yi, Wang Shuqing and Lu Yanzhen 1985, fig. 433). Giuseppe Castiglione, Shen Yuan, Zhou Kun and Ding Guanpeng, *Emperor Qianlong Enjoying Snow Scenery* (*Qianlong xuejing xingle tu*), with eighteen children depicted (see Nie Chongzheng 1986, no. 31). These are probably later works, made in imitation of this first, unsigned painting by Castiglione.

2 Tang Wenji and Luo Qingsi 1994, pp. 462–64.

3 Compare cat. 186. The painting can be interpreted as a hidden hint that Prince Hongli, the future Qianlong Emperor, had been chosen as his heir by the Yongzheng Emperor.

24
1 Hummel 1943, pp. 844–45.

2 New York 2002, pp. 82–83.

3 Wang Yuanqi et al. 1718.

4 For a map of the route, see Hong Kong 1989, p. 80.

29
1 See Nie Chongzheng 1992, pl. 87; and Li Shi 2002, p. 12.

2 See Nie Chongzheng 1992, pls 51–53.

3 Hou Ching-lang and Pirazzoli 1979.

30
1 *Shiqu baoji xubian*, pp. 2272–84.

2 *Shiqu baoji xubian*, pp. 765ff. The text of the Emperor's poetic essay is recorded in this source.

3 *Shiqu baoji xubian*, p. 1279. Chicago 2004, fig. 137. That scroll, which seems to be an earlier version, has much more realistic detail. The skaters balance children on their shoulders and on long poles, waving flags and doing handstands.

38
1 The second scroll is kept in the Musée Guimet, Paris. See fig. 42.

39
1 On confession, see Beresford 1993. The exact sequence of these 35 Buddhas is unclear but appears to follow a crisscrossing pattern beginning with the central scroll. The Five Buddhas are precisely distinguished by attributes, *mudra* and colour. They are, from left to right: Ratnasambhava (south), triple gem, *varada* (gift bestowing) *mudra*, yellow; Amitabha (west), bowl, *dhyana* (meditation) *mudra*, red; Vairocana (centre), no visible attribute, *uttarabodhi* (supreme perfection) *mudra*, white;

Aksobhya (east), *bhumisparsa* (earth-touching) *mudra*, blue; and Amoghasiddhi (north), sword, *vitarka* (discussion) *mudra*, green.

2 The *Sutra of the Three Heaps* (*Triskandhadharmasutra*; Tibetan: *Phung po gsum pa'i mdo*) is the main textual source for the practice of confession. An authoritative text on the iconography of the 35 Buddhas, especially for the Tibetan Gelugpa and for the Qing court, is a manual by Blo bzang grags pa'i dpal (1357–1419), the *Sangs rgyas so lnga'i mngon rtogs dang lha sku'i phyag tshad* (*Iconography and Iconometry of the 35 Buddhas*), which articulates the teachings of the Gelugpa founder, Tsongkhapa.

40
1 The text is translated in Wayman 1985. For Manjusri Namasamgiti's iconography see Mallmann 1964, pp. 52–56.

2 Three Yongle period Tiksna-Manjusri images are still in the Red Palace and the Jokhang, Lhasa; see Schroeder 2001, nos 354a–c. Three other examples are in the British Museum, London (Schroeder 1981, no. 144G); the State Hermitage Museum, St Petersburg (Rhie and Thurman 1991, no. 39); and the Palace Museum, Beijing (Palace Museum 2002B, no. 215).

3 Clark 1937, II, no. 155, p. 263.

41
1 See, for example, other Western Tibetan bronze images ranging in date from the late twelfth to the early fifteenth centuries, in Rhie and Thurman 1991, nos 138–43; Schroeder 1981, nos 34A–B, 38E and 39D–E; and Palace Museum 2002B, nos 128–29, 131–33 and 147–50.

42
1 For Lhamo's complete iconography, see Nebesky-Wojkowitz 1956, pp. 22–37.

2 This thangka is one of several similar paintings of the horrific Great Protectress made there at about the same time, though in different techniques. See, for example, Palace Museum 2002B, nos 141 (in full colour) and 143 (in cinnabar on black). It is also similar to a series of black-ground images, some of them augmented ink rubbings, that the Qianlong Emperor commissioned in the late 1770s. The best known of these are a group of Seven Buddhas, based on paintings the Sixth Panchen Lama sent to the court in 1777 and later immortalised as stone engravings at the Seven Buddha Pagoda at Beihai, just west of the Forbidden City. See *Precious Deposits*, v. 4, no. 47; and Palace Museum 2002B, nos 89–95.

47
1 For all eight versions, see London n.d., pp. 20–21.

2 See Berger 2003, pp. 54–61.

3 Chayet 1985, pp. 28–34.

53
1 Macau 2003, no. 82.

66–68
1 Elliott 2001, p. 8.

2 Chicago 2004, p. 101.

3 Wang Zilin 1994, p. 91.

77
1 Hostetler 2001, p. 42.

78
1 The New Year's banquet at the Pavilion of Purple Brightness became an annual custom during the reign of the Qianlong Emperor. Thus the scroll may equally depict a later one. In the imperial catalogue, it is described as an annual banquet, but this was written in 1791–93, thirty years after the event.

2 See cat. 30 (*Ice Game on the Palace Lake*).

3 The scroll was kept in the main hall of the palace, the Hall of Heavenly Purity (Qianqing gong). After the end of the dynasty it was lost and re-entered the Palace Museum only after 1949.

79
1 Zelin 2002, p. 183.

81
1 See Nie Chongzheng 1992, pl. 125.

123
1 See Chicago 2004, fig. 54.

2 *Yijing*, XVIII, Gu.

149
1 A copy of this document is also included in the collection of the Chester Beatty Library in Dublin (inv. number CBC 1730 [AC123] 1718), where it is entitled 'Imperial Edict on the Disappearance of Four Jesuits'.

168–169
1 Roderick Whitfield elsewhere has translated *Guwan tu* as *Scrolls of Antiquities*. See Whitfield 1986.

186
1 Wu Hung 1996, pp. 223–31.

187
1 The small painting *Spring's Peaceful Message* (cat. 186), depicting the Yongzheng Emperor bestowing his son, Prince Hongli, with a sprig of blossom, may also symbolise this event. The Emperor's act may of course also hint at his choice of the prince as heir to the throne. The occasion would have been New Year: the blue background of the painting points to its purpose as a New Year's picture. It is also remarkable that Prince Hongli wears the same red shoes in both paintings.

192
1 Legge 1960, vol. III, p. 61. Legge translates the passage with the seal quotation: 'Be discriminating, be undivided.' It applies to the self-cultivation of the ruler, who must be of 'pure heart and one mind' (*jing xin yi yi*) to spread virtue among the people.

194
1 Compare cat. 195, which is a copy of that painting by the court painter Ding Guanpeng. Part of the Emperor's inscription is given there.

2 For a more detailed discussion of this iconographic type see cat. 195.

195
1 *Bidian zhulin xubian*, p. 164 (National Palace Museum, Taipei, 1978, pl. 40). Compare cat. 194, which depicts the Emperor looking at this painting by Ding Yunpeng.

2 Millward et al. 2004, pp. 124ff.

3
Bidian zhulin xubian, p. 164. There are some transcription errors in the catalogue text; see the original inscription on the painting.

4
In other versions of this composition this monk is depicted washing the elephant by himself, which indicates his crucial importance in the group.

196
1 See cats 193, 194 and 195, and Edinburgh 2002, no. 56, which is a close copy after a painting by Leng Mei now in the National Palace Museum, Taipei.

2 Berger 2003, pp. 8, 22, 51–54.

3 Berger 2003, p. 86.

4 For detailed illustrations see Wu Hung 1996, figs 98, 168.

5 Berger 2003, pp. 53–54. The drawing is in the Musée de l'Homme, Paris, and the finished handscroll in the Musée Guimet, Paris. The drawing is published in Hong Kong 1997, no. 121.

6 Kahn 1971, p. 183.

198
1 The present mirror does not feature these specific ornaments. Either the wrong mirror was affixed to the screen, or the poems of the Emperor and his ministers were used again later for a different screen. This practice at times can be observed in other examples (see cat. 216).

199
1 *Shiqu baoji xubian*, pp. 4054ff.

204
1 Hummel 1943, p. 503.

211–212
1 For a translation see Watson 1963, pp. 29–30.

2 See Washington 2001, p. 45 and fig. 6.6.

3 For a translation see Watson 1963, pp. 46–48.

214
1 *Shiqu baoji xubian*, pp. 1403–04.

2 Book IV, *The Great Plan* (*Hongfan*), ch. 4 (Legge 1960, III, pp. 234 and 339). For the text of the essay see *Shiqu baoji xubian*, pp. 246–47.

3 See essay by the author in this catalogue, pp. 50–52.

215
1 *Shangshu*, Book IV, *The Great Plan* (*Hongfan*), ch. 4 (Legge 1960, vol. III, p. 324).

2 *Shiqu baoji xubian*, pp. 2448ff.

216
1 Taipei 2002, II-19.

228
1 Zhou Nanquan 1991.

230
1 *Zuozhuan*, *Xuan gong*, 2 (Legge 1960, vol. V, pp. 287–91).

2 *Shiqu baoji xubian*, pp. 2488–89. The text of the essay is recorded in this source.

3 *Shiqu baoji xubian*, p. 3870.

4 The four large seals at the beginning and end of the album are not mentioned in the *Shiqu baoji*. They must have been added after 1793, the date of completion of the catalogue.

238

1 For Daoism and the arts, see Chicago 2000; and particularly, for Wang Meng's version of the theme, p.43.

239

1 New York 1996B, p.114, citing Zhou Lianggong's *Yinrenzhuan*.

240

1 Honolulu 1988, p.164.

241

1 Hightower 1970, p.130.

243

1 From 'Double Ninth at the Cui farmhouse in Lantian', Du Fu 1985, 6.490.

2 From 'Southern Neighbour', Du Fu 1985, 9.760.

3 From 'Guest Arrives', Du Fu 1985, 9.793.

4 From first of 'Two poems inscribed at Zhongming prefect's waterside pavilion on the first of the seventh month [first day of autumn]', Du Fu 1985, 19.1652.

5 From 'Government Belvedere below Xiangji Monastery, Fucheng Prefecture', Du Fu 1985, 12.986.

6 From 'Ascending a Height', Du Fu 1985, 20.1766. Translated in Hawkes 1967, p.205.

7 From 'At dusk ascending Four Peace Monastery's bell tower, sent to Pei Shidi', Du Fu 1985, 9.783, Murck 2000, p.113.

8 From 'His Excellency Yan brings a picnic to the thatched cottage in midsummer', Du Fu 1985, 11.908.

9 From 'Autumn Meditations, second of eight poems', Du Fu 1985, 17.1486. Translated in Hung 1952, p.234, slightly modified.

10 From 'Sending off official Li to serve military commissioner Du', Du Fu 1985, 19.1680.

11 From 'Second of "Two poems inscribed at Zhongming prefect's waterside pavilion on the first of the seventh month [first day of autumn]"', Du Fu 1985, 19.1653.

12 From 'First of two poems inscribed at Recluse Zhang's residence', Du Fu 1985, 1.8.

13 In his colophon Wang Shimin records his age as 74 *sui*, which in Western reckoning equates to 73 years. The discrepancy results from the traditional Chinese method of counting a person's age from the period of gestation, so that at birth a baby was one *sui* and turned two *sui* at the following lunar new year.

14 Qian Qianyi (1582–1664), *Du shi qianzhu*; Qiu Zhao'ao (1638–1713 or after), *Du shi xiangzhu*. The Anhui painter Xiao Yuncong (1596–1673) also wrote annotations.

15 Wang, however, did not discourage his sons and grandsons from serving. One of his nine sons, Wang Shan, was grand secretary from 1712 until 1723 under the Kangxi Emperor.

244

1 Chaves 1993. For Wu Li's biography, see Hummel 1943, pp.875–77.

245

1 New York 1996B, pp.61–63, 114–15, 135–37.

2 Hawkes 1967, pp.45–47.

247

1 Hay 2001, especially chapters four, 'Zhu Ruoji's Destinies', and five, 'The Acknowledgment of Origins'.

2 Hay 2001, p.90.

3 Hay 2001, pp.145–47.

4 Hay 2001, p.89–90.

5 Watson 1961, pp.510–11. This is the same legendary poet-official who is remembered at the Dragon Boat Festival.

248

1 Du Fu wrote this in praise of the unrushed approach of the eighth-century painter Wang Zai.

2 Silbergeld 1974, pp.222–23, slightly modified.

3 Hay 2001, pp.151–52, and Silbergeld 1981, p.406. The handscroll was in the collection of Huang Binhong before entering the Palace Museum.

249

1 Silbergeld 1981, pp.408–09.

2 Chen Shih-hsiang and Acton 1976, p.9.

3 Wu Hung 1998, pp.59–60.

250

1 Murck 2000.

2 Translation from Egan 1994, p.335 (slightly modified). Also see Murck 2000, pp.163–77.

251

1 A popular name for the flower is 'forgetting cares' (*wang yu*).

2 Li Bo (701–762), 'Departing from Inn at Jinling' (Cao Yin 1960, 5.1784).

3 Hummel 1943, p.960.

252

1 Sirén 1963, pp.207–08, slightly modified.

255

1 San Francisco 1990, p.250.

257

1 Chicago 2000, p.272, citing Mary Fong's translation of Chen Wenzhu's *Tianzhong ji* (*Record of Heaven's Centre*, 1589). See Fong 1977, pp.427–28.

258

1 Here the artist uses the term *sui*, generally translated in the West as 'year'. However, in dynastic China, the counting of a person's age included the period of gestation: at birth a baby was one *sui* and turned two *sui* at the following lunar new year. Thus the *sui* count is typically one digit higher than a year count.

2 Bai 2003, pp.118–20.

3 Bai 2003, pp.212–20.

4 Yang Su, 'Sitting alone in Mountain Studio presented to Secretary Xue' (*Shan zhai duzuo zeng Xue neishi*).

259

1 Phoenix 1985, p.149.

2 Meyer-Fong 2003, pp.128–36.

3 Meyer-Fong 2003, especially pp.32–63.

260

1 Li 1974, no.52, and his list on p.248; in addition albums in San Diego Museum of Art and Stanford University Art Museum have strikingly similar leaves (Toda and Ogawa A49-023, A36-035). My thanks to Chen Lihua for help in reading Huang Shen's inscriptions on the Beijing album.

261

1 Honolulu 1988, pp.187–88.

2 Honolulu 1988, p.187.

3 Honolulu 1988, p.188, quoting Dai Xi.

262

1 Phoenix 1985, pp.188–89.

263

1 San Francisco 1990, p.126.

2 *Eight Insect Themes*, handscroll, ink on paper, colophon by Jianbaizi dated 1330, Palace Museum, Beijing. Whitfield 1993, pp.35–40; Murck 2000, pp.127–28.

3 See Karlsson 2004, for an insightful study on Luo Ping and pp.174–76 for other collaborations between Jiang and Luo.

4 For full translation, see Watson 1968, p.284.

266

1 Jan Stuart discusses whether this practice constituted enhancement or defacement in Chicago 2004, p.221.

267

1 Weng and Yang Boda 1982, p.251. For theories on early abrasion techniques, see Lu et al. 2005.

2 Chicago 2004, p.306.

268

1 Lau 1979, p.100.

2 The transience of its beauty lent further poignancy to plum tree lore. For a thorough study of the plum genre see Bickford 1996.

269

1 The painting is in the collection of the Liaoning Provincial Museum. See Sturman 1990.

288–290

1 Clunas 1997, pp.60–64.

Bibliography

ADSHEAD 1997
S.A.M. Adshead, *Material Culture in Europe and China, 1400–1800: The Rise of Consumerism*, New York, 1997

ARLINGTON AND LEWISOHN 1935
L.C. Arlington and William Lewisohn, *In Search of Old Peking*, Peking, 1935

AYERS 1980
John Ayers, *Far Eastern Ceramics in the Victoria and Albert Museum*, London, 1980

BAI 1999
Qianshen Bai, 'Image as Word: A Study of Rebus Play in Song Painting (960–1279)', *The Metropolitan Museum Journal*, 34 (1999), pp.57–72

BAI 2003
Qianshen Bai, *Fu Shan's World: The Transformation of Chinese Calligraphy in the Seventeenth Century*, Cambridge, Mass., 2003

BAILLIE 1969
G. H. Baillie, *Clocks and Watches*, vol.1, Toronto, 1978 (reprint of London 1951)

BARME 1996
Geremie Barme, 'The Garden of Brightness: A Life in Ruins', *East Asian History*, 11 (1996), pp.111–58

BARNARD 1973
Noel Barnard, 'Records of Discoveries of Bronze Vessels in Literary Sources and Some Pertinent Remarks on Aspects of Chinese Historiography', *Journal of the Institute of Chinese Studies of the Chinese University of Hong Kong*, 6.2 (1973), pp.455–546

BARNHART 1993
Richard M. Barnhart, *Painters of the Great Ming, The Imperial Court and the Zhe School*, exh. cat., Dallas Museum of Art, 1993

BARNHART ET AL. 1997
Richard M. Barnhart, Yang Xin, Nie Chongzheng, Lang Shaojun, James Cahill and Wu Hung, *Three Thousand Years of Chinese Painting*, New Haven and London; Beijing, 1997

BARTHOLOMEW 1985
Terese Tse Bartholomew, 'Botanical Puns in Chinese Art from the Collection of the Asian Art Museum of San Francisco', *Oriental Art*, 16 (September 1985), pp.18–34

BARTHOLOMEW 2002
Terese Tse Bartholomew, 'One Hundred Children: From Boys at Play to Icons of Good Fortune', in Ann Barrott Wicks (ed.), *Children in Chinese Art*, Honolulu, 2002, pp.57–83

BARTLETT 1991
Beatrice S. Bartlett, *Monarchs and Ministers: The Grand Council in Mid-Ch'ing China, 1723–1820*, Berkeley, 1991

BEIJING 1986–2001
Zhongguo gudai shuhua jianding zu (ed.), *Zhongguo gudai shuhua tumu* (*Illustrated Catalogue of Selected Works of Ancient Chinese Painting and Calligraphy*), 24 vols, Beijing, 1986–2001

BEIJING 1991
Gugong bowuyuan Lishi yishuguan chenliepin tulu (*Illustrated Catalogue of Exhibits in the Palace Museum and Historical Art Museum*), Beijing, 1991

BEIJING 1995
Beijing shi Haidianqu wenwu guanlisuo, 'Beijing shi Haidianqu Balizhuang Tangmu' ('A Tang Tomb at Balizhuang in the District of Haidian in Beijing'), *Wenwu*, 1995.11, pp.45–53

BEIJING 2000
Xia Shang Zhou duandai gongcheng zhuanjiazu, *Xia Shang Zhou duandai gongcheng 1996–2000 nian jieduan chenggong baogao* (*Report of the Achievements during 1996–2000 in Determining the Dating of Events in the Xia, Shang and Zhou Periods*), Beijing, Guangzhou, Shanghai, Xi'an, 2000

BERESFORD 1993
Brian Beresford (ed. and trans.), *Confession of Downfalls: The Confession Sutra*, Dharamsala, 1993

BERGER 2003
Patricia Berger, *Empire of Emptiness: Buddhist Art and Political Authority in Qing China*, Honolulu, 2003

BERGHOLZ 1993
Fred W. Bergholz, *The Partition of the Steppe: The Struggle of the Russians, Manchus and the Zunghar Mongols for Empire in Central Asia, 1619–1758: A Study in Power Politics*, New York, 1993

BERLIN 1985
Lothar Ledderose (ed.), *Palastmuseum Peking: Schätze aus der Verbotenen Stadt*, exh. cat., Berliner Festspiele, Berlin, 1985

BERLIN 1985B
Europa und die Kaiser von China, 1240–1816, exh. cat., Berliner Festspiele, Berlin, 1985

BEURDELEY 1971
Michel Beurdeley, *Castiglione: Peintre Jésuite à la cour de Chine*, Fribourg, 1971

BEURDELEY AND RAINDRE 1987
Michel Beurdeley and Guy Raindre, *Qing Porcelain: Famille Verte, Famille Rose*, London, 1987

BI MEIXUE 2004
Bi Meixue (Michèle Pirazzoli-t'Serstevens), 'Lang Shining yu Zhongguo shiba shiji diwang xiaoxianghua de fuxing' ('Giuseppe Castiglione and the Revival of Imperial Portraiture in Eighteenth-century China'), *Gugong bowuyuan yuankan*, 3 (2004), pp.92–104

BICKFORD 1996
Maggie Bickford, *Ink Plum: The Making of a Chinese Scholar-painting Genre*, Cambridge, 1996

BICKFORD 1999
Maggie Bickford, 'Three Rams and Three Friends: The Working Lives of Chinese Auspicious Motifs', *Asia Major*, 12, pt. 1 (1999), pp.127–58

BICKFORD 2002–03
Maggie Bickford, 'Emperor Huizong and the Aesthetics of Agency', *Archives of Asian Art*, 53 (2002–03), pp.71–104

BIDIAN ZHULIN
Bidian zhulin (*Pearl Forest of the Secret Hall*), by Zhang Zhao et al., 1744. Reprinted in *Bidian zhulin, Shiqu baoji* (*Pearl Forest of the Secret Hall, Precious Collection of the Stone Moat [Pavilion]*), 2 vols, National Palace Museum, Taipei, 1971

BIDIAN ZHULIN XUBIAN
Bidian zhulin xubian (*Pearl Forest of the Secret Hall, Supplement*), Wang Jie et al., 1793, reprinted by National Palace Museum, Taipei, 1978

BO YANG 1986
Bo Yang, *Zhongguo diwang huanghou qinwang gongzhu shixi lu* (*The Descent Lines of China's Emperors, Empresses, Princes and Princesses*), Beijing, 1986

BRINKER AND LUTZ 1989
Helmut Brinker and Albert Lutz (eds), *Chinese Cloisonné: The Pierre Uldry Collection*, Susanna Swoboda (trans.), New York, 1989

BROKAW AND CHOW 2005
Cynthia J. Brokaw and Kai-wing Chow (eds), *Printing and Book Culture in Late Imperial China*, Berkeley, 2005

CAHILL 1994
James Cahill, *The Painter's Practice: How Artists Lived and Worked in Traditional China*, New York, 1994

CAMBRIDGE 1997
Robert D. Mowry, *Worlds Within Worlds: The Richard Rosenblum Collection of Chinese Scholar's Rocks*, exh. cat., Harvard University Art Museum, Cambridge, Mass., 1997

CAMMANN 1952
Schuyler Cammann, *China's Dragon Robes*, New York, 1952

CAO YIN 1960
Cao Yin (1658–1717) et al. (compilers), *Quan Tang shi* (*Complete Poetry of the Tang*), 25 vols, Beijing, 1960

CARIOTI 1996
Patrizia Carioti, 'The Zhengs' Maritime Power in the International Context of the Seventeenth-century Far Eastern Seas: The Rise of a "Centralised Piratical Organisation" and Its Gradual Development into an Informal State', in Paola Santangelo (ed.), *Ming Qing Yanjiu* (*Research on Ming and Qing*), Naples, 1996, pp.29–67

CHAIT 1957
Ralph M. Chait, 'The Eight Prescribed Peachbloom Shapes Bearing K'ang Hsi Marks', *Oriental Art*, 3.4 (1957), pp.130–37

CHANG 1972
Te-ch'ang Chang, 'The Economic Role of the Imperial Household in the Ch'ing Dynasty', *Journal of Asian Studies*, 31.2 (1972), pp.243–73

CHANG LIN-SHENG 1996
Chang Lin-sheng, 'The National Palace Museum: A History of the Collection', in New York 1996, pp.3–25

CHAVES 1993
Jonathan Chaves, *Singing of the Source: Nature and God in the Poetry of the Chinese Painter Wu Li*, Honolulu, 1993

CHAYET 1985
Anne Chayet, *Les Temples de Jehol et leurs modèles tibétains*, Paris, 1985

CHAYET 2004
Anne Chayet, 'Architectural Wonderland', in Millward et al. 2004, pp.33–52

CHEN 1982
Chieh-hsien Chen, 'A Study of the Manchu Posthumous Titles of the Ch'ing Emperors', *Central Asiatic Journal*, 26.3–4 (1982), pp.187–92

CHEN JUANJUAN 1984
Chen Juanjuan, 'Qianlong yuyong chuo sha xiu xia chaopao' ('An Embroidered Openwork Gauze Court Robe Worn by the Qianlong Emperor'), *Gugong bowuyuan yuankan*, 2 (1984), pp.89–93

CHEN PAO-CHEN 1987
Chen Pao-chen, 'The Goddess of the Lo River: A Study of Early Chinese Narrative Handscrolls', PhD thesis, Princeton University, 1987

CHEN SHIH-HSIANG AND ACTON 1976
Chen Shih-hsiang and Harold Acton (trans.), with the collaboration of Cyril Birch, *The Peach Blossom Fan (T'ao-hua-shan) by Kung Shang-jen (1648–1718)*, Berkeley, Los Angeles and London, 1976

CHIA 1993
Ning Chia, 'The Lifanyuan and the Inner Asian Rituals in the Early Qing (1644–1795)', *Late Imperial China*, 14.1 (1993), pp.60–92

CHICAGO 2000
Stephen Little (ed.), *Taoism and the Arts of China*, exh. cat., The Art Institute of Chicago, 2000

CHICAGO 2004
Chuimei Ho and Bennet Bronson, *Splendors of China's Forbidden City: The Glorious Reign of Emperor Qianlong*, exh. cat., The Field Museum, Chicago, 2004

CHUANG 1998
Quincy Chuang (ed.), *Fine Ming and Qing Furniture in the Shanghai Museum*, Hong Kong, 1998

CHUNG 2004
Anita Chung, *Drawing Boundaries: Architectural Images in Qing China*, Honolulu, 2004

CLARK 1937
Walter Eugene Clark, *Two Lamaistic Pantheons*, Cambridge, Mass., 1937

CLEVELAND 1997
James C. Y. Watt and Anne E. Wardwell, *When Silk Was Gold: Central Asian and Chinese Textiles*, exh. cat., The Cleveland Museum of Art; The Metropolitan Museum of Art, New York, 1997

CLUNAS 1988
Craig Clunas, *Chinese Furniture*, London, 1988

CLUNAS 1991
Craig Clunas, *Superfluous Things: Material Culture and Social Status in Early Modern China*, Cambridge, 1991

CLUNAS 1997
Craig Clunas, *Pictures and Visuality in Early Modern China*, London, 1997

CORDIER 1968
Henri Cordier, *Bibliotheca Sinica: Dictionnaire bibliographique des ouvrages relatifs à l'Empire Chinois*, 2nd rev. ed., New York, 1968

CROIZIER 1977
Ralph C. Croizier, *Koxinga and Chinese Nationalism: History, Myth, and the Hero*, Cambridge, Mass., 1977

CROSSLEY 1992
Pamela Kyle Crossley, 'The Rulerships of China', *American Historical Review*, 97.2 (1992), pp.1468–83

CROSSLEY 1997
Pamela Kyle Crossley, *The Manchus*, Oxford, 1997

CROSSLEY 1999
Pamela K. Crossley, *A Translucent Mirror: History and Identity in Qing Imperial Ideology*, Berkeley, 1999

CROSSLEY AND RAWSKI 1993
Pamela Kyle Crossley and Evelyn S. Rawski, 'A Profile of the Manchu Language in Ch'ing History', *Harvard Journal of Asiatic Studies*, 53.1 (1993), pp.63–102

DAI YI ET AL. 1993
Dai Yi et al., 'Bitan shiba shiji Zhongguo yu shijie: Shiba shiji Zhongguo de chengjiu, juxian yu shidai tezheng' ('Roundtable on Eighteenth-century China and the World: Eighteenth-century China's Accomplishments, Limitations, and the Special Characteristics of the Age'), *Qingshi yanjiu*, 1 (1993), pp.1–35

DAMING HUIDIAN
Shen Shixing (1535–1614), *Daming huidian (Statutes of the Ming Dynasty)*, prefaced 1587; Taipei, 1964

DAQING HUIDIAN TU
Kun Gang, *Daqing huidian tu (Illustrations of the Statutes of the Qing Dynasty)*, 1899; Beijing, 1991

DENG 1997
Gang Deng, 'The Foreign Staple Trade of China in the Pre-modern Era', *International History Review*, 19.2 (1997), pp.253–85

DI COSMO 1999
Nicola Di Cosmo, 'Manchu Shamanic Ceremonies at the Qing Court', in Joseph P. McDermott (ed.), *State and Court Ritual in China*, Cambridge, 1999

DING 1999
Yizhuang Ding, *Manzu de funü shenghuo yu hunyin zhidu yanjiu (Research on Manchu Women's Lives and the Marriage System)*, Beijing, 1999

DOTT 2004
Brian R. Dott, *Identity Reflections: Pilgrimages to Mount Tai in Late Imperial China*, Cambridge, Mass., 2004

DU FU 1985
Du Fu (712–770), *Du shi xiangzhu (The Poetry of Du Fu, Annotated)*, Qiu Zhao'ao (ed.), Beijing, 1703; reprinted in five volumes, Beijing, 1985

DUHR 1936
Joseph Duhr, *Un Jésuite en Chine: Adam Schall, astronome et conseilleur impériale 1592–1666*, Brussels, 1936

EARLE 1983
Joe Earle, 'Genji Meets Yang Guifei: A Group of Japanese Export Lacquers', *Transactions of the Oriental Society*, 47 (1982–83), pp.45–75

EBREY 1997
Patricia B. Ebrey, 'Portrait Sculptures in Imperial Ancestral Rites in Song China', *T'oung Pao*, 83.1–3 (1997), pp.42–92

EDINBURGH 2002
Zhang Hongxing (ed.), *The Qianlong Emperor. Treasures from the Forbidden City*, exh. cat., National Museums of Scotland, Edinburgh, 2002

EGAN 1994
Ronald Egan, *Word, Image, and Deed in the Life of Su Shi*, Cambridge, Mass., 1994

EGAN 1998
Ronald Egan (trans. and ed.), *Limited Views: Essays on Ideas and Letters by Qian Zhongshu*, Cambridge, Mass., 1998

ELLIOTT 2001
Mark C. Elliott, *The Manchu Way: The Eight Banners and Ethnic Identity in Late Imperial China*, Stanford, 2001

ELLIOT AND CHIA 2004
Mark C. Elliott and Ning Chia, 'The Qing Hunt at Mulan', in Millward et al. 2004, pp.66–83

ERICKSON 2001
Susan N. Erickson, 'Investing in the Antique: Bronze Vessels of the Song Dynasty', in Dieter Kuhn and Helga Stahl (eds), *Die Gegenwart des Altertums, Formen und Funktionen des Altertumsbezugs in den Hochkulturen der Alten Welt*, Wurzburg, 2001, pp.423–35

FALKENHAUSEN 1993
Lothar von Falkenhausen, *Suspended Music: Chime Bells in the Culture of Bronze Age China*, Berkeley, Los Angeles and Oxford, 1993

FARQUHAR 1978
David Farquhar, 'Emperor as Bodhisattva in the Governance of the Ch'ing Empire', *Harvard Journal of Asiatic Studies*, 38.1 (1978), pp.5–35

FENG AND GENG 1994
Feng Xianming and Geng Baochang (eds), *Gugong bowuyuan can Qing sheng shi ci xuan cui (Selected Porcelain of the Flourishing Qing Dynasty at the Palace Museum)*, Beijing, 1994

FONG 1977
Mary H. Fong, 'A Probable Second "Chung Kuei" by Emperor Shun-chih of the Ch'ing Dynasty', *Oriental Art*, 23.4 (1977), pp.423–37

FONG 1996
Wen C. Fong, 'Imperial Patronage of the Arts Under the Ch'ing', in New York 1996

FORÊT 2000
Philippe Forêt, *Mapping Chengde: The Qing Landscape Enterprise*, Honolulu, 2000

FRANK 1998
Andre Gunder Frank, *ReOrient: Global Economy in the Asian Age*, Berkeley, 1998

FREEDBERG 1989
David Freedberg, *The Power of Images: Studies in the History and Theory of Response*, Chicago, 1989

FUCHS 1959
Walter Fuchs, 'Zum Keng-chih-t'u der Mandju-Zeit und die Japanische Ausgabe von 1808', in I. L. Kluge (ed.), *Ostasiatische Studien: Martin Ramming zum 70. Geburtstag gewidmet*, Berlin, 1959, pp.67–80

GAO JIN ET AL. 1771
Gao Jin et al., *Nanxun shengdian (Magnificent Record of the Southern Tours)*; preface dated 1771, Taipei, 1966 (reprint of 1882 edition)

GAO XIANG 1993
Gao Xiang, 'Kang Qian shengshi qianyi' ('A Discussion of the Prosperous Age of the Kangxi through Qianlong Eras'), *Qingshi yanjiu*, 1 (1993), pp.12–14

GARRETT 1994
Valery M. Garrett, *Chinese Clothing: An Illustrated Guide*, Hong Kong, 1994

GENG BAOCHANG 1993
Geng Baochang, *Ming Qing ciqi jianding (Appraisal of Ming and Qing Porcelain)*, Hong Kong, 1993

GENG BAOCHANG 2000
Geng Baochang (ed.), *Gugong bowuyuan cang wenwu zhanpin quanji: Qinghua youlihong, xia (The Complete Collection of Treasures of the Palace Museum: Blue and White Porcelain with Underglazed Red [III])*, Shanghai, 2000

GILES 1911
Lionel Giles (compiler), *An Alphabetical Index to the Chinese Encyclopaedia (Ch'in Ting Ku Chin T'u Shu Chi Ch'eng)*, The British Museum, London, 1911

GOLVERS 2003
Noel Golvers, *Ferdinand Verbiest SJ (1623–1688) and the Chinese Heaven: The Composition of the Astronomical Corpus, Its Diffusion and Reception in the European Republic of Letters*, Leuven, 2003

GONG XIAOWEI 1993
Gong Xiaowei, *Wang Shizhen* in *Zhongguo gudian wenxue jiben zhishi congshu*, Shanghai, 1993

GOODRICH 1966
L. Carrington Goodrich, *The Literary Inquisition of Chien-lung*, 2nd ed., New York, 1966

GOODY 1993
Jack Goody, *The Culture of Flowers*, Cambridge, 1993

GU LINWEN 1962
Gu Linwen, *Yangzhou Bajia shiliao*, Shanghai, 1962

GUO FUXIANG 1995
Guo Fuxiang, 'Qianlong huangdi yu Qinggong zhongbiao de jianshang he shoucang' ('The Qianlong Emperor and the Enjoyment and Collecting of Qing Palace Clocks'), *Gugong wenwu yuekan*, 13.9 (1995), pp.76–88

GUO FUXIANG 2003
Guo Fuxiang, 'Kangxi shiqi de Yangxin dian' ('The Hall of Mental Cultivation in the Kangxi Reign'), *Gugong bowuyuan yuankan*, 108.4 (2003), running no. 108

GUY 1987
R. Kent Guy, *The Emperor's Four Treasuries: Scholars and the State in the Late Ch'ien-lung Era*, Cambridge, Mass., 1987

GUY 2002
R. Kent Guy, 'Who Were the Manchus? A Review Essay', *Journal of Asian Studies*, 61.1 (2002), pp.151–64

HARGETT 1988–89
James Hargett, 'Huizong's Magic Marchmount: The Genyue Pleasure Park of Kaifeng', *Monumenta Serica*, 38 (1988–89), pp.1–48

HARRIST 1995
Robert Harrist, 'The Artist as Antiquarian: Li Gonglin's Study of Early Chinese Art', *Artibus Asiae*, 55.3–4 (1995), pp.237–80

HAWKES 1959
David Hawkes (trans.), *Ch'u Tz'u: The Songs of the South, An Ancient Chinese Anthology*, Boston, 1959

HAWKES 1967
David Hawkes, *A Little Primer of Tu Fu*, Oxford, 1967

HAWKES 1985
David Hawkes (trans.), *The Songs of the South: An Anthology of Ancient Chinese Poems by Qu Yuan and Other Poets*, Harmondsworth, 1985

HAY 2001
Jonathan Hay, *Shitao: Painting and Modernity in Early Qing China*, Cambridge, 2001

HEARN 1988
Maxwell K. Hearn, 'Document and Portrait: The Southern Inspection Tour Paintings of Kangxi and Qianlong', in Ju-hsi Chou and Claudia Brown (eds), *Chinese Painting under the Qianlong Emperor: The Symposium Papers in Two Volumes, Phoebus*, 6.1 (1988), Arizona State University, pp.91–131

HEARN 1990
Maxwell K. Hearn, 'The *Kangxi Southern Inspection Tour*: A Narrative Program by Wang Hui', PhD dissertation, Princeton University, 1990

HEDIN 1932
Sven Hedin, *Jehol, City of Emperors*, E. G. Nash (trans.), London, 1932

HENAN 1993
Henan sheng wenwu yanjiusuo, *Mi xian Dahuting Hanmu (The Han Dynasty Tombs at Dahuting in Mi xian County)*, Beijing, 1993

HERMAN 1997
John E. Herman, 'Empire in the Southwest: Early Qing Reforms to the Native Chieftain System', *Journal of Asian Studies*, 56.1 (1997), pp.47–74

HEVIA 1995
James L. Hevia, *Cherishing Men from Afar: Qing Guest Ritual and the Macartney Embassy of 1793*, Durham, 1995

HIGHTOWER 1970
James Robert Hightower, *The Poetry of T'ao Ch'ien*, Oxford, 1970

HONEY 1945
William Bowyer Honey, *The Ceramic Art of China and Other Countries of the Far East*, London, 1945

HONG KONG 1978
Ip Yee and Laurence C. S. Tam, *Chinese Bamboo Carving*, exh. cat., Hong Kong Museum of Art, 1978

HONG KONG 1984
Kao Mayching (ed.), *Paintings by Yangzhou Artists of the Qing Dynasty from the Palace Museum*, exh. cat., The Art Gallery of the Chinese University of Hong Kong, 1984

HONG KONG 1986
Gerald Tsang and Hugh Moss, *Arts from the Scholar's Studio*, exh. cat., The Oriental Ceramic Society of Hong Kong and the Fung Ping Shan Museum, University of Hong Kong, 1986

HONG KONG 1989
Qingdai dihou wanshou qingdian wenwu zhanlan (Art Treasures from Birthday Celebrations at the Qing Court), Hong Kong, 1989

HONG KONG 1997
From Beijing to Versailles: Artistic Relations Between China and France, exh. cat., Urban Council, Hong Kong, 1997

HONOLULU 1988
Howard Rogers and Sherman E. Lee, *Masterworks of Ming and Qing Painting from the Forbidden City*, exh. cat., Honolulu Academy of Arts; High Museum of Art, Atlanta; The Cleveland Museum of Art; The Minneapolis Museum of Arts; The Metropolitan Museum of Art, New York, 1988–89

HOSTETLER 2001
Laura Hostetler, *Qing Colonial Enterprise: Ethnography and Cartography in Early Modern China*, Chicago and London, 2001

HOU CHING-LANG AND PIRAZZOLI 1979
Hou Ching-lang and Michèle Pirazzoli, 'Les Chasses d'automne de l'empereur Qianlong à Mulan', *T'oung Pao*, 65.1–3 (1979), pp.13–50

HSÜ 1996
Ginger Cheng-chi Hsü, 'The Drunken Demon Queller: Chung K'uei in Eighteenth-century Chinese Painting', *Taida Journal of Art History*, 3 (1996), pp.141–75

HSÜ 2001
Ginger Cheng-chi Hsü, *A Bushel of Pearls: Painting for Sale in Eighteenth-century Yangchow*, Stanford, 2001

HU GUANGHUA 2001
Hu Guanghua (ed.), *Zhongguo Ming Qing you hua (Chinese Oil Painting of the Ming and Qing Dynasties)*, Changsha City, 2001

HU JIANZHONG 1990
Hu Jianzhong, 'Qing Gong Bingqi Yanjiu' ('Research into Qing Imperial Weapons'), *Gugong bowuyuan yuankan*, 1 (1990), pp.17–27

HU JING 1816
Hu Jing, *Guochao yuanhua lu (Record of Academy Paintings of the [Qing] Dynasty)*; preface dated 1816, in Yu Anlan, *Hua shi congshu (Compendium of Painting Histories)*, vol.5., Shanghai, 1963

HUANG 1967
Huang Zhangjian (Hwang Chang-chien), 'Manzhouguo guohao kao' ('On the Origin of the Dynastic Title "Manchu"'), *Bulletin of the Institute of History and Philology*, Academia Sinica, 37.2 (1967), pp.459–73

HUANGCHAO LIQI TUSHI
Huangchao liqi tushi (Illustrated Regulations for Ceremonial Paraphernalia of the Qing Dynasty), Fu Longan (compiler), 1766; Taipei, 1986

HUMMEL 1943
Arthur W. Hummel (ed.), *Eminent Chinese of the Ch'ing Period (1644–1912)*, 2 vols, Washington DC, 1943

HUNG 1952
William Hung, *Tu Fu, China's Greatest Poet*, Cambridge, Mass., 1952

JANG 1992
Scarlett Jang, 'Realm of the Immortals: Paintings Decorating the Jade Hall of the Northern Song', *Ars Orientalis*, 22 (1992), pp.81–96

JENYNS 1951
Soame Jenyns, *Chinese Archaic Jades in the British Museum*, London, 1951

JIANG SHUNYUAN 2001
Jiang Shunyuan, 'Ming Qing chao yan Sichuan caimu yanjiu' ('A Study of Timber-cutting in Sichuan by Order of the Imperial Courts of the Ming and Qing Dynasties'), *Gugong bowuyuan yuankan*, 96.4 (2001), pp.26–32

JIANYAN YILAI XINIAN YAOLU 1986
Li Xinchuan (1166–1243), *Jianyan yilai xinian yaolu (Chronological Record of Important Events since the Jianyan Reign Period)*, Taipei, 1986

JOHNSON ET AL. 1985
David Johnson, Andrew J. Nathan and Evelyn S. Rawski (eds), *Popular Culture in Late Imperial China*, Berkeley, 1985

JU DEYUAN 1989
Ju Deyuan, 'Qingdai Yesuhuishi yu xiyang qiqi' ('The Jesuits and Western Strange Objects of the Qing Dynasty'), part 1: *Gugong bowuyuan yuankan*, 43.1 (1989), pp.3–16; part 2: *Gugong bowuyuan yuankan*, 44.2 (1989), pp.13–23

KAHN 1971
Harold L. Kahn, *Monarchy in the Emperor's Eyes: Image and Reality in the Ch'ien-lung Reign*, Cambridge, Mass., 1971

KAHN 1985
Harold L. Kahn, 'A Matter of Taste: The Monumental and Exotic in the Qianlong Reign', in Phoenix 1985

KANE 1996
S. Kane, 'The Silver Swan: The Biography of a "Curiosity"', *Things*, 5 (Winter 1996–97), pp.39–57

KANG-I SUN CHANG 1991
Kang-i Sun Chang, *The Late Ming Poet Ch'en Tzu-lung: Crises of Love and Loyalism*, New Haven, 1991

KANGXI QIJUZHU
Kangxi qijuzhu (Diaries of Activity and Repose of the Kangxi Emperor), vol.3, Beijing, 1984

KANSAS CITY 1992
Wai-kam Ho (ed.), *The Century of Tung Ch'i-ch'ang, 1555–1636*, exh. cat., 2 vols, The Nelson-Atkins Museum of Art, Kansas City; Los Angeles County Museum of Art; The Metropolitan Museum of Art, New York, 1992–93

KAO 1986
Karl S. Y. Kao, 'Rhetoric', in William H. Nienhauser Jr (ed. and compiler), *The Indiana Companion to Traditional Chinese Literature*, Bloomington, 1986

KARLSSON 2004
Kim Karlsson, *Luo Ping: The Life, Career and Art of an Eighteenth-century Chinese Painter*, Bern, 2004

KAUFMANN 1976
Walter Kaufmann, *Musical References in the Chinese Classics*, Detroit, 1976

KEIGHTLEY 2000
David Keightley, *The Ancestral Landscape: Time, Space and Community in Late Shang China (c. 1200–1045 BC)*, Berkeley, 2000

KERR 1986
Rose Kerr, *Chinese Ceramics: Porcelain of the Qing Dynasty 1644–1911*, London, 1986

KERR 1990
Rose Kerr, *Later Chinese Bronzes*, London, 1990

KHORDAKOVSKY 1992
Michael Khordakovsky, *Where Two Worlds Met: The Russian State and the Kalmyk Nomads, 1600–1771*, Ithaca, 1992

KIM 1996
Hongnam Kim, *The Life of a Patron: Zhou Lianggong (1612–1672) and the Painters of Seventeenth-century China*, New York, 1996

KOOP 1924
Albert Koop, *Early Chinese Bronzes*, New York, 1924

KRAHL 1994
Regina Krahl, *Chinese Ceramics from the Meiyintang Collection*, 2 vols, London, 1994

KROLL 1996
Paul W. Kroll, 'Body Gods and Inner Vision: The Scripture of the Yellow Court', in Donald S. Lopez Jr (ed.), *Religions of China in Practice*, Princeton, 1996, pp.149–55

KUHN 1996
Philip A. Kuhn, *Soulstealers: The Chinese Sorcery Scare of 1768*, Cambridge, Mass., 1990

LAING 1992
Ellen Johnston Laing, 'The Development of Flower Depiction and the Origin of the Bird-and-flower Genre in Chinese Art', *Bulletin of the Museum of Far Eastern Antiquities*, Stockholm, 64 (1992), pp.180–223

LAING 1994
Ellen Johnston Laing, 'A Survey of Liao Dynasty Bird-and-flower Painting', *Journal of Sung-Yuan Studies*, 24 (1994), pp.57–99

LAU 1979
D. C. Lau (trans.), *The Analects*, New York, 1979

LAWTON 1973
Thomas Lawton, *Freer Gallery of Art Fiftieth Anniversary Exhibition. II: Chinese Figure Painting*, Washington DC, 1973

LE CORBEILLER 1970
Clare Le Corbeiller, 'James Cox: A Biographical Review', *The Burlington Magazine*, 112.807 (June 1970), pp.350–58

LEDDEROSE 1973
Lothar Ledderose, 'Subject-matter in Early Chinese Painting Criticism', *Oriental Art*, 19.1 (1973), pp.69–83

LEDDEROSE 1978–79
Lothar Ledderose, 'Some Observations on the Imperial Art Collection in China', *Transactions of the Oriental Ceramic Society*, 43 (1978–79), pp.33–46

LEDDEROSE 1979
Lothar Ledderose, *Mi Fu and the Classical Tradition of Chinese Calligraphy*, Princeton, 1979

LEDDEROSE 1983
Lothar Ledderose, 'The Earthly Paradise: Religious Elements in Chinese Landscape Art', in Susan Bush and Christian Murck (eds), *Theories of the Arts in China*, Princeton, 1983, pp.165–83

LEDDEROSE 1985
Lothar Ledderose, 'Die Kunstsammlungen der Kaiser von China', in Berlin 1985, pp.41–47

LEE ET AL. 2002
James Lee, Cameron Campbell and Wang Feng, 'Positive Check or Chinese Checks?', *Journal of Asian Studies*, 61.2 (2002), pp.591–607

LEGGE 1885
James Legge, *The Sacred Books of China: The Texts of Confucianism, Parts III and IV*, Oxford, 1885

LEGGE 1960
James Legge, *The Chinese Classics*, 5 vols, Hong Kong, 1960 (first printing 1861–72)

LESSING 1942
Ferdinand Diederich Lessing, *Yung-ho-kung: An Iconography of the Lamaist Cathedral in Peking*, Stockholm, 1942

LI 1974
Chu-tsing Li, *A Thousand Peaks and Myriad Ravines: Chinese Paintings in the Charles A. Drenowatz Collection*, 2 vols, Ascona, 1974

LI 1995
Wai-yee Li, 'The Representation of History in the Peach Blossom Fan', *Journal of the American Oriental Society*, 115 (1995), pp.421–33

LI GUOYING 1996
Li Guoying, 'Lun Yongzheng yu dandao' ('On Yongzheng and the Elixir Path'), in Wang Shuxiang (ed.), *Qingdai gongshi congtan (Conference on the History of the Qing Palace)*, Beijing, 1996, pp.175–89

LI JIUFANG 1991
Li Jiufang (ed.), *Zhongguo yuqi quanji (Anthology of Chinese Jades)*, series, vol.6: *Qing*, Hebei, 1991

LI JIUFANG 2002
Li Jiufang (ed.), *Jinshu tai falang qi (Metal-bodied Enamel Ware)*, in *Gugong bowuyuan cang wenwu zhenpin quanji (The Complete Collection of Treasures of the Palace Museum)*, vol.43, Hong Kong, 2002

LI JIUFANG 2002B
Li Jiufang (ed.), *Zhu mu ya jiao diaosu (Bamboo, Wood, Ivory and Rhinoceros Horn Carvings)*, in *Gugong bowuyuan cang wenwu zhenpin quanji (The Complete Collection of Treasures of the Palace Museum)*, vol.44, Hong Kong, 2002

LI SHI 2002
Li Shi, *Qianlong huangdi xiaoxiang hua (Portraits of the Qianlong Emperor)*, Beijing, 2002

LI SHUTONG 1967
Li Shutong, 'Tang ren xi ai mudan kao', ('Discussion of the Tang Enthusiasm for the Peony'), *Daling zazhi*, 39.1–2 (1967), pp.42–66

LI XIAOCONG 1996
Li Xiaocong, *Ouzhou shoucang bufen Zhongwen (A Descriptive Catalogue of Pre-1900 Chinese Maps Seen in Europe)*, Beijing, 1996

LIU 1981
Adam Yuen-chung Liu, *The Hanlin Academy: Training Ground for the Ambitious, 1644–1850*, Hamden, 1981

LIU JING 2004
Liu Jing, 'Zhu mu ruyi' ('Ruyi of Bamboo and Wood'), *Zijin cheng (Forbidden City)*, 1 (2004), pp.23–28

LIU LIANGYOU 1991
Liu Liangyou, *Ch'ing Official and Popular Wares: A Survey of Chinese Ceramics*, vol.5, Taipei, 1991

LIU LU 1998
Liu Lu (ed.), *Qing gong Xiyang yiqi (Scientific and Technical Instruments of the Qing Dynasty)*, in *Gugong bowuyuan cang wenwu zhenpin quanji (The Complete Collection of Treasures of the Palace Museum)*, vol. 58, Hong Kong, 1998

LIU LU 2000
Liu Lu, 'Congboxing shi yitu yu Qing Gaozong Dayuetu kaoxi – Qingdai duominzu guojia xingcheng de tuxiang jiancheng' ('Analysis of *Congboxing shi yitu* and of *The Great Inspection of Qing Gaozong*: Pictorial Testimonies of the Qing Multi-ethnic State'), *Gugong bowuyuan yuankan*, 4 (2000), pp.15–26

LIU LU 2002
Liu Lu, 'The Forbidden City during the Qianlong Reign', in Edinburgh 2002

LIU RULI 1979
Liu Ruli, *Shixue – Zhongguo zuizao de toushixue zhuzuo* (*The Study of Visual Art: The Earliest Book on the Study of Perspective Drawing*), *Nanyi xuebao*, 1 (1979)

LIU YUE 2004
Liu Yue, 'Shenshi fenyun hua ruyi' ('Diverse Notes on *Ruyi* Collected over a Lifetime'), *Zijin cheng* (*Forbidden City*), 1 (2004), pp.5–14

LIU YUEFANG 1989
Liu Yuefang, 'Qinggong zuozhongchu' ('The Clock-making Workshop of the Qing Palace'), *Gugong bowuyuan yuankan*, 46.4 (1989), pp.49–54

LONDON 1973
Howard Nelson, Helen Wallis and Yolanda Jones, *Chinese and Japanese Maps*, exh. cat., British Museum, London, 1973

LONDON 2004
Anna Jackson and Amin Jaffer (eds), *Encounters: The Meeting of Asia and Europe, 1500–1800*, exh. cat., Victoria and Albert Museum, London, 2004

LONDON 2004B
Illustrated Catalogue of Underglaze Blue and Copper Red Decorated Porcelains in the Percival David Foundation of Chinese Art, rev. ed., London, 2004

LONDON N.D.
Chinese Imperial Patronage: Treasures from Temples and Palaces, exh. cat., Christopher Bruckner Asian Art Gallery, London, n.d.

LU ET AL. 2005
P. J. Lu, N. Yao, J. F. So, G. E. Harlow, J. F. Lu, G. F. Wang and P. M. Chaikin, 'Earliest Use of Corundum and Diamond in Prehistoric China', *Archaeometry*, 47.1 (2005)

LU YANZHEN 1995
Lu Yanzhen, *Qinggong zhongbiao zhencang* (*Precious Collection of Qing Dynasty Palace Clocks*), Beijing, 1995

LU YANZHEN, LI WENSHAN AND WAN YI 1983
Lu Yanzhen, Li Wenshan and Wan Yi (eds), *Zijin cheng dihou shenghuo* (*Life of the Emperors and Empresses in the Forbidden City*), Beijing, 1983

MACAU 1999
Sheng shi feng hua: Beijing Gugong cang Qingdai Kang Yong Qian shuhua qiwu jing pin (*Splendours of a Flourishing Age: Paintings, Calligraphy and Other Treasures from the Kangxi, Yongzheng and Qianlong Reigns from the Palace Museum* [*Maravilhas de una Epoca Prospera*]), exh. cat., Macau Museum of Art, 1999

MACAU 2000
Jin xiang yu zhi – Qingdai gongting baozhuang yishu (*Qing Legacies: The Sumptuous Art of Imperial Packaging*), exh. cat., Macau Museum of Art, 2000

MACAU 2002
Haiguo bolan – Qingdai gongting xiyang chuanjiaoshi huashi huihua liupai jingpin (*The Golden Exile: Pictorial Expressions of the School of Western Missionaries' Artworks of the Qing Dynasty Court*), exh. cat., Macau Museum of Art, 2002

MACAU 2002B
Haiguo bolan – Qingdai gongting xiyang chuanjiaoshi huashi huihua liupai gai shuo (*The Golden Exile: Survey of the Western Missionaries' Painting School of the Qing Dynasty Court*), exh. cat., Macau Museum of Art, 2002

MACAU 2002C
The Life of Emperor Qianlong (*Vivencias do Imperador*), exh. cat., Macau Museum of Art, 2002

MACAU 2003
Miaodi xinchuan – Gugong zhencang zangchuan fojiao wenwuzhan (*Lightness of Essence: Tibetan Buddhist Relics of the Palace Museum*), exh. cat., Macau Museum of Art, 2003

MACAU 2004
Zhi ren wu fa – Bada Shitao Gugong Shangbo zhencang huihua jingpin (*Rules by the Masters: Paintings and Calligraphies by Ba Da and Shi Tao, Collections from the Palace Museum and Shanghai Museum*), exh. cat., 2 vols, Macau Museum of Art, 2004

MALLMANN 1964
Marie-Thérèse de Mallmann, *Étude iconographique sur Manjusri*, Paris, 1964

MALONE 1934
Carroll. B. Malone, 'History of the Peking Summer Palaces under the Ch'ing Dynasty', *Bulletin of the University of Illinois*, 31.41 (1934)

MAZUMDAR 1998
Sucheta Mazumdar, *Sugar and Society in China: Peasants, Technology and the World Market*, Cambridge, Mass., 1998

MCCAUSLAND 2001–02
Shane McCausland, 'The Emperor's Old Toys: Rethinking the Yongzheng (1723–35) *Scroll of Antiquities* in the Percival David Foundation', *Transactions of the Oriental Ceramic Society*, 66 (2001–02), pp.65–75

MCNAIR 1998
Amy McNair, *The Upright Brush: Yan Zhenqing's Calligraphy and Song Literati Politics*, Honolulu, 1998

MEDLEY 1982
Margaret Medley, *The 'Illustrated Regulations for Ceremonial Paraphernalia of the Ch'ing Dynasty'*, London, 1982

MEYER-FONG 2003
Tobie Meyer-Fong, *Building Culture in Early Qing Yangzhou*, Stanford, 2003

MILLWARD 1998
James A. Millward, *Beyond the Pass: Economy, Ethnicity and Empire in Qing Central Asia, 1759–1864*, Stanford, 1998

MILLWARD ET AL. 2004
James A. Millward, Ruth W. Dunnell, Mark C. Elliott and Philippe Forêt (eds), *New Qing Imperial History: The Making of Inner Asian Empire at Qing Chengde*, London, 2004

MOTE 1988
Frederick Mote, 'The Intellectual Climate in Eighteenth-century China: Glimpses of Beijing, Suzhou and Yangzhou in the Qianlong Period', in Ju-hsi Chou and Claudia Brown (eds), *Chinese Painting under the Qianlong Emperor: The Symposium Papers in Two Volumes*, Phoebus, 6.1 (1988), Arizona State University, pp.17–55

MOTE 1998
F. W. Mote, 'Becoming an Emperor', in Chuimei Ho and Cheri A. Jones (eds), *Life in the Imperial Court of Qing Dynasty China*, Proceedings of the Denver Museum of Natural History, 3.15 (1998), pp.11–22

MOTE 1999
F. W. Mote, *Imperial China, 900–1800*, Cambridge, Mass., and London, 1999

MURCK 2000
Alfreda Murck, *Poetry and Painting in Song China: The Subtle Art of Dissent*, Cambridge, Mass., 2000

NAKAMURA 1958
Susumu Nakamura, 'Pushapa-puja, Flower Offering in Buddhism', *Oriens*, 11 (1958), pp.177–80

NAKAMURA AND NISHIGAMI 1998
Toru Nakamura and Minoru Nishigami (eds), *Sekai bijutsu daizenshu, Toyohen* (*New History of World Art, Far Eastern Series*), vol.9: *Shin* (*Qing*), Tokyo, 1998

NAQUIN 2000
Susan Naquin, *Peking: Temples and City Life, 1400–1900*, Berkeley, 2000

NEBESKY-WOJKOWITZ 1956
René Nebesky-Wojkowitz, *Oracles and Demons of Tibet: The Cult and Iconography of the Tibetan Protective Deities*, Mouton, 1956

NEEDHAM 1959
Joseph Needham, *Science and Civilisation in China*, vol.3, *Mathematics and the Sciences of the Heavens and the Earth*, Cambridge, 1959

NEW YORK 1983
Wang Shixiang and Wan-go Weng, *Bamboo Carving of China*, exh. cat., China House Gallery, China Institute in America, New York, 1983

NEW YORK 1985
John Hay, *Kernels of Energy, Bones of Earth: The Rock in Chinese Art*, exh. cat., China House Gallery, China Institute in America, New York, 1985

NEW YORK 1987
Chu-tsing Li and James C. Y. Watt (eds), *The Chinese Scholar's Studio: Artistic Life in the Late Ming Period*, exh. cat., Asia Society, New York, 1987

NEW YORK 1996
Wen C. Fong and James C. Y. Watt, *Possessing the Past: Treasures from the National Palace Museum, Taipei*, exh. cat., The Metropolitan Museum of Art, New York; National Palace Museum, Taipei, 1996

NEW YORK 1996B
Hongnam Kim, *The Life of a Patron: Zhou Lianggong (1612–1672) and the Painters of Seventeenth-century China*, exh. cat., China Institute in America, New York, 1996

NEW YORK 2000
Philip K. Hu (Hu Guangjun), *Visible Traces: Rare Books and Special Collections from the National Library of China* (*Zhongguo guojia tushuguan shanben tecang zhenpin limei zhanlan tulu*), dual text, exh. cat., The Queens Borough Public Library Gallery, New York, 2000

NEW YORK 2002
Maxwell K. Hearn, *Cultivated Landscapes: Chinese Paintings from the Collection of Marie-Hélène and Guy Weill*, exh. cat., The Metropolitan Museum of Art, New York, 2002

NI YIBIN 2003
Ni Yibin, 'The Anatomy of Rebus in Chinese Decorative Arts', *Oriental Art*, 49.3 (2003), pp.12–23

NI YIBIN 2003B
Ni Yibin (Yibin Ni), 'Narrative Themes in Shunzhi Porcelain', presented at 'Treasures from an Unknown Reign: Shunzhi Porcelain', University of Virginia Art Museum, 21 March 2003

NIE CHONGZHENG 1979
Nie Chongzheng, 'Lang Shining he tade lishihua, youhua zuopin' ('Giuseppe Castiglione and His Historical Paintings and Oil Paintings'), *Gugong bowuyuan yuankan*, 1979.3

NIE CHONGZHENG 1980
Nie Chongzheng, 'Di hou xiaoxiang hua suotan' ('A Chat about Portraits of Emperors and Empresses'), *Gugong bowuyuan yuankan*, 1 (1980), pp.64–80

NIE CHONGZHENG 1980B
Nei Chongzheng, 'Qianlong pingding zhunbu huibu zhantu'he Qingdai de tongbanhua' ('War Paintings of the Qianlong Emperor Quelling Muslim Tribes and Qing Dynasty Copper-plate Prints'), *Wenwu*, 1980.4

NIE CHONGZHENG 1982
Nie Chongzheng, 'Xianfahua xiaokao' ('Research on Linear Perspective Technique'), *Gugong bowuyuan yuankan*, 3 (1982)

NIE CHONGZHENG 1984
Nie Chongzheng, 'Qing dai gongting huihua jigou, zhidu ji huajia' ('The Qing Court Painting Institute, Its System and Painters'), *Meishu yanjiu*, 3 (1984)

NIE CHONGZHENG 1986
Nie Chongzheng, 'Qianlong xiaoxiang mianmian guan' ('Looking at Portraits of the Qianlong Emperor'), *Zijin cheng* (*Forbidden City*), 35 (1986.4), pp.29–34

NIE CHONGZHENG 1989
'Qing chao gongting tongbanhua – Qianlong pingding zhunbu, huibu zhantu' ('Copper-plate Prints at the Qing Court: War Paintings of the Qianlong Emperor Quelling Muslim Tribes'), *Gugong bowuyuan yuankan*, 4 (1989)

NIE CHONGZHENG 1989B
Nie Chongzheng, 'Tan "Kangxi Nanxun tu" juan' ('Discussing the Scroll *The Southern Tour of the Kangxi Emperor*'), *Meishu yanjiu*, 4 (1989)

NIE CHONGZHENG 1992
Nie Chongzheng, *Gugong bowuyuan cang Qingdai gongting huihua* (*Court Paintings of the Qing Period in the Palace Museum*), Beijing, 1992

NIE CHONGZHENG 1995
Nie Chongzheng, 'Qingdai gongting youhua shulue' ('A Brief Introduction to the Qing Court Oil Paintings'), *Gugong bowuyuan yuankan*, 1995 (special issue)

NIE CHONGZHENG 1996
Nie Chongzheng (ed.), *Qingdai gongting huihua* (*Paintings by the Court Artists in the Qing Court*), in *Gugong bowuyuan cang wenwu zhenpin quanji* (*The Complete Collection of Treasures of the Palace Museum*), vol.14, Hong Kong, 1996 (reprinted Shanghai, 1999)

NIE CHONGZHENG 1996B
Nie Chongzheng, *Gongting yishu de guanghu – Qingdai gongting huihua luncong* (*Splendour of the Art at Court: Essays on the Court Painting of the Qing Period*), Taipei, 1996

NORMAN 1978
Jerry Norman, *A Concise Manchu-Chinese Lexicon*, Seattle, 1978

NOZAKI 1980
Nozaki Nobuchika, *Zhongguo jixiang tu'an Zhongguo fengsu yanjiu zhi yi* (*Chinese Auspicious Images and a Study of Chinese Customs*), Taipei, 1980 (reprint of the 2nd ed. [Tokyo, 1940] of Nozaki's *Kissho Zuan Kaidai* [*Explication of Auspicious Designs*], Tianjin, 1928)

NYLAN 2001
Michael Nylan, *The Five 'Confucian' Classics*, New Haven and London, 2001

OWEN 1992
Stephen Owen, *Readings in Chinese Literary Thought*, Cambridge, Mass., 1992

PAGANI 1995
Catherine Pagani, 'The Clocks of James Cox: Chinoiserie and the Clock Trade with China in the Late Eighteenth Century', *Apollo*, 140.395 (January 1995), pp.15–22

PAGANI 1995B
Catherine Pagani, 'Clockmaking in China under the Kangxi and Qianlong Emperors', *Arts Asiatiques*, 50 (1995), pp.76–84

PAGANI 2001
Catherine Pagani, *'Eastern Magnificence and European Ingenuity': Clocks of Late Imperial China*, Ann Arbor, 2001

PAINE 1996
S. C. M. Paine, *Imperial Rivals: China, Russia and Their Disputed Frontier*, Armonk, 1996

PAL 1983
Pratapaditya Pal, *Art of Tibet: A Catalogue of the Los Angeles County Museum of Art Collection*, Los Angeles County Museum of Art, 1983

PALACE MUSEUM 1985
The Palace Museum, *Gugong bowuyuan cang diao qi* (*Carved Lacquer in the Collection of the Palace Museum*), Beijing, 1985

PALACE MUSEUM 1992
The Palace Museum, *Qingdai gongting huihua* (*Court Paintings of the Qing Dynasty*), Beijing, 1992

PALACE MUSEUM 1992B
The Palace Museum, *Qinggong Zangchuan fojiao wenwu* (*Cultural Relics of Tibetan Buddhism Collected in the Qing Palace*), Beijing and Hong Kong, 1992

PALACE MUSEUM 1996
The Palace Museum, *Ming Qing di hou baoxi* (*Precious Seals of the Ming and Qing Emperors and Empresses*), Beijing, 1996

PALACE MUSEUM 1998
The Palace Museum, *Gugong cang biyanhu* (*Snuff Bottles in the Palace Museum*), Beijing, 1998

PALACE MUSEUM 1999
The Palace Museum, *Gugong qingtong qi* (*The Palace Museum Collection of Bronzes*), Beijing, 1999

PALACE MUSEUM 2000
The Palace Museum, *Qingdai gongting baozhuang yishu* (*The Imperial Packing Art of the Qing Dynasty*), Beijing, 2000

PALACE MUSEUM 2002
The Palace Museum, *Gugong diaoke zhen cui* (*The Palace Museum Collection of Elite Carvings*), Beijing, 2002

PALACE MUSEUM 2002B
The Palace Museum, *Zangchuan fojiao tangka* (*Buddhist Thangkas in the Tibetan Tradition*), in *Gugong bowuyuan cang wenwu zhenpin quanji* (*The Complete Collection of Treasures of the Palace Museum*), vol.59, Beijing, 2002

PALACE MUSEUM 2002C
The Palace Museum, *Zangchuan fojiao zaoxiang* (*Buddhist Sculptures in the Tibetan Tradition*), in *Gugong bowuyuan cang wenwu zhenpin quanji* (*The Complete Collection of Treasures of the Palace Museum*), vol.60, Beijing, 2002

PALACE MUSEUM SNUFF BOTTLES 2002
The Palace Museum, *Gugong bowuyuan cang wenwu zhenpin da xi* (*The Complete Collection of Treasures of the Palace Museum, Snuff Bottles*), Shanghai, 2002

PARIS 1997
La Cité interdite: vie publique et privée des empereurs de Chine (1644–1911), exh. cat., Musée du Petit Palais, Paris, 1997

PENG QINGYUN 1993
Peng Qingyun (ed.), *Zhongguo wenwu jinghua daquan: Taoci juan* (*Complete Masterpieces of Chinese Cultural Relics: Ceramics*), Taipei, 1993

PERDUE 1996
Peter C. Perdue, 'Military Mobilisation in Seventeenth and Eighteenth-century China, Russia and Mongolia', *Modern Asian Studies*, 30.4 (1996), pp.757–93

PERDUE 1998
Peter C. Perdue, 'Boundaries, Maps, and Movement: Chinese, Russian and Mongolian Empires in Early Modern Central Eurasia', *The International History Review*, 20.2 (1998), pp.263–86

PERDUE 2005
Peter Perdue, *China Marches West, The Qing Conquest of Central Asia*, Cambridge, Mass., and London, 2005

PFISTER 1932
Louis Pfister, *Notices biographiques et bibliographiques sur les Jésuites de l'ancienne mission de Chine, 1552–1773*, Shanghai, 1932

PHOENIX 1985
Ju-hsi Chou and Claudia Brown, *The Elegant Brush: Chinese Painting Under the Qianlong Emperor, 1735–1795*, exh. cat., Phoenix Art Museum, 1985

PIRAZZOLI 1985
Michèle Pirazzoli-t'Serstevens, 'Kaiser Qianlongs Herbstjagden in Mulan', in Berlin 1985B, pp.156–62

PIRAZZOLI 2002
Michèle Pirazzoli-t'Serstevens, 'Europeomania at the Chinese Court: The Palace of the Delights of Harmony (1747–1751), Architecture and Interior Decoration', *Transactions of the Oriental Ceramic Society*, 65 (2002), pp.47–58

POINTON 1999
Marcia Pointon, 'Dealer in Magic: James Cox's Jewelry Museum and the Economics of Luxurious Spectacle in Late Eighteenth-century London', in Neil De Marchi and Craufurd D. W. Goodwin (eds), *Economic Engagements with Art*, Durham, NC, 1999, pp.423–51

POMERANZ 2000
Kenneth Pomeranz, *The Great Divergence: China, Europe and the Making of the Modern World Economy*, Princeton, 2000

PRECIOUS DEPOSITS
Yan Zhongyi et al. (eds), *Precious Deposits: Historical Relics of Tibet, China*, Beijing, 2000

QING GAOZONG SHILU
Da Manzhou diguo guowuyuan (ed.), *Daqing Gaozong Chunhuangdi shilu* (*The Veritable Records of the Reign of Gaozong [the Qianlong Emperor]*), Shenyang, 1937

QING GAOZONG YUZHI SHIWEN QUANJI
Qing Gaozong yuzhi shiwen quanji (*Complete Collection of the Poetry and Prose Composed by Gaozong [the Qianlong Emperor], of the Qing Dynasty*), 1749–1800 (reprinted by the National Palace Museum), 10 vols, Taipei, 1976

QING PORCELAIN 1989
Qing Porcelain of Kangxi, Yongzheng and Qianlong Periods from the Palace Museum Collection, Hong Kong, 1989

RAWSKI 1998
Evelyn S. Rawski, *The Last Emperors: A Social History of Qing Imperial Institutions*, Berkeley, 1998

RAWSKI 2004
Evelyn S. Rawski, 'The Qing Formation and the Early-modern Period', in Lynn A. Struve (ed.), *The Qing Formation in World-historical Time*, Cambridge, Mass., 2004

RAWSKI 2005
Evelyn S. Rawski, 'Qing Publishing in Non-Han Languages', in Brokaw and Chow 2005

RAWSON 1984
Jessica Rawson, *Chinese Ornament: The Lotus and the Dragon*, London, 1984

RAWSON 1992
Jessica Rawson (ed.), *The British Museum Book of Chinese Art*, London, 1992

RAWSON 1993
Jessica Rawson, 'The Ancestry of Chinese Bronze Vessels', in Steven Lubar and W. David Kingery (eds), *History from Things: Essays on Material Culture*, Washington DC, 1993, pp.51–73

RAWSON 1996
Jessica Rawson (ed.), *Mysteries of Ancient China: New Discoveries from the Early Dynasties*, exh. cat., British Museum, London, 1996

RAWSON 2000
Jessica Rawson, 'Cosmological Systems as Sources of Art, Ornament and Design', *Bulletin of the Museum of Far Eastern Antiquities, Stockholm*, 72 (2000), pp.133–89

RAWSON 2001
Jessica Rawson, 'The Many Meanings of the Past in China', in Dieter Kuhn and Helga Stahl (eds), *Die Gegenwart des Altertums, Formen und Funktionen des Altertumsbezugs in den Hochkulturen der Alten Welt*, Wurzburg, 2001, pp.397–421

RAWSON 2004
Jessica Rawson, 'Novelties in Antiquarian Revivals: The Case of the Chinese Bronzes', *National Palace Museum Research Quarterly*, 22.1 (Autumn 2004), pp.1–34

RAWSON 2004B
Jessica Rawson, 'The Naturalness of Chinese Bird and Flower Painting? Comments on the Origin of One of the Most Successful Design Systems in the World', The Clarke Lecture delivered on 4 November 2004 at the School of Oriental and African Studies, University of London, publication forthcoming

REN 2002
David Ren, *Classical Chinese Rocks*, Beijing, 2002

RHIE AND THURMAN 1991
Marylin M. Rhie and Robert A. F. Thurman, *Wisdom and Compassion: The Sacred Art of Tibet*, San Francisco, 1991

RHIE AND THURMAN 1999
Marylin M. Rhie and Robert A. F. Thurman, *Worlds of Transformation: Tibetan Art of Wisdom and Compassion*, New York, 1999

RIELY 1992
Celia Carrington Riely, 'Tung Ch'i-ch'ang's Life', in Kansas City 1992, pp.385–457

ROBINET 1990
Isabelle Robinet, 'The Place and the Meaning of the Notion of Taiji in Taoist Sources Prior to the Ming Dynasty', *History of Religions*, 29 (1990), pp.373–411

ROBINET 1993
Isabelle Robinet, *Taoist Meditation: The Mao-shan Tradition of Great Clarity*, Albany, 1993

ROTTERDAM 1990
The Forbidden City: Court Culture of the Chinese Emperors, exh. cat., Museum Boymans van Beuningen, Rotterdam, 1990

ROWE 2001
William T. Rowe, *Saving the World: Chen Hongmou and Elite Consciousness in Eighteenth-century China*, Stanford, 2001

ROY 1993
David Roy, *The Plum in the Golden Vase or Chin P'ing Mei*, Princeton, 1993

SAN FRANCISCO 1990
Wang Fangyu and Richard M. Barnhart, *Master of the Lotus Garden: The Life and Art of Bada Shanren (1626–1705)*, exh. cat., The Asian Art Museum, San Francisco; Yale University Art Gallery, New Haven, 1990–91

SANTA ANA 2000
Yang Xin and Zhu Chengru, *Secret World of the Forbidden City: Splendours from China's Imperial Palace*, exh. cat., The Bowers Museum of Cultural Art, Santa Ana, California, 2000

SCHIPPER 1975
Kristofer M. Schipper, *Concordance du Houang-t'ing King: Nei-king et Wai-king*, Paris, 1975

SCHMIDT-GLINTZER 1990
Helwig Schmidt-Glintzer, *Geschichte der chinesischen Literatur*, Bern, 1990

SCHROEDER 1981
Ulrich von Schroeder, *Indo-Tibetan Bronzes*, Hong Kong, 1981

SCHROEDER 2001
Ulrich von Schroeder, *Buddhist Sculptures in Tibet*, Hong Kong, 2001

SCOTT 1990
James C. Scott, *Domination and the Arts of Resistance: Hidden Transcripts*, New Haven, 1990

SHAANXI 2001
Shaanxi sheng kaogu yanjiusuo, 'Xi'an faxiande Bei Zhou Anjia mu' ('The Discovery of the Northern Zhou Tomb of Anjia at Xi'an'), *Wenwu*, 1 (2001), pp.4–26

SHAANXI 2003
Shaanxi sheng kaogu yanjiusuo (ed.), *Xi'an Bei Zhou Anjia mu* (*The Northern Zhou Tomb of Anjia at Xi'an*), Beijing, 2003

SHAN GUOQIANG 2000
Shan Guoqiang, *Jinling zhujia huihua* (*Paintings of Many Nanjing Artists*), in *Gugong bowuyuan cang wenwu zhenpin quanji* (*The Complete Collection of Treasures of the Palace Museum*), vol.10, Hong Kong and Shanghai, 2000

SHANG ZHINAN 1986
Shang Zhinan, 'Qingdaigong zhong de Guangdong zhongbiao' ('Guangzhou Clocks in the Qing Palace'), *Gugong bowuyuan yuankan*, 3 (1986), pp.10–12

SHANGSHU ZHUSHU
Kong Yingda (574–648), *Shangshu zhushu* (*Venerated Documents*), Taipei, 1986

SHAO YANYI 1996
Shao Yanyi, *Si Wang Wu Yun huihua* (*Paintings of the Four Wangs, Wu Li and Yun Shouping*), in *Gugong bowuyuan cang wenwu zhenpin quanji* (*The Complete Collection of Treasures of the Palace Museum*), vol.12, Hong Kong and Shanghai, 1996

SHIQU BAOJI
Zhang Zhao et al., *Shiqu baoji* (*Precious Collection of the Stone Moat [Pavilion]*), 1745; reprinted in *Bidian zhulin, Shiqu baoji*, 2 vols, National Palace Museum, Taipei, 1971

SHIQU BAOJI SANBIAN
Hu Jing et al., *Shiqu baoji sanbian* (*Precious Collection of the Stone Moat [Pavilion], Third Series*), 1816; reprinted in 9 vols by National Palace Museum, Taipei, 1969

SHIQU BAOJI XUBIAN
Wang Jie et al., *Shiqu baoji xubian* (*Precious Collection of the Stone Moat [Pavilion], Supplement*), 1793; reprinted in 7 vols by National Palace Museum, Taipei, 1971

SHI SHUQING 1994
Shi Shuqing (ed.), *Zhongguo wenwu jinghua daquan: Jin yin yu shi juan* (*Complete Masterpieces of Chinese Cultural Relics: Gold, Silver, Jade and Stone Volume*), Hong Kong, 1994

SHIZUOKA 1988
Pekin Kokyu Hakubutsuin ten: Shikinjo rekidai koshitsu no hiho (*Treasures from the Palace Museum*), exh. cat., The Seibu Museum of Art, Shizuoka, 1988

SIGGSTEDT 1991
Mette Siggstedt, 'Forms of Fate: An Investigation of the Relationship between Formal Portraiture, Especially Ancestral Portraits, and Physiognomy (*xiangshu*) in China', in *International Colloquium on Chinese Art History*, National Palace Museum, Taipei, 1991

SIGNATURES AND SEALS 1964
Joint Board of Directors of the National Palace Museum and the National Central Museum, Taichung, Taiwan, The Republic of China (compilers), *The Signatures and Seals of Artists, Connoisseurs and Collectors on Painting and Calligraphy since Tsin Dynasty*, 4 vols, Hong Kong, 1964

SILBERGELD 1974
Jerome Silbergeld, 'Political Symbolism in the Landscape Painting and Poetry of Kung Hsien (*c.*1620–1689)', PhD dissertation, Stanford University, 1974

SILBERGELD 1980
Jerome Silbergeld, 'Kung Hsien's Self-portrait in Willows, with Notes on the Willow in Chinese Painting and Literature', *Artibus Asiae*, 62 (1980), pp.5–38

SILBERGELD 1981
Jerome Silbergeld, 'Kung Hsien: A Professional Chinese Artist and His Patronage', *The Burlington Magazine*, 123.940 (July 1981), pp.400–10

SIMON AND NELSON 1977
Walter Simon and Howard Nelson (eds), *Manchu Books in London: A Union Catalogue*, London, 1977

SIRÉN 1963
Osvald Sirén, *The Chinese on the Art of Painting, Translations and Comments*, New York and Hong Kong, 1963

SOMMER 2000
Matthew H. Sommer, *Sex, Law and Society in Late Imperial China*, Stanford, 2000

SPENCE 1966
Jonathan D. Spence, *Ts'ao Yin and the K'ang-hsi Emperor: Bondservant and Master*, New Haven, 1966

SPENCE 1990
Jonathan D. Spence, *The Search for Modern China*, London, 1990

SPENCE 2001
Jonathan D. Spence, *Treason by the Book*, New York, 2001

STAUNTON *c.*1800
Sir George Staunton, *An Authentic Account of an Embassy from the King of Great Britain to the Emperor of China*, Dublin, *c.* 1800

STEIN 1990
Rolf Stein, *The World in Miniature: Container Gardens and Dwellings in Far Eastern Religious Thought*, Phyllis Brookes (trans.), Stanford, 1990

STRUVE 1984
Lynn A. Struve, *The Southern Ming, 1644–1662*, New Haven, 1984

STUART 1998
Jan Stuart, 'Imperial Pastimes: Dilettantism as Statecraft in the Eighteenth Century', in Chuimei Ho and Cheri A. Jones, *Proceedings of the Denver Museum of Natural History: Life in the Imperial Court of Qing Dynasty China*, series 3, 15 (1 November 1998), pp.55–66

STURMAN 1990
Peter C. Sturman, 'Cranes Above Kaifeng: The Auspicious Image at the Court of Huizong', *Ars Orientalis*, 20 (1990), pp.33–68

SYDNEY 1981
Edmund Capon and Mae Anna Pang, *Chinese Paintings of the Ming and Qing Dynasties, Fourteenth–Twentieth Centuries*, exh. cat., Art Gallery of New South Wales, Sydney, 1981

T 1050
Fo shuo dacheng zhuangyan baowang jing (Karandavyuha Sutra), in Takakusu Junjiro and Watanabe Kaikyoku (eds), *Taisho Shinshu Daizokyo (Taisho Tripitaka)*, 100 vols, Tokyo, 1924–34

TAIPEI 1971
Masterpieces of Chinese Tibetan Buddhist Altar Fittings in the National Palace Museum, National Palace Museum, Taipei, 1971

TAIPEI 1997
Cheng Chia-Hua (compiler), *The National Palace Museum's Ancient Inkstones Illustrated in the Imperial Catalogue Hsi-ch'ing yen-p'u*, Taipei, 1997

TAIPEI 1999
Ming Qing falang qi zhanlan tulu (Enamel Ware of the Ming and Qing Dynasties), National Palace Museum, Taipei, 1999

TAIPEI 1999B
Monarchy and Its Buddhist Way: Tibetan-Buddhist Ritual Implements in the National Palace Museum, National Palace Museum, Taipei, 1999

TAIPEI 2002
Feng Ming-chu (ed.), *Qianlong huangdi di wenhua daye (Emperor Ch'ien-lung's Grand Cultural Enterprise)*, exh. cat., National Palace Museum, Taipei, 2002

TAIPEI 2002B
Chen Hui-hsin (text), Peggy Wan (trans.), *Qing gong shihui: yuanzang Riben qiqi tezhan/ Japanese Lacquerware in the Ching Imperial Collection*, exh. cat., National Palace Museum, Taipei, 2002

TAIPEI 2003
Through the Prism of the Past: Antiquarian Trends in Chinese Art of the Sixteenth to Eighteenth Centuries, exh. cat., National Palace Museum, Taipei, 2003

TANG WENJI AND LUO QINGSI 1994
Tang Wenji and Luo Qingsi, *Qianlong zhuan (Biography of the Qianlong Emperor)*, Beijing, 1994

TIAN JIAQING 2001
Tian Jiaqing, *Ming Qing jiaju jizhen (Notable Features of Main Schools of Ming and Qing Furniture)*, Hong Kong, 2001

TOKYO 1985
Kokyu hakubutsuin ten – Shikinjyo no kyutei geijutsu (Catalogue of an Exhibition of Art of the Imperial Court in the Forbidden City, Qing Dynasty), exh. cat., Seibu Museum of Art, Tokyo, 1985

TOKYO 1989
Pekin Kokyu hakubutsuin: Shincho kyutei bunka ten (Beijing Palace Museum: An Exhibition of Qing Dynasty Court Culture), exh. cat., Nitchu Yuko Kaikan Bijutsukan, Tokyo, 1989

TOKYO 1995
Pekin Kokyu hakubutsuin Meiho ten (Treasures from the Palace Museum, Beijing), exh. cat., Tokyo Fuji Art Museum, Tokyo, 1995

TORBERT 1977
Preston M. Torbert, *The Ch'ing Imperial Household Department: A Study of Its Organisation and Principal Functions, 1662–1796*, Cambridge, Mass., 1977

UITZINGER 1993
Ellen Uitzinger, 'For the Man Who Has Everything: Western-style Exotica in Birthday Celebrations at the Court of Ch'ien-lung', in L. Blusse and H. Zurndorfer (eds), *Conflict and Accommodation in Early Modern East Asia*, Leiden, 1993

VEIT 2005
Willibald Veit, 'Ein Taihu-Stein auf Marmorsockel: Eine Neuerwerbung des Museums für Ostasiatische Kunst Berlin', *Ostasiatische Zeitschrift*, 9 (2005), pp. 51–53

VERSAILLES 2004
Kangxi, Empereur de Chine, 1662–1722. La Cité interdite à Versailles, exh. cat., Musée National du Château de Versailles, 2004

WADLEY 1991
Stephen A. Wadley, 'The Mixed-language Verses from the Manchu Dynasty in China', *Papers on Inner Asia*, 16 (1991)

WAKEMAN 1979
Frederick Wakeman Jr, 'The Shun Interregnum of 1644', in Jonathan D. Spence and John E. Wills Jr (eds), *From Ming to Ch'ing*, New Haven, 1979

WAKEMAN 1985
Frederic Wakeman Jr, *The Great Enterprise: The Manchu Reconstruction of Imperial Order in Seventeenth-Century China*, 2 vols., Berkeley, 1985

WALEY 1942
Arthur Waley (trans.), *Monkey by Wu Ch'eng-ên*, London, 1942

WALEY 1954
Arthur Waley, *The Book of Songs*, 2nd ed., London, 1954

WALEY-COHEN 1996
Joanna Waley-Cohen, 'Commemorating War in Eighteenth-century China', *Modern Asian Studies*, 30.4 (October 1996), pp.869–99

WALEY-COHEN 1999
Joanna Waley-Cohen, *The Sextants of Beijing: Global Currents in Chinese History*, New York, 1999

WALRAVENS 1991
Hartmut Walravens, 'Father Verbiest's Chinese World Map (1674)', *Imago Mundi*, 43 (1991), pp.31–47

WAN FORTHCOMING
Maggie Wan, *Ceramics in Context: Interpreting Subject-matter of Official Porcelain in the Jiajing Court (1522–1566)*, forthcoming

WAN YI, WANG SHUQING AND LU YANZHEN 1985
Wan Yi, Wang Shuqing and Lu Yanzhen (eds), *Qingdai gongting shenghuo (Daily Life in the Forbidden City: The Qing Dynasty)*, Hong Kong, 1985

WAN YI, WANG SHUQING AND LU YANZHEN 1988
Wan Yi, Wang Shuqing and Lu Yanzhen (eds), *Daily Life in the Forbidden City: The Qing Dynasty 1644–1912*, Rosemary Scott and Erica Shipley (trans.), Harmondsworth, 1988

WANG 1973
Yeh-chien Wang, *Land Taxation in Imperial China, 1750-1911*, Cambridge, Mass., 1973

WANG 2000
Aihe Wang, *Cosmology and Political Culture in Early China*, Cambridge, 2000

WANG JIANHUA 2003
Wang Jianhua, 'Emperor Yongzheng and His Pastimes', *Transactions of the Oriental Ceramic Society*, 67 (2002–03), pp.1–11

WANG JIAPENG 1990
Wang Jiapeng, 'Gugong Yuhua Ge tanyuan' ('Inquiry into the Origins of the Pavilion of Raining Flowers'), *Gugong bowuyuan yuankan*, 47 (1990), pp.50–62

WANG JIAPENG 1991
Wang Jiapeng, 'Zhongzheng Dian yu Qinggong Zangchuan fojiao' ('The Hall of Central Righteousness and Tibetan-style Buddhism in the Qing Palace'), *Gugong bowuyuan yuankan*, 53.2 (1991), pp.58–71

WANG JIAPENG 1996
Wang Jiapeng, 'Qinggong Zangchuan wenhua kaocha' ('An Investigation into Tibetan Cultural Style in the Qing Palace'), in Qingdai gongshi yanjiuhui (eds), *Qingdai zongzhi congtan*, Beijing, 1996

WANG LIYING 1999
Wang Liying (ed.), *Wucai, doucai (Porcelains in Polychrome and Contrasting Colours)*, in *Gugong bowuyuan cang wenwu zhanpin quanji (The Complete Collection of Treasures of the Palace Museum)*, Hong Kong, 1999

WANG QINGZHENG 2000
Wang Qingzheng, *Zhongguo taoci quanji: Qing (The Complete Works of Chinese Ceramics: Qing)*, 2 vols, Shanghai, 2000

WANG SHIXIANG 1990
Wang Shixiang, *Connoisseurship of Chinese Furniture: Ming and Early Qing Dynasties*, 2 vols, Hong Kong, 1990

WANG SHIXIANG 1993
Wang Shixiang, *The Charms of the Gourd*, Hong Kong, 1993

WANG XIANGYUN 2000
Wang Xiangyun, 'The Qing Court's Tibet Connection: Lcang skya Rol pa'i rdo rje and the Qianlong Emperor', *Harvard Journal of Asiatic Studies*, 60.1 (2000), pp. 125–63

WANG YINTIAN AND LIU JUNXI 2001
Wang Yintian and Liu Junxi, 'Datong Zhijiapu Bei Wei shiguo bihua' ('Wall Paintings on a Northern Wei Stone Coffin from Zhijiapu at Datong'), *Wenwu*, 7 (2001), pp.40–51

WANG YUANQI ET AL. 1718
Wang Yuanqi et al., *Wanshou shengdian quji (Magnificent Record of the Emperor's Birthday, First Collection)*, 1718

WANG ZILIN 1994
Wang Zilin, 'Qingdai gongshi' ('Qing Dynasty Bows and Arrows'), *Gugong bowuyuan yuankan*, 1 (1986), pp.79 and 86–97

WASHINGTON 2001
Jan Stuart and Evelyn S. Rawski, *Worshipping the Ancestors: Chinese Commemorative Portraits*, exh. cat., Freer Gallery of Art and Arthur M. Sackler Gallery, Smithsonian Institution, Washington DC, in association with Stanford University Press, 2001

WATSON 1961
Burton Watson (trans.), *Records of the Grand Historian of China, Translated from the Shih chi of Ssu-ma Ch'ien*, 2 vols, New York and London, 1961

WATSON 1963
William Watson, *Chinese Jade Books in the Chester Beatty Library*, Dublin, 1963

WATSON 1968
Burton Watson (trans.), *The Complete Works of Chuang Tzu*, New York, 1968

WATSON 1993
Burton Watson (trans.), *The Lotus Sutra*, New York, 1993

WATSON 1993B
Burton Watson (trans.), *Records of the Grand Historian by Sima Qian*, Hong Kong and New York, 1993

WAYMAN 1985
Alex Wayman (trans.), *Chanting the Names of Manjusri: The Manjusri Nama-Samgiti*, Boston, 1985

WEI DONG 1992
Wei Dong, '"Huangqing Zhigong tu" chuangzhi shimo' ('Complete Creation of "Qing Imperial Illustrations of Tributaries"'), *Zijin cheng (Forbidden City)*, 5 (1992), pp.8–12

WEI DONG 1995
Wei Dong, 'Qing Imperial "Genre Painting": Art as Pictorial Record', *Orientations*, 26.7 (1995), pp.18–24

WENG AND YANG BODA 1982
Wan-go Weng and Yang Boda, *The Palace Museum, Peking*, New York, 1982

WHITFIELD 1986
Roderick Whitfield, *Chinese Rare Books in the Percival David Foundation*, London, 1986

WHITFIELD 1993
Roderick Whitfield, *Fascination of Nature: Plants and Insects in Chinese Painting and Ceramics of the Yuan Dynasty (1279–1368)*, Seoul, 1993

WILSON 1986
Verity Wilson, *Chinese Dress*, London, 1986

WILSON 2004
Ming Wilson, *Chinese Jades*, London, 2004

WITEK 1994
John W. Witek SJ (ed.), *Ferdinand Verbiest SJ (1623–1688): Jesuit Missionary, Scientist, Engineer and Diplomat*, Nettetal, 1994

WOOD 2001
Frances Wood, *The Blue Guide: China*, London, 2001

WOODSIDE 2002
Alexander Woodside, 'The Ch'ien-lung Reign', in Willard J. Peterson (ed.), *The Cambridge History of China*, vol. 9, part one: *The Ch'ing Empire to 1800*, Cambridge, 2002

WU 1970
Silas H. L. Wu, 'Emperors at Work: The Daily Schedules of the K'ang-hsi and Yung-cheng Emperors, 1661–1735', *Tsing Hua Journal of Chinese Studies*, 8.1–2 (1970), pp.210–27

WU 1970B
Silas H. L. Wu, *Communication and Imperial Control in China: Evolution of the Palace Memorial System, 1693–1735*, Cambridge, Mass., 1970

WU 1979
Silas H. L. Wu, *Passage to Power: K'ang-hsi and His Heir Apparent, 1661–1722*, Cambridge, Mass., 1979

WU HUNG 1995
Wu Hung, 'Emperor's Masquerade: "Costume Portraits" of Yongzheng and Qianlong', *Orientations*, 26.7 (1995), pp.25–41

WU HUNG 1996
Wu Hung, *The Double Screen: Medium and Representation in Chinese Painting*, Chicago, 1996

WU HUNG 1998
Wu Hung, 'Ruins, Fragmentation, and the Chinese Modern/Postmodern', in Gao Minglu (ed.), *Inside Out: New Chinese Art*, exh. cat., San Francisco Museum of Modern Art; Asia Society Galleries, New York, 1998

XIA GENGQI, ZHANG RONG, CHEN RUNMIN AND LUO YANG 1995
Xia Gengqi, Zhang Rong, Chen Runmin and Luo Yang, *Masterpieces of Snuff Bottles in the Palace Museum*, Beijing, 1995

XIANG DA 1957
Xiang Da, 'Ji Niujin suocang de zhongwenshu' ('The Chinese Book Collection at Oxford University'), *Tangdai Chang'an yu Xiyu wenming*, Beijing, 1957

XIANG DA 1957B
Xiang Da, 'Ming Qing zhiji Zhongguo meishu suoshou xiyang zhi yingxiang' ('The Influence on Chinese Art by European Painting during the Ming and Qing Periods'), *Tangdai Chang'an yu Xiyu wenming*, Beijing, 1957

XIE ZHILIU 1991
Xie Zhiliu, *Zhongguo lidai shuhua jianbie tulu* (*Catalogue of Authenticated Chinese Painting and Calligraphy*), Beijing, 1991

XIQING GUJIAN
Liang Shizheng et al., *Xiqing gujian* (*Mirror of the Antiquities of the Western Apartments*), 1749

XU BANGDA 1984
Xu Bangda, *Gu shuhua wei'e kaobian* (*Verifying Fakes and Errors in Old Calligraphy and Painting*), 4 vols, Nanjing, 1984

XU QIXIAN 2004
Xu Qixian (ed.), *Gongting zhenbao* (*Treasures of the Imperial Court*), in *Gugong bowuyuan cang wenwu zhenpin quanji* (*The Complete Collection of Treasures of the Palace Museum*), Hong Kong, 2004

XU ZIZHI TONGJIAN
Bi Yuan (1730–1797), *Xu Zizhi tongjian* (*Continuation of the Comprehensive Mirror for Aid in Government*), Beijing, 1957

YANG BODA 1987
Yang Boda, *Qingdai Guangdong gongpin* (*Tribute from Guangdong in the Qing Dynasty*), Beijing and Hong Kong, 1987

YANG BODA 1987B
Yang Boda (ed.), *Zhongguo meishu quanji: Gongyi meishu bian 10: Jin yin boli falangqi* (*Complete Series on Chinese Art: Arts and Crafts Section, 10: Gold, Silver, Glass, Enamelware*), Beijing, 1987

YANG BODA 1991
Yang Boda, 'The Ch'ien-lung [Qianlong] Painting Academy', in Alfreda Murck and Wen C. Fong (eds), *Words and Images: Chinese Poetry, Calligraphy and Painting*, exh. cat., The Metropolitan Museum of Art, New York, with Princeton University Press, 1991

YANG BODA 1993
Yang Boda, 'Guan yu "Mashu tu" ticai de kaoding' ('The Review of the Scroll Horsemanship'), *Qingdaiyuanhua*, Beijing, 1993

YANG BODA 1993B
Yang Boda, '"Wanshuyuan ciyan tu" kaoxi' ('The Examination and Analysis of *The Imperial Banquet in the Garden of Ten Thousand Trees*'), *Qingdaiyuanhua*, Beijing, 1993

YANG BODA 1993C
Yang Boda, *Qingdai yuanhua* (*Academy Painting of the Qing Period*), Beijing, 1993

YANG JINGRONG 1999
Yang Jingrong, *Yanse you* (*Monochrome Porcelain*), in *Gugong bowuyuan cang wenwu zhanpin quanji* (*The Complete Collection of Treasures of the Palace Museum*), Hong Kong, 1999

YANG XIN 1981
Yang Xin, 'Liudai qiluo diwang zhou: jieshao *Kangxi Nanxuntu dishiyi juan* qianbanbu' ('Region of Monarchs and Silks for Six Dynasties: An Introduction to the First Half of the *Kangxi Southern Inspection Tour, Scroll Eleven*'), *Zijin cheng* (*Forbidden City*), 8 (1981), pp.19–23

YANG XIN 1981B
Yang Xin, 'Zhuangzai! Changjiang: *Kangxi Nanxuntu, dishiyi juan* houbanduan jieshao' ('How Grand! The Yangzi River: An Introduction to the Last Half of the *Kangxi Southern Inspection Tour, Scroll Eleven*'), *Zijin cheng* (*Forbidden City*), 9 (1981), pp.25–27

YANG XIN ET AL. 1997
Yang Xin, Nie Chongzheng, Lang Shaojun, Richard M. Barnhart, James Cahill, Wu Hung, *Three Thousand Years of Chinese Painting*, Yale and Beijing, 1997

YANG XIN 2000
Yang Xin (ed.), *Si seng huihua* (*Paintings of the Four Monks*), in *Gugong bowuyuan cang wenwu zhenpin quanji* (*The Complete Collection of Treasures of the Palace Museum*), vol.11, Hong Kong and Shanghai, 2000

YE PEILAN 1999
Ye Peilan (ed.), *Falangcai, fencai* (*Porcelains with Cloisonné Enamel Decoration and Famille Rose Decoration*), in *Gugong bowuyuan cang wenwu zhanpin quanji* (*The Complete Collection of Treasures of the Palace Museum*), Hong Kong, 1999

YEN CHUAN-YING 1986
Yen Chuan-ying, *The Tower of Seven Jewels: The Style, Patronage and Iconography of the T'ang Monument*, PhD dissertation, Harvard University, 1986

YU HUI 1995
Yu Hui, 'Naturalism in Qing Imperial Group Portraiture', *Orientations*, 26.7 (1995), pp.42–50

YU ZHUOYUN AND HUTT 1984
Yu Zhuoyun and Graham Hutt, *Palaces of the Forbidden City*, London and New York, 1984

YUAN LIEZHOU 1997
Yuan Liezhou (ed.), *Yangzhou bajia huaji* (*Album of Eight Yangzhou Painters*), Tianjin, 1997

ZELIN 1984
Madeleine Zelin, *The Magistrate's Tael: Rationalising Fiscal Reform in Eighteenth-century Ch'ing China*, Berkeley, 1984

ZELIN 2002
Madeleine Zelin, 'The Yung-cheng reign', chapter 4 of Willard J. Peterson (ed.), *The Cambridge History of China*, vol. 9, part one: *The Ch'ing Empire to 1800*, Cambridge, 2002

ZENG JIABAO 1990
Zeng Jiabao, 'Ji fenggong, shuweiji – Qing Gaozong shiquan wugong de tuxiang jilu gongchenxiang yu zhantu' ('Victories Commemorated: Pictorial Records of the Ten Perfect Military Achievements of the Qianlong Emperor. Portraits of Meritorious Officers and Battle Paintings'), *Gugong wenwu yuekan*, 9 (1990)

ZHANG GUANGWEN 1995
Zhang Guangwen (ed.), *Yuqi* (*xia*) (*Jadeware*), vol.3, in *Gugong bowuyuan cang wenwu zhenpin quanji* (*The Complete Collection of Treasures of the Palace Museum*), vol.42, Hong Kong, 1995

ZHANG QIONG 2004
Zhang Qiong, 'Guan gan qingdai di hou chaofu yu chaofu xiangde jidian kanfa', ('A Discussion of Portraits in Regalia of Qing Dynasty Emperors and Empresses and Several Ways of Viewing Court Dress'), *Gugong bowuyuan yuankan*, 3 (2004), pp.60–74

ZHANG RONG 1998
Zhang Rong, 'Qing Gong Yuzhi Jinxing Boli', ('Qing Palace Imperially Made Aventurine Glass'), *Zijin cheng* (*Forbidden City*), 3 (1998), pp.40–41

ZHANG YING 1968
Zhang Ying (1638–1708), *Nanxun hucong jilue* (*Records from the Retinue of the Southern Tour* [of 1689]). In *Shiliao congbian* (*Compilation of Historical Resources*), Taipei, 1968

ZHAOLIAN 1909
Zhaolian, *Xiao ting zalu* (*Miscellaneous Records from the Whistle Pavilion*), Beijing, 1909 (reprinted Beijing, 1980)

ZHONGGUO SHUDIAN CHUBANSHE 1998
Zhongguo shudian chubanshe, *Qingdai dihou xiang* (*Portraits of Emperors and Empresses of the Qing Dynasty*), Beijing, 1998

ZHONGGUO SHUHUAJIA YINJIAN KUANZHI 1987
Zhongguo shuhuajia yinjian kuanzhi (*Seals and Signatures of Chinese Calligraphers and Painters*), Shanghai Museum (ed.), 2 vols, Beijing, 1987

ZHOU BODI 1981
Zhou Bodi, *Zhongguo caizheng shi* (*History of Chinese Financial Administration*), Shanghai, 1981

ZHOU NANQUAN 1980
Zhou Nanquan, 'Inkstones of Songhua Stone (*Songhua shi yan*)', *Wenwu*, 1 (1980), pp.86–87 and 93

ZHOU NANQUAN 1991
Zhou Nanquan, 'Lun kongqian fada de Qianlong chao yuqi' ('On the Unprecedented Development of Jade Sculpture under the Qianlong Emperor'), in *Gugong wenwu yuekan*, 9.8 (1991), pp.100–19

ZHU JIAJIN 1986
Zhu Jiajin (chief compiler), Graham Hutt (consulting ed.), *Treasures of the Forbidden City* (originally published as *Guobao*), Harmondsworth, 1986

ZHU JIAJIN 1988
Zhu Jiajin, 'Yongzheng Lacquerware in the Palace Museum, Beijing', *Orientations*, 19.3 (1988), pp.28–39

ZHU JIAJIN 1988B
Zhu Jiajin, 'Castiglione's *Tieluo* Paintings', *Orientations*, 19.11 (1988), pp.80–83

ZHU JIAJIN 1993
Zhu Jiajin (ed.), *Zhongguo qiqi quanji* (*Complete Series on Chinese Lacquer*), vol.6: *Qing*, Fujian, 1993

ZHU JIAJIN 2003
Zhu Jiajin (ed.), *Yangxin dian Zaoban chu shiliao jilan* (*Reader of Historical Material on the Workshops in the Hall of Mental Cultivation*), Beijing, 2003

ZHU JIAPU 2004
Zhu Jiapu, *Ming Qing shinei chenshe* (*Interior Decoration in the Ming and Qing Dynasties*), Beijing, 2004

ZHU JIAQIAN 2002
Zhu Jiaqian (ed.), *Ming Qing jiaju (shang)* (*Furniture of the Ming and Qing Dynasties*), vol.1, in *Gugong bowuyuan cang wenwu zhenpin quanji* (*The Complete Collection of Treasures of the Palace Museum*), vol.53, Hong Kong, 2002

ZHU JIAQIAN 2002B
Zhu Jiaqian (ed.), *Ming Qing jiaju (xia)* (*Furniture of the Ming and Qing Dynasties*), vol.2, in *Gugong bowuyuan cang wenwu zhenpin quanji* (*The Complete Collection of Treasures of the Palace Museum*), vol.54, Hong Kong, 2002

ZHU RENXING 1999
Zhu Renxing, 'Fojia zhenbao: qi zheng bao yu ba jixiang (shang)' ('Buddhist Treasures: The Seven Royal Treasures and the Eight Auspicious Symbols, part 1'), *Gugong wenwu yuekan*, 196 (1999), pp.4–23

ZHU RENXING 1999B
Zhu Renxing, 'Fojia zhenbao: qi zheng bao yu ba jixiang (xia)' ('Buddhist Treasures: The Seven Royal Treasures and the Eight Auspicious Symbols, part 2'), *Gugong wenwu yuekan*, 197 (1999), pp.20–33

ZITO 1995
Angela Zito, 'The Imperial Birthday: Ritual Encounters Between the Panchen Lama and the Ch'ienlong Emperor in 1780,' paper presented at the Conference on State and Ritual in East Asia, organised by the Committee for European/North American Scholarly Cooperation in East Asian Studies, Paris, 1995

ZITO 1997
Angela Zito, *Of Body and Brush*, Chicago, 1997

List of Works in Chinese Characters

1 佚名 (宮庭畫家), 《康熙朝服像》軸, 康熙晚期

2 佚名 (宮庭畫家), 《雍正朝服像》軸, 雍正

3 明黃色彩雲龍金妝男朝服, 康熙

4 纓料石頂冬朝冠, 乾隆

5 明黃男龍袍, 乾隆

6 佚名 (宮庭畫家), 《乾隆朝服像》軸, 乾隆

7 石青五彩雲金裌朝褂, 雍正(?)

8 明黃色女朝服, 乾隆

9 銅鎏金掐絲琺瑯龍一對, 乾隆

10 佚名 (宮庭畫家), 《孝聖皇后像》軸, 乾隆十六年

11 徐揚, 《京師生春詩意圖》軸, 乾隆三十二年

12 佚名 (宮庭畫家), 《臚歡薈景》冊, 清中

13 王翬 等, 《康熙南巡圖》第十一卷: 《南京至金山》, 康熙三十年 至 三十八年

14 徐揚 等, 《乾隆南巡圖》第十二卷: 《回鑾》, 乾隆二十九年 至 四十五年

15 佚名 (宮庭畫家), 《雍正十二月行樂圖》軸; 一月; 四月; 五月; 八月; 九月; 十二月

16 傳朗世寧, 《歲朝行樂圖》軸, 乾隆元年 至 二年

17 紫檀邊嵌紅漆雲龍紋屏風, 乾隆

18 紫檀邊嵌紅漆雲龍紋寶座, 乾隆

19 紫檀腳踏, 乾隆

20 掐絲琺瑯鶴, 乾隆

21 碧玉甪端一對, 乾隆

22 碧玉香筒一對, 乾隆

23 掐絲琺瑯地爐一對 乾隆

24 佚名 (宮庭畫家), 《倣康熙六旬萬壽慶典圖》第一卷, 清中

25 佚名 (宮庭畫家), 《乾隆八旬萬壽慶典圖》第二卷, 嘉慶二年

26 郎世寧 等, 《弘曆射獵圖》軸, 乾隆二十年

27 冷枚, 《避暑山庄圖》軸, 康熙五十二年

28 郎世寧 和 方琮, 《乾隆"薄行"詩意圖》軸, 乾隆二十三年

29 郎世寧 等, 《弘曆擊鹿圖》, 乾隆七年(?)

30 金昆, 程志道 和 福隆安, 《冰嬉圖》卷, 乾隆中期

31 碧玉描金雲龍紋編磬, 乾隆二十九年

32 銅鍍金雲龍紋編鐘, 康熙五十二年

33 月白色彩云龍妝花裌朝服, 雍正

34 白釉凸紋豆, 乾隆

35 白釉凸紋簠, 乾隆

36 白釉凸紋鉶, 乾隆

37 白釉凸紋簋, 乾隆

38 佚名 (宮庭畫家), 《雍正祭先農壇圖》卷, 雍正

39 五方佛像, 乾隆三十七年

40 銅文殊菩薩坐像, 清中

41 西藏, 五方佛像, 十三世紀

42 萬事大利益諸像佛威德吉祥天母, 乾隆四十二年

43 繡八吉祥與七政寶桌圍, 清中

44 琺瑯五供: 香爐; 燭臺; 花觚, 乾隆

45 碧玉七政寶, 清中

46 碧玉八吉祥: 輪; 螺; 傘; 運花; 罐; 魚; 腸, 清中

47 佚名, 《乾隆普寧寺佛裝像》軸, 約乾隆二十三年

48 紅緞繡瓔珞法衣, 清中

49 乾隆御筆, 《喇嘛說》, 乾隆五十七年

50 《大度經》, 清中

51 世章嘉國師坐像, 乾隆五十四年

52 金嵌寶石佛塔, 乾隆

53 琺瑯壇城, 清中

54 金胎畫琺瑯仕女四季花卉紋掐絲琺瑯多穆壺, 乾隆款

55 彷木多穆瓷壺, 雍正 或 乾隆

56 仿錫壽瓶, 乾隆款

57 鎏金銀藏草瓶, 清中

58 嘎巴拉碗, 清中

59 玉刻經鉢, 清中

60 御書黃庭內景外景經, 乾隆

61 佚名 (宮庭畫家), 《康熙戎裝像》軸, 康熙

62 石青色緞綉彩雲藍龍綿甲, 康熙早期

63 黑漆描金肩輿, 乾隆

64 奉天誥命, 康熙六十一年

65 郎世寧, 《乾隆大閱圖》軸, 乾隆四年 或 乾隆二十三年

66 銀絲花緞嵌紅寶石囊韃, 乾隆,

67 樺皮弓, 清

68 白檔索倫長鈚箭, 清

69 鐵鋄金鏤龍馬鞍, 乾隆

70 紅魚皮鞘寶劍, 乾隆

71 玉柄金桃皮鞘腰刀, 乾隆

72 玉柄嵌寶石皮鞘匕首, 乾隆

73 綠魚皮鞘嵌玻璃腰刀, 乾隆

74 鑲鐵嵌料珠把桃皮鞘腰刀, 乾隆

75 郎世寧 等, 《平定西域戰圖》冊, 乾隆三十一 至 三十九年

76 傳朗世寧, 王致誠, 艾啟蒙 等, 《萬樹園賜宴圖》橫幅, 乾隆二十年

77 佚名 (宮庭畫家), 《皇清職貢圖卷》第四卷: 《雲南, 貴州, 廣西》, 乾隆

78 姚文瀚, 《紫光閣賜宴圖》卷, 乾隆

79 郎世寧, 《嵩獻英芝圖》軸, 雍正二年

80 郎世寧, 《花鳥圖》軸, 雍正

81 賀清泰, 《賁鹿圖》軸, 乾隆五十五年

82 張為邦, 《歲朝圖》軸, 清中

83 佚名 (宮庭畫家), 《萬國來朝圖》軸, 乾隆二十六年

84 艾啟蒙, 《十駿犬》冊, 乾隆十年 至 二十三年

85 乾隆制銅鍍金三辰儀, 乾隆十一年

86 銀鍍金懷仁款渾天儀, 康熙八年

87 銅制測高弧象限儀, 康熙

88 嵌琺瑯孔雀尾形地平式日晷儀, 乾隆

89 南懷仁, 《靈臺儀像志》, 康熙十三年

90 南懷仁, 《坤輿全圖》, 康熙十三年

91 《圓明園, 西洋樓圖》冊, 乾隆晚期

92 英國倫敦威廉森製造, 銅鍍金塔式鐘, 十八世紀

93 英國倫敦考克斯製造, 銅鍍金鴕鳥鐘, 十八世紀

94 廣州製造, 銅鍍金嵌琺瑯四面鐘, 乾隆

95 木製塔式轉八仙樂鐘, 乾隆

List of Seals in Chinese Characters

Bada Shanren 八大山人
Baoji chongbian 寶笈重編
Baoji sanbian 寶笈三編
Bazheng maonian zhi bao 八徵耄念之寶
Bidian xinbian 秘殿新編
Bidian zhulin 秘殿朱林

Candaozhe 殘道者
Chen Fanggang 臣方綱
Chen Leng Mei 臣冷枚
Chiji qing yan 敕幾清晏
Ci huazeng shenxing wanli 此畫曾身行萬里

Deng Yan 鄧琰

Fu Shan yin 傅山印

gong 恭
Gong Xian 龔賢
Gonghua 恭畫
Guiwei zai he 癸未在和
Guxi tianzi 古稀天子
Guxi tianzi zhi bao 古稀天子之寶

Heyuan 何園
Hongli tushu 弘曆圖書
Hu Zao 胡慥
hua 畫
Hua Yan zhi yin 華嵒之印
Huang sizi zhang 皇四子章

Ji Shanseng 濟山僧
Jiaoyubu dianyan zhi zhang 教育部點驗之章
Jiaqing yu jian zhi bao 嘉慶禦鑑之寶
Jieqiu 介丘
Jigu youwen zhi zhang 稽古佑文之章
Jin Nong yin xin 金農印信
Jing shu 敬書

Kangxi chen han 康熙宸翰
Kerou 克柔

Laotao 老濤
Leshan tang tushu ji 樂善堂圖書記
Liangfeng 兩峰
Linshang zhai zhencang 林上齋珍藏
Liushi bu chu weng 六十不出翁
Lu Runzhi jiancang 陸潤之鑒藏

Minyuan zhencang 岷源珍藏

Pang Yuanji 龐元濟
Puyuan 璞園

Qianlong chen han 乾隆宸翰
Qianlong jianshang 乾隆鑑賞
Qianlong yu bi 乾隆御筆
Qianlong yulan zhi bao 乾隆御覽之寶
Qiukong yihe 秋空一鶴
Qiuyue 秋岳
Quan shu 銓書

Sanwu jiuyou 三無九有
Sanxi tang 三希堂
Sanxi tang jingjian xi 三希堂精鑑璽
Sheng yu dingmao 生於丁卯
Shining 世寧
Shiqi 石谿
Shiqu baoji 石渠寶笈
Shiqu baoji suo cang 石渠寶笈所藏
Shiqu dingjian 石渠定鑑
Shiquan laoren zhi bao 十全老人之寶
Shiru 石如
Suo bao wei xian 所寶惟賢
Suye Feixie 夙夜匪懈

Taicun zuohua 邰村作畫
Taishang huangdi zhi bao 太上皇帝之寶
Tongyin guan yin 桐隱館印

Wang Shimin yin 王時敏印
Wei jing wei yi 惟精惟一
Wei jun nan 為君難
Wufu wudai tang guxi tianzi bao
　五福五代堂古稀天子寶

Xi Lu laoren 西盧老人
Xiao shuhua fang mi wan 小書畫舫秘玩
Xiaoke yinge 小窠隱閣
Xin yu 心餘
Xuantong zunqin zhi bao 宣統尊親之寶

Yan Xiaofang zhencang jinshi shuhua
　yin 嚴小舫珍藏金石書畫印
Yeyi 野遺
Yi zisun 宜子孫
Yipian bingxin 一片冰心
Yiru buyou 意入不由
Yongzheng chen han 雍正宸翰
You ri zizi 猶日孜孜
Yousheng yinxin 友聲印信
yu de qin min 育德勤民
Yuanjian hui hao 淵鑑揮毫
Yuanjian zhai 淵鑑齋
Yuanming yuan bao 圓明園寶

Zhao qian xi ti 朝乾夕惕
Zheng Xie yin 鄭燮印
Zhenshang 真賞
Zhongshan yelao 鍾山野老
Zhulin chongding 珠林重定
Zhupo 竹坡

Lenders to
the Exhibition

Photographic
Acknowledgements

Index

*All references are to page numbers;
those in italic type indicate catalogue
plates and essay illustrations*